A World History of
Women Photographers

A World History of
Women Photographers

Edited by
Luce Lebart and Marie Robert

Note from the publishers
The geopolitical upheavals that marked the nineteenth and
twentieth centuries led to many changes in the map of the world
and in the names of countries. We have chosen to list the places
where photographers were born and died by their current names.

On the cover: *Gaze 2* by Angèle Etoundi Essamba, 1998

Translated from the French *Une histoire mondiale des
femmes photographes* by Ruth Taylor and Bethany Wright

First published in the United Kingdom in 2022 by
Thames & Hudson Ltd, 181A High Holborn, London WC1V 7QX

First published in the United States of America in 2022 by
Thames & Hudson Inc., 500 Fifth Avenue, New York, New York 10110

Original edition: *Une histoire mondiale des femmes photographes*
© 2020 Éditions Textuel, Paris
This edition © 2022 Thames & Hudson Ltd, London

This book was published with the support
of the Rencontres d'Arles and Kering

Design by Agnès Dahan Studio
Edited and typeset by Andrew Brown at Art Books Publishing Ltd

British Library Cataloguing-in-Publication Data
A catalogue record for this book is available from the British Library

Library of Congress Control Number 2021949788

ISBN 978-0-500-02541-3

Printed and bound in Belgium by Graphius

Be the first to know about our new releases,
exclusive content and author events by visiting
thamesandhudson.com
thamesandhudsonusa.com
thamesandhudson.com.au

In 2019, the Rencontres d'Arles and Kering announced their partnership and the launch in Arles of the *Women In Motion* programme, which Kering started in 2015, and set up an ambitious project to boost the visibility of past and present women photographers and to foster debates on how to achieve gender parity. Each year, the Rencontres d'Arles bestows the *Women In Motion* Award on an accomplished photographer: Susan Meiselas in 2019 and Sabine Weiss in 2020. We wanted to go further and encourage projects to highlight women in photography by creating the *Women In Motion* LAB. *Une Histoire mondiale des femmes photographes*, published by the French publisher Textuel, was its first endeavour. For two years, the brilliant French historians Luce Lebart and Marie Robert researched this book-manifesto, an ambitious project that gives women photographers from the five continents the place that they deserve. This reference book highlights the importance of their contributions with texts by 160 women authors from around the world, who have documented the work of 300 women photographers over nearly two centuries. The Rencontres d'Arles and Kering are proud to support this important publication, a necessary contribution to a re-reading of the history of photography. The Thames & Hudson translation will allow readers across the world to enjoy *A World History of Women Photographers*.

Sam Stourdzé
Director of the Rencontres d'Arles 2014–20

Towards a world history
of women photographers

Luce Lebart and Marie Robert

'Do women have a history?', asked Michelle Perrot in 1973, inaugurating a course with the eponymous title, almost twenty years before she co-edited with Georges Duby the monumental *Histoire des femmes en Occident*.[1] In the realm of photography, very few women have gained fame, and those whose names have come down to us are rare. The pantheon of photographers remains predominantly male: from Félix Nadar to Richard Avedon, Eugène Atget to André Kertész, Robert Capa, Robert Doisneau, Robert Frank and Henri Cartier-Bresson, to cite but a handful of the names familiar to readers. With the exception of a few recurrent figures – far less known to the general public than their male counterparts – such as Dorothea Lange, Germaine Krull, Diana Arbus and Berenice Abbott, women have had very little coverage in general histories of photography, particularly in France. This historiographical vacuum, transformed into a cultural 'void', was highlighted in 2004 by the Swedish historian of photography Anna Tellgren,[2] who summed up the situation in France by indicating the low number of monographic studies devoted to female figures, the rarity of nineteenth-century women photographers in anthologies, and the non-existence of global approaches explicitly posing the issue of gender. The 'desire to discover' the role of women in the history of photography has long been of secondary importance, even absent. Its literature, for the most part constituted through the construction of great men,[3] whether inventors, artists, geniuses, and through the designation of 'cultural institutions', has been primarily about the achievements of men, and aimed at men.[4] Like many fields in art, science or politics, 'the Matilda effect'[5] – a concept coined by the historian Margaret W. Rossiter to indicate the mechanisms of denial and minimization of women's contribution to the history of the sciences in the United States – is evident in the realm of photography. Even when they succeeded in gaining true recognition by their peers in their lifetime, women have tended systematically to disappear from the broader narrative of creativity.

1 Georges Duby and Michelle Perrot, *Histoire des femmes en Occident*, Paris: Plon, 1990–1, 5 vols; English translation, *A History of Women in the West*, London: Belknap Press, 1992.

2 Anna Tellgren, 'Les Femmes photographes: Aspects of French Photo History From the Perspective of Women Photographers', in Lena Johannesson and Gunilla Knape (eds), *Women Photographers: European Experience*, Gothenburg: Acta Universitatis Gothoburgensis, 2004.

3 Linda Nochlin, 'Why Have There Been No Great Women Artists?', *Artnews*, 1971.

4 Françoise Thébaud, *Écrire l'histoire des femmes et du genre*, Lyon: ENS Éditions, 2007.

5 Margaret W. Rossiter, 'The Matthew/Matilda Effect in Science', *Social Studies of Science*, vol. 23, no. 2 (May 1993), pp. 325–41.

The silences of the general histories of photography in France

Without listing here the entire historiographical production in the French language since the publication of Raymond Lécuyer's seminal *Histoire de la photographie* [6] (which, in 1945, mentioned only two women, Julia Margaret Cameron and Laure Albin Guillot!), it must be acknowledged that French universalism has barely considered the contribution made by women photographers. In 2015, Ulrich Pohlmann examined in detail their critical fortune in Western historiography during the nineteenth and twentieth centuries. He thus noted that the index to Jean-Claude Lemagny and André Rouillé's *Histoire de la photographie*, [7] compiled in 1986, contained at most seventy women's names out of a total of almost one thousand, [8] even though the content was the result of a 'polycephalous author': fifteen or so male and female contributors of varying profiles and eight different nationalities. In 1994, Michel Frizot published his impressive *Nouvelle histoire de la photographie*, [9] in which he allocated the thematic chapters to the specialists of the time. This approach was novel in that it consisted of acknowledging the plurality of the medium's players, functions and destinations, in short, conceiving photography as a social fact. Thus, the volume presented corpuses of images unseen until then. Through fifteen cases studies, the table of contents gave pride of place to several prominent figures: Nicéphore Niépce, Oscar Rejlander, Eadweard Muybridge, Eugene Smith and Minor White. Not a single entry, however, was assigned to a woman. In 2007, in *L'Art de la photographie, des origines à nos jours*, [10] André Gunthert and Michel Poivert presented a 'critical, cultural, social and technical approach to the history of photography', turning again to the great masters of the canonical history. Like their predecessors, they relied on the contribution of eleven researchers in the history of photography, university lecturers or museum curators, who had for many years gathered under the auspices of the Société Française de Photographie. Of course, it is reductive to confine ourselves to numbers, but they are telling: Pohlmann counted only forty-six images produced by women, that is to say eight per cent of the six hundred illustrations in the book. As we shall see later, since then the boundaries have powerfully shifted. To take one example, in his extensive survey of French photography since 1970, Michel Poivert was at pains to redress the balance: forty per cent of the illustrations reproduced in the book were by women. [11]

Women's gaze

Our publication belongs within the process of reframing that has taken place over the past forty years through feminist re-readings in the history of photography. The first publications to question the negative impact of sexual identity in photographic practice initially appeared in the United States, followed by Britain, Germany and, later on, France. In 1973, in *The Woman's Eye*, [12] Anne Tucker tackled the role played by gender in photographic production as well as in the reception of the works by ten North American (female) photographers. Two years later, Margery Mann and Anna Noggle followed in her footsteps with the catalogue to the exhibition *Women of Photography: An Historical Survey*, [13] held at the San Francisco Museum of Modern Art. Edited by Jeanne Moutoussamy-Ashe, in 1986 the book *Viewfinders:*

6 Raymond Lécuyer, *Histoire de la photographie*, Paris: Baschet & Cie, 1945.

7 Jean-Claude Lemagny and André Rouillé, *Histoire de la photographie*, Paris: Bordas, 1986.

8 Ulrich Pohlmann, 'Elle vient, la nouvelle femme photographe!', in Thomas Galifot, Ulrich Pohlmann and Marie Robert (eds), *Qui a peur des femmes photographes? 1839–1945*, exh. cat., Paris: Musée d'Orsay and Musée de l'Orangerie, 14 October 2015 – 25 January 2016, pp. 276–91.

9 Michel Frizot (ed.), *Nouvelle histoire de la photographie*, Paris: Bordas and Adam Biro, 1994.

10 André Gunthert and Michel Poivert (eds), *L'Art de la photographie, des origines à nos jours*, Paris: Citadelles & Mazenod, 2007.

11 Michel Poivert, *50 ans de photographie française, de 1970 à nos jours*, Paris: Textuel, 2019.

12 Anne Tucker (ed.), *The Woman's Eye*, New York: Alfred A. Knopf, 1973.

13 Margery Mann and Anne Noggle (eds), *Women of Photography: An Historical Survey*, exh. cat., San Francisco: San Francisco Museum of Modern Art (SFMOMA), 18 April–15 June 1975.

Black Women Photographers[14] presented a history of female African-American photography. Following the publication in 1990 of *Women Photographers*[15] by Constance Sullivan and Eugenia Parry Janis, Naomi Rosenblum's[16] historical survey of women photographers, predominantly North American and European, published in 1994 marked an important step. Through the richness of its index, its scope, and the quality of the illustrations, the book helped to raise awareness, on one hand, that many iconic photographers in history were women and, on the other, that women had contributed in their hundreds, particularly in the case of the United States, to the formation and growth of the world of photography. For his part, from 1977 until his death in 2003, Peter E. Palmquist, a self-taught freelance historian, rescued from oblivion, like an archaeologist, dozens of (women) photographers, many of them from California.[17] He had also provided a significant amount of the material for Naomi Rosenblum's book. In 2010, it was the turn of the American museums to take up the issue of the historiography: the exhibition *Modern Women: Women Artists at the Museum of Modern Art*[18] (and the accompanying catalogue edited by Cornelia Butler and Alexandra Schwartz) offered the opportunity to re-examine, adopting a feminist approach, not only the fundamental contribution of female artists to the avant-gardes of the twentieth century, but also that of the women who had enabled the New York museum to exist and develop: its female founders, patrons, curators, etc.

Research of a similar kind was also undertaken, this time in Europe, in the 1980s, often on the initiative of women: in 1986, Val Williams published an anthology of essays on photography[19] written exclusively by women, whether photographers, journalists, academics or curators of collections. This initial, extensive selection mainly concerned the Anglo-Saxon world. In 1985, in Germany, Brigitte Bruns and Rudolf Herz researched the Munich-based Elvira studio, managed at the beginning of the twentieth century by the two feminists Anita Augspurg and Sophia Goudstikker, while Ute Eskildsen rediscovered several German women photographers from the interwar period. In 1994, she published the summary *Fotografieren hieß teilnehmen: Fotografinnen der Weimarer Republik*.[20] The work of women artists was also highlighted in Berlin, from 1986, by Marion Beckers and Elisabeth Moortgat in the Verborgene Museum documentary centre. The related publications, such as those dedicated to Marianne Breslauer, Eva Besnyö, Lotte Jacobi or Yva, often constituted the first acknowledgment of these artists' work in Germany since 1945. In 2008, the Pinakothek der Moderne in Munich staged the exhibition by Inka Graeve Ingelmann *Female Trouble: Die Kamera als Spiegel und Bühne weiblicher Inszenierungen*,[21] which showed how women appropriated the medium to question and deconstruct stereotypes associated with women. The following year, in her book *Femmes photographes: Émancipation et performance (1850–1940)*,[22] the Italian Federica Muzzarelli examined the performative practices of twelve of these women.

14 Jeanne Moutoussamy-Ashe, *Viewfinders: Black Women Photographers*,
 New York and London: Writers & Readers Publishing, Inc., 1993.

15 Constance Sullivan (ed.), *Women Photographers*, New York: Abrams, 1990.

16 Naomi Rosenblum, *A History of Women Photographers*, New York: Abbeville Press, 1994.

17 Among other references in the bibliography of this work, we cite Peter E. Palmquist,
 Shadowcatchers I: A Directory of Women in California Photography Before 1901, Arcata, CA:
 self-published, 1990, and *Shadowcatchers II: A Directory of Women in California Photography
 1900–1920*, Arcata, CA: self-published, 1991.

18 *Modern Women: Women Artists at the Museum of Modern Art*,
 New York: Museum of Modern Art, New York, 2010.

19 Val Williams, *Women Photographers: The Other Observers, 1900 to the Present*,
 London: Virago Press, 1986.

20 Ute Eskildsen (ed.), *Fotografieren hieß teilnehmen: Fotografinnen der Weimarer Republik*,
 exh. cat., Essen: Museum Folkwang, 1994.

21 *Female Trouble: Die Kamera als Spiegel und Bühne weiblicher Inszenierungen*,
 Munich: Pinakothek der Moderne, 18 July – 26 October 2008.

22 Federica Muzzarelli, *Femmes photographes: Émancipation et performance (1850–1940)*,
 Paris: Hazan, 2009.

The proliferation of publications was not confined to monographs – it also included major collective projects, such as *Women Photographers: European Experience*, the result of a transnational research project led by Lena Johannesson and Gunilla Knape in Gothenburg. Ten contributors examined the working conditions and experience of female photographers from 1839 onwards, in Denmark, as well as in Sweden, Germany, Poland, Italy and France. In the same year, the historian and art critic Gabriele Schor founded the Verbund collection in Vienna, with the aim of highlighting the pioneering role of feminist artists in the 1970s, many of whom adopted photography. The catalogue raisonné of Cindy Sherman's early works, monographs on Birgit Jürgenssen, Francesca Woodman, Renate Bertlmann – not only were dozens of female artists rediscovered in this way, but also the congruity of a multitude of women on both sides of the Atlantic who, in the 1960s and 1970s, questioned their gender identity, were critical of the relationships of domination between the sexes, shook up social conventions. From the (her)historian's point of view, new connections were established between their approaches and those of the generations that preceded them. How can we not find, for example, edifying similarities between VALIE EXPORT's swapping of identities, Birgit Jürgenssen's sexual allusions, Eleanor Antin's games with beards, the performances of Alexis Hunter, etc. and the tableaux vivants by Lady Hawarden, who dressed her daughters up and made them play ambiguous role-playing games at the height of the Victorian era, those of Alice Austen, who with her friends, the daughters of orderly clergymen, mocked male rituals through images, or in the highly transgressive and anti-establishment mise en scène contesting the patriarchal order produced by Marie el-Khazen in Lebanon during the 1920s, those by Claude Cahun in France, or Elisabeth Hase in Germany during the interwar period?

Who's afraid of women photographers?

In France, however, it was thanks to a man, a non-academic historian and collector, that the focal point shifted: in the 1980s, Christian Bouqueret strove to obtain recognition for significant female figures in the interwar period, including Germaine Krull, Ergy Landau and Nora Dumas, to whom he dedicated exhibitions and monographs. In 1998, he published the synthesis of his studies, *Les Femmes photographes: De la nouvelle vision en France, 1920–1940*.[23] In 2007, the book *Femmes artistes, artistes femmes: Paris, de 1880 à nos jours*[24] by Catherine Gonnard and Élisabeth Lebovici re-examined the path of female photographers in Paris in the interwar period and highlighted the importance of the notion of a network to facilitate their careers.

Several French institutions then reconsidered the significance of women in history. From 2006, at the Jeu de Paume, Marta Gili created a programme including artists such as Dorothea Lange, Lee Miller, Sophie Ristelhueber, Lisette Model, Claude Cahun, Diane Arbus and Susan Meiselas. In 2009, Jorge Calado curated the exhibition *Au féminin: Women Photographing Women* at the Calouste Gulbenkian cultural centre in Paris.[25] Concurrently, at the Musée National d'Art Moderne, the important exhibition *elles@centrepompidou*, conceived and directed by Camille Morineau,[26] presented a selection of three hundred and fifty works by one hundred and fifty artists of the twentieth century, many of them female photographers. The decision to exhibit only women was as welcomed as it was contested: 'The Centre Pompidou glorifies women at the risk of placing them in a ghetto.'[27] Nevertheless, the fact that a major national institution had adopted this stance paved the way for similar approaches.

23 Christian Bouqueret, *Les Femmes photographes: De la nouvelle vision en France, 1920–1940*, Paris: Marval, 1998.

24 Catherine Gonnard and Élisabeth Lebovici, *Femmes artistes, artistes femmes: Paris, de 1880 à nos jours*, Paris: Hazan, 2007.

25 *Au féminin: Women Photographing Women*, Paris: Centre Culturel Calouste Gulbenkian, 24 June–29 September 2009.

26 *elles@centrepompidou*, Paris: Centre Pompidou, 27 May 2009 – 21 February 2011.

27 Emmanuelle Lequeux, *Le Monde*, 28 May 2009.

In 2014, the Promenades Photographiques de Vendôme was dedicated to female photographers. The following year, the exhibition *Qui a peur des femmes photographes?* – Who's afraid of women photographers? – at the Musée d'Orsay and the Musée de l'Orangerie (curated by Thomas Galifot, Ulrich Pohlmann and Marie Robert) marked a milestone by displaying the works of one hundred and eighty female photographers active between 1839 and 1945, principally in Europe and North America. The exhibition did not consist in presenting a selection of masterpieces conceived by women, nor in recounting a new history of photography through a body of work that was exclusively female, nor, obviously, in defining a 'female gaze' that would have essentialized practices determined by many different and evolving sociocultural contexts. Instead, it showed how photography had served as a means of expression and a tool of emancipation.

Let us now turn to some of the many initiatives in France that have contributed to the increased visibility of these female artists: the founding in 2014 by Camille Morineau of AWARE, Archives of Women Artists, Research and Exhibitions, an organization focusing on the creation, indexation and dissemination of information on twentieth-century women artists, including photographers; the exhibition *Son modernas, son fotógrafas* (They are modern, they are female photographers) at the Centre Pompidou in Malaga,[28] curated by Karolina Ziębińska-Lewandowska and Julie Jones (2015); the course on the history of photography through the prism of gender by Marie Robert at the École du Louvre (2014–17); Marie Docher's blog 'Atlantes et caryatides' and the work of the collective #LaPartDesFemmes, which highlights, supported by numbers,[29] the under-representation of women photographers in collections, festivals, agencies, galleries and exhibitions. At the same time, the publisher Robert Delpire, struck by the documentary *Objectif femmes*[30] made by Julie Martinovic and Manuelle Blanc in parallel with the Musée d'Orsay and Musée de l'Orangerie exhibition, decided to publish a box set of three volumes devoted to women photographers in his famous 'Photo Poche' series, which appeared in 2020.[31] We should also note Marion Hislen's commitment to the achievement of further equality, by establishing in 2016 the female professional photographers network 'Les filles de la photo', then, after being appointed as representative of photography within the Ministry of Culture, creating the itinerary 'Elles × Paris Photo', inaugurated at the 2018 edition of the fair, entrusting it to the independent curator Fannie Escoulen. Finally, we should mention the festival 'Les femmes s'exposent' (Women exhibit), organized since 2018 at Houlgate by Beatrice Tupin. Public institutions have also played their part. The work of women photographers from the nineteenth century to the present day now forms a key part of their acquisition policy.[32]

Writing the history of the world, writing the history of others

As we have seen, since the invention of photography, women have actively participated in its development and its institutionalization. Since the birth of the medium and across all continents, they have been also and above all *photographers*, that is to say independent practitioners and innovative creators. It is this that we are aiming to highlight in this collective volume, focusing on the careers and work of three hundred of them, from right across the globe, from the official birth of photography in 1839

28 *Son modernas, son fotógrafas*, Malaga: Centre Pompidou, 16 October 2015–24 January 2016.

29 *La Photographie en France au prisme du genre, 2014–2019: Chiffres et analyses*, study conducted by Marie Docher for the Ministry of Culture, Paris, 2019.

30 Julie Martinovic and Manuelle Blanc, *Objectif femmes*, Camera Lucida/France 5, 2015, 52 mins.

31 Published in English as *Women Photographers*, Clara Bouveresse and Sarah Moon (eds), London and New York: Thames & Hudson, 2020, 3 vols.

32 This is the case at the Musée d'Orsay. Parity among emerging artists is also one of the aims of the consulting committee at the Centre National des Arts Plastiques. In 2020, the entrepreneur and collector Floriane de Saint-Pierre was appointed president of the Friends of the Centre Pompidou, determined to pursue the development of acquisition funds dedicated to women artists.

until the end of the twentieth century, when the appearance of digital technology and the globalization of the photographic scene altered the landscape entirely.

With the aim of re-establishing the remarkable depth and intensity of the paths of these women photographers, and reversing a canonical history still too male and ethnocentric, we have thus come up with the dream of a collaborative project. With its geographical breadth and historical depth in mind, one question was how to proceed in order to reflect, in a single volume, the diversity of practices and usages? It is difficult to avoid the pitfall of a Western-centric approach, when one is drawing on models, concepts and methods forged in Europe in the nineteenth century,[33] and when the project itself originates in France! How to avoid favouring disproportionately cultural areas in which critical output and research are already very advanced? How to avoid restricting ourselves only to famous figures and making visible those who, little known here, have nevertheless shaken up ways of seeing in their country of birth or adoption? It is a serious challenge.

In view of the abundance of studies emanating from the West and focusing on the West, we decided immediately to give as much space as possible to proposals coming from other continents and not to limit this book's objective to European and American artists whose works are now more accessible. We made the decision to structure it in a chronological order, starting with the date of birth of each woman photographer. This arrangement along a timeline allowed for the discovery of remarkable personalities and unique worlds in geographical areas sometimes far removed from each other. One cannot fail to be struck by the intense circulation of images, ideas and approaches, as well as the permanency of cultural, social and political invariables, from Europe to Asia, and through Africa. The portfolio sections that punctuate the text are designed to encourage dialogue and comparisons that are both unexpected and heuristic.

The selection of photographers for inclusion in the book benefited from a wonderful network of volunteers and shared enthusiasms. We approached numerous people whose suggestions have proved invaluable in identifying women photographers in countries, or even continents, less covered by research, or where female photographers have not been the subject of publications or exhibitions that have promoted the discovery and diffusion of their work, such as China and Asia in general, Brazil, the Baltic states, Africa and Russia. These experts from all over the world have contributed their knowledge and passion to this project. Platforms, organizations and collectives dedicated to the history or the appreciation of women photographers have also greatly consolidated this network: among others, we must mention Fast Forward Women in Photography in Britain (where a conference held at Tate Modern in London in November 2015 stimulated our thoughts in a decisive way); Centro de la Imagen in Mexico; Wopha in Cuba; Foto Femme United in Paris; MFON: Women Photographers of the African Diaspora, co-founded by Layla Amatullah Barrayn and Adama Delphine Fawundu; and Foto Féminas, established by the Venezuelan photographer Verónica Sanchis Bencomo with the aim of promoting women photographers in Latin America and the Caribbean.

Female writers

This intellectual venture is also intended to be a testament to the role of women in today's academic community. For this reason, we decided to call upon only women writers, who we know are often less in demand or less prominent, with literary authority being considered largely a male monopoly. Over many months, in different parts of the world, these one hundred and sixty-four female historians, critics, exhibition curators, archivists and journalists, as well as photographers and writers of monographs, theses or reference works, have drawn on their collective experience and contributed their unique perspective. There may be many reasons behind their

33 Hervé Inglebert, *Le Monde, l'Histoire: Essai sur les histoires universelles*, Paris: PUF, 2014.

focus on a particular female photographer: whether that photographer was a traveller and writer in the late nineteenth century, or a Jew in Germany in the interwar period, an active member of an art movement or an activist involved in a political cause. To some of our contributors, gender is the key to examining an entire artistic approach; to others, it is not necessarily a determining factor.

The question of identity: 'who am I?' or 'where am I speaking from?' [34]

With this collection of artists, it is not so much a matter of producing a counternarrative or of deconstructing histories that already exist but of completing them. We have no desire to burn idols or topple statues, only to erect new ones, and to create a narrative that is richer and more fair. In other words, there is an urgent need to write *another* history, and to write it *differently*. This project is eminently political – it is essential to offer role models, reference points and lines of connection for *all* genders. It embraces multiculturalism and affirms the social and constructed dimension of all identities, whether they be sexual or racial. As editors, we have chosen to make this knowledge accessible and to share it, setting aside our prerogatives as academics in favour of the role of smugglers. Contrary to the academic tradition inherited from positivism, we believe that questions of science are inseparable from questions on the streets, where all discourse takes place.

The paradox facing academics today is that of simultaneously having to re-evaluate the feminine – adding the noun 'woman' to 'photographer' produces what is known in English as a 'marked term', a term distinguished from the neuter – while avoiding falling into a celebration of naturalized femininity. While we judge the contribution of the differentialist movement within feminist thought considerable and defend the principle of equality, we believe that the universal remains the best solution: it invites each of us to participate on common ground. Differentiation on the grounds of gender exists only to open up towards universality, diversity and fluidity.

This 'world tour' enables us to re-evaluate some women who were celebrated and acknowledged in their own time, to remember others now unjustly forgotten, and to discover others whose work was never exhibited or discussed during their lifetime. It is a formidable project, beginning from the dawn of photography, and partly erased from memories and histories. This volume is presented as an alternative world history of photography, seen through the prism of gender and of cultural decentralization. It lays out its '*prémices*' (beginnings) and its '*promesses*' (promises). [35] We trust that it will form part of the wider movement aimed at giving those who are invisible their rightful status, and that it will help to ensure that the history of photography also becomes the history of everyone, whatever their gender.

34 Taken from a statement by Birgit Jürgenssen: 'The question of self-identity today is no longer *Who am I?*, but rather *Where am I?...*'; extract from a letter to Doris Linda Psenicnik on 8 March 2000, quoted by Gabriele Schor: https://birgitjuergenssen.com/en/bibliography/texts-essays-interviews/schor2009.

35 These are the terms used by Patrick Boucheron in *Histoire mondiale de la France*, Paris: Le Seuil, 2017.

A long tradition
of being ignored

Marie Robert

Who recalls nowadays the tragic fate of the American reporter and paratrooper Dickey Chapelle, who died in a bomb attack in Vietnam in 1965? How many are aware that we owe the rediscovery of Eugène Atget's oeuvre to the tenacity and commitment of Berenice Abbott? That the 'photo romances' by the Indian photographer Pushpamala N. easily rival the series of self-portraits in fancy dress created by the American Cindy Sherman? Or that the publication of the first photography book in 1843 was due to Anna Atkins?

In the shadow of the master

The sidelining of women in the historiography is the result of a long tradition of being ignored. Long assigned by historians to the roles of muses, models or inspirers, women have often been described as assistants or underlings: in the retouching and colouring of photographs, laboratory work, the sticking and assembling of albums, even the selling of images. They have sometimes achieved the status of assistants or 'wives, mistresses, sisters and daughters of …'! Practitioners of an art considered inferior in the eyes of the noble arts, they, too, were considered to be second rank, because they were women. The reasons for this disqualification were many and difficult to generalize in time and place. Some, however, are recurrent: many of these women remained throughout their lives in the shadow of a 'master', at the cost of seeing their own contribution erased from memory. Such was the case of the Englishwoman Constance Talbot, who assisted her husband William Fox Talbot in his experiments in the negative/positive process. She was probably also the first woman to produce photographic images. Nevertheless, who remembers her? The French painter and photographer Amélie Guillot-Saguez exhibited her calotypes at the *Exposition des produits de l'industrie française* (Exhibition of products of French industry) held in Paris in 1849, and was awarded a bronze medal. But the spokesman for the jury confused her with her husband! In her memoirs, Harriet Tytler recounted her earlier life of travel and photographs, including those of the sepoy mutiny against the British East India Company in 1857. Even now, these images are attributed to her husband Robert, a captain whom she followed on his peregrinations in the colonial empire. When the Mexican Natalia Baquedano Hurtado died in 1936, her death certificate stated that she had no profession. As for Hilla Becher in Germany, while her work is inextricably linked with that of her husband Bernd, her forename is omitted in many articles relating their first shared exhibition in 1963.

Brought up to assist and encourage their spouse, to bury their own ambitions, women themselves have often diminished their commitment to photography, painting it as the result of restriction. Imogen Cunningham recounted how during the 1920s the daily care of her three young children barely allowed her to photograph anything but the flowers and vegetables she cultivated in her garden in Oakland. In a testimony published in 1941, Lee Miller herself minimized her artistic role with Man Ray, her partner at the time, with whom she (re)discovered, thanks to an accident in the laboratory, the principle of solarization. In her autobiography published in 1940, Madame Yevonde told of how she had embraced a career as a photographer because she lacked the physical courage to become involved in the suffragette cause!

Confinement to the private sphere

It was also because they were confined socially to the private sphere that for a long time women specialized in particular photographic genres, reinforcing the notion of a female art: photocollages, tableaux vivants and genre scenes pertaining to the domestic or marital realm – in Victorian England in the nineteenth century as in the post-revolutionary Iran experienced by Hengameh Golestan or Shadi Ghadirian – still lifes or reproductions of works of art, landscapes, self-portraits and staged representations of themselves. The portrayal of children and of women was also a constant. Women often made a virtue out of necessity: there was no option other than to find a different way around this, and there were many who highlighted their natural abilities (empathy, attention to detail, complicity) in order to exalt the art of the portrait from a female perspective. In London, Lallie Charles adopted an explicit strategy of 'photographer of women': women, she declared at the beginning of the twentieth century, prefer to be photographed by a woman. In cultural areas where sexual segregation is the result of a religious ban, female photographers who own a studio can accommodate only clients of the same sex. In 1919, in Muslim Constantinople, Naciye Suman received many women clients enamoured of portraits, but who refused to pose in front of a man. In India, Annapurna Dutta reserves her camera shots for the Muslim elite and for certain Hindu families in which the women continue to wear the veil.

This specialization was also the result of a regular and systematic exclusion from the field of photography, which was structurally androcentric in the France of the Napoleonic Code or in the Latin countries. Studios, societies or clubs, schools and, later, agencies – many institutions had for a long time closed their doors to women, whether this discrimination was explicitly inscribed in their statutes or, in a more insidious manner, was the result of an system based on patronage and co-optation. To give one example, at the beginning of the twentieth century, Buffalo Camera Club barred access to women: the Canadian Clara Sipprell was able to participate only with her photographer brother acting as intermediary.

Technical and commercial denigration

At every stage of technological invention, the inventors themselves contributed to associating women with a denigrated version of photography, for example introducing their equipment onto the market accompanied by gendered marketing strategies. In order to increase marketing opportunities with the wider public, the emphasis in their brochures and advertising posters regularly aimed to stress the (so-called) simplicity of using their product, describing it as being within the reach of women (and children!). They thereby consolidated the anthropological invariant that consisted in (symbolically) confiscating from women mastery of the most sophisticated equipment. When he announced his discovery to the public in 1838, Louis Daguerre already made it clear that 'although the result is obtained with the help of chemical means, this little work [could] be very appealing to the ladies'. From the appearance of its first portable camera in 1888, and for many decades afterwards, Kodak relied on the figure of the 'Kodak Girl', the embodiment of the (female) amateur with no

technical knowledge. In 1932, an advertisement for Leica featured a woman's hands, which, well, would no longer produce 'blurry photos' thanks to an automatic focus … and so on, up to 1972, and Polaroid, who featured a woman holding a camera, and declaring: 'It's really very easy!'

Assignment to the female sex

This multiform undervaluation was regularly consolidated by a critical press that discerned any potential 'female specificities' in images by women. In his report on the extensive exhibition organized in 1937 at the Jeu de Paume and devoted to female artists in Europe, the critic S. R. Nalys commented: 'Brutal man wields the camera like a machine gun. While what does woman do, she handles it tenderly, after having caressed with her gaze the subject she intends to capture. The two gestures are separated by an abyss: femininity.'[1]

The separation of spaces, titles and statutes provoked concerns, tensions and conflicts. These potential female rivals blurred the boundaries in the traditional division of sexual roles and tasks. From then on, they were regularly excluded on the basis of their sex. During her time spent in Islamic countries in the 1880s, the archaeologist and photographer Jane Dieulafoy chose to dress in a three-piece suit and wear her hair short (which she had already done at the time of the Franco-Prussian War in order to be able to follow her husband to the front). Her masculine style earned her such renown that she obtained a formal exemption from laws that forbade cross-dressing, but was also the subject of much taunting and mockery. Alice Schalek, who covered the Western Front during the First World War, showing the bloodshed and brutality of the weapons, was called the 'hyena of the battlefield' by the Austrian writer Karl Kraus, who showed no restraint in his efforts to combine antisemitism and misogyny. In 1928, Germaine Krull's portfolio *Metal* won unanimous support in the circles of photography's avant-garde. Consisting of sixty-four photographs of metal constructions (the transporter bridge in Marseille, the Eiffel Tower, a bridge crane in Rotterdam) transformed into abstract compositions, it embodied a triumphant modernity. But not in the eyes of some of Krull's contemporaries, who nicknamed her the 'iron Valkyrie', mocking her independence and her androgyny. Conversely, the Indian photojournalist Homai Vyarawalla was obliged to accept the nickname of 'Mummy' conferred on her by her male colleagues; desexualized in this way, it proved much easier for her to work in the masculine environment of the press and be placed on the pedestal of maturity.

The conquest of male bastions

Braving extreme climates and hostile environments, covering the far reaches of the globe, women photographers have explored the world, often travelling alone. They include Isabella Bird who crossed Asia in 1894, Geraldine Moodie who travelled in the Arctic in 1897, while Helen Messinger Murdoch embarked on a trip around the world in 1913. Put to the test by imprisonment (whether in a Moscow jail in the case of Germaine Krull in the early 1920s, or those of the Brazilian dictatorship for Nair Benedicto in 1969), or killed in action (Alexandrine Tinne, Dickey Chapelle and Gerda Taro), enlisted by totalitarian regimes (like Edith Tudor-Hart, a spy working for the KGB) or putting their lives at risk resisting Nazi oppression (Dominique Darbois joined the regular army in 1944, while Julia Pirotte, a liaison officer in the FTP-MOI, part of the French Resistance, made false papers), they were people of courage and determination.

The five hundred pages of *A World History of Women Photographers* suffice to persuade us: these women were everywhere and recorded everything. They explored every facet of photography: the fields of the fine arts (tableaux vivants and self-portraits, landscapes and architecture) and the many professional and media uses

1 'Les femmes artistes d'Europe exposent au musée du Jeu de Paume', Paris: Musée des Écoles Etrangères Contemporaines, Jeu de Paume des Tuileries, 11–28 February 1937.

of photography, from portraiture to reportage, advertising, science, fashion, travel, the nude and even pornography. Artists or dealers, professionals or amateurs, they have been as active in the public realm as they have in the private, penetrating the male bastions of sport, public space, the political sphere, and the theatre of war, as well as the representation of the gendered body.

The speed of this conquest, which of course varied from country to country, was linked to the pace of developments in their political and social status: access to a '(dark) room of one's own' – so dear to Virginia Woolf, financial independence, the opportunity to practise a profession or to move freely in public spaces, the right to vote or to study, the secularization of society. For many of them, the camera opened doors: their photographer status enabled them to gain access to places that had previously been off-limits to or little frequented by women. As in the case of the (white) South African Constance Stuart Larrabee who, in 1944–5, was allowed to photograph the Black migrant workers employed by the De Beers mining company, precisely because she was a female photographer. Or the Italian, Letizia Battaglia, who wheedled her way into the clans of the Sicilian Mafia in the 1970s.

None of the momentous events of the twentieth century eluded them: the First and Second world wars, the Spanish Civil War, the liberation of the Nazi concentration camps in 1945 or the tragedy of Hiroshima, wars of independence that heralded the age of decolonization (most notably in Algeria), the Vietnam War, the Cuban revolution, the social struggles of the 1960s and 1970s, the Iranian revolution in 1979, the galloping de-industrialization and impoverishment of the European working class in the 1980s, the Chernobyl disaster in 1986, the collapse of the Soviet bloc a few years later, the end of apartheid in South Africa in the 1990s. The camera is also a weapon, a means of resistance against oppression, whether patriarchal, colonial or political. Systematically overlooked or subordinate, women photographers often chose to turn their camera on marginalized communities. 'I want to take pictures of policemen kicking children' – that was what motivated the young Tish Murtha when she applied to Newport College of Art to study photography. Bringing their heart and soul into the frame, they observed labourers, raped and battered women, exploited children, prisoners, the disabled, exiles, gay and transgender people, all those who were marginalized or invisible, the forgotten who struggle and do not set the rules of the game. It was this empathy that turned Donna Ferrato into a tireless activist in the struggle against domestic violence and Claudia Andujar into a campaigner for the Yanomami cause, and which made Anita Conti aware of the overexploitation of the oceans.

Soon, women photographers outwitted the established codes of representation, inventing new forms, establishing innovative practices. As artists, they experimented, often as pioneers: macro photography, solarization, photograms, light drawings, double exposures, photomontage and photocollage, or colour processes. They shaped the stylistic and theoretical repertoire of modernity, after having fuelled that of Pictorialism. Julia Margaret Cameron was an inspiration to the members of the Photo-Secession. In 1913, Alfred Stieglitz dedicated an entire issue of his magazine *Camera Work* to her, saying that she was 'one of photography's few "classics"'. The work of these women played a key role in the avant-garde movements of the interwar years: Surrealism, New Objectivity, Straight Photography, and New Vision. In 1919, Hannah Höch's photomontage *Cut with the Kitchen Knife Dada …* was seen as a manifesto when Imogen Cunningham co-founded Group f/64 in San Francisco Bay in 1932. Women photographers nourished all artistic movements, whether academic or avant-garde, in the second half of the twentieth century: humanist photography, new subjectivity, plastic photography, etc. They also created what would later become known as the feminist avant-garde: during the 1960s and 1970s, new generations of artists (Francesca Woodman, Jo Spence and Anna Noggle among them) made their own bodies the principal territory of feminist and / or colonialist study, with photography becoming the favoured tool amid a variety of media (video, writing, sculpture) and performative

practices. They advocated an innovative means of appropriation of representations of the female body, questioning those of conjugal sexuality (Natalia Lach-Lachowicz made 'intimate recordings'), staging erotic fantasies, or documenting bodies that were ageing, sick or abused, for example Abigail Heyman during her own abortion.

Photographic diaries by the Swiss Annemarie Schwarzenbach or the Lithuanian Veronika Šleivytė, Inge Morath's 'artistic hoaxes', 'photo poems' by the Icelander Valdís Óskarsdóttir, Joan Lyons' 'photographic drawings', artificial negatives by the Czech Běla Kolářová, Karen Knorr's photomontages – just some of the intermedial concepts among dozens of others that mix different media in order to explore the powerful aesthetics of the photographic medium.

A host of smugglers

In addition to taking charge of the image of the female body, we can discern the recurrence of attempts to gain autonomy and recognition through the building of social networks between women, or even the formation of a singular theoretical discourse on the medium. In this book, we shall explore the extent to which women photographers have worked to share their experience, transmit their expertise, or support the vocations of others, welcoming into their studios female colleagues and, in their turn, opening clubs. Denied access to the almost exclusively male circle of the National Geographic Society, in 1924 Harriet Chalmers Adams founded the Society of Women Geographers in Washington. In Spain, after the Second World War, Rosa Szücs became involved in the running of the Grup Femení, which encouraged the teaching and practice of artistic photography within women's groups. Founders of La Azotea publishing house in Argentina in 1973, Sara Facio, María Cristina Orive and Alicia D'Amico launched a series of photography books.

Many passed their knowledge on: they welcomed apprentices into their studios (Dora Kallmus, Ergy Landau, Annemarie Heinrich, Lisette Model, Jo Spence). Helmut Newton trained with Yva in Berlin, Bill Brandt with the Viennese photographer Trude Fleischmann. Some studios were reserved for women only: those of Elena Lukinichna Mrozovskaya-Kniajevich in St Petersburg in 1913, and Florence Henri in Paris in the 1930s. Others founded educational establishments: in 1906, Jadwiga Golcz participated in the creation of the future Kirchner School in Warsaw; Gertrude Fehr founded Publiphot in Paris in 1933 (which would become a school of arts and crafts in Vevey, Switzerland); in the early 1970s, Iryna Pap set up the first school of journalism in Kiev; in Estonia, Eve Kiiler launched a conceptual school, the 'Faculty of Taste'. Among those who taught were Berenice Abbott at the New School for Social Research in New York from 1935, Lucia Moholy during the same period in London, Klára Langer in Budapest just after the Second World War, as well as Kati Horna in Mexico. Cristina García Rodero taught at the Faculty of Fine Art in Madrid from 1974, Birgit Jürgenssen at the Academy of Fine Art in Vienna in the early 1980s, Tuija Lindstrom at the photography school of Gothenburg University from 1992, and Nan Goldin at Yale and Harvard, along with many others.

Practitioners and theoreticians

From the very birth of the medium, gender-related barriers prevented women from joining photography societies, theoretically excluding them from publishing in the associated magazines. In relatively liberal Britain, the Scotswoman Mary Somerville, who was experimenting with the photosensitivity of vegetable juices, was forced to conduct her communication with her peers through the intermediary of Sir John Herschel. Nevertheless, many other women published, and at times, described, their images. Let us not forget that the first volume illustrated by photography, *Photographs of British Algae: Cyanotype Impressions*, published between 1843 and 1853, was the work of Anna Atkins.

A lesser-known fact is that women were also theoreticians and historians of photography. In addition to correspondence and personal journals, they appropriated

forms of writing monopolized by men: autobiographies, manuals, manifestos, historical overviews, university theses, works on science or advertising photography. For many, reflecting on the technical, aesthetic or ontological potential of photography amounted to reflecting on its social, and therefore gendered, dimension. Photography could definitely be employed in the emancipation of women. Many were encouraged in their photographic career by resounding articles written by American pioneers, such as Elizabeth W. Withington with 'How a Woman Makes Landscape Photographs'[2] (1876), Catherine Weed Barnes with 'Photography from a Woman's Standpoint' (1889), or Frances Benjamin Johnston with 'What a Woman Can Do with a Camera'[3] (1897). In line with this approach, in 1964, Bunny Yeager's *How I Photograph Myself* was specifically addressed to women.[4]

The influence of the interwar period, one of intense ontological reflection on the medium, led in particular by photographers themselves, was to continue in the theoretical and political upheavals of the 1970s. Published essays by Rosalind Krauss and Susan Sontag (1977),[5] who were not photographers, renewed the notion of photography in their own way. But it was through feminist movements that reflection became more revolutionary: Hannah Wilke and Martha Rosler in the mid-1970s, Val Wilmer in the 1980s, Jo Spence, Jeanne Moutoussamy-Ashe and Deborah Willis, and more recently Pia Arke, opening a debate about photography that embraces the issues of gender, class and race. The essays in this book prove, should this still be necessary, the extent to which women have occupied the field of historiography and proved themselves capable of investing it with symbolism. In doing so, they have definitively gained access to the public domain and to visibility.

2 Elizabeth W. Withington, 'How a Woman Makes Landscape Photographs',
 Philadelphia Photographer, vol. 13, no. 156, December 1876.
3 Frances Benjamin Johnston, 'What a Woman Can Do with a Camera',
 Ladies' Home Journal, vol. 14, no. 10, September 1897.
4 Bunny Yeager, *How I Photograph Myself*, New York: A.S. Barnes, 1964.
5 Susan Sontag, *On Photography*, New York: Farrar, Straus and Giroux, 1977.

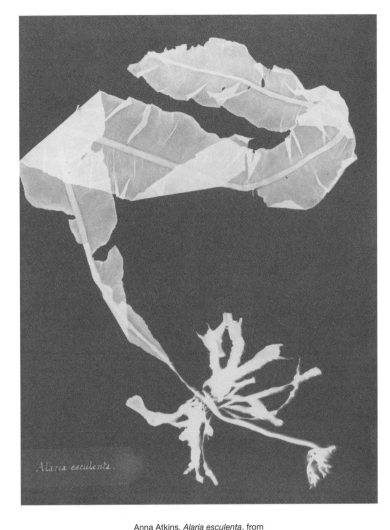

Anna Atkins, *Alaria esculenta*, from
Photographs of British Algae: Cyanotype Impressions, 1849–50

Anna Atkins, née Children, created the first book to be illustrated with photographs. Her revolutionary application of the cyanotype process marked a milestone in the history of photography.

Anna showed an interest in science throughout her childhood and her marriage – she married John Pelly Atkins in 1825 – benefiting from the encouragement of her father, John George Children, a fellow of the Royal Society, London. Her fascination with science was complemented by an artistic eye, and she became a talented watercolour artist, illustrator and lithographer. Anna was also a keen botanist, joining the Botanical Society of London, one of the few scholarly societies open to women, connecting her to a network of colleagues sharing her interest in nature.

John George Children purchased a camera for Anna in 1841, cementing her interest in the new medium. That same year, botanist William Henry Harvey published *A Manual of the British Algae*, a comprehensive but unillustrated guide to British seaweeds. Anna decided to produce a companion publication that presented specimens of algae in the form of cyanotypes, bringing Harvey's text to life. Invented by the astronomer and photography pioneer Sir John Herschel and announced in 1842, this new process allowed Atkins to present her specimens in the form of negative images on a Prussian-blue background. The chosen examples were laid on paper coated in iron salts, exposed to the Kent sunshine, then washed in water to reveal the ethereal white impression – a reproduction process in which no camera was involved. Through this innovative application of cyanotype photography, Atkins succeeded in reproducing the delicate structure of the fragile specimens, and differing levels of opacity served to highlight their intricate shapes.

In October 1843, Anna sent the first part of *Photographs of British Algae: Cyanotype Impressions* to the Royal Society. From that point on, it appeared in a series of instalments until 1853; other recipients included Sir John Herschel and William Henry Fox Talbot.

Free from the constraints of producing illustrations linked to an existing publication, Atkins diversified with a new book, *Cyanotypes of British and Foreign Flowering Plants and Ferns* (1854), a gift to her friend Anne Dixon. It is assumed that the two women collaborated on other cyanotype images of ferns, flowers and feathers.

Anna Atkins's achievement was to bring about an unprecedented union between the art of photography and the rigour of science. The thousands of cyanotype impressions that she produced constitute a unique photographic legacy and are testament to her talent, skills and dedication. **RT**

Julie Vogel, *Marguerite de Bourbon-Parme*, 1856

'Photograph by Fritz and Julie Vogel in Frankfurt a. M.', reads the inscription on one mount; the signature 'F. u. J. Vogel' appears on a series of salt-paper prints from 1846; and 'F. &. J. Vogel' is the name of a studio in Venice, found on the back of a carte de visite made a dozen years later. Despite these hints as to the photographer's identity, Julie Thérèse Vogel (née Schmidt) remains largely unknown. Born into a pastor family in Alsace in 1806, she married the lithographer Friedrich Carl Vogel, known as Fritz, originally from Frankfurt am Main, in 1830. Having declared his lithography studio bankrupt in 1843, Fritz Vogel took over a photographic studio with his wife in January 1846. Although Fritz had made daguerreotypes since 1839, the studio focused on producing hand-coloured portraits on paper. In 1850, the Vogels moved their studio to Milan, and then to Venice in 1852, where they collaborated with Friedrich's nephew Carl(o) Reichardt at the Campo Pisani.

Historians generally use Fritz Vogel's name alone when referring to the couple's work, supposing that Julie's name was included simply to improve her husband's creditworthiness. Many women worked alongside their husbands, fathers and brothers without ever receiving recognition: Constance Talbot, for instance, or Jenny Bossard-Biow. Since most worked in the background and remain anonymous, the fact that Julie Vogel is explicitly acknowledged in the studio's name constitutes a rare exception.

Despite her public identity, Julie Vogel's influence was limited: after all, it was her husband who was in contact with the authorities, took part in exhibitions (including the Great Exhibition in London in 1851 and the Exposition Photographique in Brussels in 1856), placed advertisements in the local newspapers, exchanged letters with William Henry Fox Talbot, and corresponded with journals such as *La Lumière* and the *Photographisches Journal*. It is nevertheless noteworthy that Fritz repeatedly refers to his wife in his letters: he mentions their working together on a portrait of Archduke Johann of Austria, recounts Julie's help with a group portrait in a letter to Talbot, and is requested by one of their customers, the German poet Ludwig Uhland, to pass on his greetings to his 'accomplice in the photographs'. This phrase highlights the fact that Julie was present during the sittings and that she participated actively. It would therefore be appropriate if future historians considered Julie Vogel's contribution on an equal footing with that of her husband – a shared achievement reflected in the name of their studio. **CB**[1]

Emilie Bieber, *Hamburg gymnasts in front of the mill near the Lombard Bridge*, 1850

'Taste and good technique': these are the words used by the *Photographische Mitteilungen* to describe Emilie Bieber's images at the first exhibition of the Photographic Association of Berlin in 1865. This was not the first time her work had received praise. In fact, she had participated in nearly all of the major exhibitions of the 1860s and 1870s, in Berlin, Hamburg, Paris, London and Vienna, and the critics regularly remarked upon the quality of her portraits. Representing the sole German studio run by a female photographer at these events, she was one of the few active female photographers on the international scene. At the eighth exhibition of the Société Française de Photographie in 1869, just three out of the eighty-four exhibitors were women. Aiming to increase her international reputation, Bieber set up a network of professional contacts by joining photographic associations in Berlin, Vienna, Hamburg and Paris, and her career was furthered when she was appointed official royal photographer to Prince Friedrich Karl of Prussia in 1872.

The studio that bore Bieber's name was, and always had been, more than a one-woman affair. She had created it in 1852 in partnership with Adelgunde Köttgen. The two women probably met at one of the local women's associations that they both attended. Bieber was a member of several such groups, including the Women's Association for the Support of Poor Relief, led by Charlotte Paulsen, who was the godmother to one of Köttgen's sons. Bieber looked after the studio's business matters while Köttgen took the daguerreotypes. When, in the spring of 1854, the latter had to leave Hamburg (her husband had failed to obtain a residence permit), Bieber began to manage the studio on her own. It had originally specialized in daguerreotypes and copies of oil paintings, but Köttgen's departure led Bieber to diversify. It now became a 'photographic institute', offering photographic prints on paper from June 1854 – mostly portraits of local notables in the form of daguerreotypes, prints on salted paper or business cards, often coloured by hand. Compositions follow the conventions of the time: the models are usually seated on a chair, one arm resting on a column or table decorated with a pot plant.

In 1872, the studio moved to a new address, and five years later had a workforce of around thirty employees. Over the following three decades, Bieber's studio enjoyed a worldwide reputation that continued for decades after her death. The business was taken over and expanded by her nephew Leonard Berlin, until his son, Emil Bieber, was obliged to dissolve it in 1938 when he emigrated. **CB¹**

Amélie Guillot-Saguez, *Fragment of an ancient aqueduct*, Rome, 1847

Initially confused with those of her husband, the figure and oeuvre of Amélie Guillot-Saguez have gradually taken shape, although some unclear areas still remain. In 1835, Amélie Esther Saguez married the chemist Jacques-Michel Guillot in Paris, giving birth to their son in 1841. A painter, she exhibited portraits and genre scenes at the Salons of 1840 and 1841, then, in 1847, a canvas depicting a religious subject commissioned by the queen, Marie-Amélie. She was probably introduced to the calotype around 1844, together with her husband. In 1845, the couple travelled to Rome, where Amélie produced the prints we know today. She was thus one of the first foreign photographers in the city. Until recently, a dozen prints by the artist were known, four of them in the so-called 'Regnault' album belonging to the Société Française de Photographie (*Fife player*, 1846; *Moses, Santa Maria in Cosmedin, Fragment of an ancient aqueduct*, 1847), another print of Moses (École Nationale Supérieure des Beaux-Arts) and a *Portrait of a bearded man* (Neue Pinakothek in Munich). In November 2016, her work took on a new dimension with the sale of an album dedicated to a friend called 'Madame L. des Bordes', comprising thirty-seven salt-paper prints made in Rome (twelve are signed and dated 1846 or 1847). The subjects reflect their creator's classical education – ancient monuments, a Raphael drawing, the Villa Medici – and her affection for the portrait: a proud-looking *Borghettano*, a group of canons in a cloister and the model Benedetto as a *pifferaro* (fife player), a picturesque subject then much favoured by photographers.

Guillot-Saguez's photographs were contemporary with those of Calvert Richard Jones or Giacomo Caneva. The latter, who was subsequently to frequent the artistic circles of the Caffè Greco, probably knew the couple; indeed, in 1855, he mentioned the Guillot-Saguez process described in the book *Méthode théorique et pratique de photographie sur papier* (1847), which was an attempt to improve the sensitivity and stability of paper by simplifying William Henry Fox Talbot's process. A devotee of the calotype like her husband, Guillot-Saguez was skilled in its use, drawing a velvety effect from the texture of the support. Although in the dedication to her friend she apologizes for the imperfection of her prints, one cannot but remark on her skill in photographing the imposing statue of Moses, but also the beauty and boldness of some of her compositions (contrasts of light, empty foregrounds), qualities that earn her a significant place among the early female photographers.

In 1849, some prints attributed to 'MM. Guillot-Saguez' won an award at the Exhibition of Products of French Industry and were noted by the archaeologist and politician Léon de Laborde (*Portrait of Pius IX, Shepherd, Michelangelo's Moses*). The Guillot-Saguez studio was situated initially in Rue Vivienne in Paris, then in Passage des Panoramas (in the 2nd arrondissement). Around 1857, Amélie was working alone, her husband perhaps already having left for Algeria, then under French rule, where she was to join him in 1860. She died at Koléa, south-west of Algiers, four years later. **HB**

Claiming the title 'Catholic photography', Madame Vaudé-Green specialized in the reproduction of religious masterpieces. Another woman, Eulalie Bouasse-Lebel, a printer in Paris, and a print dealer specializing in Catholic imagery and devotional objects between 1850 and 1860, also took up the same idea of themed reproductions.

As noted by Thomas Galifot in the catalogue to the exhibition *Qui a peur des femmes photographes?* (Paris, Musée d'Orsay, 2015), in the late 1850s, Vaudé-Green's work enjoyed a relative fame. On 23 August 1856, Ernest Lacan, editor-in-chief of *La Lumière* magazine, mentioned these 'photographic prints reproducing religious subjects after the great masters […] They possess all the qualities that constitute excellent prints and stand out especially for the purity of execution.' Technical skill was matched by a judicious choice of subject, according to Lacan: 'To replace insignificant productions of religious imagery with photographic copies of the most admirable compositions that genius has created is not only to carry out a good deed, but also to compete in the progress of art by popularizing masterpieces.' These photographs were distributed by 'the principal stationers in Paris and by publishers of prints'. In *La Lumière* on 13 December 1856, Lacan reported that during the first Exposition Photographique held in Brussels, Vaudé-Green had been awarded an unspecified medal alongside thirty other photographers, including a second woman, Madame Leghait. In his review *La Photographie au Salon de 1859*, Louis Figuier did not share this enthusiasm. He presented her works as being those of a man, commenting: 'One could also mention M. Vaude Green [sic] for his reproductions of paintings, which are nonetheless inferior to all of the above'.

Vaudé-Green's first studio was located in Paris at 8 Rue de Milan (in the 9th arrondissement) until 1858. The following year, she was working at 36 Rue d'Orléans in the Batignolles neighbourhood (17th arrondissement). In 1864, she transferred her studio to 'J. Laplanche' (the initial is not included on the stamps found on the back of the prints). Long believed to be a man, her successor was in fact another woman photographer, Jeanne Boucher, Laplanche's wife. It might be supposed that she came to photography via a neighbourly coincidence: in 1853, Jeanne moved into 34 Rue d'Orléans, six years later, Vaudé-Green moved in next door. Although Madame Vaudé-Green's work was essentially devoted to the reproduction of prints and paintings, a technically demanding discipline whose aesthetic qualities were little appreciated by the contemporary eye, the oeuvre of Jeanne Laplanche contained several prints of exceptional beauty, notably those representing the Pompeian House of Jérôme Napoléon in 1863. **FT**

Madame Vaudé-Green, *Madonna of Foligno*, 1856–61

Constance Talbot occupies a unique position in the history of women's photography. Her direct contribution is difficult to assess, but her letters to her husband, the scientist William Henry Fox Talbot, appear to indicate that she started practising photography as early as 1839.

Constance Mundy was born and spent her early life in Markeaton, Derbyshire, and married Talbot on 20 December 1832, at All Souls Church, Langham Place, London. The couple then began their married life at Lacock Abbey in Wiltshire. During a visit to Lake Como with his wife the following year, Henry tried and failed to sketch the view. 'One of the first days of the month of October 1833,' he later wrote, 'I was amusing myself on the lovely shores of the Lake of Como, in Italy, taking sketches with Wollaston's Camera Lucida, or rather I should say, attempting to take them: but with the smallest possible amount of success. For when the eye was removed from the prism – in which all looked beautiful – I found that the faithless pencil had left only traces on the paper melancholy to behold.' Talbot then pursued a scientific answer to his artistic frustration. In contrast to her husband, Constance demonstrated artistic talent in both pencil sketches and watercolour painting. On 7 September 1835, in a letter to Henry, Constance referred to his early small experimental cameras: 'Shall you take any of your mousetraps with you into Wales? – it would be charming for you to bring home some views.'

Following a public exhibition of his 'photogenic drawings' at the Royal Institution, London, on 25 January 1839, Talbot's pioneering invention was read at the Royal Society, London, the following week. In February that year, Constance gave birth to Matilda, their third child; only three months later, she wrote that she was 'labouring hard at the Photographs without much success'.

Constance's letters to Henry provide an indication of her photographic pursuits. In May 1839, she wrote to him: 'I ought to have begun my study of the art while you were at hand to assist me in my difficulties.' She later continued: 'I set the Camera today to take my favorite view near the Cauldron, but I believe I failed in getting the right focus, for the outline is sadly indistinct though the general idea is perfect in its resemblance.'

In October 1840, Henry photographed Constance, creating a sensitive portrait of his wife using his new invention, the calotype, which he would patent the following year.

On 1 December 1843, Constance wrote to Henry telling him of her intention to photograph a typeset poem by Thomas Moore, a friend of the family. 'Last Rose of Summer' is Constance's first documented attributed photograph. Throughout their marriage, Constance Talbot's subtle influence was ever present, as she raised their children but also supported her husband's personal and professional worlds, and consequently the birth of photography. **RT**

Constance Talbot, *Reproduction of a verse from the poem 'The Last Rose of Summer' by Thomas Moore (Irish Melodies)*, 31 November or 1 December 1843

Julia Margaret Cameron, *Annie, my first success*, January 1864

Julia Margaret Cameron (née Pattle), one of the foremost British photographers of the nineteenth century, is renowned above all for her portraits of Victorian celebrities. Since the end of the twentieth century, historians and critics have also highlighted the sensuality of her studies on the theme of maternal love. However, her expressive use of the camera is inseparable from her determination to be recognized by her peers as an artist and to profit from the sale of her photographs. Born in British India, and raised in France and the United Kingdom, Cameron herself dated the beginning of her photographic calling to 1864, when her daughter bought her a camera, but her interest in the medium in fact goes back much further.

In 1841, when Cameron was living in India, married to an English colonial official who owned coffee plantations, her friend the astronomer and chemist Sir John Herschel sent her examples of 'photogenic drawings' by William Henry Fox Talbot, the inventor of the calotype. Herschel, the pre-eminent scientist of early Victorian Britain, had made a crucial contribution to Talbot's invention, in particular by finding a suitable fixing agent for the new process. Cameron's interest in photography, therefore, was long standing and arose from her identity as a wife and mother, her close friendships with prominent men, including Alfred Tennyson, her position within English artistic circles and her largely unrealized literary ambitions.

Cameron chose to submit her photographs to the judgment of critics and the public. She shared her aspiration to 'Poetry and beauty' with painters such as George Frederick Watts, Dante Gabriel Rossetti and David Wilkie Wynfield, a maker of photographic portraits who had decisive influence on her. Visual similarities between their paintings and her photographs have overshadowed Cameron's ability to experiment with the camera and photographic process in order to transform the tenets of fine art into aesthetically compelling photographs. In 1865, she acquired a new, larger camera – more difficult to use but necessary for taking 'life-sized' portrait heads, characterized by their stunning light effects and masterly modelling of form in pictorial space. To underline the significance of material processes in her work, Cameron included in her London exhibitions of 1865 and 1868 a portrait of a young girl entitled *Annie, my first success* (that is, Cameron's first successful attempt at exposing and printing a wet collodion negative).

In 1875, Cameron moved with her family to their plantation in Sri Lanka (then Ceylon), where she died four years later. Within this colonial context, she took portraits of local men posing bare-chested – a sign, specific to a certain time and place, of the interplay between photographic agency and social privilege at work in her photography. **JL**

'What is focus – and who has a right to say what focus is the legitimate focus? My aspirations are to ennoble Photography and to secure for it the character and uses of High Art by combining the real and Ideal and sacrificing nothing of Truth by all possible devotion to Poetry and beauty.'

JULIA MARGARET CAMERON

Upon hearing about the daguerreotype, Bertha Beckmann, a hairdresser by trade, was introduced to the new process thanks to travelling photographers in Dresden. In 1842, she journeyed to Prague to complete her apprenticeship in the studio of the daguerreotypist Wilhelm Horn. The montage framing her first known work shows that she had successfully carried out some earlier attempts on her own, as she signed herself 'Bertha Beckmann de Cottbus' without reference to her teacher, as she would do later. The same year, she advertised her portraits and reproductions of works of art in a Dresden newspaper, thus becoming, as a daguerreotypist, one of Europe's first professional female photographers. A year later, the *Leipziger Tageblatt* described her as 'an artist whose images are distinguished by their high quality in all respects'. For forty years, and until the closure of her studio in 1882, this seasoned and commercially gifted photographer was to be enormously influential in everything pertaining to the new medium and the dissemination of its early technical processes.

A travelling daguerreotypist between 1843 and 1844, Beckmann opened a studio in Leipzig in 1845 with the photographer Eduard Wehnert, whom she married shortly afterwards. Their collaboration in the Studio Wehnert-Beckmann was founded on equal terms, as confirmed by the joint signature of the portraits produced at that time: 'Eduard and Bertha Wehnert'. Following Eduard's untimely death in 1847, Bertha Wehnert, under the name 'Bertha Wehnert-Beckmann', continued to run the portrait studio alone; it prospered and became a meeting place for the city's middle and leisured classes. She created a personal photographic vocabulary whose originality derived from the control of light, sophisticated settings, and the poses of her models, at the same time carefully calculated and natural.

An emancipated businesswoman and photographer who earned recognition in a professional milieu that was predominantly male, her name was known well beyond Leipzig. Between 1849 and 1851, in her studio on Broadway, New York, she photographed prominent political figures and was much talked about thanks to the then still little-known calotype technique. A pioneer of printing on paper, stereoscopic photography and photography of the nude, Bertha Wehnert-Beckmann was a trailblazer in many fields. She is also the first female German photographer from the early days of the medium whose work and remarkable career have been the subject of renewed recognition post-1980, thanks to various exhibitions and scientific publications. **DB**[1]

'Since the invention of the daguerreotype, all my efforts have consisted in learning this art in order to ensure a future for myself in this branch of activity. In ceaselessly exercising the knowledge thus acquired, I have proved capable of earning a living.'

BERTHA WEHNERT-BECKMANN

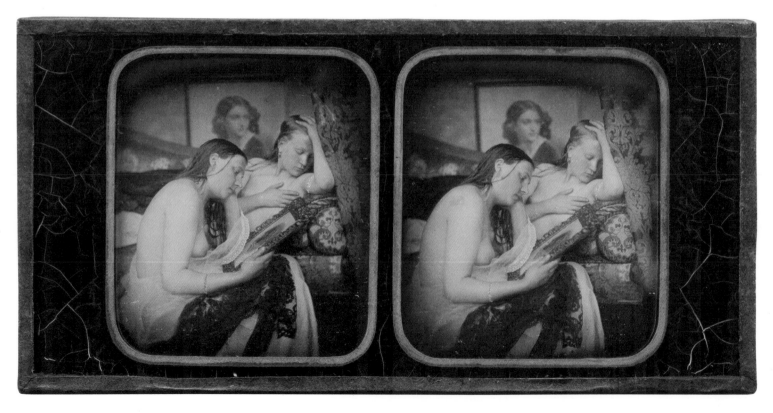

Bertha Wehnert-Beckmann, *Erotic Scene*, 1850–9

Mary Dillwyn, *Willy*, c. 1853

Mary Dillwyn, whose influential family owned Sketty Hall, near Swansea, was a pioneer of the calotype process. During the nineteenth century, the Dillwyns were important figures in the worlds of science, culture, politics and industry. Mary's elder brother, John Dillwyn Llewelyn – assisted by his wife, Emma Thomasina (née Talbot), a cousin of William Henry Fox Talbot – introduced such innovations to photography as the Oxymel process, which used a mixture of honey and acetic acid to temporarily preserve the image on wet collodion plates. Their daughter Thereza Mary also became an accomplished photographer and assisted her father in the field of astrophotography.

Mary is thought to have employed a small camera, which freed her from the constraints imposed by large plates, a cumbersome tripod and long exposure times. Since her equipment was lighter, she became an unobtrusive witness to family activities, taking snapshot images that were ahead of their time. Instantaneous photography permitted her to capture fleeting moments, which she subsequently preserved in the pages of her photograph albums. Mary's photographic skill allowed her to work with either summer sun or winter snow: indeed, her interest in the changing seasons resulted in probably the first photograph of a snowman being built, taken in 1853 at Penlle'r-gaer, the family estate.

At the 1855 Exposition Universelle in Paris, John Dillwyn Llewelyn won first prize for a series of snapshots entitled 'Motion', which included studies of waves and of a steamship in Tenby harbour. We also know of a photograph by John showing the family gathered around a November bonfire. Mary adopted this innovative approach but put it to use in her portraits. Whereas ordinary photographic portraiture was constrained by stiff, formal poses, Mary recognized the liberating capability of instantaneous photography to capture momentary expressions, such as an elusive smile.

Mary's portfolio includes portraits of people of all ages, the choir at her local church, and studies of birds and animals. Her camera became a regular companion, discreet enough to capture private family moments. This is how Mary, on a picnic with friends at Oystermouth Castle, was able to create photographs that combine artistic compositions with the informality of portraits taken outdoors.

In 1857, Mary married the Reverend Montague Welby, following which she seems to have abandoned photography. The collection of images simply annotated 'MD' shine a light on the simple pleasures of the mid-Victorian elite and constitute an extraordinary photographic record. Breaking from convention, Mary Dillwyn opened a window onto the intimate domestic world of her family with an informality rare in photographs of the era, leaving behind a record of otherwise ephemeral moments. **MC and RT**

Lady Frances Jocelyn, *Untitled [Lady Frances Jocelyn on an archery target]*, c.1860

At the time when Lady Frances Elizabeth Cowper (known as Fanny) first took an interest in photography, it was still an expensive and time-consuming pursuit, practised only by professionals or the educated, leisured aristocracy. Fanny's parents were the wealthy 5th Earl Cowper and the influential society hostess Emily Lamb (whose second marriage was to Viscount Palmerston, the future prime minister), thus ensuring that she had both the means and the social connections to take up the medium. After marrying Viscount Jocelyn in 1841, with whom she had six children, Fanny was appointed a Lady of the Bedchamber to Queen Victoria – a passionate photographic patron and enthusiastic compiler of albums. It was in this context that Fanny took up photography and produced photocollages after her husband's death from cholera in 1854. Her earliest-known photograph dates to 1858.

Using the wet-collodion process, Jocelyn produced portraits of family members self-consciously posed within domestic interiors or outside their homes, suggesting the confines of her daily life. On several occasions she exhibited her landscape views of the family's property, and particularly her stepfather's country estate, Broadlands. At the 1862 International Exhibition, held in London, Jocelyn's entries were praised as 'conspicuous for their clear detail', and she received an 'honourable mention for artistic effect in landscape photography'. Elected to the Photographic Society of London in 1859, she also joined the Amateur Photographic Association four years later. However, owing to a limited public career and the fact that most examples of her work were preserved either in an album now at the National Gallery of Australia, Canberra, or in albums assembled by family members (Victoria and Albert Museum and National Portrait Gallery, London), her photographs remained relatively unknown until recent scholarship brought them to light.

Jocelyn's albums also included her photocollages – inventive compositions that she created by combining commercially produced carte-de-visite photographs with her own watercolour paintings. The latter were typical of sketches made by English aristocratic ladies during the 1860s and 1870s and kept in drawing-room albums intended for family, friends and acquaintances. In one somewhat surreal example, Jocelyn placed photographs of babies and children on hand-painted branches, providing a witty interpretation of the family tree and of female 'nest-building'. Through both her photography and her album work, Jocelyn actively documented her family's history and expressed their social standing with great creativity.

Jocelyn took her last photographs in the late 1860s, when caring for her increasingly ill children began to take up most of her time. She died in Cannes, France, in 1880. **CN**

Louise Reynders was the daughter of Jean Paul Ferdinand Reynders, a shop-keeper from Amsterdam, and Julie Agnès Lehon, born in Tournai, Belgium. In 1840, she married Gustave Nicholas François Leghait, a landowner, born in 1809. It is not known how Louise Leghait was introduced to photography. Did she perhaps come across one of the British calotypists who were staying in the country in the wake of William Henry Fox Talbot, such as Calvert Richard Jones, who established himself in Brussels in 1853? Did she know the work of Guillaume Claine, one of the first Belgian enthusiasts of the process on paper, whose series of views of Brussels was published by Louis Désiré Blanquart-Évrard in 1854? On the basis of current knowledge, Louise Leghait's photographic career can be summed up by two exhibitions, that of the Association for the Encouragement and Development of the Industrial Arts in Belgium, held in Brussels in 1856, and of the Société Française de Photographie (SFP), in Paris in 1857. Her known production is limited to six prints conserved at the SFP.

In 1856, 'Madame L. de Bruxelles' exhibited prints taken from nature, on dry paper and with no retouching. They were noted by the photographer Louis Adolphe Humbert de Molard and the critic Ernest Lacan, the latter believing that they rivalled those by Olympe Aguado, Édouard Baldus or the Viscount Joseph Vigier. That year, she was the first woman to become a member of the SFP, and she soon emerged from obscurity. In 1857, she exhibited sixteen prints, some identical to those of the year before; the critic Perier expressed enthusiasm, criticizing only the 'overly monotonous lighting'.

Leghait's production, which includes landscapes (Bois de la Cambre, Brussels) and views of architecture, is representative of those of amateur photographers from the leisured classes, familiar with art. Picturesque sites captured her attention: for example, at Mechelen, the old Flemish houses on the banks of the Sel, a laundry near the church at Béguinage, sheets drying on the grass, or the fish market – subjects that were later to be found on postcards. In the medieval sphere, Leghait photographed the ruins of the fortified Beersel Castle, built around 1300, and those of the Cistercian Villers Abbey, which, in 1856, featured in a publication by Alphonse Wauters: another Belgian calotypist, Gilbert Radoux, also exhibited a view in 1856. The Brussels milieu offered industrial buildings; Louis Dubois de Nehaut photographed them during the same period, with boats moored in the basin. The six preserved prints, which include four views of Mechelen, including the church, and two views of the entrance to Brussels Cathedral, are signed with a large 'L' in ink; the skies are white and lacking detail, probably overexposed in comparison with the main subject. Leghait remained a member of the SFP until 1864. Following the death of her husband in 1872, she moved to the Champs-Élysées in Paris, where she died on 22 April 1874. **HB**

Louise Leghait, *Fish Market in Mechelen, Belgium*, 1857

The work of Clementina Elphinstone Fleeming (known by the name of Lady Clementina Hawarden thanks to her marriage to the Honourable Cornwallis Maude, 4th Viscount Hawarden) illustrates the reciprocal complicity between women and photography during the Victorian era. In 1857, when Hawarden began to practise photography, it was through curiosity and as a pastime, like the majority of amateurs who discovered this new instrument. However, in her hands, this instrument soon became more than just a remedy for the family and domestic life for which she was destined. In her London home, at 5 Princes Gardens in South Kensington, in which three rooms on the second floor were equipped as a photographic studio and a dark room, Hawarden discovered the hidden potential of the view camera. In the gilded isolation of her idle and comfortable life, her practice led her to create elegant portraits, in keeping with the pictorial fashion of the time. The Victorian photographer seems to have wished to break free from her enclosed, luxurious and privileged environment, and to live experiences rich in emotion: the camera offered her this opportunity. Until her death in 1865, she focused on a single subject: her two eldest daughters, Isabella Grace and Clementina Maude.

While contemporaries found in Hawarden's images a 'delightful charm', these photographs nevertheless allow us to discern their author's desire to create, through photographic staging, erotic experiences. Through the insistent presence of mirrors, endlessly multiplying the young girls' faces and bodies, as they mischievously engage in a dialogue with the hidden presence of their mother, Hawarden revealed the ambiguous attraction that she experienced for the game of psychological cross-referencing between her own image and those of her adolescent daughters.

Thus her obsession with them, the only subject in her oeuvre, became an opportunity for imaginary escape, a transference enabled by photography. The desire to flee from the real world, to evade the moral restrictions of the time, and the impossibility of achieving this other than through the imagination, found an outlet in an apparently cold and neutral piece of machinery that was, in fact, capable of channelling powerful desires and shameful confessions. Clementina Hawarden's daughters grew up and were transformed under the 'voyeuristic' gaze of the camera – and of their mother – which gave innocent scenes an irrepressible erotic charge: lips that brush, hands that voluptuously touch, a face buried in a breast, raised petticoats, revealed bodices – all unthinkable at that time for women of this class. The unsettling normality of the experience of the family photograph became, in Lady Clementina Hawarden's tableaux vivants, an opportunity for a voyeuristic-performative relationship that captured the desires and taboos of the bourgeois female world of the second half of the nineteenth century, the record of an exotic and erotic dimension within the austere confines of Victorian England. **FM²**

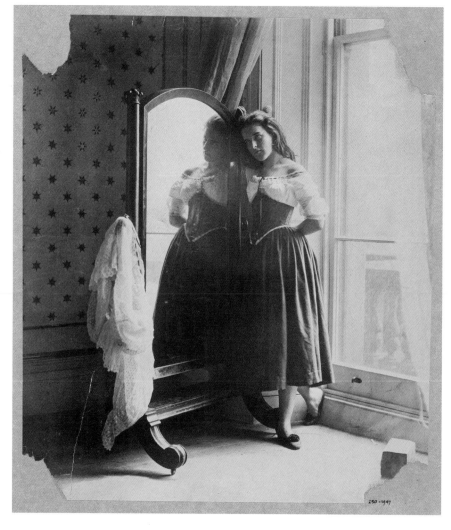

Lady Clementina Hawarden, *Clementina Maude, 5 Princes Gardens*, c.1862–3

Eliza Withington, *Exchequer Croppings, California*, c.1880

In the nineteenth century, Elizabeth W. Withington (née Kirby) was the sole female photographer in California's Amador County, where she operated a portrait studio from 1857 until her death. Eliza, as she was known, was born in 1825 in New York and moved to Michigan, where she married George Withington in 1845 and bore two daughters, in 1846 and 1848. In 1849, her husband joined the thousands of men seeking their fortunes in the gold fields of California. Not all became miners: many, like George, made a living supplying the mines and the settlements that sprang up practically overnight. In 1852, Eliza and her daughters joined him in Ione, a small city east of Sacramento: located at the junction of three mineral-rich creeks and on fertile agricultural land, it became an important supply centre for the nearby gold fields.

There was a strong demand for photographers in mining country, both to take portraits and to document land claims. In 1856, Eliza travelled east, apparently with the express intention of learning to photograph; while there, she visited several photography galleries, including Mathew Brady's illustrious New York portrait gallery. Back in Ione, in July 1857 she opened the Excelsior Ambrotype Gallery on Main Street. Although many women worked in family photography businesses or as mounters or retouchers, Withington was one

of only a handful of women to own and operate their own portrait studio. One newspaper exclaimed: 'Just think of it – your picture taken by a Lady!' Withington supplemented her income by teaching and making handicrafts. Unlike her husband, who declared bankruptcy (and from whom she separated), Eliza oversaw a thriving business.

Withington's ambitions for her photography outpaced what she could accomplish in tiny Ione. In addition to studio portraiture, she took landscape views and stereographs of the Sierra Nevada and nearby mining camps – an adventurous and technically complex undertaking that she described vividly in an essay entitled 'How a Woman Makes Landscape Photographs', published in *Philadelphia Photographer* (1876) and reprinted in *Photographic Mosaics* (1877). Having neither private transportation nor a portable darkroom, Withington – laden with bulky camera, fragile glass plates and precious chemicals – undertook precarious journeys on the public stagecoach or hitched rides on fruit trucks. She ingeniously rigged up a developing tent and a camera cover using her own dark skirts, while her parasol did double duty as a lens shield.

In 1875, at the age of fifty, she joined the newly founded Photographic Art Society of the Pacific, headquartered in San Francisco. She continued to run her studio until her death in 1877. **CK**

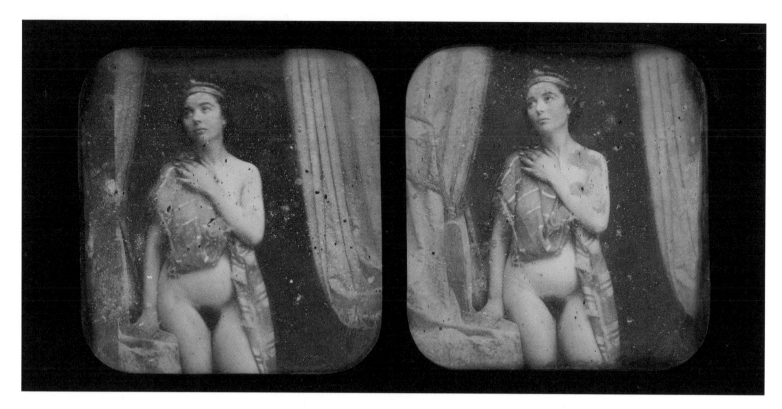

Laure Braquehais, *Seated nude wearing a headband*, c. 1855

Laure Mathilde Gouin was the daughter of Alexis Gouin and Marie Gellé. Her father had originally trained as a miniature painter, but in the late 1840s he established a daguerreotype studio in Paris. In 1850, Laure married a painter named Bruno Braquehais, who took up the daguerreotype himself and worked with his father-in-law. Both Laure and her mother were involved in the business: Marie was a highly respected colourist who sold colour materials to retouchers, while Laure both coloured and took photographs. Alexis Gouin's obituary, which appeared in *La Lumière* in 1855, praised Laure and Marie as the 'two students who always assisted him with intelligence and talent'.

After the death of her father, Laure continued to worked with her husband under her married name, producing images that were revolutionary for a woman photographer of the period: daguerreotype nudes. Photographers of the period produced obscene material, which was illegal, and academic nudes approved by the censors for artistic purposes. Examples of both kinds of nude have been attributed to Bruno Braquehais, but Laure is referred to only in connection with legitimate artistic studies. Although she rarely received credit for her work, an 1863 review in the *Moniteur de la Photographie* mentions Laure in glowing terms: 'A series of academic studies undertaken by her have been the object of unanimous praise from all artists who have seen them.'

Following Bruno's conviction for embezzlement in 1873, his imprisonment and his death two years later, Laure set up her own studio in Paris under her maiden name. According to an advertisement she placed in the *Didot-Bottin*

directory, it specialized in artistic reproductions and images for manufacturers. In 1878, she was the only woman photographer in the French section of the Exposition Universelle, where she displayed her trade photographs and obtained an honourable mention. Laure continued to receive praise for her photographic work as well as for her skills as a colourist throughout the 1870s, but in 1883 she was forced to declare bankruptcy. Although her name appears in the 1896 *Aide-mémoire des Photographes*, it is otherwise hardly mentioned. Her death certificate has not been found.

During her lifetime, Laure Braquehais registered only two photos in the name of Laure Gouin: a print showing a Chinese screen, and one of a fireplace screen for the Buteux brand in 1878. However, the photography historian Serge Nazarieff has posthumously attributed various stereoscopic daguerreotypes to her: they were formerly thought to be the work of Bruno, but they employ a single-plate format as opposed to two 1/6 plates mounted side by side, the technique used by her husband. Two daguerreotypes, now in the Getty Museum, that can potentially be attributed to Laure reveal her immense artistic and technical gifts. The clarity, careful attention to staging and distinctive luminescent use of gold and blue transform her models into living works of art. In her images, the verisimilitude and artistry of photography, two facets often understood as opposed to each other during the medium's early days, instead work in concert to yield some of the most striking daguerreotype nudes of the nineteenth century. **RR**

Born in Nashua, New Hampshire, Emma Jane Gay was unusually well educated for a girl of her time. Teacher, nurse, poet and then clerk in the dead-letter office in Washington, DC, where she had moved at the outbreak of the Civil War, she began photographing in the early 1890s.

Gay met Alice C. Fletcher, a well-respected anthropologist and advocate of Native American education and reservation reform, some time in the 1880s, and the two became close companions. In 1889, following the Dawes Act, the Commissioner of Indian Affairs sent Fletcher to work with the Nez Perce tribe in Idaho to implement a new government allotment policy. This policy – which was essentially a project of assimilation – sought to offer each individual member of Native American communities a discrete plot of land. Gay decided to go with Fletcher, and spent a summer learning photography in the hope of becoming an official member of the party. Although she did not receive a permit, Gay accompanied Fletcher on annual visits over four years, as cook, housekeeper and unofficial photographer.

While Fletcher observed the reservations, issued title deeds and wrote reports, Gay made her own personal record of the visits in the form of photographs and extensive notes. Both women were reformers, and in many of her images Gay reflects a progressive view of the government policy of the time, even if in her letters she sometimes expressed her indignation and scepticism at the way land was being redistributed and at the conditions offered by the settlers. Recent studies have also shown how her photographs betray moments of tension, and reveal a dynamic of power in these problematic exchanges, at the same time as raising questions about the status of women and the distribution of domestic tasks between the sexes at turn of the century, among both white settlers and Indigenous peoples. Together, Gay's letters and photographs constitute a valuable record of an important moment in US history. The allotment programme ended in 1894. For the Nez Perce and many other Native American communities, it was followed by decades of instability and suffering, and tribal leaders are still working on their cultural and economic reconstruction.

With the help of her niece, Emma Gay, Emma Jane Gay compiled her letters and 191 photographs in two leather-bound volumes entitled *Choup-nit-ki (With the Nez Percés)*. Begun in 1889, the project was completed twenty years later, by which time Gay had moved to live with her friend Dr Caroline Sturges in England, where she died in 1919. The volumes were donated to Radcliffe College, Cambridge, Massachusetts, in 1951, where they form part of the Schlesinger Library collections. In 1981, an anthology of Gay's letters and photographs, called *With the Nez Perces: Alice Fletcher in the Field, 1889–1892*, was published. **SK**

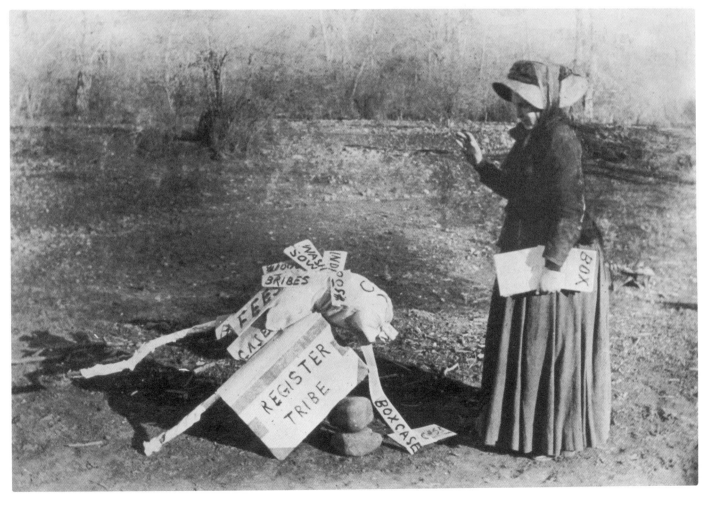

Emma Jane Gay, *Staging the 'Box' Case*, from *Choup-nit-ki: With the Nez Percés, c.*1889–92

Louise Laffon was a professional Parisian photographer who produced the wide range of work typical of a commercial studio: portraits, reproductions of antiquities, reproductions for the teaching of drawing, still lifes. Her output included a variety of subjects, but also of supports: she offered prints taken from collodion negatives ranging from visiting-card size to large-scale formats, but also photographs on enamel and cloth. In 1861, she patented transparent photographic portraits on satin and silk, offered on items including screens, glass panels, fans, bracelets and rings. Her photographs were sometimes presented in lavish frames, glued onto blue cards with gold thread, accompanied by the written and gilded letter 'L'.

Few biographical details are known of this woman born as Lusignan Lazare. She owned a studio in her own name, unusual for a woman at that time, and she occupied numerous addresses in Paris between 1859 – the date of her first studio, at 93 Boulevard Beaumarchais (3rd arrondissement) – and 1885, when she moved to her last, 3 Rue de la Paix (2nd arrondissement). Other locations included 26 Rue Vivienne (also in the 2nd arrondissement); 14 Rue de Tilsitt; 13 Rue Lord-Byron; 248 Rue du Faubourg-Saint-Honoré; and 3 Avenue Beaucoup (all in the 8th arrondissement).

Her lengthy photographic career appears to have been successful: she took part in the exhibition held by the Société Française de Photographie in 1859 (she was one of two women out of 149 exhibitors, alongside Madame Rodanet), then in those of 1861 and 1864. The same year, she became one of the first women to be admitted to the SFP. She was awarded the gold medal at the Exposition Universelle staged in Paris in 1867 and again in 1878. In his essay in the catalogue of the exhibition *Qui a peur des femmes photographes?* (Paris, Musée d'Orsay, 2015), Thomas Galifot notes her proximity to the circles of the imperial household: she photographed objects in the Musée Napoléon III and marbles in the Campana collection. In 1866, in the factories of M. Alexis Godillot, an arms manufacturer, Laffon photographed French army uniforms, plates that were later produced in colour. Her still lifes, in which the game stands out from a background painted or in knotty wood, are particularly striking in their clarity, starkness and beauty. **FT**

Louise Laffon, *Guinea Fowl*, 1862

Isabella Bird, *Author's Houseboat at Kuei Fu*, 1899

'Photographing has been an intense pleasure.
I began too late ever to be a photographer, and have
too little time to learn the technicalities of the art;
but I am able to produce negatives which are faithful,
though not artistic, records of what I see.'

ISABELLA BIRD

Isabella Bird grew up in Yorkshire in a strict religious household, her father being an Anglican vicar. She became a well-known explorer and author, and was one of many significant women photographers in Victorian England. In 1892, she took photography classes at the Regent Street Polytechnic in London, while taking advice from seasoned explorer-photographers. The same year, Bird became the first woman to be admitted to the Royal Geographic Society: five years later, she was also the first woman to become a member of the Royal Photographic Society. She is sometimes known as 'Mrs Bishop', following her marriage in 1881 to John Bishop, a doctor who died in 1886.

A veritable globetrotter, in the 1850s Bird travelled all over the world, traversing the United States, Australia, New Zealand and even Africa. She then became enamoured of Asia, which she discovered in 1894. In the space of just three years, she travelled through Korea, Japan, Manchuria, Siberia, Tibet and, particularly, China.

In her photographs, Bird exhibited a particular interest for certain subjects: public figures, topography, traditions, small traders, architecture and traditional sculpture, as well as the social conditions and health of the populations she encountered. These subjects, in addition to her direct and detached visual approach, echoed the ethnographic, economic and colonial interests common in the intellectual circles in which she moved.

Nevertheless, while these images reinforced the tendencies of the time in wishing to identify, classify and document the world's cultures, Bird also aimed to go beyond the prevailing stereotypes. As stated in the preface of her book *Chinese Pictures*, published by Cassell and Company in 1900, the Chinese were often regarded as 'cruel barbarians'. Bird also hoped to provide 'true information about the [Chinese] people, their environment and their practices', which, she believed 'cannot be understood in the light of another nation'.

Aware of public ignorance of these distant lands back home, Bird assiduously published accounts of her journey, documented and illustrated principally by her own photographs: a relatively rare phenomenon at the time, when testimonies remained for the most part private. Two of her works specifically concerned China: *The Yangtze Valley and Beyond* (1899) and *Chinese Pictures: Notes On Photographs Made in China* (1900). Her commitment to the country went beyond the mere experience and documenting of her travels, however. Affected by the great poverty of its population, she personally financed the opening of a hospital in Langzhong, a city in the southern province of Sichuan. Opened in the late 1890s, the new establishment was to bear her name: the Isabella Bird Hospital.

Isabella Bird died in Edinburgh at the age of seventy-two, her bag packed ready for a fresh voyage to China. Today, the majority of her archives are conserved at the Royal Geographic Society in London and the National Library of Scotland in Edinburgh. **MC-B**

Rosalie Sjöman is one of many prominent Swedish women photographers who were active in the early days of photography, from the 1850s to the turn of the century. She was born in Kalmar, in the south-east of Sweden, and her father was a captain in the merchant navy. At the age of twenty-two, she married Sven Sjöman, also a merchant navy captain. The couple moved to Stockholm, where in 1857 Rosalie gave birth to her first son, followed by another three years later. Their daughter, Alma, was born in 1861. Sven Sjöman died in 1864, leaving the young Rosalie as the sole provider for her three small children.

Sweden was one of the first countries where information about the new daguerreotype technique, which had been presented to the Academy of Sciences in Paris in January 1839, became widely available. In the winter of 1840, Louis Daguerre's instruction manual had been translated into six languages, including Swedish. By the 1860s, the medium had spread through Sweden, and for a decade cartes de visite enjoyed huge popularity. Rosalie Sjöman was active during this period of expansion, along with other successful women photographers, including Lotten von Düben, a pioneer of scientific photography who accompanied her husband, the physician Gustaf von Düben, on his travels to Lapland; Emma Schenson, who became famous for

her architectural photography and especially her views of Uppsala Cathedral; and Bertha Valerius, a renowned portrait photographer in Stockholm whose customers included the royal family.

In 1864, Sjöman opened a studio in Stockholm at Drottninggatan 42. The photographer Carl Jacob Malmberg is known to have had a studio at this address, and it is believed that Sjöman may have worked for him earlier in his career. Sjöman's business prospered, and towards the end of the 1870s R. Sjöman & Comp. had five employees, all of whom were women. She later opened studios at Regeringsgatan 6 in Stockholm, and in Halmstad, Kalmar and Vaxholm. She specialized above all in cartes-de-visite portraits (9 × 6 cm) and portraits in a larger format called 'cabinet cards' (13 × 10 cm). Her subjects vary from classical portraits and people in folk costumes to staged tableaux and mosaic compositions. She became known for her 'enamelled' photographs, which were made by coating the print with a thin layer of collodion to make it shiny; one photograph of her studio shows that she owned a 'Globe Enameler' – an expensive American-made gas-heated print burnisher. Her expertly hand-coloured prints are also especially eye-catching. Many represent her daughter: one of the best known shows Alma as Moder Svea ('Mother of Sweden'), dressed in blue and holding a Swedish flag. **AT**[1]

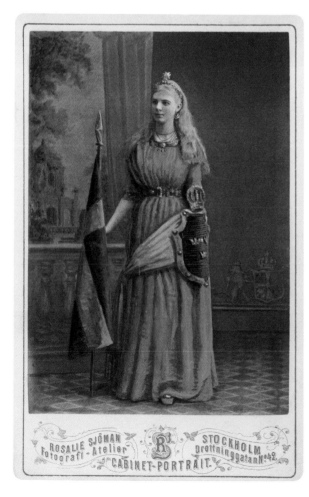

Rosalie Sjöman, *Moder Svea ('Mother of Sweden')*, c. 1875

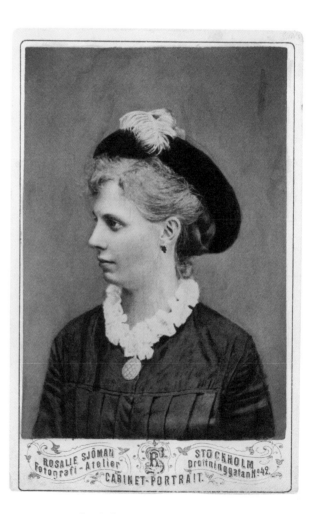

Rosalie Sjöman, *Alma Sjöman*, c. 1875

Countess of Castiglione, *Le Pé (The Foot)*, 1 August 1894

'The Eternal Father did not realize what he had created the day he brought her into the world; he lost his head at the contemplation of this marvellous work.'

COUNTESS OF CASTIGLIONE

The photographic oeuvre attributed to the Countess of Castiglione, née Virginia Oldoini, has passed from obscurity to brand-name recognition in the historical blink of an eye. Born in 1834 to minor Piedmontese nobility and married off at the age of sixteen to the Count Francesco Verasis di Castiglione, she took up photography when her husband was posted to the French court of Napoleon III, whose mistress she briefly became.

After the countess died in 1899, penniless and forgotten, Count Robert de Montesquiou, the dandy and aesthete, bought many of her effects, including 450 photographs he assembled in a scrapbook; he later wrote a book about her, *La Comtesse Divine* (1913). Starting in the 1950s, the rediscovery of her story inspired a number of pseudo-historical books, as well as two movies, all drawing on her mid-century sexual and sartorial notoriety and her brief fame at the height of the Second Empire.

Nonetheless, it was the singular nature of the photographs that propelled them into museum and corporate collections, even as they posed complicated questions of authorship and agency. For all the photographs taken of the countess were in fact the work of the studio portraitist Pierre-Louis Pierson, of the prosperous firm Mayer & Pierson. Here is one the ambiguities surrounding this archive, for while it is clear that the countess orchestrated her sittings,

costumes, props, hand-colouring and frames, it was Pierson who for forty years functioned as her personal photographer, producing approximately seven hundred glass negatives. This unusual complicity between photographer and model raises the question of authorship, insofar as the name of 'auteur' usually applies to the maker of the images, not the subject. It goes without saying that this obsessive desire for self-representation was a kind of mania, a symptom of the countess's extreme narcissism that comes through clearly in her journals.

The countess's promotion to the status of creator was prompted partly by the workings of the photography market but also, more significantly, by the burgeoning interest in women artists, photographers and other cultural producers hitherto ignored or marginalized. Somewhat problematically, her authorial status has been justified by comparing her photographs with those of contemporary artists such as Cindy Sherman. However, whereas Sherman and her counterparts approach the masquerades of femininity critically, with the countess there is little space between self and representation, and thus no possibility of distance or critique. The countess was an agent of her selfrepresentation, but was obliged to respect the strict codes that circumscribed a woman's desire during the Second and Third Republics, and to turn her public image into her own private, fetishized mirror. **AS-G**

Hannah Maynard

1834, United Kingdom–1918, Canada

Hannah Maynard, *Multiple exposure self-portrait*, c. 1895

In 1857, gold was discovered in British Columbia. A gold rush began the following year, and the small city of Victoria – the main port of entry, and the miners' supply depot – experienced a huge influx of prospectors. Hannah and her husband, Richard, were part of this boom: Richard as a prospector, survey photographer and shoemaker; Hannah as the owner and operator of a portrait studio. 'Mrs R. Maynard's Photographic Gallery', as it was known, was recognized for its professionalism and attracted a varied clientele, consisting mostly of local tradespeople and city notables. The *St Louis and Canadian Photographer* praised Maynard for her 'Gems of British Columbia' – composite photographs made from portraits of children taken in her Victoria studio. She continued to develop this popular series, and in 1891 managed to bring together 22,000 faces on the same sheet. In the late 1890s, her fifty-year career took a new direction when she applied her innovative techniques to producing mug shots for the Victoria police department.

The Maynard archives reveal Hannah to have been a complex character who skilfully used multiple exposures to create highly eccentric self- and family portraits, some of which can be read as expressions of grief following the loss of family members, and, possibly, Spiritualist visualizations through which she could remain close to them. The photograph known as *Hannah Maynard and her Grandson, Maynard MacDonald (also as a Photosculpture)* (c. 1893) is the most puzzling of these constructions, the artist appearing twice, both presenting and beholding, as does her grandson, who pretends to be transfixed by a sculpture of himself on a pedestal. The setting is a gallery of memory that includes portraits of Maynard's two daughters and her daughter-in-law, all three deceased.

As regional and feminist historians were taking a growing interest in Maynard's remarkable personal images, a visual anthropologist stepped in to show that Hannah had applied the same compelling creativity in her commercial work, for instance by combining her studio portrait of the Indigenous woman she called 'Mary' – the woman who cleaned her house – with a view of a Haida village taken by her husband, thus creating *Haida Mary* (c. 1885). Maynard was tapping into an international market for photographs of Native subjects, which were sold as authentic representations to ethnographers and tourists. Post-colonial art historians have since been severe with Maynard, criticizing not just her falsified *Haida Mary*, but also her prize-winning series 'Gems', as misrepresentations of Victoria's racial diversity.

These 'tremendous changes in social conditions', some already visible to Hannah Maynard, pose new questions of an oeuvre that succeeded on its own terms, fell into oblivion, and then re-emerged thanks to second-wave feminism and a surge of interest in Canada's photographic history. **ML**

'In my albums, I have numberless pictures taken by us in those far-off days and I never look at them without wondering how the tremendous changes in social conditions have been brought about.'

HANNAH MAYNARD

> '**I want to try everything that is new to me.**'
>
> **EMPRESS CIXI**

Born into a noble family in Beijing, Cixi was destined to become the concubine of Emperor Xianfeng, husband of Empress Ci'an. However, unlike most of the imperial concubines, she was cultivated and ambitious, enabling her to rise from the lowest rank to that of favourite. The birth in 1856 of a son, the logical heir to the throne and Empress Ci'an's backing of several plots in the Great Council propelled her to the rank of empress regent following the death of the emperor in 1861.

Cixi was interested in photography for several reasons. The image of the imperial power that she held had been seriously tainted by unsuccessful attempts at reform and military defeats, such as those of the Sino-French and Sino-Japanese wars at the end of the nineteenth century, and the virulent national xenophobic insurrection known as the 'Boxer Rebellion' in 1900. Cixi realized that this modern medium could serve as a tool to restore her image, attract the sympathy of the people once more, and relaunch international cooperation. She therefore engaged an amateur photographer, Yu Xunling, the son of an ambassador who had learnt photography in Tokyo and Paris. A studio was set up in the Summer Palace, where Cixi and the imperial court resided.

While the empress did not press the shutter release herself, she was the brains behind her staged portraits. These portraits reveal skilful creative strategies, combining visual tradition and modernity. In the most conventional, she posed seated on the throne, face on, surrounded by symbolic accessories and surmounted by a banner listing her honorific titles, in keeping with the painted portraits of sovereigns. In others, she is transformed into Guanyin, goddess of compassion in the Buddhist pantheon. Identifying oneself with deities is usually intended to indicate piety, but Cixi wished to establish her authority as a woman. In doing so, she became a pioneering figure. Passionate about the theatre and aware of the royal portraits of foreign courts, she had no hesitation in portraying herself in luxurious surroundings and assuming poses regarded as unsuitable for a women of her position (for example, cross legged, looking at herself in the mirror). The appearance of high-ranking women in public was then highly codified and restricted: other than at marriage ceremonies, women could communicate only through screens, without their faces ever being seen.

Photography served Cixi as a veritable means of visual and cultural emancipation, but also a political one. Taken for the most part between 1903 and 1904, these images were presented to local and international dignitaries as diplomatic gifts. Reproductions were also sold on the streets of Chinese cities and used in 1911 in the memoirs of Princess Der Ling (one of Cixi's ladies-in-waiting), published under the title *Two Years in the Forbidden City*. The glass negatives are today divided between the Freer Gallery of Art and Arthur M. Sackler Gallery in Washington and the National Palace Museum in Beijing. **MC-B**

Empress Cixi, *Empress Cixi in a sedan chair surrounded by eunuchs in front of the Renshoudian, Summer Palace*, Beijing, 1903–5

Alexandrine Tinne was a legend in her own lifetime. The newspapers of Europe and America were full of the most extraordinary tales about this Dutch aristocrat with a passion for travel. Her murder in the Libyan desert at the age of thirty-three only served to amplify the myth of an intrepid and unconventional character, ready to take reckless risks to conquer new horizons. Numerous essays and biographies were dedicated to her after the dramatic event, including an article in the French weekly magazine *Le Tour du monde* in 1871.

Tinne usually travelled in the company of her mother, her aunt, servants and scholars, in a huge caravan consisting of up to one hundred porters and beasts of burden. In the Nubian desert, a hundred or so camels formed part of the expedition and, in Egypt, several boats had to be chartered to carry the clothes, bedlinen, supplies, items for barter, dinner services, weapons, and even a cast-iron bed.

Along the way, Tinne also devoted herself to botany and ethnography. She made four expeditions to Africa. The first was a journey up the Nile as far as Khartoum. The second, again along the sacred river, heading towards Bahr-el-Ghazal in modern-day South Sudan, took a dramatic turn with the death of her mother, soon followed by those of her aunt and two servants. Following a third expedition, between Algiers and Libya, her fourth journey, from Tripoli to Murzuq (1869) was also to be the last. Tinne was murdered and dismembered, as were those accompanying her, probably by the Tuaregs and Arabs who were part of the expedition. The Muslim members of the group, the only ones to be spared, later testified to this terrible event.

In Tinne's adventurous life, photography merely played a secondary role. Her output, or at least what remains of it, was identified only after several decades in scattered archives, and proved to be modest. In 1860, between two of her expeditions, Tinne took twenty or so large-format (36 × 45 cm) views of The Hague, using the wet-collodion process. Her camera has never been found, but the photographs are now conserved in the city's archives. Scenes of interiors and portraits discovered in the collections of the British branch of the Tinne family have been donated to the Dutch national archives.

It is still not known what encouraged Tinne to take up photography. Perhaps she had seen the images of Egypt and Sudan by Maxime du Camp and Ernest Benecke in the Royal Library in The Hague. Did she intend to take photographs in Africa herself? There is nothing to prove this. Vague references can be found in her correspondence, as well as group portraits (bearing the stamp J. Geiser) taken in Algiers, her adopted home, probably by her. In a letter written from there, Tinne asked her brother to send her a Dubroni camera. Perhaps she was also the creator of the photographs of the earthquake that shook the region in 1867, reproduced as wood engravings in *Le Monde illustré*. **MB²**

'I have always found the fame associated with my name very difficult.'

ALEXANDRINE TINNE

Alexandrine Tinne, *View of a Street in The Hague*, 1861

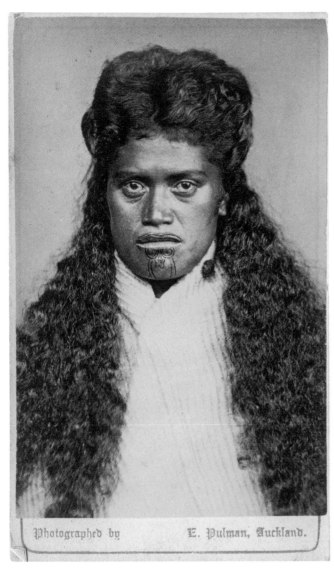

Elizabeth Pulman, *Portrait of a Maori Woman, c.* 1870

Elizabeth Pulman (née Chadd) was New Zealand's first female professional photographer. From 1871 to 1900, she managed a successful studio in Auckland, where she produced many striking portraits of Maori. Today her works are held in national photograph collections worldwide and are greatly valued by both Maori and New Zealanders of European origin.

Born in Lymm, Cheshire, Elizabeth married George Pulman, a bricklayer, in 1859, and that same year the couple emigrated to New Zealand. George first found work as a lithographer, but by 1869 he was the owner of a photography studio in Auckland where Elizabeth assisted him.

Over the next two years, George produced an important series of albumen prints in the form of carte-de-visite portraits of Maori chiefs and important women leaders that were popular with the buying public. At that time, it was not unusual for photographers to pay Maori to sit for them. When, in 1871, George died suddenly from a heart attack, Elizabeth took over the running of the studio and continued producing portraits in the same style. Cartes de visite were relatively inexpensive to produce and to buy, and in no time photographic portraits were within the reach of all classes. Not just Maori chiefs, but even commoners approached Elizabeth to have their 'likenesses' taken. As one critic has observed, 'Maori became the active engagers of a professional service rather than the exotic subjects of an enquiring lens.'

In her photographs, Pulman adopted a less formal and more experimental style than her husband. Her portraits of famous Maori leaders – Tamati Waka Nene and Te Hore Hore, for example – are taken up close, and her sitters often wear Western-style clothes rather than traditional costume. Her later portraits show that, in addition to the albumen process, Pulman had mastered the newer silver-gelatin process. At a time when racial stereotypes were rife and the tourist industry was relegating Maori to the status of ethnographic anachronisms, Pulman was producing images that emphasized her subjects' modernity and individuality.

In 1875, Pulman married the Englishman John Blackman, a former reporter for the *Auckland Star*. He acted for Elizabeth in an 1882 court case against a local photographer named Charles Henry Monkton, who was allegedly selling her work as his own. Pulman died of a stroke in February 1900, aged sixty-four. **AM**

Marie-Lydie Bonfils, née Cabanis, is an exemplary case of the invisibility of women photographers who also ran photographic studios. In 1867, having settled in Beirut with her husband Félix Bonfils and their children, she played an active role in the largest commercial photography business in the Middle East.

Marie-Lydie Bonfils was one of the photographers for the Bonfils firm, established by her husband in Beirut, and specialized in 'photographic views of the Orient'. The Reverend Samuel Manning, a British author of illustrated travel accounts, mentioned her among the photographic sources in his work *Those Holy Fields: Palestine* (1874). Bonfils continued to practise photography well into old age, since, according to the testimony of a member of the Maksad de Brummana family, she asked a Druze sheik to pose for her at the beginning of the First World War.

Nevertheless, the absence of her own signature and the significant number of studio images that were unsigned, or signed simply 'Bonfils', makes the attribution of her work difficult. Considering the moral and religious codes of the country, it can be assumed that she must have taken the studio photographs of women dressed in traditional costume, alone or in a group, in genre scenes, but it cannot be ruled out that she documented other subjects in Lebanon, or elsewhere in the region. In fact, it would be difficult to attribute to a male photographer the images 'Bedouin Entertainment' in which a bare-breasted woman can be seen. Similarly, the staging of 'Young girls of Bethlehem' reveals first and foremost a female gaze. In general, these images of women, taken in the studio in an artificial setting, highlight the sensuality and cultural otherness of her models in order to satisfy the strong demand for Eastern exoticism from travellers and tourists.

Marie-Lydie Bonfils oversaw not only the compositions but also the development of the images and their printing on albumen paper. In addition, she was involved in the management of the Bonfils firm, which became known as 'F. Bonfils & Cie' from 1878 onwards. It was she, for example, who organized a photographic sitting for Abbé Pierre-Auguste Raboisson, traveller and amateur photographer, who was looking for models during his voyage through the Middle East in 1882.

Following the death of her husband in 1885, and their son Adrien's departure for Brummana ten years later, Marie-Lydie took care of the running of the studio, which had branches in Jerusalem and Baalbek, establishing herself as the first woman photographer in the Near East. Produced by the Catholic printing company in Beirut in 1907, the *Catalogue général des vues photographiques de l'Orient* (Beirut, Vve L. Bonfils) contained 1,684 numbered photographic images.

In 1909, Bonfils entered into partnership with Abraham Guiragossian, one of the Bonfils company's former collaborators, who would acquire the business after Marie-Lydie's death in 1918. The catalogue bearing the title 'Photographie Bonfils, successeur A. Guiragossian' contained 1,650 images taken from the 1907 catalogue. The caption 'Photographie Vve L.[ydie] Bonfils, A. Guiragossian Succr Beyrouth' also appeared on the cover of albums that Guiragossian published, as well as on the back of the Bonfils postcards he reprinted.

In 1916, during the First World War, her evacuation on board the American warship USS *Des Moines* marked the end of Marie-Lydie's photographic work in Lebanon. **IA**

Marie-Lydie Bonfils, *Syrian Muslim Women in Beirut wearing city wear*, c. 1885–95

Augusta Dillon (née Crofton), a practitioner of the complicated wet-collodion process, produced one of the most vibrant and diverse photographic records of life on an Irish landed estate. It is believed that she took up photography as a teenager at her father's house in central Ireland. She continued to photograph after her marriage in 1866 to Luke Gerald Dillon, 4th Baron Clonbrock, who was also an enthusiast, and her diaries, letters and photographic records provide a detailed view of amateur practice in the mid- to late nineteenth century. Augusta's interests, which included horticulture, botany and antiquarianism, are reflected in her varied photographic output. She also produced sensitive portraits, studies of medieval sculpture, still lifes, and images of interiors and society events in London and Dublin.

During the 1860s, Dillon transported an entire darkroom into the field, including tent, trays, scales and chemicals, as well as a camera and glass plates. The 920 negatives that she stated were in her studio at Clonbrock House by May 1869 therefore represent the fruit of considerable work. There is no evidence that Dillon exhibited her photographs, which were instead exchanged with members of her family and friends or among the wider network of Anglo-Irish families. Her images were incorporated into large annotated and decorated albums.

Largely self-taught, Dillon nevertheless subscribed to photography periodicals and kept abreast of the photographic sections at the international exhibitions held in Ireland and England. So it was that, in 1865, she attended the Dublin International Exhibition, which brought together more than four thousand photographs, including the work of Lady Hawarden and Julia Margaret Cameron.

Throughout this period, Ireland was undergoing profound societal changes and agrarian unrest, as tenant farmers sought security of tenure and land purchasing rights. This brought owners such as the Dillons into direct confrontation with the local population. Nonetheless, they continued to enjoy good relations with their tenants, and Augusta's photographs reveal a bond between her and the estate workers. Dillon retained an interest in photography into her later years, adapting to new technologies and styles, and sharing her interest with her grown children. **OF**

'Took the camera out at noon and worked away until there was no more light, 2 or 3 tolerable results.'

AUGUSTA DILLON

Augusta Dillon, *Three-quarters portrait of Georgiana Dillon wearing a bodice and a buttoned dress*, c. 1880–1910

Adelaide Conroy (née Anceschi) was born in 1839 in Reggio Emilia, northern Italy, the third daughter of Rosa and Pompilio Anceschi. Not much is known about her childhood, but by the early 1860s she had joined a small circus troupe travelling from London to Naples that included the English couple James and Sarah Jane Conroy, and their teenage apprentice Richard Ellis, who would later become a celebrated Maltese photographer. Between 1855 and 1860, their plan to tour Italy was interrupted by the unrest caused by the Risorgimento, forcing them to move to the next safe haven, Malta, which was then under British rule. On 9 April 1861, the four of them – Adelaide, Richard, James and Sarah Jane – along with the Conroy's baby Jane – crossed from Messina to Malta on a ship called the *Capitole*.

The 1863 death certificate of a certain Sara Conroy, who passed away aged two in Senglea, Malta, gives the child's parents as James Conroy and Adelaide Anceschi – evidence of the group's somewhat unconventional lifestyle. Even if circus troupes were known for their liberal manners, acceptance of non-normative family structures and collective child-rearing, this kind of situation was uncommon in the conservative Victorian era.

It seems likely that Adelaide took up photography some time after 1862, the opening date of the first Conroy studio in Senglea, which produced daguerreotypes. The earliest evidence of her practice comes from private collections of cartes de visite and from legal documents, dated after 1865, that bear the stamp of 'Mrs Conroy'. The studio, then located at 134 Strada Stretta, Valletta, was producing collodion prints, mainly portraits in carte-de-visite format. There is currently no evidence to suggest that Sarah Jane Conroy was directly involved in the business.

From 1871, the address of another studio, located at 56 Strada Stretta, appears on the cartes de visite. By this time, the studio was employing additional photographers as James Conroy's health was in decline. In 1872, six months after the death of James's wife, Sarah Jane, Adelaide and James were married. Three years later, Adelaide's father, Pompilio, purchased the Conroy photographic business, giving Adelaide power of attorney and legally committing himself to care for the five young Conroy children.

The marriage was of short duration. In 1876, Adelaide legally separated from James Conroy but continued to operate the studio and advertise using her married name until 1878. It is therefore certain that Adelaide worked as a photographer making studio portraits between the late 1860s and 1880, the year in which she and James Conroy independently applied for passports to travel to Egypt, six months apart. From that point on, her fate is unknown. **LS**[1]

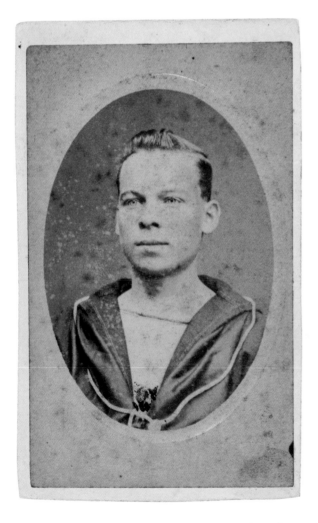

Adelaide Conroy, *Untitled*, date unknown

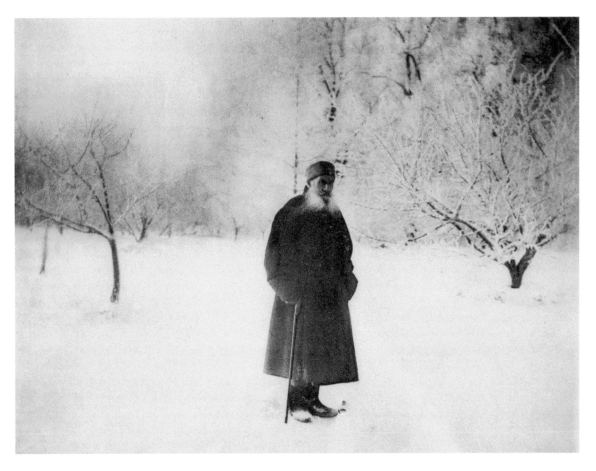

Sophia Tolstaya, *Leo Tolstoy Walking in Winter*, c.1900

Sophia Andreyevna Tolstaya, née Sophia Behrs, was born on 22 August 1844 into a family of German origin. Her father, Andrey Evstafievich Behrs, was a state councillor for the palace in Moscow, while her mother, Lyobov Alexandrovna Islavina, came from a family of traders. Sophia spent her early years in an apartment at the Kremlin, where her parents lived. Having received an excellent home education, she enrolled at Moscow University, graduating in 1861 as a home tutor. A novelist and short-story writer – she would describe in some of her writings her stormy relationship with her husband and their troubled domestic life – Sofia Behrs also kept a diary, which would later be considered one of the best of the genre.

The writer Count Lev Nikolayevich, known in English as Leo Tolstoy, who was close to the Behrs, was initially due to marry Elizabeth, the family's eldest daughter. But he changed his mind and instead wedded her younger sister, Sophia Andreyevna, on 23 September 1862. Sophia Tolstaya, as she now was, lived with him in the countryside for nineteen years, going to Moscow only for short periods. She gave birth to thirteen children, five of whom died in infancy. For many years, she managed the household at Yasnaya Polyana, near Tula, where the Tolstoys lived, around 125 miles south of Moscow. A devoted wife, Sophia served as a secretary to her husband, translating, editing, copying and proofreading his writings. She supported his ideas but sometimes argued openly with him, especially when, in accordance with his radical principles, he planned to give away the lands that he had inherited to live a peasant lifestyle or wanted to renounce the copyright to his works – decisions that would have risked pushing the family into bankruptcy.

Photography was one of the countess's hobbies, along with gardening, literature, drawing and music. Her first images, which are not especially accomplished, date to late 1880s, but her interest in photography intensified

> 'I will try to be sincere and authentic until the end. All life is interesting and mine may one day attract attention.'
>
> **SOPHIA TOLSTAYA**

in 1895 following the loss of her youngest son, Ivan, the darling of the family, who died of scarlet fever. She decided to photograph the favourite places of her beloved child, and in her diary noted that photography allowed her to overcome her grief. Sophia first used heavy, bulky equipment, now kept at the Leo Tolstoy Museum in Yasnaya Polyana, before she acquired a more manageable Kodak camera.

Sophia Tolstaya, one of the few female photographers in pre-revolutionary Russia, never worked professionally or aspired to the status of artist, choosing above all to photograph her family. She thus produced a series of photos, which later became celebrated, recording the couple's wedding anniversaries every year: the first was taken on 23 September 1895, and the last was on 23 September 1910, two months before Leo died. She also took pictures of her children and grandchildren, the house and its fittings, and sometimes peasants on the estate. Right up to Tolstoy's death, her principal subject was nonetheless her husband: she was not only his wife and partner, but also his biographer and chronicler.

In 1912, Sophia Tolstaya published a limited edition of her photography album entitled *Tolstoy in Everyday Life*. Today, the Leo Tolstoy Museum in Yasnaya Polyana holds more than 250 of her photographs. **AA³**

In Iceland, the struggle for women's equality took off in the 1850s with the creation of the first girls' school in Reykjavík. Single women were legally allowed to hold professional positions from 1861, and married women from 1900, without having to request permission from their fathers or husbands. This important change in legislation encouraged women to pursue professional careers, and photography was considered to be a respectable activity for young women from the educated middle classes, allowing them to work independently and to earn a living. Nicoline Marie Elise Weywadt was the first woman in Iceland to practise photography. She embarked on her career after studying briefly in Copenhagen in 1871–2. Given Iceland's status as a Danish colony at the time, it was logical that Weywadt should have travelled to Denmark's capital city and the administrative centre. Her father, Niels Weywadt, the head of a family of fourteen, ran a successful business as a shipowner and was the local representative of the Danish colonial society Ørum & Wulff in Djúpivogur, a trading post in eastern Iceland frequented by whalers and fishermen from abroad. About ten years after finishing her training, Nicoline had a studio built next to her family home in Teigarhorn, near Djúpivogur. This studio would be rebuilt in 2015 by the National Museum of Iceland.

Having learned photography, Weywadt also became interested in mineralogy: her home region was renowned internationally for its unique zeolites. In 1878, the Geological Museum in Copenhagen commissioned her to collect mineralogical samples for the institution. After the death of her father in 1883, Weywadt took over the management of the family farm as well as looking after the Teigarhorn weather station on behalf of the Danish Meteorological Institute.

Having begun her career using the wet-collodion process, Weywadt changed to the newer dry-plate technique in 1888 after completing another short course in Copenhagen. She photographed almost every family in her region, and her photographic archive, now housed in the National Museum of Iceland, constitutes an extraordinary record of the population in eastern Iceland during the last decades of the nineteenth century – a land marked by emigration to the United States and Canada. Her photographs are conserved as original glass plates, even if some of her landscapes exist as vintage prints. Most of her topographic views are evidence of harsh weather conditions – the result of a period of climatic cooling in the 1880s – as in her image of whaling ships at anchor in the ice-covered harbour of Djúpivogur taken against a sublime mountainous background.

The photographs also have unique historical value, in that they bear witness to the particular colonial situation that characterized this part of Iceland. Open to the sea, the Teigarhorn region fostered the mixing of cultures and races. Weywadt never married and had no children, but a cousin of hers, Hansína Regína Björnsdóttir, became her assistant. Björnsdóttir was a descendent of the Black Danish slave Hans Jonatan, who had settled in Djúpivogur in 1802. After completing a course in Copenhagen in 1902–3, she took over the studio from Weywadt, who was suffering from serious health problems, and continued to work into the 1930s. Sometimes Hansína signed her images using the masculine name 'H. Erikson', probably to make them more commercially appealing: the Icelandic suffix '-dóttir', which is reserved for women, would have sounded more parochial and therefore less chic. **ÆS**

Nicoline Weywadt, *Whaling Ships at Djúpivogur*, Iceland, Winter 1873–4

Wanda Chicińska, *Dwelling House No. 12 (Sobieskiego)*, Lublin, 1874

'Lublin is one of the oldest cities in our country; it has many architectural monuments that deserve to be better known. With this aim in mind, I have published an album of photographs of Lublin, in the belief that many people would be happy to buy it and that it could serve as a guidebook for visitors to our city.'

WANDA CHICIŃSKA

Wanda Chicińska, one of the few women to have practised documentary photography in the nineteenth century, is best known for her views of the city of Lublin, in eastern Poland. Born in Warsaw around 1850, she moved to Lublin with her parents as a child. In 1871, at the age of twenty-one, she bought a run-down photographic studio in the Hotel Europejski, located on the city's main street. Well educated and dynamic, Chicińska quickly restored the studio to its former glory with the support of experienced employees. She worked alongside several assistants and students, and acquired the latest technical innovations straight from Paris.

Chicińska was the first person to arrange photography exhibitions in Lublin. In the 1870s, she brought together a selection of photographs from different studios in Warsaw, including cartes de visite produced for a well-known Polish actress, Helena Modrzejewska. She was also one of the first women in Lublin to publicly raise the issue of women's representation in the workplace. In 1872, in response to high demand among her fellow citizens, Chicińska planned the opening of an 'art workshop for women', where painting, drawing, woodcarving, lithography, bookbinding and, above all, photography would be taught, as well its ancillary subjects of photographic chemistry, retouching, colouring and drawing. Chicińska herself was to head up the photography department, whereas drawing was to be taught by the painter Henryk Filipowicz, who worked alongside her in the studio. Unfortunately, there were not enough willing participants, and the project never saw the light of day.

Starting in 1872, Chicińska published a calendar featuring views of Lublin, printing several hundred copies. Two years later, she designed an album that constituted one of the first guidebooks to Lublin. Comprising five portfolios, each of which contained four views taken with a glass-plate camera, it presented the most important buildings of the city alongside a text explaining their history.

During an exhibition of women's work held in Warsaw in 1877, Chicińska's youthful ambitions and dedication paid off: she was awarded the gold medal, for producing 'photographs characterized by accuracy and beautiful frames'. She died in a Lublin poorhouse in 1938, at the age of eighty-seven. **KG**[1]

Jane Dieulafoy, née Magre, nicknamed by her contemporaries the 'Modern Knight', earned fame as an explorer and photographer before becoming a writer. At the age of nineteen, this young woman from a wealthy family in Toulouse married Marcel Dieulafoy, an engineer at the École Polytechnique, whom she would accompany on his expeditions. In 1870, she was distinguished for bravery in the Franco-Prussian War, and was one of the first women to be awarded the Légion d'Honneur in 1888, following the success of their missions in Persia.

Marcel Dieulafoy, an attaché in the Department of Historic Monuments, was interested in the question of the Eastern origins of Western architectural forms. In 1881, the Dieulafoys set off on an official mission across Persia for more than fourteen months; they were the first French citizens to reach Susa (south of the present province of Khuzestan, Iran). Jane, who was responsible for the photography, played an important part in this expedition's success. She returned to Paris with more than six hundred photographs, including some of the earliest ones taken in the country, thus ensuring the quality of the architectural surveys in the five volumes of *L'Art antique de la Perse*, published by Marcel in 1884–5. From 1884 to 1886, the Dieulafoys managed the first official excavation at Susa, during which Jane catalogued the various items that were discovered and photographed them in order to facilitate their reconstruction in France. They brought back the first collection of antiquities from Susa, which were presented at the Louvre in 1888 by the French president, Sadi Carnot. Five years later, Jane Dieulafoy's photographs were reproduced in her husband's book *L'Acropole de Suse*.

These missions marked a turning point in Jane Dieulafoy's life: she caused a stir by wearing her hair short and by the men's clothes that she adopted during the expeditions. Her two travel journals, illustrated with her own photographs and published in the weekly magazine *Le Tour du monde*, launched her literary career. They reflected her campaigning for the intellectual emancipation of women – she notably chaired the Prix Femina in 1905 and 1911 – and the Catholic and conservative values that characterize her work.

Although, for diplomatic reasons, the Dieulafoys never returned to Persia, archaeology and the East remained at the heart of their lives. Jane specialized in historical novels such as *Parysatis* (1890), which would inspire Camille Saint-Saëns to compose an opera staged at the Arènes de Béziers in 1902. Spain became the new focus of their studies: for more than twenty years, they travelled throughout the country. In 1914, Marcel Dieulafoy enrolled in the army and was assigned to a posting in Rabat, Morocco, as an engineering officer. Jane ran a dispensary there, where she contracted dysentery; her illness brought to an end their stay as well as their excavation project at Yakub el-Mansur.

Jane Dieulafoy died at the family chateau of Langlade, not far from Toulouse, in 1916. Her last work, *Isabelle la Grande, Reine de Castille (1451–1504)*, was published posthumously by Marcel four years later. **AL**[1]

Jane Dieulafoy, *Tomb of Darius*, Iran, 1884

'I earnestly advise women of artistic tastes to train for the unworked field of modern photography.'

GERTRUDE KÄSEBIER

Gertrude Käsebier, *Gargoyle*, 1901

In 1903, five images by Gertrude Käsebier, née Stanton, were published in the first issue of the American magazine *Camera Work*, flagship of the Photo-Secession group founded by Alfred Stieglitz, to which she belonged. When the magazine ceased publication in 1917, however, Stieglitz had long fallen out with Käsebier and turned towards a photography that was 'pure' and hazy.

Paul Strand drew attention to Käsebier's significance in his article 'Photography', which appeared in *Seven Arts* in 1917: a pioneer in American photography, according to Strand, she had achieved in her art a transnational 'universal expression'. He would have been able to identify with Käsebier's commitment to an art that reflected 'humanity'. The photographic medium attests in both of their oeuvres to the aesthetic transitions between Pictorialism and modernism.

Before 1900, Käsebier's images already contained modernist elements, as shown by the geometric structures in *Waiting for the Procession (The Grandmother, 1894–1895)*. She experimented with the techniques typical of Pictorialism, such as the gum-bichromate process and platinum plates. Her bold artistic approach, never documented, is notably evident in her images of Newfoundland in 1912. For Käsebier, photography had always been an art form. Her disagreement with Stieglitz stemmed from the fact that he idealized the 'amateur' as a true artist, whereas Käsebier earned a living from the sale of her portraits and published in magazines as diverse as *Everybody's Magazine*,

the *World's Work*, the *Ladies' Home Journal* and, above all, the *Craftsman*, while claiming the status of artist: she participated in international events, such as the influential exhibition *The New School of American Photography* organized in London (1900) and Paris (1901).

The talents of Käsebier combined art, commerce and photography with virtuosity and a strong business acumen. The photographer used the same images for exhibitions or publication in various magazines, changing their titles. This combined practice was not necessarily in keeping with the strict definitions of modern photography, but she sought to stand out, wishing to be innovative and independent.

After studying painting at the Pratt Institute in Brooklyn (from 1889 to 1893), where she followed the teachings of the painter Arthur Wesley Dow, based on the principles of Chinese and Japanese composition, Käsebier learnt the techniques of the camera shot and the rudiments of studio management from the portrait photographer Samuel H. Lifshey. The innovative ideas of Friedrich Fröbel regarding education influenced her in her photographs of children, which evoke freedom and independence. As a teacher and lecturer close to Clarence H. White – also a founding member of the Photo-Secession movement – with whom she maintained a copious correspondence, Käsebier proved capable of expressing her concept of art in a highly pedagogical manner and inspiring young talents such as Laura Gilpin and Imogen Cunningham. **BG**

Gabrielle Hébert, *Young Girl Naked Lying on the Grass*, c. 1888

An amateur painter, the German Gabriele von Uckermann discovered the work of the French painter Ernest Hébert thanks to the International Exhibition of Art and Industry held in Munich in 1879, and was filled with deep admiration, shared with her twin sister Éléonore. She met the artist in Paris shortly afterwards, when she was searching for a studio in which to further her training. In 1880, the pupil, who had in the meantime become model and assistant, married Hébert, her elder by almost forty years. In 1885, she accompanied him to Rome, where Hébert was appointed director of the Académie de France for the second time. She held receptions at the Villa Medici, and entertained the intelligentsia of Paris and Rome who came to visit the master. She continued to support him in his artistic practice, preparing his compositions, their backgrounds, transferring copies to canvas, and accompanying him on his regular excursions beyond the Eternal City, where he painted from nature.

In Rome, during the summer of 1888, Gabrielle, who had adopted the French spelling of her first name, acquired a camera, and took lessons from an Italian photographer, Vasari. With the help of Alexis Axilette, a painter who had been a *pensionnaire* at the Villa Medici for two years, she had a darkroom installed. Together, they produced images, then developed and printed them. Gabrielle Hébert created a magnificent series of female nudes in the grass, whose poses had been composed by Axilette. It marked the beginning of an intense and prolific production of images, of which she kept a record in her notebooks: portraits of friends and personalities passing through, moments of relaxation and camaraderie between the *pensionnaires*, scenes of markets

'I photo.'

GABRIELLE HÉBERT

and social gatherings in the surrounding villages, a long-term journal of the development of her husband's oeuvre. She paints of him a sensitive portrait, at the same time an artist of great nobility, preoccupied by his vocation, and a more fragile figure in decline through illness and old age. Through contact with the brothers Luigi and Giuseppe Primoli, descendants of the Bonaparte family and amateur photographers, she also created tableaux vivants in the park, a combination of classical reinterpretations and Marian references, with the collaboration of women from her immediate circle.

While the majority of these images, which she presented to the visitor or gathered in albums for consultation, were initially confined to her own circles (*pensionnaires* seeking prominence, and an artist husband to whose glory she constructed a photographic monument), others remained more private: the staged scenes of her twin in the Bosco, her own cast shadows, at a time when 'shadow mania' was in vogue, implicitly constitute a unique symbolic self-portrait. They earned her a physical presence and social status in this strictly male artistic phalanstery. **MR²**

'The natives, their ways and doings interest
me very much, though I find it hard to describe them.
When I get back, with the aid of the photos,
perhaps I will be able to do so better.'

GERALDINE MOODIE

Rather than merely accompanying her husband, an officer in the Mounted Police in Canada's Northwest Territories, from post to post, Geraldine Moore took advantage of their numerous transfers to the frontiers of the newly formed state to create an unusual photographic archive. It would be mistaken to think that her artistic practice resulted simply from the acquiescence of a devoted wife: she diligently signed her work and registered her copyrights; she negotiated official contracts and deposited some of her images in institutional collections. Entirely self-taught, Moodie opened her first studio in 1890 in Battleford, in the Province of Saskatchewan. On account of changes to her husband's postings, she subsequently moved to Maple Creek, then to Medicine Hat in Alberta. Regardless, she documented the life of the different inhabitants of the Prairies: cowboys, ranchers, officials and peoples of the First Nations. Seven years later, she packed her bags once again, heading for the Arctic. Having already obtained a commission from Prime Minister Mackenzie Bowell, she attempted to have herself appointed as official photographer to the Neptune expedition in the northern territories, but in vain. The contract was awarded to a man, about whom little is known. Moodie was not discouraged, however, going as far as trying to create a studio in an igloo. But the problems deriving from the freezing temperatures proved to be insurmountable.

Contemporary with the works of the American ethnologist photographer Edward S. Curtis, her collection of images of Indigenous people aroused similar controversy. Married to a man whose role was to impose Canadian law in distant and recently annexed territories, Moodie nurtured a colonial fascination for her subjects and marketed her images as exotic objects. As a woman, she was barely considered, while at the same time offering a unique perspective due to her femininity, she was successful in forming bonds with her Inuit companions – rarely photographed until then – who came to visit her at home. Her portraits bear witness to the complexity and ambiguity of these relationships. Ethnographic in style, aimed among other things at highlighting her models' costumes and 'type', some of her images are nonetheless filled with tenderness, notably those of mothers accompanied by their children. Moodie also attempted to show the different facets of her subjects, photographing them on several occasions, thus going beyond the stereotypes of the time. Hence Fine Day, chief of the River People band of the Plains Cree (Kamiokisihkwew), was depicted in combat, as well as a proud family patriarch. Geraldine Moodie's images thus constitute an important part of the Canadian photographic repertoire – precious evidence of the customs and attires of Indigenous people as well as those of colonial culture. **LB-R**

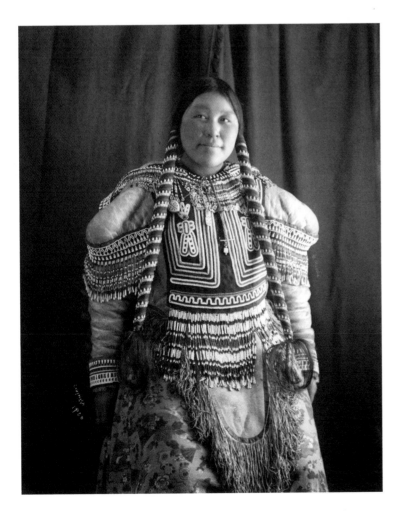

Geraldine Moodie, *Portrait of an Inuit woman, Ooktook, of the Kinepetoo people*, Cape Fullerton, Nunavut, Canada, 1904–5

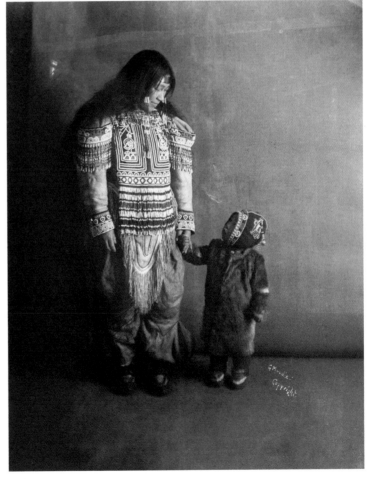

Geraldine Moodie, *Portrait of an Inuit woman, Ooktook, with child*, Cape Fullerton, Nunavut, Canada, 1904–5

Eveleen Myers, *First photo I ever took [Leo Myers]*, October 1888

'When I began taking sun pictures
I had no intention of doing more than
providing myself with a pleasant pastime,
which would have the further advantage
of enabling me to retain, in a permanent form,
fleeting impressions of my little children
as they appeared to me at different ages.'

EVELEEN MYERS

Eveleen Myers, who practised during the late Victorian period, is best known for her platinum portraits. Having taken up photography in 1888 to record the lives of her children, she gradually went on to produce powerful portraits of the notable men and women of her time. She knew Julia Margaret Cameron, having sat for her as a child, and comparisons have sometimes been made between the two women. Myers achieved recognition almost immediately and, asserting her rights as an artist, registered some of her work for copyright. In 1891, *Sun Artists*, an important early periodical on art photography, devoted an issue to her work.

Born on 21 November 1856 in Russell Square, London, Eveleen was the youngest daughter of Charles Tennant and Gertrude Collier. In 1868, the family moved to 2 Richmond Terrace, Whitehall, where her mother later hosted a famous salon frequented by political, literary and artistic celebrities. Eveleen and her sister Dorothy, an artist, both sat for John Everett Millais and George Frederic Watts; the works were exhibited at the Royal Academy. In 1880, Eveleen married the classical scholar and essayist Frederic W. H. Myers, and they moved to Leckhampton House, Cambridge, where they had three children. Eveleen Myers's first successful photograph was of her eldest son, Leo. Taken in October 1888, it appears in her family album, captioned: 'First photo I ever took'. Just a month earlier, in a letter to her husband, she had asked if she could borrow his mother's camera, explaining: 'I am thinking I would like to turn my hand that way in the studio and do lovely things of the 3 children.'

Although she was mainly self-taught, we know from her letters that she received technical advice from Albert George Dew Smith, a lens-maker and amateur photographer. As she gained in experience, she progressed quickly to photographing family and friends, including distinguished visitors to her mother's salon and fellows of the Society of Physical Research, of which her husband was a founding member. Her status as an amateur gave her the freedom to explore the medium freely and to experiment. Myers's photograph album captures the happy intimacies of prosperous upper-middle-class domestic life, featuring her children at play and artistic studies in poetic guise. Her formal portraits are intimate and compelling: simply posed and naturally lit, they reveal the sitters' psyches with great sensitivity.

Myers's photographic career seems to have come to a halt soon after her husband's death; protective of his reputation, she invested herself in editing his autobiography and essays. She died at her London home, 12 Cleveland Row, St James's, on 12 March 1937. **GA**

At the turn of the twentieth century, Danish society witnessed a gradual but decisive move towards the liberation of women, a revolution that culminated in women's right to vote being enshrined in the constitution in 1915. On 5 June, a parade of around twenty thousand women, organized by the Danish Women's Society – a non-governmental organization founded in 1871 – called at the royal palace to thank the king and then moved on to parliament. Thirty members of the vanguard, who were all dressed in white, were documented by the photographer Julie Laurberg, herself an active member of the society. This was one of the first examples of reportage produced by a woman in Denmark. Laurberg also took portraits of many leading members of the women's liberation movement and, together with her partner, Franziska Gad, also shot six minutes of film footage at the event.

Laurberg studied photography in Copenhagen with the painter and photographer Leopold Hartmann before continuing her training in Paris and Italy. In 1895, she established herself as an independent photographer in central Copenhagen, and five years later won a silver medal at the Paris Exposition Universelle. In 1907, she opened a studio with her first photography apprentice, Gad, who then became her partner. Three years later, the Julie Laurberg & Gad studio – made up almost exclusively of women – were appointed official court photographers. Apart from activists in the women's liberation movement, Laurberg also took the portraits of many famous members of Danish society, whom she often shot rather simply, relying less on studio props and staging than many other portrait photographers of the period. Throughout her career, she also wrote about photography, and in 1921 would co-author an educational book on the subject.

Laurberg was engaged in all aspects of women's liberation and in encouraging women photographers. As the first female board members of the Danish Union of Photographers, Laurberg and Mary Steen, another acclaimed pioneer, fought to bring more women into the organization. When Laurberg first established her studio, around one-third of studio portrait photographers were women, and their number continued to grow throughout the twentieth century. **MS**

'A portrait needs daylight!
Artificial light is nothing but a last resort.'

JULIE LAURBERG

Julie Laurberg, *5 June 1915*, Copenhagen, 1915

'A few years ago, [...] an artist told me that floral photography was impossible. [...] I have thought about it for a long time. And I thought that I would like to try to make of this type of photography a speciality.'

MINNA KEENE

At the turn of the twentieth century, it was difficult for a woman to achieve professional recognition, even in art. The trajectory of Minna Keene is a perfect example of technical, social and commercial skills employed to obtain success, but also of the obstacles to be overcome. Like many of her female colleagues, Minna Keene began by photographing plants and birds in the Pictorialist style in vogue at the time: soft tones and slightly soft focus, printing processes requiring great dexterity, and subjects exuding grace and sensitivity. The aim was to elevate photography from a simple tool for mechanical reproduction to the rank of artistic expression, on a par with painting. From very early on, Keene registered the copyright to her images with the Booksellers Association in London. They were subsequently reproduced in botanical and ornithology handbooks, before becoming the subject of a work that she published and marketed herself, *Keene's Nature Studies*, which was so successful that it was reprinted twice.

Following twelve years of assiduous practice, in Britain as well as in South Africa, where she had gone to live with her husband, the painter and set designer Caleb Keene, in 1908 she became the first woman to join the Royal Photographic Society, one of the oldest and most prestigious organizations dedicated to promoting the medium. She was also a member of the London Salon of Photography, participating in its annual exhibition between 1910 and 1929, and winning, the second time that she exhibited, the annual photography prize, thanks to a portrait of her daughter holding a bowl of pomegranates, symbols of fertility, abundance and vitality.

Minna Keene reflected and reproduced the trends of her time in order to satisfy her clients' demands. In her Cape Town studio, white women posed in a pseudo-natural environment and were invited to adopt a contemplative air. The result, decidedly romantic, evoked a certain feminine docility. Conversely, when she photographed coloured women, Keene adopted the colonial codes in use at the time, which categorized the individuals on the basis of their ethnographic 'type'. From her images, she made postcards and other objects highly appreciated by her Western clientele.

In 1913, Keene moved to Canada. Upon arrival, she secured a coveted contract with Canadian Pacific Railway, which asked her to document the railway crossing the Rockies. She undertook this project with her daughter Violet, who had also become a photographer, thus following on from the celebrated William Notman & Sons studio, to which the task had been awarded in the past. But her fame also aroused jealousies. In 1915, the magazine *Crag and Canyon* accused Keene of being a spy in the service of the German kaiser. Undoubtedly, it was problematic for the weekly magazine to accept that a woman might attain such a degree of independence and skill. **LB-R**

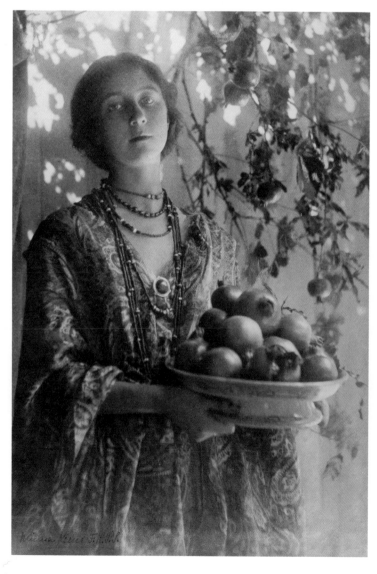

Minna Keene, *Pomegranates*, c. 1910

Edith Watson, *In the Strait [View of an iceberg]*, Newfoundland and Labrador, Canada, 16–23 August 1913

Edith Sarah Watson was born in East Windsor Hill, Connecticut, into an old New England family of merchants, printers and farmers. Although she remained an American citizen all her life, she is considered an important figure in the history of early twentieth-century photography in Canada. Over a period of four decades, Watson produced an extensive photographic record of the sites and people of rural Canada. A freelance photographer, she earned a living by publishing her images in Canadian and American illustrated magazines and newspapers such as the *New York Times*, *National Geographic*, *McCall's*, the *Toronto Star*, the *Canadian Magazine*, *Saturday Night* and *Maclean's*. In 1922, seventy-six of her Canadian pictures were published in a book entitled *Romantic Canada*, with texts by Victoria Hayward, Watson's partner in work and life.

Watson started her career as a painter, exhibiting and selling her works alongside those of her sister Amelia, a successful watercolourist. Having learnt the techniques of photography from her uncle, the Harvard botanist Sereno Watson, Edith adopted the medium as a means of expression when she was in her thirties. A lifelong traveller, she spent the next several decades photographing her expeditions. While her primary subject would remain Canada – which she documented from east to west, with a particular fondness for the Maritime provinces and what was then the Dominion of Newfoundland – her nomadic impulse also led her to explore the eastern seaboard of the United States, the Bahamas, Mexico, Cuba and Bermuda. It was in Bermuda, where from 1898 she spent most of her winters, that in 1911 she met Hayward, a journalist. Travelling together from the following year, they were able to provide magazine editors with a complete package, Watson's images supplemented by Hayward's descriptions of the places and people they encountered.

One of the photographer's most important clients was the *Canadian Magazine*, which between 1914 and 1925 published almost four hundred of her images. The Toronto-based literary periodical was edited during this period by art historian and critic Newton MacTavish, and its regular articles on Canadian culture and history were well suited to Watson's romantic ethnographic style. Her interest in traditional crafts and ways of life as yet unaffected by modernization is apparent in her depictions of individuals at work making folk objects or toiling the land. Taken at a time when Canada's industrialization was rapidly transforming people's relationship to the land, Watson's photographs demonstrate a desire to preserve – and celebrate – the ancestral practices of both Indigenous and rural settler communities. Through their dissemination in widely read publications, Watson's images contributed to a body of Canadian visual culture that championed a sense of national identity based on an idealized past. **ZT**

'People think I paint the color in, but not at all!'

HELEN MESSINGER MURDOCH

Helen Messinger Murdoch, *Self-portrait with American Flag*, 1910

Helen Messinger Murdoch was the youngest of six children from an independently wealthy family. Both parents were talented watercolour artists and members of the Boston artistic intelligentsia. After their mother's early death, the children were raised by two aunts. Helen initially trained as an artist at the Cowles School of Art, from 1885 to 1887, and exhibited widely. She learned monochrome photography from her brother John, a talented amateur, in the late 1890s, then used the Autochrome colour process, developed by Louis Lumière in 1903 and first marketed in 1907. The process could be used in any plate camera by any competent photographer, and required no specialist equipment.

In 1911 and 1912, Murdoch made expeditions to Europe over the course of several months and established a portrait studio and gallery at the Halcyon Club in London, a meeting point for women artists, writers and intellectuals. Although she was modern, independent, confident and comfortable with new technologies, she also adored Britain for its history and traditions. On 19 April 1913, Murdoch, then aged fifty-one, left Boston on a two-year round-the-world tour that she christened 'The World in its True Colors' – the first woman photographer to make such a circumnavigation – photographing on both Autochrome and monochrome plates. Her colour work from this trip would appear in *National Geographic* in March 1921.

In preparation for the voyage, Murdoch bought plates from the Lumière factory in Lyon, which was producing six thousand daily to satisfy demand. On 31 December 1913, she set sail from Marseille to Alexandria. Over the next nine months, she hardly stopped, visiting Cairo, Luxor, Jerusalem, Palestine, India, Burma, Ceylon, Hong Kong, China, Japan, the Philippines, Hawaii and Honolulu, before the outbreak of the First World War put an end to her globetrotting. She arrived back on American soil in San Francisco on 28 September 1914. The lectures that she gave during her trip, published in the photographic press, and also the letters that she wrote to her sisters describing the challenge of achieving successful results from the often temperamental Autochrome process give a vivid picture of the experiences of a lone Western woman travelling in the Near East and Asia in the early twentieth century.

A great socializer and networker, Murdoch charmed the many people whom she met and often persuaded them to help her in her photographic endeavours. Once back in Boston, Murdoch learned flying and focused on a new career: photographing and collecting anything related to aeronautics. She photographed the aviation pioneers Charles Lindbergh and Amelia Earhart, as well as cloud formations, air shows and aerial views, including, in 1928, the first Autochrome of Boston from the air. In 1944, following the death of her brother and sisters, Murdoch settled in Santa Monica, California, to be close to her surviving relatives. **PGR**

> 'I have photographed all the King's horses and all the King's men and I am never happier than when I am with my camera among the crack regiments of Britain.'

CHRISTINA BROOM

Undeterred by an event's significance, Christina Broom seized every opportunity to capture the impressive gatherings and pageants of the women's suffrage movement that animated political debate in the early twentieth century. Much of her talent lay in her innate ability to identify and frame her subjects quickly, even as she pushed through bustling crowds. Audaciously positioning herself close to the action with her plate camera and engaging directly with individuals, she created powerfully dramatic and emotive images that convey the sentiments of the Suffragettes themselves. These photographs, which were sold as affordable postcards and stamped on the reverse with Christina's married name, 'Mrs Albert Broom', had great commercial appeal.

By 1913, ten years after teaching herself how to use a camera in order to support her family, Broom – who was now fifty years old and widowed – was nearing the peak of her career. She regularly photographed high-profile subjects ranging from the annual Oxford and Cambridge boat race and the British Army's Household Division to ceremonial proceedings and outings with the royal family. Her daughter Winnie proved invaluable to her business: it was she who hand-produced the numerous postcards and other prints to order in their home darkroom.

Broom established strong working relationships with both her peers and her subjects, eventually securing royal approval. The fact that she was able to succeed in the absence of prior connections or privilege says much about her determined yet amiable character and her photographic capabilities. Instead of remaining in the relatively safe environment of the studio, she decided to stride out into the streets to record and commoditize newsworthy events, earning Broom retrospective recognition as a pioneering woman press photographer in Edwardian Britain.

The experience Broom had acquired by the outbreak of war in 1914 underpinned her empathetic portrayal of the Household Division at that significant time. As a civilian woman photographer, she was evidently not intimidated by class, rank or the opposite gender. Her images record the men's camaraderie: she captures them on duty and at ease. However, just as with the Suffragettes and their supporters, she knew how to draw their attention towards the camera. The resulting images often communicate a tender rapport and warm sense of mutual respect. Broom's successful navigation of both historically important and highly gendered environments continues to invite admiration today. **AS²**

Christina Broom, *March of the National Union of Women's Suffrage Societies*, London, 1908

Harriet Pettifore Brims was one of Australia's earliest female professional photographers. Born Harriet Elliot in 1864 in Yandila, Queensland, she married Donald Gray Brims, a Scottish immigrant, in 1881. The couple first settled in Townsville, then travelled north to Cardwell, where they were said to be the first white settlers in the Herbert River district. In 1894, they moved to the larger settlement of Ingram, where they lived for six years, during which time they had four children. It was here that Brims opened her first photography studio, which she named the 'Britannia Studio'. By 1903, she had moved her business to Mareeba, where she operated a studio for ten years and gave birth to her fifth child. During this same period, she also worked for short spells at studios in other Queensland towns, including Chillagoe (1904–5) and Irvinebank and Watsonville (1907).

Brims documented the reality of everyday life in small Queensland towns, focusing in particular on transport (aeroplanes and bullock teams), the coppersmelters of Chillagoe, one-off events such as the aftermath of a cyclone, the Melanesian labourers who worked in the North Queensland cane fields,

social gatherings, local landmarks and portraiture. Her works featured in the *North Queensland Herald* (1907) and the *Australasian Photographic Review* (1902), which described her as 'the first lady photographer who ever dared, single handed, to face the "stronger sex" in fair and open competition'.

Brims was highly regarded for the time and care that she put into her photographs. Today her work constitutes an important record of the rapid changes taking place in Queensland at the turn of the century, as the new federated state's population trebled in size and the whole nation was undergoing modernization. An unusual aspect of Brims's work was the cameras that she used at the outset of her career. In the late 1890s, while the couple were still living in the Herbert River district, her husband, an engineer by profession, fashioned dry-plate cameras from maple wood, carrying cases from cowhide, and camera shutters from sheet brass salvaged from discarded opium tins. This equipment enabled her to photograph landscapes and human activities in sharp detail.

In 1914, the family moved to Brisbane, and Harriet retired after a sixteen-year career as a professional photographer. She died on 25 October 1939. **AM**

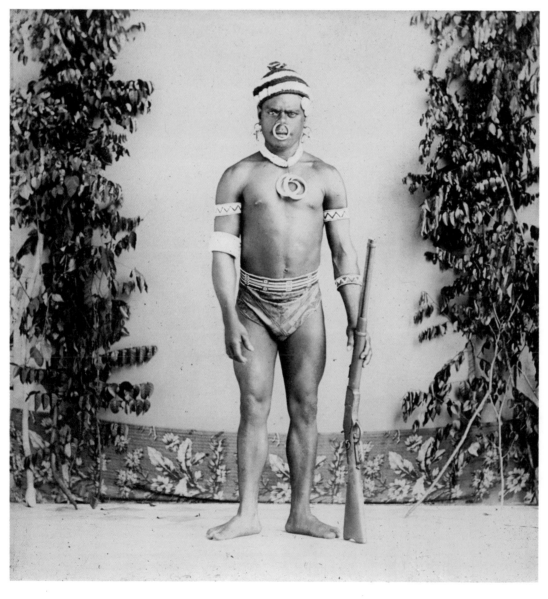

Harriet Pettifore Brims, *An Unidentified Australian South Sea Islander in traditional costume*, c. 1900

Born in Montenegro, Elena Lukinichna Kniajevich taught in a village school until her marriage, in the early 1880s, to Vladimir Pavlovitch Mrozovski, a student at the Polytechnic Institute in St Petersburg. The couple settled in the city. It is not known when Mrozovskaya's interest in photography began, but we do know that it was initially as an amateur photographer. Having been admitted onto the photography course taught at the Imperial Russian Society of Science and Techniques, and having successfully completed her studies in 1892, she went to Paris to the studio of Félix Nadar to conclude her training. Her professional activity began a year later. Her studio, situated in the heart of St Petersburg, at 20 Nevsky Prospect, in a building belonging to the Dutch Reform Church, was registered under her husband's name.

Like many artists at the end of the nineteenth and beginning of the twentieth centuries (notably Ivan Kramskoï and Mihály Zichy), her husband, an amateur painter, practised the art of photo retouching – and initially he helped his wife in her work. Between 1893 and 1897, Mrozovskaya's career rapidly prospered. Having earned the title of 'Photographer to the Court of the Prince of Montenegro', she was given the honorific title of 'Photographer to the Conservatoire of St Petersburg and the Imperial Russian Music Society'.

Highly practical, endowed with a great artistic sense and sophisticated taste, the photographer soon became popular in Bohemian theatrical circles. Her talent was particularly evident in portraits of women and children. Between 1897 and mid-1911, Mrozovskaya participated in many prestigious national and international exhibitions, winning medals for her photographs; these were published in the magazine *Niva*, an extremely popular illustrated household weekly. She separated from her husband early in the century, and on 2 February 1913, the *Bulletin of St Petersburg* announced the reorganization of the studio at 20 Nevsky Prospect, which was from then onwards to be known as the 'Elena Russo-Slav Feminine Studio of Art Photography'. Until 1917, women were able to study the profession of photographer there.

Little is known of Mrozovskaya after this time. Some researchers suggest that she retired from business in 1913, ceasing to work as a photographer in order to devote herself to teaching. Between 1900 and 1910, she acquired several plots of land in the village of Metsäkylä, on the coast of the Gulf of Finland, where she had three dachas built, occupying one herself. After the revolution, the border with Finland having been drawn some twenty miles from Petrograd, Elena Lukinichna found herself in Finnish territory. She would never return to Soviet Russia. **LS²**

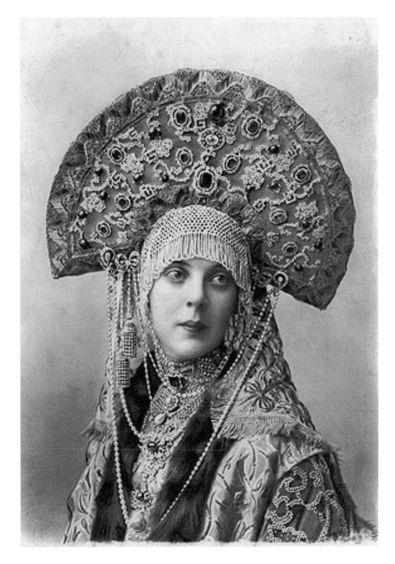

Elena Lukinichna Mrozovskaya, *Princess Olga Konstantinovna Orlova (née Princess Beloselsky-Belozwersky) wearing a kokoshnik for a ball at the Winter Palace*, St Petersburg, 1903

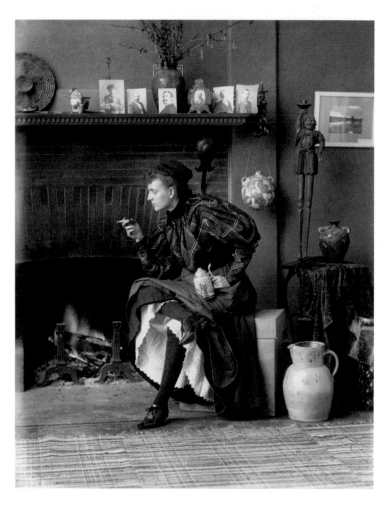

Frances Benjamin Johnston, *Self-portrait in her studio*, 1896

'The woman who makes photography profitable must have, as to personal qualities, good common sense, unlimited patience to carry her through endless failures, equally unlimited tact, good taste, a quick eye, a talent for detail, and a genius for hard work.'

FRANCES BENJAMIN JOHNSTON

1864–1952, United States

In 1897, the American Frances Benjamin Johnston, by then an established professional photographer, published the article 'What a Woman Can Do with a Camera' in the celebrated women's magazine the *Ladies' Home Journal*. She presented the profession of photographer as being particularly suitable and lucrative for a woman wishing to support herself. Chapter after chapter, she provided a detailed list of the prerequisites and problems associated with the job: a technical apprenticeship that was long and full of obstacles, preliminary study of the clientele, the creation of a darkroom, a balance between respect for commissions and originality in composition, dealing with competition.

Trained in drawing and painting at the Académie Julian in Paris (1883–5), and drawn to photography since childhood, at the time this article appeared, Johnston had already been managing her own studio for seven years, initially in Washington, then in New York, on Fifth Avenue. Her privileged and progressive family (her mother was a political journalist, an ardent defender of women's rights) undoubtedly contributed to her acquiring this independence.

The first female member of the Camera Club in Washington, Johnston organized an exhibition that brought together the work of thirty-one American women photographers at the Exposition Universelle in Paris in 1900. Her self-portraits are testimony to her assertive character, caring little about conventions. While this effective advocate of women photographers owed her fame principally to portraits of the prominent dignitaries of her nation, she was also celebrated for the photographic reportages that she produced on the education systems of Annapolis (1893), Washington (1899), West Point (1902) and Tuskagee (1902). In 1899, she spent several days documenting the Hampton Normal and Agricultural Institute in Virginia. This establishment, opened in 1868 after the American Civil War, aimed to offer African Americans (and Native Americans) an education in the fields of industry and agriculture. Widely distributed at the time, these images were presented to the Museum of Modern Art in New York in 1966. In the book accompanying this event, its author Lincoln Kirstein celebrated the photographer's qualities: 'Images Miss Johnston found grip us by their soft, sweet mono chrome. In them, hearts beat, breath is held; time ticks. Eyelids barely flutter.' In the final years of her career, Frances Johnston set out to document her country's architectural and environmental heritage. **JJ**

Alice Austen was introduced to photography in 1876 at the age of ten, when her uncle, Oswald Muller, a captain in the Danish merchant navy, gave her a simple wooden camera that he had acquired on his travels. A cupboard on the second floor of the family home on Staten Island served as her darkroom. From this makeshift studio, she made a significant contribution to photographic history, producing more than seven thousand images of a rapidly changing New York, documenting the city's immigrant populations, women's social activities, and the nature and architecture of the places to which she travelled.

One of America's first female photographers to work outside of the studio, Austen often transported more than twenty kilograms (50 lb) of photographic equipment on her bicycle. Her photographs captured street life, but also private moments, through the lens of a lesbian woman. Austen broke free from the constraints of her Victorian environment and the rules governing acceptable female behaviour. Independently wealthy for most of her life, Austen has been widely considered an amateur practitioner because she did not make her living from photography. Nonetheless, in the 1890s she carried out a paid assignment for Dr Alvah H. Doty from the New York City health department reporting on the living conditions of newly arrived immigrants quarantined on the islands of Swinburne and Hoffman. In addition, she took care to safeguard the rights to her works, which she both exhibited and published.

Alice Austen's life and relationships with other women are crucial to an understanding of her work. Until very recently, many interpretations overlooked this aspect of her photographs; however, they provide rare documentation of intimate relationships between women at the turn of the twentieth century. Her non-traditional lifestyle and that of her friends is the subject of some of her most critically acclaimed images, although they were originally intended for private viewing.

Austen lost her wealth in the stock market crash of 1929 and was finally evicted from her beloved Staten Island home, Clear Comfort, in 1945, where she had lived with her partner of fifty-three years, Gertrude Tate. The house is now the Alice Austen House Museum and is a nationally designated site of LGBTQI history. Unfortunately, the two women were separated because of their poverty, and their relationship was rejected by their families. Austen was moved to a hospice on Staten Island, where Tate would visit her weekly. In 1951, Austen's photographs were rediscovered by a historian, Oliver Jensen, who published them with a view to placing Austen in a private nursing home. The photographer died on 9 June 1952. The final wishes of Austen and Tate to be buried together were denied by their families. **VM**

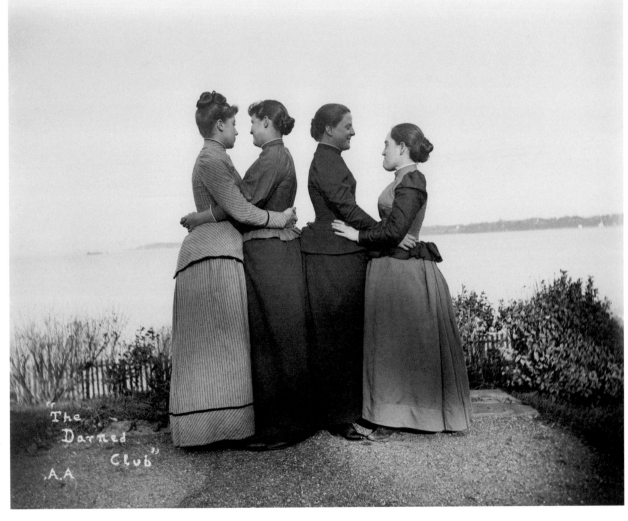

Alice Austen, *'The Darned Club'*, October 1891

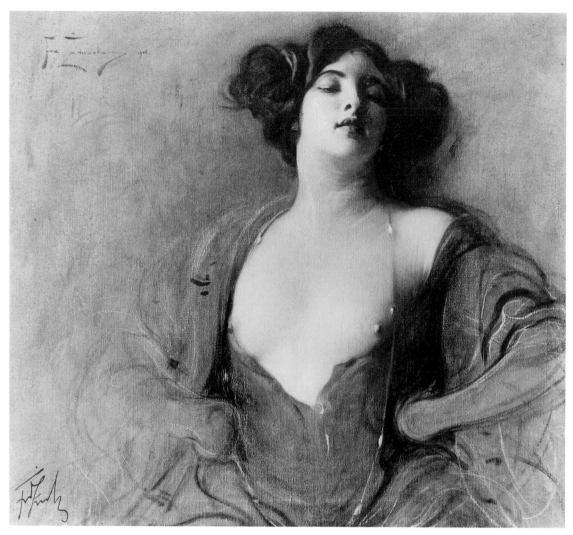

Jadwiga Golcz, *Étude de femme*, by the painter Franciszek Żmurko, 1906

Fully committed to emancipation, Jadwiga Golcz regarded photography as an excellent profession for an intelligent woman. As the first woman photographer working in nineteenth-century Warsaw, she published her landscapes of the Polish capital in the press. She was also one of the few women at that time to run a photo studio, which was located in the Bristol Hotel in Warsaw and was visited by great cultural celebrities, including the pianist Ignacy Jan Paderewski and the writer Bolesław Prus. However, Golcz's most important achievements were her work as a critic and her success in popularizing photography as an art form.

Born in 1866 into wealthy landed gentry in Kujawy, Golcz was educated in Warsaw at a famous boarding school run by Jadwiga Sikorska, at which the future Nobel prizewinner Maria Skłodowska (more commonly known under her married name, Marie Curie) was a fellow pupil. Golcz's acquaintance with Maria's family would prove significant for her career. After finishing school in 1884, she took drawing and painting lessons with the landscape artist and art historian Wojciech Gerson, and undertook an apprenticeship in a studio owned by Edward Troczewski. Golcz then decided to further her studies abroad, in Vienna, Paris and Berlin. Returning to Warsaw in 1898, she opened her own studio and began to work at the Zachęta National Gallery of Art, for which she shot works of art.

However, purely commercial work was not enough for Golcz. She is known above all as the creator and publisher of *Light*, the first Warsaw magazine devoted to photography, which first appeared in October 1898. Golcz entrusted the editorial role to Maria Skłodowska-Curie's uncle, Józef Jerzy Boguski – an eminent scholar and a physicochemist whose position lent the journal scientific legitimacy (even Curie published within its pages). Golcz's decision to publish independently was a pioneering move: over the course of the next few decades there were few other women who occupied similar positions of responsibility in the field of photography.

Golcz also financed the publication in Polish of *The Introduction to Photography* by Giuseppe Pizzighelli; it was translated by Władysław Skłodowski, Maria's father, and his son-in-law Stanisław Szalay. She also organized the first exhibition of artistic photography in Warsaw: it opened on 21 September 1901 in the prestigious rooms of the Town Hall and included works by both professional and amateur photographers. At the end of 1906, Golcz contributed financially to the creation of a photography school, in the grounds of the Warsaw Grand Theatre, which went down in history as the Kirchner School.

In seeking to promote photography over the decades, Jadwiga Golcz became impoverished and her health suffered. At the age of only forty-five, she withdrew completely from professional life. **KG**[1]

In Norway, as in other Nordic countries, it was professional women – among them a considerable number of photographers – who made up the core of the feminist movement. One of these women was Solveig Lund, a professional photographer who had her own studio in Oslo. Her photographic work has a delicate, harmonious feel that forms an interesting contrast to the pointed political demands for women's suffrage that she supported.

In the photographic archives at the Norwegian Folk Museum in Oslo is an important selection of Lund's work, including a remarkable collection of glass-plate negatives. Most are of women: some show women engaged in modern bourgeoise activities, such as skiing, while others are more allegorical in character, evoking both the pathos of Pre-Raphaelite portraiture and the intensity of silent-film heroines.

Lund also produced series organized around themes, including the four seasons, the months of the year and European nations. However, the dominant genre in her production is photographs of women in national costume – taken either in the studio or during Lund's journeys to the spectacular fjords on the western coast of Norway. Clearly aimed at the tourist market, these images appear to have journeyed all over the world. While some were distributed in the form of postcards, others were enlarged and sold as album prints, published as illustrations in magazines or used to advertise different consumer goods.

There is clearly the potential for feminist readings of Lund's photographs of women in national costume. Even if the genre signals that these photographs should be interpreted as typological representations of the country or region, these 'Norwegian women' embody much more than their 'type': they are active, hard-working, mischievous or serious, thoughtful or joyous. There is a wide range of femininities on display, but what these women have in common is their integrity and strength. Their costumes might be traditional, but the female identity they assume is modern. These portraits remind us that Lund belonged to the first generation of women who were able to shape not only their own image, but also that of other women. **SL²**

'Believe me, I was very relieved to receive these 50 krone. For several days I had been penniless…. Colouring cards takes a long time, and working with watercolour is very hard…. Yes, you have to fight to survive.'

SOLVEIG LUND

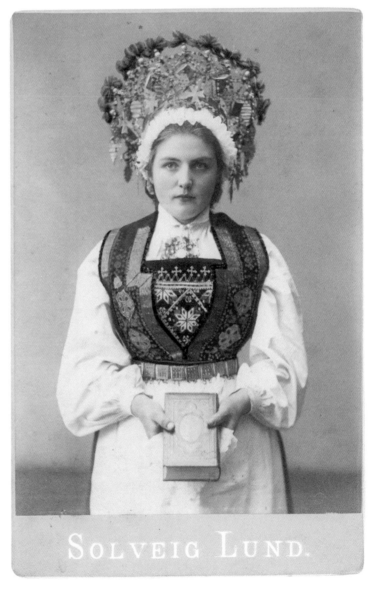

Solveig Lund, *Portrait of a woman in national costume*, hand-tinted cabinet card, c. 1895–1910

An immigrant to New Zealand, Margaret Matilda White worked in a realist style, producing two sets of important photographs: the first recording the buildings and nursing staff of New Zealand's largest mental facility; and the second documenting Maori from the east coast of the North Island.

Originally from Belfast, White arrived in Auckland in 1886, aged eighteen. In the early 1890s, she was employed by the Irish photographer John Hanna, who owned a studio on Auckland's main thoroughfare. Her first commission was to photograph the funeral ceremony of the great Maori warrior Rewi Maniapoto.

Since women photographers were poorly paid at the time, in the middle of that decade, White decided to train as a nurse. She worked first in a private hospital, then at the much larger Whau mental hospital in Avondale. At that time, New Zealand experienced a severe economic downturn that produced high rates of alcoholism, depression and suicide, and caused numbers in the asylum to soar. Around 1895, the hospital's board commissioned White to produce views of the buildings' architecture and grounds.

She took advantage of the occasion to take a number of personal photographs showing the nursing staff. However, it was the unsettling compositions she used to photograph the hospital's nursing staff – compositions that subtly hinted at the harsh regime inflicted on the building's inmates, and from which the patients themselves are absent – that revealed her talent for social commentary.

Around 1897, White undertook a four-hundred-mile trip on horseback from the tip of New Zealand's North Island to the Eastern Cape, taking photographs of schoolchildren and Maori as she went – in particular the men who had been selected to participate as volunteer mounted rifles in Queen Victoria's Diamond Jubilee celebrations in London. In the 1890s, relations between Maori and those of European descent were poor, and the market was flooded with stereotypical images of Maori people to supply the tourist industry. White's photographs, however, were unusual in that they granted Maori subjectivity and dignity. Around 1898, White opened her own photographic studio in Grafton Road, Auckland, but business was so poor that she was soon forced to close it.

In 1900, White married Albert Reed, an attendant at the Whau asylum. They moved to the small settlement of Karangahake, eighty miles south of Auckland, where she produced photographs showing the destructive effect that gold mining was having on the local landscape. White's first child was born in 1902, and a second son came in 1904. In 1910, tragedy struck when she stood on a rusty nail and died from tetanus poisoning. She was barely forty-two years old. **AM**

Margaret Matilda White, *Fanfare*, Hastings, New Zealand, c.1896–7

'The keynote of interest in modern photography is the possibility of expressing one's personal point of view.'

ZAIDA BEN-YUSUF

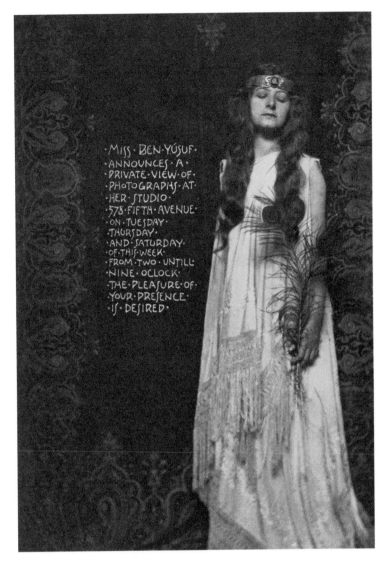

Zaida Ben-Yusuf, *Untitled [Invitation to a private view of photographs]*, 1899

Zaida Ben-Yusuf is one of the forgotten figures in the history of photography. Although she practised the profession of photographer for only about twelve years, she nevertheless produced hundreds of portraits of many influential or rising personalities on the New York cultural and political scene. From the novelist Edith Wharton and the painter Robert Horn to President Theodore Roosevelt, Ben-Yusuf transformed the portrait into a true artistic practice in which the studio was not only a location for the composition, but also a space of freedom and poetry.

Born in London under the name Esther Zeghdda Ben Youseph Nathan on 21 November 1869 to a German mother and Algerian father, at the age of twenty-seven, she decided to move to New York and to open a studio in the centre of town, on Fifth Avenue. A foreigner on account of her origins, and in addition a woman, she managed to establish herself as a portraitist and artist. In the space of only a few years, Ben-Yusuf published photographs and articles on her own practice in numerous magazines, exhibited her work in Europe and in America, and, for a while, even became a spokesperson for the Eastman Kodak Company. She created moving portraits in which it is possible to discern a search for identity that entailed the exploration of

the photographic medium at a time when Pictorialism was at its height. She also sat for other photographers, such as Fred Holland Day.

Although for financial reasons Ben-Yusuf used her talent mainly in commercial work, her portrait production, the mastery of her equipment and a certain poetic air that animates her lens leave no doubt as to the major role that she played in the rise of modern photography. She confused many critics with her fresh, sensitive and anti-conformist gaze, and history will remember her as one of the first women photographers who not only contributed to establishing the art of the portrait, but also continuously broke the rules of society that weighed upon women at the turn of the twentieth century. Photography became for her a means of artistic expression as well as a reflection of her ambition for personal freedom. Always discreet as far as her private life was concerned, it remains uncertain whether she abandoned photography around 1910, the date after which no trace of her work is known. She preferred travel, which often took her to islands (Cuba, Jamaica, the Pacific islands). She died in Brooklyn on 27 September 1933. In 2008, the National Portrait Gallery in Washington, DC, dedicated a retrospective to Zaida Ben-Yusuf, thus restoring the artist to the forefront of the international photography scene. **RK**

'There is another psychological advantage which makes, I think, for women's success in photography. This is, that we are always in the habit of making the best of everything.'

LALLIE CHARLES

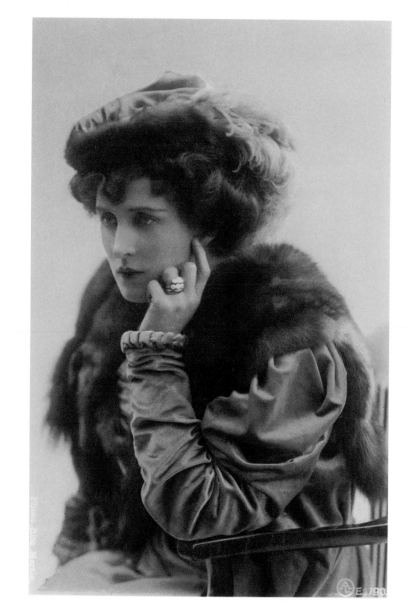

Rita Martin, *Evelyn Millard*, c. 1910

In 1896, the Irish-born photographer Lallie Charles (née Martin) set up a commercial portrait studio near Regent's Park in London, assisted by her younger sister Rita Martin. 'Madame Lallie Charles', as she was known – the French title evoking artistic credentials and giving her an exotic air – marketed herself as a 'ladies' photographer': women, she said, preferred to be photographed by a woman. In fact, men were rarely admitted to Charles's studio and, as her business grew, she employed only women; the most famous apprentice she trained was Yevonde Cumbers, better known as Madame Yevonde.

Over the course of Charles's twenty-year career, she perfected a number of strategies to achieve a flattering portrait. First, she invited her client to have tea with her, to discreetly assess the woman's features and make her feel 'at home'. Then, on the day of the sitting, Charles would personally prepare her subject, attending to her dress and styling her hair, giving her a competitive edge over male photographers, who were not in a position to provide such an intimate service. According to Cecil Beaton, women came to view Charles's studio like a beauty parlour where they would be 'beautified'.

Before establishing her reputation as a portraitist, Charles had earned a living producing photographic 'fancy pictures' and illustrations for books, developing skills that informed her later portrait work. She was therefore accustomed to directing models to convey a certain mood and knew how to construct theatrical yet graceful poses that would transform her subjects into iconic 'beauties'. During the 1900s, Charles's idealized portraits dominated the popular magazines of the period, and she was producing hundreds of negatives each day as celebrities flocked to be photographed by her. By 1910, her photographs were appearing in American *Vogue*, bringing her international fame.

In 1906, Rita Martin left her sister's business to set up her own studio on Baker Street, London, where she specialized in taking photographs of female performers for reproduction as postcards. Given that they worked together for a decade, it is unsurprising that, stylistically, the two sisters' work is often indistinguishable. To be photographed by Lallie Charles or Rita Martin was the height of Edwardian fashionability. **GM**[1]

Anne Wardrope Brigman (née Nott) took up photography in her early thirties, after a brief career as a painter. Born in Hawai'i and artistically formed in California's Bay Area, she drew her greatest inspiration from nature. In her art and writing, she melded Polynesian religion, Greek mythology and American transcendentalism to create a spiritual cult of nature that was entirely her own. This spirit is expressed in Brigman's evocative photographs of the wild Californian landscape and in the nude female bodies that she situated within it – bodies that wrap around twisted trees or emerge between craggy rocks. Intrepid and unconventionally independent (she separated from her husband in 1910), Brigman ventured into the Sierra Nevada mountains alone or with friends whom she used as models, choosing 'slim, hearty, unaffected women of early maturity living a hardy out-of-door life in high boots and jeans, toughened to wind and sun'.

Although she was self-taught, Brigman became a leader in the Bay Area photography community, and her Oakland studio was a gathering place for such renowned artists as Edward Weston, Ansel Adams and Imogen Cunningham. Yet Brigman also stood apart: one of Alfred Stieglitz's most prolific correspondents, she was admitted to his Photo-Secession group in 1902, only two years after beginning to photograph, and remained the movement's only West Coast member. Her work was published numerous times in Stieglitz's journal, *Camera Work*, of which she was a devoted reader. Brigman's minor place in the history of photography ignores a substantial exhibition record and critical acclaim in her own time – as well as the controversy that her trailblazing nudes often inspired.

Pictorialist photography such as Brigman's has long since fallen out of fashion, its overt symbolism and painterly manipulations victim to the aggressive purity espoused by modernist photographers. Her work in particular has been misread as promoting outdated and simplistic associations of the feminine and the natural. Even Stieglitz, who championed her photography in as far as it seemed to support his own ideals, never fully understood the impulse of female empowerment that drove it. Brigman's contributions to literature have also been paid scant attention, yet they offer insight into her artistic vision and the circumstances in which she worked. Full of feeling and conviction, her published texts range from exhibition reviews to defences of art photography and feminist treatises, as well as a collection of poetry, *Songs of a Pagan* (1949), illustrated with her own photographs. Whether she wielded camera or pen, Brigman expressed a spiritual communion with nature and a fiercely feminist spirit. Her vision had no equivalent among her peers. **CK**

'Cast fear out of the lives of women and they can and will take their place in the scheme of mankind and in the plan of the universe as the absolute equal of man.'

ANNE WARDROPE BRIGMAN

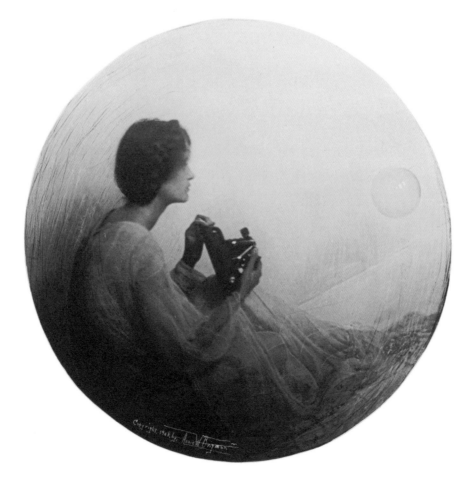

Anne Wardrope Brigman, *Kodak*, c. 1908

Signe Brander is most widely known for her masterful views of the Finnish capital. From 1907 to 1913, she took nearly nine hundred photographs for the Helsinki City Museum, thus providing a comprehensive record of the modernization of urban life, then in full swing. Owing to her systematic attention to urban change, as well as the stunning quality of her photographs, she could be described as the 'Eugène Atget of Helsinki'.

Brander was born in the small town of Parkano, in Pirkanmaa, a region in the south-west of Finland, where her family had an estate. Her father, Ernst Brander, was a lawyer, while her Swedish mother, Jenny Rääf, looked after the seven children. When her father died, the young Signe, then aged twenty-one, moved with her mother to Helsinki, where one of her brothers was already living. She trained to be a drawing teacher but never actually taught, choosing photography instead.

Little is known about Brander's early career. She probably learnt how to use a camera with Daniel Nyblin, one of the most famous photographers working in Finland at the end of the nineteenth century, whose studio, in central Helsinki, employed around twenty people, mostly women. The Norwegian-born Nyblin was a powerful figure in the Finnish photography world, not only because of the quality of this work, but also because he advocated and popularized photography through his own magazine, *Nyblins Store*. After spending some years working with Nyblin, Brander founded her own studio, Atelier Olofsbad, in Savonlinna, before moving back to Helsinki in 1904, where she opened a photography business called Helikon.

Helsinki was expanding rapidly in the early twentieth century, its population having tripled between 1870 and 1900. To meet housing needs, traditional low-rise wooden houses were being gradually replaced by stone-built apartment blocks. It is in this context that the Board of Antiquities (later the Helsinki City Museum) hired Brander in 1907 to document the many construction sites. As part of her mission, she photographed old buildings before they were destroyed, but also took an interest in capturing everyday life as it unfolded in the city's gardens, yards and streets.

Alongside her work for the City Museum, which ended in 1913, Brander also undertook two other large-scale projects for which she travelled around the country. She took eighty photographs of battlefields from the Finnish War between Russia and Sweden (1808–9), and a staggering two thousand photographs of large estates, manors and country houses. Her goal was to defend Finnish history and record the country's cultural heritage, just as she and other members of her social circle fought for Finnish independence (finally attained in 1917). Brander never married. She died tragically of malnutrition at Nikkilä Hospital during the Second World War. **EH**

'I am a photographer of cultural history.'

SIGNE BRANDER

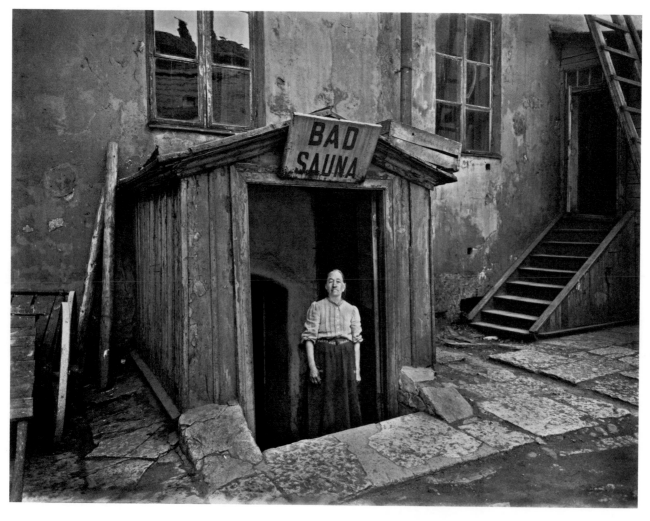

Signe Brander, *Sauna Marie-Bad, Mariankatu 13a*, Helsinki, 1913

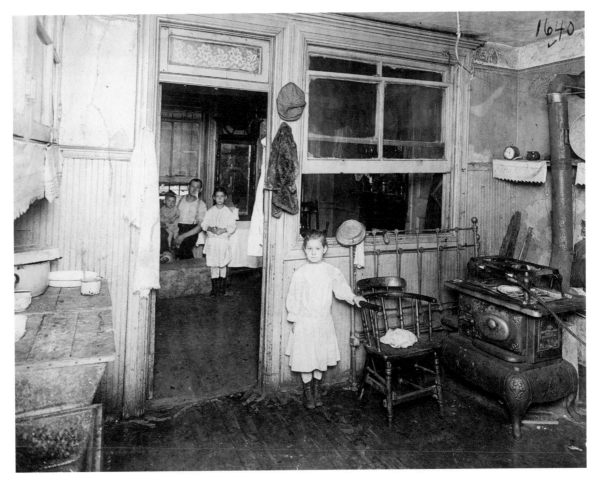

Jessie Tarbox Beals, *Young girl next to an oven, her family in the next room*, undated

Jessie Tarbox Beals was one of first female photojournalists in the United States. In 1900, her photographs of the Vermont Fair were published in local newspapers, and two years later she was hired by the *Buffalo Inquirer* and the *Courier*. Beals worked as a staff photographer only a short while, however, leaving in 1904 to photograph the St Louis World's Fair. Daring and tenacious, she demonstrated extraordinary range in the subjects she photographed: murder trials, the landscapes and customs of Native peoples, sport, fashion, homes and gardens, dignitaries, artists, New York's Greenwich Village, housing conditions, children, aerial views, prisons and suffragette marches. Her first camera – which she acquired in 1888, when she was teaching in Massachusetts – was very basic: it was a prize from a subscription to *Youth's Companion* magazine.

Like many 'lady photographers' of her era, Beals began by taking pictures of friends and family, but early on she discovered she could earn additional income by taking portrait photographs of students at the nearby Smith College. Her focus on news photography is where her trajectory radically departs from other women photographers of the time. Also striking is her decision to recruit her husband, Alfred Beals, whom she married in 1897, as her photography assistant. The publicity photographs that she devised convey her physical strength and fearlessness: we see her wielding an 8 × 10 view camera weighing twenty kilograms (50 lb), mounting ladders, travelling in a hot-air balloon to capture images and using flash powder (she is credited with being the first woman

to take photographs at night). Ambitious and unconventional, Beals did not take no for an answer: after initially being denied a press pass to the St Louis World's Fair, she made sure she was appointed the official fair photographer for several papers in New York, St Louis and elsewhere. Possessing all the 'hustle' (a word she used herself) required to be a newspaper photographer, Beals knew how to turn her status as a woman to her advantage. Accepting assignments of all kinds, she continued to expand her practice by responding to needs and opportunities that arose wherever she was, covering local and international events (from suicides to presidential visits) and social issues (especially scenes of poverty in the south of the country), and taking photographs for marketing and advertising purposes. **NP**

'If one is the possessor of health and strength, a good news instinct … a fair photographic outfit, and the ability to hustle, which is the most necessary qualification, one can be a news photographer.'

JESSIE TARBOX BEALS

1870, Canada–1942, United States

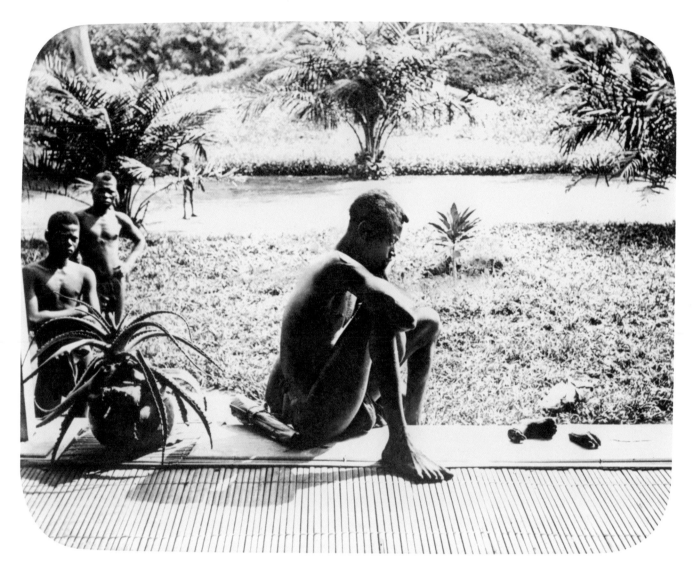

Alice Seeley Harris, *Nsala looks at his daughter's severed hand and foot*, Baringa, Congo, 15 May 1904

Alice Seeley Harris is renowned for being the first female campaigner for human rights who, armed with her faith and her Kodak camera, denounced the atrocities committed against the Congolese people, in the name of the Congo Free State, under the rule of King Leopold II of Belgium between 1885 and 1908.

At the age of nineteen, Alice Seeley entered the British Civil Service. She spent her free time preparing to become a missionary. She studied at Doric Lodge, the training college of the RBMU (Region Beyond Missionary Union), formerly the Congo-Balolo mission. In 1894, she met her future husband John Hobbis Harris. Having become a missionary in 1897, she married him, just before they departed for the Congo in May 1898. Three months later, the couple settled in Ikau, in the north-west of the country; between 1901 and 1905, they would be posted to Baringa, sixty or so miles from Ikau. Convinced of her 'civilizing mission', Alice taught English and preached to the children from the surrounding villages, but her most significant contribution remains her photographic testimony of the fate of the Congolese who were forcibly recruited to work in the rubber-tree plantations of the so-called Congo Free State. In order to satisfy the growing demand for rubber, particularly after the invention of the tyre in 1887, Leopold II's lackeys ruthlessly exploited the local population, sparing them no method of coercion: whipping, kidnapping, rape, murder, and the burning of subsistence crops and villages. On 15 May 1904,

two men from a nearby village arrived at the mission in Baringa after being punished by militiamen for failing to meet the necessary quota of rubber. One of the men, Nsala, held wrapped in banana leaves the remains of his five-year-old daughter Boali, who had been killed and mutilated. Shocked, Seeley Harris persuaded Nsala to pose with the remains of his child. The images was first published in *Regions Beyond*, the mission's magazine, before being more widely diffused via the Congo Reform Association, founded by the journalist and politician Edmund Dene Morel.

Early in 1906, Seeley Harris, who had joined the association with her husband, began a tour of the United Kingdom and United States, during which her images were projected using a magic lantern, in order to alert international public opinion. In December 1906, the daily newspaper *New York American* published a series of articles on the atrocities committed in the Congo, using her photographs. In 1933, her husband was knighted and Seeley received the title of 'Lady'. Considered by some to be the first female whistleblower in contemporary history, she died at the venerable age of one hundred. In 2014, the London gallery Autograph ABP exhibited her photos, in tandem with the work of the Congolese artist Sammy Baloji, while Judy Pollard Smith dedicated a book to her, *Don't Call Me Lady: The Journey of Lady Alice Seeley Harris* (2014). **EN**

Born into a distinguished family in the Indre region of France, Jenny de Vasson practised photography as a pastime and escape from her intellectual pursuits. Her father, a public prosecutor, an anticlerical and a free-thinker, cultivated friendships with artists: the writer George Sand, the painter Fernand Maillaud, the poet Maurice Rollinat. In 1917, de Vasson wrote: 'I was surrounded by people who thought that books were created far more to be read than to be judged.' She embarked on relationships with eminent figures of her time: the writers André Maurois and Jean-Richard Bloch, the painter and designer Bernard Naudin, the sculptor Ernest Nivet. She took up photography in 1899, following a family trip to Venice in the company of friends who were amateur photographers.

Her subjects include domestic life in the countryside and the travels of an aristocrat abroad. Inevitably, the activities of a young woman in the company of friends (readings, musical gatherings, childcare) and her accessories (embroidery baskets, dresses, hats, bouquets of flowers) occupy a significant place in her work. Although self-portraits predominate, she also captured the everyday life of the countryside and produced intimate, spontaneous and affectionate portraits of the people of her region. She practised photography as a hobby, but by no means in a casual way: she did not neglect the technical aspects, rising at dawn to print her images in her laboratories at Versailles or in Berry. At times, she produced surprising experiments, atypical compositions, contemplative views, indicative of a practice that extended beyond the trends of her time – an original by nature.

The survival of de Vasson's photographic work is something of a miracle. First, the work is lucky to have outlived its creator: a few days before her death from angina at the age of forty-eight, she destroyed her drawings, notes, letters and other writings, which she considered unworthy in comparison to the literary output of her friends. However, she spared from this *damnatio memoriae* her photographic souvenirs, which she considered the fruit of an unpretentious hobby. Then, during the Second World War, the family mansion at Versailles was plundered and the photographs stored there were destroyed. Eventually, in 1979, in the cupboard of the house where de Vasson had produced a substantial number of her images, the abbey of Varennes in Fougerolles in the Indre region, five thousand negatives were rediscovered by the photographer Jean-Marc Zaorski and Gilles Wolkowitsch, the owner of the house. Together, they uncovered a hidden treasure trove, by an artist who had sought neither success nor recognition through photography. During her lifetime, de Vasson never circulated her prints beyond her immediate circle, with one exception: the portraits that she offered to the families of the soldiers in her region who were leaving for the front during the First World War. **FT**

'My eye is the only one of my senses that is content – for a brief space of time – with pure material, without a spirit.'

JENNY DE VASSON

Jenny de Vasson, *Self-portrait with mirror*, Issoudun, France, c. 1900–1

At the end of the nineteenth century, the names of several women photographers were known in Mexico City. María Guadalupe Suárez is thought to have been the first to open a studio there in 1881, at 1 Avenida Chiconautla. In 1898, Natalia Baquedano opened hers at the corner of Avenidas 5 de Mayo and Alcaicería, offering to her clients individual or group portraits.

Baquedano was born in the town of Querétaro, about a hundred and twenty miles north-west of Mexico City, and she died in Mexico City, at the age of sixty-four. According to Eli Bartra, a researcher in women's studies, her death certificate stated that she was unmarried and a housewife. Born to a well-to-do family, she grew up with her parents, Francisco Baquedano and Isabel Hurtado, and four sisters, Mercedes, Concepción, Clemencia and Dolores. Baquedano moved to Mexico City to study at the San Carlos Academy of Fine Art. Her artistic training would play a vital role in the development of her photographic language, in which her models and subjects often seem arranged in the manner of tableaux vivants.

In 1898, with her business partner A. Rico, she announced the opening of the Fotografía Nacional studio. On 20 January 1898, *La Sombre de Arteaga*, the newspaper in the town where she was born, listed the broad range of techniques and supports that she offered: 'Photographs on platinum paper, albumen paper, silk, porcelain, metal and everything that can be applied to photographs'. Above all, it promoted the use of a new and fascinating process:

'photography on natural flowers'. This ephemeral art, for which Baquedano registered a patent, would earn her a certain renown. An article that appeared in *La Sombre de Arteaga* on 22 August 1898, reported her project for presenting to Carmen Romero Rubio de Díaz, wife of the Mexican president Porfirio Díaz, a bouquet composed of portraits on flowers.

Reconstructing household interiors in her studio, Baquedano produced conventional portraits in response to her clients' demands, but also more surprising compositions, in which her creative spirit and artistic ambitions emerge. For example, the allegorical image of an angel, played by her niece Margarita Torres Baquedano, covering the eyes of a young girl beside her with her hand. Other portraits are striking in their informality, celebrating an intimate moment recreated for the requirements of a camera shot, as in the case of one showing her parents raising their beer tankards. Within her family circle, her sister Clemencia seems to have been her favourite model.

The majority of Baquedano's photographs are today held in the family archives, managed by Shanti Lesur, her great-grandniece. This collection, for the most part unpublished, comprises about five hundred items, including prints and negatives on glass and film. Research carried out by Lesur over many years in preparation for a publication will soon allow the original oeuvre of this important figure in the history of Mexican photography to become better known. **AL²**

Natalia Baquedano Hurtado, *The photographer's parents drinking beer*, c.1900

Minya Diez-Dührkoop, *Dance mask 'Insect dancer' by Lavinia Schulz*, 1924

Daughter of the celebrated Hamburg photographer Rudolf Dührkoop, Minya Dührkoop worked alongside her father from the age of fifteen and travelled with him to Britain and the United States. As well as images of art, architecture and festive events, her father's studio mainly produced portraits in line with the ideals of a new artistic movement: Pictorialism. In 1894, Minya married the photographer Luis Diez Vazquez, originally from Malaga, and kept his name after their divorce in 1901. Little is known about their professional collaboration.

Rudolf Dührkoop was one of the first photographers in Germany to portray his clients in their own homes, in natural light. Thus distinguishing himself from the studio photographers of the time, he was soon extremely successful and opened two branches in Berlin. In 1906, Minya officially became co-manager of the 'Photographic Studio of Artistic Portraits' in Hamburg; upon the death of Rudolf in 1918, she found herself at the head of the family business. She expanded the artistic principles introduced by her father and took a close interest in the latest techniques of colour photography. Her mastery of her craft is reflected, for example, in her eclectic use of sophisticated printing processes and retouching techniques. In her images, the soft outlines around the subjects – individuals or families, everyday scenes of middle-class life – created an atmosphere that reflected the taste of the period, in pose as well as composition, clothing or accessories.

Many well-known publications, such as *Deutscher Camera-Almanach*, *Menschen der Zeit* or *Das Deutsche Lichtbild*, recognized her talents, as did the writer Wilhelm Michel. A member of the German Society of Photographers, Diez-Dührkoop was well established in the network of elite professional photographers. In addition, she formed close ties within Hamburg's literary and artistic circles, collected contemporary art, and was a (non-practising) member of the Expressionist group Die Brücke.

In constant contact with the artistic scene, she produced in her studio in 1924 portraits of the artist couple Lavinia Schulz and Walter Holdt wearing dance costumes, introducing a Constructivist look into the setting. After more than thirty years as a successful Pictorialist portraitist, it marked a departure in her work, which had until then been homogenous, creating a series in which the Expressionist conception clearly reflects the plastic vocabulary of the 1920s and illustrates the experimental exploration that she carried out on the pictorial issues of her time. **DB**[1]

Alice Schalek

1874, Austria – 1956, United States

Alice Schalek, *Observation balloon in flight*, 1915

Alice Schalek's life was marked by a desire to overcome social barriers and find a place in areas that, in her time, were reserved for men. As the only female Austrian journalist to have reported on the First World War, and through her travelogues and novels, Schalek helped to normalize the participation of the female voice in public opinion.

Born into a bourgeois Jewish family, Schalek discovered journalism through her father, the founder of the first Austrian newspaper advertising agency. From 1903 onwards, she wrote in the liberal Viennese *Neue Freie Presse* newspaper, where her accounts of her travels in Norway, Sweden, India, the Middle East, East Asia and Australia were popular. Through her journalistic background, she became a well-known figure in the upper echelons of Viennese society; nevertheless, her conversion to Protestantism at the age of thirty must have seemed a necessary step towards full integration.

In 1915, Schalek's connections, her physical fitness as an experienced mountaineer and her adept writing style earned her the position of Austria's first female war reporter; she covered the Alpine fronts in Tyrol as well as battles in Serbia and Galicia. Her two books recounting her impressions on the front, *Tirol in Waffen* (Tirol in arms; 1915) and *Am Isonzo: März bis Juli 1916* (On the Isonzo: March to July 1916), as well as the public talks that she gave from 1916 as part of her commitment to families suffering from wartime poverty, emphasize the soldiers' heroism while minimizing their suffering. Her patriotic position during the war attracted the fierce criticism of the pacifist journalist Karl Kraus, which was tinged with misogynist and anti-semitic undertones.

While Schalek's war reporting largely omitted women's war experiences, it was a question that she nevertheless addressed in her early novels *Wann wird es tagen? Ein Wiener Roman* (When will dawn break? A Viennese novel; 1902) and *Das Fräulein: Novellen* (The mademoiselle: novellas; 1905), which were published under the male pseudonym 'Paul Michaely'. Here she targeted the monotonous trajectories of bourgeois women whose sole purpose in life was to please their husbands as wives and mothers – a flight she continued after the war. She sat on the board of the Association of Women Writers and Artists of Vienna and was the first woman to be accepted into the Austrian Press Club Concordia. Her work increasingly addressed local social and political issues, as well as international women's rights. Her mobility as a travelling writer and photographer must be seen as the prime reason why she was able to cross the traditional boundaries of womanhood.

In 1939, Schalek was forced into exile in the United States to escape from Nazi persecution. Her name, so present in the Viennese press for decades, fell into oblivion. **RG**

In 2006, Patricia Viaña, Josefina Oliver's great-niece, unearthed the work of one of the first Argentine women photographers. She then undertook to bring together her albums, prints, collages and private journals, which were dispersed in Argentina, Spain and Italy, and to organize her archives.

Born in 1875 in Buenos Aires, Josefina Oliver was the daughter of immigrants from Majorca. She received a classical education, interrupted at the age of fourteen, when her mother was admitted to a psychiatric hospital. At seventeen, the young girl began to keep a personal diary, which by the end of her life was to fill twenty volumes and a total of 8,400 pages. She discovered photography at the age of twenty and learnt the basics of the medium from her father, Pedro Oliver, and from her friends and neighbours. Her amateur practice blossomed between 1898 and 1910, during her youth and in the first years of her marriage (1907), a period in which she would produce the majority of her photos – some 2,600 negatives – within her family and social circle. She captured her relatives inside her home in Buenos Aires or in their houses, in the garden of the family farm bought by her father in San Vicente in 1896, or during her picnics in and around Buenos Aires.

Her images and writings are filled with the desire to tell her own story, to record her memories and to express an opinion about her times. The entire process that Oliver established seems to defy the naturalism of the medium and demand a heightened subjectivity. The compositions that she orchestrated, the expressive colouring of her prints, and the inventive juxtapositions that she created in her albums were, similarly, a means of affirming her vision. Examining her own identity, she took approximately one hundred self-portraits over ten years, alternating elegant and conventional poses with the most fantastical fancy dress, wittily adopting accessories and disguises: capturing herself wearing her sister's wedding dress, or disguised as a peasant, or dressed as a man, sporting moustache and beret. Her room equipped as a studio became the heart of a creative theatricality; the presence of the mirror led to exercises in symmetry or duplication.

After her marriage in 1907, and then the birth of her three children, Josefina Oliver gradually abandoned photography and, in 1921, she gave it up definitively following a problem with her left eye. Nevertheless, she continued to colour her prints and to collect photographs by her close family and professionals, incorporating them into the pages of her journal and her correspondence. From 1943 until her death in 1956, she devoted her time to organizing her manuscripts, with increased inventiveness in the cutting out and juxtaposition of the images. Her photographic oeuvre testifies to a desire for freedom that she continued to express without compromise. **AL[2]**

Josefina Oliver, *Self-portrait in male dress*, Buenos Aires, 1908

Käthe Buchler, *Two Drivers*, from the series
'Women in Male Professions', *c.* 1916–17

Käthe Buchler, an amateur photographer from Brunswick in northern Germany, trained at the Lette Verein applied arts school in Berlin and with a local photographer. Her archive comprises around 1,020 negatives on glass plates or film, 400 black-and-white slides, and 240 autochromes. In 1901, she began documenting her family life and capturing still lifes using Lumière's Autochrome process, one of the earliest techniques in colour photography. Buchler's family was wealthy and had ties to the Voigtländers – the leading producers of photographic equipment at the time – giving her access to the latest technology.

Between 1913 and 1917, Käthe recorded civilian involvement in the war effort, presenting a selection of those photographs, along with some Autochromes, in slideshows at charity events. Since most men were away at war, women's associations and charities, organized by members of the bourgeoisie, were the main providers of social welfare. As a member of the Red Cross and the German Women's Association, Buchler documented activities such as child-care, tending to wounded soldiers, day-to-day life in military hospitals, and the management of supplies and waste. She also produced carefully arranged group portraits of women, children, soldiers and prisoners of war.

One series, 'Frauen in Männerberufen' (Women in male professions), gives a glimpse into the precarious conditions working-class women faced at the time. It portrays milkwomen, postal workers, tram drivers, farm workers and sweepers Buchler encountered in the streets – all jobs formerly performed by men but now, temporarily, carried out by women. She adopted a typological approach to these portraits, usually depicting the women in typical surroundings and holding job-specific attributes, but also representing them as individuals. She always approached her subjects with sympathy, but ultimately remained uncritical of existing class divisions and maintained a patriotic faith in the righteousness of war.

Newspaper reviews of the time testify to the positive reception Buchler's work received at her slideshow presentations. The emotional power of the images appealed to the public's sense of moral duty and encouraged them to be active on the home front. Although Buchler's photographs reveal little of the suffering and privations ordinary people faced during the war, they give an inside view into everyday life beyond the battlefields and into the self-perception of many middle-class women of the time. **JM**[1]

A pioneering English portrait photographer, Olive Edis is also known for the unique record she left behind of the role played by women on the Western Front shortly after the Armistice. Olive was born in London on 3 September 1876. Her mother's family, several of whom were photographers, introduced her to the medium and in 1900 gave Edis her first camera. Her father, a doctor who specialized in women's health, passed on his respect for female workers. Upon his death, Edis became a professional photographer to support herself and set up a studio in Sheringham, Norfolk, in 1905. Her subjects were diverse, but her style, which featured natural light and soft tones, was consistent. Furthermore, Edis was one of the first professional women photographers to specialize in colour. From 1912, she produced Autochromes, using a viewfinder that she had designed herself, and offered the new process to her customers. She also encouraged other women to take up photography professionally.

During the First World War, Olive promoted the contribution of British women to the war effort, photographing them in roles usually reserved for men – working in munitions factories, for example. She was a natural choice when the Imperial War Museum sought a photographer to document women on the Western Front. Olive accepted the expenses-only assignment in October 1918, noting: 'The Imperial War Museum thought that a woman photographer, living among the girls in their camps, was likely to achieve more intimate pictures, more descriptive of their everyday life, than a man press photographer.'

Unfortunately, permission to visit the Western Front was not forthcoming until March 1919, forcing Edis to document the aftermath of war rather than the conflict itself. Her subjects no longer faced enemy action but were at risk from the Spanish flu pandemic, which was then raging throughout the world. Over four weeks, she photographed women working in challenging conditions alongside the armed forces in Belgium and France. Her equipment was bulky and fragile, and the lighting was poor. Her preference for natural light required lengthy exposures, forcing her subjects to adopt stilted poses that lack the intimacy she sought. Nonetheless, her images were well received because they constituted a genuine account of women's achievements and underlined their determination not to be confined to the domestic sphere.

Olive Edis married Edwin Henry Galsworthy, a cousin of the novelist John Galsworthy, in 1928. From this point on, she undertook fewer commissions but maintained her studio until her death in 1955. **HR²**

'One is not truly a photographer unless one's work shows what is inside the sitter, as well as what is outside.'

OLIVE EDIS

Olive Edis, *Members of the Queen Mary's Army Auxiliary Corps (QMAAC) working beside soldiers among piles of clothes at the Army Ordnance Depot at Vendroux, France*, 1919

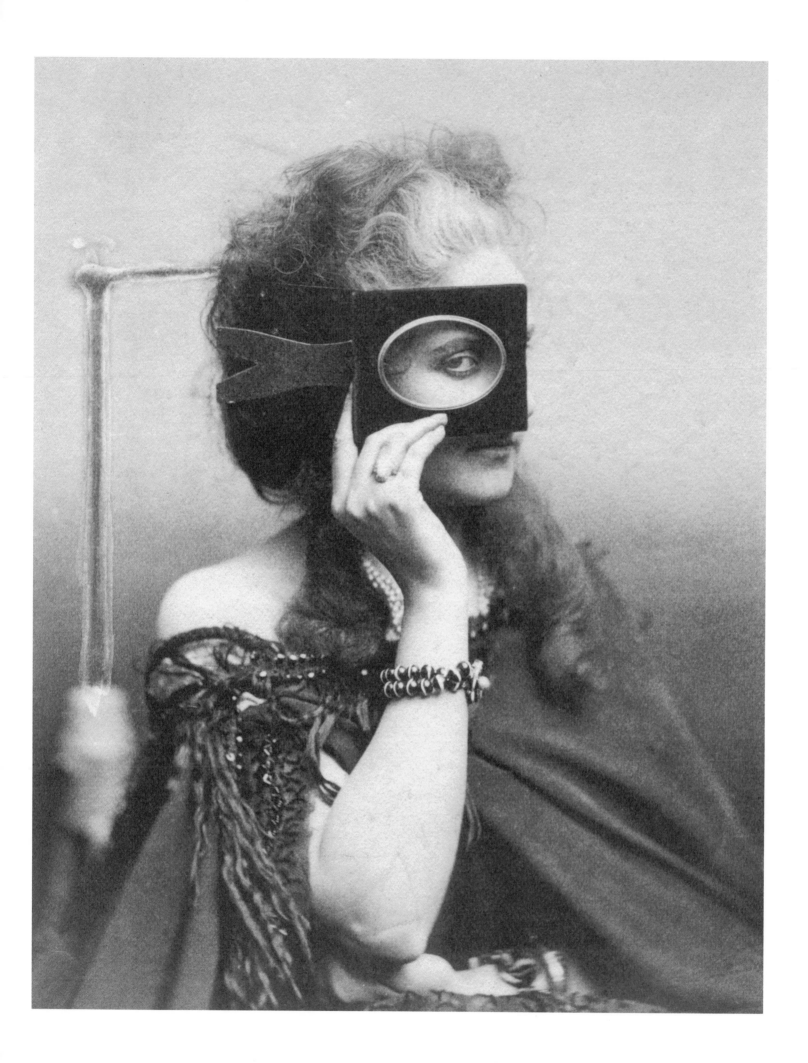

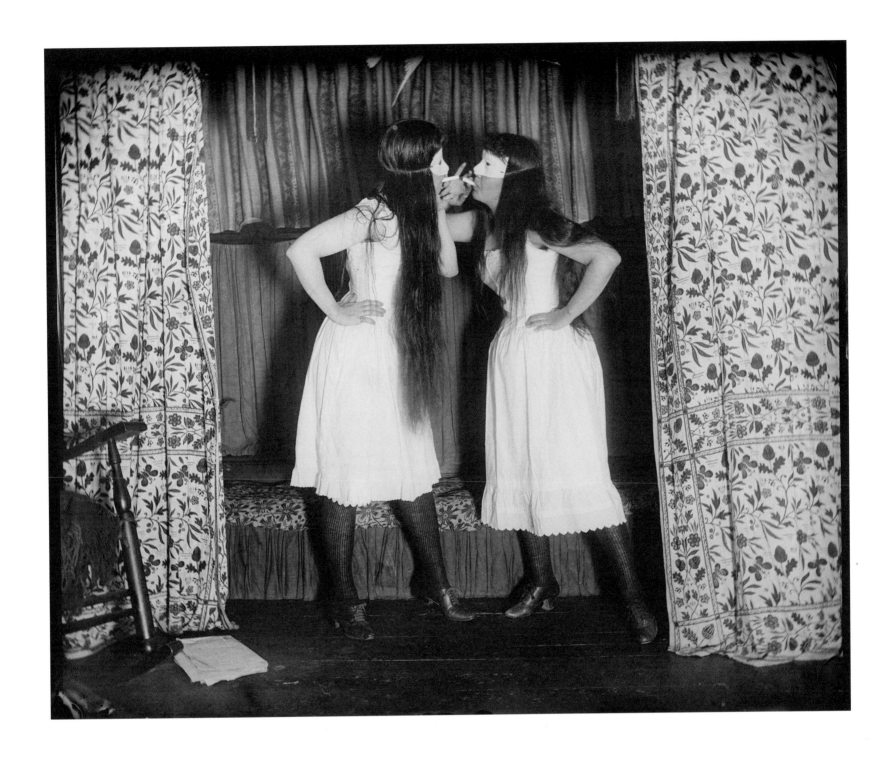

Countess of Castiglione,
Scherzo di Follia, c. 1863–6

Alice Austen,
*Trude and Me, Masked,
Short Skirts*, 6 August 1891

Josefina Oliver, *Carnival [García Oliver siblings]*, Buenos Aires, 1909

Hannah Maynard,
The Children of Charles E. Redfern,
*c.*1887

Bertha Wehnert-Beckmann,
Inside the Wehnert-Beckmann studio,
Leipzig, *c.*1850–9

Lady Frances Jocelyn,
Interior, *c.*1862

Lallie Charles, *Bea Martin,
Lallie Charles and Rita Martin*,
*c.*1899

Frances Benjamin Johnston,
*Stairway of the Treasurer's
Residence: Students at Work*,
c. 1899–1900

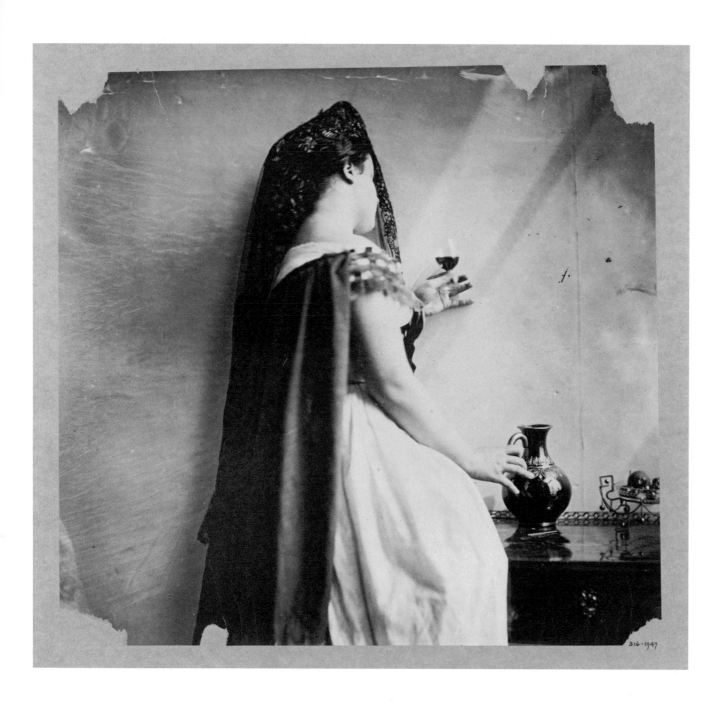

Lady Clementina Hawarden,
Florence Elizabeth, 5 Princes Gardens,
c. 1863–4

Julia Margaret Cameron,
The Double Star, 1864

96

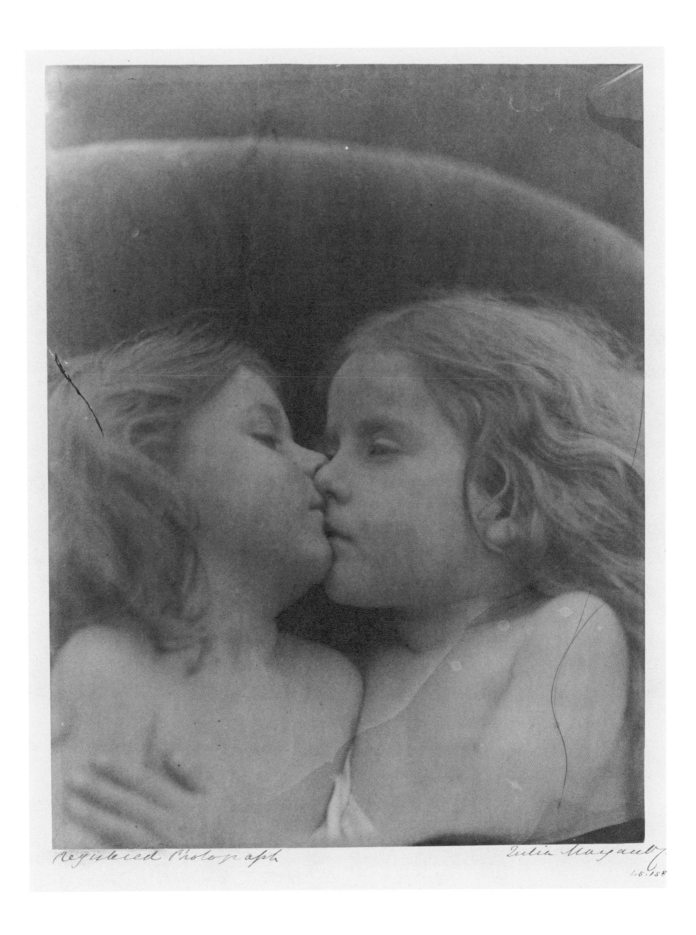

Registered Photograph *Julia Margaret*

97

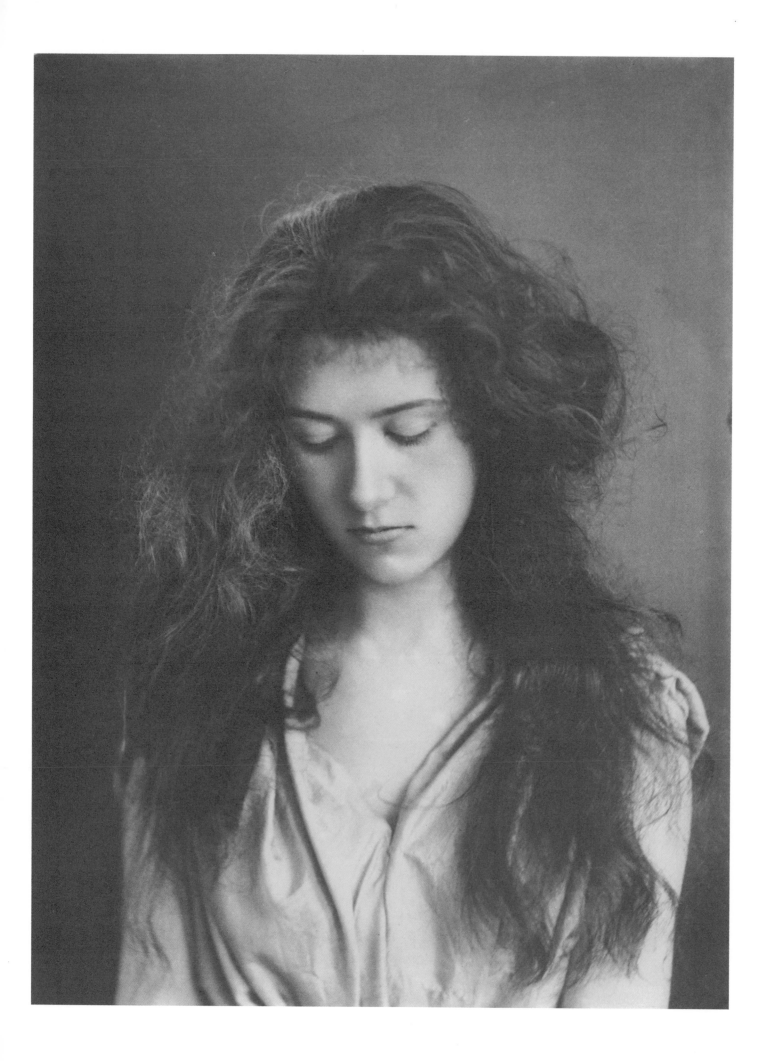

Eveleen Myers, *Adelaide Passingham*, 1889

Edith Watson, *At Tompkins (Landscape
with view of rural road)*, Newfoundland and
Labrador, Canada, 1913

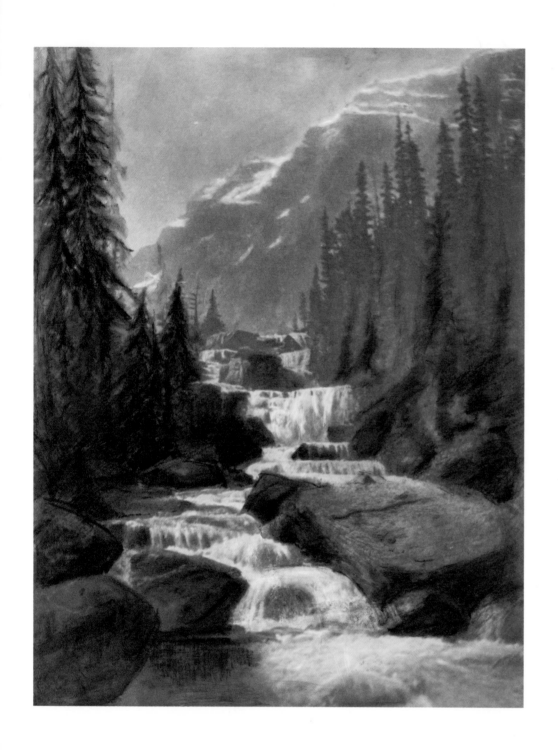

Minna Keene, *The Rockies*, c.1914

Gertrude Käsebier, *Iron White Man,
a Sioux Indian from Buffalo Bill's
Wild West Show*, c.1899

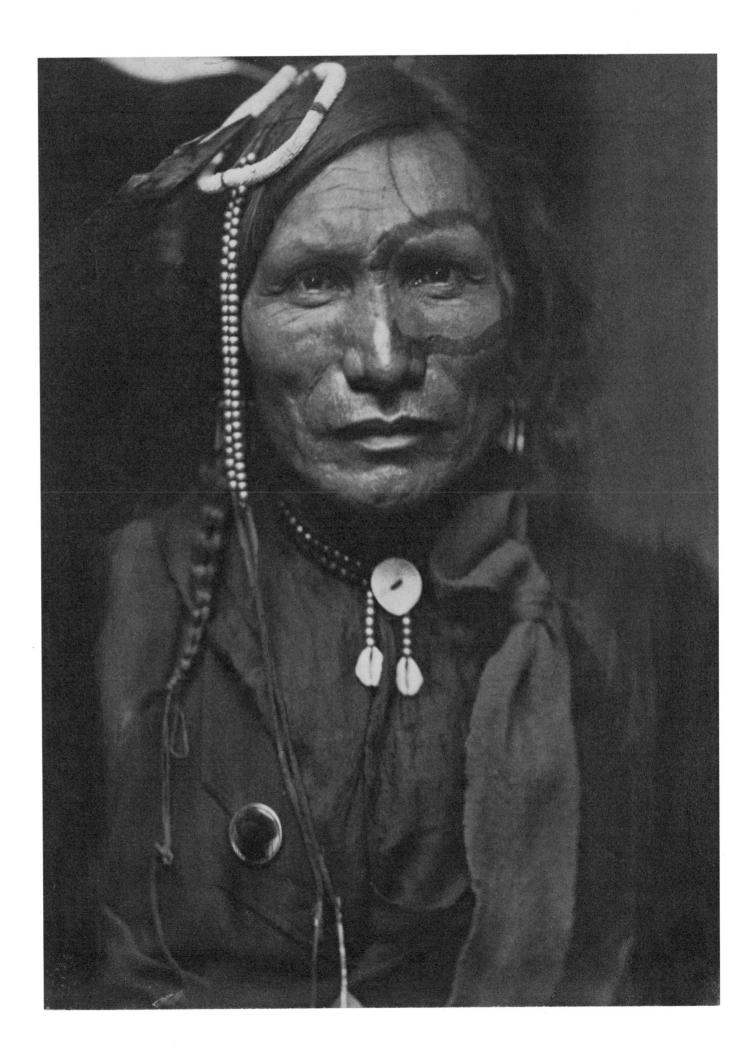

Nicoline Weywadt, *The Family of Reverend Stefán Sigfússon*, 1888

Harriet Pettifore Brims, *Balancing Rock, Australia*, undated

Geraldine Moodie,
Inuit woman ice-fishing,
Cape Fullerton, Nunavut,
Canada, 1905

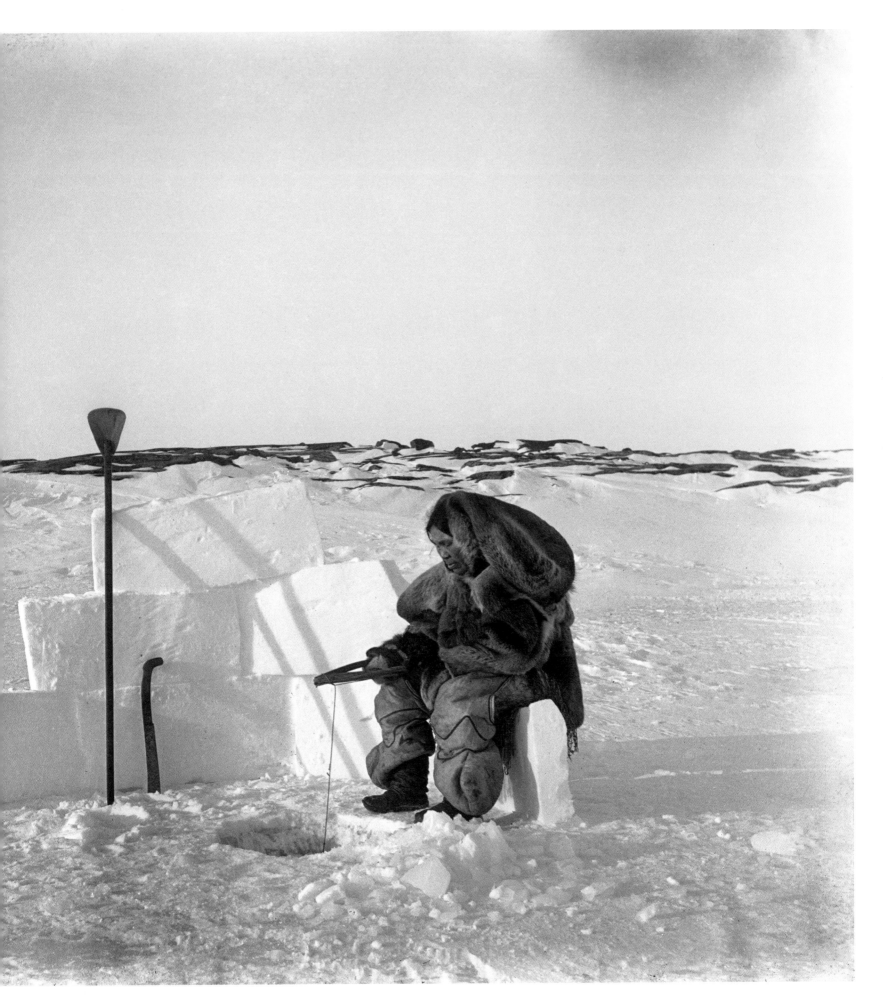

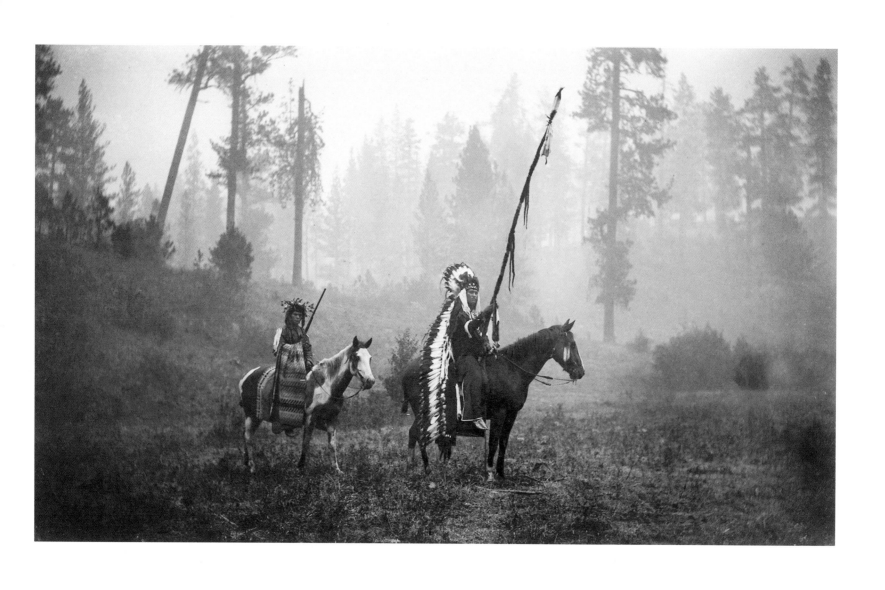

Emma Jane Gay,
They Donned War Bonnets, c. 1861

Signe Brander, *Courtyard Buildings,
Kasarmikatu 23*, Helsinki, 1907

249.

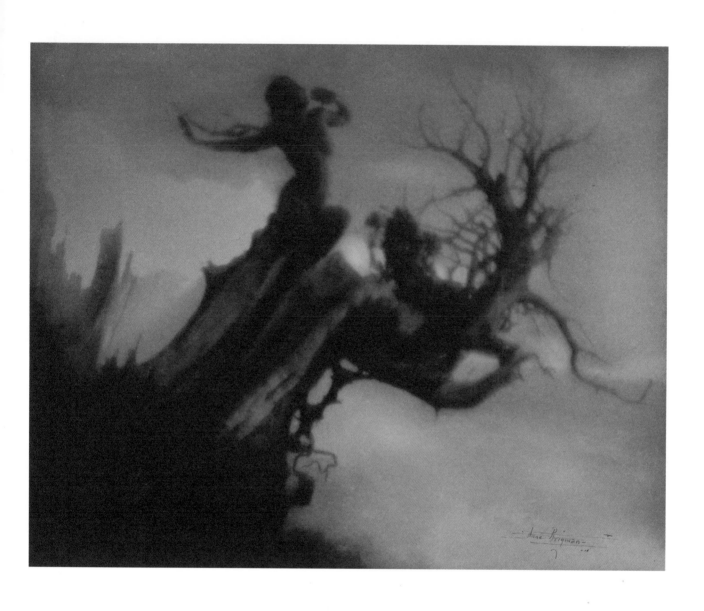

Anne Wardrope Brigman,
The Storm Tree, 1911

Helen Messinger Murdoch,
Egyptian Children, 1913

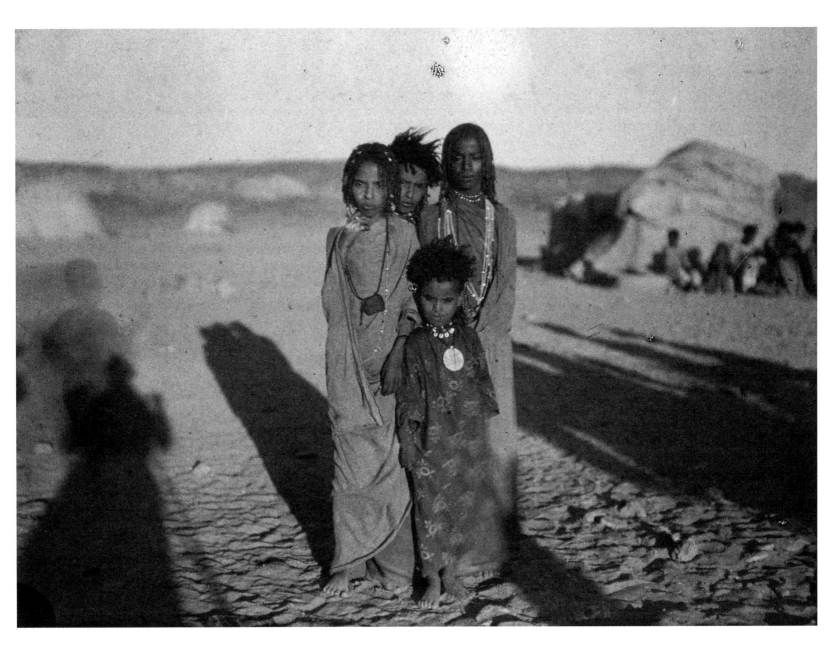

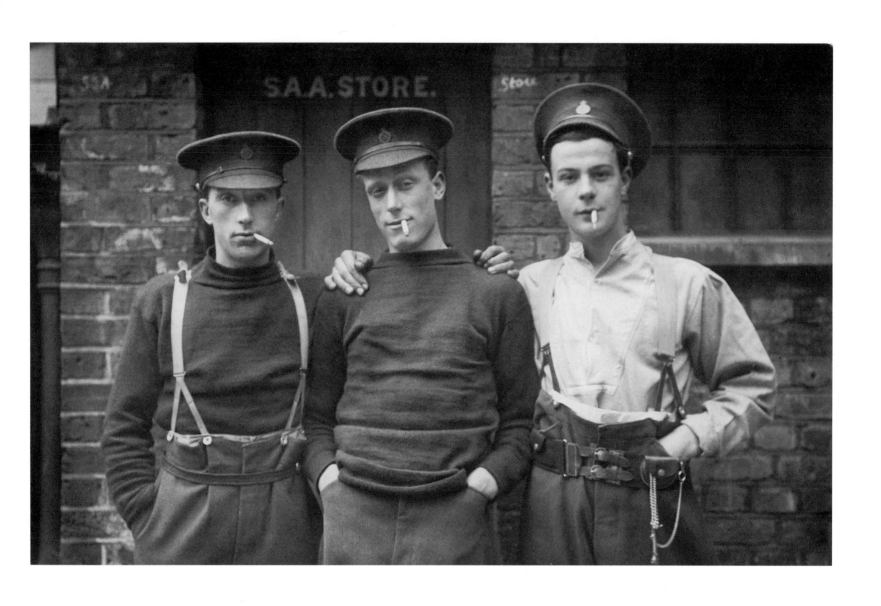

Christina Broom,
*Life Guards: S. Raper, Sidney Crockett
and William H. Beckham*, 1915

Jessie Tarbox Beals,
*Women in Academic Dress Marching
in a Suffrage Parade, New York*, 1910

110

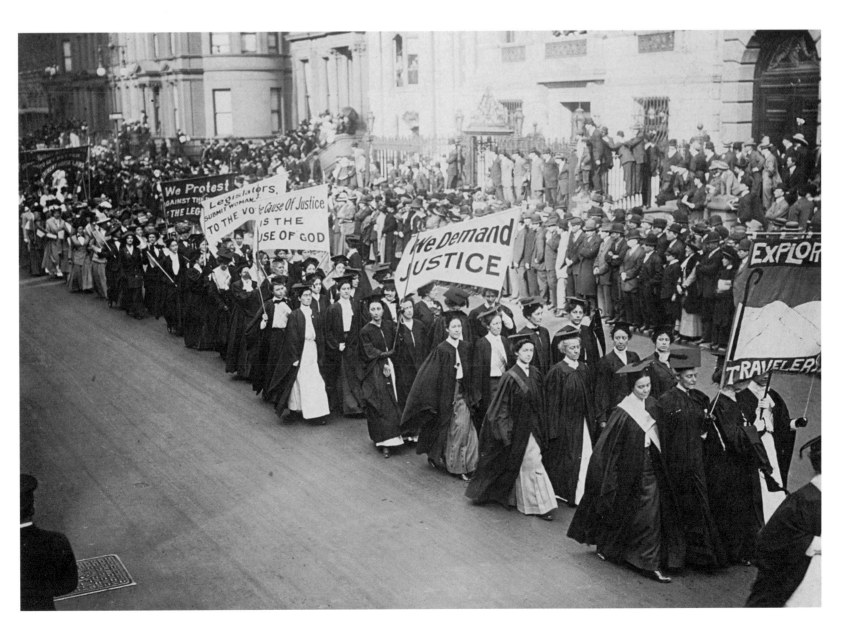

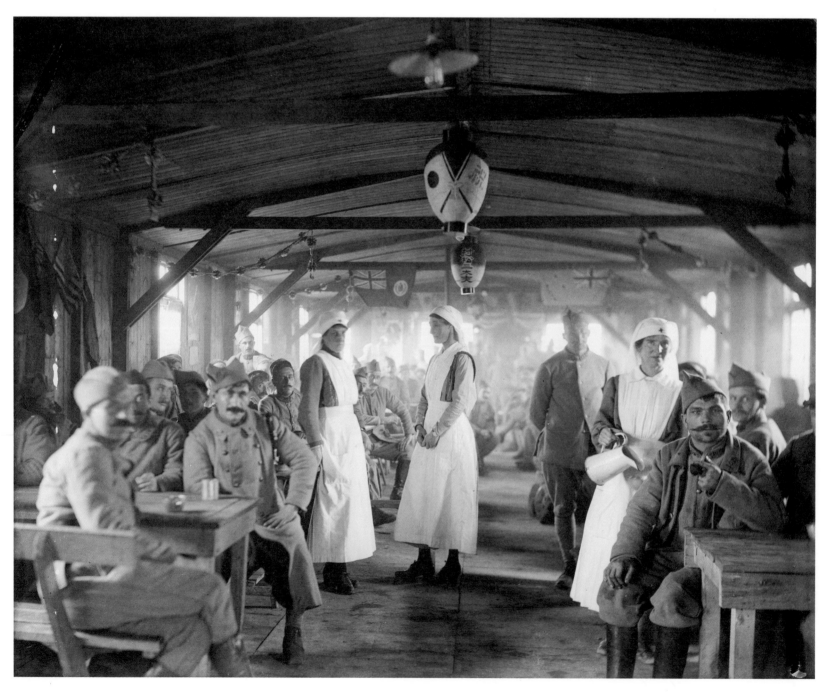

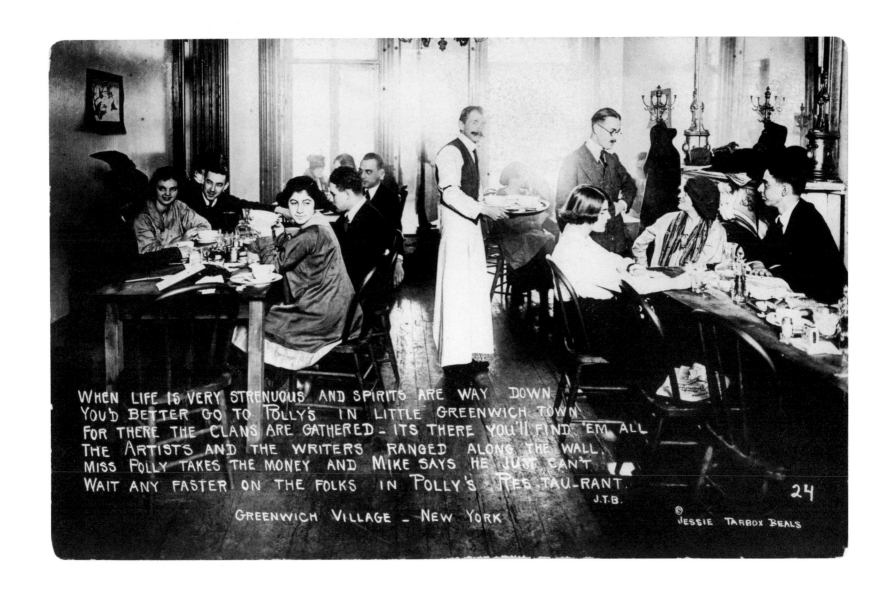

WHEN LIFE IS VERY STRENUOUS AND SPIRITS ARE WAY DOWN
YOU'D BETTER GO TO POLLY'S IN LITTLE GREENWICH TOWN
FOR THERE THE CLANS ARE GATHERED – ITS THERE YOU'LL FIND 'EM ALL
THE ARTISTS AND THE WRITERS RANGED ALONG THE WALL.
MISS POLLY TAKES THE MONEY AND MIKE SAYS HE JUST CAN'T
WAIT ANY FASTER ON THE FOLKS IN POLLY'S RES-TAU-RANT.
J.T.B.
24
GREENWICH VILLAGE – NEW YORK
JESSIE TARBOX BEALS

Olive Edis, *Three Female Red Cross Workers
(from left to right, Miss Fawcett, Miss Andrew
and Miss Pullinger) Serving Troops in a Canteen
in Compiègne*, France, 1919

Jessie Tarbox Beals, *Interior View of Polly's
Restaurant, with Waiters and Customers*,
New York, *c.*1910s–1920s

Alice Schalek, *Shooters in Pordoi*,
Dolomites, Italy, 1915

Rose Simmonds, *Breaking Wave*, 1940

Rose Simmonds (née Culpin) was an Australian photographer based in Brisbane working mainly in the Pictorialist style. She is known for her dexterous use of the bromoil process, a drawing technique that produced romantic effects. She was born in Islington, London, in 1877. Her family moved to Brisbane in Australia when she was about fourteen years old, and it was here that she studied art at the Brisbane Technical College with Godfrey Rivers. Aged twenty-three, she married a stonemason named John Simmonds who used a large-plate camera and had a darkroom at home, where he developed and printed photographs of the headstones he had made. Before long, Rose was taking her own photographs and processing them in the same darkroom. To begin with, she made snapshots of the Simmonds children, before moving on to more challenging subjects, such as her impressive, idealized landscapes of the Australian bush, in which she explored evocative light effects to enhance the atmosphere. She is also noted for her dramatically lit still-life images.

From 1927, Simmonds was active in the Queensland Camera Club, obtaining life membership in 1939, and between 1920 and 1932 her work appeared in the *Australasian Photo Review*. From 1932, she participated in exhibitions organized by the Photographic Society of New South Wales, and five years later became an associate of the Royal Photographic Society of Great Britain. Simmonds also participated in exhibitions organized by the Professional Photographers' Association of New South Wales and the Sydney Camera Circle in 1938, and in 1940 her work was included in an exhibition of Pictorialist photography held in Adelaide entitled *Should Take Up Painting*.

Simmonds's first solo exhibition was held in Brisbane in 1941. By now, she was working in the modernist style, producing semi-abstract works using man-made structures to explore the nature of light and shade, and removing from natural features any specific geographical or temporal context. In this last phase of her career, she continued to be recognized for her outstanding technical ability. Rose Simmonds died on 3 July 1960 in Auchenflower, Queensland. Her work has been commemorated at the Queensland Art Gallery, in the exhibitions *Australian Women Photographers 1840–1960* and *Queensland Pictorial Photography 1920–1950*. Most of her photographs are held at that museum and at the John Oxley Library of the State Library of Queensland, Brisbane. **AM**

Passionate about music, Laure Meifredy studied at the Lycée Molière, in Paris, and then in 1897, married Albin Guillot, a medical student and musician. The couple installed an organ in their living room and lived an aesthetic life. Dr Guillot's scientific knowledge, combined with a shared taste for beauty, led the photographer to publish her first work, *Micrographie décorative*, in 1931.

Laure Albin Guillot's first known publication was in *Vogue* in 1922, revealing her talent in rendering her models both present and mysterious at the same time. A contemporary of Paul Burty Haviland and Imogen Cunningham, she worked for numerous publications, illustrating magazines such as *L'Illustration* or *Vu*, and professional journals like *Art et médecine*.

From 1924, she exhibited in the galleries of the Société Française de Photographie. A member of the Société des Artistes Décorateurs and the Union des Artistes Modernes, Laure Albin Guillot earned a living from her craft, using her prints on boxes, screens and lamps. In 1925, at the International Exhibition of Decorative Arts in Paris, her portraits of master craftsmen such as Lalique, Leleu or Ruhlmann made an impression. Admired for her sympathetic modernity, she was a prominent member of the French photography community in the interwar years. The death of her husband in 1929 transformed the artist into an entrepreneur; she enlarged the studio at her home and held court there. She had a wide, elegant and profitable circle. Extremely prolific, she participated in many exhibitions, publications and official engagements. In 1932, she was appointed head of photography at the Academy of Fine Arts, where she was responsible for the conservation and diffusion of the archives, handled commissions and participated in acquisitions. Entrusted in January 1933 with creating a national film library, she was a member of the committee for the International Photography Exhibition at the Musée des Arts Décoratifs in 1936, and set up the project 'Women Artists of Europe Exhibit at the Musée du Jeu de Paume' the following year. The intensity of her professional life was remarkable.

In 1939, Laure Albin Guillot photographed the evacuation of the Louvre, the protection of monuments, and organized the transfer of the collections for which she was responsible. In 1940, although she withdrew from public office, her production remained significant, and many individuals wanted a portrait bearing her signature. She continued to work in advertising, also illustrating artists' books with the poet Paul Valéry and Marcelle Maurette. During the war, she exhibited in several salons and fulfilled official commissions, for example portraits of uniformed men for armament coupons.

The works she showed after the war at the Salon National de la Photographie seemed out of step compared with those of the new generation. In 1954, 'alone in the world, without a single living relative', as she wrote, she retired to the Maison des Artistes in Nogent, where she died on 22 February 1962. **DD**[1]

'Modern life is tuned to a rapid rhythm. We rush quickly by, ignore the urge to wander, have hardly any time to lose. A text must be read: it's too long. An image speaks immediately to the mind.'

LAURE ALBIN GUILLOT

Laure Albin Guillot, *Micrographie décorative*, plate IX, 1931

Between 1948 and 1956, Madame d'Ora devoted herself to a remarkable project: she visited the abattoirs of Paris and documented them in hundreds of images. Misshapen, blood-smeared carcasses and slaughter on an industrial scale assail the eye. She was not the first to tackle the raw materiality of butchery: the Surrealists, such as Eli Lotar or Wols, before her, were fascinated by the obscenity of viscera, flayed flesh, animal transformed into meat. But her photographic record was underpinned by trauma. It was as if only repellent images could survive after the Second World War, during which Madame d'Ora, who was of Jewish origin, lost some of her family. An outlet for the horror, these are the images of the aftermath. And yet, her earlier practice also continued, as she photographed the world of theatre and ballet.

Before the war, Madame d'Ora's work had been different, her compositions capturing the fin-de-siècle luxury of Mitteleuropa, the glamour of cosmopolitan high society and the refinement of an artistic milieu in which the decorative was elevated to an aesthetic. A kind of aura emanates from her portraits, and is even reflected in the pseudonym she chose shortly after opening her photographic studio in Vienna in 1907. Dora Kallmus, a young Austrian from an affluent family, 'retouched' and franchised her own first name, already displaying the sense of theatricality that would become the trademark of her oeuvre. Collaborating throughout her career with assistants who took care of the technical aspects of her work, she never took photographs herself, instead channelling her talents into staging them.

From Tamara de Lempicka to Foujita and Mistinguett, or the models sporting the Art Nouveau creations of the Wiener Werkstätte, Madame d'Ora created iconlike images that combine stellar dazzle with the needs of publicity. She raised the elegance of her subjects to a sublime level, succeeding in making them exceptional while allowing them to be widely reproduced. This glorification reflects both the serial chic that is made possible by photography and the elevation of fashion to a form of art.

In an image shot in Vienna, the actress Elsie Altmann-Loos is transformed into a Klimt-like fantasy, borrowing the femme fatale stance of the artist's *Judith* (1901). In Paris, where Madame d'Ora settled and opened a studio in the 1920s, the vocabulary of Art Nouveau permeated her iconography. Images of Josephine Baker, Arletty and the milliner Madame Agnès display a metallic sensuality, a geometrization of motifs and a celebration of the polished surface. As the form of haloes or rays, light became a form of ornamentation. It was no longer simply the raw material of photography, but elevated its subject. Ecstasy can also be found in the figures of the dancers whose daring or mystical swirls and arabesques Madame d'Ora frequently captured: the lascivious nudity of Anita Berber or the ritualistic poses of Mary Wigman, ephemeral modernist forms immortalized by the photographer. **AA**[1]

'They thought that as a woman I should be content with attending classes and they denied me access to chemical reagents as if they were dirty jokes.'

MADAME D'ORA

Madame d'Ora, *Slaughtered Animals [Calves' heads]*, from the series 'Abattoirs', Paris, 1949

118

'There is more, much more in the photo question than the mere ability to make a technically perfect photo or picture.'

MAY MOORE

May and Mina Moore, *Graham Marr*, 1911

The Moore sisters were among Australia's most successful professional photographers in the twentieth century. Working in Sydney and Melbourne, they managed a high-profile commercial operation photographing society figures, artists and celebrities of stage and film.

The two sisters were born in the small town of Wainui, near Auckland, in New Zealand. May studied painting at the Elam School of Art and Design in Auckland, and supported herself by selling her sketches. She moved to Wellington in 1908 and rented a space in a photographic studio where she painted portraits of prominent figures. Mina pursued a teaching career, which she relinquished when the sisters purchased the Alexander Orr Studio, adjacent to May's.

In the space of six weeks, they learnt camera-handling and the printing process from the exiting staff. For their first large commission, they photographed a visiting American theatre troupe. New Zealand was part of an international circuit for travelling actors that included the United States, Britain, Canada and Australia, and there was strong demand for glamorous-looking publicity shots – a demand that the sisters, with their long-held love of theatre and the arts, were ideally placed to fulfil. The Moores began experimenting with new lighting methods and introduced expensive bromide papers and mounting boards to New Zealand.

May Moore relocated to Sydney in 1910. Mina joined her in 1911 and set up a branch of the business in Melbourne, on the prestigious Collins Street. Over the next eight years, they photographed a steady stream of celebrities from both Australia and overseas, but also hundreds of soldiers at the outbreak of the First World War, whom they afforded the same glamorous treatment as their more famous clients. The New Zealand photographs were by May Moore, but those taken in Australia were signed by both sisters, making their attribution difficult; both worked in a similar style, characterized by dramatic lighting and theatrical poses. Among their more famous clients were the actresses and singers Lily Brayton, Nellie Stewart and Ada Reeve, the poet Mary Gilmore, the opera singers Anafesto Rossi and Nellie Melba, the actor and director Gaston Mervale, Cardini the magician, and the painters Frederick McCubbin and Arthur Streeton. Mina retired at the end of 1918 to raise a family, but May kept working until 1928, when illness forced her to stop work. **AM**

Naciye Suman

1881–1973, Turkey

Naciye Suman, *Woman and Child during the Early Years of the Republic*, c. 1920

'The First World War broke out and my husband left for the Front. I had to provide for the needs of [my family]. During the war years, I was short of money. I decided to open a photographic studio.'

NACIYE SUMAN

Considered the first woman photographer in the Ottoman Empire, Naciye Suman founded a photographic studio whose unique history was part of the political instabilities of the early twentieth century. Although modest, the business constituted a unique model of commercial success and emancipation, opening the way for other women photographers in Ottoman territory. The studio was created in 1919, in the laundry room of Naciye's house in Constantinople. It answered both to personal financial needs and a growing demand from the local female clientele, who in a patriarchal and predominantly Muslim society were unable to pose for a photographer of the opposite sex.

Like many women of her generation, Suman saw her husband leave for the front following the outbreak of the First World War in 1914. He was wounded and Naciye was thus forced to support her family. She decided to put to use her photographic skills, learnt from her husband during a period spent in Vienna during the Balkans War. Although the amateur practice of photography was common among women from affluent families, its professional side was reserved for men. In this respect, the career of 'Madame Naciye' or 'Naciye Hanim' (*hanim* being a Turkish title of nobility) was unique in the Middle East at the beginning of the twentieth century. Unlike her female colleagues, who practised as assistants and then successors to male photographers, she created her practice alone, developing in the shadow of neither a father nor a husband. This feminine element was explicitly stated on the inscription 'Photographic Studio for Turkish Women – Naciye' on the notice attached to the entrance of her business. In the absence of any true competition, it developed rapidly: only two years after opening, Naciye moved the studio to the Beyazit neighbourhood. Despite her female identity, the male gaze remained at the heart of the finances of the enterprise, which prospered thanks to commissions for portraits to send to husbands serving in the war. Distancing themselves from a European aesthetic, these images differ from those created by Western photographers, whose orientalist style was manifest in portraits showing native women dressed in turbans, veils and other so-called 'traditional' costumes. Oscillating between romanticism and patriotism, an image attributed to Suman seems to crystallize these characteristics: a mother with a penetrating gaze, dressed in a long black robe and veil, poses beside her young child, perched on a chair and waving a little Turkish flag.

Suman's financial and social success belonged in part to the creation of the young Turkish Republic by Mustafa Kemal Atatürk, combining modernization, the transformation of traditions and the progression of nationalism. It is, however, difficult to establish a precise chronology for her career: only six photographs bearing the stamp of her studio are known today, and are conserved in the collection of the photography historian Gülderen Bolük. **LA**

In a book of interviews published after her death, Cunningham was asked the question: 'Which of your photographs is your favorite?' She replied: 'The one I'm going to take tomorrow. ' In a continual state of self-discovery over the course of her seventy–five-year career, Cunningham was a pioneer of portrait and landscape photography on the West Coast of the United States during the first half of the twentieth century.

Cunningham graduated from the University of Washington in 1907 and went on to learn platinum printing in the studio of Edward S. Curtis – famous for his portraits of Native American peoples – in Seattle. She then studied photographic chemistry in Dresden before returning to the United States and opening a portrait studio in her Seattle home. Rather than settle with the commercial success of her studio, Cunningham pushed her practice to new limits by questioning gender norms at a time when few women gained recognition in the field of photography. In 1915, she stirred up controversy by photographing her then husband, the engraver Roi Partridge, in the nude – a practice that the Seattle press considered vulgar in a woman photographer.

As Cunningham's family grew, she increasingly sought inspiration from her domestic life, turning the lens on herself, her family and the natural environment. In 1917, she relocated to San Francisco and embarked upon one of the most prolific periods in her career. While raising her three young children, Cunningham looked to the plant life in her back garden. Like her portraits of people, Cunningham's detailed black-and-white studies of lilies, magnolia blossoms and banana leaves are at once straightforward observations and suggestive of hidden depths.

Cunningham was one of four women – along with Consuelo Kanaga, Alma Lavenson and Sonya Noskowiak – to be included in the seminal Group f.64 exhibition in San Francisco (1932). Alongside the work of her contemporaries Ansel Adams and Edward Weston, her crisp, unvarnished photographs of the American West presented an alternative to the atmospheric Pictorialism that had proliferated in Europe and on America's East Coast. In addition to the botanic images to which she returned throughout her career, Cunningham also took to the street with her camera, capturing incisive views of everyday life in San Francisco and on her travels abroad, notably to France and Germany.

Cunningham continued her photographic practice well into her nineties and served as a mentor for a new generation of photographers coming of age in the 1960s. In the final years of her life, leading up to her death in 1976, she compiled portraits of elderly subjects for a book entitled *After Ninety*, which was published posthumously. As Cunningham aged, she continued to take uncompromising self-portraits, ever committed to seeking new meaning in a changing world. **FW**

Imogen Cunningham, *On Mount Rainier 5*, Washington, 1915

Imogen Cunningham

1883–1976, United States

Nino Jorjadze – a Georgian princess descended from a prominent aristocratic family – is considered to have been the first woman photographer in Georgia and, more specifically, the country's first female war reporter.

After studying the piano in Switzerland, Austria and France, Jorjadze returned to Georgia, which at that time was annexed to the Russian Empire. In 1914, before leaving for the Caucasus Front, she trained as a nurse and joined the Red Cross organization. While serving as a volunteer, Jorjadze photographed the reality of conflict and amassed an outstanding body of documentary images.

Jorjadze covered the First World War with a Kodak camera belonging to her brother, Giorgi. In particular, she followed the Caucasus campaign, which pitted the Russian against the Ottoman empires in Sarikamish, Kars, Anis, Nazik, Karakamis, the ruins of Ani and many other locations. Her pictures show the various aspects of war: daily life on the front lines, scenes in the aftermath of battle, portraits of victims, high-ranked officers and ordinary soldiers, refugees and military doctors. They also bear witness to the horrifying typhoid epidemic outbreak, ruined infrastructure and destroyed landscapes. Their graphic simplicity and emotional power make Jorjadze's photographs a poignant record of the Great War. Other renowned photographers – Dmitri Ermakov, Vladimir Barkanov and Dmitri Nikitin, for instance – were also working in Georgia during this period, reporting on events in the Caucasus, but Jorjadze stands out because she was not a professional: she was a direct participant in the war and, in her capacity as a nurse, documented it from within.

Jorjadze's previously unseen work, which had been safeguarded by her family, was published on the one hundredth anniversary of the outbreak of the First World War. As well as her photography, she also kept a diary of observations and descriptions of the terrible consequences of war, full of reflections on the nature of human beings, personal turmoil and our sense of duty. Along with this journal, Jorjadze's images constitute an extraordinary record of the First World War on the Eastern Front. 'After the Sarikamish battle I was born anew', she wrote in March 1914. 'I saw very cruel sufferings.… People become like gods in the battle, rejecting all that's personal in the name of something supreme. It is the genuine manifestation of the human spirit in all its glory. The mind cannot embrace the full horror of war.'

The first book featuring Nino Jorjadze's war chronicles appeared in 2015, and the Georgian National Gallery in Tbilisi hosted the first ever exhibition of her images that same year. Her work, which has now taken its rightful place in the history of Georgian photography, has found a particular resonance on the country's contemporary photography scene, which today is mostly female. **NN**

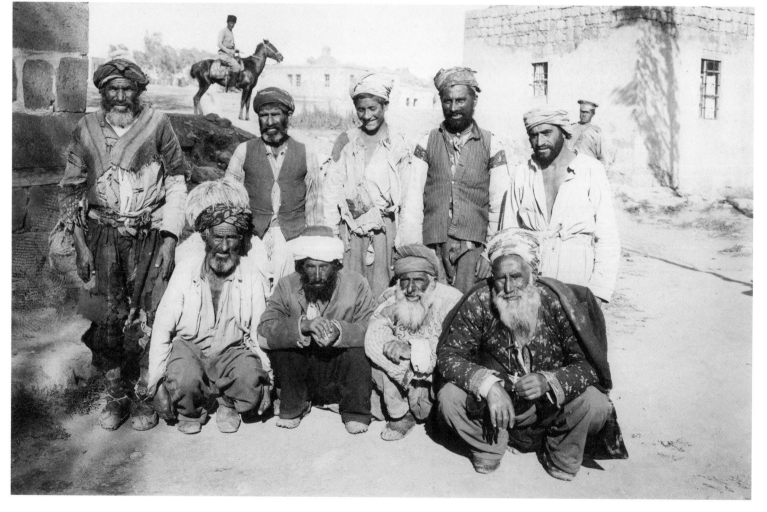

Nino Jorjadze, *Kurds*, 1916

Elsie Knocker and Mairi Chisholm, *Elsie Knocker and Two Belgian Soldiers*, 1917

One of the most striking photographic chronicles of the First World War was made by two British women, Mairi Chisholm and Elsie Knocker (later the Baroness de T'Serclaes), who volunteered as ambulance drivers in Belgium before setting up their own first-aid post in a bombed-out house in Pervyse, West Flanders, just yards from the trenches. Although neither was a trained photographer, push-the-button snapshot cameras were readily available. Manufacturers capitalized on wartime demand, with Kodak even rebranding its Vest Pocket model as 'The Soldier's Camera'. Many women serving or volunteering overseas owned snapshot cameras, eager to record their experiences.

Chisholm and Knocker's photographs testify to the intensity of their daily life under fire, and veer from humorous and domestic to graphic and disturbing. Although the authorship of individual images is not always clear, the ingénue Chisholm seems to have been the most enthusiastic and accomplished image-maker, while the worldly wise Knocker provided a confident and playful subject: she is captured pulling faces, peeking over walls and posing with soldiers on a makeshift seesaw. Free from the restrictions imposed on

British soldiers and press photographers, the women also photographed corpses and casualties of war, images rarely seen in newspapers of the period.

Some photographs were used for promotion and fundraising, featuring in G. E. Mitton's *The Cellar-House of Pervyse: A Tale of Uncommon Things from the Journals and Letters of the Baroness T'Serclaes and Mairi Chisholm* (1916). Albums of press-cuttings kept by Chisholm attest to the international celebrity of the two women, who became known as the 'Madonnas of Pervyse' and received various medals, including that of Chevalier in the Ordre de Léopold.

The two women returned home after being poisoned in a gas attack in 1918. Although neither developed a photographic career, the Imperial War Museum in London acquired copies of their images, and Chisholm compiled a number of photo albums, now kept in the National Library of Scotland. A unique record of the front line at a time when women were largely excluded, the photographs of Chisholm and Knocker offer a valuable supplement to records sanctioned by state and military agencies, and powerfully convey the overlooked participation of women in the First World War. **PO**

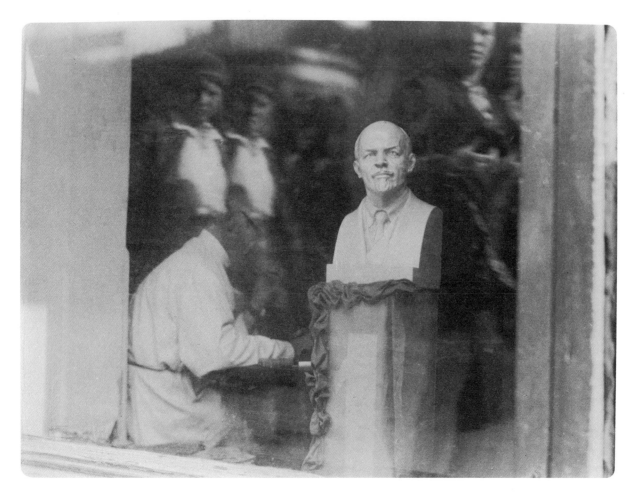

Margaret Watkins, *Shop Windows – Workers' Reflections*, Moscow, 1933

Margaret Watkins is best known for her pioneering advertising photography from the 1920s. If, in the last years of her life, her contribution to the history of photography had been largely forgotten, since her death, and increasing so over the past two decades, her legacy as a Canadian female photographer and a modernist has been reappraised.

Watkins had a relatively privileged childhood among the educated bourgeoisie of Hamilton, Ontario. Her life was shaped by the freedom she enjoyed to develop her interest in art and music, but also by the sudden need to work for a living: during her teens the family finances had declined, obliging her to contribute to the household and, eventually, to become financially independent.

In 1908, aged twenty-four, Watkins left Canada for the north-eastern United States to find employment in the arts. In 1914, she attended the Pictorialist photographer Clarence H. White's summer school in Maine, and it was there that her dedication to photography as a form of creative expression took root. She worked as White's assistant and taught at his schools in Maine, Connecticut and New York. Between 1916 and 1928, Watkins lived in New York, where she became a vital member of the city's photographic and cultural community. In addition to teaching, she worked as an assistant to the photographer Alice Boughton, was an active member of the Pictorial Photographers of America and showed her work in numerous exhibitions in New York, San Francisco, Seattle, Canada and Japan.

It was during this period that Watkins produced some of her most distinctive photographs: quasi-abstract studies of everyday objects known as 'domestic still lifes'. In 1921, *Vanity Fair* magazine published a full-page spread of these images entitled 'Photography Comes into the Kitchen'. Described in the accompanying captions as 'modernist' and 'cubist', the photographs were viewed as radical for their grittily real yet formally stunning portrayals of domesticity. Watkins' brand of modernism was much solicited by advertisers for its capacity to make 'feminine' products – Cutex nail polish, Phenix cheese, Modess sanitary pads – appealing to the modern woman. The publication of Watkins' essay 'Advertising and Photography' in the 1926 edition of *Pictorial Photography in America* reaffirmed the photographer's view that modern commercial imagery could be considered as art.

In 1928, Watkins left New York for a holiday in Europe but never returned. A visit to four ageing aunts (her mother's sisters) in Glasgow dragged on, and she became their primary caregiver, living in the family house until her death in 1969. Watkins still took photographs during the 1930s, in Glasgow and on trips to the Continent and the Soviet Union, but not, it seems, professionally. Her entire photographic output was rediscovered after her death by her friend and neighbour Joseph Mulholland, to whom she had bequeathed it and who remains its principal owner. Watkins' extensive personal archives are now in the collection of the McMaster University Library in Hamilton. **ZT**

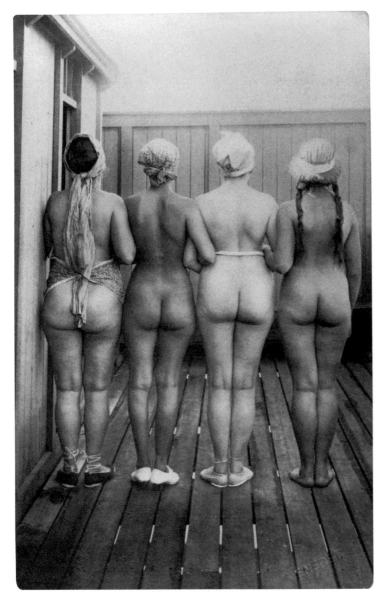

Mary Willumsen, *Untitled [Group of bathers]*, *c.* 1914–21

Mary Willumsen is known for her erotic photographs of women made from 1914 to 1921, which were mass-produced in the form of postcards and sold illegally from newspaper stands. Mary was working as a seamstress when she met and married the photographer Harald Axel Larsen, who taught her to use a camera. Shortly after his death, in 1913, she started producing staged nude portraits in the women's section of the 'Helgoland' outdoor public bath-house just outside Copenhagen.

In the beginning, it was the female clients of the bath-house who asked Mary to photograph them, purchasing the prints for private use, but she soon started looking for models herself, creating her own compositions and producing them as postcards. Her darkroom was installed in the front staircase of her small apartment in central Copenhagen. The photographs were mass-printed by various postcard publishers, and sometimes also sold as illustrations to magazines such as *Vore Damer* (Our ladies). In 1917, she married a second time, to a milkman, Jens Ludvig Georg Willumsen, who assisted her in the darkroom.

Among Danish photographers of the period, Willumsen was the only woman to produce such unconventional scenes. Drawing on both German nudist photographs and French erotic postcards for inspiration, she quickly found her own, more Nordic style, which was notable for its relaxed, sometimes humorous atmosphere in which the model evidently enjoyed posing. Most of the photographs were taken out of doors. The model usually wears underwear, as well as shoes and stockings, but her face is mostly half-hidden by a hat or parasol. Willumsen also stood out from her peers for her carefully balanced compositions. In one photograph of a woman lying on a sunbed, the wooden planks and the shaded wall to the left give a strongly graphic impression and draw attention to the image's vanishing point. In another, the triangular shape of a seated woman is echoed in the form of the bath-house in front of her. In a photograph of four women seen from behind, their natural silhouettes are emphasized, in accordance with the new ideal of the free, athletic body in contact with nature that was circulating in Denmark and across northern Europe at that time.

In 1919, Willumsen was charged with the production and distribution of licentious images, but after a year and a half of investigation, the case was closed. In the police report, she is quoted as saying that she never intended to create photographs of an erotic or obscene nature, and that she had always tried to avoid that type of image. She is thought to have produced some 1,200 provocative postcards per month. Around 1922, she stopped practising photography, and for the rest of her life made a living from selling antiques and working in a nursery. **MS**

Although well known for her portraits of prominent figures of the twentieth century, notably Albert Einstein, W. E. B. Du Bois, Robert Frost, Isamu Noguchi and Eleanor Roosevelt, Clara Sipprell is often overlooked in anthologies of photography. Indeed, rather than establishing a new aesthetic, she never ceased to refine her mastery of the principles of Pictorialism. Her virtuosity, however, derived from this commitment to professional development, making her an important representative of the movement that marked the beginnings of artistic photography.

Encouraged by her father, who employed her as an assistant in his studio in Buffalo from 1902, Sipprell rapidly developed an eye for the softness of the plays of natural light, and she focused on exploring this technique in order better to evoke the essence of the subject photographed. As Buffalo Camera Club admitted only men, she was not able to become a member but participated nevertheless in meetings and exhibitions through the mediation of her brother. After several of her contributions were awarded prizes and noted by her colleagues, she moved in 1915 with a friend, Jessica Beers, to New York, where she set up her own photography business.

Inspired by Clarence H. White, whose courses she attended at the Clarence White School of Photography, and by Gertrude Käsebier, Alice Boughton and Pirie McDonald, Sipprell continued to perfect her artistic approach. With a calculated and disarming simplicity and a skilful romanticism, enriched by years of close observation, her images, intimate and timeless, go beyond appearances to reveal the character of a person or a landscape: 'I'm not after each eyelash, each whisker, each sharply defined line…. I see the whole person. It's not a culmination of the details I'm after but rather an overall, residual effect I want.'

From 1920, she began to travel, alone or with friends, initially in the United States, then in western Europe and the Balkans, going against the conventions of the time. In Yugoslavia, she took photographs which, with their melancholy atmosphere, evoked the culture, history and spirituality of regions on the threshold of great change. Her journey to Canada in 1929, during which she carried out a commission for the Canadian Pacific Railway in the Rockies, was less fruitful. Constrained physically – by the route of the train – as well as artistically – by the demands of the railway company – she produced some images that were magnificent but lacking any soul.

With few exceptions, Sipprell's style remained unaltered, despite the rise of the various artistic movements that punctuated her career, reaching across seven decades, from modernism to humanist photography. Although, initially, she passionately adopted the aesthetic of the moment, her obstinacy testifies to her anti-conformist personality. She did not care about social norms or the demands of the market: 'I'm grateful the good Lord made me a photographer. If he hadn't made me a photographer, I would have been a bad woman.' **LB-R**

Clara Sipprell, *The Painted Desert*, Arizona, 1931

'I have always tried to exploit the photograph.
I use it like colour, or as the poet uses the word.'

HANNAH HÖCH

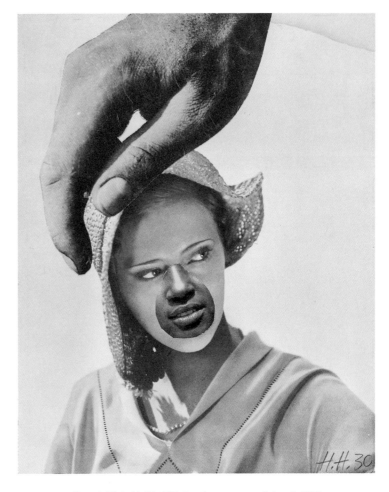

Hannah Höch, *Untitled [Big hand over a woman's head]*, 1930

Photomontage is one of the most significant contributions the Dada movement made to the art of the twentieth century. It became the technique that defined Hannah Höch's artistic production, though she also made paintings, drawings, prints and doll-like sculptures. Her visual constructions and self-portraits expanded the range of subjects readily available to women, rendering them androgynous, playful or cosmopolitan.

After studying graphic design in Berlin, from 1916 to 1926 Höch worked part-time for Ullstein Verlag, the city's most important publisher of newspapers and magazines, designing knitting, crochet and embroidery patterns. It is thus no accident that the mass media became a major theme in her work. In 1917, Höch and her lover, the artist Raoul Hausmann, turned to a new art form. Cutting images and text fragments from newspapers and magazines, they reassembled these elements to create dynamic visual collages.

In 1918, the two artists became central members of the Berlin Dada group, where Höch was the only woman. The first photomontages that she created are visually dense and overtly political, layering text fragments, mechanical motifs, and images of well-known political and cultural figures. The extraordinary *Cut with the Kitchen Knife Dada Through the Last Weimar Beer-Belly Cultural Epoch in Germany* (1919–20) – one of nine works shown at Berlin's First International Dada Fair in 1920, and an image that, on account of its size and complexity, functions as a Dadaist manifesto – remains her best known.

After 1922, Höch's works were simpler, containing fewer elements, though they were no less sophisticated in their critique. Less focused on the political situation in Germany, and inspired by Höch's romantic relationship with Til Brugman, the Dutch writer, they examine gender roles, and in particular the representation of the Weimar Republic's 'new woman', who could vote, work and generally live more freely. Höch nevertheless points up the contrast between representations of women as objects of desire omnipresent in the media and this new independent and androgynous woman who, like her, opposes bourgeois conventions. The precise aim and meaning of her series 'Aus einem ethnographischen Museum' (From an ethnographic museum; 1920–30), which comprises around twenty photomontages combining images of the human form with fragments of sculpture from Africa, Asia and the Pacific Islands, remain enigmatic.

In the late 1930s, the Nazis classified Höch's work as 'degenerate', and she lived out the war in Heiligensee, near Berlin. She continued to make art and achieved renewed recognition in 1976 thanks to retrospectives in Paris, Berlin and Lodz.

In 1959, Höch reflected on her Dada years: 'Most of our male colleagues continued for a long while to look upon us as charming and gifted amateurs, denying us implicitly any real professional status.' History has proven them wrong. **SH[1]**

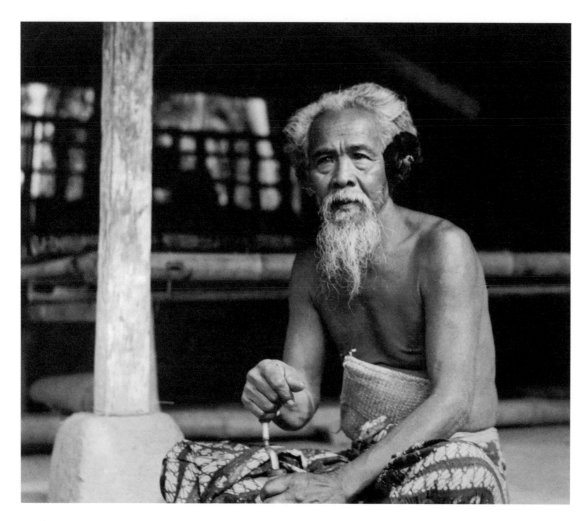

Thilly Weissenborn, *Portrait of a Balinese Man, c.*1920–38

Thilly Weissenborn was the first professional woman photographer of major significance in the Dutch East Indies, present-day Indonesia. For more than twenty years, she ran the Lux studio in Garut, a town in the province of West Java. Despite the success of her business, she is still relatively unknown today.

Born in Kediri, in east Java, in 1889, Margaretha Mathilde, known as 'Thilly', was the youngest in a family of six children. Of German origin but naturalized Dutch citizens, her parents owned a coffee plantation in Kediri, before returning to The Hague in 1892. Her sister Else studied photography in Paris and opened a studio in The Hague in 1903, where it seems that Thilly learnt the rudiments of the profession. In 1913, the young woman returned to Java with her brother Theo and continued her apprenticeship in the celebrated studio of O. Kurkdjian & Co., in Surabaya, under the supervision of George Lewis. Initially responsible for retouching negatives, she acquired a solid technical grounding there. In 1917, she moved to the mountainous region of Garut, where she established her own studio, which she christened 'Lux' in 1920. Located in a favourable geographic location, her studio benefited from the rise in tourism in West Java during the 1920s.

Echoing the romantic taste of colonial painting of the 'Beautiful Indies' (Mooi Indië), her landscapes capture a majestic nature, peaceful and timeless, celebrating its terraced rice paddies, palm trees and volcanoes. The clarity of her compositions, inherited from Kurkdjian, and her feeling for light offered skilful contrasts between the luxuriant vegetation in the foreground and the misty mountains in the background. Her views of Bali, her portraits of dancers and princes, widely reproduced in tourist publications, were instrumental in the spreading of an idyllic image of the island encouraged by the colonial powers. Her treatment of Balinese and Javanese women reveal the careful attention paid to the dignity of the pose. Although the photographer attempted to distance herself from the colonial stereotypes, her photographs would be taken up by the tourist industry, notably to promote an eroticized image of the island of Bali. In artistic terms, Weissenborn blossomed in the genres of portrait and landscape, while also excelling at commercial views of contemporary buildings, in which the modernity of the infrastructure is enhanced by the frontality and severity of the compositions. At the height of her career, she received commissions from government departments, individuals, businesses and publishers.

In 1943, Weissenborn was imprisoned in a Japanese internment camp in Bandung. Most of her studio archives were destroyed in the fire that swept through Garut after the Japanese surrender in 1945. In 1947, the photographer married Nico Wijnmalen, a long-standing friend. Nine years later, the couple moved to Baarn in the Netherlands, where Thilly died at the age of seventy-five.

The Tropenmuseum in Amsterdam conserves more than three hundred and seventy of her photographs, including an album of prints to show to her clients and forty-eight glass negatives. The Musée du Quai Branly – Jacques Chirac owns sixty-one prints, donated in 1950 to the Musée de l'Homme, mainly images of dancers and temples taken in Bali. **AL²**

In 1907, Sigríður Zoëga – the daughter of Geir T. Zoëga, principal of the secondary school in Reykjavík – joined a busy photographic studio in the city, run by the flamboyant Pétur Brynjólfsson. Several women worked there: they mostly undertook tasks such as retouching, the shooting of photographs being reserved for Brynjólfsson or his male assistants.

Despite the fact that Iceland had acquired home rule in 1904, the country remained a Danish colony, and Copenhagen in Denmark continued to be its cultural and institutional capital. Zoëga therefore decided to travel there in search of a more satisfying apprenticeship. In her rich correspondence with family and friends, she describes her desire to stand behind the camera and to perfect her photographic skills, including a wide range of printing techniques. However, she was disappointed with the low-level tasks assigned to her in the studio where she worked and sought a job as an assistant in Germany.

In 1911, she was employed by then little-known German photographer August Sander, who ran a small studio in Cologne-Lindenthal. Sander would travel with his camera through the countryside around his native town of Herdorf, where he took portraits and family photographs. Zoëga, meanwhile, assisted his wife, Anna, in developing and printing his images. Sander, who took photographs of Zoëga on several occasions, gradually entrusted her with her own assignments. Very quickly, she became involved in the social documentary project Sander that had embarked upon after moving to Cologne. In a letter written in 1960, he acknowledged the role she played in this undertaking, noting that 'my work, which you were engaged in too, will comprise more than 100 folders, if I have the energy to complete it'.

Before returning to Iceland in 1914, Zoëga bought all the equipment she needed to set up her own business in Reykjavík. She modelled her studio on Sander's: it comprised a large, fixed camera, a neutral background, no props, and simple furniture. The lighting was kept soft, so as not to cast shadows on the bare white walls. Her unassuming and straightforward style was fully in tune with the taste of her young middle-class clientele, who were looking for portraits that were both casual and modern.

She rapidly became a respected studio photographer, and co-founded the Icelandic Photographers' Society and the Society of the Friends of the Arts. In 1915, she produced more personal images in the Pictorialist style, posing her friends in the romantic Nordic summer light. A single mother, Sigríður Zoëga ran her business with the aid of her friend Steinunn Thorsteinson, a fellow photographer who took charge of the darkroom. **ÆS**

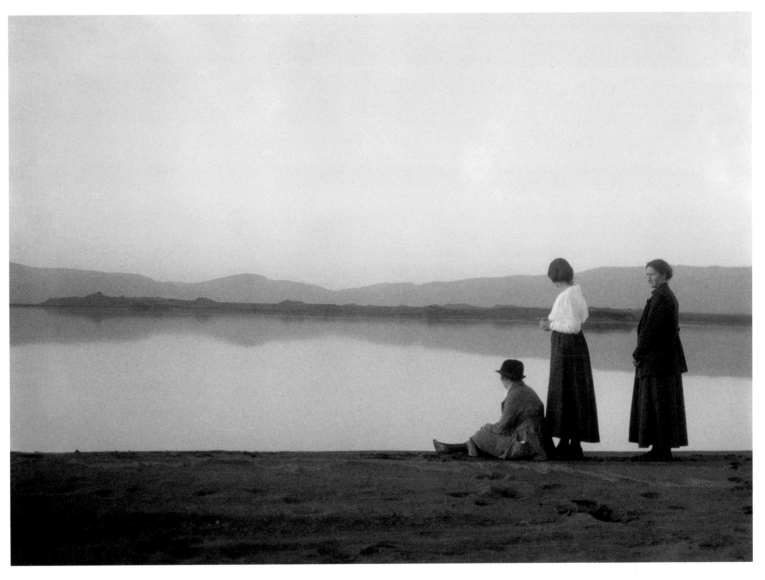

Sigríður Zoëga, *Women on the Banks of the Lake*, 1915

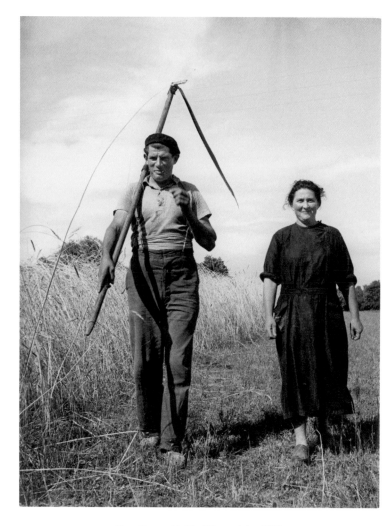

Nora Dumas, *Untitled [Peasants]*, *c*.1935

Originally from Budapest (then in Austria-Hungary), for more than ten years Nora Dumas, née Telkes de Kelenfold, portrayed the French countryside and its inhabitants during the interwar period. This fascination began after the photographer and her husband, the Swiss architect Adrien-Émile Dumas, bought a house in Moisson, in the Yvelines department, in the late 1920s. It was in this small village that Nora produced the majority of her work on peasant life.

Perfectly conscious of avoiding the picturesque and the pessimistic, her images nevertheless reveal the (demographic) ageing of the countryside after the Great War and testify to the industrial development of work on the land. Authenticity was always her aim. With great simplicity, Dumas documented the everyday, moments of work or rest, and celebrated the beauty of the landscape. Her images were often published in prominent magazines, such as *Bifur*, *L'Art vivant* or *Vu*. Exhibiting on many occasions, she never went unnoticed. The publisher Charles Peignot sang the photographer's praises, as did the art critic Jacques Guenne: 'No one has known better than Nora Dumas how to glorify the poetry of the countryside, the goodness of the earth, the ardour of the sun, the dampness of a fog, the freshness of water, the infinity of the sky.' The photographer Remy Duval commented: 'Nora Dumas's style is highly characterized, remaining within quite a severe and narrow range of blacks. It has the measure of everyday gestures. It doesn't skim the surface. It describes the smallest wrinkles on a face furrowed like a mass of ears of corn coming out of a threshing machine. It also likes to amplify, to give a sort of lyrical breath to the humble characters it describes.'

Dumas showed her first images in the exhibition *Das Lichtbild* in Munich in 1930, alongside photographs by Florence Henri, Emmanuel Sougez, Germaine Krull, Ergy Landau, François Kollar and André Kertész. Throughout the 1930s, the public was able to admire her work at the Galerie de la Pléiade, the Gallery-Bookshop de la Plume d'Or, and the Hungarian Cultural Centre in Paris; the Palais des Beaux-Arts in Bruxelles; and the Museum of Modern Art in New York. During this period, she earned a living as assistant to Ergy Landau, a fellow-Hungarian photographer living in Paris in Rue Lauriston (in the 16th arrondissement). In this studio, she perfected her printing techniques and produced many nudes and portraits. She sold these to popular magazines (*Sex Appeal*, *Paris Magazine*, *Pages folles*), as well as to art journals or publications such as *28 études de nus* by Rémy Duval (Arts et métiers graphiques, 1936). After the Second World War, she joined the ranks of the Rapho agency. In 1955, her work was included by Edward Steichen in the iconic travelling exhibition *The Family of Man*. **JJ**

'I use my Rolleiflex as a peasant women would do, which gives my prints their air of sincerity.'

NORA DUMAS

Elsa Garmann Andersen trained as an architect at the prestigious Norwegian Technological University College (NTH) in Trondheim. However, owing to poor health she was never able to practise her profession, and photography became her creative outlet. From the end of the 1920s, she was very active in the amateur camera club in Bergen, her home town, photographing landscapes, portraits, still lifes, urban scenes and local architecture.

Garmann Andersen's photographs of the scenic fjords of Hardanger on the western coast of Norway are exceptional. She was closely attached to this area, where her uncle worked as a doctor in the small village of Lofthus, and where she spent every summer. In her soft-focused photographs, the Norwegian landscape becomes a fertile paradise, with orchards in bloom, grazing lambs, children at play and women at rest. Through her lens, she perceptively registered the minor nuances of this landscape, noting every change in light and atmosphere at close range. But she also climbed mountains to capture its grand vistas. While most of these images are in Pictorialist style, other parts of her production display an evolution towards a more modernist aesthetic, for example in sharply focused studies of coastal landscapes and fragmentary views of rocks, seaweed, boats and foaming waves.

This aesthetic development needs to be viewed in the broader context of the cultural influences that informed Norwegian society at the turn of the twentieth century. In Norway, the development of photography as an amateur art form took place against a backdrop of nation-building and the development of organized tourism. Furthermore, like her compatriot Solveig Lund, Garmann Andersen was working at a time marked not only by the fight for female suffrage, but also by discussions concerning the nature of femininity and, above all, women's place in public life.

Besides practising photography, Garmann Andersen also wrote poetry, and many of her verses reaffirm her feminist engagement. She never married, and was strongly anchored in a progressive entourage of other unmarried women, sisters and close friends. But outside this safe haven, she – like the other women who chose similarly independent lifestyles – experienced the gap between acceptance and rejection, between fulfilling the demands of femininity and being on collision course with accepted norms of womanhood. For these women, the doors had just opened up, but they could very easily close again at any time. **SL²**

'Yes, of course, I will go forward! You say the road is too long and too winding, that it is made only for you men! That women are only obstacles in your way! You think I'm made for clean roads? No! I'm one of those who frequent the dusty paths, and that's where I plan to drag my boots.'

ELSA GARMANN ANDERSEN

Elsa Garmann Andersen, *Wanderer in the Mountains*, c. 1915

Born in Bethlehem, Palestine, the photographer Karimeh Abbud remained unknown for decades following her death in 1940. Her work was not rediscovered until the early twenty-first century. Entranced by the camera that she received as a gift at the age of seventeen, she immediately began photographing family members and her local surroundings. While studying Arabic literature at the American University of Beirut, she travelled to Baalbek and photographed the archaeological site.

Abbud's first professional photographs were of women and children, followed by portraits taken at weddings and other family events, for which she became highly sought after. Her earliest-known signed photograph, a view of her home city, dates to October 1919. Around this time, she took numerous photographs of public spaces in Bethlehem, Haifa, Nazareth, and Tiberias, many of which were published as postcards. The one depicting Mary's Well, also known as the 'Fountain of the Virgin', is a valuable historical record of this sacred Catholic site and shows it being used by Palestinian villagers in 1925.

By the 1930s, Abbud had set up her own studio and was calling herself 'Karimeh Abbud – Lady Photographer', as seen in the stamps in two languages that appear on the back of her photographs. She hand-coloured some of her prints, and sometimes drew on her negatives, adding elements such as trees, for example. Abbud's portrait style differed from that of her contemporaries in the region, who used European backdrops and liked to give their sitters a stately appearance. Abbud, on the other hand, preferred to use a variety of backgrounds, not only in her studio but also in her clients' homes. Her willingness to work in different contexts and the connection she, as a woman, formed with her subjects put her sitters at ease, enabling her to capture their humanity with a spontaneity seldom seen in other photographs of the time.

Abbud was the one of the first female Arab photographers to work independently and to run her own studio. A Palestinian directory of the period lists only Jewish men who were working as photographers; women were excluded, as were Armenians and Arabs. Research undertaken by Issam Nassar, a historian of Palestinian photography, has revealed two other Palestinian women who worked in the field alongside family members: Najla Raad, who hand-coloured photographs taken by her husband, Johannes Krikorian; and Margo Abdou, who ran her brother David's studio when he was away. The portraits and landscapes that Abbud left us, showing life in Palestine before 1948, constitute an enduring testament to a bygone era. The rediscovery of these female pioneers of photography invites us to re-examine preconceived ideas about the lives of women in the region, and Abbud's career confirms the contribution that women made to photography in the Middle East from its very beginnings. **KG²**

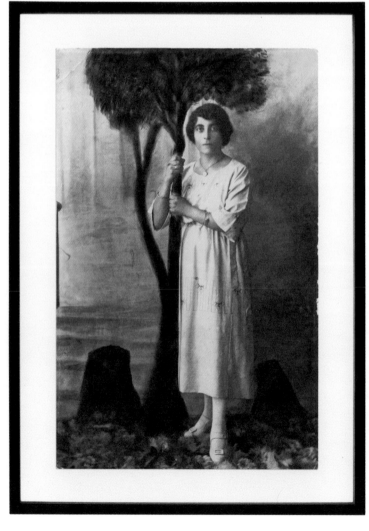

Karimeh Abbud, *Portrait of a Woman*, undated

Florence Henri, *Composition (Woman on the Beach)*, c.1930–5

'What I want above all in photography is to compose the image as I do with paintings. It is necessary that the volumes, lines, the shadows and light obey my will and say what I want them to say.'

FLORENCE HENRI

Florence Henri is one of the major representatives of the New Vision movement, elevating its visual repertoire to an exceptional level of sophistication. She appropriated its vocabulary (close-up shots, unusual and fragmentary viewpoints, high/low angles, use of mirrors) to invent a new form of space. Her work initiated a process of spatial exploration, despite photography's two-dimensionality, by means of a Cubist rupturing of perspective, a tendency towards Constructivist geometrization and the device of a frame within a frame. A desire for formalist perfection emerges from her photographs, inherent in the power of her gaze.

She submitted her subjects – faces, still life, nudes or advertised products – to the rigour of her vision. The nature of what she captured was of little importance: the aim was always to discover the structure. In this, her photography was also a mental process that 'reflected', like Jean Cocteau's mirrors. Her images turn in on themselves, questioning the mechanisms of perception. Her training as a painter under Fernand Léger in the 1920s, followed by her apprenticeship at the Bauhaus in 1927, probably account for this formal turmoil and the optical complexity it engendered.

For Henri, the art of composing an image was primal. Exemplary in this regard is the way in which, while shooting a photoessay in Brittany in 1937, she captured a seascape marked by contradictory trajectories. The figure of a young girl poses almost stubbornly, the verticality of her body contrasting with

the flatness of the sky, the rocks and the waves. There is obstinacy in her pose, while the straight line of her braided hair, echoed by a lighthouse looming in the distance, resists the dominant horizontality. A monolith as solid as the rock on which she is leaning, the girl anchors her calm internal withdrawal within the landscape, indifferent to its infinite expanse. It is as though Henri wished to bestow maximum clarity on her presence to emphasize its gravity, against the cloudiness of the foam and the clouds. The photographer's control over the image is complete – she leaves nothing to chance, demonstrating an assurance and determination typical of modern women in the interwar period. Even the accidental requires composition.

In a similar way, Henri mastered the capricious nature of focus and turned it into an integral part of her structuring of the subject, whatever its nature – landscape or figure. One of her photographs features the blurred dynamism of a female nude in motion on the beach. This emerging figure cuts through the rigidity of the composition and obstructs the view beyond. The indistinct contours of the androgynous silhouette contrast with the clarity of the sea. The only clue: the sensuality of the light which, hitting the shoulders, makes the skin gleam. The bather, a traditional motif in painting, here becomes an abstract curve that tests the eye and questions its ability to recompose reality. From a banal gesture – the ruffling of the hair – Henri creates an architecture, a sculptural momentum, a way for her to experience the space *via* her camera. **AA**[1]

'The housewife, whose life, work and unlimited devotion at times appear heroic, lies at the heart of this work, which reflects the environment and conditions in which Portuguese women live.'

MARIA LAMAS

Maria Lamas, *Women between Salreu and Canelas, Selling Fish*, Portugal, c. 1947

Maria Lamas was born in Torres Novas, a town situated about sixty miles from Lisbon. Daughter of a soldier, she married very young and travelled with her husband, also a soldier, in the south of Angola, then a Portuguese colony. She gave birth to her first child, a girl, in Luanda, where she had arrived from the interior five days before going into labour. She divorced shortly afterwards, in 1920.

Very early on, Lamas became interested in writing – as her novels and journalism illustrate – and worked for an American press agency, before successfully directing the supplement *Modas e Bordados* of the newspaper *O Século*, among other collaborations.

Even before becoming a critic of Salazar, the head of the Portuguese government since 1932, Lamas was a campaigner for women's rights, taking great interest in the work of those she considered unjustly destined to remain unseen. But it was particularly after the Second World War that she became aware of the need to oppose the Salazar regime and, in 1945, was a signatory to the petition for the founding of MUD (Movimento de Unidade Democrática, 'Democratic Union Movement') led by young people against the dictatorship. Eager to enforce the place of women in society, she devoted herself increasingly to defending their living conditions and, from 1945, presided over the National Committee of Portuguese Women, as well as many peace organizations. She became a prominent feminist, moved closer to the Communist Party, banned until 1974, and was involved in various international peace movements. She was imprisoned three times and on several occasions forced into exile.

Lamas' relationship with photography is explicitly expressed in her work *As mulheres do meu país* [The women of my country], published in 1948, which is a landmark in Portuguese ethnography. Convinced of the need to study the life of Portuguese women in different contexts throughout the country, the author set out to create 'nothing more than a lively and sincere documentary'. Armed with a Kodak, she travelled across the country, mainly in its interior, to interview women, to observe and photograph them, and to offer an overview of their lives that was critical and not idealized. The work initially appeared in the form of instalments, published bi-monthly, of her travels across the country, between 1947 and 1948.

If Lamas is considered of vital importance in the history of Portuguese photography, it is because her book was one of the first publications to be abundantly illustrated by photographs; her use of the term 'documentary' testifies to her awareness of the role of image combined with text. Among the thousands of images that illustrate the work, two hundred were by Lamas, while the others came from photographer friends or newspaper archives. Her images are not the best – some are even slightly out of focus – but the prominence that she gave to photographic illustration made this book a benchmark for the medium as well as a sociological document. **MM**

Madame Yevonde, *Mrs Michael Balcon as Minerva*, 1935

'Be original – or die!'

MADAME YEVONDE

Looking for a vocation that would suit her artistic temperament, the young Yevonde Philone Middleton (née Cumbers) first joined the Suffragette movement in 1910 and then, the following year, paid thirty guineas (£33) for three years' apprenticeship with Lallie Charles, the foremost female portrait photographer of the Edwardian era. In 1914, aged twenty-one, Yevonde established her own portrait studio, funded by her father, and for sixty years enjoyed a successful photographic career. Initially, her portraits of the British elite, and also actresses, singers and dancers, appeared in society magazines such as *Tatler*, *Sketch* and *Bystander*, and then in the American imports *Vogue* and *Harper's Bazaar*.

Yevonde married the playwright and journalist Edgar C. W. Middleton in 1920. She moved to a larger studio, where she began to do lucrative advertising work, joined both the Professional Photographers' Association and the Royal Photographic Society, and began to show her portraits in the latter's exhibitions. In the early 1930s, she embraced the new Vivex colour process, invented by the chemist Douglas Arthur Spencer, and manufactured and processed in London. In the spring of 1932, she displayed her colour prints in a well-received exhibition of portraits and 'still-life phantasies' at the Albany Gallery in Mayfair.

Vivex was a subtractive process that used three quarter-plate negatives, each one marked for red, blue or yellow separation after exposure. They were processed separately and then superimposed to produce a full-colour print. This complex process allowed for the possibility of retouching to remove blemishes and correct registration errors. Yevonde relished the opportunities that it afforded for manipulation, fantasy and exaggeration, and vaunted her expertise in handling colours in lectures and in her autobiography, published in 1940.

Yevonde's Vivex work appealed to the London elite, including royalty, who wanted something a little different. It led to the creation of her best-known work, *Goddesses and Others*, for which she reimagined in her studio the costumes from classical mythology – Medusa, Venus, Ceres, Persephone, Minerva etc. – that society beauties had worn at a recent charity ball, the Olympian Party, held at Claridge's, London, in March 1935.

In 1936, the American magazine *Fortune* commissioned her to photograph the interior of the Cunard liner *Queen Mary*, then being fitted out at the Glasgow shipyards of John Brown & Co. The project's success allowed Yevonde to develop her advertising work for luxury goods, an area in which she gave free rein to her lively Surrealist imagination.

The Vivex factory closed at the outbreak of the Second World War, but Yevonde continued to experiment with monochrome printing and solarization while also adopting a more relaxed form of portraiture, carried out in clients' homes. Madame Yevonde bequeathed a large collection of her work to the National Portrait Gallery in London. **PGR**

Thérèse Bonney, *The Vaihingen Concentration Camp*, Germany, 1945

Thérèse Bonney is known for her images of modern life in Paris in the period between the two wars (architecture, fashion and decorative arts), but also for her war reporting: in Finland in the spring of 1939, and then throughout Europe as she travelled across it during the Second World War, focusing on the fate of children. Her book *Europe's Children* appeared in 1943. After the war, Bonney abandoned her photographic activity: as she explained in 1973 in an interview with the journalist Mary Blume, photographing a face no longer made any sense.

Born in America, the ambitious Bonney studied at the University of California, then at Harvard and at Columbia, defended a thesis on the theatre of Alexandre Dumas at the Sorbonne in Paris, worked for the Red Cross in Europe, was close to feminist circles, and became an important cultural link between France and the United States. Between 1934 and 1936, she organized three exhibitions in the French gallery at the Rockefeller Center in New York, arranging the loan of important works. Before this, from 1923 to 1924, Bonney, an able businesswoman, came up with the idea of setting up a photo agency in Paris to serve the American press. It was at this point that she began her collection of historic photographs, as recounted in an article that appeared in the *Brooklyn Daily Eagle* on 15 November 1932: 'She scouted about through basements and attics, in small towns and villages, and wherever it seemed unlikely that there would be any photographs. She looked not for prints but for negatives. Today, after eight years of work, her collection numbers 20,000

pictures, 80 percent of which she has in the original negatives.' According to the *Harford Courant* on 26 November 1933, one of the cornerstones of this collection was given to her by the French photographer Charles Chusseau-Flavien, who was dying and offered her between six and eight thousand negatives, which she bought and sorted through.

Interested in plans for a photography museum, Bonney was able to exhibit her collection to the public at two exhibitions. The first, *L'Époque 1900*, was held in Paris at the Galerie Georges Petit, in June 1932. A huge success with the public, the exhibition, which then travelled to the United States and Canada under the title *Gay Nineties*, aimed to show the last decade of the nineteenth century in a humorous and curious light: 'Sovereigns, high society, stars of the theatre, common people, family or picturesque scenes pass before our eyes as though on a screen', noted the daily newspaper *Excelsior* on 4 June 1932. The second exhibition took place in October 1933, the centenary of the death of Nicéphore Niépce: Bonney showed 151 daguerreotypes from her collection at the Galerie Pierre Colle, and then on the other side of the Atlantic, at the Knoedler Galleries in New York and the Smithsonian Institution in Washington.

During the lifetime of its founder, the Thérèse Bonney collection witnessed much upheaval, and its history during the second half of the twentieth century remains to be studied in detail. In any event, it reveals the fascinating profile of a female collector, curator of exhibitions and books, passionate about the history of photography and images. **EC**

Claude Cahun – née Lucy Schwob – was one of the most radical and inventive artists of the early twentieth century. Her work is unparalleled for its investigations of gender, identity and autobiography in photographs, writing and photomontage. Particularly notable are the portraits that Cahun staged and in which she appeared, many created in collaboration with her partner, Marcel Moore, née Suzanne Malherbe. Here, she adopted many guises: aviator, doll, bodybuilder, dandy and others. In these works, gender is mutable, appearance is a mirror, and androgyny is a constant – all of which serve to challenge fixed gender roles and a stable notion of the self.

Cahun and Moore met at school in Nantes in 1909. They eventually became lovers and artistic collaborators. Cahun's first self-portraits date from about 1913 and are already marked by her theatricality and direct gaze. Living in Paris from 1918 to 1937, the couple became part of the circle of artists and writers attracted by Surrealism. They designed costumes for the theatre, created illustrations and collages, and acted and wrote. In 1925, Cahun published a column in the *Mercure de France* newspaper called 'Héroïnes', comprising short stories on women from the Bible, myth and literature. She also created photographs for *Le Coeur de Pic* (1937), a collection of poems by the Surrealist muse Lise Deharme.

In 1930, Cahun and Moore published *Aveux non avenus* (Unavowed confessions), a series of 'essay poems', and collaborated on ten photomontages to illustrate Cahun's autobiographical/fictional text. These images stand out for their psycho-sexual and Surrealist elements, and for their unprecedented use of a single figure, Cahun, whose identity is made and remade over and over again photographic and drawn fragments. The last photomontage includes the declaration 'Under this mask, another mask; I will never finish removing all these faces', which reads like an artist's manifesto. The images were exhibited at the Librairie José Corti in Paris for the book's launch.

In 1938, Cahun and Moore moved to La Rocquaise, a farm they bought on Jersey, where they continued to work. During the Second World War, Cahun and Moore were active on behalf of the French Resistance during the German occupation, writing and distributing antiwar leaflets intended for the Wehrmacht. Both were arrested in the summer of 1944 and sentenced to death. After their release in May 1945, they found La Rocquaise pillaged and much of their work destroyed.

In the mid-1980s, Cahun's work found new interest and audiences, including the 1992 publication of a biography by François Leperlier. Since then, her collaborations with Moore have been both published and exhibited widely. More importantly, Cahun has become a key touchstone for many feminist and gay artists and those whose work deals with appearance and identity, such as Cindy Sherman and ORLAN. **SH**[1]

'Neuter is the only gender that always suits me.'

CLAUDE CAHUN

Claude Cahun, *The Father*, 1932

By the last years of the nineteenth century, Kolkata – then the capital of British India – was an important commercial and cultural hub, home to a growing number of interactions that, thanks in part to a newly emerged class of white-collar workers and professionals, reached beyond family boundaries. Photography would soon play a role in this new scenario. For the first few decades that followed the arrival of commercial photography in Kolkata in the 1840s, the clients who were interested in the new medium were primarily European; it was not until 1880 that Indians started patronizing photographic studios. Initially, it was men who were photographed: it was more difficult for women to visit studios since a number of upper-class Hindu and Muslim women practised purdah (that is to say, they wore the veil or mostly stayed secluded at home). There are accounts of anxious women and fidgety children spending several stressful hours in studios, posing endlessly for the correct 'shot'.

In the first decades of the twentieth century, keen to offer women a more reassuring environment, photographers began to open *zenana* studios: premises (or parts of existing studios) that were reserved for women. Though most were still run and operated by men, a few enterprising businesses did have women photographers. Thus, by the time Annapurna Dutta set up her business, she found an existing clientele: home and outdoor photography had become increasingly popular with women who wanted not only to break out of their seclusion, but also to showcase their homes and interiors.

Dutta became a leading professional photographer during the 1930s and 1940s. Married at age twelve to Upendranath Dutta, a lawyer, she studied photography and painting in Kolkata, taking up photography as a profession when she was twenty-five years old. She did not have a studio as such, preferring to visit her clients at home, but she developed and printed the photographs herself. Dutta's commissions came mainly from households where male photographers were not allowed; she therefore specialized in portraits of elite Muslim women as well as some Hindu women from families that observed purdah. Among her clients were female relations of the politician Hasan Suhrawardy, the poet Jasimuddin and the singer Abbas Uddin. Dutta's photographic career was at least as successful as that of her husband, and the income it provided enabled her to support herself and her five children. **MK²**

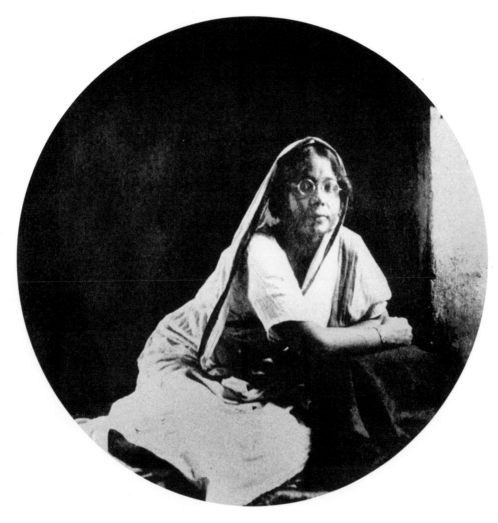

Annapurna Dutta, *Self-portrait*, undated

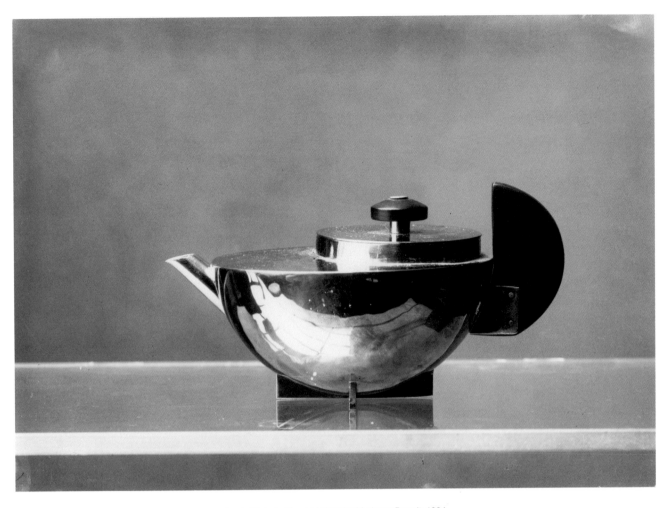

Lucia Moholy, *Teapot MT 49 by Marianne Brandt*, 1924

'The Bauhaus and its supporters unanimously expressed their support for photography, hailing it as a valuable part of the new education.'

LUCIA MOHOLY

Lucia Moholy's photographs of buildings and objects continue to mark our visual memory of the Bauhaus. For a long time, many of her images, designed for reproduction and displaying the same genius for precision and objectivity as their functionalist subjects, have been elevated to the status of works of art. In addition, Moholy also shot numerous portraits of friends and fellow travellers at the Bauhaus, photographs that also belong within the broader spectrum of the New Vision. During her exile in London, she earned a reputation as a skilful portraitist. In these images, too, the lasting appeal lies in the tension between the formal distancing and her own proximity to the sitters.

Most of Moholy's professional life, however, was taken up by her publications – for the most part little known – as author, editor, teacher, correspondent, researcher and critic. From 1930, she devoted herself to the history of photography and, in 1939, after emigrating to Britain, published a large print run of *A Hundred Years of Photography*. Moreover, she soon grasped the role that microfilm could play in science and education: in 1946, in the wake of the

founding of UNESCO, she was put in charge of setting up cultural-history archives based on microfilms. Her clear-sightedness on this topic, which emerges in her theoretical writings, makes her a pioneer of digitalization.

In 1959, Moholy settled in Switzerland; in the 1960s and 1970s, as a witness to the era, she focused with relevance and critical thinking on the 'documentary absurdities' that affected the ever-increasing number of publications on the Bauhaus. In her book *Moholy-Nagy, Marginal Notes* (1972), she describes as resembling a 'symbiotic alliance of two diverging temperaments' her relationship with László Moholy-Nagy, whom Walter Gropius had called to the Bauhaus in Weimar in 1923 and who, as his wife, she had followed. Without vanity, she recalls the role – never previously acknowledged – that she played in their shared photographic work, as well as the Bauhaus publications of which she soon became the editor, being the only person with proven editorial experience. She also describes her role as Bauhaus photographer and how she turned professional in order to document the buildings and the work of the studios, these photographs being key to the public image of the school, which was constantly under attack.

As far as her own rights as an artist were concerned, and the use of her negatives, which Gropius was not return to her until 1957, she had to battle for many years in order to earn anything from them. It was only in her final years that she saw the glimmer of the recognition that would be granted to her after her death. Lucia Moholy's photographic and written oeuvre is now conserved in the Bauhaus-Archiv, in Berlin. **SH²**

Carmel Snow, Diana Vreeland, Louise Dahl-Wolfe: from the mid-1930s to the end of the 1950s, this trio of women made their mark on the magazine *Harper's Bazaar*, together with its artistic director Alexey Brodovitch. As editor-in-chief, fashion editor and photographer, respectively, they fiercely promoted their modern vision of fashion and women. They contributed to the rise of American prêt-à-porter, advocating a young and dynamic style embodied by the designer Claire McCardell, considered the pioneer of sportswear. Under contract to *Harper's Bazaar* from 1936 to 1958, Dahl-Wolfe shot eighty-six covers, as well as six hundred photographs in colour, and many more in black and white.

Born to Norwegian parents, Louise Dahl-Wolfe studied painting and colour theory at the San Francisco Art Institute, then interior design, design and architecture in New York. Very soon, she turned to photography. Following a trip in the Tunisian desert in 1928, she created a modernist style, in which composition, balance and light were the dominant features. She was naturally drawn to colour, and in 1937 began using Kodachrome, the first amateur colour film launched two years earlier. While black and white dominated the pages of magazines, offset printing brought the benefit of greater flexibility, allowing for more faithful reproduction of colours. The costs nevertheless remained high and only fashion magazines like *Vogue* or *Harper's Bazaar* were able to afford these new experiments.

A perfectionist, always in search of the perfect balance of tones, Dahl-Wolfe was particularly demanding as far as the printing of her images was concerned, correcting the proofs herself. With skill and subtlety, she opened the way to a form of exploration that was both aesthetic and geographical. Fashion shoots in far-off and sunny lands were launched around the same time thanks to the birth of international tourism. The less-sensitive colour film suited the strong light of the countries of the southern hemisphere and the Californian desert. For *Harper's Bazaar*, the photographer travelled in North Africa and Latin America, and visited Hawaii in 1939, Cuba in 1941, Peru in 1942, Brazil in 1946 and Guatemala in 1952. Whatever the country, she rejected any traces of exotic cliché.

Following the departure of Carmel Snow and Alexey Brodovitch, Louise Dahl-Wolfe also left *Harper's Bazaar*. Her rigorous and boldly coloured images influenced a generation of photographers, particularly Richard Avedon, who succeeded her at the magazine, declaring: 'She was the bar we all measured ourselves against.' **SL**[1]

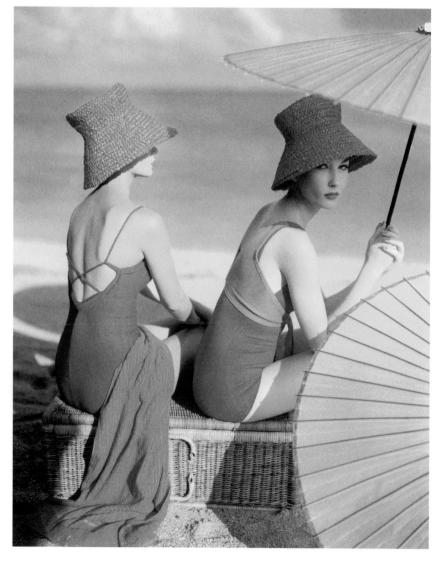

Louise Dahl-Wolfe, *Models at a Beach*, 1959

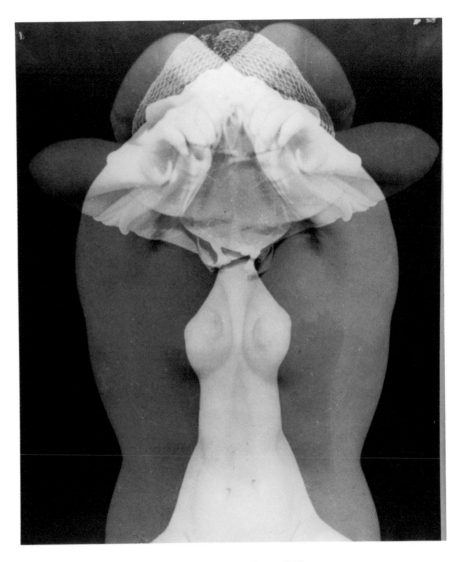

Gertrude Fehr, *Nude-Flower*, 1936

Gertrude Fehr provides an interesting and unusual example of the career of a professional woman photographer in the twentieth century. After an apprenticeship in the studio of Eduard Wasow in Munich, she opened her own studio in the same city in 1922. In addition to portraits, she produced industrial reports and received many commissions from theatres, advertising agencies and publishing houses, employing as many as six people.

In 1933, the rise of Nazism forced her to leave Germany with her future husband, the painter Jules Fehr. The couple settled in Paris and in 1934 opened the Publiphot school, which Gertrude directed. The teaching prepared students for the commercial applications of photography: Publiphot was a pioneer in this field. In addition, its numbers comprised a majority of women. Gertrude Fehr was close to the circles of New Photography. She experimented with various techniques – solarization, photograms, photomontage – which she applied to her nudes, portraits and still lifes. She trained alongside great names such as Laure Albin Guillot, Florence Henri and Man Ray.

Despite the quality of their teaching and the growing number of students – some were awarded prizes in international competitions – Gertrude and Jules Fehr were once again forced to go into exile, this time to Switzerland. In March 1940, they successfully opened a new establishment in Lausanne. In 1945, it moved to Vevey, and was integrated, not without difficulty, into the École des Arts et Métiers (now the CEPV); Gertrude Fehr can thus be considered as the founder of the Vevey School of Photography. In its early years, the Fehrs faced criticism from the Swiss Union of Photographers, who were concerned about the appearance of 'a multitude of photographers who, certainly, will saturate the market'. The school grew nevertheless, the number of courses on offer expanded – colour photography was taught from the 1950s – and its fame spread beyond Switzerland's borders. Until 1960, Gertrude Fehr was in charge of the courses on portraiture, fashion, advertising and reportage. Monique Jacot, Luc Chessex, Jeanloup Sieff, Yvan Dalain and Francis Reusser were among the many students who had trained under her guidance. Throughout her career, Fehr regularly collaborated with art and illustrated magazines, and periodicals specialized in photography. Her output reflects the diversity of her experimentation: it also reflects the development of the photographic medium from the 1930s to the 1980s.

After her retirement from teaching, Fehr remained very active, particularly in the field of artistic portraiture. She worked hard to promote and support the work of women photographers. Several solo exhibitions were devoted to her work in her lifetime and following her death in 1996. She bequeathed the contents of her studio to the Fotostiftung in Winterthur and the Musée de l'Élysée in Lausanne. **CM**

Dorothea Lange dedicated her life to creating a 'record of human experience': 'its look, its texture, its feel, its difficulty, its glories; not to show how great we are, but to show what it's like'. Over the course of her career, she photographed everyday life with purpose and care. Often picturing her subjects – migrants, workers, families – deep in thought or contemplation, she conveyed the immanence of their inner lives, tracing the marks of history in the individuals' stories.

Born in Hoboken, New Jersey, Lange contracted polio at the age of seven. As she later recalled, 'I was physically disabled, and no one who hasn't lived the life of a semi-cripple knows how much that means…. [It] formed me, guided me, instructed me, helped me, and humiliated me.' She was twelve when her parents separated and she began attending school in New York City. Lange decided, with fierce conviction, to become a photographer and, after apprenticing in New York, set off to travel the world. An encounter with a pickpocket in San Francisco forced her to cut short her travels, so Lange embarked on a career as a portrait photographer, going on to open a successful studio in the Bay Area.

At the onset of the Great Depression, Lange began to document the human impact of widespread unemployment on the streets of San Francisco. Her sensitive and humanizing portraits were admired by Paul Taylor, an agricultural economist (and, later, Lange's second husband and collaborator), when he encountered them in the studio of film-maker and critic Willard Van Dyke. By 1935, she was working with Taylor for the California State Emergency Relief Administration, a federal agency responsible for distributing funds to victims of the Depression. The two produced a series of reports pairing Taylor's social analysis with Lange's photographs, accompanied by handwritten quotes taken from interviews with the farmers and migrant workers they encountered.

Lange's photographs for government agencies taken between 1935 and 1939 helped attract attention to the environmental and economic crisis wrought by the Great Depression and the Dust Bowl drought in the American Midwest, and to advocate for social and political reform. Her incisive vision but also her careful listening – she conversed with her subjects, recording them, taking notes, establishing a relationship of trust with them – resulted in affective and intimate images.

Lange was prolific. She amassed an archive of thousands of negatives covering diverse subjects: her family; the shipyards and streets of California during the Second World War; portraits of Japanese Americans interned following Pearl Harbor; and Lange's personal political concerns, ranging from the criminal justice system to the California water crisis. More than anything, she strove to live a visual life and to convey something of that experience to us. **REB**

'I am trying here to say something about the despised, the defeated, the alienated. About death and disaster. About the wounded, the crippled, the helpless, the rootless, the dislocated. About duress and trouble. About finality. About the last ditch.'

DOROTHEA LANGE

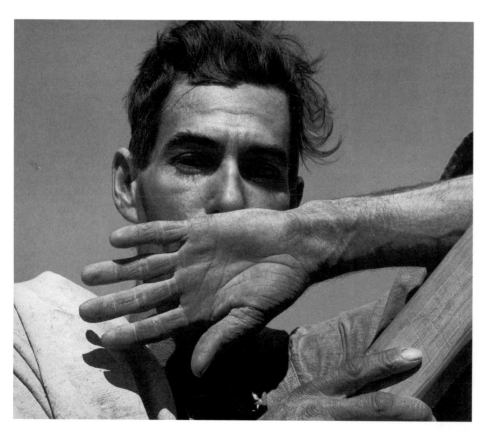

Dorothea Lange, *Migratory Cotton Picker*, Eloy, Arizona, 1940

'That's how I photographed, with a beating heart.'

TRUDE FLEISCHMANN

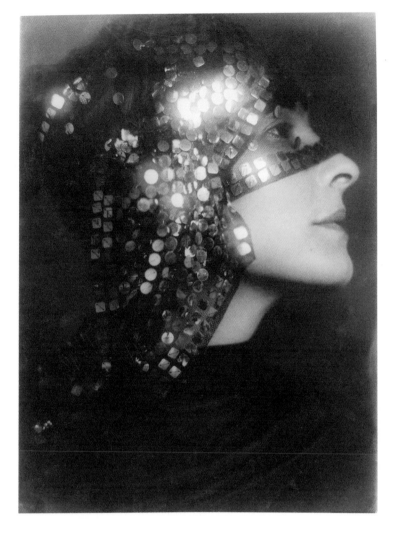

Trude Fleischmann, *Sybille Binder, Actress*, undated

Born into an affluent Jewish family in Vienna, from 1913 Trude Fleischmann attended the city's Institute of Applied Graphic Arts. Founded in 1887 by the Austro-Hungarian monarchy, this teaching establishment did not admit women until 1908. During the same period as Fleischmann, other notable Austrian women photographers of the time studying there were Edith Barakovich, Steffi Brandl, Pepa Feldscharek, Edith Glogau, Dora Horowitz, Hella Katz and Grete Kolliner, with whom she remained in contact. The influence of Rudolf Koppitz, then an assistant at the Institute, was to be decisive on a formal level in the style of Fleischmann's portraits – a moderated modernity, with a predominance of close-ups and an eye for detail. Fleischmann then worked in the studio of Dora Kallmus (Madame d'Ora) and carried out her professional traineeship with Hermann Schiebert, as an assistant and retoucher.

In 1920, she opened her own studio in the centre of Vienna. Among the young photographers who would later train there were Bill Brandt, Marion Post Wolcott and Marion's sister, Helen Post, with whom Trude probably had a romantic relationship. Fleischmann transformed her studio into a meeting place for many famous figures from the worlds of art, literature and theatre. She shot nude photographs of the dancer Claire Bauroff, which shocked contemporaries with their realist handling.

From the late 1920s, Fleischmann participated in several exhibitions in Vienna: *Akt und Porträt in der Photographie* (1929), a Viennese version of the *Film und Foto* exhibition in Stuttgart (1930); the first Secession exhibition to present works only by women photographers (1931); and *Photo und Reklame* with the graphic designer Robert Haas (1931). Fleischmann then broadened her repertoire of subjects. She published images of travels and landscapes, explained by the increasingly conservative political climate in Austria, appealing to the trend for 'patriotic landscape photography' (*Heimatfotografie*). In parallel, she shot reportages for the politically independent newspaper *Der Sonntag*.

After the annexation of Austria by Hitler in 1938, her studio closed. Fleischmann reached the United States, acquiring American citizenship in 1942. Despite strong competition from other exiles, she succeeded again in establishing herself as a portrait photographer of prominent figures, including Eleanor Roosevelt, Albert Einstein and Arturo Toscanini, whom she had photographed for the first time at the Salzburg Festival and who had provided her with numerous contacts.

In 1940, with Frank Elmer (Franz Epstein), whom she knew from Vienna, Fleischmann opened a fashion and portrait studio in Manhattan. From the following year, her images appeared in *Vogue* and *Glamour* magazines. In 1969, a farewell exhibition was held at the Austrian Cultural Institute in New York. At the age of seventy-five, Fleischmann closed her studio and went to live in Switzerland. **MF**

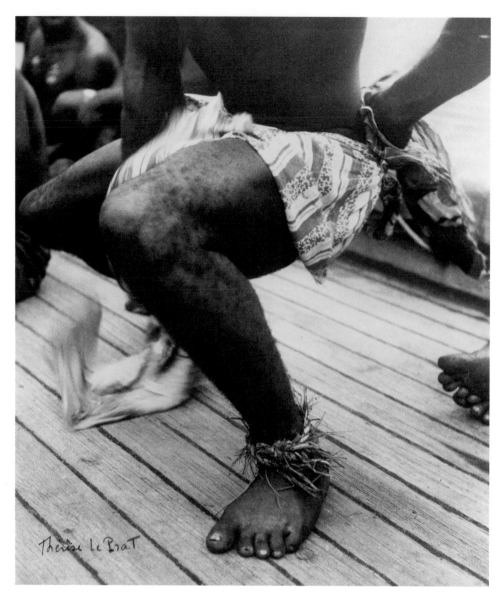

Thérèse Le Prat, *Kanak, Fragment, Shark Dance*, August–September 1937

Passionate about music, Thérèse Cahen studied violin, for which she showed great talent. She married the publisher Guillaume Le Prat, became a photographer and, between 1931 and 1938, worked for the Compagnie des Messageries Maritimes in Asia, Africa and Oceania. She also shot photoessays in Algeria, Martinique, Guadeloupe, Tahiti, the New Hebrides, Indochina, Cochin China, India, Réunion and Madagascar, where she photographed landscapes, genre scenes and portraits outdoors. In 1940, her works were exhibited at the Salon de la France Outre-Mer, at the Grand Palais, under the title 'Tropiques tristes'. During the war, persecuted as a Jew, she fled to Lyon. In November 1944, divorced from her first husband, she married Philippe Stern, future director of the Musée Guimet and father of the photographer Dominique Darbois.

Keen to limit her movements, Thérèse Le Prat gave up her commissioned work and turned to specializing in portraits, initially of children and then of the artistic, literary and scientific intelligentsia: Georges Braque, Paul Claudel, Foujita, Alberto Giacometti, Arthur Honneger, François Mauriac, Henri de Montherlant, Jean Renoir, Jules Supervielle. From 1947, she concentrated on portraits of actors in the studio wearing the costume and make-up of their character. Almost 250 plays from the classical, modern and contemporary repertoire were documented in this way. Her publications *Visages d'acteurs* (1950)

and *Autres visages d'acteurs* (1952) featured Arletty in *A Streetcar Named Desire*, Jean-Paul Belmondo in *Oscar*, Alain Cuny in *Tête d'or*, Maria Casarès in *Six Characters in Search of an Author*, Gérard Philipe in *Le Cid*, but also theatre directors such as Louis Jouvet and Jean Vilar, the Renaud-Barrault company, the Peking Opera, and the Sacha Pitoëff company. Her images appeared in magazines devoted to the theatre, such as *L'Avant-Scène* and *Théâtre de France*.

Inspired by the art and crafts of Africa and the Far East, and by Japanese theatre, she published *Masques et destin* (1955) and *Le Masque et l'Humain* (1959). For three years, to accentuate the facial expressions and concentrate on their rendition, she embarked on a close collaboration with the mime-artist Wolfram Mehring and the make-up artist Grillon. In 1964, she published *Un seul visage en ses métamorphoses* (A single face and its metamorphoses), a collection of forty-two photographs of the same face subject to the transformations of a make-up artist. Her large-format publications, printed using the rotogravure process, highlighted the sumptuous nature of her prints and established her reputation.

Thérèse Le Prat died in 1966, leaving a work that her husband published the same year, *En votre gravité: Visages*, as well as an unfinished manuscript, *Femmes et fleurs*, that remains unpublished. **FD**

In one photograph by the Studio Manassé, a woman aims her camera at the viewer. A satirical allegory of scopophilia – the possession of the other via the gaze – the image nevertheless highlights the deliberate sensuality of the woman's nude body. With her hand raised and on the point of pressing the shutter, this photographic pin-up stands with legs apart, her bag concealing her genitals. This frivolous staging of the dialectic 'see and be seen', reflecting the growing importance of the media and of the photographic reproduction of the individual, was considered to border on indecency in its day. This was a border that Studio Manassé often risked crossing from the early 1920s until 1934, the year in which the shadow of Nazism that loomed over Austria became coupled with a censorship policy that preferred the healthy embodiments of a blond and fully clothed Germanity.

Of Hungarian origin, but by 1920 married and living in Vienna, Olga Spolarics and Adorian Wlassics turned sex appeal into an aesthetic. From a historical point of view, little trace of them remains – the spelling of their names and their dates of birth continue to vary. What survives, however, is what made their style a success: a mixture of eroticism, mischief and a fetishistic love of lustre. In their hands, photography, the height of artificiality, combines saucy overtones with a proliferation of optical and decorative effects in a kitsch extravaganza.

The couple maintained complete control over the compositions that they created in a studio that could easily rival any film set. Responsible for the staging and camera angle, Olga was the photographer, while her husband developed the images, making liberal use of retouching and special effects. We owe to him the comic photomontages produced by the studio but also the uniform gloss of the slim nudes, devoid of curves, with flesh like marble, impervious to reality. The creation of these images depended as much on the hand as on the eye, so crucial was the reworking of the negatives.

A major supplier to the European illustrated press, the studio also produced portraits of actresses and cabaret stars, which, as in Hollywood, were primarily used as promotional images. Whatever the accessories – suspender belts, stockings, cigarettes, revealing veils – and the poses – ecstatic backward tilts, the crossing of legs, 'accidental' focus of the eye on breasts and buttocks – women became an attraction in all senses, sometimes at the risk of bad taste that flirted with objectification as the flip side of glamour. But the humour in some of the images often knocks male desire from its pedestal, as in the shot of a nude passer-by pointing her phallic umbrella at a policeman armed with a baton. Was excess, an integral part of the Studio Manassé's glamour, simply a means of suppressing the fears aroused by female sexuality? **AA**[1]

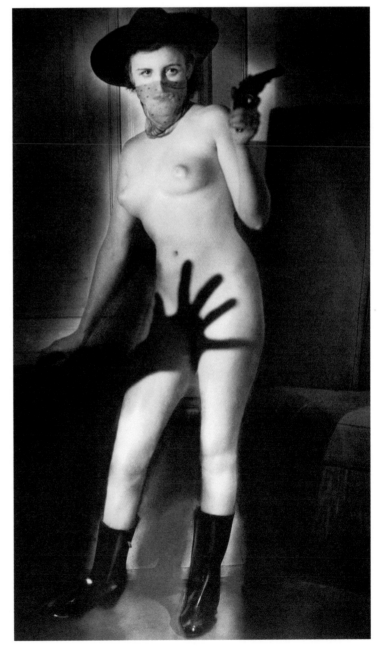

Olga Spolarics, *Black Hand*, 1947

Johanna Alexandra, known as Lotte, Jacobi belonged to the fourth generation of a family of photographers. In 1920, married and mother to a young son, she left Poznań in Poland and moved to Berlin. After attending a training course for two years at the Academy of Photography in Munich, in 1927, she revived her father's studio in the new, fashionable part of Berlin, to the west, near the Kurfürstendamm. The city presented the photographer with the ideal environment for her images – theatre, dance, but also portraits. Journals and magazines, then at a peak of their activity, became great clients.

Jacobi liked to set off on an adventure with her camera and to meet personalities from the worlds of art, theatre, literature and politics, creating very personal portraits of them – reflective, meditative, ironic, even laughing – without ever being intrusive. Among her greatest works are portraits of the actress Lotte Lenya, with a tomboy haircut and cigarette, taken during a photo session of *The Threepenny Opera* by Bertolt Brecht, of the sculptress Käthe Kollwitz, the artists Klaus and Erika Mann, in an androgynous style, and the double portrait of the cabaret performers Karl Valentin and Lisl Karlstadt. She was particularly interested in the political theatre of Erwin Piscator and passionately followed the expressive dance of Claire Bauroff and Harlad Kreutzberg, as well as the absurdist performances of Valeska Gert.

Stimulated by her friendship with the writer and journalist Egon Erwin Kisch, from 1932 to 1933, Jacobi realized her dream to travel, via Moscow, in the eastern Soviet republics of Tajikistan and Uzbekistan, as far as the ancient oasis cities of Bukara and Samarkand. Her images, revealing the blatant telescoping of past and present, were first and foremost declarations of sympathy addressed to the inhabitants of the post-revolutionary Soviet Union, caught between their Islamo-oriental culture and the modern socialist reality.

In 1935, as a Jew and victim of an order prohibiting her to practise her trade, Jacobi emigrated to New York with her mother and son, and was forced to leave most of her photographs in Berlin. Although she had no difficulty in adapting to the American way of living and in establishing a new life for herself, the very different pictorial aesthetic of the American illustrated magazines prevented her from enjoying the same success as a photographer as she had in Germany. Moreover, the living and working conditions of emigrants to the United States considerably declined during the Second World War, lasting until the 1950s.

In the 1940s, Jacobi explored cameraless photography: her 'Photogenics' were in tune with the spirit of the time, abstract art. In the mid-1950s, she retired to the solitude of the forests of New Hampshire, in New England, and campaigned for photography to be more visible in public spaces. During the last decades of her life, she became intensely involved in local politics and protests against nuclear energy and US involvement in Vietnam. **EM**

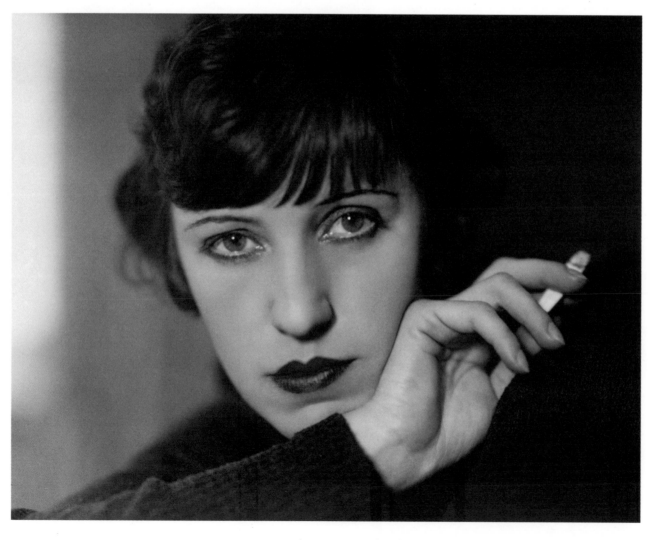

Lotte Jacobi, *Lotte Lenya, Actress*, Berlin, 1928

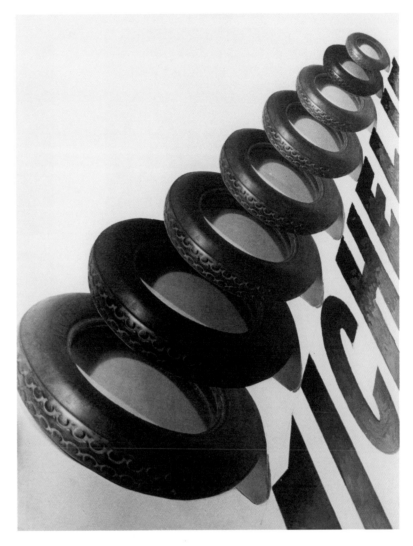

Ergy Landau, *Publicity Study for Michelin, c.* 1935

Ergy Landau's earliest images reveal a taste for a Pictorialist aesthetic: her posed portraits, with their calm composition, were created using the techniques of the bichromate gum or oil print, such as bromoil. Landau soon turned towards a style more in keeping with her time. At the end of the 1920s, she abandoned her heavy view camera in favour of the Rolleiflex. Her images became more dynamic: the frame became tighter, the subjects shifted off-centre, the grain of the image was finer.

Born Erszi Landau in Budapest (then the second capital of Austria-Hungary) to an affluent middle-class family, the future photographer grew up in a privileged environment, in which she developed her artistic and literary tastes. She studied photography in Vienna and Berlin, before returning to Budapest (1919), frequenting, among others, Lucia and László Moholy-Nagy. In 1923, she moved to Paris, where she opened a studio and adopted the name 'Ergy'. Her friendships and her integration into Parisian life led to her stylistic development. The French capital was then a major centre for followers of New Photography, with its focus on modernity. Landau earned a living principally from her activity as a portraitist. Her clients included many writers and artists, such as Paul Valéry, Thomas Mann, Antoine Bourdelle and Elsa Triolet. At the same time, she produced reportages on location, fulfilled advertising commissions and distinguished herself in the photography of

children and the female nude. In the latter genre in particular, the framing seems to 'strip' the body, to use the term coined by Paul Jay, founder of the Musée Nicéphore Niépce in Chalon-sur-Saône; the high-contrast lighting plunges the subject into subtle drama. Her love of the nude was professionally fortuitous: Landau was well suited to the contemporary publishing trend that reflected the liberation and sensuality of bodies characteristic of the early twentieth century. Her many nudes were published in booklets on health, erotic magazines and art books.

A free and independent spirit, Landau was committed to the recognition of photography as an art, but also as a profession. She was a founder member of the Société des Artistes Photographes in 1932, alongside Laure Albin Guillot and Emmanuel Sougez. In 1933, Charles Rado, a Hungarian living in Paris, founded the Rapho agency, which she joined along with others, including Ylla and Nora Dumas, both assistants in her studio. Put on hold during the Second World War, the agency was revived in Paris in 1945 by Landau, Brassaï and Raymond Grosset. Robert Doisneau and Sabine Weiss also joined this organization, which distributed and protected the photographs of its members. In 1954, Landau travelled to communist China with the writer Pierre Gascar, where she took the images that would illustrate the book they co-authored the following year, *Aujourd'hui la Chine*. **JJ**

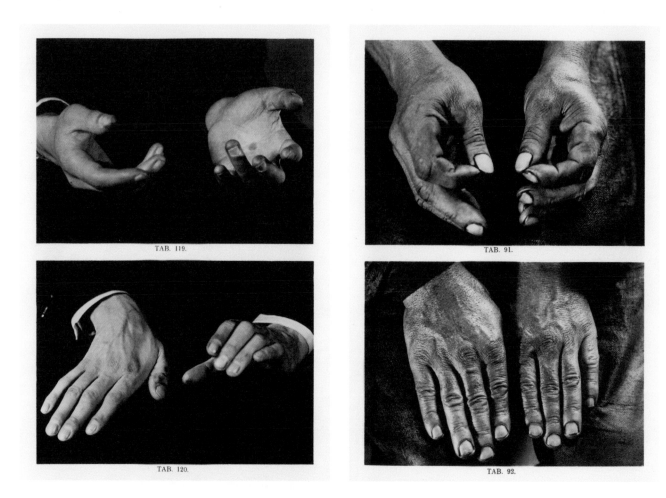

Janina Mierzecka, *Hands of a Dentist* (plates 119–20) and *Worker in a Paraffin Refinery* (plates 91–2),
taken from *Ręka pracująca* by Henryk Mierzecki, 1939

A graduate of the faculty of philosophy at Jean-Casimir University in Lwów, capital of the kingdom of Galicia and Lodomeria (present-day Lviv in Ukraine), Janina Mierzecka completed her training by attending drawing classes at the Industrial School in the same city; she also received a solid musical education. In 1910, the young woman acquired her first camera: her early attempts were mainly portraits. Her marriage to Henryk Mierzecki, in 1919, did not cause significant interruption to her career, nor did the births of her son and daughter, who inspired her to write an article encouraging women to take portraits of their children (1930).

In 1925, Mierzecka began to attend the photography classes taught by the charismatic Henryk Mikolasch, who introduced her not only to technique, but also to the profession of photographer. That same year, he invited her to co-manage his celebrated studio. In the late 1920s, she became a member of the elitist Polish Photo-Club. Her works dating from this period, mainly portraits and landscapes, were in line with the Pictorialist tradition, then very popular in Poland. Between 1924 and 1938, with her dermatologist husband, Mierzecka conducted an important research project, which consisted of describing and photographing the hands of dozens of people carrying out different professions, with a view to observing the damage inflicted on their skin. This monograph was published in 1939 under the title *Ręka pracująca* (The working hand).

At the outbreak of the Second World War, from January 1940, Mierzecka directed a photographic reproduction studio to document the objects from the collection of Lwów's Industrial Museum, where she worked ceaselessly until the arrival of the German troops, in April 1941. After the war, in difficult circumstances she organized the setting up of another studio in the National Museum and helped to found the Association of Polish Art Photographers (ZPAF). In 1949, living in Wrocław, she once again displayed her talents as an organizer, creating, among other things, a new reprography studio, this time in the Museum of Silesia (later the National Museum). At the same time, she photographed and filmed the city. In her postwar work, she systematically applied the free techniques censored during the period in which Social Realism dominated.

Mierzecka was a pioneer in the realms of scientific photography and works of art in Poland. Written from a personal perspective, her 1959 book *Fotografia zabytków i dzieł sztuki* (The photography of monuments and works of art) presented, alongside technical indications, her own reflections and experiences – she broke with the conventions that governed the customary manuals, written for the most part by men. Mierzecka was the author of many publications, two of which are invaluable for the history of Polish photography: *Całe życie z fotografią* (A whole life in photography, 1981) and *Mój świat, moje czasy* (My world, my time, 1989). **KP-R**

Born in Udine, Italy, Tina Modotti emigrated to the United States in 1913 and settled in San Francisco. She became a dressmaker and then a model and began a career as an actress in the theatre. She became noticed, made several films in Hollywood, and married the painter and poet Roubaix de l'Abrie Richey. In July 1923, with her lover, the American photographer Edward Weston, she travelled to Mexico, where she helped him to set up and run a photographic studio. Although, thanks to Weston, Modotti was able to perfect her technique and became aware of the developments of modern photography, the reception of her work also suffered from this association, with appreciation of her output remaining in Weston's shadow until the 1970s.

This personal and professional partnership lasted only for a few years, with Weston opting to return to California in 1924. They continued to exhibit their images together after this time, but Modotti pursued her career in Mexico's post-revolutionary capital alone. She frequented a circle of left-wing artists and intellectuals, and was particularly close to the muralists, including Diego Rivera, José Clemente Orozco, Máximo Pacheco and Jean Charlot. Many of them drew on her talent to document their frescoes in the city's public spaces. Her political stance became more radical: the formalism and rigorous composition of her images began to be applied to subjects that were overtly socially engaged. She published regularly in the magazines *Mexican Folkways* and *El Machete*, organs of the Mexican Communist Party, which she officially joined in 1927. In 1929, Modotti held a solo exhibition – the only one in her lifetime – at the Mexican National Library. The text that she wrote to accompany her images served as a manifesto: she stressed her rejection of Pictorialism and her devotion to a pure photographic technique, which she wanted to use for the revolutionary cause.

The following year, expelled from Mexico because of her political activism, Modotti returned to Europe. In Berlin, she became close to the militant Communist Willi Münzenberg, and it was thanks to him that some of her images were published in *Arbeiter Illustrierte Zeitung*. During this period, she also joined the press agency Unionfoto. In the summer of 1930, Lotte Jacobi invited her to use her studio and to exhibit some of her work. After a trip to the Soviet Union, Tina Modotti gave up photography completely, in order to devote herself entirely to militant activism in Spain during the Spanish Civil War, then in Mexico, where she eventually returned in secret in 1939. **JJ**

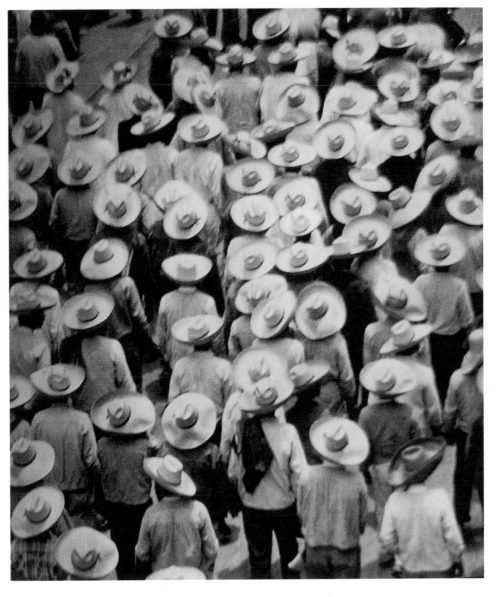

Tina Modotti, *Workers Parade*, Mexico, 1926

'The true photographer is the reporter, the witness of the everyday.'

GERMAINE KRULL

Germaine Krull, *Transporter Bridge*, Marseille, *c.*1930

The face of photographic modernity, Germaine Krull published *Metal* in 1928, a book that marked the industrial and urban world's influence on the aesthetic of the interwar period. Poetry and graphic intensity sit side by side in her images of buildings and metal structures – her 'irons' as she called them – the camera angle alternating between views from above and below. Associated with the New Vision in France, Krull also played a role in the development of modern reportage alongside André Kertész and Eli Lotar. She loved driving. Her passion for motor cars fitted well with the modernity of her work and lifestyle, 'free from conventions in every realm', as the film director Joris Ivens described her. 'Germaine, we are the two greatest photographers of our time. Me in the classical vein, you in the modern', the American artist Man Ray wrote to her. Recognized in her lifetime, Krull's oeuvre was in the limelight once again in the 1990s, thanks to the work of the collector Christian Bouqueret and the retrospective organized by the Folkwang Museum in Essen in 1999 using works in its archives.

Born in 1897 in Poznań in East Prussia (now Poland) to German parents, Krull studied photography in Munich from 1916 to 1918. After a visit to the USSR, prompted by her revolutionary commitment, she reached Berlin, frequented the Dadaists and German Expressionists, and produced, during this period and in complicity with the photographer Kurt Hubschmann, lesbian nudes. In the Netherlands, she recorded industrial activity in the port of Rotterdam. In 1926, in Paris, she befriended the Surrealists and photographed the Eiffel Tower, a symphony of cables, steel and pulleys, dizzying and fantastical images, but also photographed ordinary people, the underworld, markets, dance halls, vagrants and funfairs. Her images were shown in exhibitions such as that held at the Salon de l'Escalier in Paris, the first exhibition of modern photography held as a reaction to Pictorialist or so called 'art' photography. As highlighted by her retrospective at the Jeu de Paume, Krull worked with publication in mind, and her images appeared in a substantial number of books and a plethora of magazines. Between 1935 and 1940, Krull lived in Monaco, employed by the casino to photograph the celebrities, then resided alternately in the south of France, Brazil and in Brazzaville, where she ran the Free France propaganda service.

As a war correspondent, she followed the French campaign in Alsace and then Germany in 1944, documenting the liberation of the Natzweiler-Struthof and Vaihingen concentration camps. She travelled to Asia in 1946, visiting the front in Indochina before settling in Bangkok, where she opened a hotel that she managed for twenty years, while continuing her trade as a photographer in Burma and Cambodia, notably working in colour. From 1965, Krull lived in India alongside Tibetan refugees, frequented the Dalai Lama and dedicated herself to serving the historic heritage of Buddhism, to which she had converted. Her autobiography, *La Vie mène la danse* (Life leads the dance), which she finished writing in India in 1980, was finally published in 2015. **LL**

Berenice Abbott, *Multiple Exposure of a Swinging Ball*, c. 1958–61

Berenice Abbott is usually celebrated for her extensive documentary series on New York (1935–9), financed by the Federal Art Project, an artists' assistance fund that was part of the programme launched by the Roosevelt administration after the financial crash of 1929 and intended to revive the economy through major works of general interest. The photographer was also noted for her campaign to obtain international recognition for the oeuvre of Eugène Atget, part of which she acquired following his death in 1927. Her photographic survey of New York is often presented as the modern counterpoint of Atget's work on Paris. In more than three hundred images accompanied by historic information gathered by a team of researchers hired for the occasion, Abbott mapped the changes to the city, capturing the contrasts between the old and new that formed the urban fabric. Stripped of any nostalgia, alternating architectural details and tilted perspectives with more frontal documentary framing, the series was an enquiry into modernity and the growth of a metropolis undergoing an unprecedented process of demolition and reconstruction.

Before beginning this project, from the 1920s onwards Abbott had been an active participant in avant-garde circles, campaigning for the artistic legitimization of photography, both in Paris and New York. In 1921, she emigrated to Europe to try her luck, reconnecting with a group of expatriate American artists already living in Paris, and becoming assistant to Man Ray in his portrait studio, before opening her own studio in 1926. Her French and American clientele was drawn from high society, artistic Bohemia and

> 'Photography can never grow up and stand on its own two feet if it imitates primarily some other medium. It has to walk alone. It has to be itself.'
>
> **BERENICE ABBOTT**

the literary world. The photographer distributed her images through publications and exhibitions of contemporary photography, alongside André Kertész, Man Ray and Germaine Krull.

Admired for her portraits, and then for her documentary work in New York, in the late 1950s, Abbott embarked on a final large-scale project. Following the launch of the Sputnik I satellite by the Soviet Union in October 1957 against the background of the Cold War, the Massachusetts Institute of Technology (MIT) set up a science study committee, tasked with creating new high-school textbooks and reporting on American technological innovation. For MIT, Abbott shot scientific photographs designed to be educational tools for the dissemination of ideas. The abstract shapes on black background represent complex mechanical concepts and physical laws that were usually invisible, such as gravitation or the wave theories of light. Too often reduced to a few images, Abbott's long career proved to be rich and varied, as her archives, now held at the Ryerson Image Centre in Toronto, Canada, reveal. **GM²**

Aenne Biermann, *Fireworks*, 1928 (Galerie Berinson, Berlin)

Aenne Biermann's photographs of plants were described as 'true creations' by the German art critic Franz Roh, on whose initiative they had been shown at the Graphisches Kabinett in Munich in 1928. It was the first solo exhibition by this young woman, who had taken up photography only two years earlier and was self-taught. In the following years, and until her premature death in 1933 – she died as a result of an illness just before Hitler's rise to power – she produced a powerful body of work influenced by New Objectivity (Neue Sachlichkeit): virtuoso compositions based on objects or plants, still lifes, portraits, nudes, landscapes, architecture, but also double exposures and photomontages.

Aenne Biermann, born Anna Sibilla Sternfeld in Goch (Lower Rhineland), lived in Gera (Thuringia) from 1920. Her lack of training did not prevent her from soon becoming a prominent figure of the avant-garde. In 1930, she published her work in a book, *Aenne Biermann: 60 photos*, which appeared in the 'Fotothek' collection launched by Franz Roh, alongside monographs by László Moholy-Nagy and El Lissitzky.

Nowadays, Biermann is considered one of the most innovative female photographers of her era. Her work, characterized by a surreal approach to the essence of things, inspired Roh to coin the expression 'magical realism'. Biermann described her earliest photos – created with the aim of preserving the image of her two children – 'wandering photographs'. Her meeting with the geologist Rudolf Hundt in 1927 marked the beginning of a more serious

phase in her work. It resulted in a series of images of minerals and crystals of remarkable precision and clarity. For Biermann, it was in this 'world of seemingly dead objects', with their unique forms and very particular structures, that the multiple possibilities of the medium blossomed. As for 'living things' such as flowers, leaves and plants, in her photographs they took on a 'personal life'. The secret of these highly persuasive images lay in Biermann's ability to capture the motifs with an intuition that stemmed from her profound knowledge of her subjects, a feature that can be seen for example in the abstract form of a firework at night or in the hands of children.

Aenne Biermann's works were shown in major exhibitions of the time, including *Fotografie der Gegenwart* (Essen, 1929), *Film und Foto* (Stuttgart, 1929), *Das Lichtbild* (Munich, 1930) and *The Modern Spirit in Photography* (London, 1934). Although her photographic archives, amounting to more than three thousand negatives, are reputed to be lost, more than four hundred original prints are conserved in public and private collections. **FS**

'An object which, in its own environment, had never left the realm of familiar appearance, took on a life of its own under the frosted glass of the viewfinder …'

AENNE BIERMANN

Voula Papaioannou began working as a photographer during the 1930s, concentrating at first on landscapes, ancient monuments and museum displays. The entry of Greece into the Second World War in 1940 marked a turning point in her career, as she was especially affected by the suffering of the noncombatant Athenian population. While her colleagues left for the front line, she remained in the city to document the obstinate struggle of the civilians against the imminent threat, documenting recruitment operations, the distribution of clothing to enlisted men, and care of the wounded returning from the front. When the capital was gripped by starvation, Papaioannou ignored the prohibitions of the occupiers and photographed malnourished children and adults in the city's hospitals. With the help of the Swiss and International Red Cross, her powerful images were secretly distributed within Europe and the United States, prompting some countries to send food aid.

Papaioannou immortalized the joyful celebrations in the streets of Athens on 12 October 1944 (Liberation Day). Two months later, when the capital was in the throes of civil war, she chose to photograph not the battles that were taking place in the city but the catastrophic consequences of conflict: mutilated cityscapes, the identification of bodies exhumed from mass graves and the return of hostages taken by the Greek People's Liberation Army (ELAS). From April 1945 to August 1946, she was head of the photographic unit of the United Nations Relief and Rehabilitation Administration (UNRRA). She toured the ravaged Greek countryside and reported on the provision of aid, difficult living conditions and the country's reconstruction efforts, thus painting an image of postwar Greece. From 1947 to 1948, as the civil war spread once more, she worked for the American Mission for Aid in Greece and the Economic Cooperation Administration.

In the 1950s, Voula Papaioannou again turned her attention towards landscape photography. She joined the Greek Photographic Society (EFE) and collaborated with the Greek Tourist Organization. On her own initiative, she approached the Swiss publisher Clairefontaine / La Guilde du Livre, which published her two photographic books, *La Grèce à ciel ouvert* (1953) and *Îles Greques* (1956).

Papaioannou's work reflects the sensitivity of her character and expresses the sense of optimism that prevailed in the aftermath of war, both for the future of humankind and for the restoration of traditional values. In 1976, she donated her archives to the Benaki Museum in Athens. **AT**[2]

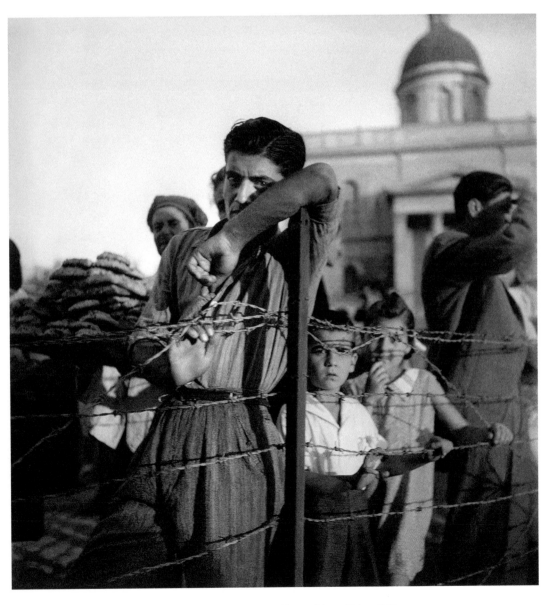

Voula Papaioannou, *Repatriation*, Piraeus, Athens, 17 June 1945

In 1976, Ilse Bing was the subject of a solo exhibition at the Lee Witkin Gallery in New York. A major photographer from the 1930s to the late 1950s, she had never previously been the subject of such attention. Some time later, in 1982, Gisèle Freund paid homage to her in the introduction she wrote to her book on photographs dedicated to women, *Women from the Cradle to Old Age, 1929–1955*, published by Éditions des Femmes: 'Today the history of photography can no longer overlook her contribution. Ilse Bing is rightly situated among the few artists of the 30s who gave to photography its aura of artistic creation.'

Bing's photographic oeuvre is marked by many influences, combined with great intelligence. Studying for a doctorate in the history of art at Frankfurt University in the early 1920s, she chose to take herself the shots of the works of art she wished to use to illustrate her thesis. Her activity as amateur photographer intensified, becoming her profession in 1929. The young woman earned her living from portraits and photojournalism. Her discovery of the work of Florence Henri, who had moved to Paris following her time at the Bauhaus, made her decide to move to the French capital, then the centre of the European photographic avant-garde. Open to the developments of New Photography as well as Surrealism, Bing diversified: while she continued to sell her images to newspapers, she also took numerous photos of dance, fashion advertising and architecture. During the 1930s, her work could be admired in the influential magazines of the time (*Vu, Arts et métiers graphiques, Harper's Bazaar, Vogue, Le Monde illustré, Le Sourire*), as well as in exhibitions in Paris (Galerie de la Pléiade, Salon International d'Art Photographique) and in New York (Julien Levy Gallery, Brooklyn Museum).

Her Leica in her hand, Bing loved to experiment: mastering high- and low-angle shots, and extreme close-ups, she was also fascinated by the rendering of movement. Unashamedly reframing her negatives, she experimented with different enlargements and regularly adopted solarization. In 1941, she moved to New York. Her style developed in a significant manner and the grain of her images became finer: she abandoned her small-format camera in favour of a Rolleiflex and increasingly resorted to the electronic flash. In 1957, she began to work exclusively in colour, before abandoning photography two years later. Feeling that she had exhausted the medium, she devoted her time from then on to poetry, drawing and collage. **JJ**

'[W]hat interests me, is the abstract in life. I photograph the accidental.'

ILSE BING

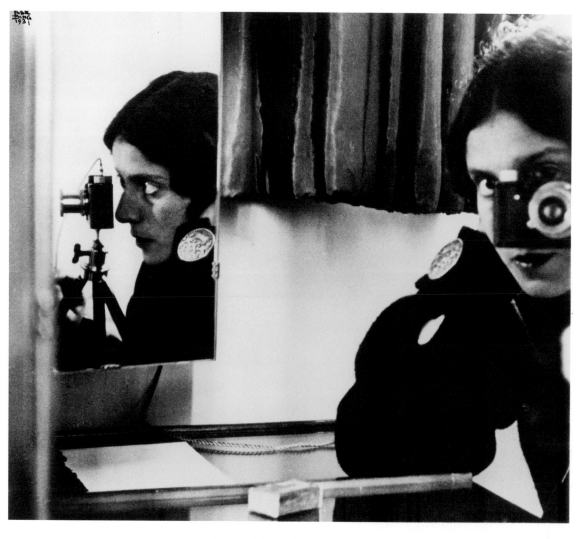

Ilse Bing, *Self-portrait with Leica*, 1931

Yvonne Chevalier, *Fan*, Spain, 1950

'I love this rapid means of grasping the
"quality" of such a moment that I am
the only one to perceive, capture, transmit.'

YVONNE CHEVALIER

Mystery and delight unfold, like the fan that the model holds in front of her crotch, in this image in which the close-up focuses on feminine intimacy, close and yet impersonal. Yvonne Chevalier wrests the photograph from its subject, which interests her less than the framing and the possibilities it offers to extract from reality. Here she frames the taboo of concentrating on a dress riding up the thighs. An audacity accentuated by the sensual rendering of the details (pattern on the fabric, flowers on the painted paper, materiality of the jewelry) and the relegation to off-camera of part of the body depicted.

Previously, in another photograph, a female bather eludes identification. Anonymous drowned figure or Ophelia of 1935, nothing remains of her except her head emerging from the water. A white oval framed by wild grass, frail columns of a floating tomb. A strange feeling emanates from this apparition whose features evoke those of the Unknown Woman of the Seine: 'eyes closed and lips that "seem to smile and to suffer"', wrote Gaston Bachelard in *L'Eau et les Rêves*. Not so much a woman as an absence, she exists only, as myth or ghost, through the cultural references to which she refers, from Rilke to Aragon or John Everett Millais. On the surface of the stream, she is merely an impression without substance. A trace acting, in the same way as photography, as a memorial surface.

Chevalier sank into oblivion after being active on the Parisian photographic scene during the 1930s and 1940s (she was a member in succession of Rectangle and the Groupe des XV). The destruction of some of her prints during the Second World War and then by the photographer herself in 1980, two years before her death, mean that our knowledge of her work is fragmentary. We know that she abandoned painting in 1929 to dedicate herself to photography, before opening her own studio a year later. She regularly published her work in magazines such as *Arts et métiers graphiques*, *La Revue du médecin* and *Art et médecine*. She was appointed official photographer to the painter Georges Rouault, and explored every genre: portrait, reportage (Algeria), still life (instruments), architectural photography (the Abbey of Thoronet). But her female nudes marked the high point in her sense of eurhythmy. From a female nude crouched on a pedestal, she creates, for example, a vertical arrow, crowned by a mass of black curls that interrupts the harmonious sinuousness of the model's limbs. The model's face eludes us, as often occurs in the work of Chevalier, who preferred to concentrate her gaze on the *rhythm* of the body, its curves. In her close-up and fragmentary images, woman becomes little more than lines and modulations of black and white.

The same tendency towards abstraction can be seen when Chevalier attempts to render visible an invisible quality – speed – by transcribing the music of a landscape seen from a car travelling at a hundred kilometres an hour. Like a musical score, her photograph captures a tempo, with a disregard for focus that reflects the creativity that she possessed. **AA**[1]

Born in Smyrna, then part of the Ottoman Empire, Maria Chroussachi settled with her family in Athens in the late 1910s. She studied singing and the piano, and later took drawing lessons with the respected painter Pavlos Mathiopoulos. In 1926, she graduated from the nursing school of the Hellenic Red Cross; from that point on, she devoted herself to humanitarian actions for the rest of her life. Working first as a volunteer nurse in outpatient wards in the poor neighbourhoods of Athens and in hospitals elsewhere in the country, she then joined the Emergency Medical Unit of the Red Cross and travelled to northern Greece to help the victims of the 1932 Ierissos earthquake. When Greece entered the Second World War, she immediately joined the field surgical units on the Albanian Front.

Chroussachi's involvement with photography, although never professional, seems to span four decades, from 1917 until the late 1950s. During the 1920s, with her camera in hand, she criss-crossed Europe for several months each year with her family, creating a visual record of the places they visited. In almost all of her assignments as a volunteer nurse, Chroussachi took her camera with her and, with the sensitivity that defined her character, documented the Red Cross's activities and the wounded. Her images from the war zone depict not the conflict itself but events behind the front line: army movements, preparations for battle and the soldiers' daily lives.

On 12 October 1944, the day on which Greece was liberated from Nazi occupation, Chroussachi photographed the joyful celebrations in the capital's streets. A couple of months later she left with the British Red Cross to carry out medical examinations and to vaccinate the children of northern Greece and the Dodecanese. On this occasion, she documented the country's postwar reconstruction, capturing the ravaged landscapes with a simple but powerful style that sometimes verges on the abstract.

Upon her return, Chroussachi became a member of the Greek Photographic Society (EFE), taking part in exhibitions and publishing her photographs in the group's quarterly journal. In addition, like many photographers of this period, she worked alongside the Greek Tourist Organization, which used her images to promote Greece abroad. Chroussachi donated her archive to the National Gallery of Greece in 1971, just one year before she passed away. **AT²**

Maria Chroussachi, *Albania, On the Road*, 1941

156

Anita Conti, *In the Shoals off Newfoundland, on Board the Trawler Bois-Rosé*, 1952

'Some films were developed in muddy and brackish waters; others dried too slowly in the damp shade of mosquito-filled huts. […] And I haven't counted the number of shipwrecks with the cameras and their load of film.'

ANITA CONTI

The first female French oceanographer, as well as a writer, Anna Conti was also a photographer. She was responsible for many tens of thousands of images, taken in extreme conditions, on board fishing vessels – trawlers, canoes – sailing from the seas of the North to those of the South, or in ports, from Dunkirk to Casablanca, via Oran or Marseille.

Celebrated in Paris during the 1920s as a craft bookbinder, she soon abandoned this profession to devote her time entirely to her interest in the marine environment. She denounced, in articles and books that she illustrated through her own efforts, the overexploitation of the oceans. Her camera accompanied her from her first assignment as an employee of the Scientific and Technical Office for Maritime Fisheries (OSTPM): in June 1939, she embarked on the cod-fishing boat *Viking*, for a mission lasting almost three months in the North Atlantic. During the war, she accompanied minesweepers, publishing her images in *L'Illustration*, and then headed towards Africa. From 1941 to 1946, travelling along the coastlines of Mauritania, Senegal, Guinea and the Ivory Coast, she studied fauna unknown in France until then, as well as fishing techniques in warm waters. From north to south, she thus documented the hard working conditions of the sailors, as well as moments of relaxation during their day. Often the only woman on board, never without her sailor's smock and white gloves, she nevertheless shared the hardships of their life, which she endeavoured to record in her images, avoiding the picturesque: the burning sun, the storms, the incessant rhythm of the boat, the promiscuity, the loneliness. Always in search of the right image, Conti was undeterred by any obstacle: anticipating waterfalls and disasters, she wrapped her cameras, lenses and films in waterproof bags; favouring high viewpoints, she had no hesitation in clambering among the masts and ropes.

In a straightforward manner, she was able to convey with great simplicity the particular humanity of these labourers of the sea, whom in 1939 she described as follows: 'Men? No. Not at all. Beings deprived of their families, bodies wrapped in clothing, with nothing remaining visible except hands and faces, and in the faces when it gets really cold, really only the eyes are still alive.… So men who are little more than gestures and glances, enclosed within these sheets of metal pushed by one thousand two hundred and fifty horsepower, these men, whether they are of open intelligence or stubborn energy, whether they are of delicate or coarse thinking, are always in some way split. Their souls are elsewhere.' **JJ**

In the early twentieth century, against the backdrop of a thriving female intelligentsia in Lebanon, activist writers such as Anbara Salam, Salma Sayegh and Adila Beyhum turned their attention to the figure of the modern woman. Their goal was to promote an image of the new woman as both an educated mother and an ideal housewife. In the 1920s, Marie el-Khazen, part of a distinguished family, took to recording her everyday life in her village of Zgharta with an Eastman Kodak. The women who appear in Marie's photographs – friends and relatives, most of them from the social elite – have other concerns than performing the role of wife or mother. She and her female acquaintances are seen enjoying activities normally associated with men, such as smoking cigarettes, driving cars and hunting. El-Khazen also practised taxidermy as a hobby.

Through her photographs – she took more than two hundred negatives in 6 × 9 format, now carefully preserved in the archives of the Arab Image Foundation in Beirut – el-Khazen established an image of the emancipated, independent woman who refused to withdraw into household duties and to cater to the man of the house. Perhaps she was drawn to photography because it gave her the choice of what to include or exclude from her domestic surroundings.

El-Khazen was not the only woman to practise photography in Lebanon and the nearby region; others had run studios there since the late nineteenth century. However, she did not produce staged portraits in a studio setting, but captured social occasions and spontaneous events, taking snapshots of friends and family going about their everyday lives. Through her images, she constructed a gender identity that did not correspond with either the values of early feminism or the traditional role of women in upholding society as proposed by the press of the time.

Indeed, Marie el-Khazen's photographs raise questions about the cultural assumptions that confine women to the domestic sphere. In shots such as *Two Women Disguised as Men*, she challenged the widespread conservative image of Arab women by representing them as liberated individuals enjoying the same rights as men. **YNT**

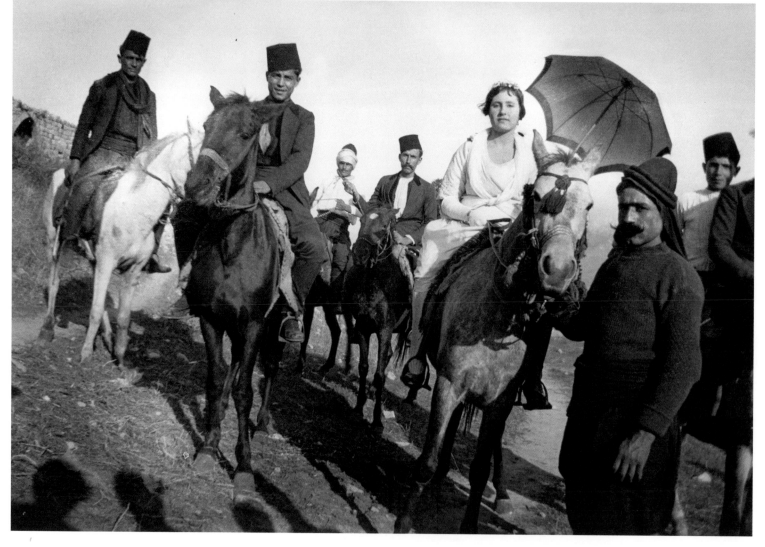

Marie el-Khazen, *A group of men and probably the sister of Marie el-Khazen, Alice, on horseback*, Lebanon, 1930

Nelly, *Greek Athlete Dimitrios Karabatis,*
champion of the Smyrna Panionian Games, Athens, 1925

Born in Aydin in Asia Minor, at that time part of the Ottoman Empire, Elli Souyoutzoglou-Seraidari moved to Greece in 1925 after studying photography in Dresden, Germany. She became highly successful and was later one of the most prolific photographers working for the regime of dictator Ioannis Metaxas, supplying authorized iconography during the interwar period. Seraidari dropped her name, which was of Turkish origin, and adopted the diminutive 'Nelly' as a professional pseudonym. Her work reflected a neoclassical, romantic aesthetic and ideology, employing staged compositions and the manipulation of the image. Her photographs of the Russian dancer Lila Nikolska at the Parthenon (1929/30) are probably her best known, illustrating the Hellenic ideal that inspired artists in the nineteenth and early twentieth centuries.

When Seraidari arrived in Athens, she subscribed to an essentially anti-modern aesthetic. She introduced the bromoil process to Greece, a Pictorialist technique popular in the early years of the twentieth century. The 'artistic' appearance that it gave Seraidari's images took Athenian society by storm. She used the process for a long time, even for documentary images, such as her 1925 photographs of refugees from Asia Minor, rendering them aestheticized and harmless. In 1936, she was commissioned by the government to provide illustrations for the first tourist publications. Her photographs contributed to the monumentalization of the Greek landscape; removed from any social context, they became an expression of a regime that looked to Germany's Third Reich for inspiration, even calling itself the 'Third Hellenic Civilization'.

The German ideology of the period had a significant influence on Seraidari's work. Subscribing to the National Socialists' concept of eugenics, she attempted to compare shepherds and village maidens to the *kouros* and *kore* sculptures of ancient Greece to demonstrate their racial continuity. Her 'Parallels' series was a simplistic yet powerful propaganda tool, just like the Nazis' comparison of 'Aryans' with ancient sculpture; it reflected a desire to prove not only racial purity but also – by including images of blond Greeks with blue eyes – a connection with contemporary 'Aryans' in a similar way to Leni Riefenstahl's famous film of the 1936 Berlin Olympic Games. By exalting the beauty, radiance and power of eternal Greece, Nelly's photographs conformed to the aesthetic, ideological and nationalist discourse developed by the regime.

Since Seraidari's rediscovery in the mid-1970s (her connections with the Metaxas regime having been glossed over), focus has shifted onto her sense of patriotism – a patriotism that prompted her to produce iconic images of 'Greekness' inherited by future generations. **PP**

Ida Nappelbaum, *Ballet Study, c.*1920

Ida was the eldest child of the photographer Moïsseï Solomonovitch Nappelbaum and Rosalie Lvovna. In 1910, the growing family left Minsk for St Petersburg, where they settled, six years later, in an apartment near the Anitchkov Bridge. The attic floor of the building located at 72 Nevsky Prospect had nine rooms. Moïsseï Nappelbaum converted three of them into a studio, which included a reception room, a studio with zenith light, equipped with a Voigtländer camera, and a laboratory. Two of his four children, Ida and Frederika, helped him to develop the negatives.

In 1918, Ida was admitted to the Institute of Art History, while Frederika entered the Arts Faculty of the university. From Autumn 1919, in their free time, both girls began to frequent the poetry studio La Conque Sonore, run by the poet Nikolaï Stepanovitch Goumilev. After his execution in 1921 by the Cheka, the political police who fought the enemies of the Bolshevik regime, his close followers continued to meet every Monday in the Nappelbaums' apartment.

Having perfectly mastered their father's technique (rejection of stillness in the model, free composition within the frame), Ida and Frederika often stood in for him in the studio, turning the enterprise into a family business through which the intellectual and political cream of the Soviet Union passed. Only a portion of the images produced by the Nappelbaum studio and taken when Moïsseï Solomonovitch was by then established in Moscow have come down to us. The stamp of the Nappelbaum studio appears on the invoices of the photographs taken during the 1920s in Leningrad, but there is nothing enabling us to determine whether Ida or Frederika was the author of the camera shot. In one of her works, a book of memories *Angle de réflexion*, Ida Nappelbaum recalls a series of portraits of Russian writers and poets created from the 1920s.

In 1925, Moïsseï and Ida Nappelbaum submitted some prints to the Exposition Universelle de Photographie in Paris, which earned a major prize for Moïsseï and two medals for his daughter. In December of that year, she married Mikhaïl Alexandrovitch Froman and moved into his apartment in Liteïny Prospect in Leningrad in 1927. It was probably at this time that the Nappelbaum salon, a very active literary circle frequented by many artists and intellectuals, ceased its activities. Ida, who had kept one of her father's cameras, continued to use it until much later, but only for personal use. As for Frederika, after her short-lived marriage in 1926, she pursued her activity as a poet in a studio close to the Théâtre d'Art, while mainly devoting her time to caring for their father.

In 1932, Ida and her husband moved to 7 Rubenstein Street in Leningrad. Ida was to remain there until her death in 1992, with an interruption during the three years the city was under siege by the German army, from September 1941 until Spring 1944, and another during her internment in a labour camp, from 1951 to 1954. It was in this apartment that the celebrated portrait was taken of the poet Anna Akhmatova, a victim of Stalinist terror, on her return from Tashkent, where she had been sent by the Writers' Union.

Ida Nappelbaum's oeuvre is almost better known abroad than in Russia. An exhibition reuniting the works of Moïsseï and Ida Nappelbaum was held at the Nathan Federovsky Gallery in Berlin in 1991. **LS²**

Born at the turn of a century she was to live through almost entirely, Barbara Morgan, née Brooks Johnson, never ceased to consider her photographic work as a commitment: through her art, she conveyed human emotions and experiences. A painter by training, and teacher at UCLA (University of California, Los Angeles), she moved to New York in the early 1930s. When she arrived, she was deeply shocked by life in the city, which had been hit particularly hard by the economic crisis. In response to these feelings, she set painting aside and opted to explore the potentials of the photographic medium.

Her husband, Willard Morgan, an amateur photographer and a salesman for Leica, taught her the techniques of printing and development in the bathroom of the family home, transformed into a darkroom. She was encouraged by László Moholy-Nagy, who had recently moved to the United States, to adopt

'As a photographer, I have had the joyful responsibility of capturing and communicating these phenomena of the human spirit which would not endure beyond performance.'

BARBARA MORGAN

photomontage. Like him, Morgan approached the practice of photography as a poetic social act that enabled her to formalize in visual terms the shattered equilibrium of the contemporary individual within his profoundly shifting environment. While she sometimes experimented with collage, juxtaposing fragments of prints, her favourite technique remained that of composition using several negatives placed in an enlarger. This process led to an exploration of the themes of fragmentation and isolation. In an interview published in September 1938 in *Photography* magazine, Morgan stated: 'I want to express the conflict between the people and their environment … to subordinate technology to human values, to dignify and glorify man.'

The presence of the human body is a constant in her oeuvre. Morgan often used fragments from her numerous shots of male or female dancers, like Pearl Primus, Erick Hawkins, José Limón and Merce Cunningham, in her compositions. In 1935, her discovery of the work of Martha Graham was the catalyst for this parallel passion for the photography of dance. Until the beginning of the 1940s, she collaborated frequently with the choreographer and members of her company. Morgan benefited during her lifetime from significant recognition. Her works were exhibited many times, notably at the Museum of Modern Art in New York. In 1952, she was co-founder of the photographic magazine *Aperture*, along with Dorothea Lange, Minor White, Ansel Adams, Dodie (Warren) Weston Thompson, and Beaumont and Nancy Newhall. **JJ**

Barbara Morgan, *Samadhi*, 1940

Else Ernestine Neulaender-Simon, known as 'Yva', opened her first studio in Berlin in 1925 and became one of the most prominent women photographers of the Weimar Republic (1918–33). She probably served her apprenticeship with the photographer Suse Byk, celebrated for her portraits and theatre photography. Although Yva's portraits, and even more so her experimental photographs known as 'synoptics' – in which the photographic plate was exposed up to seven times – were in keeping with the popular taste of the time, they were also lauded in specialist circles.

In 1927, the Berlin gallery Neumann Nierendorf, specializing in modern art, organized Yva's first solo show, exhibiting one hundred works, including multiple exposures, thus offering an insight into her usual work, with an aesthetic comparable to the photomontages of László Moholy-Nagy. Well-known advertising agencies also showed an interest in these experiments, linked to the New Vision movement of the 1920s. In 1929, Yva participated in the international avant-garde exhibition *Film und Foto* in Stuttgart, Berlin and Vienna, with double exposures. Publishing houses, in rapid expansion under the Weimar Republic, were Yva's major clients, her images appearing in numerous German magazines. In the late 1920s, Yva regularly contributed to *UHU* magazine, published by Ullstein in Berlin, notably producing photo-romances, with up to twenty-four scenes and subtly inspired by the lives of young women.

In 1930, Yva moved to west Berlin, near Kurfürstendamm, the new fashionable neighbourhood, with its cinemas, cafes, luxury shops and elegant fashion houses. From then on, fashion photography became her main activity. Her clients were celebrated couturiers and designers of accessories, whose creations she made famous by publishing them in magazines. Her favourite models were elegant, athletic young women, with wavy boyish haircuts, most often actresses or dancers, whose legs she emphasized by adopting a slight low-angle vantage point.

In 1934, Yva moved to an even more opulent studio, but was increasingly affected by the repressive measures carried out by the National Socialists against the Jews. From 1936, her business was Aryanized; the Ullstein publishing house, her principal client, was also dismantled and renamed. Yva was no longer permitted to offer any training; in 1938, her studio was closed and destroyed. Forced into compulsory work, she took photographs in the radiology department of the Jewish hospital. In the summer of 1942, she was arrested by the Gestapo with her husband Alfred Simon and deported to the Sobibor concentration camp in Nazi-occupied Poland, where she was murdered. **MB**[1]

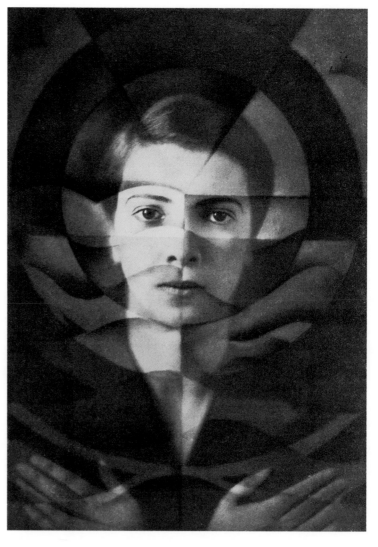

Yva, *Self-portrait*, 1926

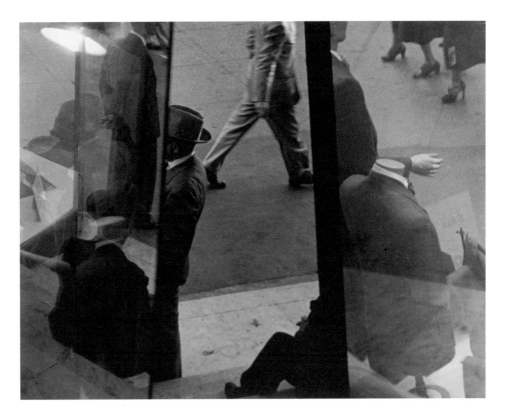

Lisette Model, *Reflections*, San Francisco, California, 1949

'The camera shutter made me believe in the crucial role of chance and the tremendous emotional power of the instant.'

LISETTE MODEL

Lisette Model, born Elise Amelie Felicie Stern in Vienna, was two years old when her father, a doctor, changed the family name to Seybert to conceal their Jewish origins. From 1919, she studied harmony with the composer Arnold Schönberg and singing with the soprano Marie Gutheil-Schoder. On the death of her father, she went to live in France with her mother and sister Olga. In Paris, she met the Russian painter Evsa Model, whom she married in 1937. From 1930, she turned to photography, learning the rudiments thanks to her sister. The Hungarian-born photographer and artist Rogi André taught her how to use a Rolleiflex.

In 1934, Model took some pictures on the Promenade des Anglais in Nice; these were published for the first time a year later in *Regards* magazine, and then, following her move to New York in 1938, in *PM's Weekly*, under the title 'One Photographer's Explanation Why France Fell'. From this time on, she arbitrarily recropped her shots in the darkroom to fit her subjects into tight frames. Model perfected this technique in her New York reportage work, adding dynamism and slightly tilting the composition. From 1940, in the 'Reflections' and 'Running Legs' series, the photographer focused on two aspects of urban life: consumerism – until then unknown in Europe – and the frenetic pace of American daily life. Moreover, she turned her camera on the inhabitants of the Lower East Side – and thus on poverty.

Her first solo show was organized in 1941 by the Photo League – a group of photographers attempting to document life in New York's working-class districts. On this occasion, she met Alexey Brodovitch, art director of the celebrated magazine *Harper's Bazaar*; he began to publish her work regularly, starting with the series 'Bathers at Coney Island', followed in 1944 by a photo-essay, 'Sammy's Bar'. Through Brodovitch, Model met Beaumont Newhall, curator at the Museum of Modern Art, who included her prints in the inaugural exhibition of its Department of Photography. Newhall's successor, Edward Steichen, continued to show and acquire her works until 1955.

Model's first solo exhibition in an art museum, the Art Institute of Chicago, was held in 1943. The following year, she acquired American citizenship. In 1948, she was invited by Ansel Adams, who had just established the first art-photography department at the California School of Arts in San Francisco, to teach the course in documentary photography. From 1951 until the end of her life, she taught at the New School for Social Research in New York, where her most outstanding student was Diane Arbus.

During the McCarthy era, suspected of being a communist, the photographer was to lose her magazine commissions; she was also prevented from carrying out her book project on the Newport Jazz Festival (Rhode Island). From 1953, Model often travelled abroad, particularly to Venezuela, where her sister lived, and to Europe.

From 1965 onwards, she was awarded several grants (Guggenheim, Ingram Merrill Foundation). In 1977, a first portfolio of her photographs was published. A year later, Model took part in the Rencontres de la Photographie in Arles and, in 1979, Aperture published her first monograph. Her work was the subject of many exhibitions in 1980 in Germany, the Netherlands, Italy, Japan and Canada. The majority of Lisette Model's work is housed at the National Gallery of Canada in Ottawa, the setting of her first critical retrospective, organized in 1990 by the curator Ann Thomas. **MF**

The thousands of photographs taken by the ethnologist Thérèse Rivière were mostly captured with a Leica, during an ethnographical expedition in the Aurès region of Algeria (1934–7). Rivière also took several hundred views during a short assignment in Morocco in May 1937, other trips to Algeria between 1937 and 1939, and in Spain in September 1939. From the summer of 1939, her preference was for a Rolleiflex.

Born in Paris to a father who was a civil servant originally from the Ardèche and a mother from Picardy, Rivière gained her education at the École du Louvre, the École Pratique des Hautes Études and the Institut d'Ethnologie, where she acquired a solid grounding in the fields of prehistory, anthropology and ethnology. At the same time, she trained as a nurse. In 1928, she joined with her brother Georges-Henri to participate in the renovation of the Musée d'Ethnographie at the Trocadéro. In 1933, she became head of its White Africa and the Levant Department. On this basis, the museum entrusted her in 1934 with an expedition to Aurès, where she teamed up with Germaine Tillion, who had also recently qualified in ethnology.

They were to carry out a survey of this mountainous area of eastern Algeria and its inhabitants, the Shawiya. A conscientious and dedicated ethnologist, Rivière set out to record life in the region. Photography is just one aspect of the material that she collected, which also included written notes, objects, drawings and film. The ethnologist appropriated the camera as a tool for experiment, following the indications of Marcel Mauss: the practice of photographing from life, systematic recording of the observed facts and documentation of the circumstances in which the shooting took place. Undoubtedly her obstinate quest for exhaustiveness and her attachment to this land led her to exploit with remarkable ability the wide range of possibilities offered by the medium. She thus increased her range of viewpoints and compositions. In addition, the complicit gazes and smiles of her subjects testify to the relationship of trust that she had created between them.

On her return to France, Rivière alternated her work at the newly reopened and renamed Musée de l'Homme with periods spent in the Aurès region and several psychiatric hospitalizations. In 1943, she organized with her friend and colleague Jacques Faublée the exhibition *L'Aurès* at the Musée de l'Homme. In 1946, she edited the film that she had shot in the same region between 1935 and 1936. Committed again to a psychiatric hospital in 1948, Rivière was to remain there until her death in 1970. Her photographs were donated to Musée de l'Homme in 1947, and her archives, conserved by Faublée, were given to the Musée du Quai Branly–Jacques Chirac in 2005. After a long period of neglect, several publications and exhibitions have recently paid rightful homage to Rivière's work. **AL²**

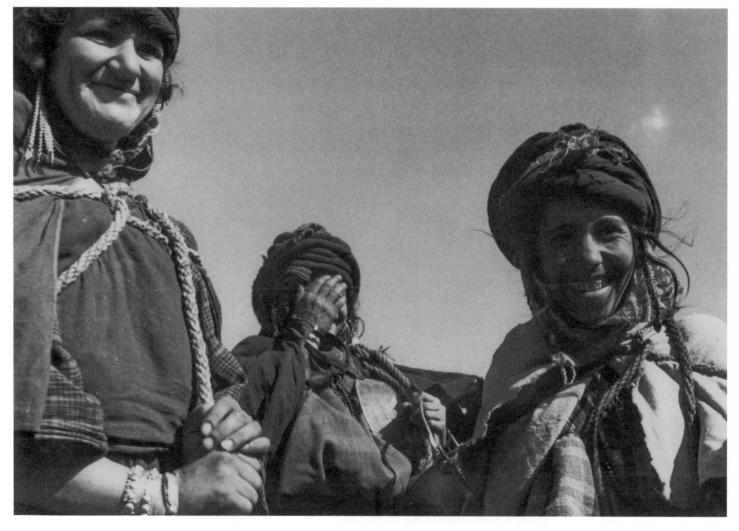

Thérèse Rivière, *Women with Goatskin Water Carriers*, Algeria, 10 April 1935

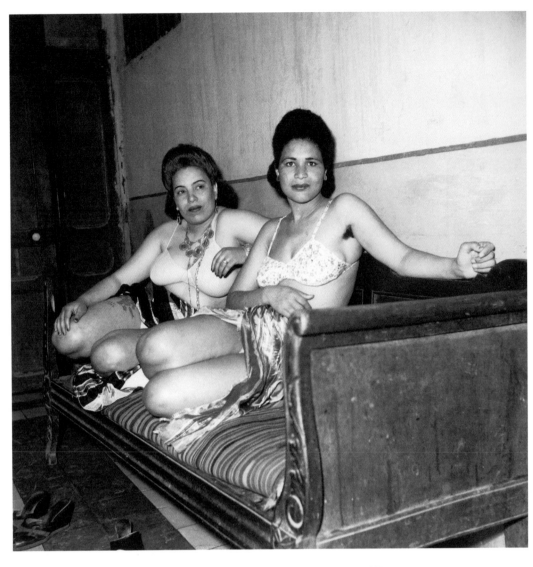

Denise Bellon, *Red-Light District*, Tunis, May–June 1947

From an affluent background, Denise Bellon trained as a photographer in the early 1930s with René Zuber and Pierre Boucher. As a young divorcee, and mother of two children, she was part of that community of women who, attracted by the independence the profession offered, embarked on the photographic adventure, in the studio or on the road.

Bellon herself was an instigator of this trend: in 1934, she was one of the founders of Alliance Photo agency, led by Maria Esner and the Zuber studio, alongside René Zuber, Pierre Boucher, Emeric Feher and Pierre Verger. Over the next few years, they were joined by Suzanne Laroche, Henri Cartier-Bresson, Chim (David Seymour) and Endre Friedmann (the future Robert Capa). A strong character and a free spirit, Bellon cultivated a style of her own, independent of any 'school'. Rolleiflex in hand, she produced reportages in France, but also in Morocco, Finland and eastern Europe. She also carried out photographic investigations of materials and forms, nudes and industrial landscapes. Her friendships with the actress Sylvia Bataille, André Breton and Jacques Prévert gave her an introduction into literary and artistic circles. She documented the exhibitions by the Surrealists and carried out reportages in the studios of many artists and sculptors, notably Yves Tanguy, Joan Miró, Jean Lurçat, André Derain and Antoine Pevsner.

Her images were published in numerous magazines, including *Paris Match*, *Regards*, *Art et médecine*, *Arts et métiers graphiques*, *Coronet*, *Lilliput*, *Paris Magazine*, *Plaisir de France*, *Revue de la S.A.G.A.*, *Beauté Magazine* and *Vu*. From 1940, she lived in unoccupied France, and continued her travels abroad after the Liberation, before settling in Paris in the mid-1950s. In the decade that followed, she produced many images on film sets, taken during shooting directed by her eldest daughter, the film-maker Yannick Bellon. She described her mother as follows: 'A young and attractive globetrotter, in love with freedom and independence […]. She had a taste for adventure, the unexpected, the challenge; she would have loved to be an explorer.' **JJ**

'Why did I choose photography? Because its magical side has always fascinated me. That by simply pressing a button, we can stop time, this eternal enemy, its perpetual anguish.'

DENISE BELLON

Zofia Chomętowska, *Walk on a Frozen Riverbank*, Polesia, 1930

Zofia Chomętowska was one of the most prominent and prolific Polish women photographers of the interwar period. The daughter of Bronisława Buchowiecka and Félix Drucki-Lubecki, Zofia was born in Porochońsk in Polesia (present-day Belarus), to a family of noble origin. Her first camera, a Kodak Box, was given to her by her grandfather when she was still a child. In 1927, while awaiting confirmation of the annulment of her marriage by the Vatican, Chomętowska bought her first small-format Leica. She quickly grasped all of its qualities and tried out its various possibilities – from then on, she would never be separated from it. Considered by many a camera for amateurs, in the course of time, the Leica nevertheless became the distinguishing feature of Chomętowska's oeuvre.

Her most interesting images were mainly produced between 1930 and 1935: portraits of peasants in neighbouring villages, market scenes, images of nature, dense, almost abstract. Chomętowska submitted her work to competitions held by specialist magazines, which paid off right from the start and earned her recognition from her peers. Her many contributions to exhibitions, individual or collective, and her admission to the elite Polish Photo-Club attest to her success.

Following her separation from Jakub Chomętowski, whom she had married in 1929, she settled in Warsaw and made photography her profession. Among her most significant commissions was a project carried out in 1936 for the Ministry of Communication: a series of views of cities and small towns in Poland, intended to decorate the compartments of railway carriages. In 1937, Chomętowska opened her own studio, where she produced advertising images and, a year later at the request of the mayor of Warsaw, conceived a documentary series illustrating the measures undertaken by the local administration. It showed the city's modern cleaning and waste management system, but also the neglected areas where intervention was required. With this series, presented on the eve of the Second World War at the National Museum in the exhibition *Warszawa wczoraj, dziś i jutro* (Warsaw yesterday, today and tomorrow), once again the photographer broke the conventions associated with her gender and her social class, women photographers being until then restricted to children's portraits and landscapes. Her negatives from before the war were miraculously saved from the burning city after the Warsaw uprising. In 1945, Chomętowska took hundreds of photographs of the Polish capital ravaged by war, not concentrating solely on the ruins, but also on the resurgence of life. A large selection of them was shown the same year in the famous exhibition *Warszawa Oskarża!* (Warsaw accuses!), which was to travel to London, Paris and New York.

In 1946, Chomętowska emigrated to Britain, where she contracted a marriage in name only with Robin Frood Barclay, an English aristocrat passionate about cycling. After spending several months in France and Italy, in September 1948, she left with her children for Argentina. Despite her efforts, Chomętowska would never again completely return to the photographic profession. Until the end of her life, however, she would devote herself to capturing everyday life, documenting reality as closely as possible. **KP-R**

The portrait, so often reproduced, of Pablo Picasso sitting on his staircase, face turned towards the light, is the work of the photographer Denise Colomb. Like many photographs that have become famous, it served the image of its subject more than the lasting fame of its author. Colomb was nevertheless, as a portraitist and reporter, a prolific and talented witness of the twentieth century.

A musician by training, Denise Loeb, as she was born, initially turned to photography as an amateur in the 1930s, during voyages in Indochina or the Maghreb with her husband, a marine engineer. In 1947, she started up as a professional photographer under the pseudonym Colomb. Until the 1960s, she practised portraiture, capturing the features of the artists of her time, beginning with the expressive and troubled face of Antonin Artaud. Through her brother, the gallery-owner Pierre Loeb, and then Christian Zervos, of *Cahiers d'Art* and François Mathey, from the Musée des Arts Décoratifs, she met many painters and sculptors.

Before her lens, Vieira da Silva, De Staël, Giacometti, Calder, Hartung, Miró, Richier, Soulages, Poliakoff, Sonia Delaunay, Ernst and César struck up a pose without affectation, surrounded by their works or their nearest and dearest, and allowed themselves be captured on the spot, while absorbed in their work. The photographer also recorded their surroundings, seeking to identify sources of inspiration and traces of creativity. Conceived in series, in black and white or in colour, her portraits convey at one and the same time the humanity, creative vivacity and aesthetic world of these artists.

Colomb also employed her talent as a portraitist with unknown figures, isolated and magnified in close-up, in her reportages. These constituted the other facet of her work: between 1948 and the 1970s, they led her to the covered markets of Paris and l'Île de Sein, the Netherlands and Israel, and were published in various illustrated magazines (*Point de vue-Images du monde*, *Réalités* ...). Invited by Aimé Césaire in 1948 to join an ethnographical expedition to the French Antilles to mark the centenary of the abolition of slavery, she produced her first major reportage: the street scenes and images of daily life that she took reveal not only her sense of composition but also a sincere humanism, characteristic of photographers of her generation. She returned in 1958 for a second reportage, at the request of the Compagnie Générale Transatlantique: this provided the opportunity to develop an approach in colour.

Exhibited regularly throughout the 1970s and 1980s, Colomb was appointed a member of the Ordre des Arts et des Lettres in 1981. In 1980, she donated a collection of more than four hundred prints representative of her entire oeuvre to the Bibliothèque Nationale, and in 1991, she bequeathed her archives to the French state: some fifty thousand of her negatives are now conserved at the Médiathèque de l'Architecture et du Patrimoine. **DV**

Denise Colomb, *Riopelle*, from the series 'Portraits of Artists', 1953

In November 1946, the *Bolétin del Club Fotográfico de Cuba* (Bulletin of the Photographic Club of Cuba) published on its cover the photograph *Josefina* by María de las Mercedes López de Quintana y Sartorio. Shortly before – under the name of Chea Quintana or Mercedes L. Quintana, her two signatures – she had won the gold medal for Cuba's Oriente province, the national Copa 'Kodak' Grand Prix, and an honourable mention in the club's regional competition. Quintana was the first woman to have her work published on the cover of the *Bolétin*; she was also the one who enjoyed the greatest recognition within the organization.

The Club Fotográfico de Cuba (1935–62) was the most important institution dedicated to artistic photography during the country's republican period (1902–59). Its rise coincided with the redefinition of the place of women in society. Their struggles to obtain equality, access to the public domain, and recognition of their status as a political and independent subject played a fundamental role in the generalization of the ideal of progress and development. The promulgation of laws relating to parental authority (1917), divorce (1918), women's right to vote (1934), and the recognition of the civil equality of spouses (1940) – which resulted from the consolidation of the feminist movement – constituted a favourable framework for the emancipation and participation of women in the economic and social life of the country.

After training to become a professional photographer in the studio of her father, Joaquín López de Quintana, Chea successfully opened her own studio in the family property in Tacajó (Oriente province) and specialized in family portraits. She received between fifteen and twenty people a day, while at the same time documenting the landscape surrounding the nearby sugar refinery. Around 1945, her name as well as those of her brother Manuel and sister Caridad appeared in the register of members of the Club Fotográfico de Cuba. Quintana began to work in other regions, particularly around the towns of Bayamo, Manzanillo, Victoria de las Tunas and Camagüey. In 1947, her photographs *La Dama del velo* (Lady with the veil) and *La Niña y el Gato* (Little girl and cat) were awarded the gold and bronze medals respectively in a regional competition. A year later, Quintana won first prize in the regional contest for *La Niña buena* (The good girl) and an honourable mention for *Katty y Potty* (Katty and Potty). The same year, she became patron of the first Cuban international exhibition of artistic photography. Keen to present her work on a national and international level, she attended photography courses in Havana and the United States in order to improve her technique.

Quintana embodied the aspirations of modern Cuban women: intellectual self-improvement, while playing an active role in public life. Running her own studio and exhibiting regularly in the club's salons, she not only defied the gender barriers traditionally assigned to women, she also created a precedent in making the work of women artists visible in the public sphere. **AD**

Chea Quintana, *Girl at Desk*, c. 1948

Margaret Michaelis, *Slum Children*, Barcelona, *c.*1934

The photographic practice of Margaret Michaelis (née Gross) was shaped by the major political and social events of the twentieth century. Born in Austria-Hungary, she studied at the Institute of Graphic Arts and Research in Vienna and worked at prominent studios run by women, including Dora Kallmus (Madame d'Ora) and Grete Kolliner. Between 1929 and 1933, she was employed by a number of studios in Berlin, but owing to her Jewish background and political radicalism, she was forced to flee to Spain after Hitler's rise to power.

In Barcelona, Michaelis became associated with the German anarcho-syndicalist group FAUD and made portraits of the anarchists Emma Goldman and Etta Federn. In 1934, she opened her own studio, foto elis, and subsequently produced important work for the progressive GATCPAC group of architects, who included Josep Lluís Sert. Michaelis's commitment to modernism is evident in her austere and strongly graphic architectural views. Some of her work was published in the radical journal *Actividad Contemporánea*. For GATCPAC, she also produced outstanding documentary photography highlighting the poor living conditions in neighbourhoods of Barcelona that the group sought to eradicate. GATCPAC's utopian ideals were never fulfilled owing to the outbreak of the Spanish Civil War in 1936. Michaelis's photographs from that year, which depict the activities of ordinary Catalonian citizens, are full of energy.

However, political events forced Michaelis to flee once again, first to Poland, and then to England, where she worked in domestic service. Through a humanitarian scheme, she received a visa for travel to Australia, arriving in Sydney in September 1939. Soon afterwards, Michaelis opened her own studio. Although subject to restrictions that affected the activities of so-called 'enemy aliens' during the war, she persisted with her business. Like many other European photographers, she did not distinguish between her commercial and private practices, and approached portraiture and dance photography as creative endeavours. Her portraits in particular stand out for their strong psychological dimension, reflecting an interest in psychology that had begun in Vienna.

In Australia, however – like many fellow migrants – Michaelis experienced feelings of uprootedness and solitude. She said of this time that she was exceptionally lonely and had not spoken 'from the sources of my real being' for many years. Owing to her poor mental health, she closed her studio in 1954 and ceased taking photographs. Her work was rediscovered in 1981 as a result of an exhibition entitled *Australian Women Photographers 1890–1950*. After her death, Michaelis's extensive archive entered the collections of the National Gallery of Australia in Canberra. **HE**[1]

Leni Riefenstahl embodies the anti-heroine par excellence – the incarnation of the artist ready to embrace all forms of transgression in order to achieve recognition. Born in Berlin at the beginning of the twentieth century, Riefenstahl identified in National Socialism a doctrine that corresponded to her own aesthetic concerns: the glorification of power, order and an idealized beauty. Despite never being a signed-up member of the Nazi Party, she became the regime's film-maker. The two films that she made at the Führer's request – *Triumph des Wilkens* (Triumph of the will), on the Nazi Party congress in Nuremberg in 1934, and *Olympia*, on the Berlin Olympics in 1936 – remain the most effective examples of Nazi propaganda and shaped the visual imagery of the Third Reich. Her ambition led her to take part in the worst atrocities, including filming gypsies interned in the concentration camps at the height of the war for her film *Tiefland*, which she would not complete until 1954.

As an adolescent, Riefenstahl studied painting and dance, notably under Mary Wigman. After promising debuts in 1923, she turned to the cinema. Her role in Arnold Fanck's *Der heilige Berg* (The holy mountain) in 1926 made her a star. In 1933, she set up her production company, and the following year she shot her first full-length feature film, *Das blaue Licht* (The blue light). When she wrote to Hitler that same year, it was as an affirmed artist. Her proximity to totalitarian power enabled her to reach the ultimate goal: at the height of the regime, it was she who represented her country and its cultural ambition abroad. The grand prize that she received from Édouard Daladier at the Exposition Universelle in Paris in 1937 and the Mussolini Cup at the Venice exhibition in 1938 marked the zenith of her achievement. The European intelligentsia jostled to meet this civilized ambassador of the Nazi regime.

The collapse of the Third Reich in 1945 signalled her own fall. Riefenstahl was the subject of three denazification trials and was banished from the world

'I have to tell you very openly that as a photographer I made myself acknowledge more than I would have liked.'

LENI RIEFENSTAHL

of culture. Although in 1937 she had published a first book of photographs, *Schönheit im Olympischen Kampf*, bringing together the most spectacular photograms from her 1936 film, her decision to turn later in life to this solitary and inexpensive art was motivated only by her failure to re-establish herself in the cinema.

In 1962, at the age of almost sixty, her discovery of a photograph of members of the Nuba tribe by George Rodger in the magazine *Stern* led her to travel to Sudan. The colour images that she took there were published in the major illustrated magazines of the time, including *Life* and *Paris Match*, and marked her gradual public rehabilitation. She was accredited by the *Sunday Times* as photographer for the Olympic Games in Munich in 1972. In 1974, she met Mick Jagger and was received in The Factory by Andy Warhol, who published her portrait of Bianca Jagger in his magazine *Interview* the following year.

Rather than the images taken during the second phase of her artistic career, it was nevertheless her Nazi propaganda work that she continued to consider her greatest achievement. Her public appearances were always controversial. Her final one was posthumous: the bequest of her archives to the German state in 2018, fifteen years after her death. **AF**

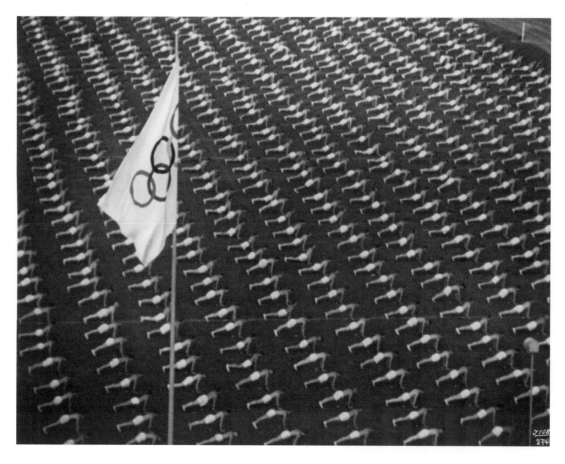

Attributed to Leni Riefenstahl, *Calisthenics in the Stadium*, Olympic Games, Berlin, 1936

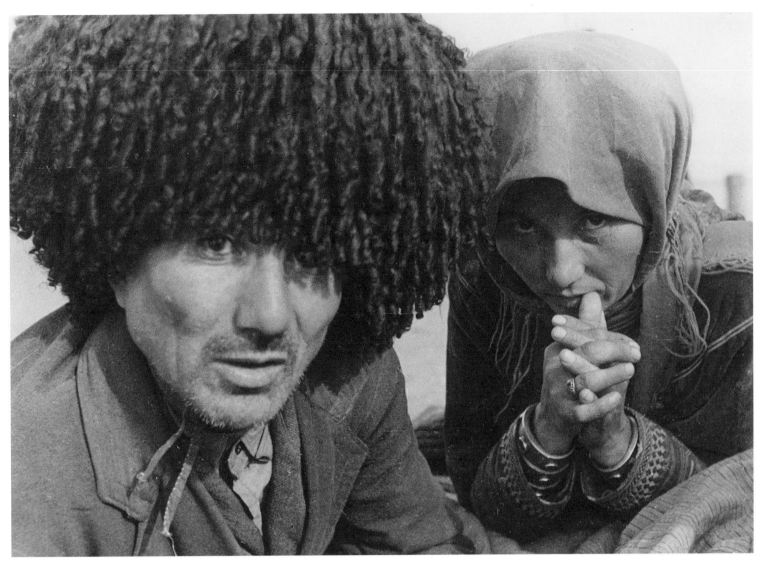

Ella Maillart, *Turkmen Couple Waiting for a Boat*, 1932

Ella Maillart travelled the world at a time when women rarely set off alone to follow their own path. The proliferation of illustrated magazines that appeared in the 1920s allowed her to turn her passion into a profession. Armed with a Leica, a notebook or typewriter, and, later, a 16mm film camera, she made travelling both the subject of her reportages and her way of life.

It was her curiosity and open-mindedness that drew Maillart to distant countries such as Afghanistan, India, Nepal and China, leading her to cross seas, steppes and mountains in order to meet people from different cultures. Motivated by her desire for personal exchange with others, she focused not on what was exotic but on the common human condition.

Ella Maillart handled her camera as if it were an extension of her eye, her body being the motor, and her senses, the means by which she perceived landscapes, architecture, sacred rituals and everyday life. Inhabiting a floating space between cultures, she knew how to immediately capture the essential, and often existential, aspects that unite all humans. The fact that she was always on the move had casually turned into a photographic method.

'If I belong nowhere –
that means I belong everywhere.'

ELLA MAILLART

Maillart's best photographs combine both an analytical and an empathetic gaze, letting the viewer guess at the social structures that governed her subjects' living conditions. She thus created iconic images of nomads, peasants, city-dwellers, women with veiled faces, exploited workers with little social status and carefree children. However, the photographer also had a sharp eye for the paradoxes of life, which sometimes bring a smile. The humorous and the serious become two sides of the same coin, and transform Maillart's photos into humanistic gifts that transcend concepts of time and space. She entrusted her photographic archives to the Musée de l'Élysée in Lausanne in 1989. **KS²**

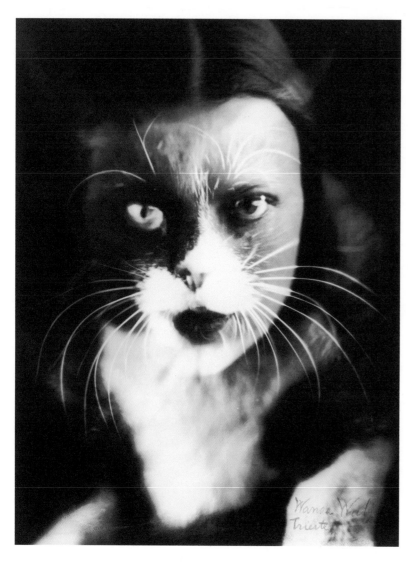

Wanda Wulz, *Me + Cat*, 1932

Wanda Wulz's reputation among historians of photography is based on a striking contrast. On the one hand, she appears in the history of photography owing to her a family legacy: in 1921, Wanda and her sister Marion inherited their father's well-established studio in Trieste. Until 1980, shortly before Wanda's death, the sisters continued the tradition of conventional middle-class portraiture that had made the studio's fortune. At the same time, beginning in the early 1930s, Wanda stepped boldly outside her classical training to explore the technical and poetic possibilities of the medium, creating six experimental works that she showcased at the second Mostra Fotografica Futurista in Trieste in 1932, to much acclaim. Among them was *Me + Cat* (1932), one of the most original works produced by an Italian photographer of the twentieth century and now a landmark of international modernism. Falling between these two extremes – the commercial portrait photographer and the daring avant-gardist – much of Wulz's outstanding talent and artistic trajectory remain unexplored. Indeed, well before her participation in the Futurist exhibition, Wulz was testing less-traditional portrait styles, moving away from the Pictorialist approach in which her father excelled and towards sophisticated reflections on gender and the art of portraiture, radically realist works, and collaborations with painters and designers.

The six photographs that Wanda Wulz presented in 1932 at the second Futurist photography exhibition mark the peak of her experimental period. In *Me + Cat*, Wulz superimposes a close-up of her cat, Mucincina, over a photograph of her own face. Although some critics have read this image as a traditional representation of female 'mystery', Wulz's human–animal hybrid is playful rather than mysterious: it explores creatively, and with great technical sophistication, themes of identity and the connection between species. Some of the other prints that she exhibited were engaging experiments in Surrealism that played with the viewer's expectations and the photographic medium's supposed objectivity, questioning the stability of both support and visual content.

Following this phase of public experimentation, Wulz continued to explore the trope of the individual and family portrait in her commercial output, capturing female subjects in non-traditional roles and probing the themes of double and family identities. Her archive – which covers six decades and is the only one by an Italian woman photographer to be included in the Fratelli Alinari collection – is a treasure yet to be explored, just as Wulz's role as an innovator in photographic portraiture still awaits to be fully acknowledged. **SV**[1]

Gertrudes Altschul was a pioneering Brazilian photographer and one of the few women to have participated in the developing modern photography scene in mid-century São Paulo. She moved to Brazil in 1937, with her husband and young son, to flee from the Nazi regime in Germany. The city of São Paulo was flourishing, its artistic scene enriched by the opening of new institutions, and an influx of migrants contributing to its economy and culture. In 1952, she joined the Foto Cine Clube Bandeirante (FCCB); like the images produced by other members, Altschul's work reflected formal characteristics often linked to European and American modernist photography from the interwar years: a break with classical rules of composition, frequent use of chiaroscuro, an emphasis on strong lines, and a focus on abstract elements and geometric motifs.

Altschul also looked to the growing city and its modern buildings for inspiration, as in the elegant photograph *Linhas e Tons* (Lines and tones, *c*.1952) that featured on the cover of the FCCB bulletin in 1953, in which she captured a striking juxtaposition of built structures. The undated *Arquitetura ou Triângulo ou Composição* (Architecture or triangle or composition), meanwhile, reads more ominously: here, the photographer has captured three buildings as if they were on an inevitable collision course. Altschul also displayed a sustained interest in photographing plants, a subject that showcased her willingness to experiment: her pictures of foliage include photograms, solarizations and photomontages. *Filigree* (*c*.1952), a close-up of a papaya leaf, is one of her earliest and most celebrated photographs. Like several others from this time, the print has a number of stamps and labels on the back, revealing her participation in and distinctions received at both regional and international exhibitions.

When Altschul passed away in 1962, an obituary published in her club newsletter lamented the fact that 'the FCCB and Brazilian photography have lost one of its most legitimate expressions, an artist of fine sensibility who honoured the country she adopted as her homeland, participating with distinction in various international salons'. Moreover, FCCB members recognized Altschul as a *bandeirante* (pioneer) who 'project[ed] herself among few international female names consecrated to photography'.

In recent years, Altschul's photographs have been displayed at the São Paulo Museum of Art (2015–16) and the Museum of Modern Art, New York (2017), as part of exhibitions that celebrated her participation as a female artist during a key period of photographic innovation in Brazil. Her pictures provide an enduring testimony of her commitment to the medium and her integration into the cultural life of a country she embraced as her own. **PK**

Gertrudes Altschul, *Untitled*, *c*.1952

Gwendolyn Morris spent most of her childhood in Adelaide. The city was home to a vibrant photographic community that had pioneered the introduction of Pictorialism to Australia, and the Art Gallery of South Australia established a photography collection as early as 1922. Morris was one of several women photographers whose work was purchased by the gallery during the 1920s and 1930s; they all came from wealthy Adelaide families, could afford to travel, and used photography to pursue their artistic interests in Australia and Europe.

In 1927, Morris left for London, where in 1929 she completed a year-long photography course at the London Polytechnic. The pictures that she took of the capital combine the soft-toned, atmospheric moodiness of Pictorialism with an awareness of modernist principles of composition acquired during her formal studies. Morris subsequently worked as a photographer at the studios of the BBC, photographing radio personalities and their guests for the *Listener* and the *Radio Times* magazines.

Morris's significance, though, lies in the artistic photographs that she created in her spare time, inspired by the architecture and mood of her London surroundings. At this time, the BBC was located just off the Strand, near Waterloo Bridge, and Morris spent her lunchtimes 'wandering all about the streets between the Embankment and Covent Garden and the Strand and Trafalgar Square'. On occasions, she returned to these sites at the end of the day, drawn to the mysterious beauty and atmosphere of the city at night, when artificial light illuminated the gloom and created reflections on rain-soaked surfaces or on the murky waters of the Thames. As she wrote on the back of one of these nocturnal views, 'the river is most fascinating at night'.

The way in which some of Morris's works are framed by a black crayon border and signed with a flourish indicate that she was actively exhibiting her work. Her photographic practice diminished from 1934 owing to marriage, motherhood and life in rural England.

Morris remained little known until research for the exhibition *A Century in Focus: South Australian Photography 1840s–1940s* at the Art Gallery of South Australia (2007) revealed her married name: Gwendolyn Wilmot-Griffiths. Her son, Hugh, subsequently donated her camera, a Newman & Guardia New Special Sibyl, and forty-eight prints to the gallery. **JR**

Gwendolyn Morris, *Adelphi Arches*, London, c. 1930

Margaret Bourke-White, *Diversion Tunnel Construction*, Fort Peck, Montana, 1936

Although recognized and admired from the 1930s, American photographer Margaret Bourke-White occupies an ambivalent critical place in the history of photography. Often celebrated as an exceptional photojournalist, particularly for her reportage work published in *Life* from 1930 to 1950, notably the liberation of the Nazi concentration camp at Buchenwald in April 1945, she was also the object of virulent and often misogynistic attacks, directed particularly at her financial success, the quality of her clothes and her love of sporting activities (riding, for example), especially following the publication of her book *You Have Seen their Faces* (1937). Published in collaboration with the writer Erskine Caldwell, this work on the poor sharecroppers and farmers of the American South was accused of sensationalism and contempt for the subjects photographed. From the 1960s, the book was judged contrary to documentary orthodoxy, which contributed to hindering Bourke-White's institutional recognition.

From the 1920s to the 1950s, Bourke-White pursued a career that covered various genres, moving swiftly from advertising and publicity for large American industrial conglomerations to commissions for *Fortune* and *Life* magazines, and the publication of personal books. These projects often overlapped and the same images were sometimes repeated in different media. In order to respond to this multiplicity, the photographer varied her formal approach: her shoots for advertisements or for the glossy magazine *Fortune*, for which she illustrated the first issue in 1930, are striking for their modernist compositions, reflecting a love of industrial buildings and machinery. The graphic qualities of her images, which emphasize the monumentality of the buildings and industrial plants, highlight the miracles of the engineering, power, stability and efficiency of the American economy as promoted by the publishers of *Fortune*, as well as satisfying the advertising needs of the clients of Bourke-White, whose studio was flourishing at the time.

In the mid-1930s, Bourke-White adopted a more frontal and distanced documentary style for certain commissions, before returning for the remainder of her career to a candid aesthetic taken from the realm of war reporting. This fluidity with which she moved from one field to another and the diversity of her areas of interest reveal a figure widely unacknowledged, even scorned, in the historiography, that of a professional capable of adapting to circumstances and of seizing the opportunities presented to her. Her publications certainly benefited from a recognition that extended beyond the realm of the press. In 1937, Beaumont Newhall included five of her prints in his historic exhibition *Photography 1839–1937* at the Museum of Modern Art in New York. Nonetheless, the controversy that had arisen around Bourke-White in the 1930s limited this institutional legitimization throughout the twentieth century. **GM²**

'It seems to me that while it is very important to get a striking picture of a line of smoke stacks or a row of dynamos, it is becoming more and more important to reflect that life that goes on behind these photographs.'

MARGARET BOURKE-WHITE

'No definition can deny the significance of photography in the social, political and emotional life of people today.'

GRETE STERN

Born into a German Jewish middle-class family, Grete Stern began her career in the late 1920s in Berlin, a city experiencing both the political and social tensions of the Weimar Republic and the effervescence of avant-garde literary and artistic circles. The capital of the Reich was the crucible for the two major movements in photographic modernism – New Vision and New Objectivity – which, combined with the revival in the fields of typography and graphic design, led in part by the Bauhaus school, reinvented the usages of the medium in the press and advertising.

After studying at the School of Applied Arts in Stuttgart between 1923 and 1925, Stern worked as an advertising designer. In 1927, she moved to Berlin and met the photographer Umbo (Otto Umbehr), a former student at the Bauhaus, who advised her to train with the professional photographer Walter Peterhans. Ellen Auerbach, Stern's future associate, joined her shortly afterwards as Peterhans's private student.

When Peterhans was appointed professor at the Bauhaus in 1929, Stern and Auerbach followed him and intermittently attended the school. Stern purchased Peterhans's equipment and opened a studio in partnership with Auerbach, with whom she shared an aesthetic complicity and left-leaning political affinities. Founded in 1930 and named 'Ringl + Pit', the studio specialized in portraits, landscape and advertising, which was thriving at that time. Working together, Stern and Auerbach introduced humour and poetic fantasy into careful compositions, intended to glorify hair or pharmaceutical products or cigarettes.

Hitler's rise to power brought the studio's work to an end and forced the two photographers into exile. While Auerbach left for Palestine, in 1933 Stern moved to London, where she joined her companion Horacio Coppola, an Argentinian photographer whom she had met at the Bauhaus. Stern continued to work as Ringl + Pit alone, while producing a series of portraits of fellow German political exiles, including the playwright Bertolt Brecht and the psychiatrist Paula Heimann.

In 1935, Stern left London for Buenos Aires, where she mixed with the community of anti-fascist intellectuals, authors and artists who gravitated around the magazine *Sur*, edited by the feminist writer Victoria Ocampo. She also took up once again the practice of photomontage in the series 'Sueños' ('Dreams'), conceived between 1948 and 1950 for the woman's magazine *Idilio*. Stern used images, imbued with dreamlike Surrealism, to illustrate psychoanalytic accounts of the dreams and anxieties of modern Argentinian women: domestic servitude, fear of motherhood, sexual inhibition.

After having run the photography studio of the Buenos Aires Fine Arts Museum (1956–70), Stern ceased working in the 1980s but continued to share with an entire generation of Argentinian artists and photographers her passion for photography in both its aesthetic and social aspects. **DA**

Grete Stern, *Who Will She Be?*, from the series 'Dreams' (No. 17), 1949

Galina San'ko, *Prisoners of Fascism*, Petrozavodsk, Russia, 1944

Along with Natalia Bode, Olga Ignatovitch and Olga Lander, Galina San'ko was one of the few female Soviet photojournalists to have covered the Second World War. When conflict broke out, she was already an established photographer, having produced numerous images of the Kamchatka Peninsula for the leading Soviet propaganda magazine *USSR in Construction*, which focused on the country's industrialization policies.

San'ko took part in an expedition to the eastern region of the Soviet Union, travelling on the *Krasin* ice-breaker, but, when her husband died early in the war, she enlisted in active service. Soviet photojournalists had combat status and, since they were often part of field action, they were accustomed to working in dangerous conditions. San'ko followed the Soviet troops to Stalingrad and Manchuria, and in 1942 was awarded a medal for merit in combat. With little biographical information, we can only guess at her motives. Decades later, in the 1960s, the Soviet people mythologized her as part of the generation that had won the war. Having adopted the Robert Capa motto 'If your pictures aren't good enough, you aren't close enough', San'ko went down in photographic history as a heroine, conforming to stereotypical notions of photojournalism that were usually associated with traditionally masculine traits.

Perhaps the most dramatic war image in San'ko's oeuvre is of a peasant family walking barefoot in the road (*Homecoming*, 1943) – a visual equivalent of the realist tradition in Russian literature. In the 1960s, she stood out thanks to her ability to incorporate her war photographs into the visual narrative of the 'thaw' that followed the death of Stalin. She managed to track down one of the subjects of her wartime image *Prisoners of Fascism* (1944) – which depicted child prisoners in a Finnish-run transfer camp in Petrozavodsk, the capital of Eastern Karelia, then part of the Soviet Union and now in Russia – and made a portrait of her twenty years on as a mother and a professional. The resulting diptych became emblematic of individuals' ability to recover from the atrocities of war, but also caused controversy centred on the status of women in the USSR.

A 1966 film called *Dikiy myod* (Wild honey), directed by Vladimir Chebotaryov and largely inspired by the life of San'ko, sought to question the photographer's resilience and the account of a young woman raised to the rank of heroine who, in the end, admits that she has failed to achieve happiness. Unlike her movie incarnation, however, San'ko did not seem to be conflicted with her past. She died in 1981, with no known family. **DP[1]**

Claude Cahun,
Untitled [Hands], *c.*1936–9

Ergy Landau,
Untitled [Mannequins], 1927

Attributed to Leni Riefenstahl,
Untitled, 1936

Yva, *Climbing the Stairs*, Berlin, c. 1935

Gertrude Fehr, advertisement for
the newspaper *L'Oeuvre*, 1929

Ilse Bing, *Can-Can,
Moulin Rouge*, Paris, 1931

Yvonne Chevalier,
100 Kilometres an Hour, c. 1930

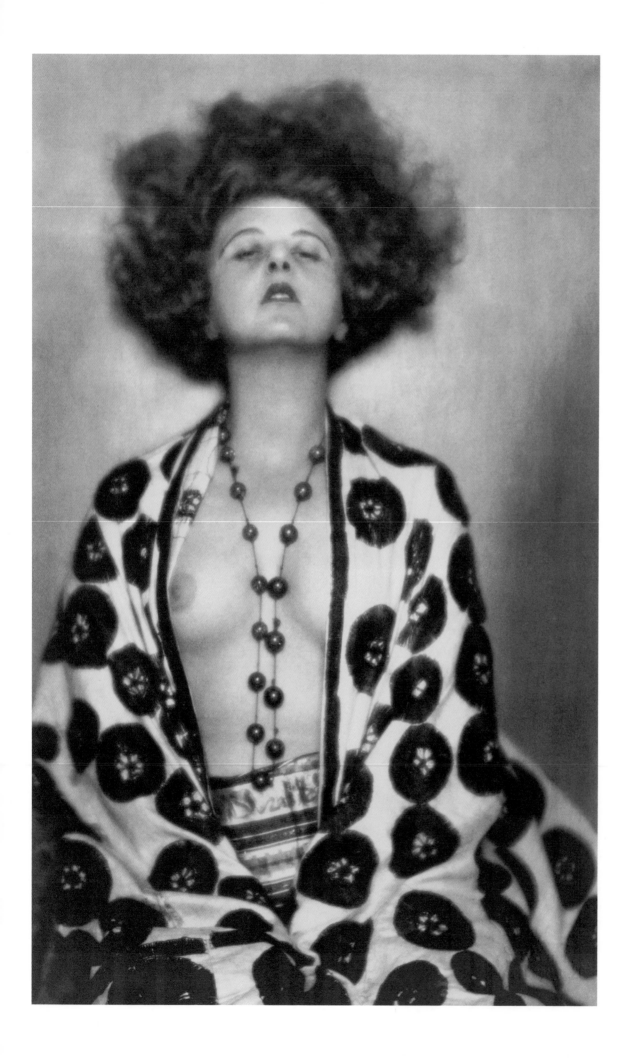

Madame d'Ora, *Portrait of the
Dancer Elsie Altmann-Loos*, 1924

Elsie Knocker and Mairi Chisholm,
Shell Burst at Pervyse, Belgium, c.1914

Tina Modotti,
Open Doors, Mexico, 1925

Nora Dumas,
Seated Female Nude, Arms Bent,
Hands Behind Head [Assia?], 1933

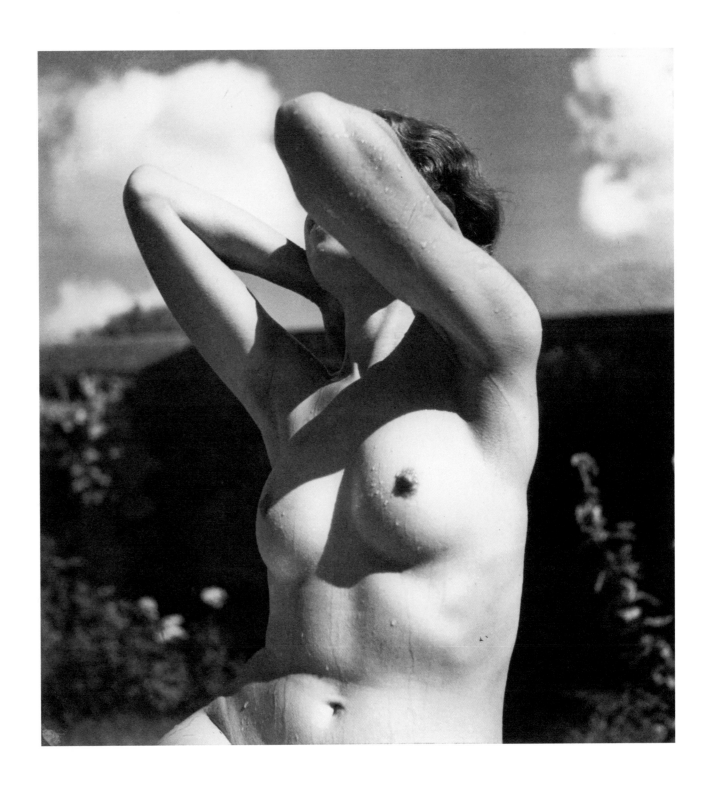

Florence Henri, *Composition
(Bobbins and Mirrors)*, 1928

Margaret Watkins,
Domestic Symphony, 1919

Gertrudes Altschul,
Lines and Tones, c. 1952

193

Aenne Biermann,
Coconut, c. 1929–30

Laure Albin Guillot,
Nude Study, 1939

Nelly, *Untitled* collage displayed
in the Greek Pavilion at the
New York World's Fair, 1939

Berenice Abbott,
Park Avenue and 39th Street,
New York, 8 October 1936

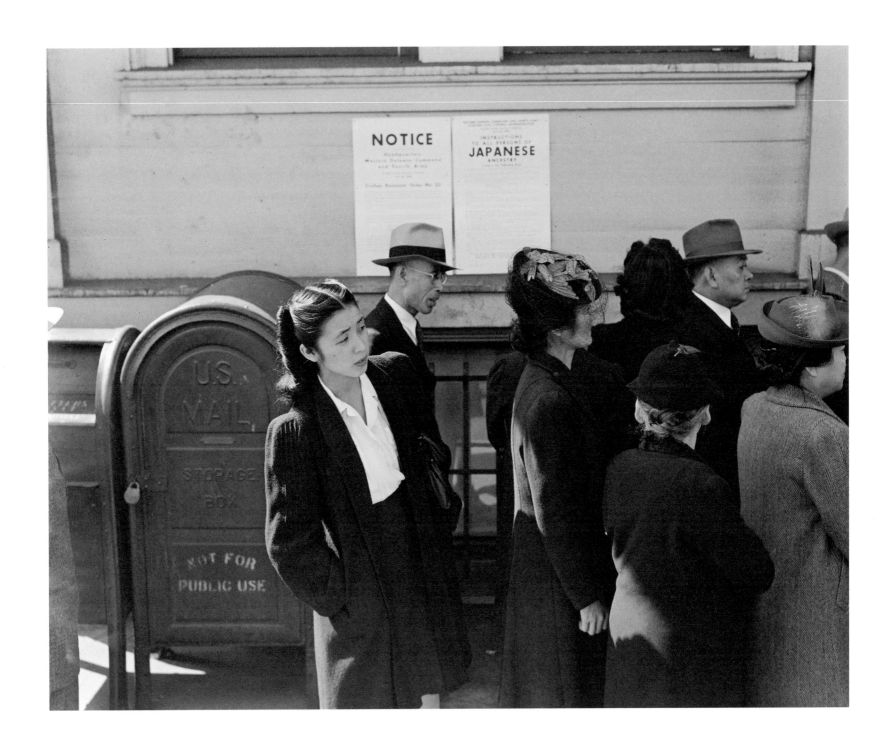

Louise Dahl-Wolfe,
Bijou Theatre, Nashville,
Tennessee, 1932

Dorothea Lange, *San Francisco*,
California, 25 April 1942

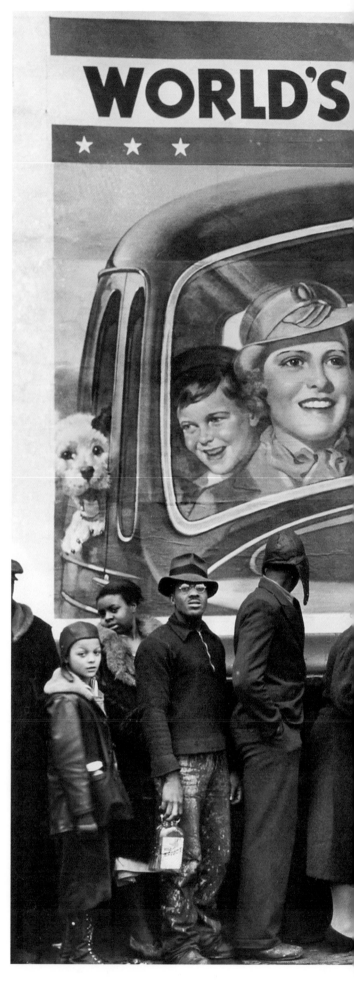

Margaret Bourke-White,
At the Time of the Louisville Flood,
Kentucky, 1937

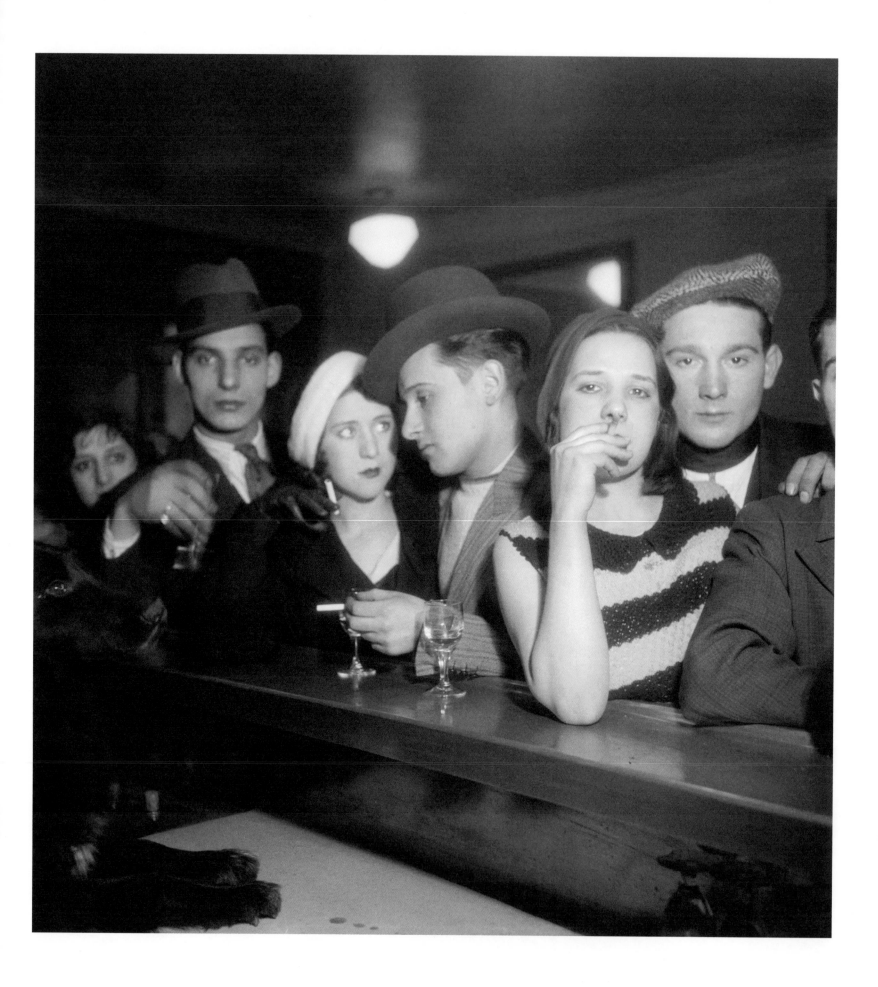

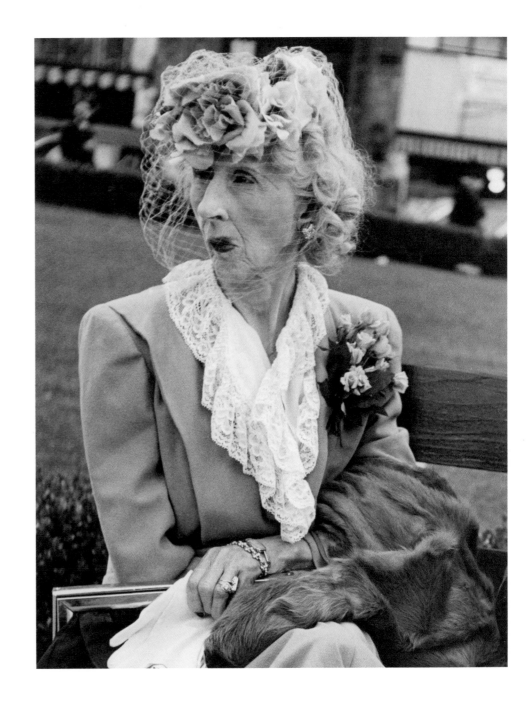

Germaine Krull,
*Paris, A Group of Young
People at a Bar*, c. 1927

Lisette Model, *Woman with Veil,
San Francisco*, California, 1949

In a series of photographs taken in 1934, Rogi André makes use of optical trickery to capture the slender body of a woman swimming underwater. The naked figure glides effortlessly and creates ripples across the image, circumventing linear perspective and clarity. She seems to be emerging from a watery dream.

The subject is Jacqueline Lamba, future painter and wife of André Breton, who, after studying art, earned a living performing in a water tank at the Coliseum, a nightclub in Pigalle. In photographing this music-hall mermaid, Rogi André adds flesh to the Surrealist fantasy. She shows the unknown woman, made elusive by her half-siren, half-animal nature, near and yet far away, behind a panel of glass. She is a white arrow, a wave, part of an erotic dynamic of liquids. This photograph, in which the female anatomy still remains intelligible, was published in *Minotaure* in 1935, then in Breton's *L'Amour fou* in 1937 as an illustration of an Ondine-like figure who has 'the air of swimming' and with whom the poet falls in love. In other images, Lamba seems to mutate, sometimes bordering on monstrousness, and throwing into question the indexical nature of photography. She is a volatile entity, always dual, reflecting the principle of oppositions so beloved of Surrealist theory since she simultaneously belongs to the air and the water, the beautiful and the deformed, the mobile and the immobile. Rogi André accentuates Lamba's mystery by experimenting with visual effects learned from her former husband, André Kertész, who had taught her photography during their brief marriage. To depict the effects of the distorting sensuality of the water at the Coliseum, she used a lens specially adapted by Kertész and a mirror. She made his knowledge her own, as well as his first name, which she adopted as a pseudonym.

Of Hungarian origin and trained at the School of Fine Arts in Budapest, Rosa Klein, to give her real name, moved to Paris around 1925 and took up photography in 1928. Her primary subject was light, which her work as a portraitist allowed her to carefully control, in order to suit the relief forms of the faces and bodies of her subjects.

From 1930 and for the next twenty years, Rogi André dedicated herself to the art of the portrait, abandoning all artifice. Simplicity and frontality were the keys to the minimalist approach that she used to capture the literary and artistic personalities of her time, at home, going about their everyday tasks: Ernst, Picasso, Maar, Léger, Duchamp, Mondrian, Matisse, Artaud, Gide, and Colette, who wrote in a dedication that she owed Rogi André for 'making me still look like a woman'. Her uncompromising gaze allowed her models to stand out, in an elegant demonstration of the 'erasure of the photographer before the photographed', in the words of the art critic Renée Beslon. Her portraits have a poise, a quiet strength, as if she lost all sense of doubt in front of the subject to be captured, shaped by the light. **AA**[1]

'The personality of the [camera] operator is to be found unwittingly in the slightest snapshot he produces. An incomprehensible but undeniable alchemy takes place between the gaze of his mind and the beam of light captured by his instrument.'

ROGI ANDRÉ

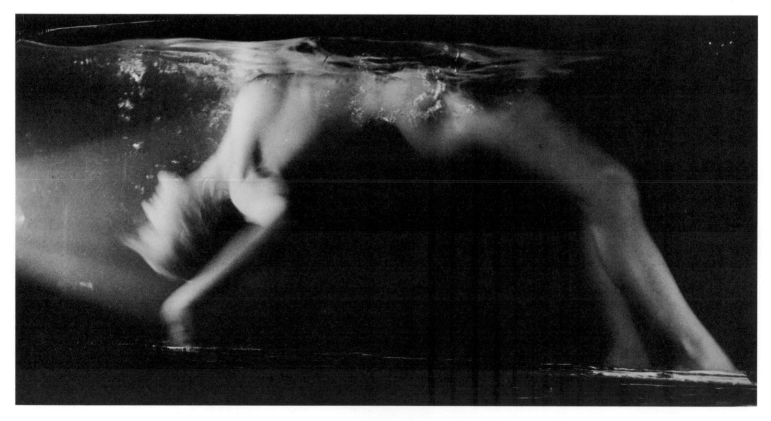

Rogi André, *Jacqueline Lamba in a Tank of Water*, 1935

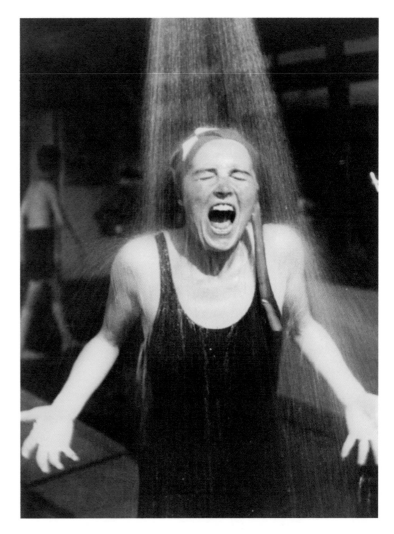

Elisabeth Hase, *Untitled [Woman in the shower]*, c. 1932

'I will never consider the way
a male photographer sees the
world as the only way.'

ELISABETH HASE

Born in Doehlen near Leipzig, Elisabeth Hase studied typography and graphic design at the Städelschule art school in Frankfurt am Main. Hase – who kept her maiden name all her life – was determined to become a photographer. She documented the evolution of Germany between the Weimar Republic and the Third Reich and the devastation that followed the Second World War. Throughout this period, she kept most of her artistic photographs secret, fearing the Nazis' brutal censorship of so-called 'degenerate' art: their term for modern art in general, but in particular works that played with perspective in the style of the Neue Sachlichkeit (New Objectivity) movement or that questioned traditional gender roles. Hase explored her own identity through role-playing: sobbing in the face of a man who seems to be judging her; screaming under an outdoor shower as if she were in mortal danger; undressing, shyly and awkwardly, step by step, in a series of photos until she is naked.

'The object changes its meaning, if I change my view of the object. In front of my camera it happily does what I want it to do', Hase wrote in her diary in 1934, as she pondered the question of how to give the objects in her photos a meaningful or Surrealist appearance. Her 'installations' can be full of drama or highly ambiguous, or they can convey a sense of humour: an iron resting on burnt cloth releases a fog of steam; a still life of a tower is built out of matchboxes; dolls photographed in stark close-up reflect women's idealization of babies.

In 1945, Hase was the only woman authorized by the US military to document the ruins of Frankfurt am Main. She wrote in her diary: 'From now on I will find sceneries I could never have invented – dramatic images built of cruel reality.'

Hase's commitment to photography remained undimmed during years marked by poverty, political threats and the difficulties of rebuilding her studio after the war. Her archives, which include original prints, glass and film negatives, private and business correspondence and her personal diaries, are evidence of the different eras she traversed. Today her work can be found in private collections and in numerous museums, including the Museum of Modern Art and the Metropolitan Museum in New York; the Museum Folkwang in Essen; the Albertina in Vienna; and the Walter Gropius Collection in the Bauhaus-Archiv in Berlin. **NS**

Ellen Auerbach's photographic work is especially marked by her personal circumstances and successive migrations. Within the space of eight years, from 1929 to 1937, the photographer moved to four new cities in four countries and worked in three different studios. As a result, her oeuvre, which covers a wide range of subjects, from advertising to landscape and portraiture, is catalogued under many names, none of them her maiden name, Ellen Rosenberg. Her ability to see with what she called her 'third eye' allowed her to perceive the essence of an object beyond its superficial appearance.

Living in Berlin in 1929, Ellen Rosenberg, who was Jewish, studied briefly under Walter Peterhans, a teacher at the Bauhaus, before beginning her career. Along with Grete Stern, a fellow student of Peterhans, Rosenberg opened a studio that they called 'Ringl + Pit' after their childhood nicknames. They produced numerous close-up portraits and advertising images, often accompanied by an ironic commentary on contemporary ideals of feminine beauty. In their advert for Pétrole Hahn hair lotion, for instance, a plastic mannequin dressed in an old-fashioned nightgown possesses the perfect attributes of the period (small mouth, narrow eyebrows, short haircut), but it is a human hand that holds up the product. When they were rediscovered in the 1980s, the two photographers who made up Ringl + Pit were celebrated as 'new women' because they were unmarried, working females who had shared a business as well as a flat. In reality, however, their modern lifestyle was possible only because Grete had received a family inheritance.

The two left Germany when Hitler came to power in 1933, before their Berlin studio had been able to establish itself. Rosenberg moved to Palestine, where she received commissions from the Jewish National Fund and the International Zionist Women's Organization. After working for three years as a photographer of children at the Ishon (Eye) studio in Tel Aviv alongside her boyfriend Walter Auerbach and friend Liselotte Grschebina, Rosenberg moved to London and spent some months working with Stern once more.

Unable to obtain a residence permit in the Britain, however, Ellen – now married and using her husband's surname – emigrated to the United States in 1937. She continued to sign her work 'Ellen Auerbach' even after the couple's separation in 1944 but never opened another studio. She took portraits of children and of her artist friends, notably the dancer Renate Schottelius, but abandoned studio photography in favour of a more dynamic approach. The images that she brought back from her travels in Europe and South America in the 1950s are evidence of the acuity of her gaze.

Despite obtaining commissions for magazines such as *Life*, Auerbach gave up photography and became an educational therapist in 1965, working with children with learning difficulties. In addition to her photographic output, she produced three short films, as well as three documentaries on Tel Aviv and the lives of children during the 1930s and 1940s. **CB**[1]

Ellen Auerbach, *Fragment of a Bride*, 1930

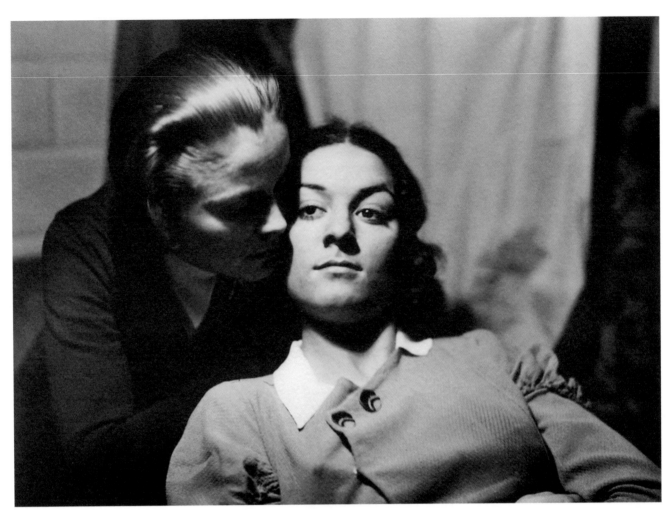

Veronika Šleivyte, *Self-portrait with Friend,* Viktariškes, Lithuania, c.1930

Veronika Šleivytė described herself as a graphic artist and painter, but did not mention the fact that she was also a photographer. She spent her childhood in a rural setting but soon realized that she wanted to be an artist. After moving to Kaunas (at that time the capital of Lithuania) to study, Šleivytė organized women's art exhibitions, co-founded and chaired the Women's Artist Community and fought against social inequality. She thus became a prominent personality on the Kaunas art scene, even if her graphic works revealed themselves to be rather ordinary.

It was in fact through photography that Šleivytė became known to the Lithuanian public: her images of the art world, personalities and important events of the interwar years appeared in periodicals alongside the work of eminent photographers of the period. The fact that she belonged to the Photographers' Society and participated in photography exhibitions suggests that she considered the medium not simply as a means of recording events, but as a form of artistic expression. However, when it comes to the images that she decided to exhibit, Šleivytė was no innovator: her work did not stand out significantly within the general context of interwar art photography, which was dominated by ethnographic and social themes and portraiture.

Šleivytė's most interesting photographs were not intended for public display, but for herself and her relatives. It is no longer documentary work, but instead forms a kind of a visual diary. Every time she took pictures of relatives, friends or loved ones, she always inserted herself into the frame, thus creating a kind of setting for her own self-image. She often supplemented her photographs with personal notes that change our perception of the image in question.

Šleivytė also used the self-portrait genre with great creativity. She observed and captured the transformation of her identity by constructing multiple images of herself, as if she were looking to discover who she really was. Here we can read the signs of introspection, self-identification, sexual questioning, and the search for an identity as a woman artist. She also experimented with double exposures, perhaps in an attempt to express her sense of the duality of life and of her own personality.

Šleivytė's photographs record her intimate friendships with women. Her diary, entitled *The Film of the Life of V. Šleivytė 1952–1953,* is a complete work on the subject of love, combining photographs, extracts from letters and brief commentaries to tell the story of her attachment to one woman.

Veronika Šleivytė proved to be an astute observer and committed documenter of everyday life. Her self-portraits reveal her to have been a modern, courageous and extremely charismatic creator who stands out not only in a national context, but also against the backdrop of international photography in the 1930s. **IM-S**

Lola Álvarez Bravo

1907–1993, Mexico

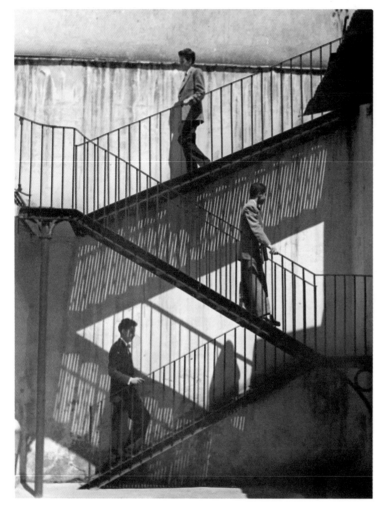

Lola Álvarez Bravo, *Some Go Up and Others Go Down*, Mexico, 1940

'If there is anything useful in my photography,
it is to be an account of my country.'

LOLA ÁLVAREZ BRAVO

Born on the west coast of Mexico, Dolores, known as 'Lola', Martinez de Anda moved with her father to Mexico City at the age of three. When he died, she went to live with the family of her half-brother. Highly independent, she rejected the Catholic and conservative education that she had received, and at the age of eighteen married Manuel Álvarez Bravo, her childhood friend. The couple settled in Oaxaca. Working as an accountant, Manuel took his first photographs with Lola's assistance. It was in Oaxaca that the young woman also took up the camera.

Returning to Mexico City in 1927, the couple opened an art gallery, where they promoted the work of the artists José Clemente Orozco, David Alfaro Siqueiros and Rufino Tamayo, as well as their own experimental photographs. In 1931, with the help of other artists and intellectuals, they founded the Cine Club Mexicano. The same year, the couple were awarded prizes for their 'modern photographs' in the competition run by Cementera Tolteca: Manuel won first prize for *Tríptico Cemento* (Cement triptych) and Lola, third prize for *Cemento forma* (Cement form).

Initially her husband's accomplice and assistant, Lola Álvarez Bravo soon formed her own style. After Manuel was forced to stop working for health reasons, she replaced him as photographer for the magazine *Mexican Folkways*, directed by the ethnologist Frances Toor. Following their separation in 1934, Lola rented a room from the artist María Izquierdo and organized with her an exhibition of women artists. Both joined the recently established Liga de Escritores y Artistas Revolucionarios (LEAR). It was at this time that Lola

Álvarez Bravo made photography her profession, in response to various commissions from publications and for portraits. Between 1935 and 1936, Álvarez Bravo worked for the Secretaría de Educación Pública, producing constructivist photomontages that appeared in the newspaper *El Maestro Rural*. In 1937, employed by the Instituto de Investigaciones Estéticas, she photographed colonial choir stalls in San Ildefonso; for this commission, she had to publicly assert her rights as an artist. Throughout this period, she collaborated with magazines such as *Voz* and *Vea* – where she was usually the only woman photojournalist – and published her avant-garde photomontages in *Frente a Frente* (LEAR's magazine).

An active advocate for modern art, she opened a gallery in 1951 in a former garage. In 1953, she presented there the only exhibition of the work of Frida Kahlo – of whom she would take some remarkable portraits – to be held in the artist's lifetime. In 1955, one of her photographs was published in *The Family of Man*, the catalogue accompanying the major exhibition organized by Edward Steichen at the Museum of Modern Art in New York.

Warm and affectionate by nature, Álvarez Bravo distinguished herself in the great art of portraiture and the innovative use that she made of photomontage. The legacy of her work continued in the socially engaged personality of her colleague Tina Modotti – a spirit that her pupils, notably Mariana Yampolsky, would inherit. Following her death in 1993, the Centre for Creative Photography, located on the campus of the University of Arizona in Tucson, acquired her oeuvre. **LG-F**

Aurora Falcón May, born in Chillán in Chile in 1907, was the eldest daughter of Francisco Falcón, who died when she was still a young child, and Aurora May. Widowed, Aurora married the pianist and composer Armando Vidal, who decided to move the entire family to Paris. The young Aurora, nicknamed 'Lola', lived for much of her youth in the French capital during the Roaring Twenties, at the very heart of the transformations in society, artistic production and the women's emancipation movement. Returning to Chile in the 1930s, Falcón married the writer Luis Enrique Délano; the couple went to live in Madrid in 1934. After several difficult years, her husband embarked on a diplomatic career, resulting in a life of incessant travelling all over the world. It was at this time that Falcón developed an interest in photography and that her son Enrique was born, later nicknamed 'Poli' by the great Chilean poet Pablo Neruda, a close family friend. Although during her time in Madrid photography had simply been a passion, it became a profession for Falcón, who had moved to New York in the late 1940s. She trained with the American photographer Berenice Abbott, then studied under the person who would become her mentor, the German Josef Breitenbach.

Her New York home became a meeting place for friends, renowned Latin American intellectuals and artists, with whom she shared a taste for Bohemian life. Falcón produced their portraits, thus helping to promote their careers. However, it was photographing in the street that fully allowed her to express her vocation freely. During this time, Falcón developed a style that was to remain her signature for the rest of her life. Her oeuvre consists of square-format black-and-white images, taken with a Rolleiflex. As the camera's viewfinder was in the upper part of the case, the photographer was able to look at waist height and release the shutter discreetly, without risk of interrupting the scene unfolding before her. This detail was essential to remaining incognito and capturing scenes on the spot.

While it is true that Lola Falcón May was a prolific photographer who tackled very different genres (studio portraits, architecture, landscapes), it is above all her treatment of social subjects – daily life, workers, children, the poor – that illustrates the sharpness of her eye. In keeping with the tradition of documentary photography, her work was tied to a political stance, which is expressed in the social and committed content of her images. **AA²**

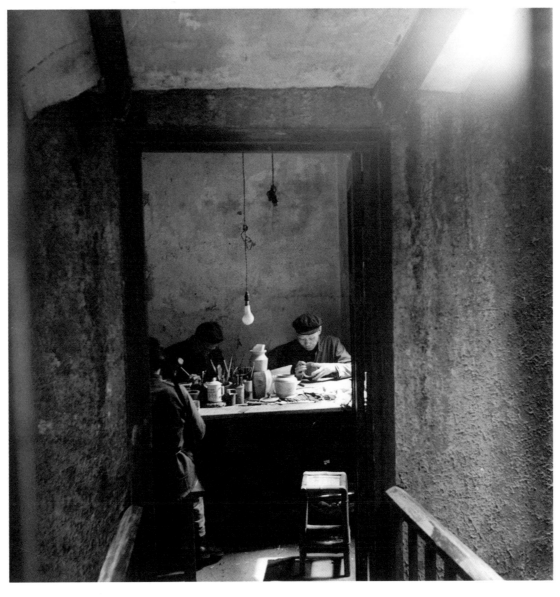

Lola Falcón May, *China*, 1960

Caught up in the turmoil of the First World War, then eager to conquer Paris in the 1920s, Sophie Jablonska led a fascinating life. When armed only with her ambition, she arrived in Paris in 1927 from Lwów (present-day Lviv, in Ukraine), to study in a film school, she had already lived through experiences that a young woman of her position should never have encountered: she had escaped across front lines, experienced seven years of destitution with her family in a Russia devastated by the revolution, assisted her father in his surgical operations, and kept the accounts for her brother's cinema. This social intrepidness guided Jablonska in her personal quest, as did her apprenticeship in cinematographic and photographic techniques, probably under the instruction of Maurice Tabard.

In Ukraine, Jablonska is remembered above all as a journalist and as being the first woman in the country to have travelled round the world (1932–4), but also for having published in the 1930s three works on the French colonies of the period: *The Charm of Morocco, Distant Horizons* (two volumes) and *In the Land of Rice and Opium*. The images illustrating them contributed to their success: photographs taken in China, Vietnam, Cambodia, Thailand, Indonesia and New Zealand. Few suspected that these images were the main aim of these voyages: Jablonska had in fact signed a contract with a company whose offices were in Indochina to produce photographs and documentary films. The rest was dictated by her immense yearning for beauty in all its forms: aeroplanes and boats; tropical forests and ancient temples; scenes of everyday life 'captured' like those of a film (in order to take them, Jablonska often had to resort to almost military strategies, photographs being perceived in certain regions as 'thieves of the soul'); and, of course, portraits – with trust, face to face, in a dialogue between equals. At that time, the European eye did not yet know how to regard Indigenous people. But after Ukraine's defeat in the war of independence following the First World War, Jablonska also felt herself to be a child of a colony, even if a white one, and growing up in multi-ethnic Galicia in the interwar years had taught her to appreciate distinctive regional and cultural identity as well as the benefits of modernity. That is why in the gaze that she turned on the Orient there is no trace of colonial superiority, of a 'white woman's burden': she surveyed the world with her camera, a sister to every living thing, identifying herself with her models without barriers of race or social class.

The Second World War marked a turning point for Jablonska, on a personal level as well as an artistic one. She was caught up by the war when in China, and had to flee again, as she had done in childhood. Returning to France in 1946 with her family – her husband, the French entrepreneur Jean Oudin, and her three children – she spent her final years at Noirmoutier, earning her living as a landscapist. At the same time, she took up writing, planning to translate and distribute her travel notebooks on the French market. Sophie Jablonska-Oudin was killed in a car accident in 1971, on her way to a meeting with her publisher in Paris. **OZ**

'To truly live, you have to become yourself.'

SOPHIE JABLONSKA-OUDIN

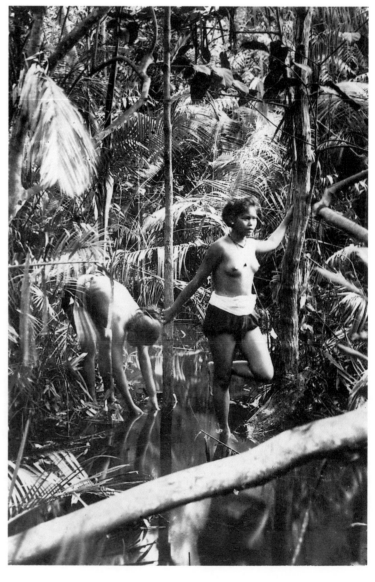

Sophie Jablonska-Oudin, *Bora-Bora*, Oceania, *c.* 1930

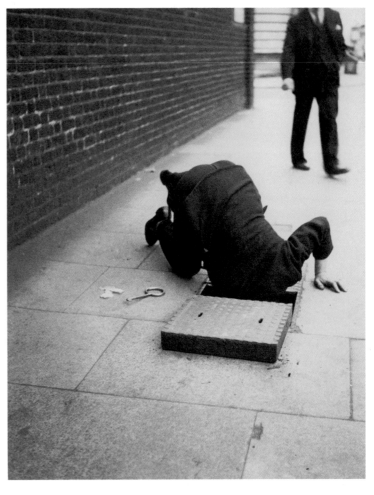

Dora Maar, *Untitled [Man looking inside a manhole]*, London, 1934

A combination of 'New Woman' and tomboy, for the specialist press during the interwar period Dora Maar perfectly embodied the modern photographer whose fame had its foundations in the overlap between the success of her commercial work and the recognition accorded to her by the Parisian artistic avant-garde.

Born in Paris to a French mother and an architect father of Croatian origin, Henriette Théodora Markovitch spent her childhood in a privileged family setting both in France and Argentina. Between 1923 and 1926, she followed the teaching of the Comité des Dames, an exclusively female institution dependent on the Union Central des Arts Décoratifs, where, among others, she formed a friendship with the painter and future fellow Surrealist Jacqueline Lamba. Immediately afterwards, she completed her artistic training, attending the Académie Julian and the academy run by the painter André Lhote.

Following in the footsteps of other women photographers active at the time – including Germaine Krull, Nora Dumas, Rogi André, and Laure Albin Guillot – Dora Maar (the name that she would adopt from the late 1920s) finally turned to photography, a profession then in vogue thanks to the rise of advertising and the illustrated press. Towards 1927, she enrolled at the École Technique de Photographie et de Cinématographie de la Ville de Paris and, during the same period, met Emmanuel Sougez, head of the photo desk at *L'Illustration* magazine, who helped her to improve her skills at working in the studio and with a large-format camera.

In 1931, she founded with her associate, the film-set designer Pierre Kéfer, the Kéfer-Dora Maar studio based in Neuilly. Until their partnership ended around 1935, the pair made portraits and produced advertisements for some of the great couture houses of Paris, such as Elsa Schiaparelli, Jeanne Lanvin and Jacques Heim. When she opened her own studio in the Rue d'Astorg, her diary was filled with commissions from women's magazines – *Votre beauté*, *Femina*, *Rester jeune*. At the same time, Maar exhibited on several occasions in galleries, showing the experimental images that she created alongside her commercial work.

The decade is also synonymous with radical political and intellectual commitment on Maar's part, especially with the Surrealists, with whom she co-wrote several anti-fascist pamphlets. Between 1933 and 1934, her interest in social issues also led her into the streets: she photographed the 'Zone', undefined areas around Paris inhabited by the poorest people, as well as beggars in London and children in the poor neighbourhoods of Barcelona. At the same time, she used her mastery of the photomontage technique to create dreamlike imagery with an unsettling atmosphere, for which she drew on material from her archive of found images and her own street photography.

In 1936, Maar entered into an artistic and romantic relationship with Pablo Picasso. A privileged observer of his work, she documented the various stages in the creation of *Guernica*, a painting commissioned from the artist by the Republican government for the Spanish pavilion at the International Exhibition held in Paris in 1937. From then onwards, she began to abandon photography to dedicate herself once again to her career as a painter. In the 1980s, Maar finally returned to the familiar world of the darkroom and produced abstract compositions, a synthesis of graphic gesturality and vibrating light. **DA**

'Women are quicker and more adaptable than men. And I think they have an intuition that helps them understand personalities more quickly than men … and a good photograph is just that – to catch a person not when he is unaware of it, but when he is his most natural self.'

LEE MILLER

In August 1956, Lee Miller wrote an article for *Vogue* magazine, in which she recounted her love for and experience of cinema – an art that 'offers us variety in vicarious living'. How many lives had Lee Miller herself lived? Fashion photographer, war reporter, portraitist in New York and Paris, muse of renowned photographers such as Man Ray, Edward Steichen and George Hoyningen-Huene, she also played a role in Jean Cocteau's *Le Sang d'un poète* (1930).

Born in Poughkeepsie in New York state, Miller travelled the world, from New York to Cairo, passing through London or Paris. Christened 'Elizabeth', she changed her name to 'Lee' in 1927 when she embarked on a modelling career after meeting Condé Nast, the founder of *Vogue*. An icon of the independent and liberated woman of the Roaring Twenties, she frequented artists of the avant-garde and celebrities from the world of cinema. Dreaming of becoming a photographer, she contacted Man Ray, then living in Paris. Lee Miller became his assistant, lover and favourite model. While her father, Theodore Miller, an enthusiastic amateur photographer, had given her an awareness of composition as well as how to use the camera, it was the American artist who taught her the basics of the profession. At the time, Man Ray was very close to the Surrealists. Sensitive to their spirit and formal innovations, Lee Miller incorporated the mark of this influence into her own work. From Man Ray, she also inherited perfect control of composition, frequent recourse to retouching and simplified framing. She undoubtedly owed her mastery of light and shade to an earlier experience: in 1925, spending a few months in Paris, Miller had attended the school of the Hungarian Ladislas Medgyès, who taught the techniques of stage design (lighting, sets, costumes).

At the beginning of the 1930s, she opened her own studio in New York, where she fulfilled numerous commissions from the worlds of fashion, advertising, theatre and cinema. This venture did not last long: in 1934 she married an Egyptian businessman, Aziz Eloui Bey, and went with him to live in Cairo. In 1937, while spending the summer in Europe, she began an affair with the painter and collector Roland Penrose, founder of the British branch of Surrealism. She met him again the following summer for a trip to Greece and Romania, returning with many images of the gypsy community. In 1939, Lee Miller went to live permanently with Penrose, in London. During the war, she worked for British *Vogue*, taking fashion photographs but also reportages on living conditions in London during the Blitz, on the liberation of Paris, and on the Nazi concentration camps of Buchenwald and Dachau. In Munich, in 1945, she photographed Hitler's abandoned apartment. **JJ**

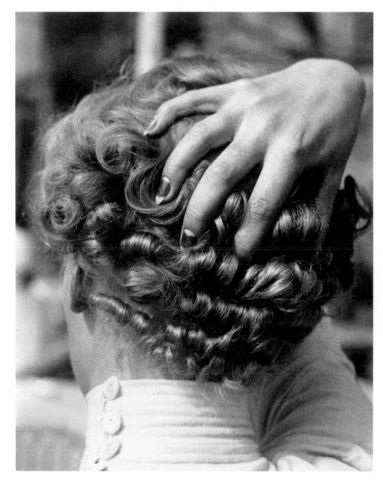

Lee Miller, *Untitled [Woman with hand in hair]*, 1931

'Thus, more than any other means, photography is capable of expressing the desires and needs of the dominant social classes, to interpret in their way the events of social life.'

GISÈLE FREUND

Gisèle Freund, *André Malraux*, Paris, 1935

Gisèle Freund was fortunate to grow up in a well-off and well-educated German family. Her father, a prestigious collector of paintings, instilled in her from an early age a love of art and books, and led her to the discovery of photography through the enlarged images of flowers or details borrowed from nature created by Karl Blossfeldt, a German artist ahead of his times. From 1933, the rise of Nazism and the menace of fascism and antisemitism forced the young woman of Jewish origin, then studying sociology, to leave her family, her fellow students and the land of her birth to seek refuge in France.

Once in Paris, forced to conceal her female identity in order to appear more credible to Parisian editors, Freund became a journalist, under the pseudonym 'Girix', and she turned to photography with a view to illustrating and selling her articles. She preferred social reportages, such as those that she produced on poverty in the north of England, of which from the very beginning she proved to be a sensitive, direct and effective photographer. During this same period, Freund frequented the bookshops of Paris and became friends with Adrienne Monnier, director of the renowned La Maison des Amis des Livres bookshop, frequented by the greatest writers of the time, André Gide, Paul Valéry, Colette, among others. She then came up with the highly original idea of taking each of their portraits, in an intimate fashion. 'Pretend I'm not here', she would repeat, leaving each genius at the mercy of his loneliness and

ghosts. No photographer had yet envisaged such a project in the form of a series. Similarly, few would have dared to use colour. The technological audacity was daunting, but not to Freund, who succeeded magnificently. Her portrait of the Irish writer James Joyce, wearing a red jacket, was to be the American magazine *Time*'s first cover in colour in 1939 – a historic date to remember in the history of the press. One of her most iconic portraits, however, was shot in 1935, in black and white: a promising young writer, André Malraux, who, weighing up the photographer, drags on his cigarette, a lock of his hair ruffled by the wind.

Freund, the left-wing German intellectual – 'no one had ever seen one', she joked – became a figure on the Parisian cultural scene in 1939 with the outbreak of the Second World War. Again following the road to exile and to going underground, she managed to escape by boat to Latin America and found herself in Buenos Aires, in Argentina, where she blossomed, opting for a life of adventure that would lead her to Tierra del Fuego, into the wings of the Perón dictatorship and to Mexico, where she frequented the artists Frida Kahlo and Diego Rivera. A member of Magnum Photos between 1947 and 1952, she continued her comings and goings in South America and then settled permanently in France. In 1981, she was chosen by François Mitterrand to take his presidential portrait; she was then ninety-one years old. **MR**[1]

Liselotte Grschebina, *Two Gymnasts*, 1931

The trajectory of Liselotte Grschebina's life ('Grschebina' is the female form of her husband's surname, Gschebin or Gjebin) was complex and tortuous, influenced by the politics the time. Born in Karlsruhe on 2 May 1908, she studied at the city's Academy of Fine Arts before taking up graphic design and commercial photography (a very new field at the time) in Stuttgart. She began teaching at the Karlsruhe Academy, where she was influenced by three of the founders of the Neue Sachlichkeit (New Objectivity) movement – Karl Hubbuch, Wilhelm Schnarrenberger and Georg Scholz – who had left Berlin for Karlsruhe, turning it into an influential centre for their ideas. When the rise of antisemitism forced her to leave the Academy, Grschebina opened her own studio, called Bilfoto; to avoid attracting the attention of the authorities, she presented herself as a specialist in child photography (even if most of her photographs were made for advertising purposes). She continued there until 1933, when she was no longer able to work as an artist and had to leave Germany.

Under the influence of Neue Sachlichkeit, Grschebina used her camera to showcase and highlight her subjects, which she addressed through unusual angles and strong diagonals, employing mirrors, reflections, and light and shadow to evoke atmosphere, interest and meaning. Her photographs feature refined objects – feathers, masks, fabrics and beads, for instance – whose texture is emphasized; she especially loved to photograph lace, which she said was 'the one thing that could give elegance to a photographed object'.

After arriving in Palestine, Grschebina faced the twin challenges of learning a new, difficult language and a job market full of photographers looking for work – many of whom were German immigrants like herself. Basing herself in Tel Aviv, Grschebina opened the Ishon (Eye) studio together with a friend from Karlsruhe, Ellen Rosenberg (Auerbach), one of the founders of Ringl + Pit. The two young women sought to make a name for themselves by specializing in children's portraits. Working in their clients' homes, they developed a personal style: the models are well dressed, posed naturally in domestic spaces, and shot from a low angle.

Grschebina left behind no records, written or otherwise; only her photographs bear witness to her unique artistic personality. In her outdoor photography, she observed her subjects like a curious spectator, surveying, examining and documenting the diversity of society with a clear, impartial eye. The photograph is proof of her presence but is not used to express or define her own identity: she is merely an observer who captures what she sees through her lens. As a young immigrant facing an unfamiliar world, Grschebina produced portraits devoid of any subjective intent: the viewer, as a result, discovers a new, objective way of seeing, that which is presented to them. **YC**

In 1960, Ida Kar became the very first photographer – male or female – to be honoured with a retrospective exhibition at a major London art gallery. Her bold installation of large board-mounted prints, entitled *Ida Kar: Portraits of Artists and Writers in Great Britain, France and the Soviet Union*, formed part of the Whitechapel Art Gallery's ambitious programme. It was both a popular and critical success: her portraits, which in the words of the novelist Colin MacInnes 'never mockingly "exposed" or "glamourised"' the sitters, sparked a debate on photography as a form of artistic expression.

Born Ida Karamian in Tambov, Russia, on 8 April 1908 to middle-class Armenian parents, Kar spent her formative years in Yerevan and Alexandria, Egypt, where she attended the Lycée Français. It was in Paris in the late 1920s that Kar, who was part of the city's artistic community, took up photography. Returning to Egypt, she opened the studio Idabel in Cairo with her first husband Edmond Belali – specializing in closely cropped portraits and surrealistic still lifes and exhibiting with the Art et Liberté group.

In 1945, Kar arrived in austere postwar London with her second husband, the poet and art dealer Victor Musgrave. Working from her studio above Musgrave's Gallery One, Kar substituted conventional theatrical 'Spotlight' portraiture with photographs of artists and writers who were part of her Bohemian milieu. Her first solo exhibition, held at Gallery One in 1954, presented the portraits of forty artists from London and Paris and was the result of an energetic period of visits to studios and ateliers.

Kar's strength lies in these rich environmental portraits, made with available light, however her photographic practice had also to provide an income. Responding to commissions from the *Tatler & Bystander* magazine, she took up a Rolleiflex and travelled to her native country in 1957 and to East Germany in 1959.

Despite the recognition that she received from the Whitechapel exhibition, which travelled to Moscow in 1962, Kar – independent and opinionated – continued to adapt her practice. Studies she made for *Animals* magazine were included in an exhibition in Birmingham, *Ida Kar: Artist with a Camera* (1963), with an introduction by the art historian Helmut Gernsheim. Her move towards reportage, in accordance with changing fashions, was evident in her 1964 Cuban portfolio, which marked the last recognized creative phase of her career.

In 1968, Kar formed the KarSEC collective, which aimed to foster new talent and gain commissions. Despite her worsening bipolar disorder, she remained committed to her work; a venture into nude photography was cut short by her death on 24 December 1974. **CF**

Ida Kar, *Tsuguharu Foujita*, 1954

Hedda Morrison (née Hammer) is known for her documentary photographs of China, Borneo and Australia. Born in Stuttgart and trained in Germany in the Neue Sachlichkeit (New Objectivity) style, she worked largely in black and white, except for a period in the early 1950s when she experimented with colour photography.

As a teenager, Hedda persuaded her parents to let her study photography instead of medicine. After training for two years at the Bavarian State Institute for Photography, she began to look for work, but Germany was in the grip of a severe economic depression; jobs were few, so she worked as a volunteer in the studio of the photographer Adolf Lazi in Stuttgart. Concerned by the mounting restrictions placed on artists by the Nazi Party, Hedda made plans to leave Germany. She knew virtually nothing about China, but nonetheless submitted an application for a studio manager's job in Beijing, which was successful. The Hartung Photo Shop was a commercial studio catering to a powerful clientele of diplomats and foreign residents. Between 1933 and 1938, she created and sold albums featuring her photographs of Chinese handicrafts, temples, imperial palaces, and 'lost tribes'. From 1938 to 1940, Hedda collaborated with the Brooklyn Museum, documenting Chinese handcrafted furniture.

Morrison met her future husband, Alastair Morrison, in 1940. The couple left China owing to increasing political unrest and settled in Sarawak, on the island of Borneo, where Alastair worked as a district officer. From 1960 to 1966, Hedda was employed by the Information Office in Kuching, the Sarawak capital, to produce photographs of an ethnographic character, especially images that depicted traditional cultures in the process of change. Conditions in Sarawak were challenging for photographers, but Morrison was resourceful. For example, she overcame the problem of having no electricity for six years by using two car batteries to power her portable enlarger, and stored her negatives in an airtight chest, using silica gel as a drying agent to protect them against the humidity of a tropical climate. In 1965, the Sarawak government awarded her the Order of the Star of Sarawak for her work.

In 1967, the Morrisons moved to Australia. Hedda continued her photography, capturing views of the people and landscapes of the Australian Capital Territory, New South Wales, Victoria and South Australia. In 1972, she published *Vanishing World: The Ibans of Borneo* while living in Canberra. She died from cancer in 1991. Her other books include *Life in a Longhouse* (1962), *Sarawak* (1965) and *Travels of a Photographer in China, 1933–1946* (1987). **AM**

'It was impossible to get bored in Beijing as there were so many things to see and photograph, and everywhere I was treated with extreme courtesy and great consideration.'

HEDDA MORRISON

Hedda Morrison, *A street hairdresser styles a client's hair into a tight braid*, Hong Kong, c. 1946–7

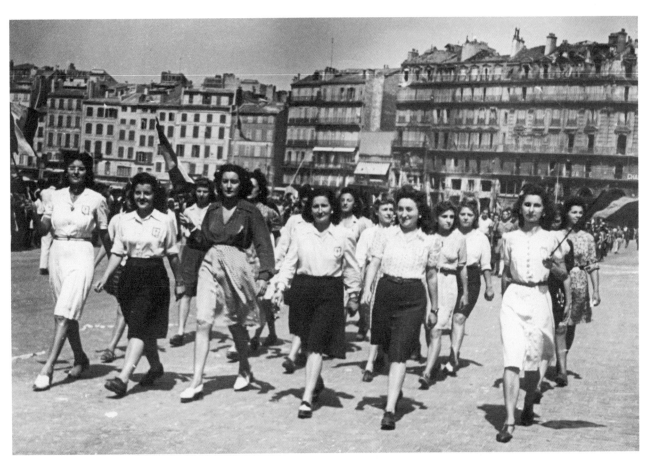

Julia Pirotte, *Victory Parade in Marseille*, 29 August 1944

'The Marseille insurrection remains forever etched in my memory. Freedom at last, the end of fear. The death of my family, too, of my friends. It wasn't a celebration, just the permission to breathe freely.'

JULIA PIROTTE

Julia Pirotte was born to a family of Jewish shopkeepers in Poland. She became a member of Progressive Youth, then, arrested for communist activities in 1926, she was imprisoned for four years. In 1934, she joined her sister Mila in Paris in order to escape further imprisonment – their brother was in Moscow – before seeking refuge in Brussels. Welcomed by the Belgian Red Relief, she fought exploitation and antisemitism. She married the trade unionist Jean Pirotte and obtained Belgian citizenship. With the Leica given to her by Suzanne Spaak, a Belgian anti-fascist campaigner who wanted to help her in her cause, she produced reportages for the newspaper *Le Drapeau rouge* – the organ of the Belgian Communist Party – on the working and living conditions of her miner compatriots in Charleroi.

When Poland was invaded by the Germans on 1 September 1939, Pirotte was despatched to the Baltic states by the Foto Waro agency. On 10 May 1940, when the German troops arrived in Belgium, she made her way to the south of France, while her family was deported from the ghettos and died in the camps. To survive, she became a worker in an aviation factory, then a photographer at the Place des Catalans in Marseille.

Her reportages for the weekly magazine *Dimanche illustré* served as a cover when she joined the Compagnie Marat, part of the Communist Party-led FTP-MOI (Francs-tireurs et partisans – main-d'oeuvre immigrée). She carried weapons, documents, made false papers for Jews and members of the Resistance, and photographed the Maquis Resistance fighters at Venelles in the summer of 1944. A reporter, she documented daily life under the Occupation in the working-class neighbourhoods and old port of Marseille, and immortalized Jewish children in the Bompard prison camp as they departed for Drancy and the death camps.

On 24 August 1944, she took part in the attack on the prefecture in Marseille, covered the insurrection, and documented the liberation of the city by the Resistance and the Allied armies. In the days and weeks that followed, she took photos of the re-enactments of the fighting and the public rejoicing; these appeared in *Combattre*, *La Marseillaise*, and *Rouge Midi*.

In 1946, she returned to Poland and worked as a photographer for the newspaper *Zolnierz Polski*, covering the reconstruction of the country, the life of Warsaw's inhabitants suffering under rationing, and that of Jewish orphans. In 1948, she photographed Picasso, Éluard, and Irène Joliot-Curie at the World Congress of Intellectuals for Peace in Wrocław. She founded the WAF photographic agency, covered the Kielce pogrom, in which forty-two Jews who had survived the Holocaust were massacred on 4 July 1946, and published her images in *Zolnierz Polski*.

Following reportages in the Socialist countries and in Israel, Pirotte was forced to break off her work in March 1968 in the face of political and antisemitic pressure and went travelling in Europe. She exhibited at the Writers' Club in Warsaw (1979), at the Rencontres de la Photographie in Arles (1980), and at the International Center of Photography in New York (1984). In 1989, she donated the entirety of her work to the Musée de la Photographie in Charleroi, Belgium, which in 1994 staged the exhibition *Julia Pirotte, une photographe dans la Résistance* and published a catalogue in which she discussed her images. **FD**

Anna Riwkin-Brick, *The Surrealists in Paris (Paul Éluard, Jean Arp, Yves Tanguy, René Crevel, Tristan Tzara, André Breton, Salvador Dalí, Max Ernst, Man Ray)*, 1933

Anna Riwkin was born in 1908 in Surasch, Belarus, at that time part of the Russian Empire. She moved with her family to Sweden in 1915. The young woman opened her first studio in 1929, the same year that she married the translator and journalist Daniel Brick, founder of the publication *Judisk krönika*. Specializing in portraits and dance photography, she took several classic portraits in the 1930s and 1940s of contemporary young Swedish writers, including Karin Boye and Harry Martinson. The progressive publishing house Spektrum, run by her brother Josef, gave her the opportunity to travel to Paris in 1933 to photograph Surrealist artists and writers. Her much reproduced group portrait of Paul Éluard, Jean Arp, Yves Tanguy, René Crevel, Tristan Tzara, André Breton, Salvador Dalí, Max Ernst and Man Ray has sometimes been wrongly attributed to Ernst on the grounds that it was found in his archives.

The outbreak of war brought financial challenges for many portrait photographers, and Riwkin was not spared. The journalist Carl-Adam Nycop advised her to travel the world and work as a photojournalist instead, and gave her assignments for the picture magazine *Se*, which he edited. Riwkin also collaborated with Elise Ottesen-Jensen (known as 'Ottar'), a journalist, educator and feminist activist who founded the Swedish Association for Sexuality Education (RFSU). She accompanied Ottesen-Jensen on her many travels and reported on her lectures on family planning. Riwkin's extensive and lively reports appeared in *Se*, as well as in *Vi* magazine, published by the Kooperativa Förbundet, a cooperative for consumers.

It was, however, the publication of nineteen children's picture books illustrated with her photographs that brought Riwkin the most success. The first, *Elle Kari* (1951), is about a Sami girl she met on one of her trips to Lapland. Among the most popular were *Eva möter Noriko-San* (Eva meets Noriko-San,

1956) and *Lilibet, cirkusbarn* (Lilibet, circus child, 1960), both written by the author Astrid Lindgren. Riwkin often worked on the picture books alongside her assignments for newspapers and magazines. They were translated into several languages and became very popular in Sweden, Israel and elsewhere.

Riwkin came from a Jewish family and travelled to Israel early on to document life in the new nation. Her book *Palestine* (1948), written by her husband, was followed a few years later by *Israel* (1955). Both recount the county's cultural history and give an optimistic view of the political and social changes that occurred after the Second World War. One of the images that she brought back from her travels – a portrait of an elderly Israeli woman with one arm raised – was included in *The Family of Man*, Edward Steichen's famous and much discussed photography exhibition at the Museum of Modern Art, New York, in 1955. Inspired by the exhibition's theme of photography as a language everyone could understand, Riwkin published the book *Medmänniskor* (Fellow human beings) in 1962, which brought together photographs of her many encounters. The photographer's whole archive was bequeathed to the Moderna Museet collection in Stockholm. **AT**[1]

> 'My dream is to be able to devote myself to work in which I feel a personal sense of commitment, aesthetically or otherwise.'
>
> **ANNA RIWKIN-BRICK**

A Swiss photographer and journalist who led a complex and tormented life, Annemarie Schwarzenbach was the creator of an intense and significant oeuvre that has only recently earned the attention it deserves. Born to a family of silk manufacturers, she was prone from a young age to emotional instability, which led to a chronic dependence on drugs and recurrent cures for addiction. Writing and photography, which enabled her to travel to discover her place in the world, were lifelines, as was her friendship with the artists Erika and Klaus Mann.

During her brief life, brutally cut short in 1942 following an accidental injury, Schwarzenbach led a nomadic existence, consisting of endless comings and goings as a writer and photographer. She created a professional identity for herself, and formed relationships with artistic and intellectual circles in which she never truly felt at ease. Her travels were frequent and admirable – she set off alone at the wheel of her Mercedes-Benz Mannheim, or with other women, notably the photographer Marianne Brelauer and the writer Ella Maillart.

Armed with a heavy Rolleiflex mounted on a tripod, or with an easier-to-handle Leica, she received commissions from the weekly magazine *Zürcher Illustrierte*, the Zurig Press-Service and the publisher Morgarten, and travelled and photographed in Spain, Czechoslovakia, Austria, then Turkey, Syria, Lebanon, Palestine, Iraq and Persia, Russia, Belgian Congo, Morocco and Afghanistan, going as far as India. Between September 1936 and January 1938, with the photographer Barbara Wright, she made two trips to the United States, where she met the novelist Carson McCullers and produced a sociological photoessay, in the wake of the 1929 financial crash and Roosevelt's New Deal, following the example of the legendary photographers of the Farm Security Administration. During her travels, Schwarzenbach's eye was always attracted to the harshest and most cruel realities: for her, photography was – and had to be – a means of denouncing poverty, exploitation, marginalization, racism and the spectre of Nazism, but also of expressing (particularly in her travels in the East) her fascination for exoticism and the other.

In parallel, Schwarzenbach wrote articles (notably 'Les Femmes de Kaboul' [Women of Kabul] on the wearing of the chador), plays (*Der Falkenkäfig*), for photographic magazines (*Winter in Vorderasien*), novels and biographies (on the Swiss photographer Lorenz Saladin). She was also the subject of striking photographic portraits taken by others, thus helping to shape and publicize the figure of the 'New Woman' of the interwar period: androgynous, elegant, ambiguous, melancholy. A dandy and lesbian icon, Schwarzenbach experienced the difficulty of being a female gay artist during the first half of the twentieth century – simultaneously strong and fragile, needing her identity to be recognized, but always seeking fusion and dissolution in the world. **FM²**

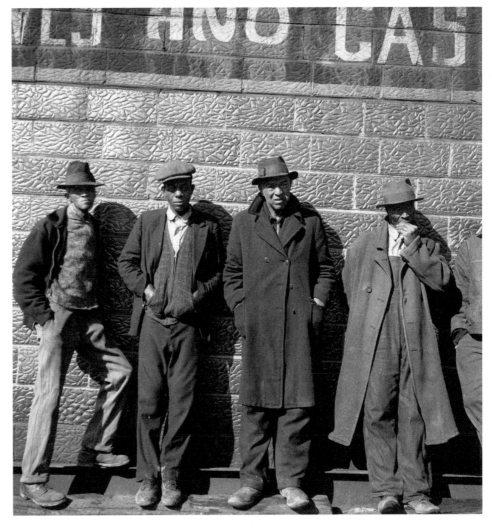

Annemarie Schwarzenbach, *Unemployed Miners at Scotts Run*, West Virginia, 1937

Having grown up in Austria during the First World War, Edith Tudor-Hart (née Suschitzky) was marked by early childhood experiences and political influences that would shape her photographic practice. Her family were Social Democrats who ran a liberal bookshop in a working-class area of Vienna. Sent to Sweden for several months to recover from the impact of the war, Edith had an early exposure to hunger and lack of education. Later, she began working as a Montessori teacher and, at the age of sixteen, travelled to London to obtain a teaching diploma. While in England in 1925, Edith met the Tudor-Hart family: Beatrix, who was a progressive educationalist, and her brother, Alexander, a doctor whom Edith would marry in 1933.

Edith turned her attention to photography, enrolling in the foundation course at the Staatliches Bauhaus in Dessau, Germany, in 1928. Her first published photographs appeared around 1930 in the illustrated magazines *Der Kuckuck* and *Die Bühne*, and she worked for TASS, the Soviet news agency. Her photographs of Vienna during this period reveal the social and political life of the city, Edith using her camera as a critical tool to document the social injustices of a changing landscape. She had been politically engaged since her adolescence, and began working for the Communist International, or Comintern, but her activities attracted unwelcome attention from the authorities. She was briefly arrested in May 1933 and decided to go into exile in England.

In London, Edith met and worked alongside other female photographers, including Helen Muspratt, Margaret Monck, Grete Stern and Vera Elkan, with whom she shared a studio from 1937. She exhibited regularly with the Artists' International Association and was an active member of the Workers' Camera Club. Her work continued to be socially engaged, and many of her photographs highlight the daily realities experienced by Britain's working classes in the 1930s and 1940s, from poverty-stricken families in the East End of London to unemployed workers marching in south Wales. Following the disintegration of her marriage, Edith supported her son, Tommy, on her own. Her photographs appeared in British magazines such as *Picture Post* and *Lilliput*, and in 1949 she published an essay entitled 'A School Where Love is a Cure' covering the Camphill School near Aberdeen, which was founded by an Austrian exile, Karl König, for children with learning difficulties.

Edith's personal politics continued to play a role in her life, and her involvement in the Cambridge Spy Ring meant that she was under regular surveillance by the British intelligence services. In 1951, she destroyed most of her photographic records but continued to work, publishing images into the 1950s that concentrated on the issues of child welfare, health and education. She died in Brighton in 1973. **AL**[3]

> 'Photography ceased to be an instrument for recording events and became a means of stimulating and influencing events. It became a living art, embracing the people.'
>
> **EDITH TUDOR-HART**

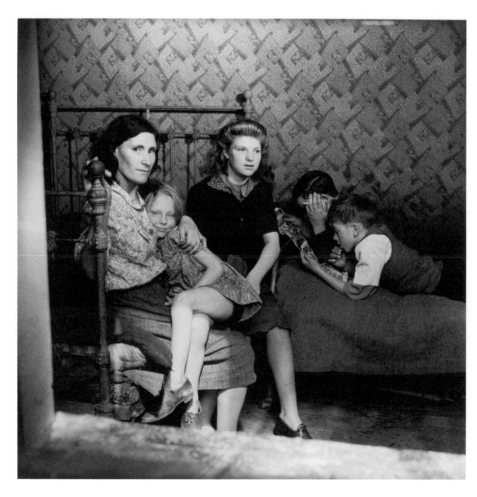

Edith Tudor-Hart, *Family*, Stepney, London, *c.*1932

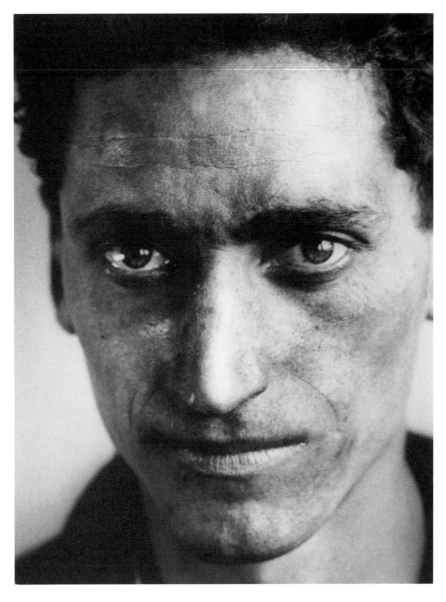

Kata Kálmán, *Ernő Weisz, 23-year-old worker*, Budapest, 1932

Kata Kálmán was one Hungary's first social-documentary photographers. As soon as she began working with a camera in 1931, she captured portraits of agricultural workers, unemployed people and children. In the Hungary of the 1930s, several other female photographers, including Kata Sugár and Klára Langer, decided to address similar themes, portraying the working classes and disadvantaged members of society with respect. Kálmán's photographs record the poverty and despair of Hungary and Transylvania by focusing on individual stories; in this way, they are in marked contrast to the so-called 'Hungarian style' associated with the work of Rudolf Balogh, who looked to project an idealized view of the country.

From 1927, Kálmán attended Alice Madzsar's school of movement, where she met her future husband, Iván Hevesy, an art writer, art historian and photographer. Thanks to her husband's position in the publishing world, Kálmán's prints benefited from a certain amount of publicity, and her photographs helped introduce the middle classes to a section of society they knew little about.

Between 1934 and 1937, Kálmán took tightly cropped head-and-shoulder shots of farmworkers – like that of Ernő Weisz, for instance – and in 1937, she published an album of twenty-four of these portraits entitled *Tiborc* ('Tiborc' being the name of the character who symbolizes the Hungarian peasantry in a drama by József Katona), with an introduction by the writer Zsigmond Móricz. The album's success paved the way for the publication of two more: *Szemtől-szemben* (From eye to eye, 1940) and *Tiborc új arca* (The new face of Tiborc, 1955).

From the 1950s, Kálmán played an active role in the Hungarian photography scene, in particular by publishing photographic books and participating in the foundation of the Association of Hungarian Photographers in 1956. In 1965, she became the editor of the *Fotóművészeti Kiskönyvtár* (Photographic art library) series published by Corvina. Four years later, she was awarded the Balázs Béla Prize, and in 1976 received an honorary prize for all of her work. **ZR**

The youngest of the six children of Albina and Léonard Szurowski, Fortunata Obrąpalska was born in Vladimir-Volynsk (then in the Russian Empire). In 1931, she passed the entrance exam to the School of Fine Art in Warsaw, but due to her financial circumstances she was unable to live in the capital, so she went to Vilnius, where she enrolled in the Faculty of Chemistry at the Stefan Batory University. In 1936, she began to study botany, which would influence the themes that she would later address.

For a young chemist with strong artistic ambitions, photography seemed an obvious choice, particularly in Vilnius, where Jan Bułhak, one of the most influential Polish photographers of the interwar years, taught and worked. His works were strongly influenced by the Pictorialist movement. During the Second World War, Obrąpalska worked as a laboratory assistant in the Biofarm pharmaceutical-chemistry factory in Vilnius. In the spring of 1945, after her repatriation, she found herself in Poznań where, with her husband, she contributed to the postwar renaissance in the field of photography. She actively collaborated with the magazine *Swiat fotografii*, in which she published articles including 'Les Effets du surréalisme en photographie' [The effects of Surrealism on photography] in 1948.

In 1947, Obrąpalska produced one her most famous series, a cycle of four images assembled initially under the description 'Diffusion in a liquid', now known by the titles *Tancerka* (The dancer), *Cisza* (Silence), *Przekleństwo* (The curse) and *Fantazja* (Fantasy). A later work is often included, *Tancerka II* (The dancer II, 1948), for which she used solarization: the image represents ink dissolving in a container filled with water. Shown at the second National Exhibition of Photography, these simple and innovative images allowed the artist to become known to the critics and the public, and above all they opened the way for her to feature in two exhibitions that included avant-garde photographs: *Nowoczesnej Fotografice Polskiej* (Contemporary Polish photography), held in Warsaw in September and October 1948, and Poland's first exhibition of modern art, which opened in December 1948 at the Art Museum in Krakow.

With the introduction, in 1949, of Socialist Realism as a compulsory doctrine, art became an instrument of propaganda and education. Obrąpalska gradually abandoned experimental photography in favour of documentary images. After the death of Stalin in 1953, when art and culture in Poland were liberated from the strict rules that he had promoted, Obrąpalska's work began to diversify. The majority of her images, the solarized macro photographs in particular, defy any simplistic interpretation – they are sometimes associated with subjective photography.

Obrąpalska increasingly moved away from the predominant trends to concentrate on nature (she worked for the botanical garden in Poznán), creating works and series that go well beyond the mere documentation of plants. In the late 1970s, a confirmed allergy to metol (one of the components of black-and-white photo developers) forced her to abandon photography altogether. **KP-R**

'Since I became interested in photography, I consider it an "everyday" activity. I have experienced it, always and everywhere, with open eyes.'

FORTUNATA OBRAPALSKA

Fortunata Obrąpalska, *Silence*, 1947

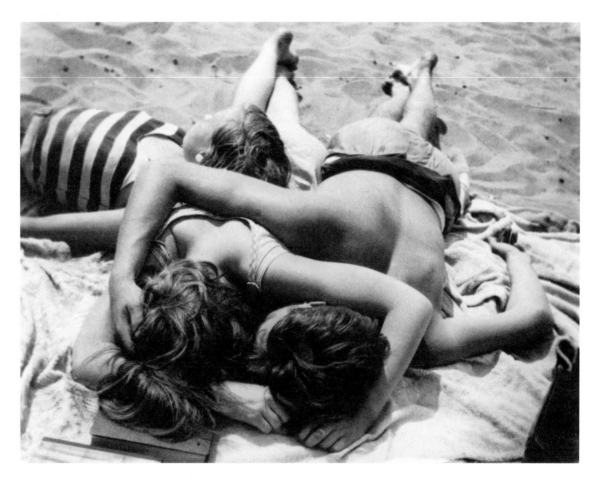

Eva Besnyö, *Young People at Wannsee Beach*, Berlin, 1931

'I don't remember ever being truly happy when I was a child […]. It was only when I began to take photographs that I was able to flourish.'

EVA BESNYÖ

Growing up in Budapest, during and just after the Great War, in the family of a respected Jewish lawyer; playing in the street with her young neighbour Endre Friedmann (the future Robert Capa); training in New Photography in Berlin in the early 1930s; leaving the turbulent Weimar Republic for Amsterdam; going underground during the Occupation; becoming a mother; facing professional precariousness in postwar Netherlands; then going on to become the official photographer of the Dutch feminist movement Dolle Mina during the 1970s – this is the remarkable summary of the life of Eva Besnyö, spanning almost the entire twentieth century. The Hungarian photographer continued to participate in European cultural life right into her old age.

Her parents would have preferred that their daughter, gifted with great artistic talent, went to study in Paris, but Besnyö chose to follow György Kepes, a friend of hers, to the lively metropolis that was Berlin at that time. Kepes worked in László Moholy-Nagy's studio, which offered the young woman the ideal environment to hone her practice of New Photography. Under the influence of the photographer Albert Renger-Patzsch, whose work *Die Welt ist schön* she considered her bible, Besnyö wandered around Berlin with her new Rolleiflex, attempting to capture life in carefully composed 6 × 6 shots in which she often used close-ups and diagonals.

Realizing that the situation in Germany was continuing to deteriorate, Besnyö, who had left-wing, even communist sympathies, decided to emigrate to the Netherlands with her future husband, the Dutch photographer and cameraman John Fernhout. In 1932, she established herself as a professional photographer in Amsterdam, specializing in children's portraits, architecture and advertising. Once again, she found herself in the right place at the right time: Fernhout's mother, Charley Toorop, was a well-known artist, around whom gathered a left-wing cultural circle bringing together the artists of the De Stijl movement, but also writers, photographers, film directors (Joris Ivens), journalists and architects (Gerrit Rietveld). After having had the opportunity to show her works in a one-man show in 1933, Besnyö became the main organizer in 1937 of the international exhibition *Foto '37* at the Stedelijk Museum in Amsterdam. Mural enlargements and images for magazines were among her most important commissions. At this time, she had already met her second husband, the graphic designer and photographer Wim Brusse.

As a Jew, Eva was forced to go into hiding during the Second World War. She joined the Resistance and, with Brusse, produced false papers. After the Liberation, she learned that her father had perished in Auschwitz. Her two children, Berthus and Yara, were born in 1945 and 1948. Although, in her words, their arrival did not help her professional career, many works dating from this period are known. After her divorce, and on joining the feminist movement during the 1970s, Besnyö began to practise photography with a passion, on her own terms – and no longer for 'aestheticism'. **MB²**

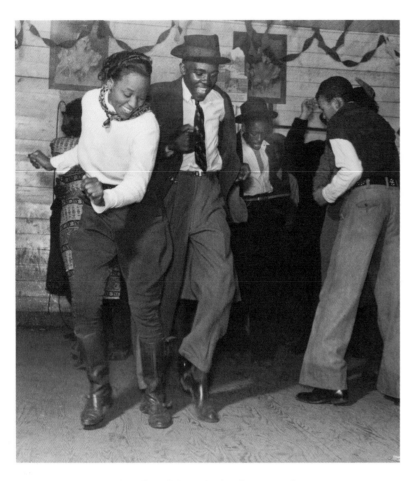

Marion Post Wolcott, *Jitterbug Dancers in a Bar near Clarksdale, Mississippi*, 1939

In 1938, Marion Post became a full-time staff photographer for the historical section of the United States Farm Security Administration (FSA), which was tasked with helping farmers affected by the Great Depression. The first woman to hold that position, she arrived at a pivotal moment, and her work played a key role in defining Roy Stryker's vision for that New Deal agency. During his first three years as head of the Information division, Stryker charged photographers with establishing a visual record that would justify the need for FSA programmes. The resulting images, such as Dorothea Lange's iconic *Migrant Mother* (1936), reflected the desperation and tenacity of ordinary Americans struggling to survive on the few resources available in the nation's rural areas and small towns. As domestic and international tensions escalated on the eve of the Second World War, however, Stryker found a more urgent need for photographs that highlighted the efficacy of FSA relief programmes and the strength of the nation's populace. Marion Post Wolcott (she added her husband's surname to her own when they married in 1941) made photographs well suited to this change in tone and emphasis.

Born in Montclair, New Jersey, Marion Post taught at an elementary school in a Massachusetts mill town before attending New York University and the New School for Social Research. In 1935, while at the University of Vienna, she met the photographer Trude Fleischmann and bought a camera; once back in New York, she trained with Ralph Steiner. The following year, she became a professional photographer, freelancing for the Associated Press before joining the staff of the *Philadelphia Evening Bulletin*. This experience left her well prepared for her job at the FSA. Charged with 'filling gaps' in the documentary record that Stryker had assembled by 1938, she travelled – alone, at a time when to do so was uncommon and sometimes dangerous for an unmarried young woman – on assignments to West Virginia, New England, Kentucky and throughout the south-eastern United States. Post Wolcott's byline most often appeared next to pictures of resource-rich terrain, cultivated fields and typical main streets that reinforced an image of prewar American patriotism. Other photographs put the spotlight just as vividly on more complex aspects of American society. Post Wolcott was a keen observer of race, class and gender relations in the South, creating telling images of customs that reveal deeply ingrained social inequalities.

When she left her successful career as a photographer in 1942, Post Wolcott managed a farm in Virginia and raised four children with a husband whose occupation required him to travel extensively. Her remarkable photographs are evidence of an astute sensibility in tune with her social environment; moreover, they embody her unmistakable strength of character, which lends a rare and valuable inflection to our understanding of her time. **LH**

'I think landscape can tell a great deal about living conditions as well as the people and the clothes they wear, and the diapers on the line, or whatever other evidence there is around.'

MARION POST WOLCOTT

Gerda Taro was a pioneer of modern photojournalism in the 1930s. Although her career spanned less than a year, she contributed some of the most influential images of the Spanish Civil War to the international press. An anti-fascist partisan, she used her camera as a political tool: her photographs featured mainly in pro-Republican magazines and newspapers.

Born Gerta Pohorylle to a Jewish merchant family in Stuttgart, Taro experienced antisemitism at an early age. She moved to Paris in 1933 after being arrested for leftist political activities. It was here that she met the Hungarian photographer Endre Friedmann, who would later become famous as Robert Capa; they both changed their names in 1936.

Taro made her first trip to Spain in August 1936, soon after the beginning of the conflict between the Spanish Republican government and the military and nationalist insurrection led by General Franco. Travelling with Capa, she went from Barcelona to Córdoba via Madrid, photographing peasants taking up arms and, in the cities, men and women joining the loyalist coalition. Near Barcelona, she took her iconic image of a militiawoman on one knee, arm outstretched, clutching a pistol, wearing heels and the monogram of the Republican fighters. Taro used a medium-format camera at the time, and many of her images are marked by strong compositions that fill the entire frame, influenced by the Russian Constructivist films that she had studied. Her first images, published in the French magazine *Vu*, were either miscredited or not credited at all.

Taro made several more trips to Spain in 1937, having switched to a 35mm Leica. Her story on the aftermath of fascist bombings in Valencia in May, which appeared on the cover of the French magazine *Regards*, marked a professional recognition of her skill and of her reputation for getting close to her subject – advice Capa must have given her when he introduced Taro to the techniques of photography. While she was covering the battle of Brunete in July 1937, she was crushed by a tank during a chaotic retreat and died soon after. She was interned at Père Lachaise cemetery in Paris, her funeral cortège attended by thousands of mourners.

Following her death, Taro's work and reputation faded into near obscurity until she eventually reappeared in the 1980s as Capa's girlfriend. A comprehensive biography published by Irme Schaber in 1994, a 2007 solo exhibition, and the discovery in 2010 of an additional 1,200 negatives helped bring Taro out of the shadows and prompted a reappraisal of her work. **CY**

Gerda Taro, *Republican militiawoman training on the beach*, Barcelona, August 1936

Best known for her work from the 1930s and 1940s, the Australian modernist Olive Cotton regarded photography as an ideal means of self-expression. 'A landscape, for instance,' she claimed in 1938, 'is there for everyone to photograph … but it can be photographed in a hundred different ways', depending on what she described as an individual's 'discernment and personality' and the formal choices they made.

Cotton was not a spontaneous photographer; she worked in a highly deliberate manner and previsualized her images. She never sought out exotic subject matter, instead favouring what was familiar and known. For her, light was crucial, and her attentiveness to its qualities resulted in images of great delicacy and intricacy. Cotton considered her process uncomplicated, and avoided 'close-ups or zooms, [I] never liked any tricks'. The occasional exception was composite printing, usually to obtain 'the sky I wanted. I kept a lot of negatives of different skies and clouds so I could do that.' Regarding printing as an intrinsic part of the creative process, she revelled in darkroom work. Her main motivation with her photography was to satisfy herself, and she was wary of art-historical groupings, saying, 'I would not like to be labelled a romanticist, pictorialist, modernist or any other "ist". I … want to feel free to photograph anything that interests me in whatever way I like.'

Cotton's best-known photograph is *Teacup Ballet* (1935), which was included at the London Salon of Photography – the pinnacle of achievement for Australian photographers of the period and an impressive feat for a twenty-four-year-old. In this pared-down composition, she uses her mastery of shadow to transform six ordinary teacups into ballet dancers. However, Cotton's legacy extends far beyond a brief period of experimentation in the studio. Above all else, she was a photographer of the natural world, expressing her love for the intricate shapes and patterns of nature through her many fine flower studies and landscapes. She also celebrated the contentment that we feel in the natural environment, especially with her views of women enjoying the sun on a beach or in the Australian wilderness.

Cotton's reputation is based on her personal photography, undertaken while she worked as an assistant at the studio of her husband, Max Dupain, in Sydney. It was only during the Second World War, when she ran the business herself, that she became known as a professional photographer. Her work is now appreciated for its relation to contemporary developments internationally and for expanding the vocabulary of modernism in Australian art. A biography of the photographer, *Olive Cotton: A Life in Photography*, was published in 2019. **HE**[1]

Olive Cotton, *Papyrus*, 1938

Zofia Rydet, *Warsaw*, 1988, from the series 'Sociological Record' (1978–90)

The oeuvre of Zofia Rydet, a major figure on the Polish scene in the postwar years, successively ranged from humanist photography and post-Surrealism to documentary photography. Born to a family of lawyers, Rydet discovered photography as an amateur in adolescence, thanks to her brother who was also an enthusiastic amateur, and produced her first images in the 1930s: the children of Polish mountain dwellers. After the war, she had a shop selling toys and articles made of paper. It was not until she was forty that she devoted herself more seriously to photography. Her first series, dedicated to childhood and entitled 'Mały człowiek' (The little man) originated from the portraits of the kids who visited her shop. In 1965, this project, which was produced over a dozen years starting in 1952, was turned into a photography book of the same title, conceived by the graphic designer Wojciech Zamecznik. It was these images that Rydet exhibited during the 1950s: her first solo show took place in 1961. The same year, she joined the Association of Professional Photographers (ZPAF) and began to teach photography at the Polytechnic school of Silesia (Faculty of Architecture). The second significant cycle of her career, which continued in the stylistic vein of humanist photography, was dedicated this time to old age.

At the end of the 1960s, keen to explore the plastic possibilities offered by photography, Rydet made a series of post-Surrealist photocollages, metaphoric and sombre, taking as her theme human emotions. Exhibited in the form of slideshows or prints, this project entitled 'Świat uczuć i wyobraźni' (The world of the emotions and the imagination, 1975–9) became in 1979 her second photography book, divided into fifteen chapters with evocative titles, such as

'I capture what will soon probably no longer exist.'

ZOFIA RYDET

'Birth', 'Lovers', 'Maternity', 'Farewells', 'Threat', 'Mannequins', 'Phantoms', 'Transformations' and 'Annihilations'.

But the great project for which the photographer is remembered in the history of the medium is her 'Zapis socjologiczny' (Sociological record). For this monumental documentary venture, which occupied her from 1978 until 1989, Rydet travelled through the rural areas of southern Poland, producing in a systematic manner the portraits of its inhabitants and the interiors of their homes. Rydet's desire to capture the everyday life of villagers in the disappearing Polish countryside was the driving force in this intimate immersion. The resulting images were portraits of families or individuals, organized in accordance with several sub-chapters, including 'Professions', 'Women on the Doorstep' and 'The Myth of the Photograph', the latter focusing on family photographs hanging in the home. Conceived on the basis of a simple and repetitive method – subjects always taken face on and sitting in the main room of the house, lit by the harsh light of the flash – this 'sociological record' consisting of tens of thousands of negatives, many of which were printed and shown in 1979, marked the birth of the new documentary in Poland. **KZ-L**

Maryam Şahinyan

1911–1996, Turkey

Maryam Şahinyan (Foto Galatasaray), *Untitled*, Beyoğlu, Istanbul, July 1949

Situated in the lively Beyoğlu neighbourhood of Istanbul, Foto Galatasaray was the location of countless photographic mises en scène. Trained by her father, the photographer Mihran Şahinyan, Maryam Şahinyan started as an assistant prior to running this modest studio herself from 1937. This change meant also opening up to a female clientele, who could then pose comfortably in front of a woman's camera. Continuing in this way until 1985, Maryam Şahinyan's career attests not only to the progressive professionalization of women photographers during the course of the twentieth century, but also the importance of the Armenian community in the development of photography in Turkey, and in the Middle East in general. For almost fifty years, Şahinyan received clients of all ages, backgrounds and nationalities, testifying to Turkey's complex and layered social fabric. When she died, she left behind her abundant and meticulously catalogued archives – almost two hundred thousand negatives, offering a valuable account of the development of photographic conventions, fashions and local traditions and customs.

Like other studios in the Middle East in the middle of the century, Foto Galatasaray became a space for individual expression: a place for play, disguises and gender performance. Equipped with a bellows camera, Şahinyan was successful in printing high-quality black-and-white portraits, thanks to a remarkable mastery of focus. Contrasting light, play of shadows and poses contributed to creating flattering, almost idealized, images of her subjects. She also revealed photography's performative power, encouraging her models to play with their own image. In addition, Şahinyan was able to build a relationship of trust with her clients, some of whom liked to play with their femininity, allowing themselves to be portrayed in elegant dress or for their hair to fall over their shoulders. The use of make-up and accessories was common, particularly with men: some posed dressed as women, wearing evening dress, playing the young newly married couple, or pretending to kiss. It is difficult to say whether these manifestly theatrical portraits arise from a conscious questioning of gender and sexual identity, or if they are instead mises-en-scène overturning social and cultural norms. These images could equally be indicators of the homosociality particularly common in this region, where social conventions were disapproving of ostentatious associations between people of the opposite sex. Imbued with this ambiguity, Maryam Şahinyan's images act as vestiges of a past era, bearers of new historical significations. **LA**

230

Eva Sandberg was born in Silesia, part of the German Empire (now south-west Poland). Following the death of her father, a neurologist, and the evaporation of the family fortune through inflation, her mother produced and sold photos to tourists. In 1929, Sandberg studied at the Institute of Film and Photography in Munich; the following year, she was reunited with her brother Herbert, who directed the Stockholm Opera, and opened a studio in that city. She then left for Moscow, where she was introduced into literary circles by the writer Isaac Babel. The young woman married the Chinese poet Emi Siao, a childhood friend of Mao Zedong. She pursued her photography work and was granted Soviet citizenship (1934–9). When the war broke out, Emi Siao returned to China; Eva joined him there in August 1940.

Eva Siao stayed with her two oldest sons and her husband in the Yan'an caves, Mao Zedong's headquarters, and met him, as well as Zhou Enlai and the commander-in-chief Zhu De. As a foreigner, she was forbidden to take photographs. After separating from her husband, at the end of 1943 she decided to return to the USSR, but before she could leave, she was arrested by the KMT, the Chinese Nationalist Party. When she was released after three weeks, she settled in Kazakhstan with her children and survived by doing food photography. She returned to Moscow in 1945, thanks to the Red Cross, and several years later reunited with Emi Siao, who was visiting with a peace delegation. The whole family returned to Beijing in summer 1949.

On 1 October 1949, the Chinese Democratic Republic was established. Eva Siao became correspondent for the Chinese Xin Hua agency and the Soviet news agency TASS; she travelled with Emi, now secretary of the Chinese peace delegation, covering the organization's conferences and congresses, and photographed Prague, Vienna, Berlin, Stockholm, Budapest (1950–3). She worked for the official propaganda service, as well as that of the government of the German Democratic Republic, and made documentary films for GDR television (1958–64), a job that she was forced to give up due to political developments in China. She published two books on Tibet, photographed daily life in China away from the propaganda, but also the circles of power, the ex-Emperor Puyi and visiting Westerners, including Henri Cartier-Bresson, Frédéric Joliot-Curie, John Heartfield, Joris Ivens and Pablo Neruda. When her husband was sidelined, she obtained Chinese nationality in 1964.

In 1966, Mao Zedong launched the cultural revolution. The following year, Eva Siao was arrested at almost the same time as Emi. Imprisoned in a military jail, they were freed seven years later and rehabilitated in 1979. Eva again took up her work with the GDR and with West Germany (1983–9). Her photographs remained in storage in Berlin for three years. Her first exhibition was held in Stockholm. She published her autobiography, *China, mein Traum, mein Leben* (China, my dream and my life), in 1990. She travelled in Germany and the United States, where one of her three children had settled. Eva Siao bequeathed a large number of her negatives and prints to the Ludwig Museum in Cologne, and died in Beijing, where her other two children lived. **FD**

'In thirty-seven years of dreaming, China has become a reality. I shared in the joys and sorrows. I blended into that country.'

EVA SIAO

Eva Siao, *In the train heading for Beidaihe on the coast of the Bohai Sea*, China, 1957

Rosa Szücs de Truñó was one of the most remarkable photographers of the Grup Femení in the Agrupació Fotogràfica de Catalunya (AFC), which she joined in 1961. Established in Barcelona in 1923 by a group of passionate photographers, the AFC rapidly became a focal point for amateur photography in Spain, particularly after the Civil War (1936–9). With several female members right from the beginning, during the 1950s, it offered courses exclusively intended for them. It was thus that a group of amateur women photographers formed around figures such as Milagros Caturla, Carme García and Glòria Salas; they exhibited all over Spain and won numerous prizes.

Being single made access to photography easier for many of these women. Married and a housewife, Szücs was instead forced to find in photography competitions the means to finance a passion not accounted for in the family budget. Thanks to her black-and-white landscapes, portraits of women and anecdotal snapshots of everyday life, Szücs won prizes on many occasions, notably in the 1st Concurso Nacional Fotográfico de Masías Catalanas S.A. (1966), the Section féminine de la Phalange (1970), the Concurso Nacional de Fotografía de la Agrupación El Gra (1971), and the Sant Jordi de Fotografía del IEFC Prize (1978).

Szücs rapidly became involved in the organization of the Grup Femení, facilitating new theoretical, technical and artistic photography courses addressed to women. In fact, the Grup Femení encouraged teaching and the practice of artistic photography as a group, the notion of the collective emphasizing and promoting mutual support between members. It should be remembered that at this time Spanish women faced many difficulties in terms of emancipation: a minority within photographic circles, they had limited opportunities to take part in the rise of the new form of expression represented by street photography. Since women's freedom of movement had been considerably restricted during Franco's dictatorship, they had vanished from the public sphere.

Rosa Szücs developed a documentary approach focused on Barcelona and the rural landscape of Catalonia. She attributed great importance to focusing on the relationship that individuals create with their immediate environment in order to take their portrait. This approach situated her work in the ambivalent middle ground between social reportage and post-Pictorialist photography. Szücs's oeuvre is now conserved in the Museu Nacional d'Art de Catalunya. **LD and NFR**

Rosa Szücs, *Untitled [Barcelona]*, undated

Eve Arnold, *Bar Girl in a Brothel in the Red-Light District*, Havana, Cuba, 1954

'My photographs are really myself.'

EVE ARNOLD

In 1975, while preparing her first monograph, Eve Arnold decided to include a first-person account alongside her images, so that she might tell her own story about her encounters and her discoveries. While the contemporary trend was to give prominence to the images by minimizing the accompanying text, Arnold thought that this story would shed light on her photographs without detracting from their impact. Her book thus bears witness to her talent as a lively and spirited writer.

After having travelled the world and published her photoessays in numerous magazines, for this autobiographical summary she chose to include only images of women – one of her favourite subjects throughout her career, and one that, above all, enabled her to stand out. She had always shown women in a different light, in the intimacy of their everyday life, concentrating on private scenes and moments rarely seen, such as giving birth or the time devoted to domestic chores. Even when she was photographing celebrities, she lifted the curtain behind the scenes, focusing for example on the actress Joan Crawford's preparations before her public appearances. Her book thus demonstrates the extent to which the smooth and seductive images were in fact derived from the hard work and skill that were part of the stars' daily lives. Her photographs were the result of an encounter and an exchange – as shown by her work with Marilyn Monroe, to whom she was very close, far removed from the rigid poses of the studio. The book's title, *The Unretouched Woman*, was a manifesto of this sincere and committed approach.

Eve Cohen was born in Philadelphia to a modest family of Ukranian Jewish origin. She worked initially in an estate agency and then in a photographic processing factory. After her marriage, she took her husband's name and became Eve Arnold, giving birth to a son, Francis, in 1948. She studied photography with Alexey Brodovitch, the influential art director of *Harper's Bazaar*. Her first photoessay on fashion shows in Harlem was published in *Picture Post* in 1950. The following year, she joined Magnum Photos, becoming one of its first female members. After moving to London in 1963, she divorced and embarked on a long collaboration with the *Sunday Times Magazine*, while continuing to shoot advertising campaigns. She also tried her hand at directing, with a film on the veiled women of the Middle East, *Behind the Veil*, in 1971.

Arnold's reportage work took her to many countries, including Russia, China and South Africa. She also took portraits of famous figures, including Malcolm X and Queen Elizabeth II, created many exhibitions and published a dozen books devoted to her own work, reflecting on her path as a pioneer in the very male world of photojournalism. **CB²**

Semiha Es, *Turkish Brigade at Busan*, South Korea, c. 1950–3

Semiha Es began her working life in a telephone exchange at the age of fifteen. Shortly after, she met and married the journalist Feridun Es, despite her parents' protests that they would not be able to provide for themselves. Her photography career began when she agreed to take photographs to illustrate her husband's articles. For their first project together, at the initiative of *Akşam* newspaper and *Yedigün* magazine, the couple conducted an interview with President Roosevelt in Washington, then travelled to Hollywood to meet celebrities.

In the 1950s, Es became the country's first war photographer; in a baptism of fire, she covered the Korean War for the *Hürriyet* newspaper. Her work was published in prominent weeklies and dailies such as *Hayat*, a magazine comparable to *Life*, but her name rarely appeared beside her photographs: instead, they were published under the heading 'Hikmet Feridun Es was there', even if her husband never appeared on the magazine's payroll. In the pre-television era, the couple's reportage played a significant role in shaping global visual culture and the popular perception of current events. They sometimes travelled to 'exotic' places, especially remote villages in Africa and Asia.

Es's photographs from the Korean battlegrounds depicted the courageousness and heroism of soldiers rather than the destruction of war; when she did capture homesickness and other hardships, they were framed as necessary sacrifices for one's country. Above all, she relayed the human side of war – soldiers running to swim in the sea during leave, writing letters or shaving, for instance – but she did not completely ignore the darker subjects. Five years after her death, many remarkable photographs were discovered in her archive (entrusted to the journalist Özgün Akbayır, who was then working on a photojournalism project) showing subjects that the mainstream media had chosen not to publish. Es had once stated: 'It was a difficult and bitter experience for me to witness the cruelty and troubles civilians endure all because wars that result from conflicts of self-interest among politicians.'

Es bore witness to the daily lives of her subjects and sought to capture their emotions – not only in her photographs of conflict in Korea, Vietnam and Rwanda, but also those she brought back from her travels. Instead of reinforcing established ideas about war and distant cultures, she approached her work as a means of highlighting certain sociological, cultural and psychological aspects of those countries. Es passed away in 2012 at the age of one hundred, leaving behind an exceptional body of work, much of which remains to be rediscovered. **DYD**

Often linked with the artists with whom she formed connections, such as Robert Capa, Leonora Carrington and Remedios Varo, Kati Horna was the author of an oeuvre whose historical and aesthetic significance was recognized during the final years of her life. Little known until then, her photographic production was bound to a career marked by departure and exile, each occasion leading to a different name: Deutsch in Hungary, Polgare in Germany, Horna in Spain and Mexico.

Born in Budapest in Austria-Hungary (modern Hungary) to a family of bankers of Jewish origin, Katalin Deutsch Blau grew up during Hungary's disintegration and its conservative counter-revolution. In 1930, she went to live in Berlin with her husband, Pal Partós (Paul Polgare), a Hungarian anarchist who gravitated to the circles of Karl Korsch and Bertolt Brecht. After the rise of Nazism in 1933, she returned briefly to Budapest, where she trained with the celebrated Hungarian photographer József Pécsi. Moving to Paris that same year, she worked for the Lutetia-Press photo agency, then for the *Die Volks Illustrierte* newspaper, in which she published the satirical series 'Hitler Egg', created in collaboration with the German painter Wolfgang Burger and co-signed under the pseudonym 'Wo-ti' (Wolfgang-Kati).

In 1937, with Partós and at the same time as Robert Capa, her childhood friend, she settled in Valencia, in Spain, under the name of Catalina Polgare. Hired by the National Confederation of Labour, she documented the Spanish Civil War, produced images for Republican posters and collaborated with anarchist or feminist magazines, such as *Mujeres libres*, *Tierra y libertad* and *Umbral*. While working for the latter, she met the Andalusian designer José Horna, whom she would later marry. At the end of the Civil War, she succeeded in getting him released from a camp for Spanish refugees where he was imprisoned, and they emigrated to Mexico via New York, under a new identity: Catalina Horna Lechuga, 'Spanish of Hungarian origin'.

Upon her arrival in Mexico in 1939, Kati Horna developed an intense practice in various genres of photography: she produced photoreportages for the press, portraits, and architectural views, as well as teaching photography and documenting theatre productions. She created some of her images with the artists Leonora Carrington, Remedios Varo and Alejandro Jodorowsky.

The central theme of her oeuvre was symbolic foreshadowing: it was through montage, double exposure and reutilization – techniques all dear to the Surrealists – that she created an emotional and aesthetic impact. Her photography is distinguished by the 'uncanny strangeness' mentioned by Freud: the juxtaposition of the living and the inanimate, the mysterious and the familiar, the body depicted as an object, what lies hidden beneath the everyday. From this stemmed her obsession with recumbent – almost as if dead – bodies, with mannequins and dolls, and with the ghostly images that she created through double exposure. From the printed page to her personal oeuvre, Kati Horna's photography seeks to delve into our consciences to exorcise, in each of us, the destructive effect of war. **LG-F**

'The camera is not an obstacle,
it is a mirror in itself.'

KATI HORNA

Kati Horna, *Untitled*, from the series 'Hitler Egg',
in collaboration with Wolfgang Burger, Paris, 1936

From 1930 to 1934, Klára Langer attended István Szőnyi's school of painting and studied graphic design under György Nemes in Budapest. In the early 1930s, she became involved in the Group of Socialist Artists through the mediation of another woman photographer, Kata Sugár. The members of this group discussed the social role of artists and their duties, undertook research in rural villages and documented the country's poverty and social decline. Langer participated in this movement and turned to social-documentary photography from the mid-1930s. Along with those of Kata Kálmán, Langer's pictures stood in contrast to examples of 'Hungarian-style' photography represented by Rudolf Balogh and Ernő Vadas, which depicted a more idealized vision of life in Hungary. Langer later qualified as a photographer's assistant in Emery Révész-Bíró's studio before continuing her training under Marian Reismann in 1935. She specialized in children's portraits but, as a supporter of the political left, she also took photographs of neglected children, persecuted Jewish refugees and the destitute. Travelling through Hungary and Transylvania, she made several series on Hungarian and Romanian peasant life.

In the years of general unemployment caused by the Great Depression, Langer struggled to find work in Hungary. In 1938, she went to Paris and worked as an illustrator. Forced on account of her Jewish ancestry to return to Hungary at the outbreak of war, she continued to practise commercial photography in her home country, producing advertisements for the cosmetics brand Exotic, for instance. During the war, she used her skills as a graphic artist and photographer to falsify documents. Later, she published her photographs of refugees and war orphans in a series entitled *Üldözött emberek* (Persecuted people).

After the war, Langer was a prominent member of the Hungarian photography scene and taught at the Secondary School of Visual Arts for two decades. In 1956, she helped to establish the Association of Hungarian Photographers, and received an honorary artist award for her photographic work in 1962. **ZR**

'My childhood experiences have led me to become a social-documentary photographer of peasant life in Hungary and Romania.'

KLÁRA LANGER

Klára Langer, *Jewish Child*, 1943

Ata Kandó, *Madeleine Kandó*, from the series 'Dream in the Forest', Switzerland, 1955

'It is through the eyes that we understand life', declared Ata Kandó, née Etelka Görög, speaking about herself in the documentary *Ata filmje* (Ata film) by József Molnár (2005). In the course of her long life, she was able not only to understand life through the eyes, but also to learn several photographic languages. After winning with her husband the first prize – a camera – in a poster competition in Barcelona in the early 1930s, the young woman, who had initially studied painting, decided to become a photographer. On returning to Budapest, she began her training in the medium.

Twice married, each time to an artist – the Hungarian painter Gyula Kandó and then the Dutch photographer Ed van der Elsken, whom she met in 1950 in the Magnum Photos' Parisian laboratory – Kandó experienced the life and poverty of the emigrant. In Paris and in Amsterdam, she provided for her family thanks to jobs in laboratories, then fashion photos for Dior, Givenchy and Balmain. Divorced for the second time, she raised her three children alone and became an independent photographer.

Keen to travel the world, as a single woman Kandó had to fight to defend her freedom of movement. The 1960s offered her the opportunity to travel abroad and to undertake a project in more depth. In 1961, she journeyed to Venezuela, then Peru and Brazil. Soon, she was taking photographs in a mortuary, a diamond mine, and in the jungle. Thanks to her determination – described by her contemporaries as 'obstinacy' – she even succeeded in meeting an Indigenous tribe in southern Venezeula, the Yecuana, who had never seen a white woman before. Mindful of their way of life, Kandó saw the threat that deforestation imposed on these isolated communities due to the exploitation of cultivated land or drilling for oil. These experiences in Latin America were published in *A Hold véréből* (From the blood of the Moon, 1970). With this book, as well as other writings, conferences, an illustrated work, *Slaaf of Dood* (Slave or death, 1970), and travelling exhibitions, she drew attention to the genocide perpetrated by companies in the Amazon rainforest.

Her first collections of photographs date to the mid-1950s. At Christmas 1956, together with the Dutch photographer Violette Cornelius, Kandó published a book in aid of Hungarian children taking refuge in the West after the October revolution. Half a century later, an heir to humanitarian photography, she collaborated on a collective work (*The Living Other*, 2009) devoted to animals who were the victims of human cruelty, in which she presented a series on whale fishing.

The works produced with her children when they were still adolescents bear witness to an entirely different reflection. During holidays in Switzerland and Austria, Kandó staged them in images evoking a mythical world, which would be published in *Droom in het woud* (Dream in the forest, 1957), and in photographs illustrating the wanderings of Ulysses (*Kalypso & Nausicaa*, 2004). Ata Kandó was as sensitive to the visual expression of social issues as she was determined to find a way to capture the invisible with her pictures. **EF**

A woman is posed dramatically, sitting among rocks on a river bank, holding her head with one arm, her sari pulled up to her knees and her feet in the water. This photograph of the late 1930s, of a woman in a public space, bold and unencumbered in her body language, is far from the typical image to come out of India at this time: very few women enjoyed such freedoms, and almost all photographers were male. This portrait by Homai Vyarawalla, of her friend Rehana Moghul, is a rare example of the female gaze and of the often unseen dynamics that arise between a female sitter and a female photographer.

Born into a Parsi family in 1913, Vyarawalla studied at an English school in Mumbai, the city where she grew up, and went on to an arts college. As a member of the Parsi community, which had an affinity with British culture and the West, Vyarawalla had an access to a world that was atypical for Indian women of her time. She attributed her initial interest in photography to her boyfriend-turned-husband, Maneckshaw Vyarawalla, with whom she had been in a relationship since the age of thirteen. Despite the fact that she secured and executed her own commissions by herself, she signed her first published works with her husband's initials, 'M. J. V.', revealing the patriarchal bent of Indian society.

Vyarawalla's first forays into photography took place in Mumbai before and during the Second World War, when India was still a British colony. Her early work included portraits of Parsi women and images of her community, which appeared in publications such as the *Illustrated Weekly* and the *Bombay Chronicle*. In 1942, she moved to Delhi to work for the British Information Services as their official photographer, taking pictures in the city while the country's independence movement was at its peak. As India's only woman press photographer, Homai must have stood out among her male colleagues, who nicknamed her 'Mummy'. Perhaps by fitting into the role of a mother figure, she effectively became desexualized – a fact that sometimes made it easier for her to operate professionally in a sphere dominated by men.

Vyarawalla documented some of the most significant moments of this period – such as the vote for partition, decided by a handful of politicians on 3 June 1947; the raising of the flag by the first prime minister of an independent India, Jawaharlal Nehru; and Gandhi's funeral – she regretted having missed the chance to cover Gandhi's assassination, particularly since she was an ardent admirer of his philosophy. Nehru, who was her favourite subject, granted her exclusive access, which explains his frequent appearance in Vyarawalla's work. Overall, Vyarawalla built up a rich archive that constitutes a crucial visual record of Indian history and independence. Her contribution to photography has been highlighted by the scholar and film-maker Sabeena Gadihoke, who wrote a biography of the photographer.

Homai Vyarawalla continued to shoot until the late 1960s, when she felt that the attitude of high-ranking political figures towards press photographers had begun to change: the access they had previously enjoyed was increasingly restricted. Vyarawalla retired in 1970, never to pick up the camera again. **TM**

Homai Vyarawalla, *Indira Gandhi with Rajiv and Sanjay
at the First Asian Games at the National Stadium*, New Delhi, 1951

Helen Levitt, *New York*, 1971

Chalk drawings, improvised celebrations, battles, dances … Helen Levitt focused on New York City life, in the Lower East Side or in Harlem, and in particular on children's games. Less known than some of her contemporary colleagues, such as Walker Evans or Henri Cartier-Bresson (with whom she collaborated from the late 1940s), Levitt nevertheless enjoyed true visibility, even during her lifetime. Her images were widely disseminated: the public was able to view them in popular magazines like *PM* or *Fortune*, as well as in the publications of the avant-garde. In 1942, in the first issue of the Surrealist magazine *VVV*, directed by David Hare, alongside André Breton, Marcel Duchamp and Max Ernst, two of her photos appeared as illustrations in an article by Roger Caillois about the 'myth of secret childhood treasures'. A few months later, in 1943, the author Charles Henri Ford invited Levitt to contribute to the 'Americana Fantastica' issue of the artistic and literary review *View*, in which the iconography was centred on the world of childhood and the imaginary. The same year, the Museum of Modern Art in New York staged a solo show of her work. This was organized at the suggestion of James Thrall Soby, an ardent champion of Surrealism in the United States, and an influential figure in the museum at the time, who considered the photographer's work particularly 'exciting' and 'contemporary'.

'Everything I see influences me.'

HELEN LEVITT

The subjects of Levitt's images – the street, children, the African-American community – embed her work in a social context; her style, characterized by great spontaneity, allowed for a subjective and poetic exploration of these themes. The photographer brought together many influences: fascinated by Cartier-Bresson, Evans, Ben Shahn, she was also very interested in the cinema. Alongside photography, she tried her hand at this medium during the 1940s, as director and editor, before devoting herself to it entirely during the following decade. Her friendships with Janice Loeb, a documentary film-maker, and James Agee, a film critic, were decisive. In 1946, Agee paid her great homage in the celebrated essay 'A Way of Seeing', published for the first time in 1965 in an eponymous monograph. According to Agee, reality was not 'transformed' by Levitt, but she depicted it accurately, while highlighting its 'mysteries'. Neither 'journalist' nor objective 'documenter', as intended at the time, she cultivated instead a form of 'lyricism'. Her images transcribe a form of 'innocence' about life, a 'full original wildness, fierceness, and instinct for grace and form'. **JJ**

Emmy Andriesse, *Jewish Man outside Wagner & Houtman, Rain Clothes Shop at 49 St Anthony Street, Amsterdam*, Spring 1942

In 1944–5, during the last winter of the Second World War, the Dutch photographer Emmy Andriesse photographed daily life in hunger-stricken Amsterdam. She concentrated on individuals: children looking for something to eat, adults scavenging for food and fuel among the rubble of the city. A number of these photographs, such as *Boy with a Pan*, embody, for the first time in her career, the intensity and concentration for which this photographer became famous. Andriesse's gaze achieves a delicate balance between detachment and involvement, between direct representation and emotional impact. Her image of the small boy, with his sad face, his bare feet in open sandals and his seemingly empty pan, is still – according to Piet Zwart's description in the catalogue of the group show *Foto '48* (Stedelijk Museum, Amsterdam) – 'a social monument to World War II'.

The designer Zwart had been one of Andriesse's mentors when she studied at the Royal Academy of the Hague from 1933 to 1937. Like his colleagues Gerrit Kiljan and Paul Schuitema, Andriesse's teachers for the brand new and very avant-garde course in advertising, Zwart believed in photography (and cinema) as a 'new form of expression and necessity', in the spirit of the German Bauhaus, that great example of modernist artistic education. Combining an open and experimental attitude to photography with leftist political ideas, Andriesse was to become part of the first generation of documentary photographers in the Netherlands. After her graduation and well into the war, she

worked in Amsterdam as a photographer for dailies and weeklies. She mainly shot reportages of everyday life and fashion and developed a sober, frontal approach, in images leaning on harmony and symmetry, a style that was also defined by her use of the Rolleiflex, with its square format.

Forced as a Jew to wear the star – despite her mixed marriage to the designer Dick Elffers – Andriesse found it impossible to work and in 1943 had to go into hiding. After obtaining a forged declaration to the effect that she was of Aryan origin, she started photographing once more, as a member of a loosely organized group – later known as De Ondergedoken Camera (The underground camera) – that documented the deplorable situation in Amsterdam.

After the war, Andriesse mostly concentrated on four subjects: portraits of artists, fashion images, people in foreign countries, and reportages inspired by Vincent van Gogh. Her artist portraits are composed like still lifes, whereas her fashion photographs are an intriguing mixture of feminine elegance and lively reportages of beautiful women. Andriesse's last project, an impressive commissioned series inspired by the paintings of van Gogh, was published posthumously in 1953, soon after her death from cancer at the age of thirty-nine. A personal selection of her own photographs, *Beeldroman*, was published in 1956. It shows a photographer who was essentially a portraitist and who possessed a great emotional response to the poetry and humour of the everyday, the allure of texture and light, and the dignity of the individual. **HV**

When Jette Bang graduated from high school, she travelled to Paris. It was here that she met the artist, writer and Greenland explorer Eigil Knuth, who would introduce her to his network of 'Greenland enthusiasts' back home in Denmark. Having returned to Copenhagen, she became an apprentice at the advertising photography company Jonals Co., where she worked from 1933 to 1935. In 1936, when she was twenty-two years old, she embarked on her first trip to Greenland, which had been a Danish colony since 1814. This trip was a remarkable odyssey for such a young woman, since Greenland was unknown territory for most people and travelling there required specific permission from the Danish authorities. Travelling along the west coast by dogsled – sometimes alone and sometimes as part of a four-man expedition accompanied by Knuth – she aimed to depict the everyday life of the Inuit, and especially their hunting parties, conducted during the short winter days under freezing conditions.

When, in 1937, she returned to Copenhagen after her eight-month journey, Bang exhibited her photographs at the Museum of Decorative Arts, with the Danish prime minister Thorvald Stauning acting as sponsor. The exhibition was a crowd-puller, since the Danes were not used to seeing photographs of ordinary people from Greenland. The photographs taken on this first trip remain her masterpiece. Later that year, Bang travelled to east Greenland, where she started working on a colour documentary film, *Inuit*, which was finished in 1940. At the same time, she published her first book of photographs, entitled *Greenland*, which also featured a foreword by the prime minister.

Bang returned to west Greenland on numerous occasions, in 1938–9, 1945 and 1956, and travelled to east Greenland and Thule in the north in 1961 and 1962 – journeys that inspired several books and documentary films.

Before Bang, Greenland had hardly ever been regarded as a subject in its own right: those who brought back photographs were explorers, colonial administrators, priests or teachers. Bang, however, went to Greenland with the sole purpose of photographing the traditional Inuit way of life with an ethnographic curiosity, and she used the newest photographic equipment: she had a Rolleiflex, but also a 16mm camera and the new Kodachrome colour films. Her photographs are remarkable both because of her modernist, simple compositions and close-ups, and because she approached her subjects, often children and women, sympathetically. She documented the slow but inevitable modernization of Greenland as well as the Inuits' disappearing hunting and fishing culture, traditional clothing and modest houses. Bang took more than eleven thousand still photographs in Greenland, which today are kept at the Danish Arctic Institute in Copenhagen. **MS**

'My only chance to capture the real Greenland was that I could move unnoticed and slip naturally into the country's daily life.'

JETTE BANG

Jette Bang, *Didrik and Katrine Nikodemussen with their children inside their house at Ikerasak*, August 1956

'I am curious. Even if I am afraid, I still want to go and look – to show the world what I have seen.'

TSUNEKO SASAMOTO

Tsuneko Sasamoto was the first Japanese woman photojournalist. She hoped to become a novelist or a painter; however, as her father considered that 'it was not a woman's place', she began to study economics, which she soon abandoned. Passionate about fashion, she worked as a part-time illustrator for *Nichinichi Shimbun* (now *Mainichi Shimbun*), one of Japan's leading daily newspapers.

In 1937, Sasamoto discovered the work of Man Ray – this revelation led her to become a photographer. Three years later, at the age of twenty-six, she joined the Japanese Photographic Society (Shashin Kyôkai), of which she was one of the first members.

For almost eighty years, Sasamoto continuously photographed the events and celebrities of her times. By turns witness to the Japanese imperialism of the 1940s, beleaguered Japan in the postwar years and the birth of the world's first economic power in the 1960s, she is one of the rare photojournalists to have covered all the major stages in the country's history during the twentieth century. She photographed the signature of the tripartite pact between Japan, Italy and Germany, the Hitler Youth visiting the country, the Hiroshima dome destroyed by the atomic bomb, the Japanese people on their knees, and a triumphant General MacArthur during the American postwar occupation, the coal miners' strikes and student demonstrations of the 1960s. Sasamoto also captured famous faces from Japan's political and cultural worlds. In 1955, she took a portrait of Inejiro Asanuma, the leader of the Socialist Party, on the eve of his assassination.

Inspired by the American photographer Margaret Bourke-White, ten years her senior, Sasamoto worked in a classic documentary style, in black and white, and always using a flash, which was considered obligatory by contemporary Japanese photography: similar professional expectations also forced her to wear a skirt and high heels (a considerable technical handicap). As a woman, she was regularly on the receiving end of sexist comments from her colleagues and even from her subjects. Women became a central theme of her work: much of her oeuvre is devoted to the independent and unsung heroines of the Meiji era (1868–1912) and the early Shôwa era (1926–89), confronting endemic male chauvinism and attempting to make their voices heard as novelists, social campaigners or actresses. In 2014, to celebrate her hundredth year, Sasamoto curated the exhibition *100 Women* in Tokyo, which celebrated the strength and accomplishments of women in the face of long-standing sexual discrimination.

In 1985, an exhibition relaunched Tsuneko Sasamoto's career. The photographer has now become an authority in her homeland, where she is known as 'the Japanese Annie Leibovitz' and considered a 'national treasure'. Numerous books have been devoted to her, all in Japanese. She gained recognition in the United States more recently: in 2016, she was awarded a Lucy Award for her entire career, and in 2021 her work was included in Andrea Nelson's exhibition and publication *The New Woman Behind the Camera*. **PV**

Tsuneko Sasamoto, *Atomic bomb dome*, Hiroshima, 1952

Constance Stuart Larrabee, *Johannesburg Social Center*, South Africa, 1948

'I always wanted to be a photographer.
I had one road to take; there were no others.'

CONSTANCE STUART LARRABEE

When we consider Constance Stuart Larrabee's career and her extensive photographic legacy, it seems clear that the many places in which she lived and worked had a marked effect on her photography. Born in England in 1914, she moved to South Africa as a baby with her mother to join her father, who was working in the mines. In the early 1930s, she stayed for a period in London to study photography – most notably under Madame Yevonde, one of the first photographers to practise the new colour process called 'Vivex' – then moved to Germany. Returning to South Africa in 1936 as a professional photographer, she opened the Constance Stuart Portrait Studio in Pretoria; a second studio opened in Johannesburg ten years later.

Aside from her activity as a portraitist, Stuart Larrabee ventured into the rural areas of South Africa, where she began engaging with local tribes – the Ndebele, Bushmen, Lobedu, Zulu, Swazi, Sotho and Xhosa peoples – and taking photographs of them. The notion of a white woman photographing Black African tribes raises the question of the gaze, in particular the colonial gaze. Could Stuart Larrabee be guilty of pointing her camera at the 'other' in a form of ethnographic documentation? A closer examination shows that her images were taken from a low vantage point, giving her subjects a position of superiority and allowing one to conclude that her interest did not lie in procuring scientific evidence. Her lower viewpoint could be the result of her small stature but also a reflection of how she saw the world.

Stuart Larrabee was commissioned by publications such as the liberal magazine *Libertas* to cover the war in Italy and France between 1944 and 1945. Having agreed to follow the South African troops, she took advantage of her mission to show civilian populations and the consequences of war on local villages. South African mining companies such as De Beers also hired her to showcase their operations and report on the 'success' of the closed compound system, which was built to house Black male migrant miners. However, these male-dominated spaces were difficult to access as a woman photographer. When she was in Italy, Stuart Larrabee was not, as the only female war correspondent, allowed to stay in the press camp but was billeted elsewhere, with nurses. Despite these challenges, she went on to create what the South African writer Peter Elliott described as 'enduring images of the battle-scarred landscape'. Whatever difficulties Stuart Larrabee faced during her travels, her photographs, inspired by the links that she formed with those she met all over the world, are testaments to humanity's rich diversity. **NB**

Suzi Pilet, *Overprinted self-portrait*, c. 1940

A woman ahead of her times – this is probably the best way of describing Suzi Pilet. Distinguished by her independent spirit, she was one of the first women to earn a living in French-speaking Switzerland as a photographer, thanks to her successful business in portrait commissions. Working from the same studio in Rue Grand-Saint-Jean in Lausanne for more than fifty years (1958–2009), she became one of the city's most iconic figures.

Born on 18 April 1916 at la Tour-de-Peliz, Pilet decided very early on that photography would be her profession. After her apprenticeship, she formed friendships with a circle of French-speaking literary and artistic figures with whom she would establish the group La Chevalerie errant (Knights-errant). Gathering in the middle of the Bois de Finges, in the Canton of Valais, these artists and writers lived like adventurers enamoured of freedom, despite the precariousness of their means. At Finges, Pilet photographed the pine forest, lakes, marshes and the Rhône. She captured the river, still unspoilt at that time, with her Rolleiflex, as it flowed from Switzerland all the way to France. Dominated by natural elements from where all human presence was excluded or minimized, her images bear witness to the communion that she experienced not only with nature, but also with these lands.

Her contacts with the literary world also emerged in her images of materials and motifs: flowers, vegetation, iron filings, paint, glass … Pilet created a visual vocabulary, a repertoire of forms, shadows and light, which she used on many occasions to invent new images. She experimented with the plasticity of the photos using collage and superimposition: while the former involved

'There are mysteries in black and white.'

SUZI PILET

the physical manipulation of the thick matte paper of the positive print, and thus imposed certain limits, the latter occurred at an earlier stage, with the superimposition of the negatives. Pilet experimented with transparent effects, solarization and a play of positive/negative to create unusual, dreamlike and Surrealist images, imbued with a personal and mystical symbolism that she developed throughout her life. The photograph was thus transformed into visual poetry, whose meanings became layered and multiple.

Contrary to this symbolic language was the 'search for shock', which led her to capture the marginalized of the time, with a realist and at times brutal gaze. She made several portraits of a former inmate of the Prison de la Santé in Paris, a Geneva prostitute, a disabled person suffering from addiction. During her travels in France, Spain and Romania, she always covered, in black and white, street scenes and the daily life of the Roma communities, rural villages, women, peasants, labourers and children. This side of her practice could be considered as part of the 'humanist' movement that characterized the work of great names in photography, such as Sabine Weiss and Robert Doisneau. An elusive, non-conformist, Bohemian and ironical woman, Suzi Pilet's oeuvre reflects her personality – a mystery to unravel. **JB**

Iryna Pap, a Ukrainian photographer whose oeuvre was rediscovered only recently, occupies a special place among her contemporaries, and the significance of her legacy continues to grow. Her work owes its strength to her access to restricted areas, the viewpoints that she adopted, and her unbreakable spirit and fearlessness. One of the few female Soviet photojournalists working for the prestigious *Izvestia* newspaper, Pap was the first to be allowed to take aerial shots of the streets of Kiev, rebuilt following the Second World War; she even ventured inside the turbine of a nuclear reactor in her search for the best possible shot.

This legendary photographer was born in 1917, the same year that *Izvestia*, for which she worked from 1958 to 1971, was founded. Pap's personal biography largely echoes the grand narrative of that period in the Soviet Union's history during which whole populations were relocated, long-standing family links were suddenly disrupted, and new places were quickly settled in an idiosyncratic manner. Born in Odessa into a family of Lithuanian Jews working in the printing business, Pap grew up in Kiev and in 1941 graduated from the newly formed Ukrainian Institute of Cinematography. The war and her work took Pap and her family all over the Soviet Union – from Kuibyshev (Samara) to Uzhgorod and eventually back to Kiev. Her time at *Izvestia* coincided with 'Khrushchev's Thaw', an era of major infrastructural construction, economic growth, space exploration and the weakening of ideological tensions. It is in this political context that Pap's photography should be considered. It captures exemplary factory and collective farm workers around the country, construction sites in new neighbourhoods of Kiev, party congresses and official visits by foreign delegations. In a way, her portfolio represents Socialist Realism as viewed through the camera lens: real life in the Soviet Union is replaced by an idyllic picture of ever-smiling workers and rich harvests. It is an official history written in the photographic language, functioning as both authorized document and primary source recording an epoch.

Iryna Pap is also well known for her talents as an educator, having launched Kiev's first professional school of journalism in the early 1970s. For a long time it was the only school in the entire Soviet Union to provide any kind of professional training for photojournalists. She succeeded in cultivating high standards and introduced the idea of peer-reviewed portfolios, as a result contributing to the emergence of a new generation of Ukrainian photographers. **KF**

Iryna Pap, *The first Soviet A-segment car, the ZAZ 965 Zaporozhets, in the drying chamber of the Kommunar car factory*, Zaporizhzhia, Ukraine, 1960

The American photojournalist Dickey Chapelle was deeply committed to reporting from the heart of battle zones, having started with the conflicts of the Second World War, and ending in Vietnam, where she was killed in 1965. Photographs reveal her as a wiry woman in cat-eye glasses, often sporting military fatigues, an Australian bush hat and pearl earrings, with a Leica in hand and a wry smile on her lips. She is usually in the company of the troops, among whom she was entirely at ease. As one US Marine Corps commandant put it after Chapelle's death: 'She was one of us.'

Photography would give meaning to Chapelle's life, but it was not her first love. Born Georgette Meyer in a suburb of Milwaukee in 1919, she had a passionate interest in aviation at a young age (the nickname 'Dickey' was inspired by an early hero, the explorer Richard Byrd). She briefly studied aeronautic design and took on a variety of aviation jobs, including a stint at Trans World Airlines in New York; while there, she took a photography class taught by Tony Chapelle, whom she married in 1940. Dickey was soon working as a photographer herself; after obtaining her military press credentials, she was assigned to cover the US forces' combat training in Panama in 1942 and the battles of Iwo Jima and Okinawa in 1945.

As her photographs attest, Chapelle did not lack nerve. After the Second World War, she roamed the globe as a reporter for a range of outlets including *Life*, *Look* and *National Geographic*, earning a reputation for going to remarkable lengths for a story. She was imprisoned for seven weeks during the 1956 Hungarian Revolution. In 1958, she accompanied Fidel Castro and his cohort into the jungles of Cuba. She later parachuted alongside US soldiers

'If you call yourself a correspondent, your reason for being is first to see. And then, of course, to tell.'

DICKEY CHAPELLE

into Korea, the Dominican Republic and Vietnam – always adhering, just as she did in her photographic practice, to her instructor's directive: 'Keep your eyes wide open.'

Chapelle was supportive of the US intervention in Vietnam: her photographs from that war, though sometimes unabashedly heroizing, are among her strongest. An engaging writer, she published many articles and books, including the 1962 autobiography *What's a Woman Doing Here?*, which garnered her a George Polk Memorial Award, the highest honour for bravery awarded to a journalist by the Overseas Press Club. Three years later, on 4 November 1965, she was accompanying marines near the coastal city of Chu Lai when she was killed by a booby-trap explosive, becoming one of the first American correspondents to die in Vietnam.

Combat photography is a realm dominated by men even today; in her time, Chapelle was a clear anomaly on the battlefield. That did not deter her: she was fascinated by war and by the decidedly male military context that she navigated so deftly, producing a body of work that testifies to her exceptional fearlessness. **DCS**

Dickey Chapelle, *Execution by Firing Squad*, Algeria, 1957

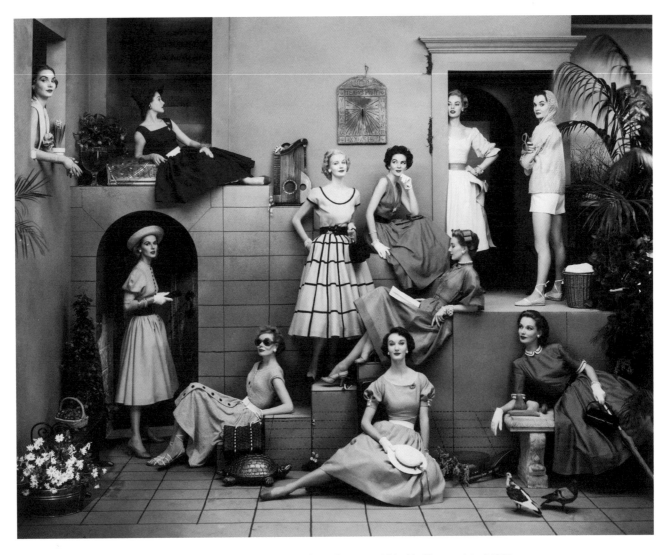

Frances McLaughlin-Gill, *Models in Green Dresses*, published in *Glamour*, 1 April 1957

Frances McLaughlin was born in Brooklyn to an American mother and an Irish father, who died when she was a baby. The family moved to Wallingford, Connecticut, and while they were still at school, Frances and her twin sister Kathryn became interested in photography. In 1941, they both graduated with a bachelor of fine arts degree from Pratt Institute, Brooklyn, and received an honourable mention in *Vogue*'s Prix de Paris, a prestigious competition open to female college students.

Soon after graduating, Frances worked as a stylist for the fashion house Montgomery Ward and as studio assistant to the photographer Leslie Gill. In 1943, *Vogue*'s art director, Alexander Liberman, hired Frances, admiring her spontaneous approach – which formed a stark contrast to the more arti-ficial aesthetic of European masters such as Cecil Beaton and Horst P. Horst. Frances was inspired by cinema and described her work up to the early 1950s as her 'filmic period', during which she 'captured motion or reality, the feeling of a moment passing'.

Using a small-format camera and fast film, McLaughlin often shot for Condé Nast's junior magazine, *Glamour*. Her pictures revolutionized the image of young American women, transforming them from prim debutantes into relaxed, self-confident individuals, casually situated in urban environments.

She also shot still lifes and covers for *House & Garden* and took portraits of sitters including a teenage Jacqueline Bouvier (the future Jacqueline Kennedy-Onassis), Eleanor Roosevelt, and George H. W. Bush. In 1954, she altered her contract with Condé Nast to become freelance. She continued to work for *House & Garden*, *Glamour* and *Vogue*, becoming a regular contributor to British *Vogue* until the 1960s.

In 1948, Frances married Leslie Gill, who died suddenly in 1958, shortly after the birth of their daughter, Leslie. After two decades in the fashion industry, Frances worked as an independent film producer, and in the late 1970s began giving photography seminars at New York's School of Visual Arts. In 1975, she participated in the landmark exhibition *Breadth of Vision: Portfolios of Women Photographers* at the Fashion Institute of Technology. She was an early member of Professional Women Photographers, a non-profit organization founded in 1975 in New York to support the work of women photographers.

In her later career, Frances published several books, and her photographs can be found in the collections of the Metropolitan Museum of Art and the International Center of Photography (ICP), New York; the Smithsonian National Portrait Gallery, Washington, DC; Cleveland Museum of Art; and the National Portrait Gallery, London. **SB²**

Daughter of the photographer Razafinatapanea, known as 'Joseph Razafy', founder and owner of the Joseph Razafy studio, based in the family home in Ampasanisadoda, an eastern neighbourhood of Antananarivo, the capital of Madagascar, Edwige Razafy was immersed in photography from early childhood. She watched her father in his studio, and, at the age of seven, began her apprenticeship. Small and delicate, the teenager became an expert in retouching and colouring. Armed with this experience, as an adult, she elected to join the studio. Following her father's death in 1949, Edwige assumed the position of director, while continuing to work in the darkroom. The new manager soon replaced the 'Joseph Razafy' stamp with 'Studio Razafy'; this company name would endure until 1964, when she retired.

The studio's official photographer, Edwige inherited her father's clients, mainly Senegalese soldiers from the French army living in the eastern part of the city, in addition to members of Antananarivo's smart set, married couples who were friends of her sister, a newspaper owner, who shared the same family home. The clientele were loyal, since the Joseph Razafy studio did not produce multiple prints but took new shots.

Edwige was joined by her elder brother, Andrianarivelo Razafy, who had attended drawing classes; he assisted and advised her. Her brother-in-law Arsène Ramahazomanana, a journalist, often employed her for reportages, which testify to the sharpness of her eye. Edwige Razafy became increasingly focused on details. The self-portraits that she took using a self-timer express grace and femininity: we see her, for example, seated on the ground, her dress artistically arranged, hands and feet adorned, sophisticated hair and make-up, jewelry in full view. She was renowned among her colleagues for the art of her composition. The accuracy of movement in her snapshots suggests that they were staged. The clear, sharp gestures of her niece dancing confirm the photographer's skill.

Although her artistic and family images were reproduced in the capital's newspapers, Razafy did not sell prints in her lifetime. Forced to close the studio in 1964 due to deteriorating health, she nevertheless continued to practise photography with a passion. Until her death on 22 April 1988, Edwige Razafy continued to capture her close family in the most sophisticated poses. **HR**[1]

Edwige Razafy, *Baovola Ramahazomanana performing a traditional dance before the Franco-Malagasy Circle,* Antananarivo, 17 January 1959

Alice Brill, *Posters on the Conde Prates building under construction*, São Paulo, c. 1954

Alice Brill usually introduced herself as an artist, but it is for her work as a photographer in São Paulo, from 1947 to 1960, that her name is remembered. As a Jew, she sought refuge in Brazil in 1934, just before her fourteenth birthday, with her father, a German painter with links to the artistic avant-garde, and her mother, a feminist journalist. Very soon, the young Brill was forced to give up her studies to help her mother pay the bills. Finding it impossible to adapt to life in Brazil, her father returned to Germany in 1936 and died in a concentration camp six years later. Deciding to devote herself to painting, Brill soon entered São Paulo's artistic milieu and began to attend life-drawing classes at the Grupo Santa Helena, a free studio shared by modern artists in the city centre.

In 1946, after obtaining a scholarship, she left for the United States with the aim of studying painting, printmaking and photography at the University of New Mexico in Albuquerque, where she remained for a year. She spent the first trimester of the following year at the Art Student's League in New York. Her plan was to acquire the technical skills that would allow her to work as a photojournalist and to sell her images to American agencies and Brazilian magazines – this would, however, never materialize.

Returning to São Paulo at the beginning of 1948, Brill began to collaborate with the Museu de Arte (MASP), photographing works of art, exhibitions, art and design courses, and other events. Her images were often published in *Habitat*, the magazine produced by the museum. Although she did not have her own studio, she printed portraits of artists – in many cases, her friends since the late 1930s – and, above all, children.

In the mid-1950s, the Italian critic Pietro Maria Bardi, then director of MASP, invited Brill to create a series of photographs on São Paulo itself, intended to illustrate a book marking the city's four-hundredth anniversary. In the end, the work was never published, but gave rise to the artist's most important body of images. Brill juxtaposed old buildings with others built more recently or still under construction; she explored the structures, scaffolding and visual pollution of advertising to produce images of striking graphic impact. Focusing on the poorest neighbourhoods, she was one of the rare photographers to paint the portrait of a multi-ethnic São Paulo, concentrating especially on the Black population.

In Brazil at that time, photojournalism and advertising were dominated by men. This is probably the reason why, despite the quality of her images, Brill never enjoyed a successful career as a photojournalist. She primarily photographed children and families, while her husband was studying medicine. In 1950, Brill gave birth to the first of her four children; as she herself recounted, she gave up photography once her husband was able to support the family – which explains why her body of work did not continue to grow. Nevertheless, her images stand out for their technical qualities and the subtlety of their sculptural forms, and the visible empathy of the photographer for her subjects, whatever their origin. **HE²**

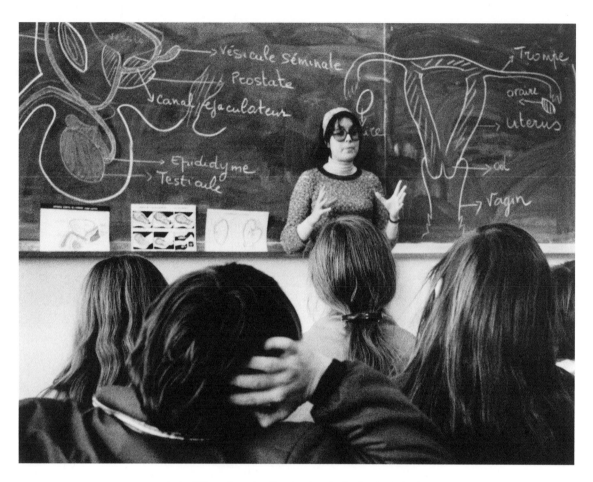

Janine Niépce, *Sex education class by a family planning instructor in a school in the suburbs of Paris*, 1973

'When I started photographing in factories, I was taken for either the photographer's assistant or his wife.'

JANINE NIÉPCE

A distant relative of Nicéphore Niépce, from a family of Burgundian wine-growers, Janine Niépce was the daughter of a brilliant aviation industrialist. While studying art and archaeology at the Sorbonne, she learnt photographic technique from a Prisma correspondence course, passing from a small Kodak to a Rolleiflex, and then a Leica. She joined the Resistance developing films, became a liaison officer with the armed resistance group Francs-tireurs et partisans (FTP), and took part in the liberation of Paris, but had neither the permission nor the time to take photographs. On a mission in Brittany, she took her first images of the joining up of the French Forces of the Interior (FFI) and the Allied Forces in the Atlantic ports in June 1944. When the war was over, she married the colonel of her network.

Armed with her camera, she travelled across France, bearing witness to changes in the country and society during the postwar boom decades. Like many of her colleagues, she worked for the French Tourism Commission (1948), but also for the Ministry for Foreign Affairs, which organized numerous, often travelling, exhibitions for her, with the aim of promoting France and its capital. In 1955, she joined the Rapho agency and its team of humanist photographers, and published *Le Livre de Paris* (1957). From 1963, she travelled the world and produced reportages in New York, Brazil, Cambodia, India and Japan. At the request of Albert Plécy, founder of the Association Gens d'Images, she presided over the Niépce Prize (1955–89). She covered the social upheavals of 1968, in colour, in France and across the world, and in 1970 published *Ce monde qui change* (This world that is changing), with an introduction by François Nourissier. But she preferred in-depth work in her own country to all too often superficial reportages.

For more than forty years, Niépce photographed women's struggle for their rights. She captured the developments in the female condition – painless childbirth, the advent of contraception, the right to abortion, the demands for equal pay – and documented family planning by photographing campaigners and their work. She took portraits of women who made a mark on their times – Simone de Beauvoir, Marguerite Duras, Gisèle Halimi, Hélène Langevin, Simone Veil – and those who broke away from traditionally assigned gender roles: Anne Chopinet, first female valedictorian at the École Polytechnique, carrying the flag on the Champs-Élysées on 14 July 1973; Danielle Decure, Air France's first female co-pilot; but also young girls at the Renault school, studying in the computer, robotics, mechanics, boiler-making, and bodywork workshops.

In 1974, Niépce presented the exhibition *La Femme, avenir de l'homme* (Woman, man's future) at Unesco. In 1983, the minister for women's rights commissioned the series 'Les Femmes et des métiers non traditionnels' (Women and non-traditional professions). The photographer published *France*, with an introduction by Marguerite Duras, to mark the retrospective exhibition of her work in 1992, and *Les Années femme* (1993), then *Françaises & Français, 1944–1968: Le goût de vivre* (2005). **FD**

'The image I seek is of youth betrayed by age, of spirit strong but fragile with time.'

ANNE NOGGLE

Unlike most photographers, Anne Noggle first fell in love not with taking photographs but with flying aeroplanes. Decades before she became aware of her gift for image-making, Noggle graduated as a pilot at the age of eighteen, pursuing a successful career with the US Army's civilian Women Airforce Service Pilots until 1945. While stationed as an officer in Paris, she discovered a love for art during routine visits to the Louvre. In 1958, suffering from lung disease, she was forced to take early retirement from active service.

The following year, Noggle enrolled to study art history at the University of New Mexico. In 1966, one year before her graduation, she picked up a camera and felt an immediate attraction to portraiture. What interested her was not so much the aesthetics and techniques of the genre as connecting with the subjects who sat for her, locating their glimmer of essence no matter their physical appearance. In particular, Noggle took photographs of ageing individuals, referring to her work as 'a saga of fallen flesh'. From tender images of her mother, sister and friends to portraits of women pilots, couples and strangers, Noggle never developed the conventional habit of photographing comfortable expressions. Despite these tensions, when we look at her images we never get the sense that her subjects were uneasy in her presence.

In 1970, a year after receiving her master's degree from her alma mater, Noggle became an assistant professor there, as well as working as the photography curator at the Museum of New Mexico in Santa Fe. Now fully established in her profession, Noggle exhibited her work, published three books and received numerous awards, including a Guggenheim fellowship in 1982. She began taking her renowned self-portraits in 1975, this time applying her ability to capture the intricacies of her subjects to herself. Fascinated by the ageing process visible in her own body, she photographed, up close, her wrinkles and imperfections – including an ironic documentation of her facelift. As her photographs and writing suggest, her objective was not to shame women for feeling uncomfortable with ageing, but rather to highlight its complexities, letting her subjects know that their uneasiness was a collective, messy and beautiful experience.

Producing work in the era of second-wave feminism, Noggle hinted that she was not in alignment with the movement's theoretical values, but that did not mean she was not an advocate for women. In 1975, she curated an exhibition with Margery Mann at the San Francisco Museum of Modern Art called *Women of Photography: An Historical Survey*. Noggle passed away on 16 August 2005 – her birthday – in Albuquerque, New Mexico. Her career in photography proved to be every bit as successful as it had been in aviation. **CL**

Anne Noggle, *Stonehenge Decoded*, 1977

In the 1960s and 1970s, artists forged new expressive possibilities with colour photography, a medium until then chiefly associated with advertising. Marie Cosindas was one such pioneer.

Born in Boston, she graduated from the Modern School of Fashion Design. She also studied painting, drawing and graphic design at the school of the Museum of Fine Arts, where she was drawn particularly to the Nabis painters Paul Bonnard and Édouard Vuillard. Following her studies, Cosindas worked as a textile designer and illustrator. Her interest in photography began in the mid-1950s, when she came into contact with an influential circle of photographers – Minor White, Paul Caponigro and others – who showed at the Carl Siembab Gallery, which occupied the same building as her design studio.

Cosindas first explored photography's creative potential in black and white. In 1961, she attended a workshop in California organized by Ansel Adams, who encouraged her to work in colour, convinced that, even when using black-and-white film, she 'thought' in colour. Cosindas was one of the first photographers to test the new Polacolor film in 1962. She experimented with light sources, exposure times, colour temperature and filters; the instant film meant that she could review the results quickly and perfect her visual vocabulary of lush tones and sensual moods.

Cosindas's aesthetic is often described as 'painterly', but the calm twilight and vibrant lushness can only be created through photography. In her instant and dye-transfer prints, she made light as tactile as skin or silk or painted wood. For her first solo show at the Museum of Modern Art, New York, in 1966, John Szarkowski wrote of her images: 'Their delicate otherworldliness refers to a place and time not quite identifiable – to a place with the morning-fresh textures and the opalescent light of a private Arcady, and to a time suspended, as in a child's long holiday.'

Cosindas's still-life compositions, full of flowers, ferns, masks, dolls and textiles, evoke an unusual visual universe – one that we find also in her portrait series, such as 'Dandies' and 'The Grandes Dames of Couture', which feature Andy Warhol, Elsa Schiaparelli and Coco Chanel. She photographed the famous – Truman Capote and Yves Saint Laurent, for instance – as well as people she met while travelling.

Cosindas's career reached its height in the 1960s and 1970s. She received a Guggenheim fellowship in 1967. Her work appeared in major magazines, such as *Life*, *Esquire* and *Vogue*. When the German magazine *Die Welt* moved to colour reproductions in 1968, Cosindas's portrait of the writer Tom Wolfe graced the cover. But when, in the late 1970s, the documentary clarity of William Eggleston and Stephen Shore became the new vision in colour photography, she fell from prominence. Her theatrical portraits and evocative still lifes nonetheless constitute a rich and unique aesthetic that would later find echoes in the work of Deborah Turbeville and Sarah Moon. **SH**[1]

Marie Cosindas, *Masks*, Boston, 1966

'I want to evoke the mystery of colour.'

MARIE COSINDAS

'I really believe there are things which nobody would see unless I photographed them.'

DIANE ARBUS

Over fifteen key years, from 1956 to 1971, the American photographer Diane Arbus produced some of the most compelling and demanding portraits of the twentieth century – a body of work that would revolutionize not only the genre of portraiture, but the artistic possibilities of photography in general.

Arbus began making photographs in the 1940s, dedicating herself to it fully by 1956. She marked that moment by numbering a roll of 35mm film and its contact sheet with the inscription '#1'. Arbus later recalled, 'It was my teacher, Lisette Model, who finally made it clear to me that the more specific you are, the more general it'll be.' Following this advice, Arbus actively looked for people and contexts outside her own background and personal experience, creating portraits that reflect her yearning to bring together the diverse range of humanity.

Working mostly in and around New York City, Arbus photographed couples, children, nudists, suburban families, female impersonators, circus performers and celebrities, among others. She photographed the privileged as well as those overlooked by society, with a directness that confronts their singularity and arouses our curiosity but without introducing any note of ridicule – creating what curator Sandy Phillips has described as a 'productive tension between empathy and critical distance'. Arbus was moved to describe the differences between us as human beings clearly and precisely. For all their directness and detail, the photographs retain an otherworldly quality, perhaps nowhere more evident than in her enigmatic series 'Untitled' (1969–71).

In 1962, Arbus began to use a medium-format camera, first a Rolleiflex and later a Mamiyaflex, with its distinctive 2¼-inch square negative; the prints that she made, with their soft edges, became her signature. She was awarded a John Simon Guggenheim Foundation grant in 1963 for her project *American Rites, Manners, and Customs*, and again in 1966 for *The Interior Landscape*. During the 1960s, Arbus published more than one hundred photographs in leading magazines, such as *Esquire* and *Harper's Bazaar*.

At the end of the decade, Arbus gained important recognition. Curator John Szarkowski included her in *New Documents* (1967) at the Museum of Modern Art, New York, alongside Lee Friedlander and Garry Winogrand – a now landmark exhibition that defined new directions in documentary photography. Later, *Artforum* published a photograph by Arbus on the cover of their May 1971 issue, along with five others inside – the first time the influential magazine had featured any photographer's work.

Arbus died by suicide in July 1971. The Museum of Modern Art's 1972 touring retrospective and the monograph published by Aperture, which has never been out of print, introduced her work to a broad public; since then its significance has only grown. **SH**[1]

Diane Arbus, *Three female impersonators, N.Y.C., 1962*

Běla Kolářová

1923–2010, Czech Republic

A Czech photographer and visual artist, Běla Kolářová achieved international fame thanks to her series of photograms and luminous drawings and her assemblages. Educated at a business school in Prague, she initially worked for the Mlade Proudy publishing house, then, self-taught, began to photograph at the age of thirty-three. During the war, she met the avant-garde poet Jiří Kolář, co-founder of the artists' collective Skupina 42, and married him in 1949. She was encouraged in her creativity through contact with the artistic milieu of her husband, a follower of Dada and Surrealism.

In 1955, suffering from tuberculosis, Kolářová left her job and embarked on a documentary project in the streets of Prague, photographing children playing on the pavements of the capital ('Children's Games', 1957). This debut, close to the humanist photography movement, although characterized by a love of the unusual, was thrown into question with the exhibition *The Family of Man*, curated by Edward Steichen for the Museum of Modern Art in New York, which she viewed critically. Giving up street photography, she shut herself away at home and began to experiment in the darkroom. Refuting the claim that 'the whole world has been photographed', she set out to discover things that were the exception to this rule, which led her to everything that was rejected, discarded, the insignificant, and that would fall under the category of 'non-being'.

In 1961, she made her first 'artificial negatives' following a technique that she had discovered, consisting of fixing on a rectangle of celluloid, in paraffin, segments of plants, onion or potato peelings, small everyday domestic objects, to make prints from them. The resulting images were dark, abstract and formless, placing her within the abstract pictorial movement but also the 'poor art' style. A year later, in exposing a rotating photosensitive support to a light source, she created a drawing from light, the first of a cycle that became iconic, known as 'Rontgenograms' ('Radiogrammes'). This series, produced in the spirit of László Moholy-Nagy's reflections on light and movement, close to op art, was followed by minimalist compositions: Surrealist still lifes, bringing together cut hair, egg shells, bottle tops, tools and kitchen utensils, rubbish and pottery shards. Her compositions, often using objects belonging to the female domestic realm, would later lead to them being interpreted, in a similar way to her drawings created using make-up products, as feminist statements.

Běla Kolářová practised photography for only about fifteen years, producing above all, from the 1970s, assemblages of objects and drawings. It is, however, through her photographic work that she became known as an artist and was exhibited from 1961 in her own country as well as abroad, particularly in France, after she and Kolář were forced into exile in the 1980s, and at Documenta 12, in Kassel, Germany, in 2007. **KZ-L**

Běla Kolářová, *Radiogram of Circle, XI*, 1963

'Little by little, I began to perceive a world that was effectively sidelined, ignored by photographers. A world so negligible and everyday, as though unworthy of being photographed.'

BĚLA KOLÁŘOVÁ

Inge Morath, *Reno*, Nevada, 1960

'I felt I had found my language in photography.'

INGE MORATH

Inge Morath turned to photography after working as a translator and journalist. This form of expression suited her to the extent of it becoming a platform for dialogue with artists from other disciplines. For example, between 1958 and 1966, with the American artist Saul Steinberg, she created a strange masquerade: they staged a performance with their friends, wearing cardboard and paper masks invented by Steinberg. Morath photographed the costumed models, subverting the conventions of the portrait. The classical and serious poses contrasted with the grimacing paper faces, creating an equivocal reportage in the form of an artistic joke. The photographer also maintained a long relationship with the cinema, working on sets and photographing the actors. In 1960, during the filming of John Huston's *The Misfits*, she met the playwright Arthur Miller, whom she would later marry. Together, they created books on Russia, China and Connecticut, based this time on the dialogue between literary and visual expression. According to Miller, 'Travel with her was a privilege because I would

never have been able to penetrate that way.' Her colleague Eve Arnold expressed it differently: 'Before going to photograph in Russia, she learnt Russian. Before going to China, she studied Chinese to be able to make herself understood by the people whose faces she was borrowing.' Morath used her multilingual talents to speak her favourite idiom, 'the language of photography', better.

Born in Austria, Inge Morath grew up in several European countries and studied languages in Berlin. She started out as a copywriter and editor for *Heute* magazine in Vienna, where she formed a friendship with the photographer Ernst Haas, who was published in the magazine. She followed him to Paris when he joined the Magnum Photos agency, becoming one of its editors. She was then drawn to photography and worked as Henri Cartier-Bresson's assistant in 1953.

Morath was, together with Arnold, one of the first women to become members of Magnum Photos in 1955. She travelled in Europe, South America, the Middle East and North Africa, and published books on Spain and Iran with the publisher Robert Delpire. Her work ranged from portraiture to travel photography, as well as writing and reportage, displaying a particular attention to the human figure and a taste for the unexpected full of elegance and surprises. **CB²**

Alice Springs, *Advertisement for Gitanes cigarettes*, Paris, 1977

Mrs Newton. June Newton. Alice Springs. June Browne. June Brunell. Many names for a woman who had many professions – actress, model, art director, curator, painter, photographer – and who assumed a new identity each time. This seems appropriate for a person whose first love, according to her husband, the fashion photographer Helmut Newton, was acting. It was perhaps because Alice understood so well the power of putting on a mask that she was so drawn to portrait photography, a genre that continuously plays with tensions between authenticity and performativity.

Alice grew up in the countryside of Victoria, exhibiting a wild spirit that stayed with her through life. She had no ambitions to be a photographer when she married the Melbourne-based Newton in 1948. In 1970, however, Alice began working as a fashion and editorial photographer, essentially wherever Helmut's increasingly prominent profile took them. She soon settled on the field of portraiture, concentrating for the most part on celebrities to whom she had access through her husband: figures from the fashion world, actors,

writers and artists (including other photographers). It would be a mistake to characterize the development of Springs' practice as simply a product of her marriage: she always used her position in front of and behind the lens (she was often photographed by Helmut) to create and maintain the image of someone who both belonged to the cosmopolitan world she frequented and also knew how to step aside from it and watch from a distance.

This is not to suggest that Springs' work – especially her portraits – were the product of cynical or sceptical observation. There is certainly a warmth to her portraits: she was not interested in dissecting her sitters' characters, reflecting that 'Nothing ever works well with me, if they're not at ease.' Indeed, she approached portrait photography not as a critique, but as an art form that, carefully used, could reveal something about the personality and individuality of the sitter. The people she shot – and her best photographs are of women – were used to the experience, having used photography to form their public persona. At their best, Springs' portraits reveal something of this performativity. They avoid overt stylization and rely instead on the principles of authenticity and 'matter-of-factness', allowing the subject and their picture (rather than the photographer) to speak.

In this aspect of Springs' work it is possible to recognize a kind of riposte to Helmut's hyper-stylization, which reflects and encodes male desire. What we have in her photographs is 'no-style'. Springs has clearly thought about this, and the implications of what it means to shoot as a woman. In her portraits, we see women negotiating desire: not necessarily the kind of violent desire that drove Helmut's work, but desire as an ambivalent form of energy whose object is always insatiable, a process that is continuously performed and enacted. **AO'H**

'A woman photographer can never, ever get what a man can out of a woman. I used all the acting skills I had to make people relax, dwell within themselves and just look at me.'

ALICE SPRINGS

Hou Bo, one of China's most famous female photographers, is also known as the 'Red Wall photographer' for having worked full-time for Mao Zedong and the principal comrades of the Central Committee of the Chinese Communist Party (CCP) between 1949 and 1961.

Born in Xiaxian, Shanxi Province, Hou Bo joined the Communist Party at the age of fourteen. Later she attended high school in Yan'an, a city whose universities between 1939 and 1944 were hotbeds of Marxism-Leninism and Maoist ideology. In 1942, she married the film photographer Xu Xiaobing and began to study photography herself. Following the Sino-Japanese War of 1937–45, Hou Bo followed her husband to the Northeast Film Studios (now the Changchun Film Studio), where she was hired as the head of the photography department. Here, she learned more complex photography techniques and engaged in film photography.

In 1949, Hou Bo was appointed chief cinema photographer in Beijing. The same year, having transferred to headquarters as the head of the photography section at the general office of the CPC Central Committee, she became Chairman Mao Zedong's full-time photographer. Over the next twelve years, Hou Bo covered the political activities of party and state leaders – founding ceremonies, national holidays, political meetings, inspections, meetings with heads of state and friends, interviews with famous people from all walks of life, and visits to urban and rural populations – and attended the main sessions of the Party Central Committee. After finishing her service at central headquarters, she then worked as a senior reporter at Xinhua, China's official news agency, and was also honorary chair of the China Women Photographers Association.

From 1986, Hou Bo and her husband organized various photography exhibitions in China, Japan, France and Britain. *Hou Bo & Xu Xiaobing: Mao's Photographers*, held in 2004 at the Photographers' Gallery in London, brought together sixty black-and-white photos covering Mao Zedong between the Yan'an period and the beginning of the Cultural Revolution. Together they showed how the Great Helmsman used photography as propaganda to fuel his personality cult. In 2003, a documentary film about Hou Bo, shot by the French historian Claude Hudelot and the film-maker Jean-Michel Vecchiet, was screened at the Rencontres de la Photographie in Arles.

Hou Bo died on 26 November 2017 in Beijing at the age of ninety-three. According to statistics that are still incomplete, more than four hundred of her photos of Mao Zedong's public and private life were published. She was incontestably the most important photographer of China's Red Period. **YH**

Hou Bo, *Chairman Mao Zedong with the students and teachers of the Shaoshan School*, China, 1959

'I am eaten up by curiosity: I would like to go into every home, discover the life of others. I sometimes go into forbidden places.'

SABINE WEISS

Sabine Weiss was the longest-working female professional photographer in France. Less known than her elders Robert Doisneau, Willy Ronis or Édouard Boubat, independent and discreet, she was slow for a long time to submit herself to the public eye. The taste for the encounter, attention to technique and a constant and lively curiosity for observing people – anonymous or public figures – in their environment are the common thread in an extremely diverse oeuvre.

Born in 1924, Sabine Weber chose to be a photographer at the age of eighteen. After an apprenticeship with Paul Boissonnas in Geneva, she worked in Paris with the German portraitist and fashion photographer Willy Maywald from 1946 until 1949, then set out as a reporter-illustrator, a profession considered as masculine. In 1950, she married the American artist Hugh Weiss, and moved with him to a small house-workshop near the Porte Molitor; the couple worked there side by side, surrounded by artist friends, for almost sixty years.

Spotted by Doisneau in 1952, she joined the Rapho agency and worked intensely for the illustrated press. An equal interest in different techniques and subjects, from advertising to social reportage, fashion and artistic portraits, from the Rolleiflex to the Leica or the darkroom, distinguished her from her colleagues. With a good command of English, attracted by travel and popular cultures, she was often sent abroad and closely collaborated with the Rapho Guillumette Pictures agency, directed by Charles Rado in New York. Recognition would come from the Museum of Modern Art in New York (with the exhibitions *Post-War European Photography* in 1953, and *The Family of Man* in 1955) and the Art Institute of Chicago (a solo exhibition in 1954), prior to the Bibliothèque Nationale de France presenting her work at the Salon National de la Photographie in 1955, 1957 and 1961. At a moment in which changes in society led to the proliferation of new magazines devoted to consumerism, leisure or tourism, and in which the influence of humanist photography was declining, Weiss adapted to demand. Her mastery of colour and her relationship with Rapho Guillumette earned her a stream of commissions from the 1950s to the 1990s, from magazines such as *Holiday*, *Margriet*, *European Travel and Life* and *Town & Country*. She was also in demand in advertising and fashion, particularly for portraits of young children and babies. These commissions enabled her to earn a living at a time when many humanist photographers were struggling.

It was not until 1978, with a retrospective at Arras, two monographs and the public's enthusiasm for the photography of the 1950s, that she herself rediscovered and recommenced her work in black and white. Posters and publications followed, some of her images became famous but several recent exhibitions, notably the retrospective organized by the Jeu de Paume at the Château de Tours in 2016, or *Sabine Weiss: Les villes, la rue, l'autre* (Sabine Weiss: Cities, the street, the other) at the Centre Pompidou in Paris in 2018, have shown that the reassessment of her archives and her oeuvre has only just begun. In 2020, Kering and the Rencontres d'Arles awarded Sabine Weiss the *Women In Motion* Award, paying tribute to a remarkable career. **VC**

Sabine Weiss, *Horse, Porte de Vanves*, 1951

Lisetta Carmi, *The Transvestites*, 1965

b. 1924, Italy

'When people ask who taught me to photograph, I always reply: life.'

LISETTA CARMI

In 1965, when Lisetta Carmi photographed transvestites in their homes in a neighbourhood of Genoa, five years had gone by since she decided to abandon a promising career as a pianist to devote herself instead to photography. Her first experience was in Puglia, with the ethnomusicologist Leo Levi. Armed with a small viewfinder camera – an Agfa Silette – she realized that this was where her vocation lay, learnt the technique of shooting and printing, while her father encouraged her by giving her a Leica. She was ready to show what really interested her: the harshness of the world of labour, demonstrations, sick children at the Gaslini hospital in Genoa, the birth of premature babies. Carmi knew what she wanted to do: recount, denounce, reveal and provoke. And provocative is the word to describe the images that she took in 1964 in the port of Genoa, where portraying the dockers was not an easy task for a woman. The result was a cruel and poignant reportage on the extreme hardship of this job: 'Genova porto: monopoli e potere operaio' ('Genoa port: monopolies and worker's power'). The exhibition, under the patronage of the FILP-CGIL, the Italian federation of port workers, and accompanied by texts by the Italian dramatist Giuliano Scabia, was favourably received and shown in other Italian cities, even in the Soviet Union.

Carmi then produced unsettling images of the monumental Staglieno cemetery, published in 1966 in *Erotismo e autoritarismo a Staglieno* (Eroticism and authoritarianism at Staglieno), and an artist's book, *Metropolitan*, printed in a single copy, with text by Alain Robbe-Grillet, the result of two intense weeks: shots taken in Paris that uncompromisingly showed the anonymous lives of passers-by, of tired and distracted travellers, a beggar's hands. In 1966, at the invitation of Gaetano Fusaroli, director of ANSA, the Italian associated press agency, Carmi photographed Ezra Pound at his home in Sant'Ambrogio di Rapallo, already old and exhausted after a long period in a psychiatric hospital. Twenty shots taken in just a few minutes captured the poet's rebellious and brilliant spirit – and earned their author the Niépce Prize.

But the power and originality of her portraits emerged particularly in her images of transvestites in the Genoa ghetto, immortalized at home during private parties, surrounded by familiar objects – trinkets, dolls, kittens …, with text-interviews by the psychoanalyst Elvio Fachinelli. It was an account of friendship and work, which, after several rejections, erupted in 1972 in the book *I travestiti*, thanks to Sergio Donnabella, who founded a publishing company, Essedi, in order to publish it. The book caused such a scandal that bookshops would not display it (and, of course, would not sell it). Of the three thousand initial copies, only a few hundred would avoid being pulped and would be gifted by Carmi, Donnabella and Fachinelli.

However, soon Lisetta Carmi gradually began to abandon photography in favour of fresh existential experiences, firstly in India in 1976, when she met the master Babaji, then with the opening of an ashram at Cisternino in Puglia. Still today, *I travestiti* is a valuable testimony and an object sought after by collectors. **FM²**

Dominique Darbois, *Untitled*, taken from the book *Kai Ming, le petit pêcheur chinois*, Nathan, 1957

Dominique Darbois was the daughter of Philippe Stern, a specialist in Asian art, and Madeleine Schwab, née Meyer, a novelist known by the name Madeleine Sabine. In 1941, at the age of sixteen, under the pseudonym Dominique Darbois, which she would retain, she joined the Free French Forces. As a Jew, she was imprisoned at the camp in Drancy in 1942, surviving there for two years, and then taking part in the liberation of Paris after the camp was liberated. In 1944, she added five years to her age in order to join the regular army for the Eastern Front and retake Alsace-Lorraine. Once France was liberated, Dominique Darbois served in Indochina: in Tonkin, as a second lieutenant; in Hanoi, in the code room; and in Haiphong, in the evacuation of civilians. By the age of twenty, awarded a medal by the Resistance and the Croix de Guerre, the young woman had already lived several lives. Introduced to the profession by the photographer Pierre Jahan, between 1946 and 1948, she began to produce her first reportages in 1950.

In 1951–2, with the ethnologist Francis Mazière and Wladimir Ivanov, director of photography, she travelled in Amazonia and Guyana, taking images that would be published by the French and international press, as well as in publications *Parana le petit Indien* (Parana the little Indian, 1953) – the first in the series 'Enfants du monde' published by Nathan – which was translated into eight languages, *Indiens d'Amazonie* (Amazonian Indians, 1953), *Expédition Tumuc-Humac* (Tumuc-Humac expedition, 1953), and *Yanamale, Village of the Amazon* (1956).

Dominique Darbois embarked on an extensive project on childhood. In a series of twenty books, the series 'Enfants du monde' (Children of the world),

published between 1952 and 1978, offered a trip around the world, not from an ethnological point of view, but that of a photographer going to meet children who were not all equipped with the same tools to tackle life. Camera shots, prints, texts – Darbois worked continuously and travelled through more than fifty countries. She covered the first years of communism in China in 1957 and the struggles for freedom.

Joining the Jeanson network in France, which supported the Algerian National Liberation Front (FLN), she again entered the Resistance, this time on the side of the Algerians. Tried in absentia and sentenced to ten years in prison in 1960, she remained in hiding until the amnesty. *Les Algériens en guerre* (Algerians at war, 1961), a reportage on the Resistance and the FLN training camps in Tunisia, appeared in Italy, but this polemical publication was banned in France.

In Cuba with Fidel and Raúl Castro; in Algeria where oil flowed like water; in Afghanistan where she photographed what would remain the only trace of destroyed masterpieces – she documented states in the making as well as ancient civilizations. She clocked up numerous commissions, but also images that were more personal, taken with her Rolleiflex. 'With it, you look, you don't take aim.'

At the age of seventy-five plus, she once again took up the cause of women, in France as well as in Africa, and published *Afrique, terre de femmes* (Africa, land of women, 2004). *Terre d'enfants* (Land of children) was the final salute to life by Dominique Darbois, a photographer whose only goal had always been freedom, a remarkable woman with an uncompromising eye. **FD**

Characterized by great intellectual curiosity, cultured and determined, Mariana Yampolsky – whose father died just after she had graduated from the University of Chicago – decided at the age of eighteen to move to Mexico. She had heard about the Taller de Gráfica Popular (TGP or People's Graphic Workshop), founded in 1937 in Mexico City, which transformed printed graphics into a revolutionary tool, and decided to discover more about this collective of anti-fascist activists. Her baggage contained above all values that were intangible: the culture of her Russian great-grandfather, who had fled Tsarist antisemitism in the late nineteenth century; the passion of her anthropologist uncle, Franz Boas; and the aesthetic sensibility of her father, Oskar Yampolsky, a painter and sculptor who had met her mother Hedwig in Rome, while he was there to receive the Prix de Rome.

In Mexico, this legacy of experiences and values enabled the young woman to develop a protean artistic and social practice – she devoted herself to graphic design, curating exhibitions, photography, publishing books, promoting popular art and defending the rights of Indigenous women. After obtaining Mexican citizenship in 1948, she was refused entry to the United States, country of her birth, for several decades, which she accepted – she would never deny being a communist. Her change of nationality also strengthened her desire to live in a country that was imperfect and unjust, but extremely beautiful and of a deep humanity. Mexico would be the place where she could put into practice an ethical code of shared things – an ethic defended by the TGP.

When she joined the TGP in 1945, Yampolsky became an engraver, activist and exhibition organizer, but in 1949, it was her meeting with Hannes Meyer, former director of the Bauhaus, that led her to take up the camera as a means of expression. She learnt technique from Lola Álvarez Bravo, who allowed her to work at night in her laboratory. From that time onwards, Yampolsky began to record the landscapes, people, traditions, buildings and festivals of her adopted country. She developed, edited, ordered, classified and published thousands of photos of Mexico's popular culture – she was passionate about archives.

Meticulous and affable in equal measure, Yampolsky sought to erase her own presence from what she was photographing. Neutral in appearance, as though the people and things were representing themselves, her images are in reality the result of a careful composition before and after the camera shot. The photographer applied the same care to her books, examples of skill in editing and layout: for example, *La casa que canta* (1981), a reference book on Mexican popular architecture. From then onwards, she produced a series of publications on different locations in Mexico, accompanied by texts by her friend Elena Poniatowska.

Mariana Yampolsky also devoted her energies to developing educational projects for Indigenous young people. She produced *Colibrí*, an encyclopaedia for the young, which sold thousands of copies. In 1989, she organized a major exhibition on the history of Mexican photography. Shortly after her death, in 2003, she was appointed an honorary member of the Mexican Academy of Architecture. **LG-F**

'You see, teaching others to look is a gift.'

MARIANA YAMPOLSKY

Mariana Yampolsky, *Eagle with Ladder*, Zacatecas, Mexico, 2000

Vivian Maier, *Chicago*, 1962

Within just a few years of an auction disposing of her photographs and personal effects, Vivian Maier had acquired a posthumous reputation as a street photographer like no other. That she should be known for her street photography is noteworthy: the genre has rarely been exploited by women on account of its potential dangers (if, for instance, the subject has not given his or her consent) and the fact that, historically, women have not enjoyed the same freedom in public spaces as men. Another unusual feature of Maier's corpus is that, despite its enormous scale – it comprises an estimated one thousand prints, one hundred thousand negatives, one thousand rolls of undeveloped film, countless boxes of Kodak slides, contact sheets, Super 8 films and audio cassettes – she neither exhibited nor shared her work. Moreover, as the figures above demonstrate, only a small portion was ever developed or printed.

Although Maier devoted forty years of her life to shooting photographs, once she had settled in the Chicago suburbs after leaving New York in 1956, she made her living as a live-in nanny and housekeeper, mostly working for families with children. While we will never know why Maier chose not to make a living from professional photography or even to display her pictures, their staggering quantity – and often their quality – indicate an intense desire to depict the various worlds she inhabited, whether it was her mother's home village in the Alps, the streets of New York and Chicago, or the far-flung landscapes she captured during a five-month world tour in 1959.

An extremely secretive woman, Maier often misrepresented facts about her life. As Pamela Bannos, author of the book *Vivian Maier: A Photographer's Life and Afterlife* (2017), discovered, Maier was not born in France, as she had claimed, but in Manhattan. She said she had no living family, thus denying the existence of her mother and brother, both of whom lived in New York. There is no sign that she ever had an intimate relationship with anyone.

It was during a visit to the Champsaur valley, her mother's birthplace, in 1950 that Maier first took up photography. By the time she returned to New York, she had taken around three thousand pictures and had become proficient in the medium. She further refined her skills and she was clearly aware of developments in contemporary photography, regularly visiting the Museum of Modern Art's exhibitions.

Her subjects, which she photographed tirelessly, reflect her physical location, her work (there are lots of children) and the animated streets of various cities, principally Chicago. Among the most striking elements in her work are the self-portraits she often includes: reflections in mirrors or shop windows, or shadows cast on the ground. In 1955, she used Kodachrome film to make 35mm colour slides. In her final years, she faced significant financial hardship and was supported by the children of a family that she had cared for forty years previously. She died intestate, and issues surrounding the ownership of her images remain unresolved. **AS-G**

Paraska Plytka-Horytsvit was an artist, photographer, amateur philosopher and ethnographer. In 1945, after joining the national liberation movement against Soviet occupation as a courier for the Ukrainian Insurgent Army, she was arrested and sentenced to ten years in a labour camp in Kazakhstan. Upon her return home, to the village of Kryvorivnia in the Carpathians, she decided to devote herself to art.

In 2014, sixteen years after her death, a box full of negatives was discovered under Paraska's bed. They had been stored under poor conditions and were partly ruined by dust and mildew that, paradoxically, added a new historical and conceptual layer to the pictures' surface. This accidental discovery prompted a gradual reinterpretation of Paraska's art, and further analysis of her archive led to her inscription in the story of Ukrainian photography.

Comprising more than four thousand photographs, Plytka-Horytsvit's archive chronicled life in her native village. She started taking photos immediately after her return from the labour camps in the 1950s. She spent her first salary on a camera, her second on an enlarger. Her family and closest friends provided her main subjects. She took pictures at celebrations and funerals; she shot individual and group photos, landscapes and scenes from everyday life. Owing to the technical limitations of her camera and film sensitivity, most of her photographs were taken out of doors; only a few indoor photographs survive. Plytka-Horytsvit may have been an amateur photographer, but she was nonetheless an innovator and experimentalist. She stayed up to date with the latest trends in the photo industry and combined several media – drawing, painting, text and photography – in her artworks.

Bringing these techniques together, Paraska produced a series of portraits entitled 'Greetings from Kryvorivnia', for which she customized pieces of cardboard. She cut out holes for faces and painted colourful flowers around the border, creating an ornamental frame in the style of greetings cards. Her intention was not just to create keepsakes, but to produce images that could be posted across the country or abroad. She also used elementary retouching techniques, painting patterns onto her negatives with ink or signing her name, thus introducing additional layers of meaning.

Paraska Plytka-Horytsvit never treated photography as her main artistic medium. It was, rather, just one of her tools for recording everyday life and creating illustrations for her own books. Nonetheless, her archive records both the changes her country was undergoing and her personal search for an individual visual language. **KR**

Paraska Plytka-Horytsvit, *Untitled*, undated

Gisèle Freund, *Miners by the Sea*,
northern England, 1935

Gerda Taro, *Air raid victims
in the morgue*, Valencia,
Spain, May 1937

Lee Miller, *German guards
beaten by liberated prisoners*,
Buchenwald, Germany, 1945

266

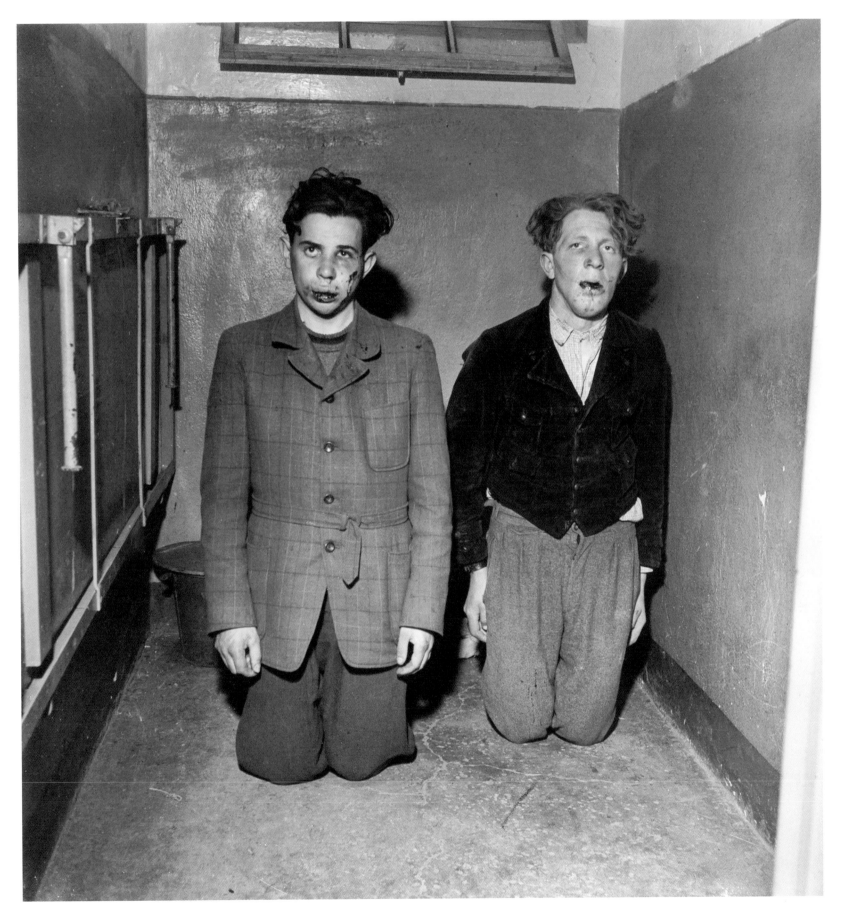

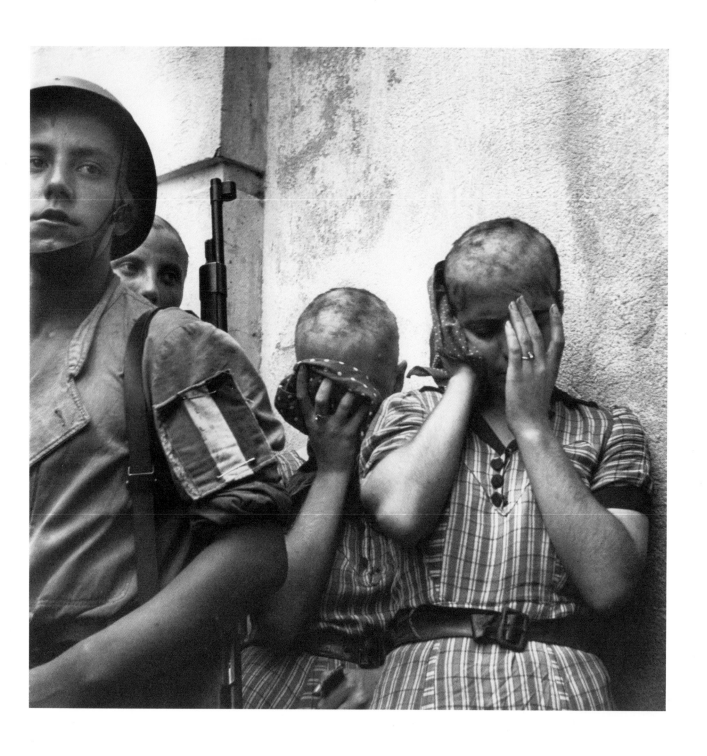

Constance Stuart Larrabee,
*Untitled [Collaboration,
Saint-Tropez, France]*, 1944

Suzi Pilet, *Untitled*, undated

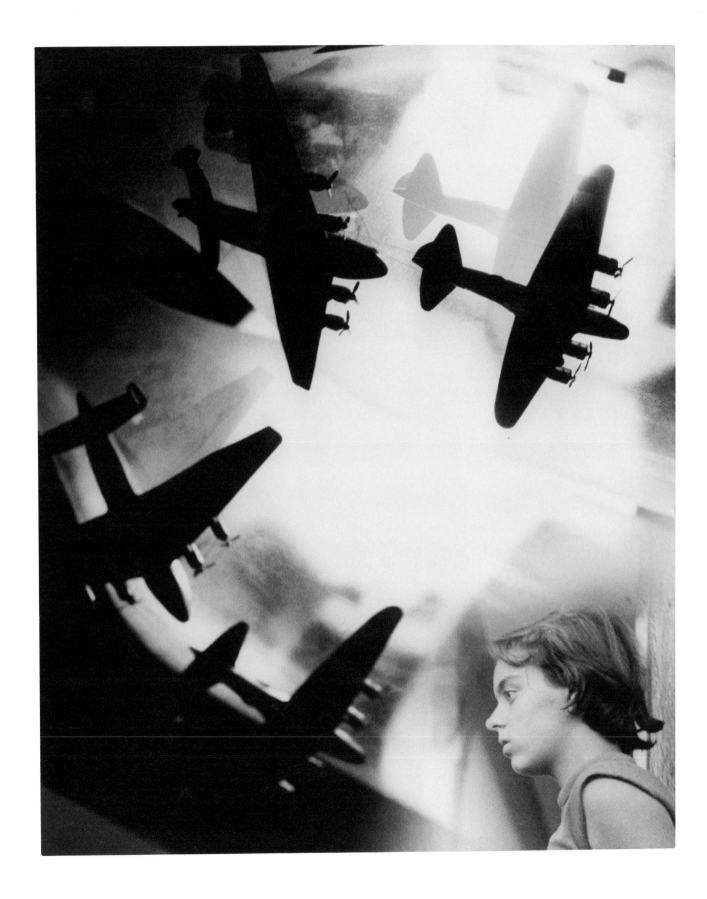

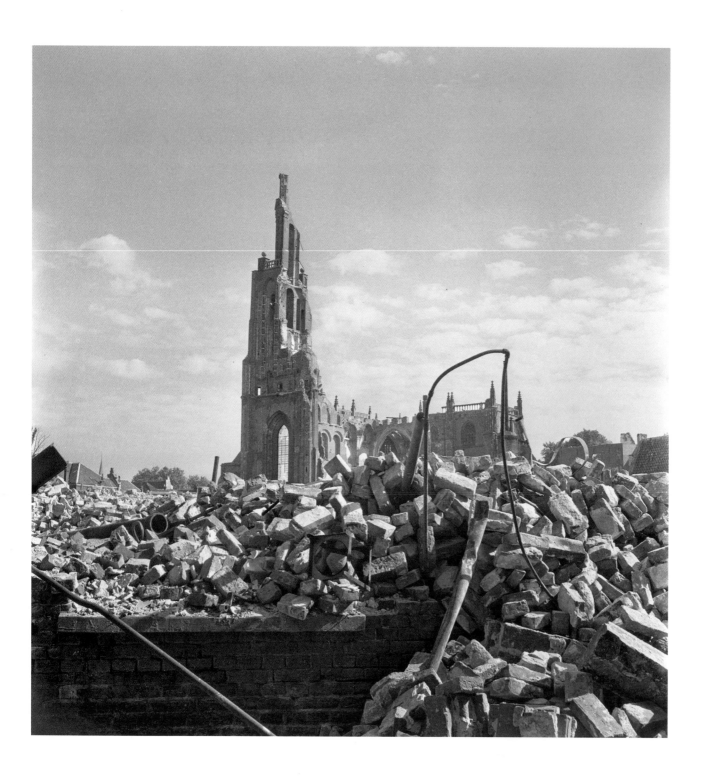

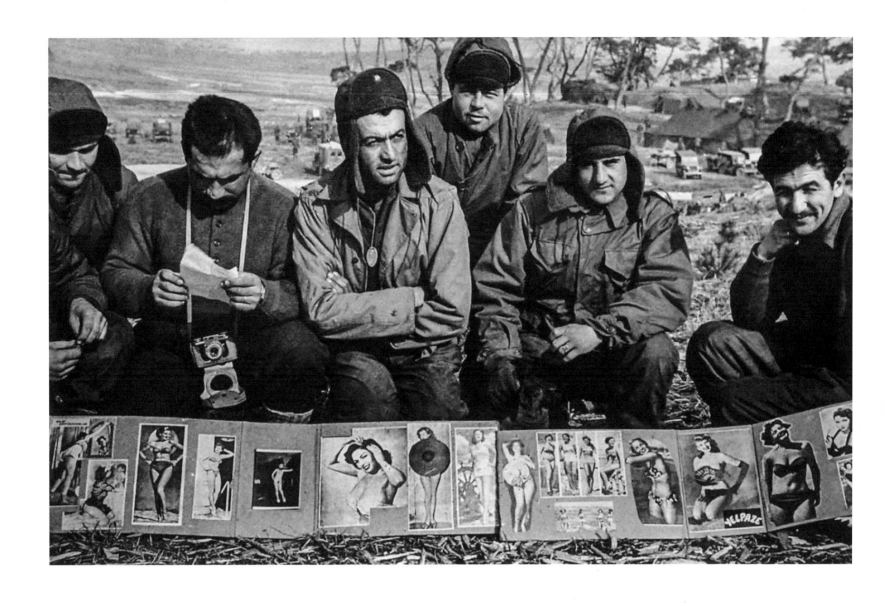

Emmy Andriesse,
The Ruins of St Eusebius Church, Arnhem,
Netherlands, Autumn 1945

Semiha Es,
The Turkish Brigade in Busan,
South Korea, *c*.1950–3

272

Sabine Weiss,
Bread Sellers, Athens, 1958

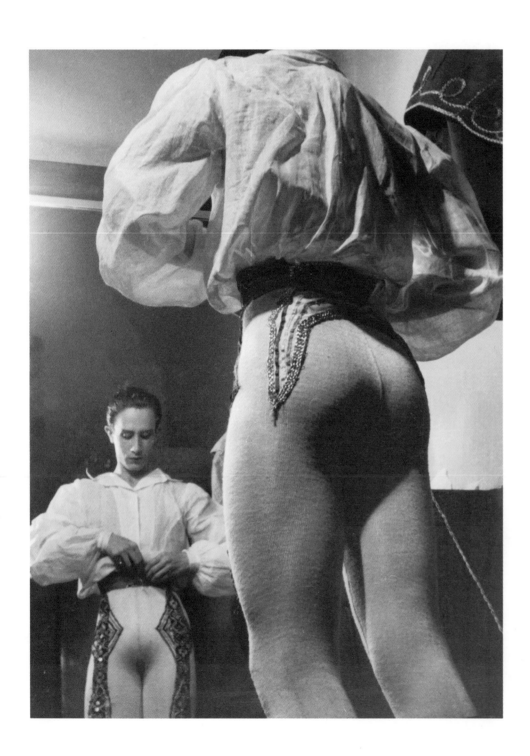

Lola Álvarez Bravo,
A flor de piel, undated

Tsuneko Sasamoto,
Ginza 4-chome and P.X. Tokyo,
Ginza, Tokyo, 1946

Eva Siao,
*Tiananmen Square under
construction*, Beijing, 1958

Dickey Chapelle,
A group of Castro forces,
Cuba, *c.*1958–9

Lisetta Carmi, *Kabul*,
Afghanistan, 1970

Mariana Yampolsky,
Caricia [Caress],
San Simón de la Laguna,
Mexico, 1989

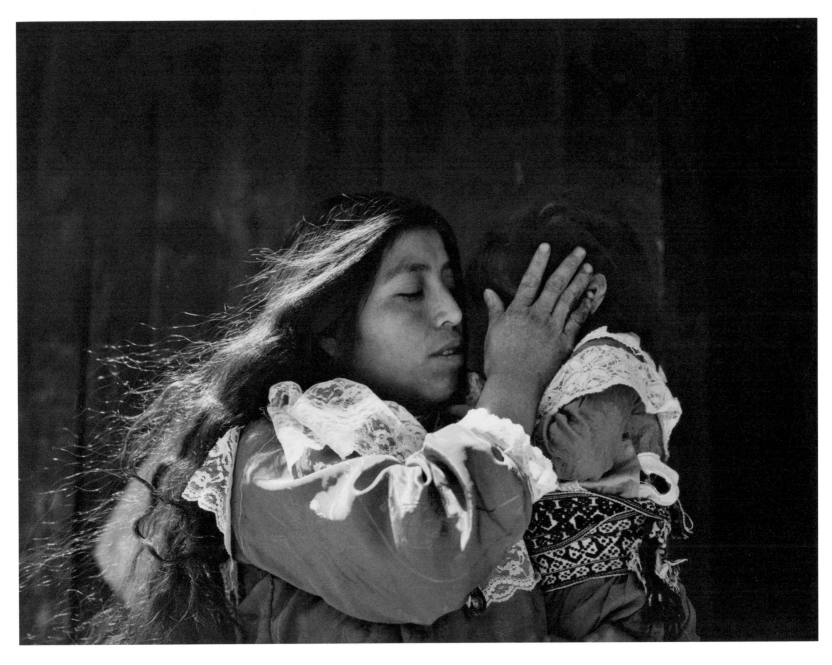

Maryam Şahinyan (Foto Galatasaray),
Untitled, Beyoğlu, Istanbul, May 1961

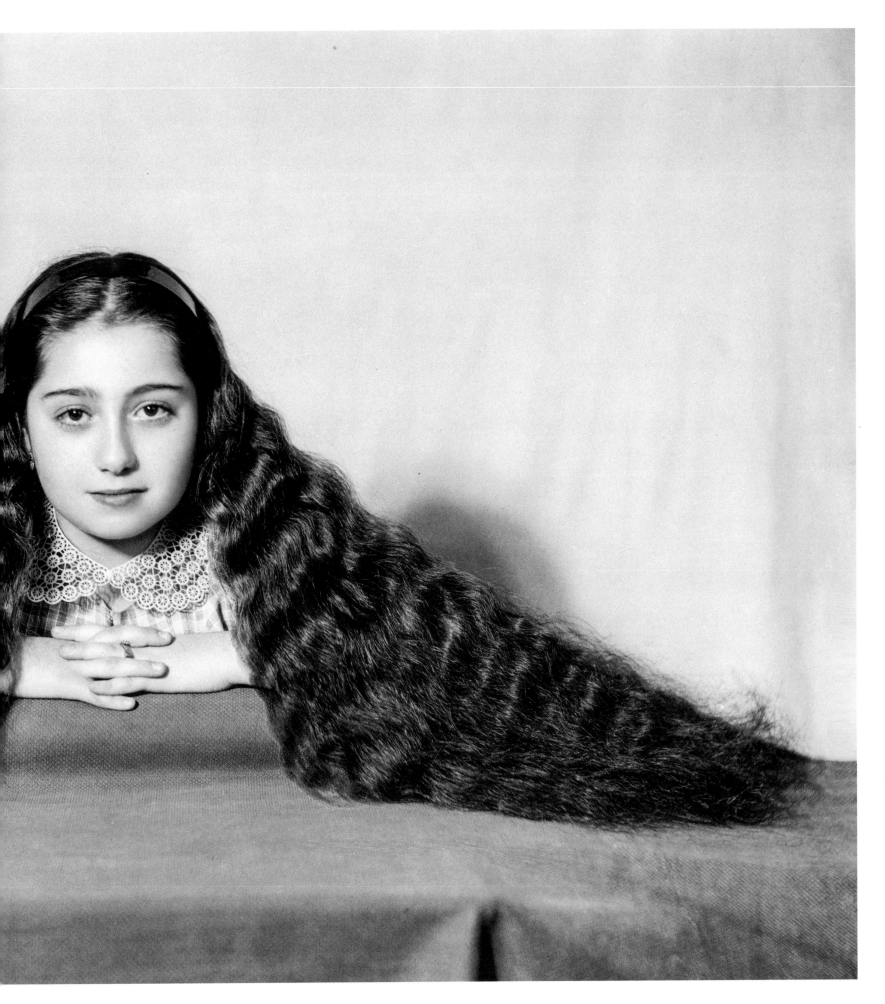

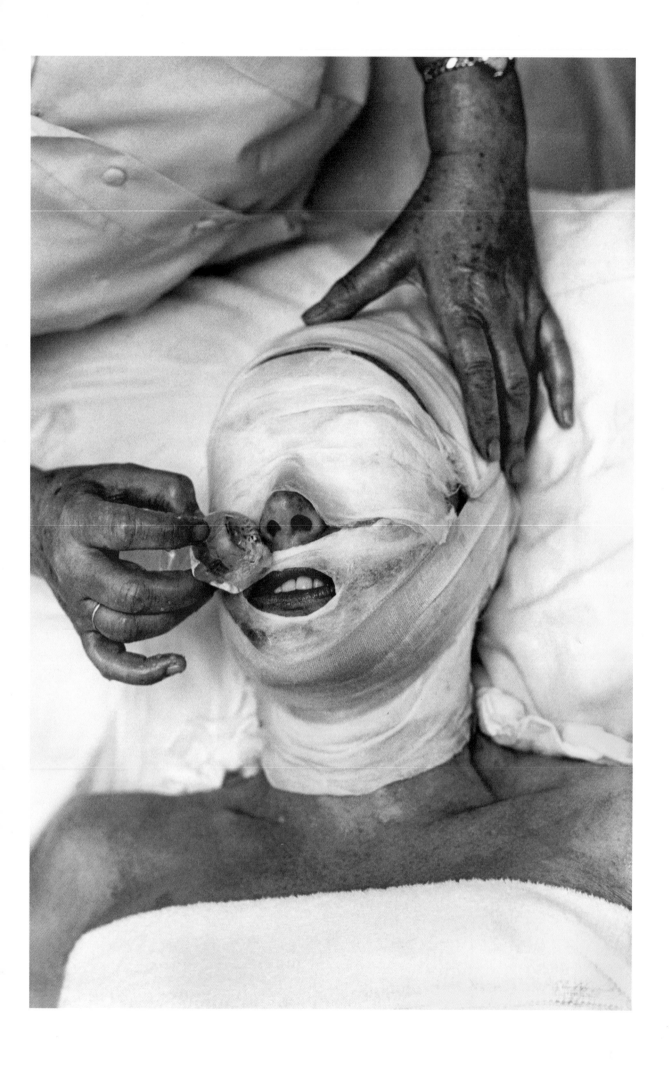

Eve Arnold,
Actress Joan Crawford,
Los Angeles, 1959

Iryna Pap, *Prefabricated
Housing Factory No. 1, Kiev*,
Ukraine, August 1960

Anne Noggle,
Myself as a Pilot, 1982

Inge Morath,
A llama in Times Square,
New York, 1957

284

Janine Niépce,
*The Events of May–June 1968:
Occupation of the Sorbonne*,
Paris, 1968

Vivian Maier,
Chicago, 1959

Helen Levitt,
New York, 1980

Emila Medková, *Charles Bridge*, Prague, 1961–2

Every photographic work by Emila Medková, née Tláskalová, whether plastic or documentary, was nourished by her experience of Czech Surrealism. At the age of fourteen, Medková began a course at the School of Graphic Arts in Prague, where the photography department was run by Josef Ehm and the teachers included, among others, the avant-garde photographers Jaromir Funke and Eugene Wiškovsky. At the end of her training, she joined the Jantar group (1945–6), alongside artists such as Dagmar Hochová and Josef Lehoučka. She was well acquainted with the work of Jindřich Styrský and Miroslav Hàk, photographers close to the artists' collective Skupina 42, who exhibited and published throughout the 1940s, and it was their Surrealist vision – sombre and melancholy – that guided her work to a greater degree than the modern photography taught in the school. The prominent artists of the time also included Toyen, whose Surrealist work directly inspired many of her own creations. Medková was already working as a photographer when she met the Surrealist painter Mikolaš Medek in 1947. They both frequented the artist and critic Karel Teige, with whom they collaborated in Surrealist enquiry, 'exquisite corpse' drawings, poetry collections and other independent publications. It was within this group that Medková began as an artist. During this period, between 1947 and 1951, in collaboration with Medek she produced several series of scenes played before the camera, characterized by the absurd, the uncanny and black humour, including 'Jeux d'ombres' (Shadow plays): photographs, but also compositions arranged in the studio or in nature, containing a repertoire of Surrealist motifs and objects, such as eggs, hands, the eyes and hair.

The year 1951 marked a turning point for Medková. Soon after marrying Medek, she abandoned studio photography to devote herself entirely to her quest for the strangeness she found in the streets of Prague and which she now immortalized in images. In the late 1940s, she had begun by photographing shop windows, doors and abandoned sites, but it was not until ten years later that these motifs became the main subject of her work – they would remain so for the rest of her life. With time, Medková tightened her framing, seeking, for example, details on a wall in which she found, through their material expressiveness, the ability to trigger poetic associations. Reminiscent in this way of the *informel*, her images inspired several Czech photographers who developed a similar aesthetic in the 1960s. This work, while at times recalling Brassaï's graffiti, assumed a political dimension, conveying the atmosphere of confinement and cultural disintegration in Czechoslovakia at the time – a climate in which the sense of claustrophobia experienced by Czech society emerged more explicitly in the series 'Fermé' (Closed).

From 1960, the artist exhibited in her own country as well as abroad, often giving her photos titles that reinforced the triggering of associations. Faithful to her early fascination with Surrealism and subjects such as mannequins, rubbish dumps or abattoirs, Emila Medková exploited these motifs right up to the final works in an oeuvre which, after fifty years of practice, numbered several thousand images. **KZ-L**

'If a photograph has no mystery, if its reality has no other form, then it is empty.'

EMILA MEDKOVÁ

Romanian in origin and little known in Europe, Thea Segall is a key figure in Venezuelan photography. A prolific photographer, she travelled throughout Venezuela from 1958 until her death, gathering a multitude of images and a documentation that nowadays constitutes a visual archive of major importance of the country's cultural and geographical riches, as a well as a testimony of its transformation.

Thea Segall Rubin was born in 1929 in Burdujeni, Romania. In 1947, in an attempt to win a place in the School of Architecture, she entered the Photographic Centre of Bucharest's School of Journalism and trained under the Austrian photographer Otto Grosar, who taught her the rudiments of the profession. From 1948 until 1957, she worked as a photoreporter for the press agency Agerpres. On her assignments, she tended to avoid the most topical stories in order to concentrate on the landscapes that she passed through and the rural life of the people whom she encountered.

At the age of twenty-nine, seeking a different world and a different light, Segall left her native land for Venezuela. She did not speak Spanish and did not plan to settle there. In 1959, she went to San Juan de Manapiare, in Amazonas state, to cover a press conference about the work of missions in Indigenous communities. This trip marked a decisive turning point in her career and the beginning of her personal project, deeply embedded in the local culture.

The same year, in Sabana Grande (Trujillo state), Segall opened the Studio Fotográfico Thea, which would continue until 1994. This commercial work allowed her to finance her own research expeditions.

From then on, driven by the dual aim of wishing to understand the Indigenous world and to bear witness for future generations, Thea Segall ceaselessly recorded traditional ways of life in various communities, their relationship with the environment and their artisan craft techniques. From the 1960s onwards, she created her own visual language in the form of 'Fotosecuencias' (Photographic sequences), which used a sequential and narrative style to record activities in a step-by-step way. She captured actions and skills in her own personal style and, over the course of her work, honed her perception of light. Shot in 1969, 'Curiara', one of her first and most famous series, documented the steps involved in making a *curiara* (a light dugout canoe) by the Yekuana people in Amazonas state. Her photographic style blossomed when shooting subjects of an ethnographic nature, but her aesthetic approach transcended the subject matter and conferred on it a strong point of view.

Thea Segall's themed sequences of images were widely published. Through her numerous photographic publications, with accompanying text written by specialists, she discovered her own favoured form of expression. **AL²**

Thea Segall, *Sanding the shell of a drum*, from the series 'El Tambor', Miranda state, Venezuela, 1978

Tired of the predatory stance of the reporter, who, as hunter of shocking images, turns individuals into dehumanized extras, Marilyn Silverstone abandoned her career as a reporter in 1977 to become a Buddhist nun. After years of studying Tibetan and Buddhist philosophy, she participated in the founding of a monastery near Katmandu in Nepal. This path might seem surprising, but it is in keeping with an existential approach that is not uncommon in the photography profession. Many reporters hope, in fact, through their images, to contribute to making the world a better place, to enabling the planet's inhabitants to know each other better and thus to understand one another. This hope, which runs through humanist photography, is often thwarted, clashing with the physical and economic constraints of the profession. In Silverstone's case, this search for an ideal and her long-standing interest in Tibetan culture also turned into fresh spiritual engagement.

In her former life, she had led a successful career as an independent photographer, which began in 1955 after working as an editor for art and design magazines. In 1956, she went to India, where she met Frank Moraes, chief editor of the *Indian Express*, and lived with him in New Delhi until his death in 1974. In 1964, she joined the Magnum Photos agency, travelled across Asia, and documented Indian and Nepalese cultural life. In 1985, her images, characterized by their empathy and a sophisticated knowledge of these regions, were assembled in a publication entitled *Ocean of Life*. She also published three books for children with the author Luree Miller: intended for Western children, they showed distant cultures, recounting, for example, the adventures of a little Indian or Nepalese boy.

One of her images taken in the early 1970s embodies the hope of transforming photography into a tool for change and sharing, a bridge between cultures: villagers in the state of Sikkim, in the north of India, look at slides taken by the photographer and recognize their own faces.

Long before the rise of collaborative practices, Silverstone sought ways in which not simply to 'take' photographs, but also to 'give something back'. Her ethical requirements and her reflection on human relationships led her from the profession of photographer to Buddhist meditation, on a path marked by benevolence and an opening of the spirit. Her most striking images occur when these two commitments meet, when she bestows a serene and intimate gaze on the life of Nepalese monasteries. **CB²**

'You get to taking pictures of people like pieces of meat.'

MARILYN SILVERSTONE

Marilyn Silverstone, *Villagers looking at slides of themselves*, Yumthang, India, 1971

Bunny Yeager, *Bunny with her Burke & James 8 × 10 Camera*, 1963

As a teenager, Linnea Eleanor 'Bunny' Yeager moved from Pittsburgh to Miami, where she got her start as a pin-up girl and local beach-beauty queen, winning no fewer than seventeen titles. After posing for a photography evening class, Yeager decided to learn how to use a camera herself. The first woman to be both glamour model *and* photographer, she created self-portraits that were often elaborately staged. Especially prolific throughout the 1950s and 1960s, she created a huge, inventive body of work, mainly for the pages of men's magazines and how-to books, that is inflected with a sense of playfulness.

In an era when women appeared as objects of desire crafted by and for men, Yeager's work in this arena is a notable anomaly. She sold pictures to many popular pin-up magazines of the time, including *Playboy*. In 1954, she collaborated with the model Bettie Page, of whom she made more than a thousand photographs, including a shoot with two live cheetahs and a now-infamous *Playboy* centrefold in which Page wears only a Santa hat. Yeager also made a handful of nudie films and played small roles in mainstream Hollywood movies. Acutely aware of both her charm and her persona, she appeared on popular game and talk shows, including *What's My Line?* and *The Tonight Show*.

Of her many achievements, Yeager is best known for her how-to photography books, most notably *How I Photograph Myself* (1964). A manual addressed specifically to women, it offers tips on everything from lighting and costume to poses, facial expressions and fashion design (Yeager is often credited with inventing the bikini, and frequently made garments for herself and her models). Though much of the instruction is self-consciously geared towards pleasing men, the spirit of the book encourages women to delight in and take control of the projection of their sexuality.

Since the 1990s, Yeager's work has been the subject of a number of exhibitions, garnering the attention of a new generation. Although light-hearted and of their time, her images also suggest a deep and complex awareness of the cultural construction and performance of gender, thus prefiguring feminist art-world explorations of the 1970s and 1980s, in particular the self-portraiture of such artists as Cindy Sherman and Suzy Lake. **SK**

'When you start photographing yourself, you are going to be amazed at all the things you find out about yourself, and you'll be glad you did.'

BUNNY YEAGER

Rosalind Fox Solomon

b. 1930, United States

Rosalind Fox Solomon, *Foxes Masquerade, Mardi Gras, New Orleans, Louisiana*, 1992

A graduate in political sciences at Goucher College near Baltimore, Maryland, Rosalind Fox Solomon married and devoted herself to her family in Chattanooga, Tennessee, before embarking on her career as a photographer at the age of thirty-eight. In the early 1970s, she trained with Lisette Model, who became her mentor while she was learning the profession. She produced a first series of photographs of dolls found in flea markets before turning to portraits of figures from American artistic and political circles. Fox Solomon stands out for her photographs characterized by their metaphorical qualities uncompromisingly showing the violence of life, while expressing her personal questioning of her own culture. Her images, in which the immediate environment sometimes appears more significant than the subject photographed, are testimony to an almost anthropological approach that reflects her interest in rituals. The hardships of human existence, particularly of survival and vulnerability, lie at the heart of her work.

Fox Solomon travelled the world to broaden her field of investigation to South America, India, Vietnam and Europe. In the early 1980s, she undertook a project in the Ancash region of Peru, struck by a violent earthquake in 1970, which she would pursue for twenty years. Her series on patients in Chattanooga's hospital in the mid-1970s and 'portraits in the time of AIDS' in 1987 presented a fresh view of the disease. During the same period, the photographer also tackled ethnic violence, notably in a series on apartheid in

'I want each image to evoke an emotional response that may be unexpected depending on the viewer's history and experience.'

ROSALIND FOX SOLOMON

South Africa, or in 'Polish Shadow', revisiting the Holocaust in Poland. Her book *Liberty Theater* (2018) re-examined racial segregation in the southern United States in the period between 1970 and 1990. In 2014, she was one of twelve international photographers selected for the project thisplace.org to explore the complexities of the territories of Israel and the West Bank. Throughout her career, Fox Solomon remained faithful to black and white, the use of flash and the 6 × 6 format; she never cropped her images and her skill in printing enabled her to interpret them in a rich and subtle range of tonalities and contrasts. From the 1980s, she explored other artistic forms, creating multimedia installations (*Adios* and *Catacombs*), and focused on writing text and poetry for her books of photographs and video performances. Now based in New York, Rosalind Fox Solomon continues to pursue her artistic career while organizing her archives, which were donated to the Centre for Creative Photography in Tucson, Arizona, in 2007. **AL**[1]

The high priestess of Erotic-Gothic photography, Irina Ionesco still provokes debate. Born Irène Ionesco in Paris in 1930 to Romanian parents, her family history is extremely complex and made up of multiple personal re-elaborations. Ionesco spent her childhood in Romania and did not return to France until the late 1940s. In her autobiographical novel *L'Oeil de la poupée* (The doll's eye, 2004), she evoked her youth spent in the circus, surrounded by boa constrictors, tightrope walkers and knife throwers. She gave performances and travelled a lot, before a serious accident put an end to her career. Like a European Frida Kahlo, physical pain opened the doors to creativity.

Initially a writer and painter, Ionesco turned to photography in the 1960s. From her very first images, her subjects were almost exclusively women, whom she considered as doubles of herself, in baroque or erotic tableaux. The exploration of every fantasy was encouraged by the intellectual and artistic circles in which she developed. Her first portfolio, *Liliacées langoureuses aux parfums d'Arabie* (Languorous liliaceae with Arabian scents), published in 1974, had a preface by André Pieyre de Mandiargues, Surrealist poet and passionate fan of curiosa.

The year 1974 marked her consecration: Ionesco exhibited her work alone for the first time, at the Galerie Nikon in Paris, where her soft and sensual world, consisting of masks, corsets, lace and elaborate crowns, was much remarked on. Undoubtedly, the public was also attracted by the air of transgression. Most of the images displayed in the exhibition featured Eva, the photographer's daughter, who was just ten years old at the time.

From a very young age, Eva had been her mother's muse and one of her principal fantasy objects. In the documentary dedicated to her in 2003 by Delphine Camolli, *Irina Ionesco: Nocturnes porte Dorée*, Ionesco stated: 'I began to do Eva, she must have been two.… I dramatized her, because it was me, the circus, my mother, the trapeze.… She was the favourite, because a child has far more charisma and novelty than anyone who has already grown up.' Between incestuous investment, paedophile imagery and perversity, the photographs that Ionesco devoted to Eva were disturbing and conditioned the way in which all of her work was viewed. They have also led to a series of lawsuits between mother and daughter in recent decades.

But in taking the legal tribulations of this family in a permanent state of discord too much into account, it is easy to forget the extent to which the photography of the 1960s and 1970s was assigned the role of instinctual revealer. Close to the sexually transgressive work of the Surrealist photographer Pierre Molinier in the fetishized staging of the self and the recurrent display of a body submitted to violence, Irina Ionesco's oeuvre can also be read as the expression of a fascination for dolls that runs right through the twentieth century. Her fashion photographs – Ionesco's main field since the early 2000s – continue to focus on this ambivalent figure, defenceless object and potential threat, in a style that merges aestheticized pornography with a revendication of the freedom of the female body. **SG-C**

'Making images is dynamic,
it's my great performance.'

IRINA IONESCO

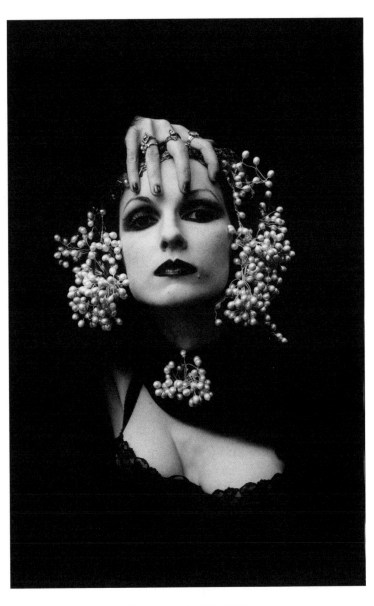

Irina Ionesco, *Jocelyne*, 1977

Arlette Rosa-Lameynardie's career represents the perfect example of the condition of a female photographer in the Antilles in the 1960s. Born in Paris, Rosa-Lameynardie began her photographic career in the agency of the French Communist Party and on the pages of newspapers such as *L'Humanité*, *Ce soir* and *Regards*. She covered news stories: miscellaneous items, demonstrations, political congresses and entertainment. Reportages led her to travel abroad: Germany, Poland, USSR, China, Vietnam.

After her marriage, she followed her husband to Martinique in 1961. Photographic practice was little developed there and was above all commercial. Rosa-Lameynardie opened one of the first studios in Fort-de-France. However, in addition to her official commissions, ministerial visits and historical monuments, during her excursions to discover the island that was now her home, she engaged in informal photojournalism. She thus immortalized a rapidly changing Martinique, on the threshold of modernity, even though, fifteen years after departmentalization, social and architectural development sometimes seemed barely perceptible. Certain shots – spontaneous settlement, street scenes – depict a reality similar to the images produced by Denise Colomb in 1948, during an ethnographic assignment to commemorate the centenary of the abolition of slavery.

Thanks to her discretion, without focusing, Rosa-Lameynardie quickly captured views of crowds, unbeknown to passers-by: street or beach scenes, fairs and ceremonies, religious rituals, a whole population on the move and at work, agricultural labourers, fishermen, traders. She captured workers, mothers and children in an unaffected way and the authenticity of their behaviour, far removed from any exoticism or concession to tourism, thus gathering, over a period of twenty years or so, a valuable documentary resource, now the property of the territorial collectivity of Martinique.

For thirty years, Rosa-Lameynardie produced images, printing them without ever showing them to anyone, and even destroying some of them. Her professional isolation, the lack of any exchange with her peers deprived her of any confidence in the value of her images.

It was only in 1989 that a local publisher, Exbrayat, published *Regards*, a selection of her photos of Martinique in the 1960s. A second book was published by Diaphane in 2017, *Chemin faisant* (On the way), on the occasion of the Photaumnales festival in Beauvais. At the same time, Rosa-Lameynardie gradually abandoned photography to devote her time to children's literature, with a book published by École des Loisirs, called *L'Appel des tambours* (The call of the drums, 1981). **DB²**

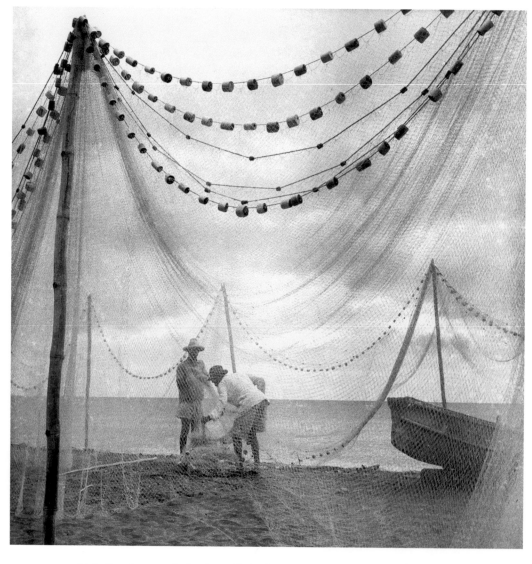

Arlette Rosa-Lameynardie, *Les Anses-d'Arlet, Grande Anse: Fishing Nets*, Martinique, 1969

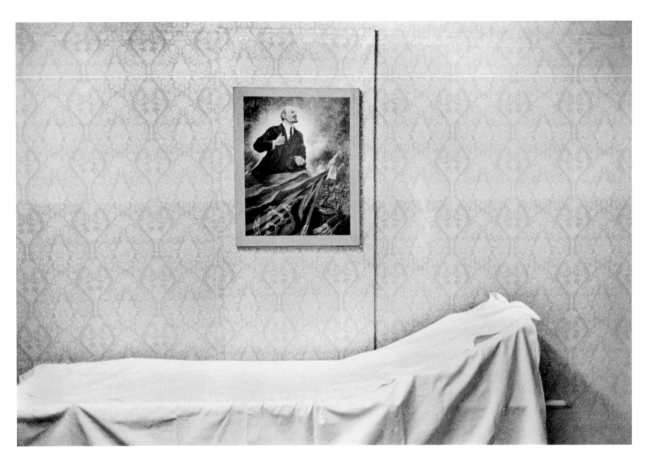

Evelyn Richter, *Entrance to a convalescent home*, Leipzig, c. 1985

In the German cultural landscape of the postwar years and that of the German Democratic Republic, Evelyn Richter occupied an exemplary position, both for the precision that characterized her work and for her demanding approach to auteur photography.

Born in Dresden, Richter grew up in a well-off and cultivated family, with anti-Nazi beliefs. In the aftermath of the Second World War, she discovered the artistic scene in Dresden, which was then flourishing and reconnecting with the avant-gardes that Nazism had suppressed – these would once again be deemed decadent under the GDR, founded in 1949. Richter trained with Franz Fiedler, an adherent of New Objectivity, and Pan Walther, also a pupil of Fiedler, before abandoning the formalism of her mentors to follow a documentary path, guided by a humanist sensibility and under American influence: the travelling exhibition *The Family of Man*, conceived by Edward Steichen and shown in West Berlin in 1955; the images resulting from commissions by the Farm Security Agency; and the work of Robert Frank. Nevertheless, throughout her career she maintained an interest in experimentation, inspired by the Bauhaus, which would characterize her self-portraits in particular.

Admitted in 1953 to the Hochschule für Grafik und Buchkunst (HGB) in Leipzig, the only art school in the GDR offering teaching in photography, her independence with regard to the dogma of Socialist Realism led to her being expelled before completing her course. From then on, Richter strove to represent with honesty the living conditions of her fellow citizens, going against the flow of propaganda images.

In 1956, with several male and female colleagues, she founded the group Action Fotografie, which stood for a photography that was subjective and closer to life; marginalized by the authorities, the group disbanded in 1958. Despite a few publications, it was in an increasingly private setting, 'for the drawers', that Richter's series saw the light of day, developing in the longer term. Her images were founded on the observation of psychological and social processes: commuters on public transport, in transit between the private sphere and social existence, artists and musicians absorbed in creativity, visitors to museums before works of art.

Richter's most emblematic work is without a doubt her series of portraits of women at work, the result of an immersion in the factories of the state. Far from being glorified by their supposed faith in progress, or by their emancipation, which the regime had made one of its standards, Richter's women appeared alienated by the machine, exhausted by production plans and by the double burden of work and running the home. These denials, radical as they were, were expressed in a language that was subtle and metaphoric, perfectly accessible to an East German public accustomed to reading 'between the lines'.

Despite the limited distribution of her work until the late 1970s, Evelyn Richter established herself as a key figure in East German photography and exerted a decisive influence on a whole generation of students at the HGB, where she taught from 1981 until 2001. **SV²**

'In these times of total manipulation, we must strive to maintain, in the face of the flood of false images, an individual position as author, aware of our responsibility, deserving of trust and guaranteeing it personally.'

EVELYN RICHTER

Deeply affected by the Second World War and by the bombings in 1945 that destroyed her home and fatally injured her father, Toyoko Tokiwa became a photographer in the early 1950s, a few years after the birth of the Provoke collective, to which she would later belong. Influenced by the photographer Ken Dômon, she documented the consequences of the American postwar occupation, particularly prostitution among Japanese women around the military base at the port of Yokohama, near Tokyo. The red-light areas became her preferred subject and, by extension, the development of the place of women in Japanese society. In 1956, her first exhibition in Tokyo, *Hataraku Jôsei* (Women at work), met with critical acclaim. Her subjects were prostitutes, female wrestlers, nurses, and models posing in the nude. In 1957, Tokiwa was included in the historic collective exhibition *Jûnin ni Me* (The eyes of ten people), alongside Ikkô Narahara and Shômei Tômatsu, among others.

The same year, she published her first book, *Kiken na Adabana*, which made her famous. The red wrapper around the book when it came out bore this flashy catchline from the publisher Mikasa Shôbô: 'A young woman, alone, armed with her camera, sets off to brave the streets. Here are the testimony and notes of a "woman of the street!"' The book was made up of a hundred black-and-white images, as well as many texts written by Tokiwa in the first person.

Its title, which means 'dangerous toxic (or poison) flowers', was a euphemism referring to the prostitutes, but also a means for Tokiwa to express the way in which the 'women who work' were perceived in Japan. The cover showed Tokiwa behind the camera, looking straight ahead with one eye covered by her camera, with a slight smile and much aplomb – a radical gesture: female photographers were rare in Japan at that time, and women, in general, were very little seen or heard. One can also see, reflected in her lens, one of her photographs: a women seen from behind, her arm being brutally grabbed by a man. This cover, subversive at the time, was indicative of Tokiwa's work – of her passion for photography as well as her advocacy for women's agency. The historian of photography Kôtarô Iizawa considers this book 'one of the most powerful of its generation'.

Tokiwa's work was published in some of the greatest Japanese magazines and newspapers of the time, notably *Asahi Camera*, *Camera Mainichi* and *Nippon Camera*. From the 1960s to the 1980s, Tokiwa continued to photograph the American military bases in Japan. She also travelled to Taiwan, Malaysia and the USSR, and from the 1980s devoted herself to the issue of old age in Japanese society. Her photographs are to be found in the most prestigious collections in Japan, notably at TOP Museum (Tokyo Metropolitan Museum of Photography). **PV**

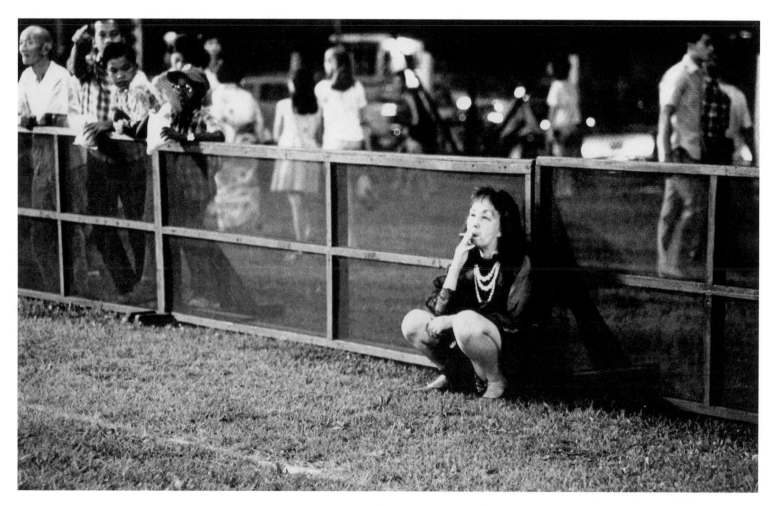

Toyoko Tokiwa, 日米親善国際盆踊り大会 (Bon Dance Festival celebrating the friendship between Japan and the United States), 1955

Claudia Andujar, *Collective house on fire*, from the 'Habitation' series, Catrimani, Roreima, Brazil, 1972–6

In 1971, at the age of forty, Claudia Andujar met the Yanomami in Brazilian Amazonia. She then began the most significant project of her career as a photographer and activist. Andujar arrived in Brazil in 1955, and during the 1960s, devoted herself both to artistic projects and photojournalism. She photographed Brazilian families, Indigenous communities, and collaborated with the magazine *Realidade*, producing reportages on immigrants, homosexuals and prostitutes. It was during her work for an issue on Amazonia that she came into contact with the Yanomami. Following this assignment, she decided to undertake a long-term documentary project.

During the 1970s, she made several trips to Catrimani, in Roriama state, where she accompanied collective hunts in the forest and lived in native villages. She gradually captured the Yanomami's social structure, seeking above all to understand their view of the world. Intrinsically connected to a different metaphysical world, the Yanomami turn to Shamanism in order to reach it. Using photographic techniques (light filters and low shutter speed), Andujar started from everyday scenes to recreate this sensory and intangible story in images. While attempting to convey this spiritual world, she discovered her own original style as a photographer.

Refusing to confine herself to the role of the outsider who observes Indigenous peoples from a distance, she worked instead in close proximity to the Yanomami, seeking to learn their culture. In the 1970s, she invited them to represent their way of life, which gave rise to a hundred or so drawings, in which they described their cosmology, myths and rituals.

Born in Switzerland, Andujar spent her childhood in Transylvania, which she left during the Second World War, after losing her entire family on her father's side to the concentration camps. It was probably her experience of the Nazi genocide that led her to react so strongly to the decimation of entire Indigenous communities. The aggressive programme of the development of Amazonia during the military dictatorship in Brazil (1964–85) opened the way for roads, epidemics, gold panning and deforestation. In the late 1970s, Andujar turned her photographic project into a political campaign.

Dividing her time between Amazonia and São Paulo, she publishes books, organizes exhibitions and creates audiovisual installations, turning photography into a tool for activism. In 1978, she was behind the foundation of the Commission for the Creation of the Yanomami Park (CCPY), with the aim of fighting for the demarcation of the Indigenous lands drawn up in 1992. As coordinator of the CCPY, in the 1980s she set up a health project and followed doctors on their missions, printing identity photographs for the population's medical records.

Alongside Davi Kopenawa, an Indigenous spokesperson and her campaign partner, Andujar gave visibility to the Yanomami people: 'She is not Yanomami, but she is a true friend. She has taken photographs of births, women, children. Then she taught me to fight, to defend my people. […] Those who don't know the Yanomami will know them through her images.' **VT**

Sheila Maureen Bisilliat, *Gabriela, girl with a cockerel*, Salvador, *c.*1960

Nicknamed 'the Irish gypsy' by the Brazilian writer João Guimarães Rosa, Sheila Maureen Bisilliat was born in Surrey, in the south of England, to an Irish mother and an Argentinian father. Her father's career as a diplomat meant that throughout her childhood she lived in many different countries across Europe and North and South America, before settling in Brazil in 1957, at the age of twenty-six. Bisilliat studied fine art under André Lhote at his academy in Paris, and then at the Art Students League in New York, but shortly after arriving in Brazil, she gave up painting and decided to pursue a career in photography.

Bisilliat started working as a photojournalist for major Brazilian magazines and began a project that would prove decisive for her career. After reading *The Devil to Pay in the Backlands* by Guimarães Rosa, Bisilliat decided to travel around Brazil and visit all the places described in the novel. Published in 1966, her work *A João Guimarães Rosa* was the first in a long series of publications that centred on great works of Brazilian literature, transforming passages into poetic, creative images.

Embracing her gypsy roots, Bisilliat's photographic work focuses on chance meetings during her travels around Brazil. She trains her camera on cultural events and practices that are deeply rooted in Brazilian life, with a particular focus on specifically feminine activities, such as her series on women of the Xingu tribes, the crab catchers of Paraíba and farm women from São Paulo state.

Bisilliat traces her love of photography back to her first husband, Spanish photographer José Antonio Carbonell, while her second, Jacques Bisilliat, gave her the name under which she became famous. Throughout her career, which has spanned more than six decades, her work has been marked by a highly personal approach. Often backlit, capturing vast empty spaces, her documentary photographs make interesting use of the contrast between light and dark. Sometimes in black and white, sometimes in colour, all of her photographs show artistry and social engagement in equal measure. Capturing her subjects' rich culture, Bisilliat's portraits show the inhabitants of deprived regions in Brazil in a respectful light, a far cry from the stereotypes of victimization often applied to them. **EZ**

300

'If we don't concern ourselves with Latin American photography, talk photographically of our own realities … nobody is going to do it on our behalf.'

MARÍA CRISTINA ORIVE

María Cristina Orive was a peripatetic photographer, an ambassador for Latin American photography, and a professional artist active in many different media. After attending university in the United States and spending years as a cultural journalist in Guatemala, working with both radio and the written word, Orive moved to Paris in 1957. She developed Spanish-language programming for the French radio and television company ORTF and formed friendships with colleagues, including the renowned writers Julio Cortázar and Mario Vargas Llosa. It was, paradoxically, in the French capital that she deepened her knowledge of Latin America. It was also where she began taking photographs.

In the 1960s and 1970s, Orive worked for various agencies, including ASA Press, SIPA and Gamma; her pictures appeared in magazines such as *Paris Match*, *Stern*, *Newsweek* and *L'Express*, and in newspapers worldwide. In the early 1970s, she travelled through Venezuela, Peru, Brazil, Colombia, Panama, Chile and Guatemala, documenting key political and cultural events. She took an iconic photograph of Salvador Allende, and was in Santiago, Chile, on the fateful day of General Augusto Pinochet's coup against Allende's government on 11 September 1973. The following year, she attended the funeral of Juan Domingo Perón in Argentina.

Through her agency work, Orive developed a keen understanding of the dynamic between photographer and editor. However, aware that her images could be used to serve someone else's ideological position and their own version of the reality that she was capturing, she eventually grew tired of what she described as 'media manipulation'. Photography publishing, on the other hand, offered the possibility of a 'pure, direct form of communication between photographer and public' – one that was more honest in its reflection of 'combined sensitivities'.

It was this sensibility that informed decades of work for La Azotea, the photography publisher that Orive and the Argentine photographer Sara Facio founded in Buenos Aires in 1973. La Azotea went on to publish more than one hundred books, including volumes on key figures of twentieth-century Latin American photography such as Alejandro S. Witcomb and Grete Stern in Argentina, Sandra Eleta in Panama, and Luis González Palma in Guatemala. Orive was particularly committed to publishing the work of women photographers, whom she believed to have greater solidarity with each other than men. 'It goes without saying that I'm a feminist', she said. Facio and Orive collaborated as photographers on the book *Actos de Fe en Guatemala* (1980), a rich account in colour of syncretic religious celebrations across Guatemala. The volume broke with the black-and-white photography tradition typical in Latin America at the time and created a lasting testament of Orive's faith-based and deeply chromatic vision of her country. **PK**

María Cristina Orive, *Fidel Castro*, 1973

Photographer, editor and director of an exhibition space dedicated to photography, Sara Facio is probably the figure who has contributed most to the appreciation of photography as an art form in Latin America. Born in 1932, she studied painting at the Escuela Nacional de Bellas Artes in Buenos Aires, graduating in 1953. In 1947, she met fellow student Alicia D'Amico, whose father was a photographer, and the two began an artistic collaboration that would last for more than thirty years. After being awarded scholarships by the French government, both women moved in 1955 to Paris, where they made a name for themselves in Europe. On her return to Argentina two years later, Facio continued her training by working with professional photographers, including Annemarie Heinrich. In 1960, she opened a photography studio with D'Amico.

Facio and D'Amico dedicated themselves to promoting photography among the general public. They wrote articles on the subject for journals and magazines such as *Clarín* (1964–5) and *La Nación* (1966–74), as well as publishing numerous books of their own work. The most iconic were *Buenos Aires, Buenos Aires* (1968), a celebration of their city, and *Humanario*, which focused on psychiatric hospitals. This was due to be published on 26 March 1976, ten years after the photographs had been taken, but the coup on 24 March, and the subsequent establishment of a military dictatorship in Argentina that lasted until 1983, prevented it from reaching bookshops.

Humanario was the first book published by La Azotea, the first Latin American publishing house dedicated to photography, which Facio and D'Amico founded in 1973 with the Guatemalan photographer María Cristina Orive. Their aim was to promote the work of great Latin American photographers, an ambition that shaped all areas of Facio's life.

In 1979, Facio founded the Argentinian Photography Council (Consejo Argentino de Fotografía) in conjunction with six colleagues, including D'Amico and Heinrich. The institution worked to promote artistic photography by Argentinians, both at home and abroad. Six years later, when her collaboration with D'Amico came to an end, Facio set up the photography gallery at the San Martín theatre in Buenos Aires (Fotogalería del Teatro San Martín), the country's first permanent exhibition space for photography. The gallery opened in 1985, showcasing the work of three well-known names in Argentinian photography: Grete Stern, Annemarie Heinrich and Horacio Coppola. Between 1985 and 1998, Facio put on more than 160 exhibitions there, establishing her reputation as the country's most influential photography historian.

In 1995, Facio was appointed head of the photography department at the Museo Nacional de Bellas Artes in Buenos Aires, a role she continued in until her retirement in 2010. She donated 172 photographs from her collection to the museum, a generous gift from a woman who has dedicated her life to establishing Argentina's reputation on the world stage of photography. **AF**

Sara Facio, *Untitled*, from the series 'Humanist', 1966

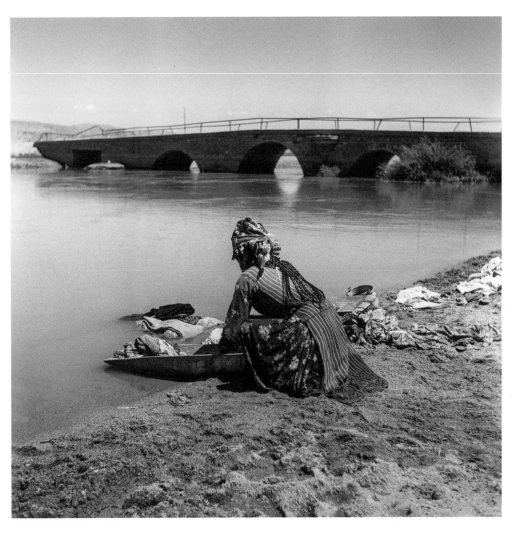

Yıldız Moran, *Anatolia*, 1956

The first academically trained woman photographer in Turkey, Yıldız Moran was born into a family of intellectuals in Istanbul. Encouraged by her art historian uncle, she travelled to England to study photography. After working as an assistant to John Vickers, the photographer at the Old Vic theatre in London, she exhibited her personal work in Cambridge (1953) and London (1954). She then travelled across Europe, including Spain and Portugal, before returning to Turkey in 1954.

The country was undergoing political and economic upheaval during this period: Turkey held its first multi-party elections since the founding of the republic twenty-seven years earlier, it joined NATO, and it was witnessing rampant urbanization following the government's decision to encourage a rural exodus. *Hayat Mecmuası* magazine, which was similar to *Life*, was making extensive use of photography to attract readers.

Many of her contemporaries gravitated towards photojournalism, but Moran, who considered photography to be an artistic discipline, chose to make her living producing studio portraiture. In her spare time, she recorded everyday life in Istanbul, which was being transformed by internal migration and government-mandated demolitions.

Moran also journeyed to Anatolia on her own at a time when it was almost impossible for women to travel alone, focusing her camera on the lives of ordinary people, especially women and children. But rather than adopt a neutral stance, she was interested in establishing a relationship with her

> 'The camera must be like an extension of your being so that it doesn't create an obstruction between you and your subjects. Anything that has poetry in it is the subject of photography.'
>
> **YILDIZ MORAN**

sitters. Furthermore, unlike her contemporaries who used 'Anatolia' to create a glorified, ideal image of the young republic, Moran avoided an orientalizing approach: her Anatolia is not a forgotten backwater.

Moran's mastery of light and composition is particularly evident in her shot of a horse-drawn carriage in Cappadocia, or the photograph that she took in the workshop of the famous ceramicist Füreya Koral. When working out of doors, she employed all of her technical skill at the same time as taking formal issues into consideration, as is evident in her photographs of men crocheting in Anatolia and of a Greek grocery-store owner and his wife on the Princes' Islands, Istanbul.

In 1963, Moran married the poet Özdemir Asaf, with whom she had three children. She stopped taking photographs professionally and became a translator and lexicographer. When she died in 1995, she left behind some eight thousand images, taken between 1950 and 1962. **DYD**

Xiao Zhuang, formerly known as Zhuang Dongying, was born in Fenghua, Zhejiang Province, in 1933. At the age of seventeen, she joined the guerrillas in the Siming Mountain region of Zhejiang Province as a cultural worker. The following year, she studied photography in the army, and two years later, in September 1952, became a photographer for the Xinhua agency, making her one of the first women photographers in the young People's Republic of China. In a portrait of the young woman taken in the early 1950s, when she was about eighteen years old, we can see that Xiao Zhuang is holding a Leica camera. Her green eyes avoid the lens and stare at the camera instead. As a young soldier serving in the cultural regiment of the People's Liberation Army, she had been appointed photographer in the army press service. A Leica camera was evidently a precious object, and a real reward for photographers after the founding of the new regime in 1949. Xiao Zhuang would use it to document the twists and turns of this significant era.

From the 1950s to the 1970s, Xiao Zhuang followed developments in Communist China closely, covering landmark historical situations such as the country's relations with the United States and Korea, agricultural cooperation, public–private partnership, the Great Leap Forward, the rise of iron- and steel-smelting, the decentralization of the executive classes, educated youth being sent to the countryside, and the Cultural Revolution. In these black-and-white photos taken on different cameras, it is always groups, symbolizing Chinese collectivism, that are at the core of her narrative. At the same time, Xiao Zhuang was also interested in the lives of ordinary people and took many shots of their day-to-day activities – such as a mother dressing her daughter in new clothes, or customers buying vegetables at the market.

After the Cultural Revolution, in 1980, Xiao Zhuang joined Jiangsu People's Publishing, where she led the team of photographers. The following year, she founded the magazine *Light and Photography*. She retired in 1994 but continued to work on her personal photography projects. *The Red Album: Photographic Notes of Xiaozhuang*, published in 2011, brings together Xiao Zhuang's most striking documentary photographs and accompanying notes. It constitutes a valuable record of the history of modern China. **YH**

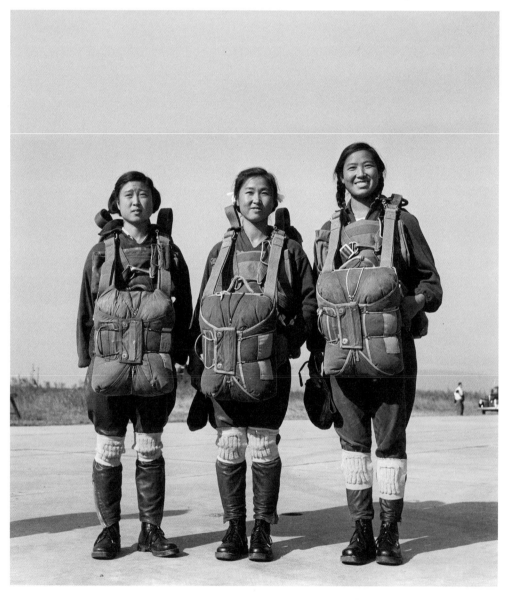

Xiao Zhuang, *Three paratroopers in a military sports parade initiated by the Jiangsu Provincial Sports Commission*, 1958

Helena Almeida, *Drawing*, 1999

'Make an image from an image ... look at ourselves differently, as if seeing ourselves from the outside.'

HELENA ALMEIDA

Helena Almeida is an artist who defies classification. Her work straddles the border between photography, body art and conceptual art. She uses her own body as a medium to investigate space and images. From the beginning of her career, she has resisted the simplistic categorizations of artistic production, refusing to adhere to strict divisions between media. Her images evoke an uncomfortable feeling of being in between, which springs from both her artistic process and her discomfiting vision of existence.

Almeida's subject is almost exclusively her body – or parts of it – modified by powdered pigments, mirrors, fabric, paper, wire, hemp and horsehair. She sketches out movements that she then performs, films and photographs. Her husband, the architect Arturo Rosa, takes the photographs according to her instructions. Her work often shows a stark, traditional silhouette, wearing a black dress and high heels or with bare feet. Each image is a kind of story without a plot, with her body's poses reminiscent of being tied up, gagged, choked or obliterated, even to the point of disappearing. Almeida makes use of a fragmentary aesthetic in her exploration of a subjectivity that offers no explicit interpretation. In interviews, she often recalls how she felt constrained by having to pose for long periods for her father, Leopoldo de Almeida, who was the official sculptor of the Estado Novo, the Portuguese fascist state.

Almeida studied painting at the School of Fine Arts in Lisbon. Her first solo exhibition in 1967 featured conceptual canvases that questioned the status of art and the limits of representation. During the 1970s, Almeida decided it was time to 'abandon painting' and turned instead to photography, which began to play a major role in her work. The series 'Sente-me, ouve-me, vê-me' (Feel me, hear me, see me, 1979) revealed her political side, denouncing the Salazar regime and the vulnerable situation of Portuguese women. Successful series such as 'Dentro de mim' (Inside myself, 1998) or 'Seduzir' (Seduce, 2001) explored the sexual connotations of certain poses, outfits or body parts that they represented. In 2010, another well-known series shocked many with its erotic violence: 'Untitled' showed a couple with their legs tied together, caught in an impossible *danse macabre*. Almeida's work depicts a model (herself) who refuses to be caught in the snares of other people's perception. Her work became more well known in France after the Jeu de Paume gallery put on a retrospective, *Helena Almeida: Corpus*, in 2016, two years before her death. **SR**

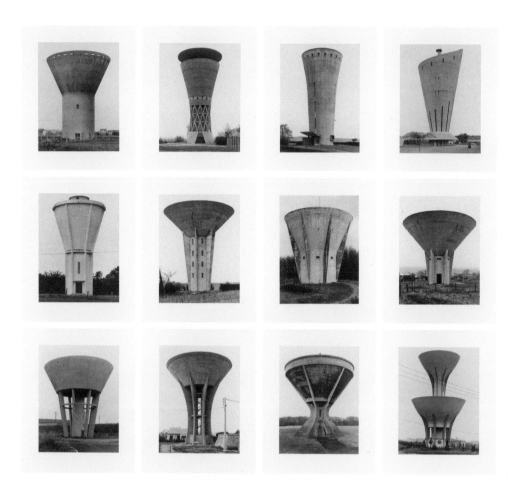

Bernd and Hilla Becher, *Water Towers*, 1972–90

'We didn't teach together; he was the
master, and that was the time.'

HILLA BECHER

The work of Hilla Becher is inextricably linked to that of her husband Bernd. The couple was reluctant to explain the precise role that each played in their work together, and it took a long time for Hilla Becher to be recognized as her husband's equal. Born in Potsdam, Hilla Wobeser grew up in East Germany. From 1951 to 1953, she was an apprentice in Walter Eichgrün's studio, which specialized in architectural photography. She moved to the West in 1954 and worked as a photographer at an advertising agency in Düsseldorf. Three years later, she met her future husband there. Unlike Hilla, Bernd Becher had studied painting and drawing at art school, and did not have a technical grounding in photography. Inspired by a shared interest in industrial sites, Bernd and Hilla Becher started working together from 1959.

As Daniel Palmer notes in *Photography and Collaboration: From Conceptual Art to Crowdsourcing*, in the early days of their collaboration, Hilla Becher did not enjoy much public recognition. In March 1963, the first exhibition of the couple's photographs, at the Ruth Nohl Gallery in Siegen, was called *Bernhard Becher: Fotos*. The following year, art historian Volker Kahmen published an article about their work entitled 'Bernhard Becher', without even mentioning Hilla's name. Kahmen also left her out of an essay that he wrote

in 1965 to accompany *Anonyme Architektur* (Anonymous architecture), their exhibition at the Pro Gallery in Bonn. It was not until 1967 that Hilla was mentioned alongside Bernd in the title of their first museum exhibition at the Neue Sammlung in Munich. In 1970, they were both credited on the cover of their first book, *Anonyme Skulpturen* (Anonymous sculptures), published in Düsseldorf and New York. From then on, their work was attributed to the two of them as a couple.

Becher's photographs began to gain recognition in the contemporary art world. In 1970, the Museum of Modern Art in New York bought a series of thirty images of cooling towers, which it showed as part of its exhibition on conceptual photography, *Information*. Two years later, *Artforum* published a seminal article by Carl Andre, 'A Note on Bernd and Hilla Becher', while Harald Szeemann included their work in the Documenta 5 exhibition in Kassel. For many, the Bechers' success in the art world was due to their archivistic use of the medium, which, although it went against the contemporary trends in art photography, echoed practices in conceptual art. This old-fashioned approach to photography that made the couple's name can in great part be traced back to Hilla Becher's classical training.

However, in 1976, when the Kunstakademie in Düsseldorf wanted to recruit a shining star of contemporary art, they turned to Bernd Becher alone, offering him a professorship. Bernd worked there until 1996, but despite the couple's growing fame, Hilla did not have an official role at the art school. However, she often led sessions in the photography lab and the couple held classes together in their home. Their students made no distinction between Bernd and Hilla when they spoke of their time studying under the couple, acknowledging the influence of both husband and wife. **AF**

Jo Spence is known primarily as a socialist-feminist photographer, but she began by taking portraits on her local high street in London between 1967 and 1974. Perturbed by watching parents trying to mould their young into 'ideal children' in front of her lens, in 1973 she helped to establish the Children's Rights Workshop, where she explored photography's role in establishing normative constructions of childhood and the nuclear family unit. The following year, Spence met the photographer Terry Dennett, who became her collaborator and romantic partner. She also embarked on what would be her first attempt to work in the classic documentary mode, photographing inhabitants of illegal gypsy encampments throughout London. Feeling both privileged at the opportunity and troubled at observing a world she knew nothing about, she became interested in how individuals – especially children, women and the working classes – could use photography to represent themselves.

Spence's political and photographic practice unfolded against the backdrop of 1970s London – a place where myriad countercultures and institutions were shaped by a desire to provide an alternative to dominant establishments and their modes of production. Spence and Dennett therefore co-founded Photography Workshop Ltd – a place (in fact their apartment) where individuals could learn practical skills, participate in exhibitions and engage in discussions about photography and education.

Spence was diagnosed with breast cancer in 1982, but her inclination towards self-representation and education continued in a new form. Documenting her experience with Western medical orthodoxy and recording her use of traditional Chinese medicine as an alternative, the series 'The Picture of Health?' (1982–6) is a continuation of Spence's critical engagement with institutions and systems that represent and make decisions on behalf of others. Her collaborative work with phototherapy, in which she combined her holistic health practice with portraiture, was an extension of this interest. Acting out scenarios from her own psychotherapy sessions – childhood abandonment when her mother was a factory worker during the Second World War, or her feelings surrounding marriage and the female libido, for example – she pieced together a portrait of herself comprised of many 'selves', thus giving depth to the predominantly uniform images of women.

Confronting Spence's work begs the question: is it art, activism, self-help, or all of the above? The power of her images lies in her bold approach to picture-making, drawn from an experience of everyday life, and our inability to pigeonhole them. **CH**

'Somebody like me wanders, without a category. In a sense, I don't want a category. I like being a moving target, I feel I'll survive longer.'

JO SPENCE

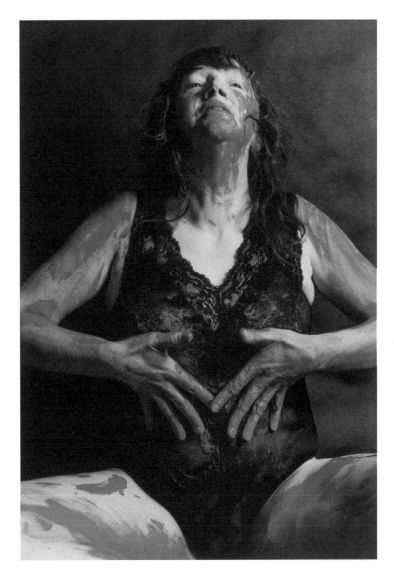

Jo Spence and Rosy Martin,
Untitled, from the series 'Libido Uprising', 1989

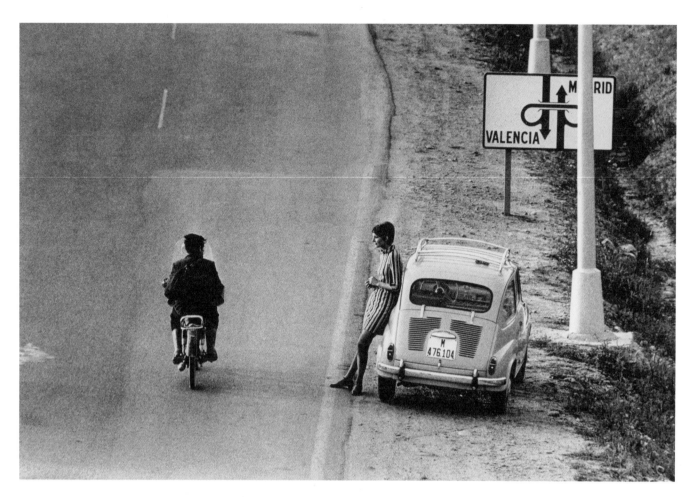

Joana Biarnés, *Broken-down car at the side of a road*, 1967

Although this statement could be qualified slightly, Joana Biarnés is generally considered to be Spain's first female photojournalist, with no woman before her widely published in the press. Between 1953 and 1961, she had more than one hundred reports to her name in *El Mundo Deportivo*, and almost fifteen hundred in the daily newspaper *El Pueblo* between 1963 and 1972. Biarnés also worked with newspapers and magazines such as *Tarrasa Información*, *Club*, *Vida Deportiva*, *Por Qué*, *Destino*, *Ondas*, *Semana*, *ABC* and *Blanco y Negro*.

Her first photographs were published when she was seventeen years old. At that time, women's access to the public sphere was considerably restricted by Franco's regime, and photojournalism was seen as 'a man's job'. There was also no real photography school in Spain. It was Biarnés's father who trained her

'When I finished studying journalism, all the newspapers closed their doors on me [...] They had never seen a woman journalist.'

JOANA BIARNÉS

and helped her to build a career in photography. In the 1950s, a difficult period during which Spain was still dealing with the consequences of the Civil War, Biarnés's father worked at a bank on weekdays and as a sports photographer on weekends, travelling to small villages around Barcelona. Because their family name was considered above suspicion by the Francoist regime, and thanks to her father's reputation among sporting institutions, Biarnés managed to secure the official accreditation she needed to cover sporting events. However, during one football match, there were so many jeers and whistles from the crowd that the referee told her to leave, simply because she was a woman.

In 1954, Biarnés decided to study journalism in Barcelona, in order to gain a press card that would allow her to cover other kinds of events and report for various national media outlets. In 1963, one of her photographs came to the attention of the publisher of *El Pueblo*. When he invited her to a meeting in Madrid, he said it was the first time he had seen a 'woman photographer', and asked her to work for the newspaper. Biarnés gained recognition across Spain, even if certain doors remained closed to her – such as those of the Cortes, the legislative chambers of the Congress and Senate. Her reports covered a wide variety of subjects, ranging from news to culture and fashion, and often reflecting the new yé-yé youth culture that sprang up in the 1960s. **LD and NFR**

Walking out of your front door and stumbling across a dead body left in the street like a dirty bin bag seems to extinguish all hope of a peaceful life in one fell swoop. Shot from above and showing a crowd of curious people who seem to be indifferent to the horror of the scene, this famous image entitled *È stato ucciso mantre andava in garage a prendere la macchina Palermo* (Dead man lying on a garage ramp, Palermo, 1977) captures a moment in time, a pause like an ellipsis. Death lurks on every street corner in Sicily, with daily life marked by an unspoken turf war: that of the Cosa Nostra. Throughout the 1970s and 1980s, the island was engulfed by a wave of terror, its inhabitants suffering the crimes of the Sicilian mafia.

Born in 1935 in Palermo, Letizia Battaglia (her names meaning 'joy' and 'battle', as she liked to point out) is now considered one of the most important chroniclers of these bloody years. Sicilian society was highly patriarchal, and women's lives were controlled by men. A rebellious young woman, Battaglia dreamed of escaping her father's stranglehold. She married and had a child at the age of sixteen. At thirty-seven, she left her husband, taking her three daughters with her and carving out a new identity for herself as a liberated, politically engaged woman.

In 1974, when she had been working for four years as a journalist for the Palermo daily newspaper *L'Ora*, which was investigating the mafia, Battaglia started to take photographs of the Corleonesi clan's brutal crimes. The only woman in a group of men, she took deceptively simple photographs that bore witness to the tragedy overwhelming Sicily. In this backward society, she had to fight to be accepted as a female photographer. She followed this dangerous path for around thirty years, photographing the island and her city, where life and death stood side by side every day, and documenting the daily existence of Sicilians. It was a fight that she continued in the political realm. In 1991, she was elected as a deputy in the Sicilian regional assembly, and the following year she became an advisor to the Mayor of Palermo, tasked with combating crime and corruption.

Battaglia's photographs also have a great sense of vivacity and joy, such as her images of euphoric women dancing until they are out of breath. In another photograph, she captured the 'serious, grave look' of a young girl, in order to 'make visible the thoughts, dreams and desires of women-to-be'. This image reflects her own childhood years and her desire for adventure.

An activist as well as a photographer, Battaglia founded her own publishing house and the feminist journal *Mezzocielo* in 1991. In 2017, she invested in the Centro internazionale di fotografia in Palermo, which hosted both well-known and early career photographers. In the first days of this project, she said in an interview, 'My life is still a battle, but it's a beautiful battle.' She was awarded the W. Eugene Smith Prize for photojournalism in 1986, and in 2007, she received the Erich Salomon Award, given to a photographer or news organization for outstanding journalism. **LG**

'Fighting is a gift. The chance to fight without dying, that's a great gift.'

LETIZIA BATTAGLIA

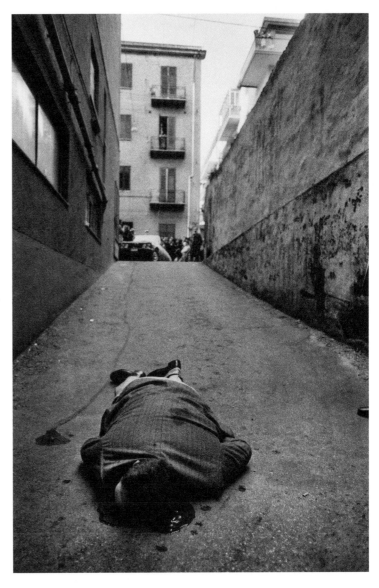

Letizia Battaglia, *Dead man lying on a garage ramp,* Palermo, 1977

'When someone looks at these pictures, they know who I am and they know that I am a good photographer. I take my time in dressing them. I make sure I look good so the customers know they will look good too.'

FELICIA ANSAH ABBAN

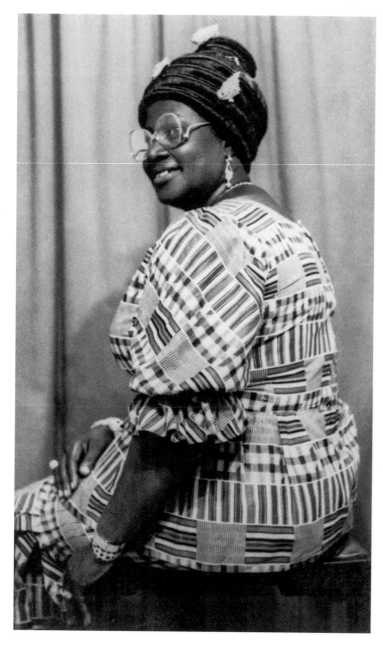

Felicia Ansah Abban, *Untitled*, c. 1960–70

Nowadays, Felicia Ansah Abban is recognized as the first professional female photographer in Ghana – in fact, in all of West Africa. The eldest of six children, Abban is the sister of the film-maker Kwaw Ansah. In 1950, she began her apprenticeship at her father's studio. Joseph Emmanuel Ansah, a pianist and playwright, had opened a photography studio in 1940 to take portraits of the well-off residents of Sekondi, a port city in the south-west of Ghana. In 1953, Felicia married businessman Robert Abban, an increasingly influential figure in the Convention People's Party (CPP) led by Kwame Nkrumah, the first president of the Republic of Ghana. That same year, she opened her own studio, Mrs Felicia Abban's Day and Night Quality Art Studio, in Jamestown, the historic quarter of Accra, not far from the renowned Deo Gratias studio. She was named President Nkrumah's official photographer, and for some time she worked as a freelance journalist for the daily newspaper *Guinea Press Limited* (now the *Ghanaian Times*), founded when the country gained independence in 1957. Throughout her career as a photographer, she covered both public and private events, including weddings, anniversaries and baptisms. For a period, she was also president of Ghana's Association of Professional Photographers.

Although Abban retired in the early 2010s, she is still active, always ready to share her memories and expertise with the next generation. Her personal archives consist mainly of portraits taken between the 1950s and 1970s, including many self-portraits. Abban made a habit of photographing herself before attending important society events. In an interview with Laurian R. Bowles for *African Arts*, when asked why she took these photographs, Abban replied simply, 'Because I was beautiful and it was good for business!' These self-portraits, showing the photographer dressed in fashionable, elegant clothes, were placed in the window of her studio. Today, they provide a picture of the feminine ideal in Ghana at the time.

Felicia Ansah Abban's work was exhibited for the first time in 2017, at the ANO Gallery in Accra. Her self-portraits were shown in 2019 alongside the work of artists El Anatsui, Lynette Yiadom-Boakye, Ibrahim Mahama, Selasi Awusi Sosu and John Akomfrah at the 58th Venice Biennale, the first time that Ghana had a pavilion there, and also at the twelfth edition of the Bamako Encounters – African Biennale of Photography.

In Accra, young artists and curators are working to organize her archive and re-evaluate her work in the light of current trends and concerns. There are plans to turn her studio into a museum to exhibit her work, as well as a space to support the next generation of artists. **EN**

Anna and Bernhard Blume, *Kitchen Frenzy*, 1986

Over the course of more than thirty years, Anna Blume and her husband Bernhard, who died in 2011, played at being a perfect West German couple. Clad in a skirt suit or a knee-length dress and sporting a traditional haircut, Anna imitated a housewife in her fifties, drifting between her Formica kitchen counters and her holidays in the countryside. It must be said that there was a real danger that the photographer would find herself dismissed as an embodiment of this stereotype.

Born in 1937 in a small town in the Rhineland, Anna Blume studied at the Kunstakademie in Düsseldorf between 1960 and 1965. She met her husband there and moved with him to Cologne in 1966, giving birth to twins the following year. For twenty years, she taught fine arts at various secondary schools in the area. Alongside her roles as a model wife and mother, she continued her artistic practice, taking the female body as her main subject. Her influence on her husband's photographic work also grew steadily, until she began to share credit on his works in 1984. In the series that the couple created together, their criticism of stereotypes is laced with humour: Anna dresses up as the archetypal German postwar woman in scenes inspired by performances and audience-participation events that the couple first encountered in Düsseldorf.

The objects that populate these neat and ordered domestic scenes go far beyond their ordinary functions. Their choice is far from neutral: 'The places where we live are places of madness', said Bernhard Blume. *Im Wahzimmer* (In the room of madness), taken in 1984, features furniture taken from Anna's parents' living room, mass-produced pieces that gained popularity during the miraculous postwar recovery of the Germany economy. *Küchenkoller* (Kitchen frenzy, 1986) shows Anna being attacked by a swarm of potatoes, a staple food in Germany. In 1987, the cheap white plates of *Trautes Heim* (Sweet home) function as a metaphor for the kitchen, a woman's proper place according to conservative society. The everyday environment is infused with madness, causing the very foundations on which German society is built to shake. The loss of meaning – whether literal or figurative – is heightened by the huge size of the canvases on which the photos are printed and their organization into series, which allow the viewer to lose themselves in the images.

The choice of photography as a medium was a deliberate one. In West Germany, photography flourished from the 1950s onwards and became the domain of the middle classes, a medium used to take prosaic, everyday snaps or to record the growing trend for leisure pursuits. It recorded images from the blissful postwar years, with people joking around for the camera, which every amateur photographer could capture among their family and friends. In the work of Anna and Bernhard Blume, family photo albums are seen in a new light. The blurred focus and poor framing of their images mimic technical faults produced by instant cameras. From 1975 onwards, the couple used colour Polaroids as a way of exploring their interest in the role of photography among the general public. In the same vein, they included standardized pieces of 1950s furniture in the staging of their exhibitions. Much like amateur photography, it is these objects that bear witness to the most banal moments of everyday life, that perhaps best express our common cultural imagination. **AF**

311

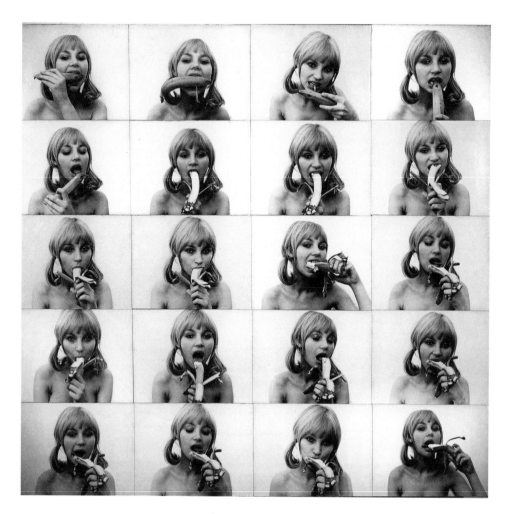

Natalia LL, *Consumer Art*, 1972–5

'Simply knowing about photography gave me a certainty that our view of reality can be reduced to the use of objective media.'

NATALIA LL

Natalia LL (full name Lach-Lachowicz) is a pioneering figure and major artist in the feminist movement in Poland. She began to practise photography on graduating from art school in 1963, at first focusing on documentary photos of her close friends and family, but quickly moving on to a more analytical approach. Her first portraits, in a close-up style inspired by Stanisław Ignacy Witkiewicz, formed the series 'Geografia twarzy' (Geography of faces, 1964).

In 1962, Natalia LL met the artist Andrzej Lachowicz, with whom she was in a relationship for almost thirty years. He brought her into the world of conceptual art, which was very influential in Wrocław in the 1970s. The couple occasionally worked together, most notably on series focused on the human body, a theme that became increasingly important in Natalia LL's work. Since 1968, the artist has produced numerous images of a heterosexual couple's sex life (sometimes featuring herself and Lachowicz), using the approach that Lachowicz named 'permanent photography'. The technique consists of photographing a situation at regular intervals, for example every sixty seconds, over a long period of time. The series 'Rejestracje intymne' (The intimate

sphere, 1968–9), was followed by a radical installation, *Fotografia intymna* (Intimate photography, 1968–71), where Natalia LL put up walls within the gallery to create a small room covered with enlargements of photographs showing a sexual act. The piece was exhibited at PERMAFO, a mobile gallery that Natalia LL and Lachowicz founded in 1970 with Zbigniew Dłubak and Antoni Dzieduszycki. Until it closed in 1981, it was the home of avant-garde, conceptual and international feminist art in Wrocław.

Natalia LL's most famous series, 'Consumer Art' (1972–5), are filmed and photographed performances in which a naked young woman eats fruit and sausages in a highly suggestive manner. The masculine – symbolized by the phallic foods – is reduced to a mere consumer product. In the next series, 'Post-Consumer Art', the young woman vomits up the food she's eaten, in a radical rejection of stereotypical representations of femininity and female sexuality. These series made Natalia LL's name in the international feminist art world and led to her work being featured in the 1975 exhibition *Frauen Kunst – Neue Tendenzen* (Women – art – new trends) at the Krinzinger Gallery in Innsbruck. She was also on the cover of *Flash Art* magazine in 1976.

Since the late 1970s, Natalia LL's photographs have explored the relationship between humans and the universe, nature or animals – although eroticism, urges and the unconscious remain driving forces behind her work. She has continued to produce series of photographs, such as 'Sztuka zwierzęca' (Animal art, 1978–2007), 'Śnienie' (Dreaming, 1979) and 'Punkty podparcia' (Points of support, 1980), and her approach has lost none of its radicalism. **KZ-L**

The Visual Studies Workshop (VSW), established in Rochester, New York, in 1969, put its founder Nathan Lyons on the map, but the photography education centre would not have gained such a strong reputation without the work of Joan Fischman. She married Lyons shortly after meeting him at Alfred University, a private university around sixty miles south of Rochester, where she was studying ceramics. Although this specialism may seem surprising given her photographic work, it was not unusual: many photographers of her generation first studied more craft-based practices. The influence of the Servicemen's Readjustment Act, passed in 1944, meant that jewelry-making, tapestry and ceramics were added to Master of Fine Arts courses, in order to diversify the training offered to veterans by the government. The aim was to support veterans to re-enter the world of work, but it also benefited the education system more widely.

At Alfred, Joan Lyons also tried her hand at painting, engraving and drawing. The influence of the Bauhaus movement, which first reached the United States in the 1930s, remained strong at many artistic institutions, especially its emphasis on combining different art forms. One of Lyons's professors, John Wood, played an especially important role in the young artist's personal development. The founder of the photography and printmaking programmes, he encouraged his students to adopt a mixed-media approach inspired by László Moholy-Nagy, and also supported Joan in producing her first photography books. At the time, the term 'photobook' did not yet exist, and her early attempts hinted at the trailblazing role that she would play at the VSW.

In 1971, Joan Lyons founded the VSW Press, which helped artists such as Alison Knowles to publish their book projects. Lyons always prioritized her teaching over promoting her own work, but she is now enjoying a belated and well-deserved recognition. Among her most important works are early examples of photocopier art. Along with Sonia Sheridan and Catherine Jansen, Lyons was one of the first artists to use a photocopier as a means of artistic production. 'Found media' in the truest sense of the word, the Haloid-Xerox machine sitting in the VSW headquarters was already outdated when Lyons decided to use it to create 'Women's Portraits' and 'Symmetrical Drawings'. These two series combine photography, printmaking and drawing to explore the preoccupations of a female artist. Joan incorporated self-portraits and floral motifs as a way of interrogating feminine archetypes and focusing on the decorative, a concept that was strongly rejected by the modernist movement. In places, Lyons manually reworked the original, which she then photocopied. Graphic and photographic elements come together to form what the artist calls 'photographic drawings' – precious remnants of a decade marked by mixed-media work. **MA**

'In Rochester, most photographers were trying to capture the image they could see in their viewfinder. Personally, I didn't need my eyes. A photograph can't be reduced to seeing something through a lens.'

JOAN LYONS

Joan Lyons, *Untitled*, from the series 'Women's Portraits', 1976

Although Marianne Wex began her career as a painter, her growing interest in body language and the power dynamics of gender led her to begin systematically photographing the 'unconscious' postures and facial expressions of men and women in Hamburg. From 1972 to 1977, she photographed her subjects with a medium-format camera, from a distance so as to remain unnoticed, and in public spaces out of doors, most often train stations. To her own photographs, Wex added images appropriated from popular media, including newspapers, magazines, reproductions of art and images from film and television.

Wex amassed an archive of more than five thousand images, out of which she built an exhibition and a book. For both, she divided her images by gender and into comparative groupings focusing on specific postures – for example, 'Standing persons, leg and feet positions', 'Sitting persons, arm and hand positions'. Seemingly aware of the highly engineered nature of her social observations, with each layout, Wex also included exceptions to the rule. She was acutely conscious of the cultural and performative nature of gender, and one section, entitled 'An experiment', invites subjects to perform various postures in the guise of the opposite sex, leaving open possibilities for gender fluidity and neutrality. The project remains an inventive, obsessive and compelling graphic and creative experiment.

Wex initially mounted a wide selection of her images onto large cardboard panels, which were first showed at the Neue Gesellschaft für Bildende Künste in West Berlin in 1977, in conjunction with *Women Artists International, 1877–1977*. Drawing from the same source material, *Let's Take Back Our Space: 'Female' and 'Male' Body Language as a Result of Patriarchal Structures* was published in German and English in 1979. This book, with a landscape format and soft cover, includes a wider selection of images from the original archive, a second section not included in the panels, showing historical sculpture and statuary from ancient Egypt to the nineteenth century, and several texts by Wex. She writes, unambiguously: 'I see a direct connection between the manner in which women move and the narrow psychic and economic room which is allotted to them in the male-dominated society.'

Unseen for nearly thirty years, *Let's Take Back Our Space* was revisited, to much acclaim, in an exhibition at the Focal Point Gallery in Southend, south-east England, in 2009, setting off a surge of renewed interest in Wex's work. Created at the climax of the second-wave feminist movement, the project has been reclaimed as a seminal feminist work from this era. It has been compared to similarly obsessive photographic typologies and visual archives, including Eadweard Muybridge's *Animal Locomotion* (1877) and Aby Warburg's *Mnemosyne Atlas* (1924–9), as well as to signal feminist works of the time, such as Mary Kelley's *Post-Partum Document* (1973–9), Judy Chicago's *The Dinner Party* (1974–9) and Martha Rosler's *Vital Statistics of a Citizen, Simply Obtained* (1977). **SK**

Marianne Wex, *Let's Take Back Our Space: 'Female' and 'Male' Body Language as a Result of Patriarchal Structures*, 1977

Martine Franck, *Swimming pool designed by Alain Capeillères*, Le Brusc, France, Summer 1976

'To be a photographer, you need a good eye, an understanding of composition, a sense of compassion and commitment.'

MARTINE FRANCK

Martine Franck cut an unusual figure among the photographers of her day – modest and naturally elegant, 'not made to pound the pavements', as her husband joked. However, her shyness disappeared when she was holding a camera, and she became positively bold.

Born into a family of collectors in Anvers, Franck's first love was sculpture. It was on a long trip to the East in 1963 that she discovered her passion for photography. Very early on, Franck was interested in artists, first the sculptors Étienne-Martin and Augustin Cardenas, then all kinds of writers and musicians whom she openly sought out and engaged with. Along with Ariane Mnouchkine, she was involved in the Théâtre du Soleil stage ensemble from its early days, and she also helped to set up the agencies Vu and Viva. In 1970, she married Henri Cartier-Bresson, who encouraged her to pursue a career in photography, and joined the Magnum Photos agency, which still represents her work today.

A woman of great contradictions, Franck was both charming and tenacious. Her work combines a desire to bear witness with a deep concern for composition. It conveys the sense of wonder and profound joy to be found in humanity, while also displaying the great empathy that fuelled Franck's fight against poverty in all its forms. Appalled by the social exclusion that she witnessed, she photographed many groups that were shut out from society – women, Tibetans, older people, refugees and residents of Tory Island – and campaigned for numerous causes, a bold step for a well-brought-up young woman who had been taught to toe the line. However, 'there are moments when human suffering and degradation grab hold of you, force you to stop and pay attention', she said. Franck's worthy sentiments may sometimes make her seem austere, but with this statement she distanced herself from the excesses of mainstream photojournalism that did not suit her.

Franck's works are a celebration of life, where the unexpected is to be found in movement – children jumping, birds, waves or clouds. For her, photographing a landscape was an exercise in meditation, far divorced from systematic topographical approaches. Her exploration of form and light can be traced back to her deep knowledge of sculpture, as is evident in her last images, remarkable stone landscapes soaked in light.

As well as her own achievements as a photographer, Franck founded the Fondation Henri Cartier-Bresson in 2003, along with her husband and their daughter Mélanie. For Franck, the institution represented ultimate freedom: the freedom to create, preserve and collect. On her death in August 2012, she left her archive to the Foundation, although she requested that the institution's name remain unchanged. It was a final act of modesty from a woman who forged her own artistic career in the shadow of a great tree, as she liked to joke, with a laugh that surprised everyone by its power and freedom. **AS**[1]

Katalin Nádor, *Movements in space with natural forms / lilac – sunflower – grass – insect moulting – sunflower – sand / brick wall – stone wall – stones,* from the series 'Nature – Vision – Creation III', Pécs, Hungary, 1972–6

Until recently, Katalin Nádor had been left out of the history of Hungarian photography, but she has now claimed her rightful place thanks to the rediscovery of her exceptional experimental works from the 1970s. Under the communist regime in Hungary, Nádor was not allowed to attend university because she came from a bourgeois family. In the 1940s, she started working as an apprentice in a photography studio in Szekszárd, then she moved to the photography company Fényszöv in Bonyhàd, joining her mother, who was already a studio photographer there. Between 1961 and 1990, Nádor worked at the Janus Pannonius Museum in Pécs, photographing artworks and archaeological artefacts. That was where she first discovered modernist art and perfected her technique, especially her use of light.

Nádor was familiar with the work of László Moholy-Nagy, as well as the abstract paintings of Tihamér Gyarmathy and Victor Vasarely (a museum dedicated to his work opened in Pécs in 1976), both of whom were sources of inspiration for her experimental images. Through her work for the archaeology department, photographing details of skulls and other objects, and with painter Ferenc Lantos on his publication *Nature – Vision – Creation* (1972–6), she also discovered the medium's potential to render objects abstract.

In 1970, Nádor began a collaboration that would prove pivotal for her personal research, with a group of five artists, a decade younger than herself, known as the 'Pécs Workshop'. They included the artists Sándor Pinczehelyi and Károly Hopp-Hálasz, who were interested in abstract painting, particularly hard-edge painting and op art, and also put on conceptual works of performance art, which Nádor photographed. She introduced the group to photography, and they taught her that 'you can photograph anything in any way, even upside down'. She took hundreds of photographs during her

'In the end, I was so focused on photography that I forgot to get married, to enjoy my life, to pay attention to how I dressed.'

KATALIN NÁDOR

seven-year collaboration with the group, many of which were small-format images created without the use of a camera, and used them to explore different types of abstraction. She developed her own individual technique, using photograms, layering images on top of each other, working with collage or printing negatives, to create series such as 'Jáléok' (Games), 'Hálók' (Nets), 'Buborékok' (Bubbles), 'Grafikai hatások' (Graphic effects), and many others that she left untitled. Nádor proposed a photographic version of op art and abstraction, running parallel to contemporary trends in painting. However, the group did not encourage her research: aside from featuring a few of her images in the exhibition *Workshop* at the legendary Balatonboglár Chapel in Pécs in the summer of 1972, and including her in the group exhibition *Mozgás* at the Museum of Pécs in 1970, they did not show her work. However, Nádor's work as a museum photographer was recognized, that same year, with an exhibition of her reproductions of artworks, although it did not feature her fascinating work *Képzeletbeli múzeum* (Imaginary museum) or her abstract photographs. Katalin Nádor stopped producing personal work towards the end of the 1970s. **KZ-L**

Ursula Schulz-Dornburg's practice explores the complex relationships between human civilization, landscape, architecture and the environment. Born in Berlin in 1938, she has spent almost half a century working in places beyond the borders of her native Germany, including Armenia, Azerbaijan, Georgia, Iraq, Iran, Kazakhstan, Laos, Russia, Saudi Arabia, Spain and Syria. Her images, which investigate sites of social, political and cultural conflict, are rooted in the traditions of minimalism and conceptual art, especially its American practitioners; she is not part the Düsseldorf School, despite living in the city for much of her life.

Exploring the relationship between time, space, landscape and history, Schulz-Dornburg investigates how major historical events transform the landscape, leaving traces and causing degradation. Her practice has consistently explored the themes of borders and boundaries, both natural and man-made, visible and invisible. In Iraq, Mesopotamia, Syria, Georgia and Azerbaijan, it has highlighted how shifts in power or the rise and fall of empires over time can change the status of the landscape and affect those who live there. Her work documenting nuclear test sites in the former Soviet Union and the wheat archive of the Vavilov Institute in St Petersburg highlights the relationship between politics and the environment, and the often devastating

impact human civilization has had on nature. In her series 'From Medina to Jordan Border', which traces her journey along what remains of the Ottoman-era narrow-gauge Hejaz Railway that ran from Syria to Saudia Arabia, or in 'Bushaltestellen' (Bus shelters), taken in Armenia, the photographer focuses on the so-called 'soft power' represented by architecture and infrastructure and how ideology permeates the urban landscape. In this latter series, the bus stops resemble fragments of sculpture emerging from the ground. Once symbols of originality and sociability, these shelters are now a decaying reminder of the past, having outlived the ideology of their designers.

Alongside her social and political concerns, Schulz-Dornburg has developed a carefully considered formal approach, evident in both her images and the way in which she presents them. She prefers to organize her series in the form of small-size black-and-white photographs, which she installs in grid-like structures whose spaces form an integral part of the viewing experience. Her interest in anthropology, politics, history and society has driven her to systematically explore subjects, events and regions that are often overlooked. This ongoing, enduring commitment is testimony to her dedication, not only as an artist, but also as an activist, drawing our attention to that which we tend to ignore or forget. **SM²**

Ursula Schulz-Dornburg, *Erevan – Goris*, from the series 'Bus Shelters', 2000

Multidisciplinary artist Nil Yalter was born in 1938 in Cairo to Turkish parents, who moved to Istanbul four years later. She attended the Robert College in Istanbul and learned French from her grandfather. Although she never studied the visual arts, she was diligent about learning from her observations, a fact that informs her unique artistic outlook.

In the 1950s, Turkey was marked by increasing immigration, a growing population and escalating unemployment. A decade later, France was battling with civil unrest and student protests. Upon moving to Paris in 1965, Yalter was deeply influenced by these phenomena; as a Marxist-feminist immigrant herself, she could not have remained indifferent. After trying out different techniques, she settled on photography, video and installation as her mode of artistic expression, and they became strong components of her narrative. Her pioneering style and the artistic path that she forged were to inspire many women artists in Turkey.

Photography and video play a significant role in constructing memory as they attest to facts and reinforce a sense of identity. Combining art with textual documents – a rare approach at the time – Yalter embraced the potential of both media to highlight problems in society and in the communication between cultures in a fast-changing world. Her focus is on outcasts, gentrification and how those ignored by society struggle to survive – a theme Yalter explored in *The Headless Woman or the Bellydance* (1974) and several other works that followed.

'People said it was not art, it was politics. It was too early for that kind of work in 1974 and 1975.'

NIL YALTER

In her series 'Temporary Dwellings' (1974–7), for instance, Yalter depicts immigrant communities in Istanbul, Paris, New York, Lyon and Grenoble, where the multilayered stories they tell themselves are open to unexpected interpretations. In a similar way, the series 'Pink New York' (1976–80) brings collective and personal memories together in a structured narrative consisting of eighty-seven Polaroids. This work in turn contains echoes of *Paris Ville Lumière* (1974), an installation that she produced in collaboration with the artist Judy Blum. Comprising text and images, it constitutes a kind of sociopolitical panorama of the city and focuses in particular on the 20th arrondissement. *La Roquette, Prison de Femmes* (1974) portrays the routine of its female prisoners, gender roles, places of confinement and the correlation between these different elements in prison institutions. Yalter's 'Turkish Immigrants' series (1977), which also incorporates drawing, focuses on immigrants' living conditions and the wider experience of exile. **DP²**

Nil Yalter, 'Turkish Immigrants', 10th Paris Biennial, 1977

Nair Benedicto, *Amazon rainforest – hairdresser working in a bar*, Guritaí, Brazil, October 1985

'It doesn't matter whether I'm photographing an Indian, a labourer or a prostitute. What matters is what I think, how I situate myself as a woman.'

NAIR BENEDICTO

From the beginning of her career, Nair Benedicto's work as a photographer has been inseparable from her political activity. While studying for a degree in communications in São Paulo, she joined a left-wing organization and started campaigning. In 1969, she was arrested and tortured by the military dictatorship in power in Brazil at the time. Although she was released after nine months in prison, Benedicto was branded a criminal and was therefore unable to pursue her dream of working in television, as the regime considered it a strategically important industry. Instead, she chose to become a photojournalist, forging a career in which she consistently fought to protect artistic freedom.

Benedicto was one of the leading figures in the professionalization of Brazilian photojournalists from the mid-1970s onwards. In 1979, she co-founded the cooperative photo agency F4 along with photographers Juca Martins, Ricardo Malta and Delfim Martins, and in 1991 she established Nafoto, a collective that aimed to promote photography events and discussions about the medium. The creation of F4 was undeniably linked to the political context of the dictatorship in place at the time, as it was driven by a need for security in terms of employment rights and a desire to secure recognition for the role of photographers. By banding together in this way, Brazilian photographers were finally granted copyright of the images that they created. Another important step forward, according to Martins, was that photographers no longer had to simply follow the instructions of their editors, but could become 'authors of their own subjects'. Nair Benedicto fought long and hard for this freedom to produce visual material that was not dictated by the interests of newspapers, but which 'had a longer life, a historic importance'.

A significant portion of her photographic work was dedicated to recording the daily life and struggles of minorities in Brazilian society. In the early 1980s, Benedicto documented the workers' strikes in São Paulo that led to the fall of the military dictatorship, and denounced the terrible conditions in which the state held young offenders. She also used her work to draw attention to daily life and political activism among Brazil's Indigenous population, as well as marches for women's rights and LGBTQI rights. Her photographs represent an important part of Brazilian visual culture. They pay special attention to the role of women, whether at work or in the political protests that marked the last four decades. **EZ**

Mary Ellen Mark, *Tiny blowing a bubble*, Seattle, 1983

With her long, dark hair tightly braided, and dressed in sumptuously layered textiles, Mary Ellen Mark was a dramatic presence. Her voice was inflected sometimes with a droll knowingness, and always with fierce conviction and passion – especially when it came to defending photography's power to document, provoke, tell stories and elicit empathy. From the early 1960s until 2015, when at the age of seventy-five she died of cancer, Mark's portraits of people and animals and her narratives – often focused on girls and women and always intense – affirmed her faith in the medium. Several of her long-term projects, which usually turned into books, started out as photoessays for magazines. Her commitment to her subjects – several of whom she revisited repeatedly – is in part what distinguishes her work.

Perhaps Mark's most enduring protagonist is Tiny (Erin Blackwell Charles), who first appeared in 1983 in *Life* before featuring in a film (directed by Mark's husband, Martin Bell, in 1984) and a book (1988), both entitled *Streetwise*. It was while following a precociously independent group of children and teens surviving on the streets of Seattle as hustlers, beggars, petty thieves, pimps and prostitutes that Mark initially photographed Tiny at the age of thirteen. Mark would continue to document her and, eventually, Tiny's ten children over the next thirty years, publishing *Tiny: Streetwise Revisited* shortly before her death. She also photographed the Damm family on several occasions, having created one of her most iconic images in 1987 showing them living in their car.

Mark strove to depict the other face of America, the vulnerable and those forgotten by society, as in the photographs she took in the mid-1970s in a secure psychiatric ward for women (published as *Ward 81*, 1979). She also revelled in the country's quirkier events and rituals, using a Polaroid 20 × 24 camera to record twins' festivals and proms (the resulting work was published in 2003 and 2012, respectively).

Beyond the United States, Mark often turned her camera on India and Mexico, countries that overwhelmed her with their beauty and pathos. In India, having gradually earned their trust, she photographed the prostitutes of Mumbai (*Falkland Road*, 1981), covered Mother Teresa in the early 1980s, and became enraptured with the circus in the 1980s and 1990s (*Indian Circus*, 1993). In Mexico, she likewise focused on the circus in the 1990s and 2000s, and held, by all accounts, remarkable workshops in Oaxaca. Mary Ellen Mark's work neither judges nor exoticizes. Rather, it helps to give voice to those who are otherwise marginalized or forgotten. **MH**

'I have always tried to make my photographs a voice for people with less chance to speak for themselves.'

MARY ELLEN MARK

Judy Dater's evocative images of the people and landscapes of her native California draw upon the traditions of West Coast Straight Photography – including the formal language of Group f.64, created in 1932 – while remaining firmly of their time and place. Born in Hollywood in 1941, Dater witnessed the power of images in her father's movie theatre at a young age. After studying at the University of California, Los Angeles, she moved to San Francisco in the early 1960s to major in photography at San Francisco State University. Dater quickly came into contact with an older generation of West Coast photographers, including Imogen Cunningham, Ansel Adams and Wynn Bullock, who took a keen interest in her work.

During her early years, Dater looked to Cunningham as a mentor and friend, sharing with the older artist a straightforward photographic approach coupled with a psychological interest in her subjects. *Imogen and Twinka at Yosemite* (1974) pays homage to Cunningham's first allegorical scenes in natural settings while offering a feminist reinterpretation of a painting by Thomas Hart Benton, *Persephone* (1938–9). In this meeting of youth and age, the nude model Twinka Thiebaud and Cunningham appear equally startled and intrigued by one another's presence. By replacing the concupiscent Pluto in the original with the photographer, armed with her famous Rolleiflex, Dater eliminates the male gaze from this classical encounter. Her image marked the first time that *Life* magazine published a picture of a full-frontal nude.

In the early 1980s, Dater took a series of self-portraits in which the topography of her body echoed the natural formations of America's national parks. In works such as *Self-Portrait with Steam Vent* (1981) – in which she stands, naked, above a gaping crater, presenting the female body as an extension of nature – Dater reclaimed the body at a divisive time in the women's movement, when depictions of female nudity were often viewed as a form of objectification.

Although Dater has also worked in colour and digital photography over the years, she continues to use the large-format camera that set her early work apart from that of her peers. Her series of tightly framed black-and-white images of members of her Berkeley community, finished in the early 2000s, is anything but anachronistic, however. The multiplicity of faces from different ethnic backgrounds reveals Dater's enduring commitment to capturing individualized expressions of contemporary society. **FW**

'The nude body – women, men, and myself – became an important vehicle for me to express ideas about sexuality, gender politics, freedom, vulnerability, strength, and character.'

JUDY DATER

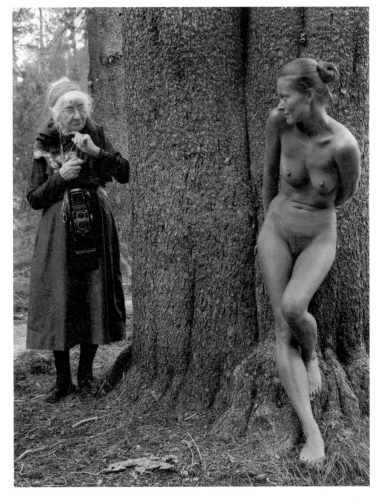

Judy Dater, *Imogen and Twinka at Yosemite*, 1974

Until the late 1960s, Nina Raginsky worked as a photographer for the National Film Board of Canada, as well as for the international press. In the early days of her career, she focused on street photography, taking classic black-and-white photographs that captured scenes of daily life in Montreal, Europe and Mexico, where she briefly lived. Afterwards, she settled in Victoria, British Columbia, where she created a major series of 'local' portraits of the Canadian West. On her walks around the area, she took photographs that together formed a kind of social inventory: neighbours, shoe-shiners, waitresses, children, mechanics, politicians, lawyers, farmers, etc. She invited people from across Canadian society to pose for her, without any hierarchical distinctions. In addition to the documentary function of her images, Raginsky sought to develop a relationship with her subjects and convey something of their encounter in her photographs.

In the 1970s, Raginsky started to hand-colour these portraits with pastel-toned pigments. This manual process introduced a unique, Surrealist element to her work, revealing her artistic intentions, which were to accentuate the beauty in the world. In this way, she sought to enhance a world that she sometimes found 'brutal and difficult to endure'. Having initially studied sculpture and painting alongside household names in the Pop art movement (Roy Lichtenstein, George Segal and Allan Kaprow), Raginsky drew on her training in the fine arts as she transformed her sepia photographs into unique works. This new approach reveals a more subjective view of the subject, now 'made up' with added colour, giving the images a dreamlike, unreal quality that plays with notions of time. The photographer's manipulation of her images allows for multiple interpretations. Despite these manual interventions, these portraits still fulfil their original documentary function, representing sections of Canadian society at the time.

Although her influences are drawn from literature, music and the fine arts, Nina Raginsky undeniably belongs to the tradition of humanist photographers. Her works form part of the collections at major institutions, although it is many decades now since she stepped backed from photography as a medium and returned to painting. **SB**[1]

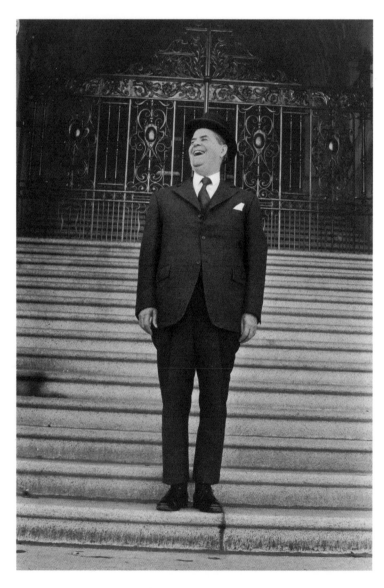

Nina Raginsky, *Mr W. A. C. Bennett, Former Premier of British Columbia*, Victoria, British Columbia, 1973

'My vision is coloured by the knowledge that the moment dies as soon as I seize it.'

SARAH MOON

Sarah Moon, *The Amaryllis*, 2012

Certain images flutter like butterflies' wings and land delicately to take root in our memory. This is true of the photographs of Sarah Moon. In *The Seagull* (1998), she captured a gull's beating wings against a wash of greys merging into the background, an image in which the wind breathes through the bird's feathers. Moon's photograph grants this gull a second life, as she does to all her subjects. Her images go beyond simply what we can see, offering a very personal view of the passing of time. Photography has the ability to transform its subjects in this way – creating an image of something real means reinterpreting it. The silent world of the photograph is transformed under Moon's tender gaze into a poetic construct. She pays close attention to the tools offered by the medium of photography and how they allow her to reinvent the world. She plays with perspective, chemistry and the flexibility of the material, treating it as an opportunity for experimentation. A modern-day magician, Moon acknowledges the history of photography in her visual inventions, which are suffused with poetry. The Polaroid, a symbol of immediacy, is her favoured medium. 'The advantage of Polaroids is the wear and tear, the fact that the image seems to have been snatched by the photographer', explains Moon, a remark that resonates with the famous 'it was' defined by Roland Barthes in *Camera Lucida*. The photographer's experience of time is unlike

any other; the images that they create are small miracles, moments in which time is suspended.

Moon started out on the other side of the camera as a model, before becoming a fashion photographer herself in the early 1970s. After allowing her body to be the subject for others, she started photographing her model friends, as a kind of game. A meeting at Cacharel led to collaborations with some of the major couture houses, including Dior and Chanel, as well as with *Vogue*. Alongside her professional work, Moon developed a very unusual personal style. She was awarded numerous prizes, most notably France's Grand Prix National de la Photographie in 1995, for her work as a whole. She exhibited regularly at the Rencontres d'Arles photography festival, and published many books, including the gift set *1 2 3 4 5*, published by Editions Delpire in 2008, which was awarded the Nadar Prize. Switching her focus from photographs to moving images, she made films and documentaries, including the famous *Henri Cartier-Bresson: Point d'interrogation* (Henri Cartier-Bresson: question mark, 1994). Her photographs are like musical notes that surprise with their gentleness. 'I want to find an echo between myself and the world, a resonance', she says. Moon invites us into her world of possibilities where tiny visual accidents lead to wonderful revelations, like the songs of our childhood memories. **LG**

Val Wilmer's photographs of jazz musicians are inseparable from her writing about Black music. Wilmer grew up in Streatham, south London, with her mother, brother Clive Wilmer (who became a poet) and various lodgers. An interest in chemistry and magazines such as *Lilliput* laid the foundations for her photographic endeavours. She took her first photograph of a musician – Louis Armstrong – with her mother's Kodak Brownie in 1956. From 1959 to 1960, Wilmer attended the School of Photography at the Regent Street Polytechnic, directed by Margaret Harker, before working at the National Gallery as a darkroom assistant.

It was Wilmer's passion for jazz and her interest in journalism that brought her into contact with many musicians. She worked as a receptionist at *Tropic*, one of the first Black magazines in Britain, and as a photographer at Nigerian family events. In 1962, Wilmer made the first of many extended trips to New York, where she got to know other photographers working in the jazz world. Using a Rolleiflex and, from 1963, a Pentax, she began a series of emotive high-contrast black-and-white portraits, often to illustrate her interviews. Inspired by Ida

Kar's retrospective exhibition in 1960, she photographed sculptors, including Barbara Hepworth and Anthony Caro. Social-documentary photographers such as Eugene Smith became a point of reference. The photographer and underground figure John 'Hoppy' Hopkins became a friend, introducing her to Sun Ra and other musicians of the jazz avant-garde in New York.

By the 1970s, Wilmer had mastered the dual practice of writing and photography, seeking to both connect with and portray the inner life of her subjects. Following her groundbreaking exhibition *Jazz Seen: The Face of Black Music* (1973) at the Victoria and Albert Museum in London, she received two grants to take photographs in the southern states of the United States, where she had first travelled in 1971. Her insights into racism, an understanding of the fight for Black liberation and her increasing involvement in the women's movement informed her work, which appeared in publications ranging from *The Times* to *Spare Rib*. Alongside fellow women photographers, she organized two exhibitions at the Half Moon Gallery (1974 and 1975). In 1983, in collaboration with photographer Maggie Murray, Wilmer co-founded the Format women's agency, which aimed to support and give greater visibility to under-represented female photographers. Thanks to exhibitions of her perceptive documentary portraits, such as *Sorrow Songs, Soulful Shout*, shown in Lewisham and Massachusetts (1986), and publications including *The Face of Black Music* (1976) and *As Serious as Your Life* (1977), a history of the free jazz movement, Wilmer has become an internationally celebrated figure. **CF**

'My concern is with the interior of the person rather than the exterior.'

VAL WILMER

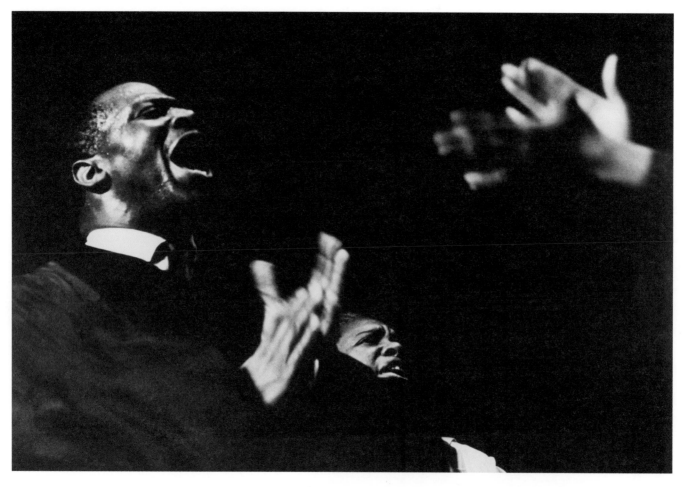

Val Wilmer, *Reverend John I. Little in concert, Spiritual and Gospel Festival, Fairfield Hall, Croydon*, February 1965

Sandra Eleta, *Putulungo and Alma, Portobelo couple*, 1977

Panama's most prominent photographer of the twentieth century, Sandra Eleta is best known for her images of the inhabitants of Portobelo, a village on the country's Caribbean coast, where she began to live in the early 1970s. Its people are mostly descended from enslaved Africans from the colonial period, and she has described being fascinated by 'the magic of the culture, the maroon ancestry, and the strong character that defied any outside interferences'. In an artistic career that has spanned fifty years, Eleta has also produced photoessays documenting a revolutionary community of artists on Nicaragua's Solentiname archipelago, and the Guna and Emberá Indigenous groups in Panama. Like her 'Portobelo' series, most of these photographs – with their rich black-and-white tones – are born of a sense of empathy for and personal interaction with those who live in marginalized communities, in circumstances far removed from her own privileged background.

Although Eleta does not consider herself a true photojournalist, her images often document social inequality. This is the case in her series 'La servidumbre' (The household staff) and 'Las campesinas' (The peasants) where, aside from revealing her subjects' true natures and their human dignity, the photographs also show a deep sensitivity to different cultures, a belief in equal rights and a keen awareness of the role of women in society. In addition to her photography, Eleta has worked to encourage a wider recognition of Portobelo's cultural and historical values and has founded artistic workshops for the villagers.

'I try to erase the difference between subject and object. It dissolves in the moment I take the photo. They are a part of that photograph, as much as I am. There is no space for the ego.'

SANDRA ELETA

Eleta also stands out as the first artist in Panama to have created multimedia work, most notably *Sirenata en B*, which comprised fourteen hundred images and nine projectors, and was first presented in New York in 1983. Throughout her career, Eleta has gained more recognition internationally than in her native country. From the 1970s, she was invited to exhibit abroad and to participate in such events as the first Coloquio Latinoamericano de Fotografía in Mexico and Rencontres de la Photographie in Arles, which brought her into contact with an international artistic network. In 1985, the publication of the photobook *Sandra Eleta: Portobelo, fotografía de Panamá* reaffirmed her position among contemporary Latin American photographers. **MEK**

Abigail Heyman, *Abortion*, 1974

'I am so conditioned not to fight.' This sentence is one of the pithy comments sprinkled throughout Abigail Heyman's autobiographical manifesto, *Growing Up Female: A Personal Photo-Journal*, published in 1974. The book places images and texts side by side as a means of interrogating the norms and codes that govern the lives of women in American society. An avowed feminist, Heyman's stark, uncompromising work disproves this assertion, her 'photo-text' forming a kind of battle cry. Espousing the famous claim that 'the personal is political', she focuses on private spaces, domestic tasks and intimacy between couples, placing questions that are often considered taboo centre stage and showing their scope and significance.

One of her photographs shows Heyman having an abortion: the doctor's silhouette appears between her splayed legs, which are violently illuminated by the surgical lamp, in a brutal display of the powerlessness of patients against medical institutions. The sentence that accompanies the image – 'Nothing ever made me feel more like a sex object than going through an abortion alone.' – questions this power dynamic in the context of feminist calls for women to be given control over their own bodies. Throughout the book, autobiography is interspersed with handwritten quotes from other women that embody the story.

Born in Connecticut, Abigail Heyman studied at Sarah Lawrence College in Bronxville, New York, then trained in photography with Ken Heyman (no relation) and Charles Harbutt in 1967. She became a freelance photographer and worked for various magazines and newspapers, having images published in *Life*, *Time* and the *New York Times*. In 1974, she joined Magnum Photos, and she became an associate in 1980, but left in 1981 to found another agency, Archive Pictures, with a group of former Magnum photographers that included

Harbutt and Joan Liftin. She also taught at the International Center of Photography in New York.

Her work is marked by consistent engagement with feminism, including her second book, *Butcher, Baker, Cabinetmaker: Photographs of Women at Work*, which she published in 1978 with the writer Wendy Saul. It was aimed at children and depicted women working in various professions, especially those that were traditionally seen as men's jobs, in order to show young girls that they could pursue any career.

Heyman continued to present her work in book form, publishing a collection of wedding photographs in 1987 as a pointed interrogation of the rituals of marriage ceremonies. She then edited a joint work that gathered family photographs from many professional photographers, continuing her interest in the private sphere. Heyman's work is a critique of the American female condition, at once intimate and political, which is now echoed in more modern feminist explorations. **CB²**

'I have disregarded women, as I disregarded myself. And I have changed. I have faced the conflicts inherent in growing up female, as I am now facing the conflicts in trying to change. This is where I come from; this is what I want to document.'

ABIGAIL HEYMAN

Graciela Iturbide's fascination with photography began at an early age; as a young child, she loved to flick through family photo albums, sometimes even stealing photographs. But it was not until much later, towards the end of the 1960s, that she turned her passion for photography into a career. While studying film at the Centro Universitario de Estudios Cinematográficos de Mexico, Iturbide met Manuel Álvarez Bravo, who became her mentor and friend, and awakened in her a desire to know her country better by exploring popular culture, which was still strongly influenced by the country's pre-Columbian heritage. Iturbide was very critical of the exoticization and idealization of Indigenous culture, and decided to work with different Indigenous communities on a more equal basis, producing portraits that speak to her collaborative relationship with her subjects.

Using the visual as a means of reflecting on divisions within a culturally diverse country became an important feature of her work. Conscious of the intrinsic ambivalence of photography – a medium that can equally be used to document exactly or to serve the imagination – Iturbide explicitly acknowledges her own subjectivity: first and foremost, her photographs are born from a shared experience. Sometimes her projects are short-term, such as the one that she created during her stay in the Sonora desert, while others develop over a longer period of time, such as the one focused on Juchitán, in the state of Oaxaca, which she worked on for more than ten years.

Iturbide's book *Juchitán of the Women*, published in 1989, a collection of photographs of the village and its inhabitants, marked a turning point in the renewal of the Mexican imagination and made her name on the international stage. Invited to Juchitán by the painter Francisco Toledo, who was part of the Zapotec community there, Iturbide became especially interested in the local people's fight for democracy and defence of their Indigenous culture, in which women played a decisive role. In her photographs, she portrayed them as strong, independent and politically aware individuals. By living alongside them and sharing their day-to-day lives, she formed a strong bond that allows those who view her photographs to enter into the world of a different, profoundly unique culture.

Her work testifies to the diversity of her interests: festivals and rituals, portraits and landscapes, stones, birds, wild plants in botanic gardens … in Mexico, but also in many other countries that she visited. Her photographs capture moments, places and encounters that resonate with her deepest obsessions – what she loves, but also what hurts her. For Iturbide, photography is always a pretext for getting to know her subject, for establishing contact with a part of reality that reveals itself only in the brilliant intensity of personal experience. That is how photography becomes synonymous with life. **MD**

'I've always thought that photography is a pretext for seeing the world.'

GRACIELA ITURBIDE

Graciela Iturbide, *Magnolia with Mirror*, Juchitán de Zaragoza, Oaxaca, Mexico, 1986

The photographic archives of Masha Ivashintsova, a Soviet Bohemian, were discovered in her attic by her daughter seventeen years after her death. Ivashintsova was a muse, a wife, a mother and a 'free spirit', both passionate about and wary of love and art. She studied theatre criticism in Leningrad and made a living doing a variety of odd jobs, working as a librarian, elevator mechanic and lightning-rod technician. She also wrote poetry, kept a diary and took photographs that she never exhibited.

Ivashintsova's fascination with photography was presumably sparked by her romantic involvement with Boris Smelov, a prominent Soviet photographer who promoted an aesthetic approach to photography (contrary to the officially disseminated idea that photojournalism was superior). Although, before the two met, she had occasionally taken photographs with her mother's camera, it was Smelov who lent her his Leica and Rolleiflex. They often walked together and took photographs as they went: Ivashintsova's image of the statue of Seneca in the Summer Garden (a public garden favoured by the Leningrad intelligentsia), for instance, mirrors one taken by Smelov. Following their separation, she gravitated towards a more spontaneous approach.

Although familiar with the cultural underground, Ivashintsova remained largely in the shadow of her artistic friends. Today, her photographic legacy – a mix of street photography, Bohemian portraits and insightful snapshots of everyday life – is becoming known to a wider public. A highly sensitive and appreciative observer, she took part in some of the most important underground art events in Leningrad: unnamed and previously unrecognized by researchers, she can be seen in old photographs visiting a famous exhibition of art photography, *Under the Parachute*, which took place in the apartment of the poet Viktor Krivulin in order to escape censorship. She documented an exhibition by Smelov just before censors closed it down, which reinforced her status as an outcast, a non-conformist artist.

Yet her own creativity was never appreciated. Overly critical of both her own artistic and technical skills, she was reluctant to share her work extensively with others and was thus never recognized as an artist. In 1981, having suffered from severe depression for years, Ivashintsova was sent to a psychiatric hospital where she remained for a decade. She continued photographing until her death in 2000. **DP**[1]

Masha Ivashintsova, *Zoo*, Leningrad, USSR, 1985

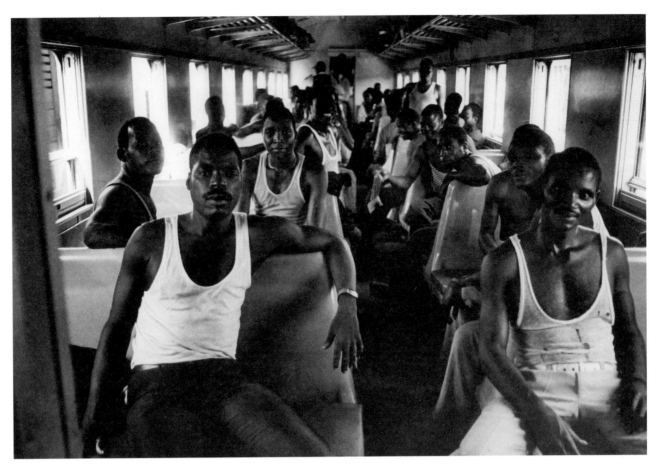

Moira Forjaz, *Mozambican migrant miners on their way to South Africa*, 1978

In 1961, Moira Forjaz began studying graphic art at the School of Arts and Design in Johannesburg, although her particular interest was photography. That same year, she sold the leather jacket that her father had bought her and used the money to buy her first camera – a Pentax.

The following year, Forjaz started training as a photojournalist alongside many other well-known South African photographers, including Sam Haskins. She joined the independent studio Tropix, founded by Jürgen Schadaberg, where she worked with David Goldblatt, among others. Her career as a photographer – like her personal life – was shaped by anti-colonial struggles. In the 1960s, she left South Africa when her friends Ruth First and Joe Slovo, who were both important figures in the fight against apartheid, went into exile. She and her future husband, the Portuguese architect José Forjaz, lived for some time between Portugal, the United States and Swaziland. The couple finally settled in Mozambique in 1975, with the aim of joining the revolution and trying to build a new, independent country.

Forjaz then dedicated herself to documenting the Liberation Front of Mozambique's (FRELIMO) struggle against the Portuguese colonial powers. The Forjazes were very close to Samora Machel, the leader of FRELIMO, who became the first president of an independent Mozambique in 1975: José was named National Director of Housing, while Moira worked for the international press agency, then the Ministry of Information and the National Institute of Cinema.

Forjaz was one of the founding members (and director) of the Mozambican Photography Association in Maputo. Between 1975 and 1985, she had a productive period as a photographer and film-maker. She directed the films *Mineiro Moçambicano* (The Mozambican miner, 1977), which was born out of research into the conditions in the mines in Mozambique conducted by Ruth First at the African Studies Centre, and *Um dia numa aldeia communal* (A day in a communal village, 1978), which focused on a utopian communal village in Maputo province and won first prize at the Anti-Fascist Film Festival in Leipzig in 1982. That same year, Forjaz published her first photography book, *Muhipiti*, which focused on the inhabitants of Mozambique's islands and the country's colonial architecture. In 2015, she published her second book, *Mozambique 1975/1985*, which gathered together photographs showing important moments in the country's history since independence, especially the struggle against apartheid and efforts to rebuild the country.

Towards the end of the 1980s, Forjaz moved to Lisbon, Portugal. In 1989, she founded the gallery Moira de Arte, which she continued to run until 2001. She is also an executive director of a music festival in Viana do Castelo (Portugal) and director of the Maputo International Music Festival (Mozambique). Since 2012, Moira Forjaz has lived in Muhipiti. In 2018, she published a book, *Islanders/Ilhéus*, that paid homage to the people of the island, with images showing the unique beauty of their daily life. It was the first book of hers to feature colour photographs taken with a Nikon digital camera. **JM²**

Pilar Aymerich's photographs are inextricably linked to key moments in Spanish history: the last years of the Franco regime and the country's first steps towards democracy, which began in 1975. As a photojournalist, Aymerich took pictures of the protests that sprang up throughout this era, but her work is also intimately connected to her own activism, campaigning for freedoms that were harshly suppressed under the dictatorship. Aymerich's aim was to bear witness to protests, especially the feminist movement – a cause that played an important role in both her activism and her artistic output.

Nowadays, Aymerich is recognized as a key figure whose work highlighted the pivotal role played by women and the importance of the feminist movement in Spain's transition to democracy. The feminist movement in which she was active fought to improve living conditions for workers, stood in solidarity with workers' strikes across different industries, joined forces with factory unions, but also took great risks in organizing illegal protests calling for the reform of unjust and discriminatory laws against, among others, adultery, divorce and homosexuality.

Aymerich trained at the Adrià Gual School of Dramatic Art, a hub of intellectual resistance under the dictatorship. But it was in London in 1965 that she first felt compelled to express herself through photography, and it was while staying with her uncle in Montrichard, Loir-et-Cher, France, that she refined her technique. On returning to Barcelona in 1968, she became a photojournalist for the most progressive magazines at the time, working closely with the writers Manuel Vázquez Montalbán and Montserrat Roig. Together, they reported on what was happening in the streets and tried to work out how to make sure their images would not be censored.

As well as reporting on news and the theatre world, with which she was always closely involved, Aymerich's other main interest was portraiture. She took photographs of artists and intellectuals who defended culture and human rights and fought against Francoism. As well as being published in newspapers and magazines, her work soon found a place in exhibitions, at a time when photography did not enjoy great recognition and legitimacy at an institutional level. Pilar Aymerich was one of the first Spanish photojournalists to have an exhibition of her work, at the Eude Gallery and Palau de Virreina in Barcelona in 1977, when it was still rare for Spanish art galleries to feature photography. **MD**

'Many of my photographs were commissions for magazines […] But many others, I went looking for them. […] I felt that if I didn't photograph something that had happened, it was as if it hadn't existed.'

PILAR AYMERICH

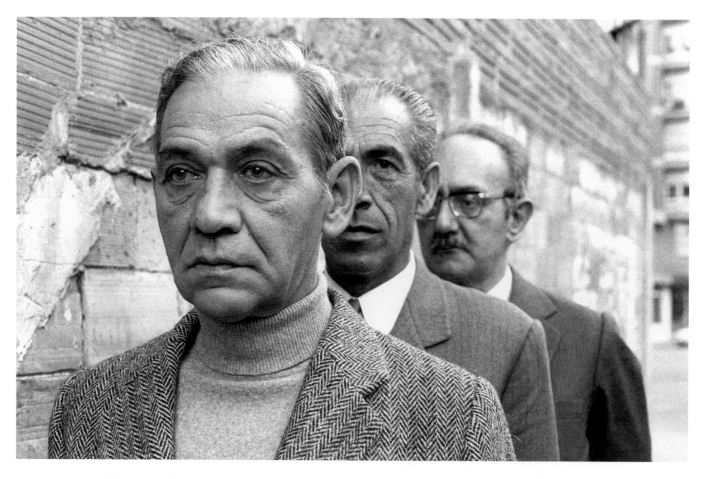

Pilar Aymerich, *Catalan survivors of the Mauthausen Nazi camp: Ferran Planas, Joan Pagès and Joaquim Amat-Piniella*, 1972

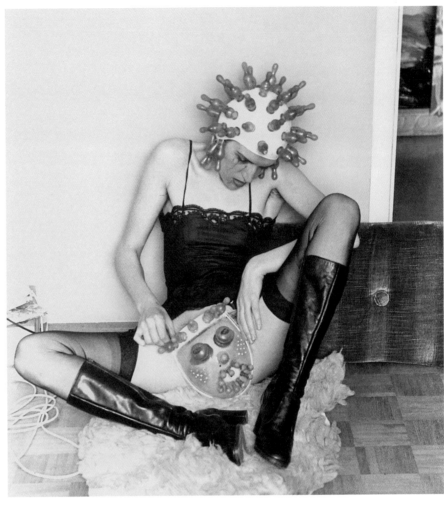

'AMO ERGO SUM'

RENATE BERTLMANN

Renate Bertlmann, *Tender Pantomime*, 1976

Renate Bertlmann was fourteen years old when her uncle gave her her first camera and started helping her to develop the negatives. In 1969, she began her first artistic photography project: using a timer, she took a series of self-portraits wearing different clothes and hairstyles, which she called 'Metamorphoses'.

Since then, photography has played a part in her diverse artistic output, which also includes drawings, latex objects, installations, videos and performances. After reading Linda Nochlin's groundbreaking essay 'Why Have There Been No Great Women Artists?', published in 1971, Bertlmann – like many of her contemporaries – began to appreciate how women had been shut out of the art world due to patriarchal structures. She started to get involved with feminist movements and wrote the pamphlet 'Why Doesn't She Paint Flowers?', in which she argued that creativity, artistic drive and genius are seen as the preserve of men, whereas female creativity is not taken seriously, and is even mocked.

In her art, Bertlmann creates an entire *kósmos* (from the ancient Greek for 'order of the universe'). Her motto is '*Amo ergo sum*' ('I love, therefore I am') – a counter-proposition to René Descartes's logic-driven '*Cogito ergo sum*' (I think, therefore I am), which portrayed thought as the ultimate confirmation of selfhood. For Bertlmann, however, 'living love' proves to be the decisive existential experience. Her art is critical of the Church's troubled relationship with the body, the aggressive treatment of women in pornography and the

restrictions on women's sensual experience. She explores the interconnectedness of body, soul and spirit, which form an indivisible whole. In one interview, she said her work 'Amo ergo sum' can be interpreted according to three main themes: 'Pornography addresses the "war of the sexes", with its "victims and perpetrators." Irony traces longings and aggressions back to their roots in childhood, and tries to come to terms with the sensations of pleasure and disgust that emerge. Utopia is not about visions of the future. Instead, it confronts the unknown, with asceticism, denial and practices of death.'

Bertlmann uses her rebellious spirit to interrogate repressed sexuality. She returns again and again to her obsession with the human body, including its most intimate parts. In the series 'Tender Touches' (1976), two blown-up condoms draw close, brush against each other and penetrate one another. Bertlmann uses her art to explore repressed desires, as seen in the latex nipples in *Caress*, part of her installation 'Washing Day' (1976). She uses the penis as a symbol of oppression. In 1980, she created *The Firstborn*, a baby-phallus made of latex, wearing a wrinkled hood and a lace dress with a blue bow – an object imbued with irony but also a certain tenderness. Sensuality and tenderness are often combined with coldness and aggression, as in *Knife-Pacifier-Hands* (1981). There is a simultaneous attraction and repulsion, acceptance and protest, anger and tenderness at play in her work, which explores the ambivalence of our feelings. **GS**

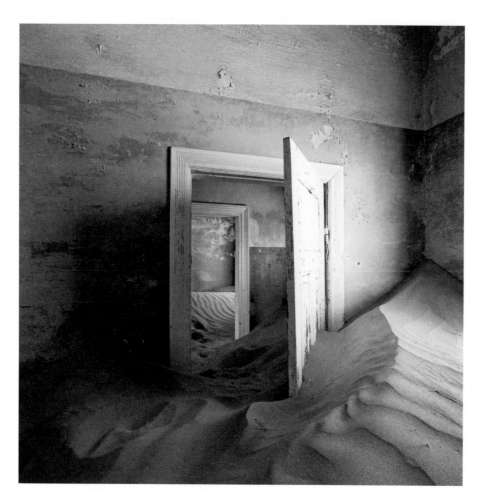

Helga Kohl, *Family Accommodation*, from the series 'Kolmanskop', Namibia, 1994

Born in Silesia, Poland, Helga Kohl is a Namibian photographer. In 1958, her parents emigrated to West Germany, where she went on to study photography, gaining her degree in 1967 from the Münster Chamber of Trade. In 1970, she moved to Windhoek in Namibia, and five years later started working as a freelance photographer. Although her main focus is architecture, she also takes documentary photographs showing the daily life of the Indigenous San people. Kohl also takes a great interest in the work of Namibian artists for the National Gallery of Namibia. On an international level, she is best known for her personal work on the ruins of mining sites from Namibia's colonial period.

In the middle of a sandstorm in 1971, she discovered the ghost town of Kolmanskop, which had been an active mining town between 1908 and 1948 but was abandoned to the sands of the Namib desert in 1954. Since that day, as she told the *New Internationalist* in June 2007, 'I returned many times over the years and carefully scrutinized each house, I examined every corner and noted every hole in every roof and wall. Much of my time was spent simply watching the shifting of the dunes in the rooms […] It was in these moments of solitude that I transformed myself into the past, and in so doing saw a life which somehow brought a profound understanding of the present.'

Throughout the 1990s, Kohl was featured in numerous exhibitions across southern Africa, notably exhibiting at many Standard Bank Namibia Biennales, where she also won first prize in 2001. 'Kolmanskop' – now in the permanent collections of the National Archives of Namibia and the National Museum of Mali – remains her best-known series, since it was featured at the Bamako Encounters – African Biennale of Photography in 2005.

> 'One day I knew I was ready to capture the beauty once created by people and taken over by nature.'
>
> **HELGA KOHL**

Ten years later, Kohl returned to Bamako for the 2015 anniversary edition of the biennale, under the artistic direction of the Nigerian curator and art critic Bisi Silva. She exhibited her black-and-white series 'Elizabeth Bay' (1997), which featured another abandoned diamond mine. Afterwards, she had many exhibitions across Africa, Europe and the United States. In 2013–14, she took part in the exhibition *Earth Matters: Land as Material and Metaphor in the Arts of Africa* at the Smithsonian National Museum of African Art in Washington, DC, and in 2019 her work entered the museum's permanent collection after the exhibition *I am … Contemporary Women Artists of Africa*.

Having used a medium-format camera throughout her career, Helga Kohl pays close attention to space, colour and light in the composition of her images. She has won multiple awards, including, in 1993, the President's Award (South Africa) and, in 1998, the Mbapira Award, for her reference work *Art in Namibia*. She was also made a Fellow in Art Photography (in 1998) and Architectural Photography (in 2004) by the Professional Photographers in Southern Africa (PPSA). **EN**

'I am taken by wonky plugs, odd-sized vents, crooked walls, mutant lamps, chatting chairs…. There has to be something a bit off, a bit out-of-whack, cockeyed, for me to take notice.'

LYNNE COHEN

In her award-winning photographic practice, Lynne Cohen was rigorous, consistent, true to herself. For more than four decades, she photographed interiors – both private and public spaces – from a self-consciously neutral viewpoint. Her early images featured living rooms, men's clubs, banquet halls, lobbies and beauty salons; in the mid-1980s, she turned to institutional spaces such as laboratories, classrooms, military sites, spas and conference centres. Cohen's photography invites reflection on the built environments in which people live and work – on how these places affect bodies, and vice versa. Invariably devoid of any human presence, her images nonetheless contain traces of humanity in the form of mannequins, dummies, silhouettes or chairs.

Although sometimes associated with the photographers in the landmark *New Topographics* exhibition (1975–6), Cohen insisted that she did not create inventories but was simply interested, consistently, in certain types of space, just as a painter might return repeatedly to the same subject over the course of a career. Her art training in the late 1960s, especially in sculpture and print-making, would have a lasting impact on her work and on her perception of the sites that she chose to photograph. Early influences were the conceptual and Pop art practices of artists such as Marcel Duchamp, Richard Hamilton, Richard Artschwager and Claes Oldenburg, but also the utilitarian commercial imagery of which they made such prolific use. Cohen saw the spaces she selected as ready-mades, 'found installations' excised from the world through the photographic medium. Exploiting the strategies and tactics of documentary photography, she used a large-format view camera, first in black and white and later also in colour, positioned usually at some remove from the scene and providing a high level of uniform detail. She did not alter the lighting or otherwise manipulate the scene, preferring to capture spaces as she found them.

Cohen wrote persuasively about her photographs (her texts appear in several monographs and exhibition catalogues) but refused to dictate their meaning, opting instead to leave clues in her pictures that would allow viewers to imagine a possible narrative. These hints, always present but also alluded to directly in the titles of later works, point to elements of the scene – the architecture, a particular object, the lighting – that seem strange or eerily at odds with the whole, details that elicit laughter or disbelief. While not denying that her work often possessed a political or social twist, Cohen also saw it as imbued with a particular kind of humour, 'closer in spirit to Jacques Tati than to Michel Foucault'. **ZT**

Lynne Cohen, *Untitled [Red door]*, 2007

In 1966, Paz Errázuriz began studying to be a schoolteacher at the Cambridge Institute of Education in England, then at the Catholic University of Chile, where she earned her degree in 1972. Throughout this time, she was also teaching herself photography. In 1973, when Augusto Pinochet seized power after the 11 September coup, Errázuriz lost her job as a teacher and turned to photography as a means of political resistance.

Conscious of the need to record what was happening around her, to bear witness to and denounce the military government's repression, Errázuriz began her photography career. She co-founded the Association of Independent Photographers (AFI), which aimed to promote and defend the work of its members, knowing that they were unable to rely on the established institutions to do so. While documenting daily life around her, Errázuriz also started to develop her own artistic eye, which she trained on more intimate subjects and which would earn her national and international recognition.

Her photographs, usually in black and white, are shaped by her political beliefs and social conscience. She uses her portraits to draw attention to those who have been marginalized by modern society. Her series focus on people who are ignored or excluded from official discourse: people who sleep on the streets in 'Dormidos' (The sleepers, 1979–80), circus performers in 'Circo' (Circus, 1984), boxers in 'Boxeadores' (Boxers, 1987), transvestites in 'La manzana de Adán' (Adam's apple, 1987), older people, blind people, fighters in 'Luchadores del Ring' (Ring fighters, 1988–91), prostitutes, and people with mental illnesses in 'El infarto del alma' (Heart attack of the soul, 1994).

Errázuriz allies herself with individuals on the margins of society, signing a kind of pact of silence with them. Creating each of her series is a lengthy process, not because taking the photographs themselves requires a great deal of time, but because she allows a lot of time to prepare and ensure that she is approaching the subject of her portrait in a sensitive way. Taking time to get to know someone allows her to understand the specificity of each person's reality. Her pictures do not make use of forced poses or staged scenes; instead they rely on a bond and trust between photographer and subject.

In returning again and again to the subject of outcasts in different areas of society, Paz Errázuriz interrogates the concepts of power and beauty, destabilizing the established norms. In her own words, her work is a 'permanent self-portrait', a way of seeking her own identity; it is also an important body of work in the history of Chilean photography. **AA²**

'I am always trying to construct my own self-portrait, to find myself in the people I photograph, to claim something for myself. Holding up a mirror, with the camera as my greatest ally, always leads me to a simultaneous identification and division.'

PAZ ERRÁZURIZ

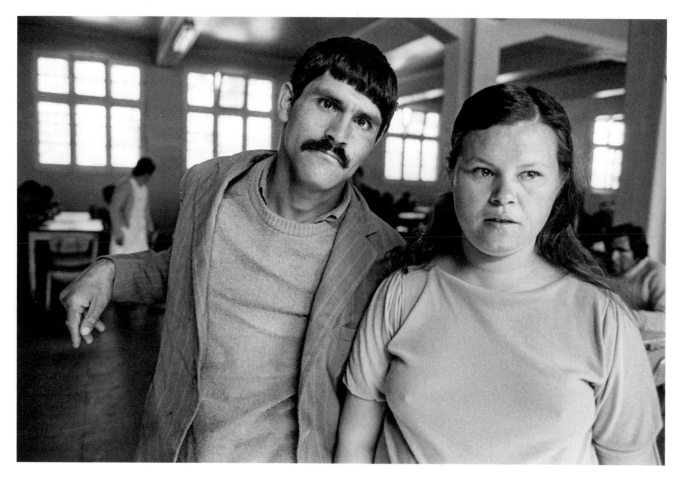

Paz Errázuriz, *Infarto 23* (Heart attack 23), from the series 'El infarto del alma' (Heart attack of the soul, 1994), Putaendo, Chile, 1992

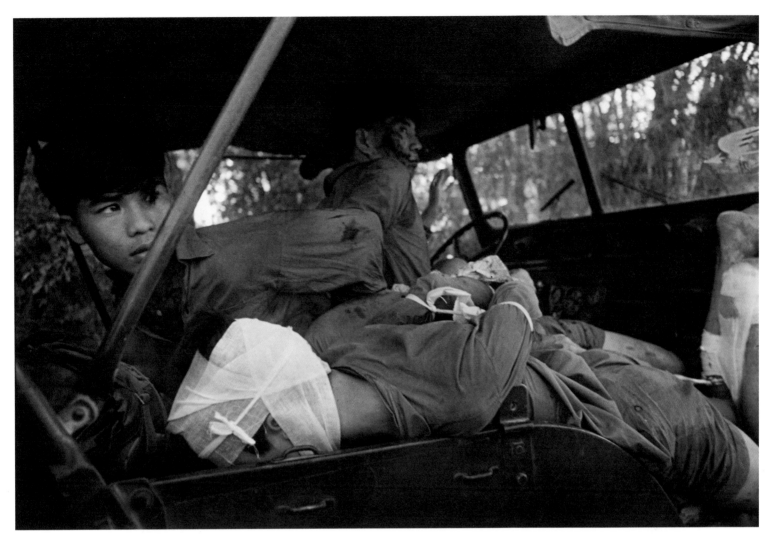

Catherine Leroy, *Vietnam War, arresting two North Vietnamese suspects during the Tet offensive*, Hue, February 1968

The Vietnam War was the setting where many iconic figures in the history of photojournalism made their name. Catherine Leroy, the first French woman authorized by the Americans to cover the conflict, produced her fair share of the most powerful images, searing photographs of a war that lasted twenty years. She was twenty-one years old when, with a Leica in her pocket, she first set foot on Vietnamese soil. Self-taught, like many photojournalists of her era, she was drawn to Vietnam by a yearning for independence as much as a desire to cover the war.

The conflict had already dragged on for around ten years and claimed many victims. The American war correspondent Dickey Chapelle had died in bombing a few months before her French counterpart arrived. It was dangerous ground. Leroy immersed herself in the chaos and bore witness to American soldiers' life on the front lines. This conflict was the photographer's first experience of war, a subject that would remain central to her work until her death from cancer at sixty-one years old. She went on to cover all the major conflicts of the late twentieth century, most notably the civil war in Lebanon. In 1976, she became the first woman to win the Robert Capa Gold Medal, for her work documenting that conflict.

Leroy immersed herself in the masculine world of battle, making sure she was at the heart of the fighting, close to the individuals affected. In her famous series 'Vernon Wike by the side of a mortally injured marine on Hill 881, April–May 1967', she revealed the vulnerability of men in the chaos of battle. In 2005, she photographed the same former medic, Vernon Wike, back home, creating images that sensitively bear witness to those dark years.

'Watching people die means watching yourself die.'

CATHERINE LEROY

The three years that Leroy spent in Vietnam left an indelible mark on her. She had an iron will and the courage to face whatever was thrown at her. At twenty-two years old, she was the only photographer to parachute in with American soldiers as part of Operation Junction City. Shortly afterwards, in May 1967, during the battle of Hill 881, she was seriously injured during an operation in the demilitarized zone. The following year she was taken prisoner along with the French journalist François Mazure, a correspondent for France-Presse. During their brief period of captivity, she wrote an exclusive report on the North Vietnamese, providing both text and photographs. It made the cover of *Life* magazine on 16 February 1968.

Her work is notable for its humanity, a trait that is especially evident in the documentary *Operation Last Patrol*, which she co-directed. The film followed the anti-war activist Ron Kovic, who was paralysed while serving in Vietnam, and his veterans' association as they travelled to Miami, Florida, in 1972 to protest against the war at the Republican Party convention. Bearing witness to the litany of atrocities that accompany war, Catherine Leroy's work reveals the fear, exhaustion and incomprehension on the faces of those caught up in this absurd human creation. **LG**

'After I was taken prisoner in Beirut in 1982
by Al-Mourabitoun fighters, I returned to Madrid,
the city of my childhood, and decided that,
for every photograph I took of mourning,
I would create an image of beauty.'

CHRISTINE SPENGLER

In *The Opera of the World, after the bombing of Phnom Penh, Cambodia, April 1975* (1990), a heavy red-and-gold curtain opens on a theatre of war as the scene plays out before our eyes. In 1975, the Khmer Rouge bombed Phnom Penh, ten days before they took power in Cambodia. Christine Spengler was there, bearing witness to one of the many conflicts of the Cold War. Fifteen years later, she revisited this Dantean image, drawing inspiration from Goya's *Black Paintings* in the Prado, and framed it in plush velvet, paying homage to the victims of this battlefield. Death has been a common thread in Spengler's photographic work, while her faith helped her to face it without fear. There are two forces at work in her photographs: one that compels the viewer to confront the horror, and the other that asserts its claim to life. On the one hand, she is a war reporter, while on the other, she is an artist.

Born around the end of the Second World War, Spengler was one of the three major female French war correspondents of the late twentieth century, alongside Catherine Leroy and Françoise de Mulder. In Chad, in 1970, at only twenty-five, she took a famous photograph of two Toubou fighters shaking hands. With a simple click of her camera, she captured the brotherly spirit between rebels. That same year, she travelled to the Tibesti region with her younger brother Éric for the funeral of their father, who had died in Alsace. Imprisoned by French legionnaires, she discovered her vocation as a war reporter. Over three decades, she photographed mourning rituals across the world: in Northern Ireland, Vietnam, Cambodia, Western Sahara, Lebanon, Iran, Nicaragua, Salvador, Kosovo, Afghanistan and Iraq. The framing and light in these pictures shape the faces and landscapes. Spengler does not shy away from grappling with the unfamiliar cultures that are not her own: she learned Arabic and wore a chador to get close to women during the Iranian Revolution in the 1970s. In the photographs that she took, their serious expressions seem to challenge the viewer and insist on the nobility of their presence. Like ghosts, the figures of two women walking between the rows of poles in the cemetery in Qom, Iran, hint at the horror of war without showing it explicitly.

'In Iran and throughout the Arab world, white lilies symbolize peace and hope, while the red carnations are the blood of the martyrs', Spengler explained. Metaphor plays an important role in her visual language. Behind the dark war correspondent hides an artist who celebrates life and colour. Product of the daughter of Huguette Spengler, the 'last of the Surrealists' and muse of Jean Cocteau, Christine's work is also populated by the religious images that permeate Spanish culture. The timeless virgins, the colourful demi-gods, worthy of the post-Francoist works of the Movida movement, all embody hope and peace in the kaleidoscope of flamboyant colours that Spengler avoided during the war years. **LG**

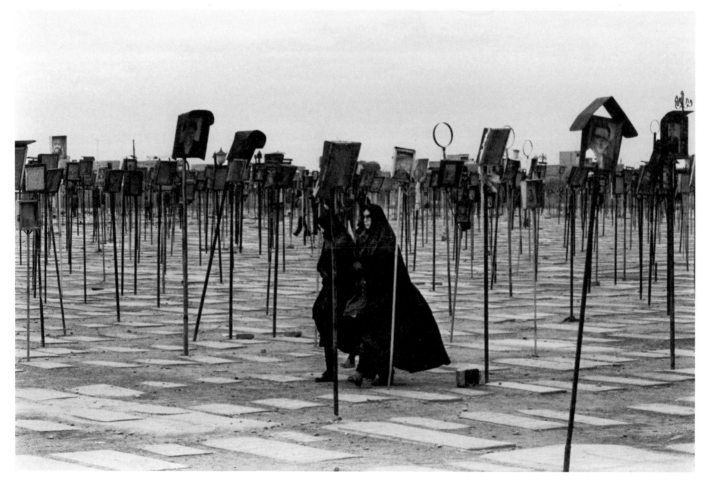

Christine Spengler, *Cemetery of the Martyrs of Qom*, Iran, 31 March 1979

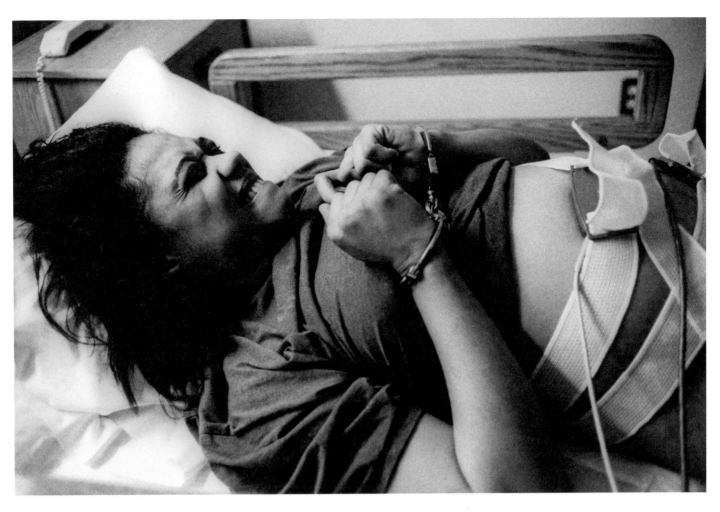

Jane Evelyn Atwood, *Handcuffed, pregnant inmate writhes in pain during a gynecological examination, moments before she gave birth by caesarean. Two armed guards were posted outside the open door to her hospital room. Providence City Hospital, Anchorage, Alaska, USA*, from the series 'Too Much Time: Women in Prison', 1993

Born in New York, Jane Evelyn Atwood has lived in France since 1971. She underwent psychoanalysis in Paris and said that, over the course of a few years, this released her creativity and led her, almost by accident, to photography. Up until that point, her only encounter with the medium was a Diane Arbus exhibition that had made a lasting impression through its strangeness. She began her career quite spontaneously, taking photographs of prostitutes on the Rue des Lombards in 1976. The traits that would come to characterize her work were already clear: she was not intimidated by technical aspects (her friend and model Blondine waited patiently as the 'beginner' adjusted the focus), but she was instinctively drawn to unknown worlds and had an almost scientific curiosity about closed environments. After photographing prostitutes on the streets, Atwood spent a year with trans people in Pigalle, then ten years on and off in a centre for blind children.

For Atwood, the experience of photography always stretches over a long period of time, and her perseverance is legendary. What other photographer could have spent ten years in women's prisons across the world? In forty jails and penitentiaries in nine countries, including Russia and the United States, where she spent time with inmates on death row? The photographs and stories that she gathered there formed the basis of a stage play in 2019.

Atwood accumulates iconic images, often featuring bodies, usually suffering, or a hidden beauty where we least expect it. The strength of her work lies in a nuanced understanding of body language. Bodies talk, whether alone or interacting with others – she captures gestures of love, friendship or despair,

the hesitation of blind children, the provocative poses of transsexuals, the skin lesions that presaged death for Jean-Louis (the first official 'face' of AIDS in Europe; the photographer spent time with him during his last months and her photographs of him were published by *Paris Match* from 1987), the camaraderie of legionnaires and firefighters, bodies mutilated by anti-personnel mines.

Atwood's ability to gain her subjects' trust and her unaffected style allow her to push her work further and create a true intimacy. She understands just how much space to allow each individual. Knowing where her place is, having a feel for what is going on, anticipating danger or sensing the kind of photograph that could emerge – all of that requires a strong understanding of human relationships, which we could also call empathy. For Atwood, photography is a moral pursuit and she is a 'witness', acutely aware of the privilege of being accepted by people from whom society, by and large, has turned away. She has published thirteen books and been awarded all the most prestigious international prizes, including the W. Eugene Smith Award in 1980. **MR**[1]

'A young photographer cannot "decide" to work a certain way so as to be taken seriously. A photographer must have something to say!'

JANE EVELYN ATWOOD

On the international photography scene, Suzy Lake is best known for her work on femininity and, recently, on ageing female bodies. Since the early days of her career in the 1970s, she has concentrated on her own body and used it to stage performances that she immortalizes with photography. Her works are born of a commitment to questioning the boundaries of photography as a medium.

Lake uses a wide range of formats and techniques – black and white or colour printing, distortion, collage, painted highlights, handmade frames and light boxes – in her experiments in combining the visual and plastic arts. In 'Choreographed Puppets' (1976), the artist is suspended in a harness, hanging from a wooden structure that was specially built for the performance. Lake's feet do not touch the floor, and two fellow performers lying on top of the frame manipulate her body like a puppet. The black-and-white photographs taken during the performance capture the whole apparatus and show the artist's limp body forced to follow the movements imposed by the harness's straps. In this immersive installation, Lake combines performance and photography to force viewers to think about control and resistance in relation to female bodies.

In 'Forever Young' (2000) and 'Beauty at a Proper Distance' (2001–2), the artist created two series of bold self-portraits that show the ageing of the female body. The first shows Lake wearing clothes, jewelry and make-up generally considered inappropriate for a woman of her age: a garish crop top, skin-tight leopard-print leggings, platform shoes, red lipstick, etc. Brandishing a microphone and a guitar, she adopts the exaggerated persona of an American pop singer, whom she calls Suzy Spice, as a way of flouting the social expectations imposed on women that control how they present themselves.

In 'Beauty at a Proper Distance', a series of three large-scale colour photographs, Lake brings her confidence and sense of humour to the fore, refusing to conform to society's expectations of a woman of her age. The triptych of close-up photographs focuses on the lower half of her face, showing the artist singing and forcing the viewer to confront in great detail the signs of ageing: the hairs on her chin, her yellowed teeth or the wrinkles around her mouth. Focusing on these signs of the passing of time, which women usually try to conceal, challenges traditional ideas of beauty, claiming a place to celebrate maturity without a filter. **GM²**

> 'I can do anything Britney Spears can do.'
>
> **SUZY LAKE**

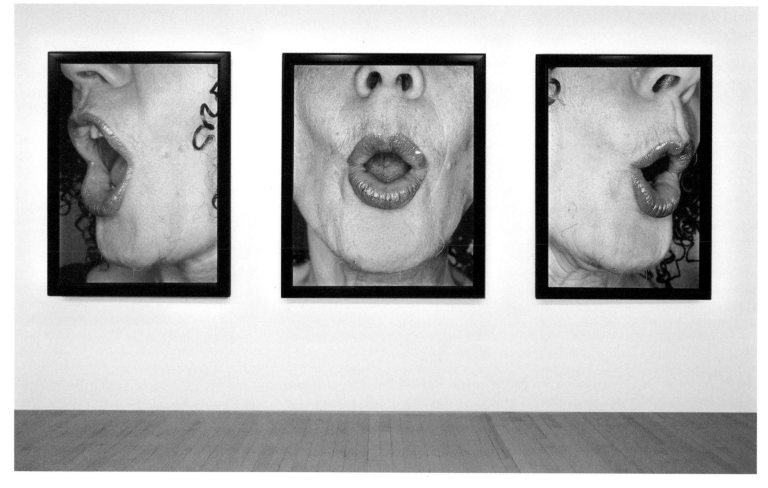

Suzy Lake, *Beauty at a Proper Distance / In Song #4*, c. 2001–2

338

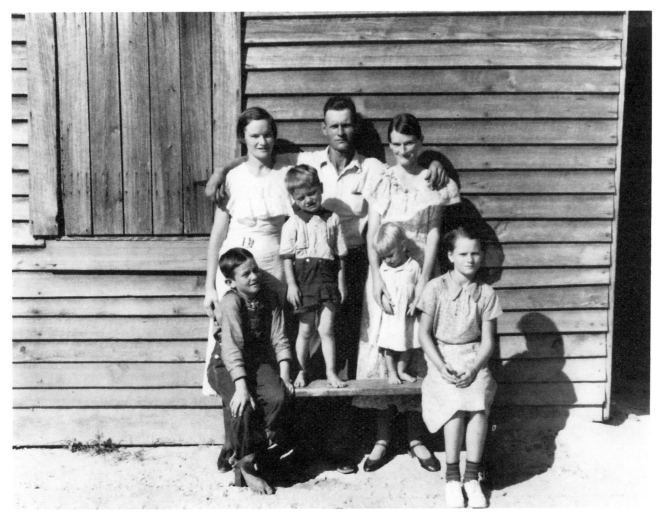

Sherrie Levine, *After Walker Evans: 2 [Burroughs Family Portrait]*, 1981

'What does it mean to own something, and, stranger still, what does it mean to own an image?'

SHERRIE LEVINE

In 1980, Sherrie Levine took photographs of six images by Edward Weston that she found on a poster advertising the publication of the portfolio *Six Nudes of Neil* (1925) by the Witkin Gallery in 1977. In an essay entitled 'The Photographic Activity of Postmodernism', the critic Douglas Crimp recounts how a friend of Levine's, seeing these photographs of photographs (which Levine claimed as her own work), remarked that they only made him curious to see the originals. 'Of course,' she replied, 'and the originals make you want to see that little boy, but when you see the boy, the art is gone.' Levine's career has been a long exploration of the ever-receding indexicality of photographs, and of copies in general. Each new body of work offers an incisive comment on originality, ownership and property.

Born in Pennsylvania in 1947, Levine grew up in a suburb of St Louis. In the late 1960s and early 1970s, she pursued both her bachelor and master of fine arts degrees at the University of Wisconsin at Madison. Although magazines of the time blindly asserted that the art world was blossoming on the far coasts of New York and, to a lesser extent, Los Angeles, the Midwest of the United States had its own radical thrust, and Levine, who studied photographic printing, immersed herself in both the philosophy of the Frankfurt School and the films of the French New Wave. She moved to New York in 1975, and two years later took part in the *Pictures* exhibition organized by Crimp at Artists Space, thus situating firmly her within what became known as the 'Pictures Generation', the era's wry retort to a media-saturated cultural climate. It was a time when anything was possible in art, and yet, to a young artist of the 1970s, it looked as if everything had already been done. Sherrie Levine therefore blasted forward with something new by appropriating imagery that was not hers, photographing reproductions found in books, magazines and other publications; her most famous series is 'After Walker Evans 1–22'.

Since the 1980s, her work has included sculpture and painting, notably replicas of artworks by Duchamp, Brancusi and Renoir, among others. Using various levels of direct quotation and different media, Levine continues to question the notion of originality, encouraging the viewer never to take the meaning inherent in an object for granted and, in her own words, 'perpetually dispatching you toward interpretation, urging you beyond dogmatism, beyond doctrine, beyond ideology, beyond authority'. **SBG**

Ishiuchi Miyako

b. 1947, Japan

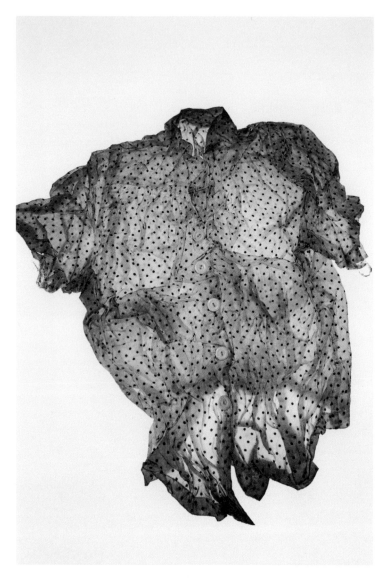

Ishiuchi Miyako, ひろしま/*hiroshima#69*, 2007. Donor: Abe, H.

'I'm interested in the way that time records itself into things and people.'

ISHIUCHI MIYAKO

Having taken up photography at the age of twenty-eight, Ishiuchi Miyako revisited her hometown, Yokosuka, in 1976, recording the town and American naval base with a handheld camera. The Yokosuka that appears in her grainy silver-gelatin prints is closely related to her childhood; one of the best-known works from the series – a dynamic, dark photograph of a young girl walking towards Ishiuchi – can be interpreted as a self-portrait. Entitled 'Yokosuka Story', this series would mark the beginning of a career that has spanned more than forty years and led to Ishiuchi winning the Hasselblad Award in 2014.

Ishiuchi's oeuvre can be divided into three main periods. The first consists of 'Yokosuka Story' (1976–7), 'Apartment' (1977–8) and 'Endless Night' (1978–80), a black-and-white trilogy in which the facades of old buildings, dark apartments bearing visible traces of their countless inhabitants, and spaces in former nightclubs all convey a strong sense of transience. 'I took photographs as a way of revisiting my old memories', the artist has said. Her second period, which began with the series '1·9·4·7' (1988–9), in which Ishiuchi photographed the hands and feet of women who were born in the same year as her, focuses on the human body and reveals skin textures and scars in extreme detail. The series 'Mother's' (2000–5), which represented Japan at the Venice Biennale

in 2005, marks the beginning of her third phase. Since then, Ishiuchi has worked mostly with colour photography. She has aimed her camera at fabrics and personal objects, often photographing belongings left behind by the deceased, including her own mother. A major project on which she has worked since 2007 is 'hiroshima', which features clothes, shoes and other objects formerly belonging to victims of the bombing of Hiroshima on 6 August 1945 and now kept in the Hiroshima Peace Memorial Museum. Ishiuchi 'portrays' them in close-up without showing the museum context. Sometimes she shoots them on a light box, thus producing an impression of translucency and perpetual lightness and evoking the ghostly *memento mori* aesthetic. The series typifies the power of Ishiuchi's work: it calmly seduces the viewer by expressing the unique beauty of the ephemeral.

Ishiuchi has addressed multiple themes and subjects, ranging from deserted bordellos and an elderly dancer's body to the personal belongings of Frida Kahlo. However, there is one thread that has remained consistent throughout: the visible effects of time and decay, intertwined with human memories. Ishiuchi's poetic photography speaks of people, mortality and bittersweet remembrance. **LF**

Nancy Burson was one of the first artists to use computer software in photography, recreating it into digital portraits through her collaboration with Massachusetts Institute of Technology (MIT) in the mid-1970s. As one of the pioneers of 'morphing' technologies, she generated composite portraits into new faces that were virtual, fictional and timeless. She also used similar software to artificially age or de-age faces for the 'Age Machine', changed people's ethnicities in the 'Human Race Machine', combined the faces of politicians, and created new animal hybrids such as Lion/Lamb for the benefit of world peace. Burson's revolutionary work sits somewhere between poetry, science and science fiction. She used it to question the idea of classifying humans, starting with races and genders, and to warn us of the dangers of imposing rigid, arbitrary categories of identity. These fuzzy, disturbing black-and-white images shake up the rules of photographic portraits and undermine the supposed truthfulness of the medium.

As well as their artistic value, Burson's photographs also made an important contribution to society. In the 1970s, the FBI used her artificial ageing techniques to create photographs of missing children, so that people would be able to recognize them years after their disappearance. Burson is also well known for the political nature of her work: one of her most famous portraits, *Big Brother* (1983) – a composite of the faces of Hitler, Stalin, Khomeini, Mao and Mussolini – was a commission from the American TV channel CBS for a news special called '1984 Revisited', in homage to George Orwell's novel. More

> 'I wanted to find a way of making invisible things visible.'
>
> **NANCY BURSON**

recently, her composite portrait of Vladimir Putin and Donald Trump, which was on the cover of *Time* magazine's 20 July 2018 issue, also got people talking.

Her portrait *Androgyny (6 Men + 6 Women)* (1982) was featured in the book *100 Photographs: The Most Influential Images of All Time*, published by *Time* in 2016, accompanied by these words from the editors: 'Photography is a perfect medium for recording the past. But until Nancy Burson's *Androgyny*, it was useless for predicting the future.' It is indeed the future, and more generally the 'uncapturable', that interests Burson, and this has also led her to create a photographic study of the paranormal. Like a scientist, she documents personal experiences, from hazes of light to the appearance of a glowing Virgin Mary dancing in the dark. Through this systematic documentary approach, she has created images that are imbued with a rare beauty. Just like the composite portraits, their metaphysical nature poses new questions. From morphing to photographic proofs of the invisible, supernatural realm, Burson is both a photographer of speculative reality and a visionary artist. **PV**

Nancy Burson, *Big Brother*, 1983

Deborah Willis is an artist, author and curator whose pioneering research sheds light on the legacy of Black photography. Willis's father, an amateur photographer, was a notable early influence, but she was also inspired to become an artist after reading *The Sweet Flypaper of Life* (1955), an iconic collaboration between photographer Roy DeCarava and poet Langston Hughes that recorded Harlem life in the 1950s. In DeCarava's elegant images, Willis recognized how photography can resist dominant notions of racial inferiority while also representing the complexity and range of Black lives.

These challenges have stimulated and shaped Willis's practice since the late 1970s. Her photographs are profoundly self-expressive and explore themes of blackness, gender and identity centred on the complicated notion of beauty. Her ongoing work is testament to the important role that photography has played in communicating the positive aspects of African-American society. Willis has also demonstrated her dedication to and passion for photography as curator of numerous exhibitions, such as *Posing Beauty: African American Images from the 1890s to the Present* (Newark Museum, New Jersey, 2009), *Out [o] Fashion Photography: Embracing Beauty* (Henry Art Gallery, Washington, DC, 2013), *Went Looking for Beauty: Refashioning Self* (African American Museum, Philadelphia, 2018), and *Migrations and Meaning(s) in Art* (Maryland Institute of Art, Baltimore, 2020).

'The photograph has historically served as a powerful mirror in the African American community, reflecting the achievements and triumphs … all too often erased from the culture at large.'

DEBORAH WILLIS

Willis holds a BFA degree in photography from Philadelphia College of Art (1975); an MFA in photography from the Pratt Institute, New York (1979); an MA in art history from City College of New York (1986); and a PhD from the Cultural Studies Program of George Mason University, Fairfax, Virginia (2001). In 2000, she was awarded an esteemed MacArthur Fellowship. She is the author of more than twenty publications, including *Black Photographers, 1840–1940: An Illustrated Bio-bibliography* (1985); *Reflections in Black: A History of Black Photographers, 1840 to the Present* (2000); and, with Carla Williams, *The Black Female Body: A Photographic History* (2002). She is currently Chair of the Department of Photography & Imagery at the Tisch School of the Arts, New York University. **JC**

Deborah Willis, *Carrie at Euro Salon*, Eatonville, Florida, 2009

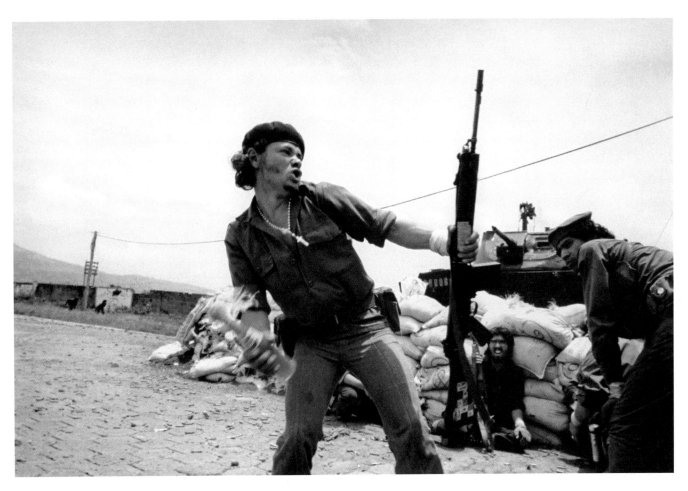

Susan Meiselas, *Molotov Man*, from the series 'Nicaragua', *c.*1978–9

Susan Meiselas's most important contribution to contemporary photography is undoubtedly the way she understood that every image belongs to a specific biographical, social, historical and political context. Every photograph has a creator, every gesture has a body, every body has a desire. For Meiselas, every image is made up of a multitude of subjectivities, which, like the life of each individual person, demand that we pay attention.

One of Meiselas's main interests is how an image's meaning changes when it is viewed in different contexts. That is why she gets to know the subjects of her photographs and allows them to be part of the process of creating their own narratives, which span different times and places. Her series focus on a wide range of themes, from military conflicts ('Nicaragua', 1978–9, and 'Kurdistan', 1991–2007, for example) to the sex industry ('Carnival Strippers', 1972–5, and 'Pandora's Box', 1991) and abuse of women ('A Room of Their Own', 2015).

One of her best-known projects is the series of photographs that she took in Nicaragua between 1978 and 1979, following the popular uprising that ousted dictator Anastasio Somoza. These images were seen around the world and became iconic representations of the conflict; they go beyond silently bearing witness. Meiselas spent thirty years identifying and tracking down the people she photographed for the project, trying to find out each of their individual stories, both past and present. Her film *Pictures from a Revolution* (1991) charts this research, while her project 'Mediations' (1978–2009), ana-lysed the contexts in which her images have been published and how they were used by mass media.

Meiselas's work embodies how individual and collective knowledge are shared, through the very act of bearing witness. Her ambitious project on Kurdistan, which she worked on for eighteen years (1991–2007), brings together photo-graphs, videos, cards, oral testimony and archive material – family albums, historical photographs and individual accounts from Kurdish communities in exile – which give a greater meaning and context to her photographs that show Kurdish mass graves being exhumed in Iraq in 1991.

Meiselas's work questions the role of photographer, who is often seen as the only narrator and witness to what is happening in front of their lens. In showing how stories are shared, the photographer creates a dense network of gestures, images, personal stories and meanings, which only deepens as she grapples with the complexity of recounting other people's lived experiences. In 2019, Kering and the Rencontres d'Arles photography festival recognized Meiselas's exceptional career by presenting her with the *Women In Motion* Award. **MG¹**

'Each image is a mysterious part of something not yet revealed.'

SUSAN MEISELAS

Cristina García Rodero, *Penitent kneeling in front of the Virgin of Fatima*, Portugal, undated

In September 2018, a museum celebrating the work of Cristina García Rodero opened in Puertollano, the mining town in Castilla where she was born in 1949. It is the only museum in Spain dedicated to a single photographer. How is it that such an unassuming, still living artist, better known for her books than for speaking out in public, has gained such recognition at an institutional level?

García Rodero defines herself not as a press photographer or a photojournalist, but as a documentary photographer. She prefers this term because it conveys the hybrid nature of her process, which is shaped as much by artistic culture as it is by a personal, intimate investment in her subjects. She studied painting at the School of Fine Arts at the University of Madrid and discovered photography in 1972. In the mid-1970s, she was one of very few people in Spain to pursue reportage photography. In contrast to the emphasis on physical art in the Movida movement, which exploded onto the scene around that time, she made a name for herself through her book *España occulta*, published in 1989. This first book, which won numerous prizes, including the W. Eugene Smith Award, established her approach: all her personal projects took a long time to create, as she immersed herself in her environment and got to know her subjects intimately. Unlike Eugene Smith – whose report 'Spanish Village', which appeared in *Life* in 1951, had a lasting impact on the photography scene both within Spain and internationally – García Rodero acknowledged and celebrated her own subjectivity, which allowed her to convey the strangeness of her subjects more effectively.

García Rodero sought out strangeness and distortion. Critics often praised her handling of religious subjects, seeing her work as a kind of ethnological pursuit. But it was not a question of science: whether her subject was pornography or mystical trances, beauty contests or mass pilgrimages, she never ceased to interrogate body language – capturing bodies that cavort and struggle, grimacing, at once seductive and repulsive, without trying to produce an academic interpretation or impart a universal lesson. Her photographs of the holy Ethiopian town of Lalibela, published in 2017, are perhaps the calmest among all her works, but they still display her rigorous, bold sense of composition, which transforms the expressions on the faces into questions aimed at the viewer. What does it mean to see? How can we really look? We must look closely, from the inside, as much as possible. That is why García Rodero immersed herself in the mud of Haitian rituals, was anointed with the blood of sacrifices to Maria Lionza in Venezuela, and swallowed heaps of pigment in India at the spring festival, losing many of her cameras along the way.

García Rodero's acknowledgment of her own subjectivity has shaped her ethical approach to photography. She also imparted this to her students at the School of Fine Arts in Madrid, where she taught from 1974 to 2007. She joined the agency Vu, and then Magnum Photos, in 2005, becoming its first Spanish full member in 2007. **SGC**

'The photographer's greatest enemy
is not people, but fear.'

CRISTINA GARCÍA RODERO

Donna Ferrato's reportage, mostly carried out in the United States, is remarkable for its combination of journalistic integrity, humanism and policy-changing advocacy. Ferrato's fraught battleground is the home. Published in 1991, her body of evidence, *Living with the Enemy*, revealed that domestic violence is terrifyingly prevalent, long before the O. J. Simpson trial and an array of films on battering brought wider attention to the horror.

In the 1970s and early 1980s, Ferrato's initial focus was swingers and those with sexually liberated lifestyles, placing these choices in a feminist context – affirming women's erotic desires – and perceiving them as empowering. Published thirty years later, *Love and Lust* (2005) is largely the result of this work; it explores the myriad manifestations of sexual intimacy and accompanying thrills. In 1981, Japanese *Playboy* commissioned Ferrato to produce a story on 'couples who epitomized the glamorous life-style of that era'. She

immediately asked Lisa and Garth, whom she had met while covering the New York swingers' club Plato's Retreat, if she might live with them and their young children, and photograph them. They agreed. One night, hearing screaming in the bathroom, Ferrato arrived just as Garth was slapping Lisa. Her instincts prevailed, and Ferrato bore photographic witness while shouting at Garth to stop. Her life would be changed inexorably.

Determined to expose domestic abuse as criminal and lethal (previously, it was often viewed as 'private' – a 'family matter'), Ferrato photographed women who had been battered – often nearly to death – and recorded their stories. She also accompanied police on domestic violence call-outs and embedded herself in shelters, emergency rooms and prisons where women who had fought back were incarcerated, as well as in the homes of abusers enrolled in re-education programmes. Ferrato's stark photos and accompanying narratives reveal that this violence permeates all classes, races and religions.

Devoting herself to the defence of women's rights, in 1992 Ferrato founded the non-profit Domestic Abuse Awareness Project, weaponizing her photographs to create or improve laws concerning violence against women and to help fund women's shelters. In 2014, she began the series 'I Am Unbeatable', following up with many of the abused women and children she had photographed in the 1980s.

Ferrato's accolades include the W. Eugene Smith Grant and the Robert F. Kennedy Award, both for humanistic photography. In 2008, New York City observed a 'Donna Ferrato Appreciation Day' in recognition of her work on behalf of women and children. **MH**

> 'The first thing you notice about Ferrato's war photos is that you've never seen anything like them…. How does she get these pictures?… If wife beating has been hidden from public scrutiny since the beginning of time, how does a photographer photograph it?'
>
> **ANN JONES, CRITIC**

Donna Ferrato, *Garth hits Lisa*, 1982

Birgit Jürgenssen, *I Want Out of Here!*, 1976

'I can't repeat shots. I can create series, which I do in great numbers, but I can't replicate [actions that I've photographed]. It's not humanly possible for me. It doesn't work. I operate in a very spontaneous way.'

BIRGIT JÜRGENSSEN

In March 1975, the exhibition *MAGNA: Feminismus – Kunst und Kreativität* (MAGNA: feminism – art and creativity) opened to the public at the Galerie Nächst St Stephan in Vienna. Organized by the artist and performer VALIE EXPORT, the exhibition brought together the work of many feminist artists, including Renate Bertlmann, Meret Oppenheim, Maria Lassnig and Birgit Jürgenssen. Still a young artist at the time, having recently graduated from the University of Applied Arts in Vienna, Jürgenssen contributed a collection of works on the theme of 'the housewife'. As she would continue to do throughout her career, she used objects, drawings and photographs – described by artist Peter Weibel as 'razor-sharp' – to denounce and break down the cultural and social roles imposed on women, as well as the means of repression associated with them.

After studying graphic arts, Jürgenssen set up a darkroom in her workshop in the early 1970s. She was fascinated by French Surrealist literature and art, as well as by structuralist ideas. Her first self-portraits, which she took using a timer, bear the mark of these influences. Jürgenssen appears wearing masks, make-up and costumes, in scenes that range from the serious to the farcical. She often makes use of written language, with its visual associations, which reinforce the performative nature of her practice. She allows images to be projected onto her body, both literally and figuratively: male fantasies, clichés and gender roles. Performance is at the heart of her practice: the camera and the image become sites of action and freedom. The environment in which she developed as an artist was a particularly fertile one: after the Second World War, Austrian conservatism sparked a wave of feminist protests that flourished in the political, cultural and artistic spheres.

In the early 1980s, Jürgenssen joined the Academy of Fine Arts in Vienna, where she set up a photography programme, which had thus far been absent from the institution's curriculum. She joined the collective Die Damen (The women) in 1988 and took part in numerous performances with them until 1994. Although she is without a doubt one of the most important figures in feminist art, Birgit Jürgenssen has only recently begun to enjoy true recognition as an artist. **JJ**

While attending art school in Melbourne in the late 1960s, Carol Jerrems began to stamp the back of her prints with the words 'carol jerrems photographic artist'. By doing so, she asserted her wish to be accepted as an artist – a wish that, in the context of Australian photography at the time, was highly unusual, especially for a young woman with very few local role models to inspire her. But there was never any doubt that Jerrems was in possession of a rare and special talent.

Around 1972, Jerrems began to refine her practice, developing a very particular social-documentary mode that reflected her politics, her personality and her influences – especially that of Diane Arbus, the only photographer she ever recognized as having affected her approach. It was from Arbus that Jerrems learned the power of placing the subject in the centre of the image, facing the lens, in a way that frankly acknowledges the complex relationship between photographer and sitter and the transformative moment it enables. Her methodology was at once directorial and collaborative: with a few exceptions, she guided her subjects in a transaction that would often take hours. She took her time, waiting for a connection with her sitters and for

'I love people, and trying to communicate something of what I see and feel. Sharing.'

CAROL JERREMS

the mask of self-consciousness to drop away. Her best photographs capture her subjects in a way that transcends the everyday. This was the context for her most famous work, *Vale Street* (1975), a luminous image of otherworldly strangeness, conjured up by Jerrems but one in which the subjects remain in control. They are totally of their time and yet also soar above it. Myth-like and enigmatic, *Vale Street* has lost none of its force or ability to challenge.

Jerrems was part of a generation of young Australian artists of the late 1960s and 1970s who considered photography as a medium in tune with a wider quest for a more socially inclusive society, one without racial or gender discrimination. 'I want to focus on the under-dogs,' she claimed, 'the under-privileged of Australian society and all the things that people don't want to talk about or know about.' She turned her camera – often at great personal risk – to women's and gay liberation, youth culture and the plight of First Nations people in Australia's cities.

In 1974, Jerrems wrote: 'There is so much beauty around us if only we could take the time to open our eyes and perceive it. And then share it. Love is the key word.' She remained true to this aspirational credo throughout her life, and it is this attempt to connect with others and to convey that experience to her audience that gives her photographs such resonance. Jerrems found life difficult, suffering at times from debilitating bouts of depression. From this place, she had a remarkable ability to see through people's bravura to what lay below. She was able to combine a poetic, romantic strain with a gritty toughness, an earnest, passionate desire for authenticity, in a way that was all her own. **AO'H**

Carol Jerrems, *Boys*, 1973

Sophie Ristelhueber, *Every One #14*, 1994

'As an artist, I am also at war myself.'

SOPHIE RISTELHUEBER

Sophie Ristelhueber's iconic early works already bear the markers of her approach as an archaeologist of the visible. Her analytical distance, her understanding of physical space both in an image and in her exhibitions, her sense of time passing and hints of what is outside the frame all play an important part in her work, which consists of visual and sound installations as well as films.

Ristelhueber's work is strongly influenced by her literary background. She studied the work of Alain Robbe-Grillet at the Sorbonne and carried over certain principles from his theory of the Nouveau Roman: abandoning traditional approaches to character, using factual – almost surgical – description, and doing away with cohesive plot. Her tight, front-on compositions, in harsh, intense black-and-white or muted colours, form a visual syntax in which traces and hints are loaded with meaning. In her autobiographical series 'Vulaines' (1989), the empty interiors and worn furniture evoke the people who would once have inhabited these spaces in her childhood, who are shown in the archive photography placed alongside these images. Instead of focusing on an individual's specific facial features, Ristelhueber prefers the universality of bodies, which are often wounded: in the series 'Every One' (1994), scars become reminders of trauma but also signs of resilience, a possible link between past, present and future.

Although she is associated with documentary photography, Ristelhueber's work rejects traditional photoreportage and, in contrast to up-to-the-minute media representations of current events, prefers focusing on what is happening at the edges or in the aftermath. This is especially clear in her series 'Fait' (1992), on the legacy of the Gulf War, which focused on traces of the conflict that she captured at various levels – from the air or at ground level in the Kuwaiti desert. In the installation 'Eleven Blowups' (2006), she created photomontages that combined video rushes from Reuters correspondents with her own prints from earlier work in Turkmenistan, Syria, Iraq and the West Bank. She drew on the motif of the crater, a symbol of absence and suffering, in order to create a physical work that plays with the material, format and status of images. Similar preoccupations are at work in her series 'Sunset Years', exhibited in 2019 at the Galerie Jérôme Poggi in Paris, which juxtaposes the concave motif of sinkholes around the Dead Sea, where the ground collapses in on itself, with the convex image of pavements where the bitumen is swelling in a heatwave.

Ristelhueber's work has been exhibited at major museums across the world, confirming her status as an uncompromising, committed artist who reveals the disasters caused by human folly, bearing witness to destruction but also hinting at the possibility of rebuilding. **HC**

Born in Dakar in 1949, Awa Tounkara was part of the first generation of female African photojournalists who emerged shortly after their countries gained independence. According to Aminata Touré Sagna, in an article published by the African News Agency in 2008, Tounkara '[wrote] information into images, a camera around her neck, travelling across Senegal, along tracks and through woods, but also into the upper-class salons of Dakar and mass public gatherings in the capital'.

Tounkara was interested in the visual arts from an early age. In 1971, she began studying photography at the Maison des jeunes et de la culture (Youth and Culture House) in Dakar. In August 1972, she joined the photography department at the recently established national newspaper *Le Soleil*, founded two years earlier. She was offered numerous scholarships to continue her studies abroad, but had to turn them down due to poor health. As the only woman in the team, she was interviewed by the journalist Papa Amet Diop for the magazine *Amina* in March 1973. At first, Tounkara worked in the newspaper's archives and was in charge of developing film, selecting images and captioning them ready for use in the next day's issue. She became, in her own words, 'a master of the laboratory' and had to fight to be allowed out of the darkroom, but her desire to go into the field was so strong that she eventually won over the management. She landed a job on the sports desk, covering basketball and football tournaments. She fought tirelessly for greater recognition of women in photojournalism and always made sure to help train new recruits at the newspaper. To establish her professional credentials, she took the entrance exam for the Centre d'études des sciences et techniques de l'information (Centre for Information Sciences and Technology Studies, CESTI), so that she could join the journalists' union.

Tounkara took part in numerous joint exhibitions, both within Senegal and internationally. After showing portraits of female painters at the salon Femin'Art in Dakar in October 1998, she exhibited her darkroom experiments (photograms of flowers and portraits taken using a Nescafé tin – the famous camera obscura process) at the French Cultural Centre of Abidjan in May 2000. Her work has been recognized with numerous prizes within Senegal; in 1996, on World Press Freedom Day, she was given an award for her series – created that year – on women panning for gold in Kédougou and harvesting salt in Lake Retba in Siné-Saloum. Tounkara says that 'anyone who relies on digital technology is not a true photographer'. She has used digital photography only once, after retiring in 2009.

Tounkara was honoured by the International Francophone Press Union in November 2019 as the first female photojournalist in Senegal. She is celebrated, in the words of Aly Diouf, as a 'legend of Senegalese photojournalism'. **EN**

'The laboratory is the foundation of photography.'

AWA TOUNKARA

Awa Tounkara, *Women's basketball match between the Association sportive des fonctionnaires (ASFO) and the Association sportive et culturelle Jeanne d'Arc*, Dakar, 30 December 2000

Wong Wo Bik is one of Hong Kong's most respected photographers. As one of the very few women working in the field, she has had a long and active career, in terms of both her own photography practice and her work in art education. She is also a founding member of the Hong Kong International Photo Festival, launched in 2010.

Wong Wo Bik studied sculpture and printmaking at Columbus College of Art and Design, Ohio, before earning a master's degree in photography from the Tyler School of Art, Philadelphia, in 1979. Upon her return to Hong Kong in the early 1980s, she gained experience working with performance artists and with a new dance troupe, the City Contemporary Dance Company (CCDC), which was directed by the choreographer Willy Tsao. This collaboration would lead to a multimedia installation presented by the CCDC in 1988.

Wong's interest in storytelling through movement began to inform her photography just as she started to experiment with Polaroid instant film. For this endeavour, Wong received a commission from Polaroid to publish her work in book form; the result was called *Color & Consent* (1983). This collection of fifty images combines normal views with manipulated images, for which she took apart the film, reprinted certain sections and used layers of film to create photocollages.

Wong's subjects range from herself to daily life and scenes from the urban environment, images that are often imbued with a surreal edge. Thus her best-known photographs show some of Hong Kong's landmarks before they were demolished, together with evidence of the lives of past occupants. Her work is not truly documentary: the images tell of the artist's subjective experience of these places as seen through a prism of details: sunlight, patterned wallpaper, a banister, an architectural feature or abandoned belongings.

Wong Wo Bik continues to push the boundaries of photography today because she is drawn to introspection rather than storytelling. Her approach to the image (sometimes symbolic, sometimes Surrealist), technique (super-imposed negatives and the use of various printing processes) and materials (she prints her images on rice paper and cloth as well as on traditional photographic paper) is important both for the story of photography in Hong Kong and for the influence it has had on some of her contemporaries, including Holly Lee and Lee Ka-sing. In 2013, Wong Wo Bik's contribution to photography was recognized by the Hong Kong Federation of Women. Examples of her work are held in several private and public collections, including the M+ and the Hong Kong Heritage Museum in Hong Kong; the Guangdong Museum of Art in Guangzhou; and the Archive of Modern Conflict in London. **KS**[1]

Wong Wo Bik, *Ice Skating, Lai Yuen Amusement Park*, Hong Kong, 1997

Valdís Óskarsdóttir, *My grandmother, Aðalbjörg*, 1974

Valdís Óskarsdóttir, a writer and photographer turned director and prize-winning film editor, graduated from the Danish National Film School. She has worked as an editor with directors including Gus Van Sant, Michel Gondry, Sean Penn and Thomas Winterberg.

Óskarsdóttir acquired her first camera as a present from her father when she was twelve years old, and from that point on she photographed everything, often using her younger sisters as models. Studio work did not appeal, so instead she turned to the masculine world of press photography. In 1967, she started working in the photo archives of the daily *Tíminn* in Reykjavík, where she learned her profession from the newspaper's press photographers. From 1971 to 1973, she was employed in the darkroom at the daily *Morgunblaðið*, but was also often invited, armed with a Pentax, to join the staff photographers on their daily walks in search of a good cover photo.

Between 1973 and 1987, Óskarsdóttir worked as a freelance reporter, selling her stories to journals and magazines in Iceland. Her reportages demonstrate her keen interest in social subjects and everyday life, reflecting the importance of visual communication in the contemporary media. Always working on location and considering her photojournalism as fieldwork, she showed how habits and behaviours consciously or unconsciously shape the visual narrative, whether her subjects were fishermen at sea or a translator sitting at his desk.

Crossing the barriers of age and gender, she also focused on the overlooked and the silenced, as in her article 'Varúlfar og vampýrur' ('Werewolves and vampires'; *Tíminn*, 27 January 1974). For this piece, she documented the daily chores of her grandmother, who lived alone on an isolated farm. We see the old woman braiding her hair, smoking a pipe and preparing a meal in front of the kitchen window, bathed in a cold winter light. The poetry and intimacy expressed in these images, which resemble the genre scenes of Dutch and northern painters, contrast with the descriptive, straightforward tone in the accompanying text.

Óskarsdóttir's more personal work is marked by political and social activism, which assumed a more rhetorical role in the feminist and anti-war collages reproduced in the book *Rauði svifnökkvinn* (The red gliding boat, 1975), accompanied by a text by Ólafur Haukur Símonarson. Using avant-garde and Surrealist visual language, Óskarsdóttir addressed issues including the climate crisis, the Vietnam War, militarism, and the environmental problems connected with consumption and waste. Employing the visual technique of montage, she constructed complex levels of meaning by combining her own photographs with generic press images and advertising, creating a work that anticipates today's concept of 'dark ecology'. **ÆS**

Birgit Jürgenssen,
Untitled [Improvisation], 1976

352

Paz Errázuriz, *Evelyn, La Palmera, Santiago*,
from the series 'Adam's Apple', 1983

Jane Evelyn Atwood, *The Departmental Institute for the Blind,
Saint-Mandé, France*, from the series 'Exterior Night', 1980

Ishiuchi Miyako,
Mother's #36, 2002

Helena Almeida,
Inhabited Painting, 1975

357

Natalia LL,
Animal Art, 1977

Abigail Heyman,
Supermarket, 1971

359

Mary Ellen Mark,
The Damm family in their car,
Los Angeles, California, 1987

Lynne Cohen,
Blackboard, *c*.1985

360

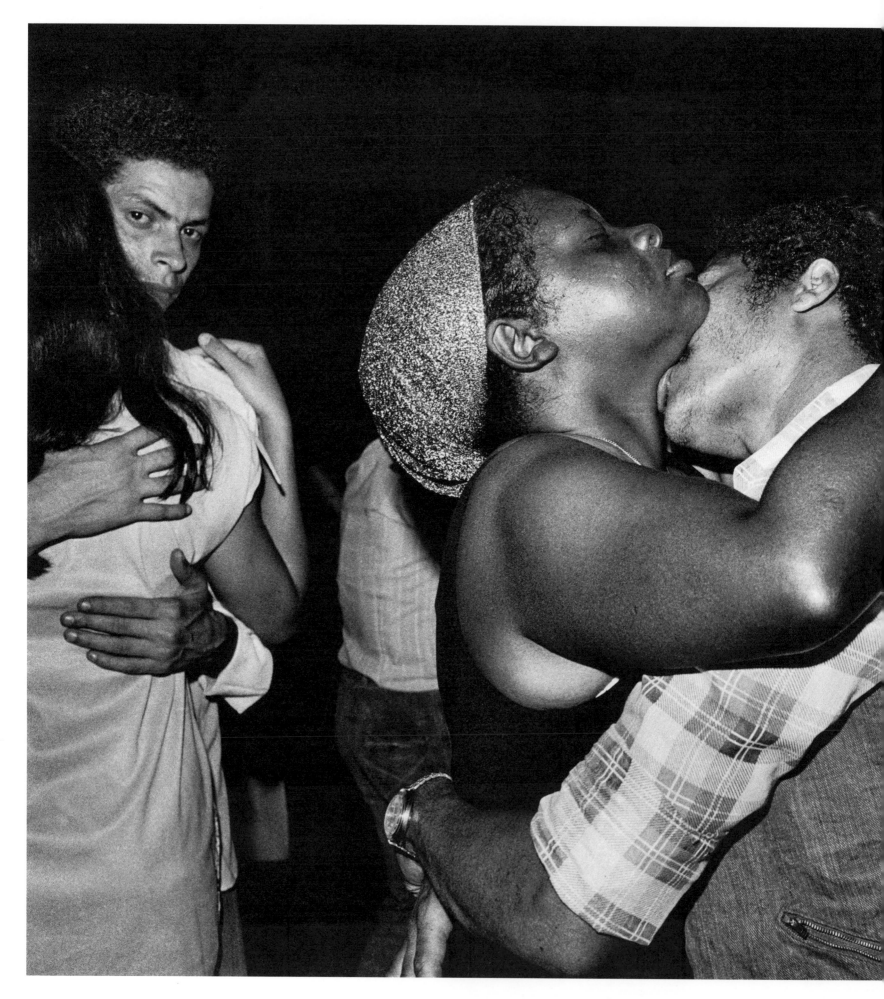

Nair Benedicto,
Kissing at a Mario Zan concert,
São Paulo, 1978

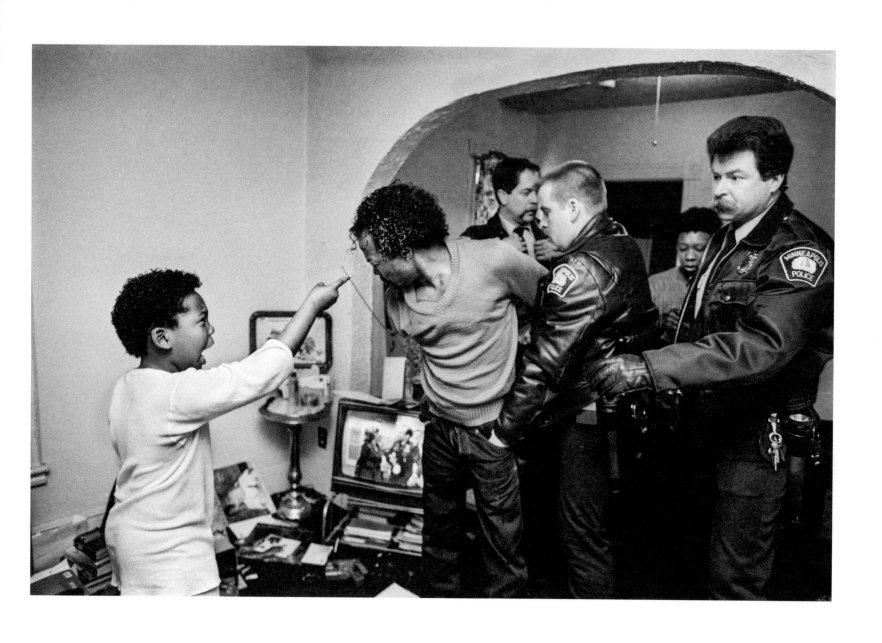

Donna Ferrato, *Six-year-old child Diamond shouts at his father as the police arrest him for domestic violence*, Minneapolis, 1986

Rosalind Fox Solomon, *Mother, Daughter, Maid*, Johannesburg, 1988

365

Cristina García Rodero,
Waiter! Chocolate with churros,
Cartagena, Spain, 1981

Xiao Zhuang, *Women with pushchairs
at the Chinese national festival in Nanjing,*
China, 1954

Masha Ivashintsova,
Stalin, Leningrad, USSR, 1985

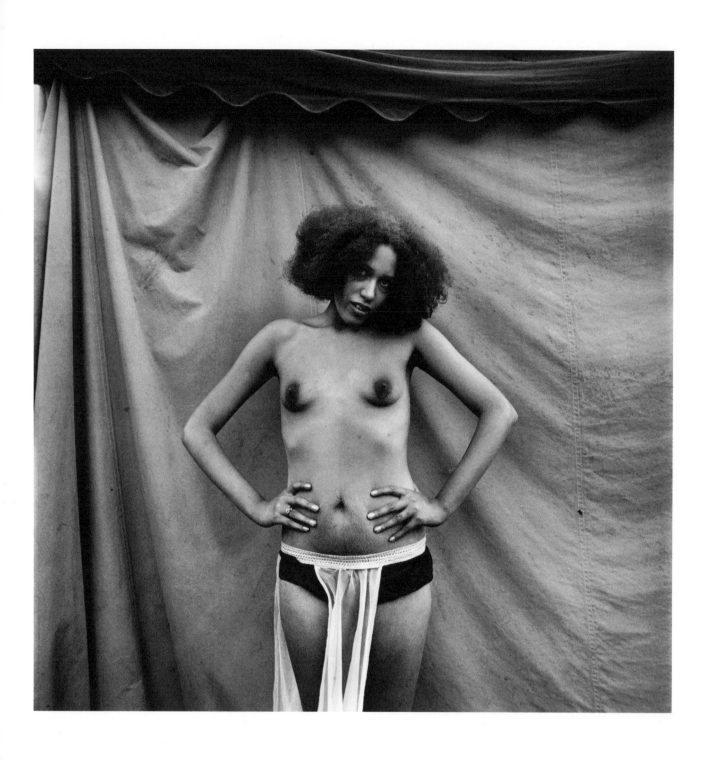

Susan Meiselas, *Untitled*,
from the series 'Carnival Strippers', 1975

Graciela Iturbide, *Our Lady of the Iguanas*,
Juchitán de Zaragoza, Oaxaca, Mexico, 1979

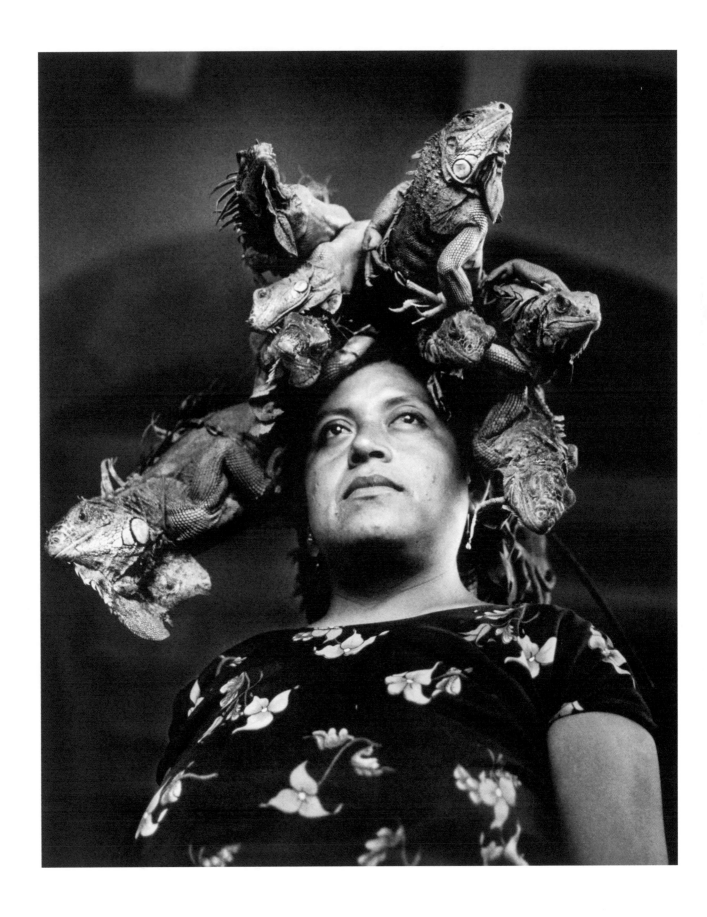

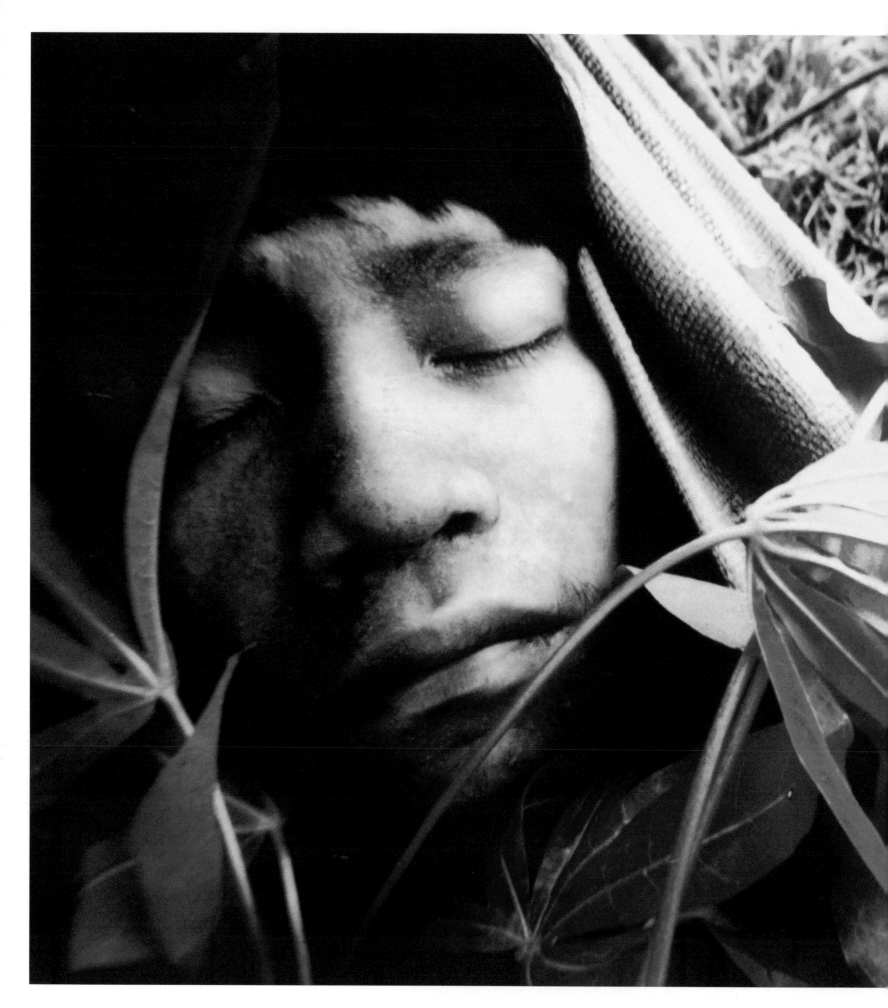

Claudia Andujar, *Young Wakatha u thĕri,*
a measles victim, is treated by shamans and
paramedics from Catrimani's Catholic mission,
from the series 'Consequences of Contact', 1976

Renate Bertlmann,
Tender Touches, 1976–2009

Jo Spence and Terry Dennett,
Property of Jo Spence?,
from the series 'Picture of Health?', 1982

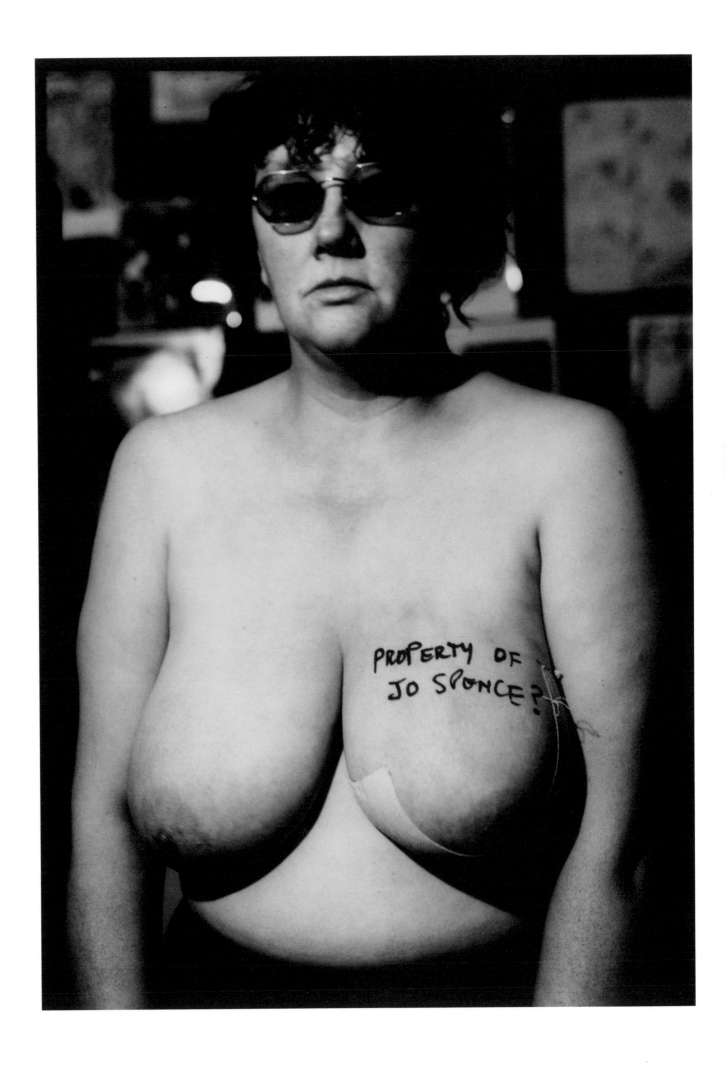

Sophie Ristelhueber,
Eleven Blowups #10, 2006

'The most important thing for me is the moment when I take a photograph and print it. When I've got a good print, that's it for me.'

TUIJA LINDSTRÖM

Born in Kotka, south-east Finland, Tuija Lindström moved to Stockholm in 1975. As a student at the Konstfack University College of Arts, Crafts and Design between 1981 and 1984, she experimented with large-format cameras and advanced darkroom techniques. Her breakthrough came with a series of intimate black-and-white portraits of friends and prominent figures in the art world. Lindström was part of the circle around the legendary photographer Christer Strömholm, whose photographic style and methods inspired generations of young photographers. The catalogue for Strömholm's exhibition *9 sekunder av mitt liv* (9 seconds of my life), held at the Moderna Museet in Stockholm in 1986, includes a famous nude portrait of him, taken by Tuija in 1985 as part of a series she was then working on.

One of Lindström's best-known works is the series *Kvinnorna vid Tjursjön* (The girls at Bull's Pond, 1991), which comprises twelve photographs of women and twelve irons viewed in close-up. About half of the irons are covered in red paint that looks like blood. The women, for their part, are shown naked, floating in various positions on the dark water. When they are hung together, the two types of image create a tension, the wet, pale bodies contrasting with the sharp contours of the irons. The work is accompanied by a 16mm black-and-white film.

In 1992, Lindström became the first woman to be appointed professor at the School of Photography of the University of Gothenburg, where she would work for ten years. The school initially provided a traditional training, focused mainly on studio work and reportage, cameras and the use of different techniques. Under Lindström's leadership, the curriculum took a noticeably more theoretical and artistic direction, which was hugely significant for the students who graduated during this period. She became a role model, especially for many young women photographers in Sweden and other Nordic countries.

After working in Gothenburg, Tuija Lindström lived for some years on the island of Öland, in the south-east of Sweden, before returning to Stockholm. Her late works include a series of colour photographs of carnivorous plants against a white background.

Throughout her career, Lindström continued to experiment and to renew her practice, whether she was working on portraits, landscapes or still lifes. A feminist perspective was always present in her art. She had a major retrospective at the Liljevalchs Konsthall in Stockholm in 2004, followed by exhibitions at the Hasselblad Center in Gothenburg in 2012, and at the Institut Suédois in Paris and the Finnish Museum of Photography in Helsinki in 2014. **AT**[1]

Tuija Lindström, *Red Iron*,
from the series 'The Girl's at Bull's Pond', 1991

styczeń 1989 - Sama z dywanem.

Anna Beata Bohdziewicz, *January 1989 – Alone with a carpet*,
series 'Photodiary or Song about the End of the World', 1989

Anna Beata Bohdziewicz is best known for her epic series 'Fotodziennik czyli piosenka o końcu świata' (Photodiary or song about the end of the world), which features more than seven thousand photographs, each glued onto a piece of graph paper and accompanied by a date and a short handwritten commentary. This project is an exhaustive record of everyday life in Poland since 1982. Bohdziewicz was thirty-two when she settled on this approach, which allowed her to preserve images of the history unfolding before her eyes, and she has not deviated from it since then. Martial law had been introduced in communist Poland the year before to suppress the pro-democracy movement Solidarity. Bohdziewicz belonged to the movement herself and set out to document how daily life had changed, bringing a personal touch to political events or, vice versa, showing how the everyday had become politicized. An intimate account told from a highly subjective point of view, 'Photodiary' is, like every diary, a valuable record of its time.

Born into a family of intellectuals, Bohdziewicz studied ethnography, but very quickly found herself working with film-makers such as Walerian Borowczyk and Krzysztof Kieślowski, first as an assistant and then as assistant director. Her passion for photography was cemented during this time: in 1978, she had her first exhibition of photographs taken on a visit to Afghanistan, which displayed a strongly Pictorialist aesthetic. As the Solidarity movement began to grow, then as martial law was introduced in December 1981, Bohdziewicz abandoned this artistic language and turned to documentary photography, training her camera on scenes of daily life, which she observed with humour, clarity and precision. She took her photographs quickly, like snapshots, and they straddle the border between journalism and private photography. Her work for the underground press led to her witnessing and being involved in the events that shaped political life – protests, secret meetings, the visits of Pope John Paul II. Ever curious, she is often drawn more to the anecdotal and the apparently insignificant detail than to the main event.

For Bohdziewicz, recording history is an almost vital act. During the 1980s, she accompanied the photographer Zofia Rydet, who was already more than seventy years old at the time, on her travels to create her monumental 'Sociological Record'. This work showed Bohdziewicz the evocative power of the everyday and of what can be found on the fringes of society, recording the grand sweep of history from an individual perspective in order to give the account a more personal dimension. At the same time, Bohdziewicz created other photography series, most notably 'The Shrines of Warsaw', 'Private Television', 'Beautiful and Happy' and 'Anti-Postcards', taken on her many travels after the fall of the Berlin Wall. Since the collapse of communism in Poland, she has worked as a freelance photographer, sometimes working with the press. She has collected her photographs in multiple books, but her 'Photodiary' is still yet to be published in its entirety. **KZ-L**

Ming Smith, *Sun Ra Space II, New York, NY*, 1978

Ming Smith was born in Detroit and raised in Columbus, Ohio. In 1973, she moved to New York to pursue a modelling career: Smith was one of the first African-American women to break the colour barrier in the fashion world. In New York, she met Louis Draper, a key member of the renowned Kamoinge collective, founded in 1963, which strove to challenge negative representations of African Americans in photography; Smith was initially the only woman in the group. She applied her singular vision and Surrealist style to a wide range of figures from the artistic, musical and literary black community, including personalities such as James Baldwin, Sun Ra, Grace Jones and Katherine Dunham, but also to many anonymous characters photographed in the street.

Smith is known for her shadowy, atmospheric photographs – a style that at times partly conceals her subjects and results in out-of-focus images that mask the finer details of figure and background. This deliberate blurriness creates a semi-abstract, ephemeral effect, as if the photographer wanted to avoid giving full access to her subjects. She also uses experimental post-production techniques, including double exposure, collage and painting on prints. Personal and expressive without veering into sentimentality, Smith's work challenges preconceived ideas that result in African-American photography being reduced to a documentary role.

Smith's place in photography's 175-year history was affirmed by her inclusion in the groundbreaking exhibition *Pictures by Women: A History of Modern Photography*, held at New York's Museum of Modern Art (2010). The last few years have shown increased interest in her work, which has been included in several prominent exhibitions, many of which examined the reactions of Black artists to sociopolitical conditions during the civil rights movement, including *Soul of a Nation: Art in the Age of Black Power* (Tate Modern, London, 2017); *We Wanted a Revolution: Black Radical Women, 1965–85* (Brooklyn Museum of Art, 2017); and *Art of Rebellion: Black Art of the Civil Rights Movement* (Detroit Institute of Arts, 2017). Numerous public collections hold works by Ming Smith, including the Museum of Modern Art, New York; the Schomburg Center for Research in Black Culture, New York; the Smithsonian Anacostia Museum, Washington, DC; and the Art Gallery of Ontario, Toronto. **JC**

'What the memory often holds is not exactly what the camera records…. Wondrous imagery keeps cropping up, stuffing themselves into [Ms Smith's] sight. She grasps them and gives eternal life to things that might well have been forgotten.'

GORDON PARKS, PHOTOGRAPHER

Born in Leningrad in 1951, Olga Borisovna Korsunova studied law at Leningrad State University, following in the family tradition, before taking a position as a secretary in the law courts. In 1971, she began working in the photographic laboratory of the military academy at Frunze, the capital of Kyrgyzstan. It was at this time that Olga met Boris Smelov, a photographer from Leningrad whom she called her 'teacher', though they were the same age. Smelov, who was the leader of what would soon be called 'unofficial photography', introduced her into this underground circle that valued the importance of the print run and the materiality of each print. After leaving university, Korsunova began to take photographs for the Soviet state, working for the Artists of Russia publishing house, the Youth Theatre, the Melodiya record company, and various theatres, museums and publishers in Leningrad.

In early 1980s, Korsunova left Leningrad for the countryside. With her husband, the archaeologist Kirill Lagotsky, she settled near Lake Ladoga. While Kirill hunted and fished, Olga worked on a farm, set up a photography school for children and practised handicrafts. In 1996, the couple and their children returned to the city, which had now reverted to its original name of St Petersburg.

Following Smelov's death in 1998, Korsunova became more involved in the photographic scene of St Petersburg. Until 2005, she led the Baltic School of Photography, whose objective was to identify and train up talented young artists; she organized masterclasses and visits to legendary photo laboratories and studios, created spaces for projects and exhibitions, and arranged meetings between young artists and professional photographers. Korsunova was by this time working as a senior researcher at the State Centre for Modern Art, then at the State Centre for Photography. In 2005, alongside her colleagues, she founded the St Petersburg State Photography Workshops Foundation. From 2005 to 2008, she hosted several international summer workshops.

Korsunova's photographs have been the subject of a number of solo exhibitions and have been shown in numerous group exhibitions in Russia and elsewhere. She is represented in the collections of the Russian National Library, St Petersburg, and the Moscow House of Photography; in the Dodge Collection of Soviet Nonconformist Art at the Zimmerli Art Museum, Rutgers University, New Jersey; and in Russian and international private collections. Korsunova also curated more than forty photography projects, including a retrospective of Boris Smelov's work at the State Hermitage Museum in 2009 and its accompanying catalogue. **AA**[3]

Olga Borisovna Korsunova, *Anatoly Belkin and his Girlfriend*, Leningrad, 1975

The strength, consistency and originality of American photographer Sally Mann's work lie in the themes to which she returns again and again: childhood, desire, humanity's relationship with other living things, the fleeting nature of time and the morbidity of the flesh have all been at the heart of her work since the mid-1980s. Although her photographs are rooted in her day-to-day reality – focusing on everyday spaces, family and close friends – they achieve a certain universality through the way Mann conveys very human fears, desires and doubts. This ambiguity has been present from the very first series that made her name. Despite their realist approach, the portraits of teenage girls in her series 'At Twelve: Portraits of Young Women' (1988) possess all the strangeness and discomfort usually associated with that age, when a new vitality is at war with a growing awareness of mortality.

In the portraits of her children, Mann aims to make visible the threat that lurks behind even lively, peaceful scenes (games, picnics, naps outdoors). The transient, ephemeral nature of existence is also a leitmotif throughout much of her other work: for example, the series 'Proud Flesh' (2009) focuses on the body of her partner, who has muscular dystrophy, while the polyptychs that she creates by combining close-up images of faces, made using the collodion process, recall the post-mortem photographs of the nineteenth century.

Mann began using collodion negatives as an integral part of her artistic practice towards the end of the 1990s. The manual method of creating these negatives introduces all sorts of accidents – drips, marks, breakages – that are visible in the final prints. Mann embraces the unpredictability of the medium – this 'angel of uncertainty', as she puts it – as it mirrors and draws out the vulnerability of her subjects. This old-fashioned technique also gives her prints a distinctive patina that evokes a sense of time hanging heavy over the landscapes of the present; Mann used this approach to photograph former battlefields from the American Civil War, searching out the scars left by the past to evoke the 'spirit of the place'.

Although her process is very tactile and physical, Mann uses it to capture what is intangible and invisible, mysterious and unreal. Time and again, she interrogates the forces and relationships that transcend the temporal and physical boundaries of her individual subjects: symbolic relationships and ones passed down through the generations in the series 'Two Virginias' (1991); an innocent relationship with the natural world, as in a lost Eden, in the portraits of her children; relationships that bind people to a particular area and its history, such as in the region of Lexington, Virginia, where Mann has lived since childhood. Like Clarence John Laughlin, another photographer from the American South, she has inherited a culture that is bursting with magical representations but also weighed down by a tragic past. This heritage seeps into all her photographs, which are peopled by vibrant, mortal bodies but also haunted by ghosts. **DV**

Sally Mann, *Battlefields, Antietam (Starry Night)*, 2001

Wang Miao, *Young men and women of the Yi people at the Dayao flower festival at Yunnan*, China, April 1989

Wang Miao was born in Beijing two years after the People's Republic of China was proclaimed. Her career as a professional photographer began in 1972, in the middle of the Cultural Revolution (1966–76), at a time when a generation of educated young city-dwellers was being sent out to the countryside to retrain in poor farming communities. The prevailing Maoist ideology and social focus of the era shaped the role of professional photographers. Wang Miao was initially assigned to document historical remains before becoming a press photographer for the China News Service, the government news agency. But, aside from her official work, in 1979 she joined a group of amateur photographers with whom she founded the historic April Photographic Society. This association evolved out of the April 5 Photographers, so named because they spontaneously recorded the crowds that came to Tiananmen Square in 1976 to mourn the death of premier Zhou Enlai, around the time of the Qingming festival.

Between 1979 and 1981, the April Photographic Society held three annual exhibitions under the title *Nature, Society and Man*, where the accent was firmly on a humanistic approach to photography and in stark contrast to the officially sanctioned visual culture of the time. One of Wang Miao's photographs, *Inside or Outside the Cage*, was criticized on the grounds that it seemed to draw an analogy between life under the communist regime and imprisonment. In this era of openness and reform, which was marked by the radical changes in economic policy brought about by Deng Xiaoping in 1978,

the group's activities went a long way to encourage the practice of photography as an expression of everyday life.

In 1986, Wang Miao held her first solo exhibition, entitled *Tibet Through My Eyes*, which brought together photographs that she had made during trips to the Tibetan Plateau. This was followed in 1987 by a second show, called *A Journey Through Sichuan and Tibet*. Since then, the photographer has taken part in numerous exhibitions, the most recent of which was a retrospective entitled *Sorrow and Joy of China* (2012).

Having published collections of her own work since 2003, Wang Miao began to work as an exhibition curator and editor of photography books, such as the major series *24 Hours In …*, which offers a comprehensive overview of daily life in various cities and regions across China. A second series soon followed: *Impressions of …*, for which she asked Chinese photographers for their personal thoughts on the cities of London, Sydney, Nagasaki, Los Angeles and New York – their town planning, architecture and monuments, but also their inhabitants and cultural life.

Wang Miao has held the positions of vice-director and editor-in-chief of the Hong Kong China Tourism Press, and editor-in-chief for *China Cultural Geography* magazine, which looks mainly at the geographical and cultural diversity of mainland China. Having previously worked as the director of the China Photographers Association, she is currently chair of the International Union of Chinese Photography. **KS**[1]

Jeanne Moutoussamy-Ashe grew up in Chicago, where her mother was an interior decorator and her father was an architect. At nineteen, she got her first camera and enrolled at the Cooper Union, a prestigious New York art school, from which she graduated in 1975. The year before, as part of her studies, she lived for six months in West Africa, where she became interested in the culture of fishing villages in Ghana and the legacy of the transatlantic slave trade. This time in Africa was a formative experience for her. A few years later, she decided to photograph the Gullah community living on islands off the south-east coast of the United States. Made up of direct descendants of slaves brought over from Africa, this community has preserved its African heritage. Moutoussamy-Ashe was particularly interested in the Gullah people living on Daufuskie Island, off the coast of South Carolina. She visited the island numerous times between 1977 and 1982, documenting this unique culture that was on the brink of extinction, with the local people being driven out by building projects that were gradually transforming the island into a holiday resort for the wealthy. Moutoussamy-Ashe's book *Daufuskie Island: A Photographic Essay* was published in 1982. It was reissued twenty-five years later, with a foreword by her friend and colleague Deborah Willis, who also provided the inspiration for another of her major projects: *Viewfinders: Black Women Photographers*. This book, in which Moutoussamy-Ashe traced the history of female African-American photographers, was first published in 1986 and also reissued in 1993.

In 1976, when Moutoussamy had already embarked on her career as a photographer, she met her future husband, the famous tennis player Arthur Ashe, while covering a benefit gala for NBC News. The couple married a few months later, and their daughter Camera was born in 1986. In 1988, Arthur discovered that he was HIV-positive, having received a contaminated blood transfusion during an operation. In 1992, Jeanne began recording precious moments in their daily life, especially the close relationship between Camera and her father. These tender, loving photographs became the subject of a children's book: *Daddy and Me: A Photo Story of Arthur Ashe and His Daughter, Camera*. After her husband's death, Moutoussamy-Ashe became president of the Arthur Ashe Foundation, which raises money to fund research into HIV treatment and prevention. In 2008, she opened the non-profit Arthur Ashe Student Health & Wellness Center at the University of California, Los Angeles.

She continued to pursue her photography work, staging exhibitions, taking on freelance commissions, speaking at conferences and teaching classes. In 2013, she received funding from the Ford Foundation to carry out research and put on an exhibition at the Leica Gallery in New York celebrating the fiftieth anniversary of the March on Washington in 1963. As well as her own book projects, Moutoussamy-Ashe's photographs (both commissions and reportage) have been published in newspapers and magazines such as *Life*, *Ebony*, *Sports Illustrated* and the *New York Times*. **EN**

'I don't pick up my camera and say to myself that I should take a particular shot. I pick it up because of my response to the light, the way the light is rendering a particular subject. Artificial light to me doesn't have the artistic quality of natural light.'

JEANNE MOUTOUSSAMY-ASHE

Jeanne Moutoussamy-Ashe, *A young man reflects on his day as he goes home*, from the series 'Daufuskie Island', 1981

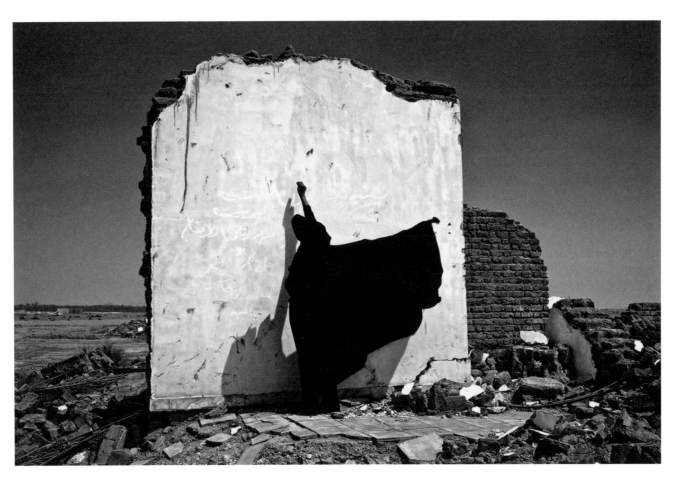

Isabel Muñoz, *Untitled*, from the series 'Bam', 2005

The body has always been central to Isabel Muñoz's approach to photography. One of her early images, *Flamenco Dance* (1989), shows two dancers from the waist down, their bodies emanating a powerful eroticism. The woman's legs are bare while the man is wearing trousers; the muscles in her thighs are tensed and she grasps him by the waist in a gesture that turns traditional power relations on their head.

From her early days studying at the Photocentro de Madrid, then at the Visual Studio and the International Center of Photography in New York, Muñoz has been inspired by the sensual movements of flamenco and bull fighting, both intrinsic to her Spanish culture. She has gone on to interrogate the theme of the body and the rituals surrounding it across a wide range of cultures, from the Mediterranean to Latin America, Africa and Asia. Muñoz has trained her camera on the sculptures of the Baroque era in Rome, moving bodies in Eastern and Latin dance, the contorted bodies of Turkish fighters, tattooed bodies of Mara gang members, and even bodies lost in mystic Sufi trances. She sees the body as a collection of coded signs, a sexual, social, spiritual and political entity, which can be subject to ecstasy and suffering but also to metamorphoses such as those undergone by trans people or the gods that she photographed for her series 'Mitologias' (Mythologies), which was exhibited by Christian Caujolle for Paris Photo Month in 2014. Her latest work, on primates and horses, explores the humanity within each animal and the animality within human beings. From 'Man' (1998) to '9 Gods' (2017), she has pursued a kind of anthropological research into humans and the universe. In her work, the body is often seen in parts: the feet, hands or chest are omnipresent. These body parts waiting to be reunited as a whole recall the

'I try to capture the body because that is how you capture a person's soul, their emotions, what their eyes have seen. That also says something about civilization.'

ISABEL MUÑOZ

architectural fragments of the Alhambra or the Khmer temples, which Muñoz has also photographed. The sense of touch creates a common link between the diverse communities that form the subject of Muñoz's work, going beyond their individual markers of belonging. She pays particular attention to the texture of skin, fabric and other materials in her photographs, and takes great care over her physical prints. She first came across the platinum printing process while at the University of Maine, where she was taught by Craig Stevens in the 1980s, and it quickly became her preferred method.

Muñoz has had multiple exhibitions across the world. Her work is a quest for new forms of expression; her black-and-white images, often shot in a large format, have a certain graphic quality and play with light, but they also have a documentary slant, as in the series 'Camboya herida' (The wounded Cambodia, 1996), which focused on disabled people in that country, or 'Bam' (2005), which shows the destruction caused by an earthquake in the Iranian city. For Isabel Muñoz, documentary photography can also be used to create sophisticated images, rich with symbolism. **HC**

b. 1951, Spain

Bente Geving, *Steam Bath II*, from the series 'Anna, Inga and Ellen', 1985

Bente Geving embarked on her artistic career in the early 1980s, just a few years after the cultural and political renewal of the Sámi people of northern Norway had begun. For her first exhibition, which was held at the Fotogalleriet in Oslo in the autumn of 1988, Geving presented a series of images entitled 'Anna, Inga and Ellen'. This project – a documentary portrait of the photographer's Sámi grandmother and her sisters – was the first to address a theme that has dominated Geving's art ever since: her attachment to and exploration of Sámi culture and Nordic landscapes.

In this series of black-and-white photographs, Geving portrays her grandmother and aunts with affection and respect, but her approach is nonetheless direct. Her subjects feel confident revealing their private worlds to the gaze of her camera: we see them tidying the kitchen, dancing with a tea towel in hand, taking a nap, singing hymns around the kitchen table, and even enjoying their weekly steam bath. Geving's documentary approach thus meets the requirements of Sámi art activists, who wanted their people to be represented in a modern manner, avoiding the conventional ethnographic images of herds of reindeer and the Sámi in their costumes in the mountains.

Geving also aligned herself with the Scandinavian documentary tradition of the mid-1980s by participating in a workshop given by the Swedish documentary photographer Anders Petersen, thus sharing a common aesthetic ground with Petersen and others who were influenced by Christer Strömholm. Like them, she produced intimate portraits in strongly contrasted black and white. But where these male photographers direct their gazes at 'exotic others' – transsexuals and prostitutes in Paris or clients in the rough bars of Hamburg – Geving turns her camera northwards. She was interested in the lives of the women in her own family, observing their closeness and their humble lifestyle while searching for her own identity and her connections with Sámi culture. Geving's photographs perform an alternative mode of historicity, responding to a world in which history may be just as much a burden as a source of power. They show that photography can work as destabilizing force in an area that, in both the distant and more recent past, has been defined by outsiders. **SL²**

'Using photography, I want to reveal the relationship between past and present, nature and culture, dream and reality.'

BENTE GEVING

Hengameh Golestan is one of the pioneers of contemporary Iranian photography. She first encountered the medium at eighteen years old, when she met the famous photojournalist Kaveh Golestan, whom she later married and with whom she collaborated throughout his life. Over the course of ten years, from 1974 to 1984, she developed her practice and built up a striking portrait of Iranian society around the time of the Islamic Revolution (1979). Golestan was committed to representing those who were least visible in society: women and children. She photographed them within the intimate space of their homes and recorded everyday life and family relations, especially at wedding ceremonies in Tehran, Kurdistan and other rural areas.

Golestan's photographs testify to her spontaneous approach, as her subjects are often captured while moving. They are strongly influenced by the context in which they were shot, with Golestan's aim being not simply to document an event, but to allow viewers to experience it. In terms of her visual style, her compositions have an improvised, vital quality and she sometimes colours certain portions of the images, often decorative objects such as rugs and blankets, or her subjects' clothing. These very precise, deliberate changes introduce often vibrant colours that highlight the subjective, emotional aspect of her documentary approach. At the same time, this technique evokes visual memories linked to old family photographs, which Golestan uses to revisit her own work.

In the series 'Witness 1979', Golestan stepped out from the domestic sphere to create a unique record of an important stage in the Islamic Revolution, a decisive moment for Iranian women. On 8 March 1979, Tehran was blanketed

> ## 'I take photographs using only my instinct and my emotions.'
>
> **HENGAMEH GOLESTAN**

in snow. On the eve of a march organized to celebrate International Women's Day, a dark cloud had been cast over events by a statement from the imam Khomeini, restricting women's rights and announcing that they must wear the veil in public. Golestan attended the march the following day and took pictures as it turned into a protest. The images that she captured have an undeniable historical value. Their power lies not only in the demands of these women, who came together from all professions and social classes to defend their rights; the courage and symbolic significance of their actions, captured by Golestan, who was in the middle of the crowd, bear powerful witness to female solidarity. After having observed them in domestic settings, Golestan showed in this series how women are also capable of making their voices heard in the public sphere. Her photographs were among the last to show unveiled women on the streets of Iran. Looking at these joyful, determined women, their expressions and attitudes as they speak up in public, it is clear that these images go beyond simply recording facts. They convey the ideas and emotions at the heart of this historic moment. To this day, the legacy of this protest can still be felt in Iran. **CP**

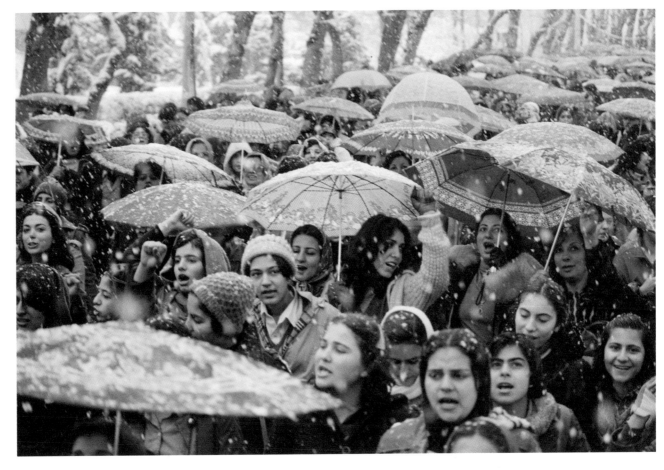

Hengameh Golestan, *Untitled*, from the series 'Witness 1979', Tehran, March 1979

The work of German-Canadian photographer Angela Grauerholz is shaped by an almost obsessive interest in archives, collections and the places where these are held. Rather than celebrating the grandeur of these institutions, like other artists such as Candida Höfer or Ahmet Ertug, Grauerholz's images invite the viewer to reflect on them, like the two men staring at an endless wall of books in her photograph *La bibliothèque* (1993). These figures could be seen as a stand-in for the artist; throughout her career, Grauerholz has emphasized the role of the individual in creating their own cultural reference points, both personal and shared. She explores how cultural memory is created, transmitted and made accessible, and questions the roles of the artist, curator and viewer in this process.

At Documenta 9 in 1992, Grauerholz replaced certain nineteenth-century paintings that were hanging in the Neue Galerie in Kassel with her own images, as a means of showing how the context in which a work is presented affects the way we view it. Three years later, for her installation *Eclogue or Filling the Landscape* (1995), she recreated the necessary conditions for preserving fragile artefacts, even going so far as to limit access to the exhibition, with visitors having to sign up for guided tours in which only specific museum employees were allowed to touch the exhibits. In *Sententia I–LXII* (1998), the reverse was true: this time, visitors could slide any of the thirty-one frames out of a specially created wooden cabinet, choosing whether or not to reveal the photographs within.

In an attempt at transparency, Grauerholz has also subjected her own archives to this treatment. In early 2000, a fire destroyed her library. She could not bring herself to throw away her books, instead keeping them in boxes, and a year later she used them to create a new artistic work. Moved by the beauty of these objects, which were now illegible, she started to question the intentions, format and structure of books. For *Privation* (2001–2), she scanned almost four hundred volumes, some more damaged than others, to create an overview of the writings that have influenced her thinking. She used a similar process for *Reading Room for the Working Artist* (2003–4), an installation made up of her own photographs and others that have inspired her, as well as postcards, brochures and newspaper cuttings. 'I needed to create a certain order in my own collection. To organize it, to give shape to something that was at once tangible and abstract – my memory. I wanted to create a project that would show how we, as artists, recognize and acknowledge the influence of our predecessors, and to show the public how our artistic process is born out of our experiences, what we read, the exhibitions that we visit and, depending on the artist, our daily life, both professional and personal.' **LB-R**

'My artistic practice has developed into, among other things, a criticism of museums as spaces that take certain works hostage.'

ANGELA GRAUERHOLZ

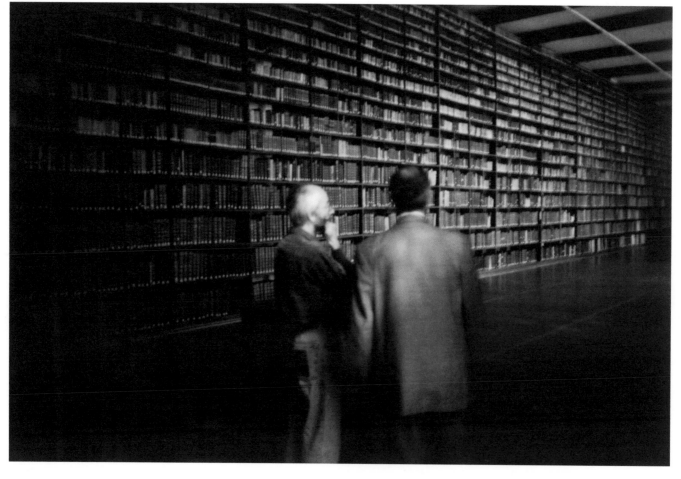

Angela Grauerholz, *La bibliothèque* (The library), 1993

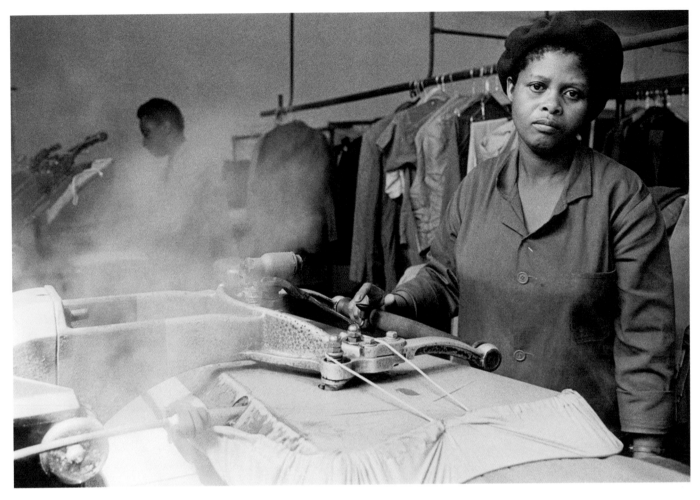

Lesley Lawson, *A woman presser operates the 'abortion machine' in a Johannesburg laundry*, 1983

Amid the political turmoil in South Africa in the 1980s, the need to document everyday life became apparent. The right-wing media had dehumanized Black South Africans, and the injustices of apartheid meant that it was now necessary to bring about change by wielding a camera. In 1981, Omar Badsha, Lesley Lawson and a group of other emerging photographers established Afripix, an organization whose role was to promote the development of socially informed documentary photography during apartheid and to challenge existing stereotypes surrounding the living conditions of Black citizens in the country.

Drawing on their daily experiences, the increasing number of community, labour and women's organizations and the rise of grassroots activism, many Afripix photographers moved away from the front line of the anti-apartheid struggle to document their communities and to show how people constructed their lives in difficult circumstances. This went against the more iconic fists-and-banners approach, and instead focused on football in the townships, commutes to and from work, and the social landscape of shebeens and beer halls.

In 1985, Lesley Lawson produced a book entitled *Working Women: A Portrait of South Africa's Black Women Workers*. Her involvement with various civil organizations, such as trade unions and health and literacy associations, enabled her to study the working conditions of many Black South Africans, especially women. Her photographs constituted a useful archive for the emerging women's movement in the trade unions, for whom she had worked.

The book is simple yet profound. Using both photographs and interviews, Lawson put together the personal stories of women at work and at home. Whether they show factory workers or office cleaners, these images reveal the plight of many women as they fought against gender discrimination and restrictive laws. Lesley Lawson's portraits remind us of the importance of paying tribute to those Black women who, during apartheid, strove continuously for better living conditions and showed extraordinary resilience and strength. **FM**[1]

Canadian photographer and writer Alix Cléo Roubaud, née Blanchette, had her own unique theory of and practical approach to image-making. Combining autobiography with conceptual exploration, her work, which was cut brutally short by her premature death in 1983, is at once intimate and theoretical, literary and physical. Roubaud took numerous self-portraits depicting her daily life, the places where she lived and her relationship with her husband, the poet and mathematician Jacques Roubaud, but she also produced more speculative series, in which she attempted to use images to define the essence of photography.

The private notebooks that she wrote towards the end of her life were posthumously released in 1984 (as *Journal*, 1979–83), but her theoretical texts remain mostly unpublished, although they represent an important part of her work. Roubaud studied philosophy – she had begun a thesis on the work of Austrian philosopher Ludwig Wittgenstein – and sought to establish a definition of the image. She explained some of her theories in Jean Eustache's short film about her, *Les Photos d'Alix*, released in 1980.

Roubaud's reflections on photography allowed her to develop a highly individual approach to the medium. Rather than focusing on the moment of capturing an image, she argued that negatives were the 'painter's palette' and that true photography could be achieved only through intense work in the darkroom. She systematically destroyed all the originals of her work once she had created the first prints, meaning that all of her surviving photographs are unique. Roubaud never tired of pushing the boundaries of the medium, conducting experiment after experiment in the printing process. That was how she developed her 'light-brush' technique, in which she used a narrow beam of light to draw on the light-sensitive surface.

Roubaud's well-known series 'Si quelque chose noir' (If something black), made up of seventeen images and exhibited for the first time at the Rencontres d'Arles photography festival in 1983, is emblematic of her work: it combines texts and images, staged scenes and experiments in form, self-portraits and explorations of aesthetics. Her work was rediscovered in the 2010s, and she was given a retrospective at the Bibliothèque Nationale de France in 2014. **HG**

'The act of printing: drawing something out of the darkness, bringing it to light. An act of remembering. Through memory, we can still "touch" the fragment of the world captured by photography.'

ALIX CLÉO ROUBAUD

Alix Cléo Roubaud, *Fifteen Minutes Overnight at Breathing Rhythm*, 1980

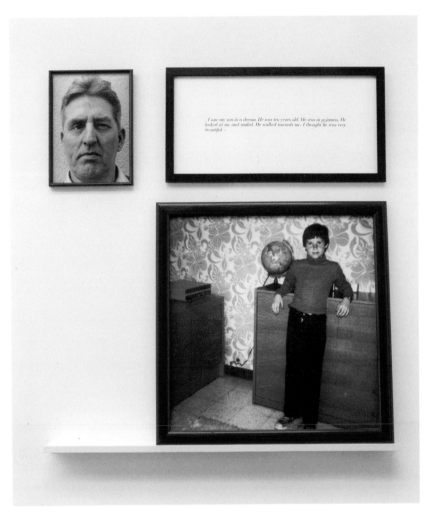

Sophie Calle, *My Son*, from the series 'The Blind', 1986

A photographer, writer, film-maker, performer and conceptual artist whose work revolves around exposure and appropriation, Sophie Calle has been active since the late 1970s, using a wide range of artistic media and approaches, which she reinvents and repurposes for each new piece. She transforms her personal experiences into performances, using a different set of rules each time, and combines texts, images and objects to create narratives and elaborate installations that are sometimes playful and sometimes serious. She uses her own life as raw material for her work. Her *True Stories* are emblematic of her approach, which transcends the real through the use of staging, literary allusions and art.

Calle's work reveals a taste for playing with multiple roles and mirroring: to create *The Shadow* (1981), she was followed by a private detective while, unknown to him, she also recorded her experience of being tailed. She explores the numerous facets of her personality, as expressed through different interpersonal relationships: her role as her mother's daughter in *Rachel Monique* (2007–14) and her father's daughter in *True Stories* (1988–2003) and *Autobiographies* (2010–16); as her husband's wife in *No Sex Last Night* (1992); as a friend in *Birthday Ceremony* (1980–93); as an abandoned lover calling out

'The lovers will have to live with the other's secret close at hand but out of reach.'

SOPHIE CALLE

to a vast network of her fellow women for help in *Take Care of Yourself* (2004–7); or as a character created by a writer's imagination in *Gotham Handbook* (1994). Calle also sometimes undergoes a transformation or assumes a false identity: impersonating a stripper in Pigalle in *The Strip Tease* (1979) or a chambermaid in Venice in *The Hotel* (1981). She even flirts with illegal activity in *The Address Book* (1983), made after she found a lost address book, photocopied its contents without the owner knowing and tried to find out more about the man it belonged to by contacting the names listed in it.

Calle's work is driven by a fascination with otherness: she has created multiple series focused on blind people and another about the residents of deprived areas in Istanbul (*Voir la mer*, 2011). Her approach dances on the line between intimacy and indecency, her work interrogating the role of the observer and the uncrossable distance between the self and the other. Her *Parisian Shadows* (1978–9) and *Venetian Suite* (1980) lead to abortive encounters; the unknown subjects of *The Sleepers* (1979) are at the mercy of the artist's purposes even as they escape from her into the refuge of sleep. In *Exquisite Pain* (1984–2003), suffering remains a lonely experience, despite all efforts to become lost in the pain of others. Calle even took this attempt to remove all distance between the self and the other to the extreme when she sent her bed to a Californian admirer in *Journey to California* (2003).

Sophie Calle's recent works are haunted by absence, whether in the empty frames of *Purloined* (1994–2013) or the deaths of those close to her. One particularly arresting image from *True Stories*, which focused on her father's illness, shows a ram blinded by its own horns, a symbol of the loss of sight, which prefigures and symbolizes death. **SV²**

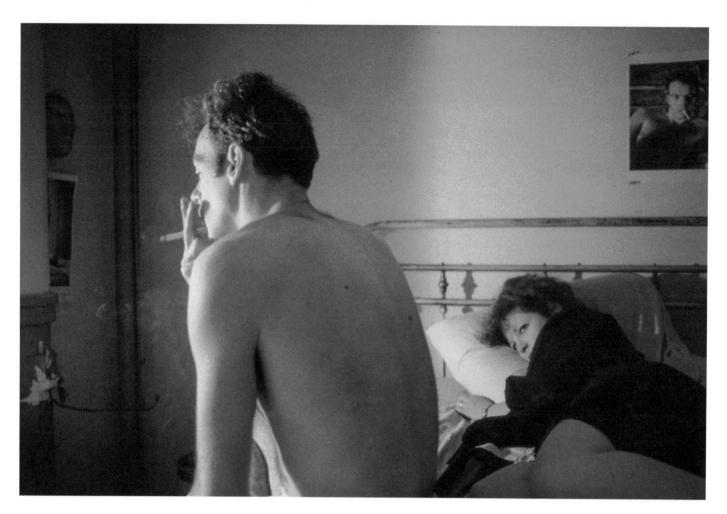

Nan Goldin, *Nan and Brian in bed, New York*, 1983

Nan Goldin's life and work are inextricably linked. Often called a photographer of intimacy, Goldin is inseparable from her camera, which she calls her 'substitute memory'.

Born in Washington into a family of academics, Nancy Goldin lost her older sister on 12 April 1965. Her parents retreated into silence, preferring to believe their daughter's death had been accidental rather than suicide, and the teenage Nancy escaped from her quiet home by seeking out marginal communities who refused to conform to the traditional American way of life. She met Suzanne Fletcher and David Armstrong in 1969 while studying at the experimental Satya Community School in Lincoln, Massachusetts, and started to take photographs of their cross-dressing games. It was Armstrong who gave her the nickname Nan and introduced her to the alternative scene in Boston.

Although her first pictures were black and white, Goldin quickly switched to colour when photographing those close to her: her friends, drag queens and members of the LGBTQI community. She preferred shooting with ambient light, although she sometimes used flash to introduce greater contrast and sharpness. She liked to show her images as projections; while she was a student at the School of the Museum of Fine Arts in Boston in the early 1970s, she presented them as slideshows.

In the late 1970s, she immersed herself in London's 'no future' punk culture, before moving to New York. She staged events at the bar in Times Square where she worked as a waitress, showing projections of her photographs set to a soundtrack. The images were of shared moments between friends, drug-taking and sexual scenes, as well as violence, illness and death, all set to music by Kurt Weill, Boris Vian and the rock group Creedence Clearwater Revival.

The Ballad of Sexual Dependency (1981), its name a reference to Bertolt Brecht and Weill's *The Threepenny Opera*, was shown as a slideshow in 1985 at the Whitney Museum of American Art in New York, while the photographs were published by Aperture. After being featured at the Rencontres d'Arles photography festival in July 1987, *The Ballad ...* was exhibited regularly at various galleries.

Throughout the early 1990s, Goldin's photographs were haunted by the spectre of AIDS. She was also inspired by her travels in Asia and her meeting with the Japanese photographer Nobuyoshi Araki, for whom, like Goldin, photography is like breathing. The two artists collaborated together in 1994, creating an exhibition and a book, both called *Tokyo Love: Spring Fever*. The following year, Goldin directed a film about her life and work, *I'll Be Your Mirror*. A retrospective at the Whitney Museum in 1996 saw her gain further international recognition. Nan Goldin's influence on contemporary photography is even stronger due to her teaching work at American universities such as Yale and Harvard. **LL**

'The camera is part of my daily life like talking, eating or having sex.'

NAN GOLDIN

For Carrie Mae Weems, photography is a way of correcting the invisibility of Black bodies, especially Black female bodies, in Western society, where they are often reduced to simplistic or degrading representations. She began taking photographs as an amateur at eighteen, before discovering *The Black Photographers Annual*, a collection that brought together the work of various African-American photographers, edited by the Kamoinge Workshop collective. Through this publication, Weems realized how important it was for African Americans to see themselves as active subjects who could create their own representations of themselves. Alongside this realization, over the next few years, she also became interested in Marxist and feminist theories.

In the early 1980s, Weems began regularly using text and incorporating a performative element into her pictures. This was a way of disrupting traditional norms in documentary photography: 'for my photographs to be credible, I needed to make a direct intervention, extend the [documentary] form by playing with it, manipulating it, creating representations that appeared to be documents but were in fact staged. In the same breath I began incorporating text, using multiples images, diptychs and triptychs, and constructing narratives.' Using these new techniques, series such as 'Ain't Jokin' (1987–8) and 'American Icons' (1988–9) were sharply critical of stereotypes about African Americans. 'The Kitchen Table Series' (1990) has also become iconic. The photographer posed in her kitchen, alone or with people who appear to be family members or friends. The poses are static, controlled and perfectly composed. The texts accompanying the images are made up of common clichés. As Weems explains, this series was a response to the need to examine the 'ways in which women had been discussed in film, theater, and photography': 'I needed to speak of representation and systems.' Weems uses her own body and the medium of photography as a means of openly addressing the problems linked to the 'idea' and 'consequences of power', as well as its role in structuring social and familial relationships. In her later works, Carrie Mae Weems uses aspects of African heritage to reflect on the way in which history is constructed and on the role of memory. **JJ**

'I realized at a certain moment that I could not count on white men to construct images of myself that I would find appealing or useful or meaningful or complex. I can't count on anybody else but me to deliver on my own promise to myself.'

CARRIE MAE WEEMS

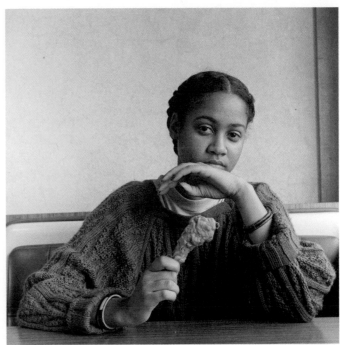

BLACK WOMAN WITH CHICKEN

Carrie Mae Weems, *Black Woman with Chicken*, c. 1987–8

It is February in Lagos, 1977. The sun-stained sky is clear, relegated to a fine sliver of white above the curve of the Nigerian National Stadium's rounded stands, which are packed to the brim. A young Nigerian Navy-man is spotted in the crowd: standing tall, shoulders eased back. He wears a spotless white uniform, cap positioned atop his slightly tilted head. His eyes are softened, and he sports an easy-going smile – teeth slightly visible between lips spread wide, propped up by strong chin. He leans against a placard that reads: 'NIGERIA, FESTAC '77'. As an announcement of the time, place and occasion, it is rather matter-of-fact, elegantly executed in tightly controlled typography. A group of thirteen southern African male dancers inhabit the remainder of the image, their limbs overlapping, some crouched, others bent, all standing closely. Most are unaware of the Nigerian sailor, and of the image that is being taken. Only the sailor retains strong eye contact with the photographer, Marilyn Nance.

A Brooklynite fresh out of the Pratt Institute, Nance was only in her early twenties when she joined more than fifteen thousand artists, intellectuals and performers from fifty-five nations in Lagos in early 1977 for the Second World Black and African Festival of Arts and Culture (FESTAC). Taking place in the heyday of Nigeria's oil wealth and following the African continent's potent decade of decolonization, this event marked the peak of pan-Africanist

and diasporic expression. As a photographer for the US contingent of the North American delegation, Nance took more than fifteen hundred images throughout the course of the festival.

To date, her archive is the most complete photographic representation of FESTAC, chronicling the exuberant intensity and sociopolitical significance of this singular event from her perspective as an African-American woman photographer. Recognizing FESTAC's foundational role in the collective memory of the Black Arts movement in the United States, Nance's work offers a rich entry point for understanding the festival's undeniable spirit and propulsive force, which gathered notions of pride and continuity throughout the African continent and across the African diaspora.

Following FESTAC, Nance went on to produce photographs that under-scored the vitality of political and spiritual life in Black communities across the United States. With subject matter spanning the Oyotunji African Village in South Carolina, the Audubon Ballroom in Manhattan, where Malcolm X was assassinated in 1965, and churchgoers in Brooklyn, throughout the course of her career Marilyn Nance has photographed unique moments in the cultural history of the US and African diaspora, culminating in an expansive body of images of late twentieth-century Black life. **OCO**

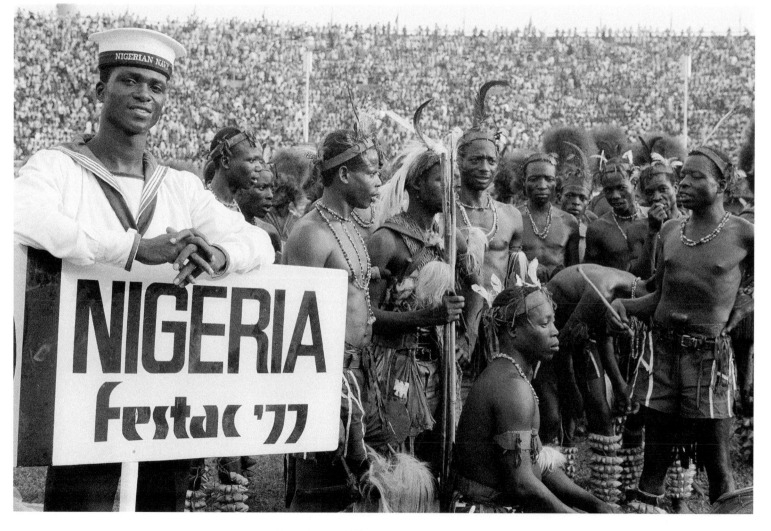

Marilyn Nance, *NIGERIA Festac '77*, 15 January 1977

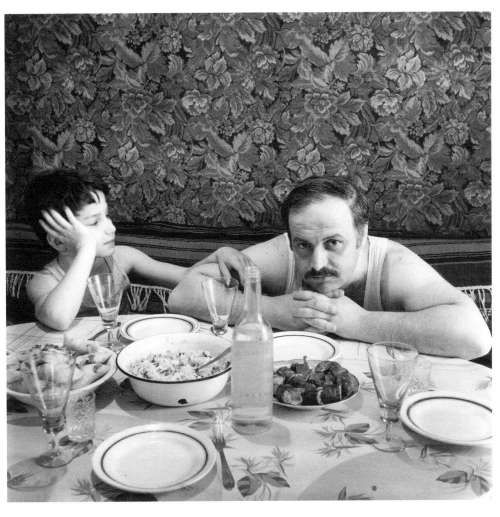

Rita Ostrovska, *My husband Alik with our son Sasha*, Bila Tserkva, Ukraine, 1988

Rita Ostrovska created her first portraits at the age of fourteen. She had acquired a small camera and a striking rangefinder with an eighty-centimetre string that she placed on the nose of the person she wanted to photograph – a technique that allowed her to break the ice and maintain the shortest possible distance between herself and her model. This desire to observe the world carefully and affectionately can be seen in all of her work.

One of the few female photographers in Soviet Ukraine, Ostrovska is generally seen as a documentary photographer. However, looking at her work, it is difficult to say exactly what she sought to capture: what she saw? A projection of herself in what she saw? Or how what she saw was reflected in herself? Perhaps we cannot even speak of 'seeking'? Ostrovska said of her own approach, 'When you contemplate your subject, the feeling is completely different from what you feel when you try to capture something. You begin the process of taking a picture and the subjects reveal themselves before your eyes. That is the ultimate pleasure.'

Ostrovska's main photography lab was in her marital bedroom, where she worked on her prints at night. She also set up a darkroom in a tiny room in the building where she worked during the day, and bought a 6 × 6 camera (her preferred format) and a tripod. Ostrovska's early images had a long exposure time, which allowed her to 'go from being a judge to being an observer'. In the early 1980s, in this room 'near the toilets', she developed the first photographs in her series 'Family Album': 'At that moment, I felt like I had found my path.'

The work of art photographers from the West rarely made it across the Iron Curtain, which makes it all the more surprising that Ostrovska's pictures do not really adhere to the Soviet Union's ideology; instead, they fit seamlessly into the wider history of photography, sitting easily alongside the work of legendary female photographers such as Julia Margaret Cameron or Diane Arbus. Today, her works can be found in private and public collections across the world.

'I created portraits of everything', said Ostrovska. These 'portraits', to use her word, are of water and fire, of her house, of abandoned Jewish villages, of Jewish cemeteries, of members of her family and friends who left the Soviet Union after it collapsed. In all of her series, the immediate and the eternal merge together. For Ostrovska, everything begins and ends with light and shadow. They are the alpha and the omega of her photographic universe. 'Everything is born of light and shadow. Above all else, photography is painting with light', she said. 'And there is so much to discover in that! The divine beauty of the world!' **NGB**

'I've always listened to my intuition and I created, as I call them, "portraits of everything".'

RITA OSTROVSKA

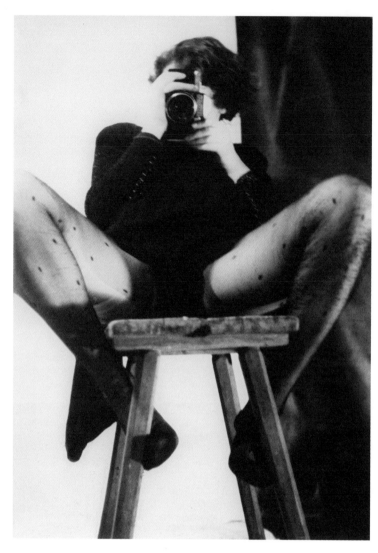

Gabriele Stötzer, *Self-Trial before a Mirror*, 1984

'I wanted to believe in myself as a woman, wanted to believe in women as a driving force in society, wanted to believe in art as a way of existing outside of the State.'

GABRIELE STÖTZER

A major figure in the underground art scene in East Germany, Gabriele Stötzer (known as Stötzer-Kachold until 1991) was born in a village in Thuringia. Her life and work were shaped by a refusal to submit to authority, which showed itself early on. In 1976, when she was a student at the Erfurt School of Education, she wrote a letter to the Minister of Education in support of a fellow student who had been expelled for criticizing the curriculum, and was expelled herself.

That same year, a petition against the expatriation of controversial singer Wolf Biermann was circulating in Berlin, and Stötzer organized a similar protest in Erfurt, for which she was sentenced to a year in the women's prison at Hoheneck, where conditions were notoriously bad. This experience led her to embrace her identity as a woman and a dissident, as well as to appreciate her body's potential as a means of expression, and she began to assert herself as a writer and artist. After her release in 1978, Stötzer published numerous articles in the underground press, reporting on conditions in prisons and their traumatic effects on inmates, both physical and psychological.

Stötzer began taking photographs in 1980 and became more prolific from 1983 onwards. Her work was marked by a subversive feminine aesthetic that centred on exploring the body – her own as well as that of her models. She often collected her works into large-format books, where individual pages could be detached and exhibited at private events. Works such as *Heilerde* (Healing earth, 1983), *Carmens Schrei* (Carmen's scream, 1983) and *Spiegelreflexion* (Mirror reflection, 1984) convey a kind of despair and isolation but are also imbued with energy, desire and a dreamlike quality. While Stötzer's work highlights feminist concerns – denouncing the patriarchal structures that shaped the East German art scene and reinforced the state's stranglehold – works such as *Trans als Mann* (Trans as a man, 1985) also display an interest in the shifting borders between genders, a subject that was seen as taboo in East Germany.

Braving state prohibitions and constant surveillance by the Stasi secret police until 1989, Stötzer worked on numerous joint initiatives, often with other women: she ran a private gallery, organized outdoor events in the forest, put on 'fashion and object' shows, co-directed films and founded an artists' collective that evolved over the years and was named Exterra XX after the fall of the Berlin Wall. She was also involved in Erfurt's punk scene and transformed the occupied building at 41 Pergamentergasse into an artists' space dedicated to various disciplines, following the Bauhaus model. Her personal work took the form of performances, photographs, Super-8 films, textile works, sculptures and drawings.

In the days that followed the fall of the Berlin Wall on 9 November 1989, Stötzer occupied the Stasi headquarters in Erfurt to prevent the archives from being destroyed. To this day, she continues her activism, publishing works that testify to her political, feminist and artistic engagement in the former East Germany. **SV²**

Relying on a process of careful consideration and preparation, Pesi Girsch stages photographs that unite her chosen subjects with their setting, the time of day, and the ambient light and shadow, creating clear, theatrical images without recourse to darkroom manipulations or digital retouching. They resemble complex rituals of life and death, or impossible situations or events. These scenes are a form of introspection through which Girsch considers herself and her past, echoing her childhood memories. She was born in Munich, the daughter of Holocaust survivors, after the Second World War, and became aware of its horrors only in adulthood, when she was exposed to the contrast between her Jewish family and her Christian environment. Her mother encouraged her to study art in Israel, where she emigrated at the age of fourteen. She initially focused on figurative sculpture: it was only when she studied at HaMidrasha Faculty of the Arts that she discovered the medium of photography and became captivated by it.

Over the years, Girsch has developed a very personal style, and has been described as an outsider. Her photographs can be divided into series on the basis of their subject matter. Staged landscapes are a prominent theme: she chooses models from among her family and immediate social circle, and has them pose in a natural setting without looking at the camera. As a result, the camera focuses on their bodies rather than their individual features. Truncated, their body parts resemble broken pieces of classical sculpture or sacred relics, but in fact Girsch was inspired by horrific photographs that she discovered in a book about the Holocaust that her grandmother had hidden. Her own works, which she places in boxes or metal frames, invite the viewer to participate in a kind of ritual: they are obliged to open the boxes to see the images or, alternatively, to close them, thus establishing a connection but also recalling the crematorium doors of concentration camps.

Animal still lifes are another prominent theme in Girsch's work. Dead birds, laboratory animals and cockroaches – which usually evoke a reaction of disgust – are treated as if they were precious objects and given back some dignity. For some subjects, she uses soft, refined compositions that arouse compassion and appeal to our sense of touch, while on others she bestows a certain splendour or beauty, placing them on serving dishes. Expressing loneliness and anxiety and an empathy for the weak, bruised or suffering, Girsch's images are all related to her personal experiences and her sensitive nature – a quality borne out by her private life, in which she embraces and supports her acquaintances and is in turn surrounded by the abandoned cats for which she cares. **YC**

'Drawing attention to animals, but also human beings who are marginalized, everything that's at the bottom of the food chain – that's what I wanted to do: to save and be saved.'

PESI GIRSCH

Pesi Girsch, *Fawn, dead from hunger*, 2000

Shelley Niro

Since the late 1980s, multidisciplinary artist Shelley Niro has been creating mixed-media works that combine photographs, beadwork, archive images, family photos, videos, traditional objects and installations. Born in the town of Niagara Falls (in New York state), on the US–Canadian border, Niro grew up in Brantford (Ontario, Canada). A member of the Mohawk nation from the Six Nations reserve (Turtle Clan, Bay of Quinte), she challenges stereotypical representations of the Indigenous people of Canada and the United States. The reductive clichés that paint Native Americans as either victims or warriors have dominated North American society since the era of colonization, and they permeate all of popular culture, especially cinema, but also the media and public opinion. Niro's work evokes the violent impact of colonization by European settlers, but also often surprises with its humour and irony.

Niro pays particular attention to the place and role of women in Indigenous communities. She places her self-portraits, as well as her portraits of female friends and family members (her mother, sister and daughters), alongside political messages about questions of sovereignty and resistance. The photographs make use of heightened, vibrant colours to highlight the clothing and make-up, emphasizing how culture is passed down from woman to woman.

This critique of oppression – both patriarchal and colonial – is also strongly felt in Niro's series 'The Shirt' (2003). She took these photographs during production on the film of the same name. Made up of nine large-format light boxes, the work allowed Niro to bring together her interests in performance, film and photography. Against the backdrop of a Texan landscape, the artist Hulleah J. Tsinhnahjinnie, a member of the Dene nation, poses wearing different T-shirts emblazoned with slogans such as 'My ancestors were annihilated, exterminated, murdered and massacred', 'Attempts were made to assimilate, colonize, enslave and displace them', and 'And all's I get is this shirt'. Tsinhnahjinnie also poses bare-chested, with her arms crossed, displaying and reclaiming her partially naked body as an act of resistance. The light boxes are flanked on either side by photographs of the landscape, highlighting the importance of the land in the fight for Indigenous people's right to self-determination. Parodying souvenirs bought by tourists, the T-shirts embody memories of colonialism; their simple, clear, direct messages, presented to the general public, defy stereotypes and open up a space to explore new narratives about North America's colonial history. **GM²**

b. 1954, Canada

Shelley Niro, *The 500 Year Itch*, 1992

'As I contemplate the years that have culminated until now, I feel the Indigenous world has increased in knowledge, awareness, justice and imagination.'

SHELLEY NIRO

398

'It was in the tradition of regular self-portraits,
out of the curiosity of studying a face.'

CINDY SHERMAN

Cindy Sherman, *Untitled*, 1976/2000

It was while studying at the State University of New York College at Buffalo in 1975 that Cindy Sherman created the series 'Untitled' – her 'first real work of art', as she called it. The series is made up of twenty-three small headshots (mostly black and white, although some were hand-coloured) in which she transforms herself from a serious-looking student into a sexy pin-up. In her early works, she focused on her face, exploring how it could be altered through make-up and facial expressions. Shortly afterwards, she moved on to cutting her full silhouette out of photography paper. The series 'Bus Riders' also started off as cut-out figures. She dressed up as thirty-five different passengers on a public bus: the driver, an exhausted woman with her shopping bags, gossiping schoolchildren and the rebels smoking at the back of the bus.

In the summer of 1977, Sherman moved to New York and began work on her series 'Untitled Film Stills'. These seventy photographs, in which she poses in various costumes to explore representations of women in cinema, have rightly become iconic images in the history of art. Although they do not reference specific scenes from real films, the photographs are imbued with a neorealist, film-noir sensibility and recall the cinematic language of Hitchcock, Antonioni and Godard. Born in 1954, Sherman belonged to the generation for which television was a novelty. As a child, she loved watching classic films such as *King Kong*, *Citizen Kane* and *La Dolce Vita*. The meaning of her 'Untitled Film Stills' is hard to pin down. A woman wearing a black dress stands in a room, staring at the doorway. Her pose seems to suggest that something bad is about to happen. Who is about the enter the room? Is there a danger lurking outside?

Throughout the 1980s and 1990s, Sherman turned her attention to a new theme: the abject, which she explored through compositions featuring dolls, masks and prosthetics. For around twenty years, her work has engaged with the phenomenon of ageing. Her models in 'Hollywood / Hampton Types' (2000–2) are older women harking back to their youth. In 'Society Portraits' (2008), Sherman confronts the viewer with a series of portraits of women from the upper echelons of American society, whose faces have been altered through cosmetic surgery to hide their age. The pictures have an oppressive atmosphere; they emanate a certain majesty, but also a touching sense of sadness. 'I have a lot in common with these women', says Sherman. 'They give an impression of having experienced a lot of hardship, of being survivors.' In 2016, Sherman created the series 'Flappers', in which she poses as ageing 1920s film stars, who refuse to be dismissed despite their older age: 'I, as an older woman, am struggling with the idea of being an older woman.'

Cindy Sherman publicly acknowledges how difficult it is for a woman to grow old with dignity. The photographs in which she dresses up as mature women serve to give them greater visibility. And that is admirable, because it is a taboo subject. Older women are rarely so visible in television or film, or in the worlds of fashion, advertising, politics and art. **GS**

Karen Knorr

b. 1954, Germany

'Storytellers have a fundamental role. They exist in order to help explain our world and our place within it, encouraging us to develop as individuals, to discover meaning, and to teach and nurture future generations.'

KAREN KNORR

Karen Knorr, *I live in the nineteenth century*, from the series 'Belgravia', *c*.1979–81

Working independently and collaboratively since the late 1970s, Karen Knorr employs visual and textual strategies of disruption to interrogate cultural heritage, social behaviours and structures of power and influence.

Born in Germany of American-Polish and German-Norwegian descent, Knorr grew up in Puerto Rico and studied photography and fine art in New Hampshire, Paris and London. As a student in 1976, she collaborated with the Swiss photographer Olivier Richon on a series documenting London's punk subculture. This early work reveals Knorr's desire to 'problematize' the documentary mode and its 'naive theories of reflective realism'. An artist statement accompanying the series revealed her desire 'to get away from the candid strategy of the invisible but truthful hit-and-run photographer, as well as avoiding the rough, grainy picture associated with that mode of working'.

The series 'Punks' (1977) earned Knorr a place at the Polytechnic of Central London on a radical theory-driven photography course led by the artist Victor Burgin. The course immersed Knorr in post-structuralist theory and led her to engage with cultural studies, film theory, literature and psycho-analysis. Her work from this period combines social commentary with a deconstruction of the relationship between image, text and meaning. In both 'Belgravia' (1979–81), first exhibited at La Remise du Parc, Paris, in 1980, and 'Gentlemen' (1981–83), Knorr juxtaposed meticulously staged portraits with short statements constructed from journals, books and newspapers, using humour and irony to address questions of power and privilege in Margaret Thatcher's Britain.

Knorr was the subject of a retrospective exhibition at the Moderna Museet, Stockholm, in 1993. Around this time, she began creating composite images using digital and analogue technologies, which she likened to '*phototissage*, a form of photographic stitching or weaving'. 'Fables' (2003–8) combines architectural images of cultural sites with photographs of live or taxidermied animals, photographed separately and digitally inserted into each location. Roaming through these spaces, the animals function as a disruptive tool, intended to defamiliarize and to highlight dissonance between nature and culture.

Further series by Knorr have parodied ideas of beauty and taste within contemporary British culture ('Connoisseurs', 1986–90); explored financial institutions and their relationships to trade and industry ('Capital', 1990–1); and questioned the various legitimizing power structures at play in the art academy ('Academies', 1994–2005).

Karen Knorr's work is included in several international collections and has been exhibited worldwide. Alongside her role as professor of photography at the University for the Creative Arts, Farnham, Knorr is a passionate advocate for women in photography and mentors international artists and curators. **SJ-G**

'Society has withdrawn its contract from these young people: can they now be expected to live by its rules?'

TISH MURTHA

At the age of twenty, Patricia 'Tish' Murtha applied to study documentary photography at the Newport College of Art in South Wales. During her interview, the Magnum photographer David Hurn asked Murtha what she wanted to photograph. Her response secured her a place on the course: 'I want to learn to take photographs of policemen kicking kids.' Hurn later acknowledged: 'I knew exactly what she meant and knew she had the deep passion and drive to be a social photographer.'

Murtha, the third of ten siblings, grew up in a working-class community in Elswick, Newcastle-upon-Tyne, against a backdrop of economic depression and industrial decline in the north of England. From an early age, photography offered her the means to express her anger at the poverty, injustice and social malaise she saw around her. Part of a new wave of university-educated documentary photographers in the 1970s interested in exploring British society, Murtha stood out from her contemporaries for her commitment to documenting marginalized working-class communities from the inside. The people who feature most frequently in her photographs are those with whom she had grown up. When she was working away from Newcastle – for the series 'Newport Pub' (1976–78), produced while she was studying in Wales, or 'London by Night' (1983), a series critiquing the sex industry in Soho, commissioned by the Photographers' Gallery – Murtha took care to integrate herself into the communities she was photographing, devoting time to developing friendships and building a relationship of trust.

Hired as a community photographer by Side Gallery in Newcastle in 1978, Murtha made some of her most significant bodies of work during this period. 'Juvenile Jazz Bands' (1979) focused on troupes of children's marching bands, a distinctive feature of life in mining villages. In 'Youth Unemployment' (1981), Murtha revealed, in devastating detail, the impact of deindustrialization on her own friends and family in west Newcastle, where levels of unemployment were double that of the surrounding areas. Described by photographic historian Val Williams as 'a mute opera of social passion, set in a theatre of decline and decay', Murtha's photographs reveal tender moments of camaraderie between friends while making evident the extent of social deprivation in the North East. 'Youth Unemployment' exposed the listlessness and dissatisfaction of a young generation with no employment prospects, and stimulated real discussion about the effects of government policy. Murtha's series, which included a scathing written statement, was referred to during a parliamentary debate about the government's failure to provide meaningful futures for young people.

Murtha suffered a brain aneurysm in 2013, the day before her fifty-seventh birthday. Posthumously, her work has been exhibited, published and collected by various national institutions. **SJ-G**

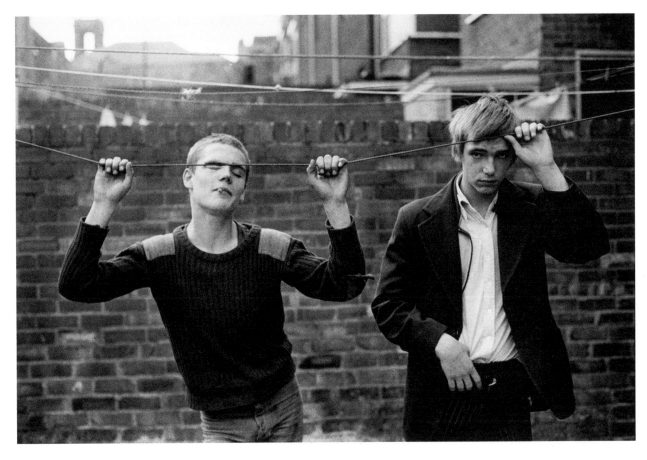

Tish Murtha, *Untitled* from the series 'Youth Unemployment', 1981

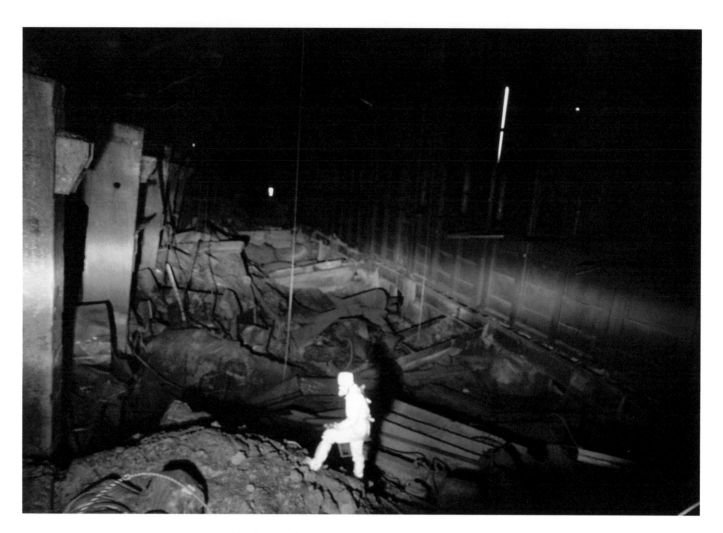

Victoria Ivleva, *Dosimetrist Yuri Kobsar climbs radioactive debris inside the fourth reactor at Chernobyl nuclear power plant*, 1991

'I always side with the weak.'

VICTORIA IVLEVA

Victoria Ivleva is a photographer, journalist and human rights activist. Born in Leningrad in 1956, she graduated from the Moscow State University faculty of journalism in 1983 and began working as a freelance photographer and journalist, documenting conflicts in the various Soviet republics at a time when the whole of the USSR was undergoing dramatic historical change. In 1990, she worked in Nagorno-Karabakh, a territory disputed between Armenia and Azerbaijan. That same year, Ivleva took a series of photographs in female prisons in Chelyabinsk and Samara. This project, which focused on motherhood and infancy in prison, showed pregnant inmates as well as young mothers separated from their young children, who were kept in special childcare facilities and saw their mothers only at feeding time. Her visual language is lyrical, and her work is full of compassion for the women who have little hope of a better life after their release. Ivleva returned to this topic in 2013, travelling this time to a women's prison settlement in Nizhny Tagil.

In 1992, Ivleva received the World Press Photo Golden Eye award for her photographic series taken inside the ruined fourth reactor of the Chernobyl nuclear power plant the previous year. She is the only journalist in the world to have stepped inside that reactor, at extremely high risk to her health. Her pictures depict the wreckage of the reactor, the personnel still working there, and the eerie deserted city of Pripyat, which was evacuated in 1986. For two years, in 1992–3, Ivleva captured the consequences of Tajikistan's little-publicized civil war, which left tens of thousands dead or displaced and destroyed the country's economy. In 1994, she accompanied humanitarian missions to Rwanda at the height of the genocide.

Russia's *Novaya Gazeta* is the only periodical that employed Victoria in-house, but her work has been published in many other Russian and international newspapers, including *Ogonyok, Moskovskiye Novosti, Der Spiegel, Le Figaro,* the *Guardian,* the *New York Times* and the *Independent.*

In 2007, Victoria Ivleva received the Golden Quill Award from the Russian Union of Journalists and, the following year, the Gerd Bucerius Free Press of Eastern Europe Award. Today she continues to work as a photojournalist, documenting conflicts in both photographs and the written word, her main focus being the fate of the oppressed and the suffering of people whose lives have been affected by disaster. **MG²**

Although she is considered one of India's most important women photographers, Pushpamala N. has rarely taken a photograph. Instead, she meticulously designs the sets for her tableaux – in which she often poses as the principal figure – which are then shot by a photographer-collaborator, thereby questioning the conventions of photographic authorship. As a performer, she generally shows an impassive face that provides no insight into her state of mind. She gave her first live performance as recently as 2010 and manages to keep her stage fright at bay by performing for only the camera, which acts as mediator between her artistic persona and the public. Pushpamala N. is therefore a photographer who does not take photographs and a performer who does not perform in public, but she is nonetheless a full-time photo-performer.

Pushpamala N.'s staged self-portraits often take inspiration from vernacular Indian sources, with one important exception: the 'Hartcourt Set' (2009), a series commissioned by the Centre Pompidou in Paris. Her decision to re-enact a famous image of the nineteenth-century courtesan Countess of Castiglione reveals her elective affinities. Like the countess, Pushpamala N. loves masks and asserts her right to objectify herself, but on her own terms. Her best-known series, 'Native Women of South India: Manners and Customs' (2000–4), produced in collaboration with the English photographer Clare Arni, is an amalgam of quotations from Indian popular culture. The artist masquerades as goddess, tribal member, film star, knife-thrower and circus girl: a selection of archetypes recreated with such obsessive fidelity that they end up highlighting their contrived nature. Her 'Ethnographic Series' (2004), a series of re-enactments of nineteenth-century ethnographic portraiture, is remarkable for its subversive use of the measuring tools central to the nascent discipline of anthropology. The grid, the ruler, the arm-stand and the calipers are kept centre stage, along with the main figure. However, the viewer is also invited to observe activity off stage: for instance, at the edge of the photograph we can see a hand propping up a backdrop, revealing one set within another.

However, there is no need to travel so far back in time to retrace the artist's fascination with photography's classifying impulse: her self-portrait as a criminal (2004; inspired by a newspaper image from 2001), in which she performs as a miscreant with a descriptive plaque hanging from her neck, is a playful homage to police mug shots and yet another testament to this photographer's taste for parody. **LMD**

'My work has introduced humour, wit, irony, satire and emotion into photography. It has created an interest in discredited forms … and brought a conceptual versus a documentary vision into Indian photography.'

PUSHPAMALA N.

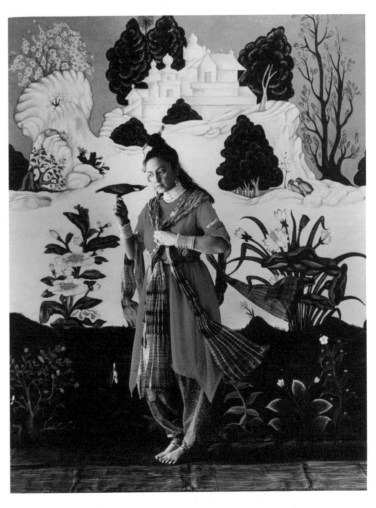

Pushpamala N., in collaboration with Clare Arni,
Yogini (after a sixteenth-century miniature, Bijapur), from the series
'From Native Women of South India: Manners and Customs', *c*. 2000–4

Bárbara Allende Gil de Biedma first encountered photography in post-Franco Spain in the late 1970s. At the heart of the countercultural Movida movement, she began to develop a body of work that she described as an attempt to 'make the everyday sublime'. Driven by a passion for painting, which she had loved from a very young age, Bárbara Allende decided to study painting, drawing and sculpture. In 1976, a friend suggested that she should enrol at the photography school Photocentro de Madrid. The photographers Pablo Pérez Mínguez and Jorge Rueda, who were also involved in the groundbreaking magazine *Nueva Lente*, were bowled over by her work. Their enthusiastic reaction led to her photographs quickly gaining wider recognition, and she was featured in the book *Principio: Nueve jóvenes fotógrafos españoles* (Principio: new young Spanish photographers, 1976). Allende also exhibited her work at the ninth edition of the Rencontres d'Arles photography festival in 1978. From then on, she taught herself, leaving behind black-and-white photography and starting to colour her images using watercolours.

Allende moved to Barcelona in 1978, and a year later she created 'Peluquería' (Hair salon), a series of humorous, Surrealist portraits showing her circle of friends sporting incongruous accessories – octopuses, shoes and knives. The series was exhibited at the Spectrum-Canon gallery, whose founder, Albert Guspi, suggested that Allende sign her name as 'Ouka Leele'. This pseudonym, taken from a constellation drawn by the Spanish painter El Hortelano, allowed Allende to lean into the mystical aspects of her approach to art.

After stays in New York and Mexico, Ouka Leele returned to Madrid in 1981, at the height of Movida, a multidisciplinary artistic movement that sprang up in reaction to the suppression of culture under the Francoist dictatorship. In the midst of this whirlwind, Ouka Leele turned away from social critique and began using her work to explore the flesh, mysticism and Surrealism. Her experiments in form allowed her to redefine genres such as the portrait, still life and mythological scenes.

Ouka Leele's creative process includes many stages: first conceiving the subject of a photograph, then setting up the shot, creating a black-and-white print and adding colour. For her, photography is just one aspect of an artistic practice that includes theatre, performance (implicit in her process and the way in which she directs her models), painting and photography. **AVB**

'My name is Ouka Leele, I am the artist of the mystical-domestic. I say this because people interpret my images as a social critique, when in fact it's the exact opposite: it's about taking the everyday, the domestic space, and making them sublime.'

OUKA LEELE

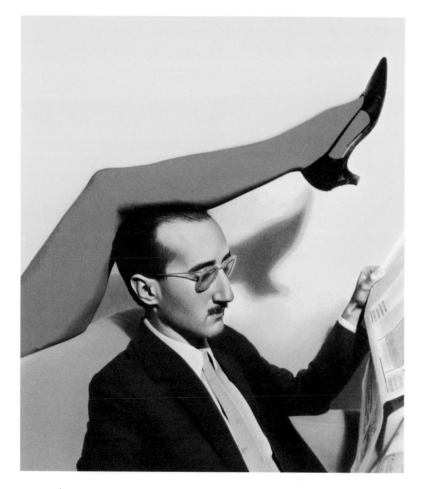

Ouka Leele, *Roman School*, 1980

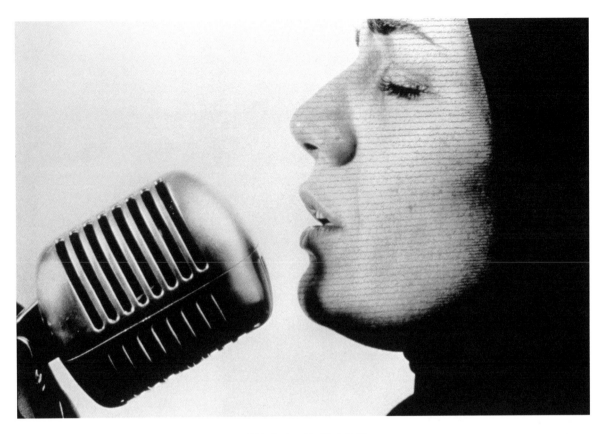

Shirin Neshat, *Mystified*, 1997

Born in Qazvin, Iran, Shirin Neshat moved to the United States in 1974. When she returned to her homeland a decade after the 1979 Revolution, she found a country radically changed by the Islamic regime, most obvious in the obligation of women to wear a headscarf. For Neshat, it was as if colour had disappeared completely, leaving only black and white. It was this observation that resulted in her 'Women of Allah' series (1993–7). Her black-and-white portraits represent women wearing the chador, holding weapons and gazing with intent; the images are overlaid with texts by the contemporary poets Forough Farrokhzad and Tahereh Saffarzadeh. Farrokhzad's poetry speaks of the personal struggles of women against social codes rooted in religion, but also the strength of their desires. As for Saffarzadeh, she explores the complex question of martyrdom, a notion that, in the West, is often presented in a way that is both simplistic and stereotyped. With this series, Neshat sought to transform 'the feminine body into that of a warrior, determined and even heroic'. Her works transform the body into a battleground where politics and language collide, breaking down orientalist tropes of female submission by showing women who are empowered.

Neshat went on to produce numerous films, including *Turbulent* (1998), in which she addresses the duality between her native culture and her identity in exile, at the same time as constantly questioning social, cultural and religious codes and taboos. Poetic language – both visual and textual in form – and politics come together in powerful photographs and videos such as *Fervor*, *Soliloquy*, *Passage* and *Tooba*. The series 'Women Without Men' (2009) comprises five films whose heroines are searching for an identity and sense of individuality.

Neshat also found inspiration in the stories of those who had participated in the 2009 Iranian Green Movement and the Arab Spring for her series 'The Book of Kings' (2012). Borrowing its title from the thousand-year-old

'Being the product of a revolution, my life and my work seem to be permanently traversed by a dual political and personal dimension. My job is to mediate between facts and the imaginary, the unbelievable.'

SHIRIN NESHAT

Persian epic *Shahnameh*, which recounts the heroic deeds of former rulers, the series is an ode to patriotism, nationalism, politics, history, revolt and heroism. Comprising photographs of individuals divided into three categories – the 'Masses', the 'Patriots' and the 'Villains' – it explores the paradoxes of past and present, of power and submission, through a poetic combination of portraiture and history. Neshat again inscribed each photograph with verses in Farsi by contemporary Iranian poets, giving a voice to the figures in the 'Masses' and 'Patriots'. The 'Villains', however, are painted with red and black acrylic tattoos depicting warriors and battle scenes from the Persian manuscript. The mythological archetypes of kings and heroes suggest parallels between events in contemporary Iran and the history of Persia.

For her groundbreaking and arresting work, Neshat has received many international awards, including the Praemium Imperiale Award (Tokyo, 2017), the Crystal Award at the World Economic Forum (Davos, 2014), the Silver Lion at the 66th Venice Film Festival (2009), and the First International Prize at the 48th Venice Biennale (1999). **KG²**

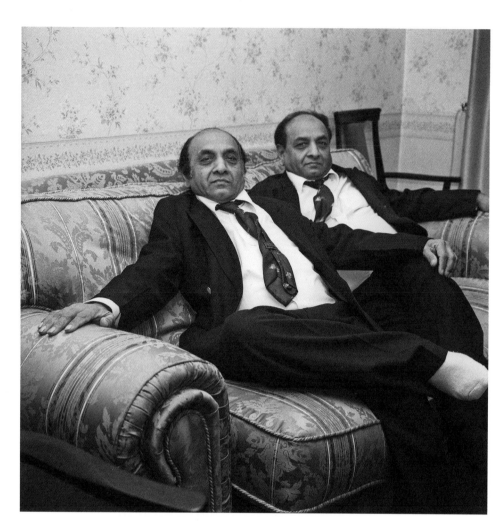

Ketaki Sheth, *Ramesh and Suresh*, Middlesex, United Kingdom, 1997

'These photographs go beyond a mere immersion in the anthropological oddity of twins. We do not stare, we enter.'

RAGHUBIR SINGH, FOREWORD TO *TWINSPOTTING*

In 1995, when she was living in London, Ketaki Sheth discovered by chance the high prevalence of twins among families called Patel, a Hindu surname originating in Gujarat. She realized that documenting them – in both the UK and India – 'would be a unique way of photographing a community'. The project, carried out between 1995 and 1998, culminated in the book *Twinspotting: Photographs of Patel Twins in Britain and India* (2007), whose title – while evoking a harmless pastime – can also be read as an attempt to use the double as a metaphor for a community split by diaspora. Its 125 black-and-white square-format portraits make for a convincing visual translation of the twins' bonds. They also form an observation on the similarity of the Patels' domestic spaces across continents.

Sheth was born in 1957 in Mumbai, a megalopolis known for the promiscuous coexistence of abject poverty and ostentatious luxury. The city is the backdrop for 'Bombay Mix' (1989–2004), a series of monochrome photographs belonging to the traditionally male-dominated genre of street photography that was published as *Bombay Mix: Street Photographs* (2007). One of the most densely populated cities in the world, Mumbai forces many of its underprivileged inhabitants to live their most private moments in public view. This subject is perfectly suited to Sheth's subtle powers of observation. *Bombay Mix* can be seen as a choral work that includes fleeting moments (the boy jumping over a puddle, the circus girl hanging from a pole) and scenes in which time appears suspended (like the street sleepers who appear several times in the book), resulting in a raw but respectful portrayal of these highly visible lives.

A Certain Grace: The Sidi – Indians of African Descent is another remarkable body of work, in which Sheth turned her attention to the descendants of African slave-soldiers, traders and Muslim pilgrims who migrated to the Indian subcontinent between the ninth and sixteenth centuries. The ensuing book is an intimate and quasi-anthropological portrait of a somewhat insular community to which she had access partly on account of her gender. On the cover was the image of a woman smiling and covering her face. When asked why she chose that particular photograph, Sheth replied: 'I chose it because … she was shy and graceful *exactly* like she really was.' If a good likeness is about portraying who the sitter really is, as opposed to what he or she looks like, this portrait is a perfect example. **LMD**

Since the 1990s, following Greenland's home-rule referendum in 1979, artists from the country have started to work with and debate their own history and identity, and to negotiate its (post-)colonial relationship with Denmark. Pia Arke is regarded as a Nordic pioneer in this context. Denmark is a country with an extensive colonial history, but it has almost repressed this aspect of its culture. Arke made it her main subject, managing to shed important light on previously unarticulated facets of this inheritance and on the culture and history of Greenland – in particular by making forgotten archival photographs talk.

Arke was born in Scoresbysund (now Ittoqqortoormiit), a small town in east Greenland, to a Greenlandic mother and a Danish father who had come to Greenland to work as a telegraph operator. After initial schooling in Danish-language schools, she moved with her family to Denmark for a period when she was thirteen. In 1987, Arke returned to Denmark, where she attended the Royal Danish Academy of Fine Arts in Copenhagen and graduated in 1995. Her master's thesis, published under the title *Etnoæstetik* (Ethno-aesthetics), criticized the traditional idea of 'Eskimo art' and discussed what it meant to produce art in a post-colonial context.

In 1993, while still a student, Arke created her overtly political piece *Untitled (Put your kamik on your head, so everyone can see where you come from)*. With her back turned to the viewer, the artist mockingly wears a traditional example of Greenlandic handicrafts, a kamik boot, on her head. She is standing in front of a photograph of her childhood landscape, produced using a life-size pinhole camera large enough that she could enter while taking the shot, thus using her own body as an integral part of the image production. In works such as *Krabbe/Jensen* (1997), she combined and contrasted anthropological images of the Inuit found in books and archives with private snapshots, reflecting on the power of the photographic gaze. In *Nature Morte* (1994), she displayed portraits of an Inuit woman who had undergone breast-cancer treatment alongside a photo of Arke's childhood toy dog, given to her by an American soldier at the Thule air base, and books, illustrations and measuring tools from the colonial past.

Although Arke's work also includes texts, video performances and installations, photography remains her main means of expression. Through her work, she has managed to hijack and redirect one of the main tools of colonialism: photography. **MS**

'I make the history of colonialism part of my history in the only way I know, namely by taking it personally.'

PIA ARKE

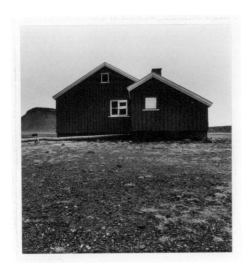 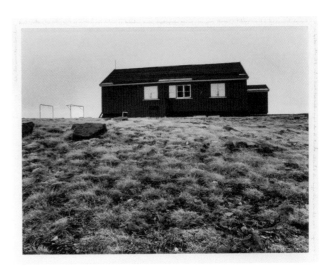

Pia Arke, *Imaginary Homelands alias Ultima Thule alias Dundas*, 'The Old Thule', *c.* 1992–3

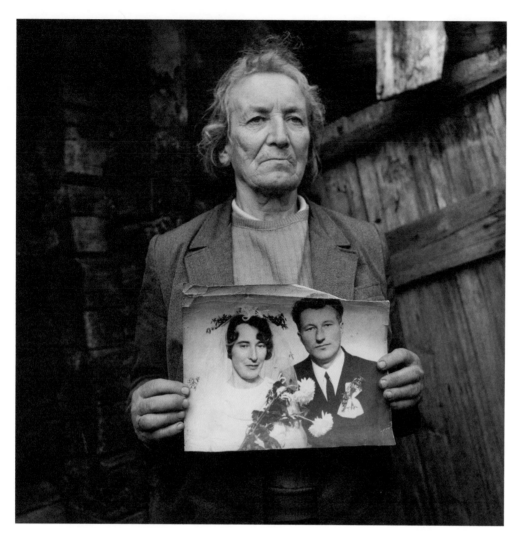

Inta Ruka, *Daina Tavare, Balvi, Latvia*, 2011

'I don't feel like an artist. I'm a photographer.'

INTA RUKA

Inta Ruka, whose career spans four decades, is widely recognized for her compelling and sympathetic portraits of the people of her native Latvia. She favours an immersive approach, often spending long periods collaborating with and integrating herself into the communities she wishes to photograph.

Ruka's first camera, a Zorki, was a present from her mother, who encouraged her daughter's hobby. At the outset she was self-taught but, keen to learn more, she started to attend courses organized by amateur photo clubs and later joined the main photography associations in Riga, such as the TTT club and the popular workshop at VEF Culture Palace. In 1982, Ruka joined Egons Spuris's studio in Ogre, a town about twenty miles from the capital. Under the influence of this distinguished Latvian photographer and his 'subjective documentary' style in black and white, Ruka aimed for a more personal aesthetic and developed her own printing techniques. Her main focus was portraiture,

a genre in which she excelled thanks to her extraordinary ability to capture something authentically 'human' in every mood and situation.

It is people and their interaction with place that particularly interest Ruka – a relationship that she frames by photographing the subject in their natural surroundings. To best reveal the sitter's character, she attaches great importance to the process of taking a photograph. Using a medium-format Rolleiflex, a camera that can be held at waist level or placed on a tripod, she produces highly sensitive portraits that are capable of conveying the bond that she formed with her sitters. In accordance with her documentary approach, Ruka chooses a factual, descriptive title for each image and often makes personal notes on the experience of taking the portrait. Images and words combine to create an intimate space between the viewer and the model. In 1999, the photographer put the finishing touches to her series and presented it at the 48th Venice Biennale.

Latvia regained its independence from the Soviet Union in 1991. Ruka adapted her work to the transition from socialism to capitalism and produced several new series, including *Cilvēki, kurus satiku* (People I happened to meet, 1999–2004), *Amālijas Street 5a* (2004–8) and *Zem tām pašām debesim* (Under the same sky, 2017–19). **BT**

Over the course of eight years, between 1973 and 1981, Francesca Woodman created an astonishing body of work, both in terms of its form and its content. She produced many small black-and-white photographs, a few films, some large-format 'blue' prints (cyanotypes), drawings and multiple books.

Woodman grew up in a bilingual family, and during her childhood, her time was divided between Colorado and Italy. From 1975 to 1978, she studied at the Rhode Island School of Design in Providence, where she set up her own photography studio. She lived and worked in an abandoned factory, using natural light that streamed in through the windows even when the curtains were closed. Many of her images portray the mysterious erasure of a female character. These have often been seen as a foreshadowing of her early death by suicide in January 1981, at the age of twenty-two, but that interpretation ignores the vitality, pleasure and joy that Woodman found in the 'here and now'. As soon as she had finished a roll of film, she developed it herself in the darkroom.

During her studies, she spent a year in Rome, where she discovered the Surrealists and read the work of Marcel Proust, among others, at the Maldoror bookshop and gallery. 'She couldn't live without poetry', said Giuseppe Casetti, who co-owned the shop with Paolo Missigoi. Neither could she live without taking photographs. Her pictures are like short poems that she composes from the objects she found around her or brought along specially: strips of peeled-off wallpaper, the crumbling render on walls, damaged fireplaces, plastic sheets, mirrors, gloves, eels, lemons, flour … and often her own body,

'I have a lot of ideas cooking, simply need to get started working before they stick to the bottom of the pan.'

FRANCESCA WOODMAN

which was both her tool and her instrument, as was the case for many female artists in the 1970s.

Woodman was particularly interested in photographing symbols. She used them to evoke the passage of time in the series 'Fish Calendar' (1977), where three lemons symbolize the month of March, and each of the marine eels symbolizes a day of the week. Woodman's photographs spring from her poetic 'way of being in the world'. Her approach is almost literary as she searches for connections, for parables. In one image from the series 'Eel' (1978), fish intertwine their bodies in a round bowl placed on the floor, while a naked female body curves around it. If you look closely at the print, you can appreciate the harmony of its composition even if you do not immediately notice that the pattern on the mosaic floor also fits snugly around the curve of the woman's body, creating four formal echoes in the photograph. This composition, like many others, springs from Woodman's extraordinary way of being present in the world. Her work conveys a sense of immanence, rather than transcendence. **GS**

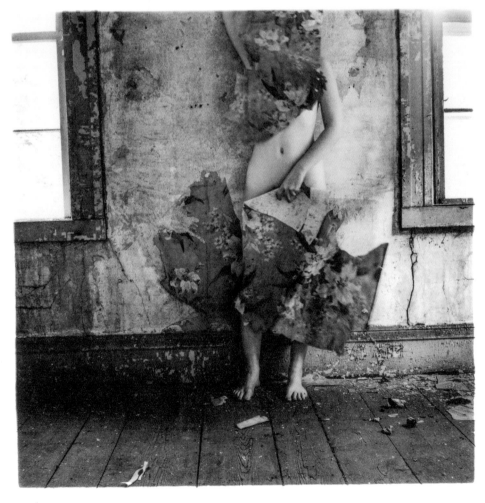

Francesca Woodman, *From Space 2*, Providence, Rhode Island, 1976

Anita Dube, *I–32 Tara Apartments*, 2000

Anita Dube is not a photographer. But she uses photography as a bridge between her body and material practice. Photography is just one of a number of mediums that ideas pass through, like a membrane, to be expressed. Dube's promiscuous approach to materials contrasts with her dedication to explore how the visible conveys and betrays meaning.

Born in 1958, Dube studied art history at the only school in India to offer the subject at the time, the Maharaja Shivajirao University in Baroda, Gujarat. Her interest in avant-garde art and liberal political ideology led her to join the Indian Radical Painters and Sculptors Association, who reacted against the established narrative painting tradition in favour of a socially and politically conscious art.

Dube's photographs of her own flat at Tara Apartments, a modernist building in New Delhi by the architect Charles Correa, constitute an intimate account of everyday life. The framing, lighting and close-up format draw on the language of classic still-life imagery. Together, these photographs evoke the impression of a strange artistic personality in search of itself: they record spaces that in turn record the body that inhabits them.

As co-founder of the Khoj International Artists Association, whose aim is to support contemporary art and emerging artists from South Asia, Dube has created spaces in which artists and experimental art forms can develop. Her own practice has evolved from sculpture to installation and performance. Photographs of words carved out of meat are in fact stills from a video documenting a performance at Khoj. Referencing the Marxist theorist Raymond Williams's notion of 'keywords', Dube's meat-words, incised using a scalpel that belonged to her father, describe contemporary issues. The fleshiness of the meat connects abstract ideas to the physical body: the word becomes flesh, and the flesh, word.

Mass-produced copper and enamel eyes, which usually adorn the forehead of Hindu deities in order to 'awaken' the divine, are a recurring motif in Dube's installation art. In 'Offering', a series created in 2000, the artist places these eyes on her own hands and mouth, thus affirming the presence of the body while giving it an abstract dimension. Visually, this gesture seems to evoke contamination or contagion, but also the idea of transformation. By copying and inverting one of the images to form a diptych entitled *Sea Creature*, Dube transforms her hands into a different kind of living form. **DD²**

'It's curious how … one motif move[s] from one medium to the other. I'm very open. Material is not the criterion.'

ANITA DUBE

> 'When you take a photograph
> (and I'm paraphrasing [Hervé] Guibert here)
> you end up with an image, but all of the
> emotion that was present when you were
> taking it is kind of transmuted into
> something else. It's become an object.'

MOYRA DAVEY

If, as Moyra Davey believes, 'all of the emotion that was present when you were taking [a photograph] is kind of transmuted into something else', then her work, by contrast, makes the customs of our time intelligible, especially those that are often invisible because they are thought of as natural. Using typologies, Davey explores the multitude of exchanges that shape our lives, both personal and public.

In the early 1990s, Davey collected American one-cent coins and took close-up photographs of the side showing the face of Abraham Lincoln. The notches, oxidation and dust are all traces of how the coins have passed from person to person, symbolizing their commercial function. Photographing them is almost an act of forgery: it increases their value because the prints are sold at a much higher price than the coins themselves are worth. Thus Davey interrogates the very foundations of capitalism and its role in art.

Davey is also interested in newspaper stands, which are a common sight on the streets of New York, her adopted city. She laments the fact that they are disappearing, because they function as an important hub for exchanges: hearing the latest news and rumours, offering the possibility of sudden wealth through lottery tickets and sports betting, selling snacks such as chocolate bars and packets of chewing gum. She spent a year photographing these stands, some of which were closed, others doing a roaring trade. In her pictures, they possess a kind of humanity, perhaps an anthropomorphism. Each kiosk seems to have its own personality, dictated by its architecture, the graffiti scrawled on its sides, its location and the way its products are laid out. Davey has also used a similar approach to photograph other subjects: empty alcohol bottles in the series 'Empties' (1996–2000) and passengers writing on the subway in 'Subway Writers' (2011–14).

Regardless of the subject, Davey's style allows her to reflect on shared experiences. Inspired by correspondence between famous authors and at the suggestion of a friend, she started to send prints through the post, folding them so that the image was on the outside. The marks they picked up along the way – addresses, stamps, scraps of coloured tape and franking – created abstract motifs that symbolize how an image travels across different locations and times. Although this approach is analogue in nature, the images themselves and the act of sharing them is reminiscent of pictures being posted on social networks such as Instagram, where users publish moments from their daily lives for others to consume. In this way, Davey draws out a range of contemporary connections between ways of creating and sharing images. **LB-R**

Moyra Davey, *Untitled*, from the series 'Subway Writers', c. 2011–14

After graduating from the National Art School in Havana in 1984, Marta María Pérez Bravo went on to become a pioneering figure in contemporary Cuban photography. Her work broke with the aesthetic of the 1960s and 1970s, when photography was used as a tool to reinforce the populist values of the Cuban revolutionary project (which began in 1959), with photojournalists working with the state to push its political agenda and propagate its official iconography.

In the early 1980s, Pérez Bravo was inspired by meeting the Cuban artist Ana Mendieta, as well as by the quest for new forms of expression in the context of the 'renaissance' period in Cuban art. In response, she developed an artistic approach that was critical of society's expectations of femininity and of stereotypical, essentialist definitions of identity. Pérez Bravo was the first artist in Cuba to use photography as a means of exploring the body. Her pictures are inspired by stories she encountered during her ethnological research; they use religious practices to create a visual language heavy with symbolism. Her early works (1984–5) draw inspiration from the early days of Cuban land art. According to the academic Rachel Price, the New Cuban Art movement of the 1980s grappled with ecological questions at a local level and was influenced by land art in Europe and the United States. However, Pérez Bravo's works and performances in the rural areas take inspiration from popular culture (myths, fables, superstitions and rituals) that has been passed down orally from generation to generation. The photographer takes

these traditional stories from the Indigenous *guajiro* culture and reinterprets them in visual form, depicting unusual occurrences, such as the apparition of mythical beings or religious offerings. Her photographs portray a world in which the forest, lagoons and crossroads are sacred sites. The texts that sit alongside her pictures hint at a mystery, a sort of trembling, something that is there, that cannot be seen but nonetheless exists. Her unique approach to land art, like her later exploration of gender, was influenced by her specific cultural context: oral archives (of myths), religious traditions and rituals in the Cuban countryside, the 'creolization' of parts of sub-Saharan Africa, Christianity and spirituality on the island of Cuba.

From 1985 to 1988, after becoming a mother herself, Pérez Bravo's work began to explore the concept of motherhood. Her photographs from this time challenge the idealized representation of pregnancy in Western culture, highlighting the fact that this condition poses a danger to the mother's body. The celebrated series 'Para concebir' (To conceive) introduced, in the words of writer Juan Antonio Molina, a new perspective that it would have been difficult to imagine existing in Cuba before the 1980s.

Drawing on Cuba's rich folkloric traditions, Marta María Pérez Bravo's photographs form an unprecedented transnational archive that explores the place of mythology – as well as traditional African religious practices – in the female psychosocial landscape of the Caribbean. **AD**

Marta María Pérez Bravo, *Neither Kill, Nor Watch Animals Being Killed*, from the series 'To Conceive', 1986

'I hope that my portraits can gain universal value and will tell their own story within the context of their subject. In the concentrated and clenched moment of a picture, and the small details you can perceive in it, you can generate attention and meaning, which mostly escape us in everyday life.'

RINEKE DIJKSTRA

Rineke Dijkstra, *Vila Franca de Xira, Portugal, 8 May 1994*

Rineke Dijkstra's oeuvre could be described as the expression of a constant desire to analyse and reveal human emotions through portraiture, with all the possibilities and limitations that entails. After training at the Rietveld Academy in Amsterdam, for several years Dijkstra produced portraits for the press, learning the formal discipline involved in one of the most fundamental elements of portrait photography: the pose.

In her *Strandportretten* (Beach portraits, 1992–3) – which portrayed teenagers from all over the world standing on a beach in front of the sea, wearing swimsuits – Dijkstra concentrated on the moment the models let go and relaxed. Her rigorous approach – which is in fact a form of studio photography outdoors, and includes a formal frontal pose and the use of a flashlight – resulted in monumental and moving representations of the uncertainty and vulnerability of youth.

One of Dijkstra's main themes is the inevitable relation between pose and mask, knowing that every individual wants to control what he or she shows to the outside world. In two other projects, on women who have just given birth (1994) and bullfighters after the fight (1994), she tried to get behind that mask by photographing people who have just gone through a major experience.

Change as a result of the passage of time or existential circumstances is the subject of several series that Dijkstra has made over the years, for instance on the Bosnian refugee Almerisa (1994–ongoing), Israeli women soldiers entering military service (1999–2002) or Olivier, a volunteer in the French Foreign Legion (2000–3). Here she makes glorious use of the ability of the camera to fix moments in time. As always, her approach is strict, her method formal, her eye precise and analytical. It is because of these self-imposed constraints that the photographer obtains a result that is both full of emotion and yet impressive in its simplicity.

If photography has the ability to freeze moments in time, video can show how a situation evolves over time. Dijkstra's first video work, *The Buzz Club, Liverpool, UK/Mystery World, Zaandam* (1996–7), filmed with a static camera, uses portraits of young people dancing to recreate the magical atmosphere of a nightclub. Throughout her career, Dijkstra has expressed her fascination with people who are totally immersed in an activity: playing games or making music or creating art, for example. This interest has become a major theme in some of her videos. *Annemiek* (1997), a moving four-minute video, illustrates the artist's ideas on recognition and reflection. It shows a thirteen-year-old girl miming to the pop song 'I Wanna Be With You', totally absorbed in the music that she loves but obviously uncomfortable. Perhaps it is the gap between her youth and the erotic nature of the song that makes her performance both touching and strange at the same time. Or perhaps, as in all of Dijkstra's works, it is a product of the interest and deep empathy that the photographer shows for the young. **HV**

Katerina Kalogeraki's projects elucidate the idea that documentary photography provides important access to both facts and feelings. Despite their straight documentary style, her images are essentially a personal quest into her identity and origins, while at the same time challenging both hegemonic representations and social ideologies.

Among Kalogeraki's most celebrated works, the series 'My Father's Land' (1987–97), which records the experience of returning home, exemplifies this double role: it is both a piece of social documentary and a personal interpretation of family and homeland. Having lived for several years in England, where she distanced herself from the morals and values of 1980s Greece, Kalogeraki returned to her island of Crete in order to produce a portrait of the land and its people. The outcome was an extensive social document, devoid of romanticism, that allowed her to investigate the way in which issues of gender, nationality and place of origin influence the formation of subjectivities and identities. Sometimes combining photographs and texts, Kalogeraki developed a dynamic between the image and the word that proved instrumental in the formation of narrative. She addressed her family's demands and expectations and the degree to which she still 'belonged' to this land: her portrait of an elderly aunt is placed next to her rebuke when Kalogeraki dared enter the male-dominated area of the cafe, ignoring the cultural codes of the village; a typical family portrait is followed by her mother's lecture that, 'The ultimate purpose in a person's life is to get married and have children.'

'My Father's Land' did not set out to be an objective document of Greek rural life but, rather, a record of the photographer's own subjective experience. Looking back on her own origins, Kalogeraki arrived at a feeling of liberation from the narrow bonds of village mentality. In this sense, the series also advanced a 'politics of representation' that challenged dominant images, ideologies and sociocultural stereotypes, revealing how they play a role in the construction of subjectivity. **PP**

'They have never been in an elevator nor in a plane. They do not have television or radio. Yet, in their own way, these people are wise.'

KATERINA KALOGERAKI

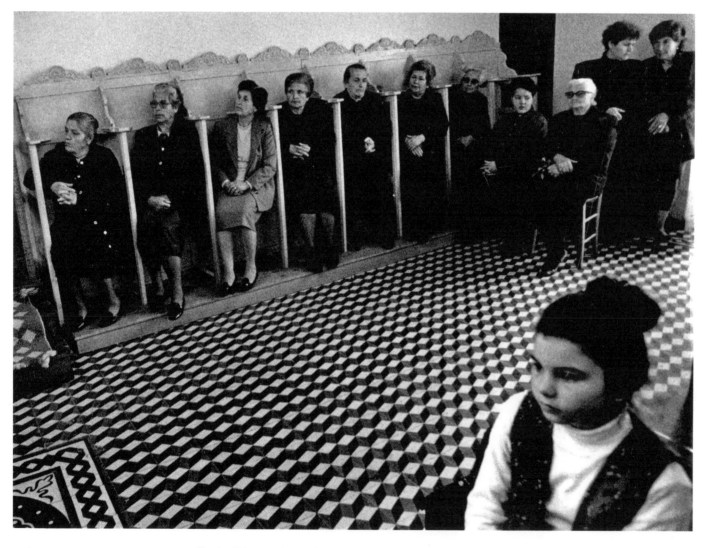

Katerina Kalogeraki, *Sunday Service*, from the series 'My Father's Land', 1990

Renée Cox, *The Liberation of Aunt Jemima and Uncle Ben*, 1998

Renée Cox's often provocative photographs challenge stereotypes around the representation of Black female bodies. Born in Jamaica, Cox studied at the School of Visual Arts in New York. In her self-portraits, she adopts the characteristics of borrowed personas, fictional or real superheroines, in order to explore questions of power, race and gender. The series 'Flippin' the Script', in which she posed as the Virgin Mary, Christ and St Sebastian in turn, reinterprets iconic European works of religious art. In 1999, the work *Yo Mama's Last Supper* caused a scandal. A photographic reinterpretation of Leonardo da Vinci's *Last Supper*, it showed Cox posing naked in the place of Christ, surrounded by Black apostles, except for Judas, who is white. Divided into five panels, this work lays claim to greater visibility for women in a world where white male experiences are foregrounded.

In 1998, Cox invented the superheroine Raje, a dynamic, muscular woman who wears thigh-high boots and a spandex suit in the colours of the Jamaican flag. Cox depicts the character performing various heroic deeds that testify to her energy and power. The most iconic image of Raje is entitled *The Liberation of Aunt Jemima and Uncle Ben*. In it, Cox presents a new, positive vision of Black bodies. Cox's attachment to the island of her birth can also be seen in the figure of Queen Nanny, a Jamaican national heroine whose portrait features on the national currency. She was the leader of a community of formerly enslaved Maroons who fought a successful guerrilla war against the British in the eighteenth century.

These pictures explore how contemporary photography approaches the idea of narrative. Here, the narrative is distilled into a single, independent image, which contains the entirety of the story; the viewer is able to interpret

'I refuse to be put down, squashed, or made invisible. I'm here, seven feet tall, larger than life. The thing that I use is the gaze. Ninety percent of the time, I'm looking back at the viewer looking at me.'

RENÉE COX

it because they recognize the characters and props that form part of our collective unconscious and our cultural norms.

For Cox, the self-portrait is a means of challenging the official, one-sided narrative of history, as well as the invisibility of Black bodies in culture and art. She comes from a long line of activist artists such as Betye Saar, Faith Ringgold, Sonia Boyce, Carrie Mae Weems, Ellen Gallagher, Tracey Rose and Kara Walker.

Cox's recent series 'Sacred Geometry' marks a radical departure from her earlier work, both in terms of its aesthetic and the concepts it explores. It also focuses on Black bodies, often naked – that of the artist, her sons or her friends – which she uses digital technology to break into fragments, duplicate and reassemble into complex mandalas, sculptural kaleidoscopes influenced by the fractal fluidity characteristic of African art and textiles. This series explores the infinite nature of time and space. **DB²**

Eve Kiiler, *The Estonian Home*, 1992–3

In 1986, Eve Kiiler received a degree in interior and furniture design from the Estonian State Art Institute. She was already practising photography, but at that time it was not considered a proper art form in Estonia and was not taught at university level. Kiiler's first solo exhibition, *Layered Landscapes*, was held at the Kiek in de Kök Museum, Tallinn, in 1984.

The early 1990s was a period of great change. Estonia gained its independence from the Soviet Union in 1991, and for Estonians who were trying to survive economically there were incredible opportunities waiting to be seized. Kiiler became one of the country's key figures, who, through her artistic and curatorial practice, changed the general perception of photography. A fresh voice in art photography, she experimented in her work, focusing on the invisible, the in-between, the hidden: she encouraged people to stop and consider the spaces between houses and behind fences, and the views reflected in windowpanes.

Her early works, including the well-known *Eesti Kodu* (The Estonian home, 1992–3), pushed the boundaries of photography, treating it as a tool through which Kiiler could express conceptual ideas on history and modernity. Her series of collages is one of her first to address themes of place and memory. By bringing together apparently random views of places and photographs of family members, and by including a commentary alongside those images, the artist forces the viewer to focus his or her attention on the links that unite these disparate elements, and to consider how Estonia's past and present meet and transcend the personal stories of the individuals depicted in these photographs.

'What I'm interested in is looking where other photographers don't look.'

EVE KIILER

The arrival of philanthropist George Soros's Open Foundation in Estonia in the 1990s gave photography a boost by ensuring that photographs were included in major exhibitions. Moreover, with the country now independent following the fall of the Soviet Union, it was opening up: Kiiler was invited to participate in residencies abroad (in Berlin, San Francisco and Chicago) and to widen her research there. She collected educational material for her students at the Estonian Academy of Arts (EAA), where she had started to teach in 1994.

It was at this time that Kiiler, together with her partner, the artist and curator Peeter Linnap, founded a conceptual school known as the 'Faculty of Taste'. It offered a unique space for the development of creative ideas, free from any kind of hierarchy, in which contributions by tutors and students were given equal recognition. The same team also organized the first international art biennial in Estonia, the Saaremaa Biennial (1995, 1997), which was highly influential. In 1996, Kiiler became a member of the Estonian Art Association. From 1998 to 2005, she was the first to lead the newly established Bachelor of Arts course in Photography at the EAA. She currently teaches photography at Tallinn University. **MK**[1]

Since the late 1980s the photographer and film-maker Tracey Moffatt has consistently drawn attention to the psychodynamics of colonialism. Frequently using herself as a model in highly staged photographs, she presents tableaux that explore the tensions that underpin unequal power relationships.

Moffatt conceives her works as multipart series, a form that enables her to inventively present non-linear narratives where the real and the imaginary unfold alongside each other. In each series, she adapts a distinct aesthetic, which draws on a range of visual sources from nineteenth-century photographs to film and television history. By crafting a visual vocabulary out of Western popular culture, Moffatt produces work that resonates with a broad range of audiences and across different cultures.

In her series 'Laudanum' (1998), which comprises nineteen photographs, Moffatt created an atmosphere of sexual hysteria and power struggle between a mistress and her Asian maid. Taken in Sydney during a residency in a nineteenth-century colonial house, these images evoke the past through the period interiors, the women's clothing and the photographer's decision to use the photogravure printing process, which dates back to the 1850s. Employing the tropes of the horror film to present her reconstruction, Moffatt expresses the emotional landscape of the colonial exchange, defined by claustrophobia, co-dependency and insanity.

Born in Brisbane, Moffatt first gained international acclaim for her film *Night Cries: A Rural Tragedy*, which was selected for official competition at the 1990 Cannes Film Festival. She has exhibited widely, including at the Dia Center for the Arts (1997–8) and the Museum of Modern Art (2012), both in New York. Her 'Body Remembers' series was commissioned for the Australian Pavilion of the Venice Biennale in 2017. **MZ**

Tracey Moffatt, *Something More #8*, 1989

Maud Sulter, *Alas the Heroine: Madame Laura is at Home*, from the series 'Syrcas', 1993

Scottish-Ghanaian artist and writer Maud Sulter's work highlighted how Black women have been left out of history and art, long before debates about diversity spread across the art and media worlds. A feminist campaigner and member of the Black British Arts Movement, she sought to disrupt canonical images, placing Black women at the centre of a historical narrative that had erased them. Sulter began her creative career as a poet, winning her first award, the Vera Bell Prize, in 1985 for the collection *As a Black Woman*. That same year, she took part in *The Thin Black Line*, a joint exhibition featuring work by many young Black and Asian female artists, curated by the artist Lubaina Himid and displayed at the Institute of Contemporary Arts in London.

'Sphinx' (1987) – a collection of black-and-white photographs taken in Gambia, showing the ruins of a slave shipping port – was her first major photographic series. In her artistic practice, Sulter liked to establish links between poetry and photography, as in *Zabat* (1989), a collection of poems that sit alongside a series of Cibachrome portraits that show her and eight other Black artists posing as the nine Greek muses. Her final work, *Sekhmet* (2005), brought together portraits of the two branches of her family, Scottish and Ghanaian, accompanied by poems about her ties to the diaspora.

Not to be pinned down, Sulter also founded her own publishing house, Urban Fox Press, where she published, among other works, *Passion: Discourses on Blackwomen's Creativity* (1990), a pioneering work that combined texts and images drawn from the Blackwomen's Creativity Project, which she set up with the photographer Ingrid Pollard in the 1980s. She also founded a gallery, Rich Women of Zurich, in Clerkenwell, London. A graduate of the Derby School of Art, Sulter spent some time teaching at university level and researching the cultural history of the African diaspora in Europe. Her series 'Hysteria' (1991) was inspired by the life of Edmonia Lewis (1844–1907), a sculptor of African-American and Native American (Ojibwe) descent, who worked in Rome at the end of the nineteenth century. The series 'Syrcas' (1993) consists of sixteen photomontages in the form of postcards, which 'Africanize' classics of European painting, as a means of challenging how Black people have been left out of the history of genocides perpetrated by the Nazi regime. This series led to Sulter representing Britain at *Africus*, the first Johannesburg Biennial, in 1995.

Throughout her career, Sulter had an enduring fascination with the figure of Jeanne Duval, the muse and partner of the poet Charles Baudelaire. She posed as Duval in 'Les Bijoux' (2002), a series of nine self-portraits. In the catalogue that accompanied the exhibition *Jeanne Duval: A Melodrama* (2003), she wrote: 'My visual fascination with Jeanne Duval began in 1988 with a visceral response to a photograph by Nadar entitled *Femme inconnue* [Unknown woman]. She was looking at me, asking me to give her a name, an identity, a voice.'

Sulter died from cancer in February 2008. The retrospective *Maud Sulter: Passion* at the Street Level Photoworks gallery in Glasgow in 2015 was a reminder of how profoundly she shaped the photography scene at the end of the twentieth century. **EN**

'It's important for me as an individual, and obviously as a black woman artist, to put black women back in the centre of the frame – both literally within the photographic image, but also within the cultural institutions where our work operates.'

MAUD SULTER

Dayanita Singh's drawing room features a single photograph, which shows the interiors and terrace of a Japanese home. A closer look reveals that what at first looks like a neatly angular, single space is actually a photomontage that mixes interior with exterior, dislocating the viewer as he or she tries to understand it. Built along the fault lines of pain, fantasy or desire, this imaginary house is the keeper of secrets, certain areas remaining for ever hidden. Singh's own home, where she displays some of her works, is at once a museum, archive space and workshop. Trained at the National Institute of Design in Ahmedabad and the International Center for Photography in New York, she was a photojournalist in India for more than a decade. Since publishing *Myself Mona Ahmed* (2001), a book in which she blurs the boundaries between fiction and reality, she has worked mainly on the theme of the house, which features notably in *Privacy* (2004), *Dream Villa* (2010) and *House of Love* (2011).

Singh's series on house-museums, such as the Anand Bhavan in Allahabad, where the Nehru-Gandhi family lived, and others in Mumbai and Kolkata, shows them empty, without their occupants, even as clothes, furniture and memorabilia recreate the presence of their absent owners. She has taken the concept further in the 'Museum Bhavan' project (2017), which suggests an alternative type of art institution, combining publishing house, gallery and museum. Shown at the Kiran Nadar Museum of Art in New Delhi and acquired in part by the Metropolitan Museum of Art, New York, 'Museum Bhavan' redefines the idea of the photographic exhibition, making it mobile, changeable and unpredictable. There is also a miniature version of the exhibition, comprising nine 'museums' in the form of books, whose images are displayed on a wooden framework.

> 'I realized that photography could open up the world to me. Photography could help me to escape the restrictions of class and gender. I wanted to be a photographer, to be free, to be open to all the surprises life has to offer, to travel and to be as I pleased.'
>
> **DAYANITA SINGH**

For Singh, the house is a space that inspires her extended imaginative creations. Book, book-object or the shifting panels of her exhibits – all find a place here. Her decision to cut up prints is relatively recent for the artist, even if her goal of challenging the viewer's expectations is not. By adopting the technique of collage, she asserts her authorship and ownership, creating puzzles and optical illusions that skew a predictable narrative. Singh is protective when she talks about the works of the 'Museum Bhavan' that inhabit her home – the *Museum of Love* or the *Museum of Little Ladies*, for instance – but her approach is not gendered. She does not view her images as 'women's photography', even if they reference her home and aspects of domesticity. In the pictures that she creates and in the lives that they subsequently acquire, Dayanita Singh makes the home an uncertain place where things can be hidden, transformed, rejected, welcomed or shared. **SN**

Dayanita Singh, *Privacy*, 2003

Jungjin Lee, *The American Desert II, 94-03*, 1994

Drawing inspiration from both Asian and Western cultures, Jungjin Lee renounces all forms of narrative in her photographs. She shows her unique body of work in two main formats: large black-and-white prints that seem to float on the walls, and books that she treats as their own distinct artistic projects. She combines the visual and tactile sensibilities of her South Korean heritage with references to Western aesthetics, which allows her to create a unique language based on materiality, texture and craftsmanship.

Lee moved to New York in 1988 to study photography. She worked as an assistant to Robert Frank, who encouraged her to travel around the United States and be more experimental in her artistic practice. In the early 1990s, she first visited the American desert – vast, dotted with rocks and bushes – and it became a major source of inspiration in her work, as seen in her series 'The American Desert' (1990–4). Lee lives in the United States but goes back to South Korea regularly. She is also interested in the traces of lost civilizations. When she looks at objects or architecture, they become pretexts

> 'I was able to see, not only the land, but my own mind, with its uneven terrain and movements, and to touch something elemental.'
>
> **JUNGJIN LEE**

for abstraction, allowing her to explore new forms. In the series 'Pagodas' (1998), she divorced her subject from reality: the towering structures of five-storey pagodas are reflected along the line of their foundations, doubling their height while also rooting them in the depths below. Other series followed, in which Lee explored her interest in nature and in the borders between cultures, through depicting forms and textures, as in her series on everyday objects, entitled 'Thing' (2003–7). There is no topographical or factual information to be found in Lee's photographs. Whether her subject is the American desert, Buddhist temples or everyday objects, it is always seen outside of space and time.

Lee creates her prints manually, using a brush to apply photo-sensitive emulsion to large sheets of mulberry paper. Using this traditional Korean paper allows her to work with a natural material that reacts in unpredictable ways. Materiality is central to her work; she studied ceramics and calligraphy in Seoul, two disciplines in which handcrafting and materials are vital. Lee's method is very physical and highly experimental, combining modern chemistry with a very traditional Eastern material. Rejecting a realist approach, she sees the supposed faults that arise from this technique as an important part of the creative process.

Jungjin Lee turns the act of photographing into an exploratory, emotional moment. With an almost meditative calm, she describes her pictures as an echo of her inner self. For her, a picture works in the same way as a poem; it should be read multiple times. Her photographs hold the viewer's gaze, an invitation to introspection. **NH**

Corinne Day was a photographer whose work, variously labelled as 'realist', 'anti-glamour' or 'grunge', came to prominence as a subversion of fashion photography in the early 1990s. Although one of the few women photographers to have a visible, long-term career in the fashion world, she sometimes commented that her shoots were not 'work' but more like 'going away on holiday'. This did not indicate a flippant approach to image-making, but rather was a way of distinguishing herself and her creative interests from the requirements of the fashion system, with which she had an ambivalent relationship.

Day, herself a former model, was self-taught and started making photographs after meeting Mark Szaszy on a train in Japan in 1985. Szaszy, who was also a model and an aspiring film-maker, taught her how to use a camera and became her life partner. Her breakthrough was a cover story for *The Face* magazine, published in May 1990, featuring a then unknown young model, Kate Moss, in an eight-page fashion feature called 'The Third Summer of Love'. These images were hailed as expressing a new vision of beauty that challenged established standards of glamour and femininity in the fashion world. Day continued to produce radical work into the late 1990s, including Moss's first cover for *Vogue* in March 1993.

In 2000, Day published *Diary*, a sequence of raw biographical images centred around her close friend the stylist Tara St Hill, who appears on the book's cover. It is a candid account of Day's life and community during the 1990s, depicting the isolation, desperation and chaos, as well as the intimacy, joy and camaraderie, of a close-knit group of young people immersed in music culture. Alongside images of St Hill, the series includes Day herself and their circle of friends, most of whom were associated with the band Pusherman. It also contains a birthday photograph of Mary Day, the beloved grandmother who had raised her, and records Day's diagnosis with a brain tumour in New York in 1996. Significantly, the book is testament to the depth and importance of her personal documentary practice. At the same time, she continued to produce fashion images, which became increasingly stylized from the early 2000s.

In 2007, Day was commissioned by the National Portrait Gallery, London, to make a portrait of Kate Moss. She chose a grid of informal black-and-white images, creating a conversational and multifaceted likeness that stands out as a portrait of one of the world's most successful models, but also celebrates an extraordinary friendship.

Corinne Day's tumour returned in 2008, and she died in 2010. *May the Circle Remain Unbroken*, the most in-depth survey of her work to date, appeared posthumously. The book highlights the uncompromising originality, courage and beauty of her photography, and shows unequivocally that it was photography, not fashion, that defined her life. **MK**[3]

Corinne Day, *Me after the doctor told me I had a brain tumour, Bellevue Hospital, New York*, 1996

Born in Douala, Cameroon, Angèle Etoundi Essamba moved to France at the age of ten. She began studying photography at the Nederlandse Fotovakschool (University of Applied Photography) in Amsterdam in 1984. Since the late 1980s, she has divided her time between the Netherlands, where she now lives, and Cameroon. She uses photography as a means of interrogating representations of the Black female body and deconstructing the stereotypes associated with it. For her, the image of the Black woman is a constant source of inspiration, a symbol that she never ceases to question. Over the course of more than twenty years, Etoundi Essamba has become one of the few female photographers from the African continent to gain recognition on the international art scene.

Refusing to exoticize her subjects, Etoundi Essamba rejects the clichés associated with Black women's bodies in order to tell a universal story. Her work is a poetic and political defence of the Black female body, her images forming an iconography of resistance. She uses her mastery of technique to enhance her models' bodies, combining a talent for setting up the shot with great precision in capturing it and attention to detail in the printing stage. Whether still or in motion, bodies and parts of bodies lie at the heart of her work.

The series 'Noir' (Black), created in the 1980s and 1990s, confirmed Angèle Etoundi Essamba's unique perspective and formed a kind of manifesto.

Through a collection of individual and group portraits, she explores the possibilities of black and white, playing with a range of greys and contrasts. In each of the images, women's bodies are treated as sacred objects. The models' intense gazes meet the viewer's eye, raising questions about the symbolism linked to Black bodies and the way that they have been depicted in art over the centuries.

This desire to question symbols was also evident in the series 'Voiles et dévoilements' (Veils and unveilings), created in the 2000s, where Etoundi Essamba used fabrics, textures and colours to examine the iconography of veils in the history of Western painting. This was the first of her works to place colour at its heart – saturated, vibrant, shifting colours that expanded on her earlier black-and-white work, further complicating her representation of the female body. She shook off the iconic restraint of black and white in favour of exploring colour, using it as a way of depicting reality.

Since her first exhibition at the Descartes House in Amsterdam in 1985, Angèle Etoundi Essamba's work has featured in numerous exhibitions at institutions, biennales, fairs and galleries across Europe, Africa, the United States, Latin America and Asia. Her work is also in many private and public collections across the world. **JM²**

Angèle Etoundi Essamba, *Gaze 2*, 1998

Pamela Singh, *Treasure Map 022*, 1994–5, painted in 2015

Since studying documentary photography at the International Center of Photography in New York, Pamela Singh has produced work that reflects her quest to connect the physical and spiritual worlds. Integrating self-portraiture and performance with the physical adornment of her photographs and references to Indian visual traditions, she transports the viewer to a place of fantasy.

An early series, the glowing and emotive 'Tantric Self-Portraits' (2001), was inspired by *rangoli*, a traditional art form in which the floor is decorated with rice powder or petals. By painting her photographs with auspicious *rangoli* symbols and religious motifs selected by her guru, Singh sought to imbue each unique piece with tantric blessings. Large in scale, the photographs are luminous, their lush colour hand-applied in oil, acrylic, vermillion, mud and gold.

In the mid-1990s, Singh produced a large body of black-and-white silver-gelatin prints. Affixing a rear-view mirror to her camera, she took shots of herself in her surroundings. In this 'pre-selfie' period, she spent days wandering through the maze of New Delhi, inserting herself within the daily life of townspeople. Her most recent series, 'Treasure Maps', was painted in 2014–15 but shot in the mid-1990s and edited by the photographer Raghubir Singh. These works feature subtle layers of paint and a muted palette. Utilizing the techniques of nineteenth-century hand-coloured photographs from Rajasthan, Pamela Singh thus added a magical element to her images,

'I have become part of their lives, with our humanity melting together. When you share a space with someone, there is no separation.'

PAMELA SINGH

which came to resemble religious iconography. What were once photographs are now bejewelled narratives of her enchanted world.

Over the last few years, Singh has increasingly brought performance into her work. Her wanderings through Italy, Brazil and India have become backdrops for performances. She whirls and writhes in private settings and explores monumental city streets. Singh imprints her presence on the 'Treasure Maps' series through her actions and movements: she welcomes us into her life and her journey.

Born in New Delhi in 1962, Singh attended Parsons School of Design in New York and the American College in Paris. In the 1990s, she worked as a photojournalist, notably for the *Washington Post*, *Newsweek*, the *Sunday Times* and *Paris Match*. Her work has been exhibited internationally and is in many private collections worldwide. **EE**

Zubeida Vallie, *Activist June Esau in a celebrative mood at a mass meeting in Bonteheuwel Civic Centre in Cape Town*, South Africa, 1989

'Is the story of the anti-apartheid struggle complete?'

ZUBEIDA VALLIE

Zubeida Vallie portrays a generation of activists who came of political age in Cape Town during the 1980s. They gave impetus to the mass democratic movement led by the United Democratic Front (UDF) and the Congress of South African Trade Unions (COSATU). Vallie witnessed the founding of the UDF in 1983, in one of the city's largest townships, Mitchells Plain. She was part of the alternative-press movement that supported domestic resistance efforts, providing images and information that waged a war against censorship and pro-apartheid media. An avalanche of small but defiant campaigns forced the nation to declare a state of emergency twice that decade: one in 1985 and the other a year later, in 1986. During this period of unrest and state repression, political funerals were banned, curfews were imposed, and thousands of people were detained by the regime as its legitimacy in the eyes of the world drew to a close.

As a 'cultural worker', Vallie discovered a real community within the militant art and media collectives working across the country and in exile at the time, such as the International Defence and Aid Fund, the local *Grassroots Community Newspaper*, the Vakaliza Art Collective, Afrapix, the Black Society of Photographers, Dynamic Images, and The Brotherhood. These organizations – which weaponized image-making in the struggle against apartheid – were dominated by men. Vallie claims that the fact that she was often the only local woman photographer covering events did not bother her then, but now, post-apartheid, it is a concern. Her inclusion as the only Black woman photographer in the iconic photography book of the decade, *Beyond the Barricades: Popular Resistance in South Africa, Photographs by Twenty South Africa Photographers* (1989), marks a significant moment in the emergence of Black women in South African photography.

'Black' is a political identity in South Africa that includes women like Vallie, whose grandfathers, both Indian, married local women and were followers of Islam. She came to photography through family members who were photographers and who gave Vallie, before she went to high school, her first camera: a Kodak Instamatic with a tungsten flash bulb. She joined the school photographic club and, after leaving, studied photography at the iconic Ruth Prowse Art School and the Peninsula Technikon, a move that her cosmopolitan and politically enlightened family supported. Documentary activism may have defined her photographic career, but Vallie has explored other genres with her camera, including medical photography, portraits of women, family photography and journalism. Since 1990, she has taught photography and journalism at the Cape Peninsula Technikon. **CJ**

Since 1991, the Russian-Ghanaian photographer Liz Johnson Artur has photographed people of African descent around the world. Whether her subjects are congregating at parties or clubs, on streets, at protests, in parks or at churches, her photographs emphasize themes of family, friendship, style and joy, without generalization. The nuances of blackness evident in her work expand the types of images of Black individuals and communities. 'What I do is people', she says. 'And it's those people whom I don't see represented anywhere.' In colour and black and white, her dynamic documentary photographs yield a complex portrait of Black identities.

Johnson Artur, who grew up in Germany and Russia, travelled to New York City in 1986 and found herself, for the first time, in a predominantly Black neighbourhood in Brooklyn. This sparked a hunger to find and photograph Black communities. She moved to London in 1991 to study at the Royal College of Art and has lived in south London since then. By the mid-1990s, Johnson Artur was steadily working for magazines, including *i-D*, *The Face* and *Vibe*, that defined a new generation of creative talents in fashion, music and art. She has photographed musicians from Mos Def to the Spice Girls, toured with M.I.A., Lady Gaga and Seun Kuti, and created photographs and video for Rihanna's Fenty fashion brand.

Her editorial and commercial work has given Johnson Artur opportunities to pursue her major project, 'Black Balloon Archive' (1991–ongoing), which consists of photographs of the African global diaspora. She drew the title from the song 'Black Balloons' (1969) by the American soul singer Syl Johnson,

with its image of black balloons against a 'snow-white' sky. Indeed, Johnson Artur has likened her work to a search for 'black balloons'. Collaboration is key to her approach, and she assures her subjects, who are chiefly strangers, 'I will keep you in good company.' Sketchbooks containing photographs, drawings and text gather and structure her thoughts on the growing archive.

Since 2016, Johnson Artur has regularly exhibited her work. Her installations feature various display strategies: unframed prints, large-scale vinyl reproductions, photographs on fabric, slideshows in public spaces, and altar-like structures. She has also begun to create audio and video works, on the Ghanaian photographer James Barnor, for instance, and on Russians of African and Caribbean descent.

Two major solo exhibitions took place in 2019, *Liz Johnson Artur: Dusha* at the Brooklyn Museum, and *Liz Johnson Artur: If You Know the Beginning, The End is No Trouble* at the South London Gallery. A monograph on her work was published in 2016: the *New York Times* lauded it as one of the best photography books of the year. In 2021, Kering and the Rencontres d'Arles photography festival presented her with the *Women In Motion* Award. **SH**[1]

'I wanted to record the normality of black lives and black culture.'

LIZ JOHNSON ARTUR

Liz Johnson Artur, *Country Show*, Brixton, London, 2010

Rula Halawani, *Untitled*, from the series 'Negative Incursion', 2002

'My projects are political, yes. But they also
try to express aspects of our experience
and feelings as Palestinians, as a people.'

RULA HALAWANI

Born in Jerusalem, where she lives today, Rula Halawani first discovered photography when she moved to Canada to study maths and physics in the 1980s. After working as a photojournalist for ten years, she decided to abandon this approach. Motivated by her personal ties to the situation in Palestine, she wanted to find a less straightforward visual language. Since 2002, her subject has been the impossibility of conveying her experience as a Palestinian – an identity that is denied her on her passport and that she has sought to express through her work, leading her to seek out a different way of manifesting it.

In her first series, 'Negative Incursion' (2002), she was already using one of the techniques to which she would return again and again in her work: employing filters and various effects to avoid confronting the reality of her subject head on. In 'Negative Incursion', her use of negatives symbolizes and denounces the way in which Palestinians' lived reality is negated under occupation. In 'Irrational' (2003), 'The Wall' (2005), 'Gates of Heaven' (2013) and 'For my Father' (2015), Halawani uses blurring to create ghostly images that capture the daily violence that has transformed her country into a war zone. All of these series consist of images that are deliberately blurry, as if they are caught in a nebula that transports the viewer to an unreal world, a nightmare from which they are desperate to wake up.

Her first series was also the last in which her photographs showed recognizable faces. Afterwards, Halawani shifted her focus to the landscape, photographing land that had been confiscated by Israel, land that bears the marks of occupation, humiliation and distress, both personal and collective. Driven by a desire to reveal the extent of the oppressive system, Halawani also documents its impact on architecture: crumbling walls, broken-down doors, militarized spaces. The wounded, mutilated landscape becomes the centrepiece of her images. A landscape that holds the memories of the past is subjected to the terrors of the present and points towards a future devoid of hope.

Halawani also seeks to reanimate history and restore the memory of a people who are being erased. Her work seeks out a landscape that is now unrecognizable, that of historic Palestine, as a way of understanding the scope of the destruction and rescuing an earlier way of life. This is why her use of archives is central to her later works. Through old photographs, as well as objects and various private documents, she seeks to reconstruct a collective memory that she can use to create the possibility of a different future. While these are nostalgic images, sometimes tragic and dark, they also testify to the intensity of resilience. **SM**[1]

Since her first works appeared in the early 1990s, Valérie Belin has been interrogating appearances and stereotypes in a world saturated with images and artifice. Looking at her photographs, the viewer is struck by the beauty of her subjects but at the same time disconcerted by the images, sometimes struggling to distinguish between what is animate and inanimate, real and artificial.

After studying fine arts and philosophy of art, Belin created her first works in 1993, photographing light sources and objects made of crystal. Even in these early works, she had a clear method and distinctive minimalist style. Until 2006, she worked exclusively in black and white. At first she concentrated on objects (mirrors, cars, dresses), which she photographed with great precision, not featuring human figures until 1999. She placed her subjects alone in front of a neutral black or white background and photographed them straight on, scrutinizing materials and forms. Her 'Moroccan Brides' disappear into their finery, her 'Bodybuilders' display the bodies they have painstakingly constructed, while the faces of her 'Black Women' or 'Models' have an inhuman quality. Her work is characterized by pared-down compositions, two-dimensionality and a sense of the monumental.

'I photograph images.'

VALÉRIE BELIN

From 2006 onwards, Belin began to introduce colour into her work. As photography changed, moving from the analogue to the digital age, she started to explore all the tools available to her. Although she did not manipulate or retouch any of the images in her early series, from 2009 she started to put her pictures together in post-production. She combined photographs, added to them, superimposed them, printed over them and solarized them, introducing an abundance of symbols to make them more difficult to interpret. The viewer is overwhelmed by the proliferation of details in these series of complex works, such as 'Black Eyed Susan', 'Brides', 'Bob', 'Super Models' and 'All Star'.

In series after series, Belin challenges the rampant consumerism of the society in which we live, choosing her subjects for their relevance to popular culture (Michael Jackson lookalikes, carnival masks, beauty queens, magicians, cabaret dancers). When she takes humans as her subject, she examines the transformations that they undergo in beautifying themselves, making themselves up or changing their appearance to fit in with the demands of a society that is dominated by image. Her photographs raise questions about appearances and the oppressive nature of society's gaze. 'If sometimes there is an element of the grotesque in my choice of subjects, there is also an element of the sublime. The sublime can become grotesque and vice versa; I play with this ambiguity.' Deliberately blurring the line between real and retouched (as in 'Painted Ladies'), Belin is interested in people who, chameleon-like, conceal themselves behind constantly changing identities. **NH**

Valérie Belin, *Untitled*, from the series 'Engines', 2002

Zoraida Díaz, *Rebel Love*, La Uribe, Meta, Colombia, 1988

'Mine was an uncontrollable desire to capture "sacred moments" in lives intervened by invisible forces, experiences that when captured by the camera in a thousandth of a second became visceral memories, mythical narratives.'

ZORAIDA DÍAZ

In the early 1980s, the first generation of female photojournalists in the Colombian media emerged. Among them was Zoraida Díaz, who was then working freelance for the Gamma Liaison photo agency in New York and for Reuters. She was documenting a critical event: the armed conflict between the state and Marxist guerrilla groups of the 1980s. Later, she would cover other crucial developments across Latin America, including the United States' invasion of Panama (1989), Hugo Chávez's attempted coup d'état in Venezuela (1992), the Tupac Amarú hostage crisis in Lima (1997), and the historic visit of Pope John Paul II to Cuba (1998).

Having emigrated to the United States with her family as a child, Díaz studied journalism and Latin American literature at the University of Maryland with authors including the Argentinian writer Tomás Eloy Martínez; she also met respected Latin American intellectuals such as Octavio Paz, Jorge Luis Borges and Eduardo Galeano. The vision of Latin America that she formed from its literary and political culture directly influenced the concise language of her photography, which is capable of condensing the rich subtleties of human experience into a single image.

Díaz discovered documentary photography as a student, when she joined a Fulbright-Hays expedition to Honduras and Guatemala as a research assistant. Their mission was to study the Caribbean ethnic Garifuna group, who are descended from Indigenous Caribbean peoples and African slaves. The portraits that she took of the community exposed her to the psychological depth inherent in the connection between photographer and subject. In an interview with the researcher Santiago Rueda, she described the existence of 'a communion … a perfect space in which someone in front of me has let me see and capture something possibly secret of his being'. The unveiling of a wide range of human emotions became a powerful trait of her documentary practice.

Her passion for the history and culture of Latin America encouraged Díaz to return to Colombia in 1987. Over a period of six years, she documented the country's social, political and economic situation, both the ongoing armed conflict and the urban landscape. At that time, clashes between the different armed factions were escalating owing to the involvement of drug cartels and far-right paramilitary groups fighting the guerrillas alongside the army. Through her images of daily life within the Revolutionary Armed Forces of Colombia (FARC), her portraiture and her intimate connection with her subjects, Díaz succeeded in conveying the complexities of the social and political climate. Díaz currently lives in Baltimore, where she continues her photodocumentary work, focusing in particular on racial tensions in that city. **CPdL**

'For me the most important part of working on the photo project is communication with people, then comes the photography.'

NATELA GRIGALASHVILI

Essentially self-taught, Natela Grigalashvili is indisputably one of the most remarkable and important artists of a generation that came of age in the social and cultural aftermath of the Soviet Union's collapse. Born in the small town of Khashuri, in central Georgia, Grigalashvili dreamt of becoming a film-maker from an early age but ended up as a photographer. In 1981, she left for Tblisi, the capital, to start her professional career. Five years later, she turned to photography, training in various studios. By the age of twenty-three, she was already working as a reporter – the first female photojournalist in a male-dominated industry – and covered social and political stories in the post-Soviet period, even spending a few years working for the Ministry of the Interior.

During the same period, Grigalashvili started to undertake long-term personal projects in which she developed her own unique, incisive style – a style defined by the artist's sincerity and free from outside influence. Her first series in black and white, on the everyday life of her native village and its landscapes, helped form her photographic practice and has become an iconic work. Far from offering an idealized vision of peasant life, this minimalist pastoral seems be inspired by the visual language of New Wave Georgian cinema of the early 1960s. When she photographed her village, Grigalashvili did not turn to sophisticated methods but simply took photographs every-where she went. By being present in numerous places – in the fields when the peasants were working; in the forest while her mother took a nap; by the river where the village women bathe; in the cemetery where families remember their dead – she invested her 'raw' black-and-white images with a rare strength, the result of her visionary gaze.

In 1997, Grigalashvili launched a lifelong personal documentary project entitled *Tagveti* (Village of the mice). It examines the village where the photographer was born and raised, and reads like a timeless story of a return to basics and an escape from the violence of the modern, changing world.

Since 2000, Natela Grigalashvili has travelled to remote parts of Georgia, focusing on life in high mountain villages or regions inhabited by religious and ethnic minorities. In 2007, she was awarded the Alexander Roinishvili Prize for her contribution to the promotion of photography in Georgia. As one of the most prominent figures in contemporary Georgian photography, she has inspired a whole new generation of female practitioners. **NN**

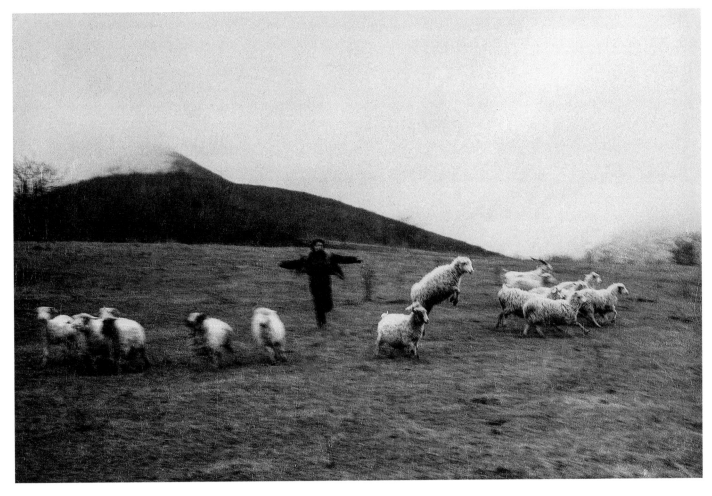

Natela Grigalashvili, *Village of the Mice*, 1990–2019

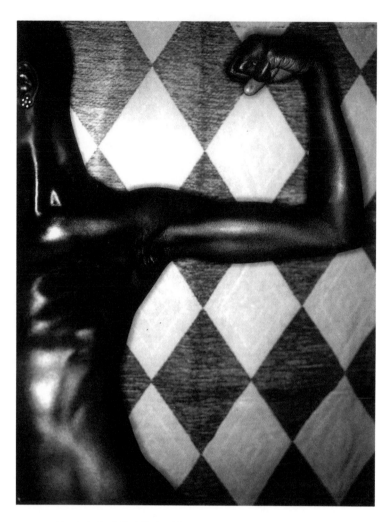

Mmekutmfon 'Mfon' Essien, *The Amazon's New Clothes, No. 2*, 1999

'My work is not about what we see,
but about what we feel.'

MMEKUTMFON 'MFON' ESSIEN

Mmekutmfon 'Mfon' Essien, born in Ikot Ekpene, Nigeria, grew up in Baltimore. She earned her bachelor of arts degree from Morgan State University in Maryland, and in the early 1990s she moved to New York, where her career as a photographer blossomed. During this period, she created editorial and fashion spreads for top music and lifestyle magazines, such as *Vibe* and *People*, but was it was her artworks that brought her recognition. In 2000, her series 'The Amazon's New Clothes' earned Mfon the opportunity to participate in the international Dak'Art Biennale in Dakar, Senegal. On 15 February 2001, the day after her death, 'The Amazon's New Clothes' featured prominently at the Brooklyn Museum of Art's *Committed to the Image: Contemporary Black Photographers*, Mfon's first museum exhibition.

Mfon conceived 'The Amazon's New Clothes' after receiving a terminal breast cancer diagnosis in 1998, in her early thirties. Owing to the aggressive nature of the disease, she underwent a mastectomy. As a way of dealing with the shock and grief of this trauma, Mfon pointed the camera at her own body, using photography as a therapy.

Keeping within the tradition of the medium, Mfon worked in black and white using a large-format camera. As with Claude Cahun and Carrie Mae Weems, a woman turning her gaze on her own body interrogates, disrupts and brings new light to the medium of photography. Mfon transforms her body into that of a symbolic Amazon – nude, dark and firmly toned, sitting eloquently on a white chair. Following it from the neck down (the face is hidden), we become intrigued by the beauty of this asymmetrical body. Mfon adopts the dignified, confident pose of a warrior, the slight tilt in her shoulder suggesting fearlessness and lending the image a touch of grace while also disrupting its symmetry. Her shoulders draw our eyes to the scar that has replaced her missing breast. She wears two white shoes that occupy the foreground of the photograph; unstrapped and yet stunning, they look the same but are in fact mismatched.

The title of the series borrows from the tale 'The Emperor's New Clothes' by Hans Christian Andersen. Perhaps the viewer is being asked to consider the 'new clothes' of an Amazon waging war against an ideology that views only Vitruvian Man as the pinnacle of perfect beauty.

Mfon's full name, Mmekutmfon, translates as 'I have seen the goodness of God'. Describing her artistic impulses, she proclaimed, 'I am constantly shooting myself so I can continue to appreciate what I have and where I am. I am totally diggin' where I am. I feel sexy now. And I have never felt like that before.' Mfon always placed herself at the centre of her work, but the act of speaking of herself contained a message for the whole of humankind. **ADF**

Xing Danwen was among the first wave of experimental photographers that appeared in China in the 1990s. She trained her lens on a new underground scene that was constantly changing, as was her approach to photography, which secured her place in the emerging Chinese contemporary art scene.

Xing first encountered photography at the age of seventeen and taught herself how to use the medium while studying painting at the Academy of Fine Arts in Xi'an in 1986, then in Beijing in 1992. In 1998, she moved to the United States, where she gained a master's in photography from the School of Visual Arts in New York. She now lives in Beijing.

In the late 1970s, the generation before her broke with the idea of using photography as a propaganda tool and founded the first collectives of independent photographers (April Photographic Society, Friday Salon). Xing went even further, emphasizing the artistic aspects of the medium. Inspired by the experimental artists with whom she spent time, including the alternative scene of the Beijing East Village, she lived a life outside of society's expectations. The result was 'A Personal Diary' (1993–2003), a series of sensual and sometimes humorous portraits of artists – performers, poets and rock musicians – from that time, taken before they became stars on the contemporary cultural scene. The portraits are imbued with poetry, captured in Xing's unique narrative style. She created a powerful record of a disenchanted generation in her series 'I Am a Woman' (1994–6) and 'Born with Cultural Revolution' (1995), in which pregnant women posed naked in front of images of Mao Zedong. A distinctive symbol in her work, Xing's camera, when not in her hand, often makes a surreptitious appearance in her photographs. In 'Scroll' (1999–2000) – an abstract vision of Beijing – she began to develop an interest in manipulating images, juxtaposing 120mm films.

Since 2000, Xing Danwen's practice has included analogue photography as well as digital photography and film. She explores themes such as fiction and reality, globalization and tradition, environmental issues and concerns around the excesses of consumerism. She has enjoyed international recognition since 1995 (when she was on the cover of *Photonews* magazine in Hamburg), and today her work features in the collections of the most prestigious museums in the world, including the Centre Pompidou in Paris, the Victoria and Albert Museum in London, and the Metropolitan Museum of Art in New York. **BA**

'I draw inspiration from life itself. Looking at society and people with a sensitive, critical eye, I like to ask questions and reflect on them.'

XING DANWEN

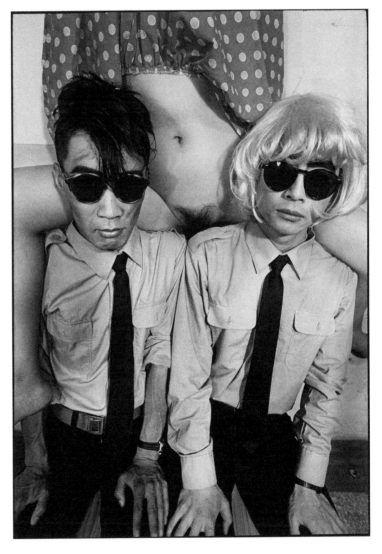

Xing Danwen, *Liu Anping & Wang Jinsong*, from the series 'An Intimate Diary', Beijing, 1995

b. 1967, China

'I want my work to be perceived as being created by an individual, not by a woman. I believe the purpose of art is to realize one's own individuality, which is beyond gender.'

CUI XIUWEN

From a very early age, Cui Xiuwen insisted on her own independence. She thought the characters that made up her given name – 'beautiful' (*xiu*) and 'culture' (*wen*) – were too common, so she looked up different characters with the same pronunciation and renamed herself 'the news that comes from mountain caves'. This act of renaming reveals the desire to explore the depths of the human soul – whether it is a question of gender, identity or spirituality – that drove her to constantly refine and reinvent her approach.

Born in Haerbin, Cui Xiuwen grew up in a country that was undergoing seismic changes, liberalizing its economy and gradually opening up to the rest of the world. She studied at the Northeast Normal University in Changchun (graduating in 1990), then at the Central Academy of Fine Arts in Beijing (1996), where she learned about oil painting, French philosophy (Michel Foucault, Jean-Paul Sartre), the works of Sigmund Freud, Buddhist thought and modern Western art (Alberto Giacometti, Max Beckmann). After graduating, in 1998, she founded the Siren Art Studio with three other female artists and exhibited her work in her apartment, at a time when contemporary art was rarely given its rightful place in public exhibitions. Even her early works were provocative, paintings of naked bodies – male, female and couples embracing. In 1998, the National Art Museum of China in Beijing put on an exhibition,

Century Woman, featuring work by seventy female artists, including Cui. It was the first time that her work was shown in an institutional context, and her first international exhibitions followed soon afterwards.

Abandoning her paintbrushes, Cui began experimenting with photography and film, mediums in which she was self-taught. Her first film work, *Ladies' Room* (2000), focused on escorts and was removed by official censors at the first Guangzhou Triennial. *Twice and Toot* also grabbed the headlines the following year.

In her photographs, Cui examines the impact of patriarchy, communism and religion. She focuses on the position of women in China, in series that show her models over a long period of time, from childhood to adulthood. Her pictures show girls with extremely white skin and rouged cheeks, who look like dolls, their images often multiplied and digitally manipulated. *Sanjie* (The three kingdoms, 2003) is inspired by the Last Supper, with a schoolgirl playing all the roles, posing suggestively, the red tie of the Young Pioneers (an organization run by the Communist Youth League) knotted at her throat. In 'One Day in 2004' (2004), Cui photographed a young girl wearing a white dress in various locations around the Chinese capital that are associated with power or tradition, such as the Forbidden City. A few years later, she explored rape and duality in the series 'Angel' (2006–8), which shows a pregnant teenager against urban landscapes in saturated colours, and in 'Existential Emptiness' (2009), where a young woman is photographed alongside a doll made in her likeness, in the middle of a snowy landscape.

The later part of Cui Xiuwen's career was marked by an interest in spirituality and Buddhism. From 2012, she returned to painting, producing mainly abstract paintings and installations. She died following a long illness in 2018, having made her name on the international stage. In 2004, she was the first Chinese artist to have an exhibition at the Tate Modern in London. Her works form part of the collections of major institutions such as the Centre Pompidou, Tate Modern and the Brooklyn Museum. **VJ**

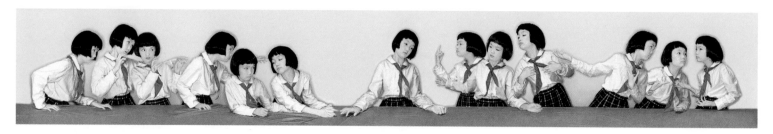

Cui Xiuwen, *Sanjie*, 2003

Deanna Templeton grew up in Huntington Beach, a highly conservative suburb of Los Angeles, and spent her teenage years going to punk-rock gigs. Her mother gave Deanna her first camera when she was sixteen, and she started to take photographs of her school friends, with a particular interest in portraiture. At eighteen, she met Ed Templeton, who encouraged her to take her photography seriously. They married four years later, and the two live and work closely alongside each other.

Deanna Templeton took photos of her circle of friends – who belonged to the Californian skating scene of the 1990s – on a daily basis, creating a kind of intimate diary. Adolescence and post-adolescence are at the heart of her work, and her portraits also function as self-portraits. A feminist and a romantic, she brings a certain softness to the hard, misogynistic skating and rock scenes, which are more often photographed by men. This tenderness distinguishes her work from that of Larry Clark, the pioneer of the genre, and Ari Marcopoulos, who documented the skating scene in New York in the 1990s, as well as that of Ed Templeton himself.

Rejecting the mainstream, Deanna Templeton is an alternative photographer. In the late 1990s, she became one of the key figures publishing zines, a groundbreaking kind of creative, independent publication. Her first zine, *Little Girls Hate Both of You*, was a chaotic mixture of drawings, collages, photographs, poems and thoughts. She now thinks of it as a 'personal manifesto born of the desire to express myself and share my emotions, a shield against my shyness'.

It was the artist Margaret Kilgallen who inspired Templeton to forge her own path and find her own version of feminism. Although she admires the work of Ed Ruscha and Robert Frank, she has a special affection for the work of the women who came before her. One major influence is the Japanese artist Hiromix, a provocative photographer and DJ from the 1990s. She also has great admiration for Diane Arbus and Vivian Maier. Known for her black-and-white Californian portraits, Templeton also takes colour photographs, both always on film. Whether she is in Berlin, Tokyo or London, her subjects remain the same: her daily life with Ed Templeton, young women, night-time and those on the edges of society.

Templeton has also published many books, including, recently, *What She Said* (2021) and *Swimming Pool* (2016), a collection of photographs in both colour and black and white that show nude bodies swimming alone in a vibrant blue pool, serene, cut off from the world. These pictures reflect Templeton's approach to life: leading a liberated existence, unshackled by the puritan Republican morals of her childhood. Her work is marked by the visceral, vital rejection of these values – an inner rebellion that mirrors that of her subjects, giving rise to a paradoxically gentle and peaceful body of work. **PV**

Deanna Templeton, *Five packs of cigarettes*, 1998

'In the beginning … I felt like I was a part of the boy's club. It's always been more male-dominated.'

DEANNA TEMPLETON

b. 1969, United States

433

Gauri Gill's images redefine the notion of collaboration. Working over extended periods of time, usually years, Gill forms lasting bonds with her subjects. Her photographs reject the trappings of the documentary image, even if the two share certain visual characteristics. Her work proposes new ways of being a photographer and, for the viewer, new ways of looking.

Born in 1970 and raised in Chandigarh, Dehradun, Kasauli and New Delhi, Gill studied painting and applied arts at the Delhi College of Art. Motivated by an interest in photography, she took evening classes at Triveni Kala Sangam (at that time the only place in Delhi to teach photography), before studying at Parsons The New School in New York and, later, at Stanford. While in the United States, she photographed her extended family and friends from the South Asian American community. Published as a book entitled *The Americans*, this work updates Robert Frank's iconic 1958 book of the same name and, for Gill, established a photographic practice based on intimacy.

The 'Notes from the Desert' series (1990–2010) brings together an extensive body of photographs taken by Gill in the wilderness of western Rajasthan over the twenty years that she visited friends among Jogi nomads, Muslim migrants and Bishnois peasants. This corpus itself includes several series and uses different forms of image creation.

'Balika Mela' (2003–10) is a series of portraits taken in Lunkaransar, in rural Rajasthan. Produced in a makeshift studio created by Gill at a fair for young girls, these images are performances of self-presentation, with the subjects choosing their own props, gestures and compositions. The portraits address the concept of specificity, countering the history of colonial tourist photography in the region, which generalized the Indian body through an authoritative eye.

Creative agency is shared between the photographer, the sitters, and even onlookers who chimed in with suggestions. Given the way rural communities are organized, much of Gill's work concentrates on women's spaces and testifies to the privileged link she has with her models. In an astonishing series of birth photographs taken in 2005, we discover images that could have been taken only by a trusted friend, by someone who was helping as much as recording. Likewise, the rural community is represented not through themes of poverty or disaster, but ordinary life events, at once both personal and epic.

In subsequent work, Gill invited rural artists to become co-authors and collaborators. For example, 'Fields of Sight' (2013–ongoing) is a project that combines photographs taken around the village of Ganjad in coastal Maharashtra with drawings by Rajesh Vangad, a master of Warli painting. The result not only is a collaboration, but also represents the coexistence of two temporalities, two different figural codes that deconstruct the very meaning of photographic representation. **DD²**

'I like to work with specific realities and being physically put in certain places that I might not go to without a camera. I like the idea of bearing witness, of making a history.'

GAURI GILL

Gauri Gill, *Alok and Sumati Patel-Parekh, Silicon Valley, California*, from the series 'The Americans', 2001

Louiza Ammi, *Cemetery of Sidi Rezine*, Baraki, Autumn 1997

'Louiza'. To this day, the photographer's first name is still closely associated with Algeria in the 1990s. Since the popular uprising that began on 22 February 2019, Louiza Ammi has been recognized both on the streets and on social media as one of the few female photojournalists who covered the years of 'civil war' – a period marked by political upheaval and extreme violence, which formed the backdrop to the first ten years of her career as a press photographer.

It was seeing a report about a female war photographer on television when she was a child that inspired Ammi to pursue the same career. Her older brother introduced her to photography and encouraged her to study at one of the few professional photography courses available in Algiers. At only twenty-one, qualification in hand, Louiza Ammi was hired by one of the many independent newspapers that had been set up in response to political reforms. In an attempt to calm the widespread public anger that had reached a peak in October 1988, the government legalized 'non-political organizations' and independent press outlets not controlled by the regime. During this brief moment of democracy, independent newspapers sprang up across the country. The dynamic nature of the Algerian press at that time, but also the internal pressures, threats and assassinations targeting journalists and intellectuals, meant that editorial teams had to change constantly. Like many of her colleagues, Louiza frequently switched between working for different newspapers. Attacks and massacres were part of daily life for Algerians and this unsettled context influenced photographers' way of working, as they were often exposed to violence, a violence that many sought to capture in brutal, unflinching pictures. This led Louiza to produce some very hard images; she once had to make herself squint to stop her eyes from focusing on a dead body that she needed to photograph. But she also decided to foreground the scenes of daily life alongside this violence, even if it was painful. She photographed families in villages that had been devastated by the conflict, approached women and children at moments of extreme distress. Her photographs were noticed. She signed the photographs with her first name, 'Louiza', to avoid reprisals for herself and her family.

From the end of the 1990s, photography began to occupy a less central place in Algerian newspapers. Louiza still continued to take press photographs, notably covering the Kabyle uprising in 2001, while simultaneously developing and exhibiting personal projects, as well as some of her work from the 1990s. Since February 2019, Louiza has once again been very active on the ground, tirelessly photographing the Hirak anti-regime protests, where photography is at the heart of the movement. **AH**

Zanele Muholi, *Bona III, ISGM, Boston*, from the series 'Somnyama Ngonyama', 2019

South Africa was the first country in the world to institute legislation protecting the rights of the LGBTQI community, its constitution banning discrimination on the grounds of gender or sexual orientation, and is the only African nation to allow same-sex marriage. Although these laws have been in effect since 1995, statistics show that members of the LGBTQI community are still commonly the victims of homophobic attitudes and violence. Similar patterns are found elsewhere on the continent and around the world, but there is one aspect that is particular to South African communities: the group most targeted by hate crimes, including corrective rape, are Black lesbian women from the townships.

At the forefront of denouncing these brutalities, Zanele Muholi uses the medium of photography to highlight the plight of these marginalized women, producing work that is inseparable from the homophobic cultural and social context in South Africa and elsewhere. Long believing that the visual arts did not sufficiently represent the LGBTQI community in the townships, Muholi felt propelled to stimulate a dialogue within and outside of the community around the issues it faced. The lack of representation in mainstream media and the history books encouraged them to bear witness to their life and to create an archive that, by showing sensitive portraits of love, intimacy and resilience, tried to debunk the notion that homosexuality is un-African and to give a human dimension to what society names 'the Others'.

Muholi's most iconic series, 'Faces and Phases' (2006–14), which highlights the need to make the LGBTQI community visible in the townships, is today

'I always say to people that I'm an activist before I'm an artist. To me, you take a particular photo in order for other people to take action. So you become an agent for change in a way.'

ZANELE MUHOLI

considered their most important body of work, as it brings together ambitious, bold and undeniably powerful portraits of lesbians, gays and transgendered from Black communities across South Africa. This series shows each individual against a plain or patterned background, forcing the viewer to engage directly with them. Often arranged in the form of dense grid, the series has been exhibited all over the world, in particular at the Ryerson Image Centre, Toronto, as part of WorldPride in 2014.

Zanele Muholi – whose work has been hailed by many cultural institutions, and who in 2017 was named a Chevalier in the Ordre des Arts et des Lettres by the French government – has evidently succeeded in bringing visibility to the South African LGBTQI community, as well as achieving immense renown within the art world. **FM[1]**

Shadi Ghadirian was one of the first artists in Iran to take staged photographs. Her series convey a subtle but strong message centred on themes that are linked to her country's recent history, but also to contemporary art, feminism and her own interests. Her photographs are a record, an account and an act of protest.

In the late 1990s, when it was still difficult for Iranians to travel abroad or to access the internet, Ghadirian conceived her first project, 'Qajar' – named after the dynasty that ruled Iran from the eighteenth to the twentieth century and was responsible for introducing photography to the country. The series of staged photographs that launched her career showed women caught between tradition and modernity. Two decades after a revolution that had rocked Iran and changed the face of the world, and shortly after the end of a long, brutal war with Iraq, her pictures shed light on what had previously been unknown: despite what had filtered down through the media, art – and sometimes photography – was being practised in Iran; women were able to produce and exhibit their work. In this series, the contrast between modern-day objects and traditional clothing emphasizes the conflicting forces that have always been at work in Iranian society. These photographs established Shadi Ghadirian's name as one of the most prominent Iranian photographers.

Over the years that followed, Ghadirian produced other series. 'Like Everyday' focused on women whose daily lives revolved around common objects – ladles, bowls or sieves. 'Be Colorful' highlighted the absence of colour in Iranian women's clothing. 'Nil, Nil' referred to the result of a match in which there is no winner. Ghadirian's work offers a female perspective on war, a subject usually photographed only by men. She said of this series, 'Our war photographs are taken by men on the battlefields or by male photojournalists. But no one has yet seen war through the female gaze.'

'White Square' evokes a hope for peace, while 'Miss Butterfly', created during the protests that followed the presidential elections in 2009, 'shows how we have to fight with all we have to hold on to hope, whether that means enduring oppression or fighting against it, braving all dangers'. Finally, 'Too Loud a Solitude' tells the story of the individuals who live alongside us, people we pass by without knowing where they come from or where they are going, until the day when we take the same path as them.

Shadi Ghadirian says that her subjects choose her, often simply and by chance. Drawing on Persian poetry, she clothes her subjects in metaphor and approaches them from a different angle in order to analyse the recent history that she has lived through. The emotions that her works evoke invite the viewer to explore and reflect on an unfamiliar world. **AGE**

'To me, a woman, an Iranian woman, a woman like me, stands at the crossroads of all the unknown borders between tradition and modernity.'

SHADI GHADIRIAN

Shadi Ghadirian, *Nil, Nil #19*, 2008

A Chinese conceptual artist who worked mainly in the medium of photography throughout her brief, intense career (1999–2005), Chen Lingyang shaped the conceptualization of femininity and its relationship to Chinese culture and traditions in the 1990s.

Born in Zhejiang, Chen graduated from the China Academy of Art in Hangzhou in 1995, then studied painting at the Central Academy of Fine Arts in Beijing, graduating in 1999. That same year, she took part in many exhibitions while she was still a student, and immediately caught the attention of the contemporary art scene in China. Although her training was in painting, she quickly became interested in photography as a medium and used it to explore the themes of the body and self-representation. Her most striking work is a series entitled 'Twelve Flower Months' (1999–2000), which set the photography world on fire, sparking countless controversies about the representation of women. It consisted of twelve photographs that Chen took over the course of a year, each one while she was on her period. Each picture shows a flower in full bloom, a reference to the twelve flowers of traditional Chinese calendars. Next to each flower is a mirror, which shows in its reflection the artist's body during her period. Some of the reflected images are close up, while others are further away, showing the artist's vagina or leg. The unflinching detail in which her genitals are shown is counterbalanced by the harmony of the composition, with details drawn from traditional Chinese images of femininity, such as the female virtues associated with each flower, or the feminine world of the walled garden evoked by the framing of the images, which sometimes look as if they are glimpsed through an open door or window. The 1990s saw the emergence of a new generation of experimental photographers who dared to defy convention and depict nudity, but no artist in China had gone as far as Chen in their representation of the body, or in transgressing the classical image of women.

In the early 2000s, Chen continued to explore her complex feelings towards herself, mainly through photographic work that took her own body as her subject. She enjoyed considerable success on the international stage, with her work appearing at the Fukuoka Asian Art Museum (2000), the Rencontres d'Arles photography festival, and the Centre Pompidou (2003) in Paris.

On 8 March 2005, International Women's Day, Chen Lingyang decided to withdraw from the art world. She had had a profound impact on photography and contemporary art in China as it moved from the twentieth to the twenty-first century. **BA**

> 'My photographs are about me,
> and I am a woman.'
>
> **CHEN LINGYANG**

Chen Lingyang, *The Seventh Month Orchid*, from the series 'Twelve Flower Months', *c.*1999–2000

Newsha Tavakolian, *Cicek was killed at the age of 17 in Kobane. The only belonging of hers that could be brought back to her family was this scarf. Her body is still in Kobane and cannot be returned to her hometown to be buried there.* Syria, 2015

'A pioneer of photography', 'an iron will', 'daring': these are the kinds of compliments showered upon Newsha Tavakolian in the press. She started taking photographs at the age of sixteen, but at first this was simply a way of avoiding school. Tavakolian is dyslexic and went to an alternative school, where she specialized in photography, a language that made more sense to her. Her coming of age coincided with a historic change in Iran. The reformer Mohammad Khatami was elected president and introduced various new laws, including the legalization of moderate newspapers. Directly influenced by the changes in her country, Tavakolian dedicated herself to press photography. Then, in 1999, the reforms were revoked and everything changed. The army raided a student dormitory and fired on protesters. Tavakolian spent many days photographing events as they unfolded.

From the age of nineteen, Tavakolian fought to gain acceptance in the male-dominated world of photojournalism and began to make a name for herself in the international press. She made her first cover, *Newsweek*, in 2000. In 2004, she joined Eve Photographers, a collective of female photojournalists. Five years later, she founded Rawiya, a network of female photographers from across the Middle East that aimed to give them greater control over their work and stories.

In 2013, Tavakolian won the Carmignac Photojournalism Award. Challenging simplistic, stereotypical representations, her series 'Blank Pages of An Iranian Photo Album' depicted a young, middle-class generation growing up with little hope. In 2015, she won the prestigious Prince Claus Award and joined Magnum Photos, leading to even greater recognition of her work. She also helped to promote Iranian photography with the exhibition *Iran: Year 38* at the Rencontres d'Arles photography festival in 2017. The show, which she co-curated, featured the work of around sixty photographers.

For some years now, Tavakolian's work has been taking a more conceptual, artistic direction. She never tries to communicate a message directly, preferring a metaphorical, often poetic approach. Questions of justice, equality and freedom permeate her work. 'Listen' (2010–11) depicts female Iranian singers, who – unlike their male counterparts – are prevented by Islamic law from performing alone or recording songs under their own name. More recently, Tavakolian's series 'Öcalan's Angels' (which recalls the photographs she has taken in Iraq since 2002) focused on young Kurdish women who joined the Women's Protection Units (YPJ) in Iraq and Syria to fight against the Islamic State, but also for gender equality and an end to the oppression of women.

In recent years, Tavakolian has been moving towards film and installation work, although she has not abandoned photography. She invites viewers to reflect on her practice, piecing together the different parts of a puzzle to reveal her unique vision of the world. **AGE**

'I learned to say what I thought through my photos by handling the ambiguity, without ever being explicit. It took a lot of training to get there.'

NEWSHA TAVAKOLIAN

Tuija Lindström, *Jonas and Jussi*, 1982

Carrie Mae Weems, *Untitled*
[Man reading newspaper],
from 'The Kitchen Table Series',1990

441

Liz Johnson Artur,
Coupé-décalé, Paris, 2004

Tish Murtha, *Karen*,
from the series 'London by Night', 1983

Rita Ostrovska,
Alik and me, 1994

444

Gauri Gill, *Untitled (26)*,
from the series 'The Mark on the Wall',
1999–ongoing

446

Francesca Woodman,
Self-portrait talking to Vince,
Providence, Rhode Island, 1977

Pesi Girsch,
Hand and Foot, 1988

Angèle Etoundi Essamba,
Cobra, 1986

Jungjin Lee,
American Desert I, 91–23, 1991

451

Ming Smith,
'Revelations' by Alvin Ailey,
Harlem, New York, c. 1975

Pushpamala N.,
Golden Dreams #10, 1998

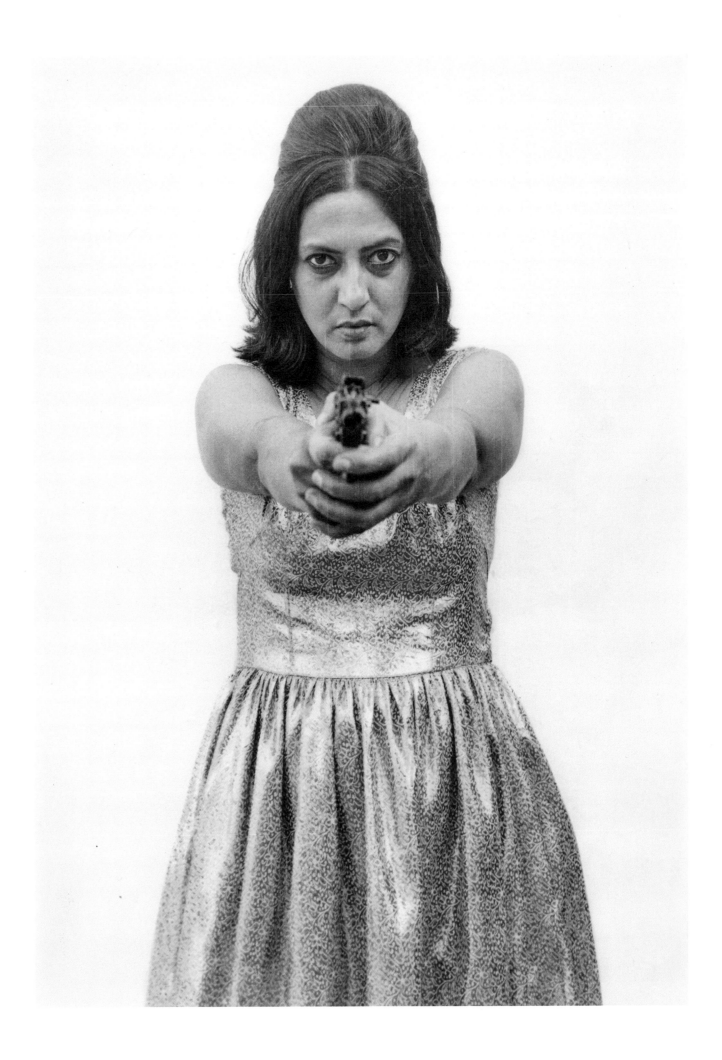

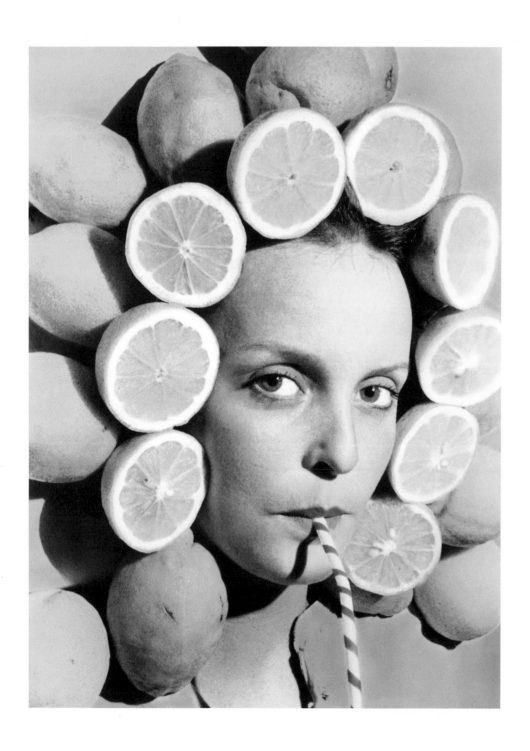

Ouka Leele, *At the Hairdresser: Lemons*, 1979

Maud Sulter, *Terpsichore*, from the series 'Zabat', 1989

454

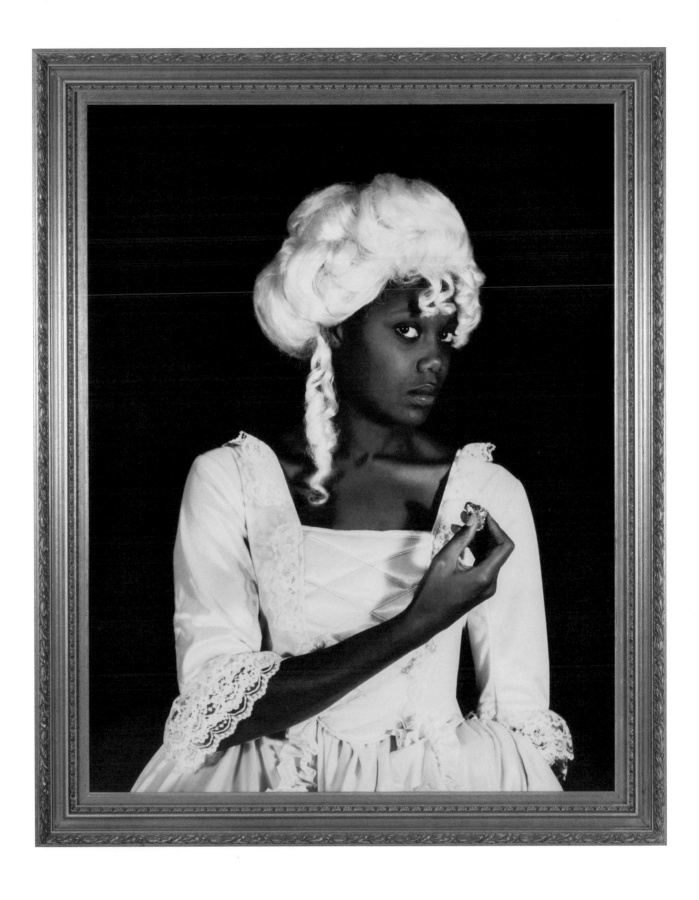

Zubeida Vallie,
*Mass protest for open
beaches at Strand Beach*,
Cape Town, South Africa,
Saturday, 19 August 1989

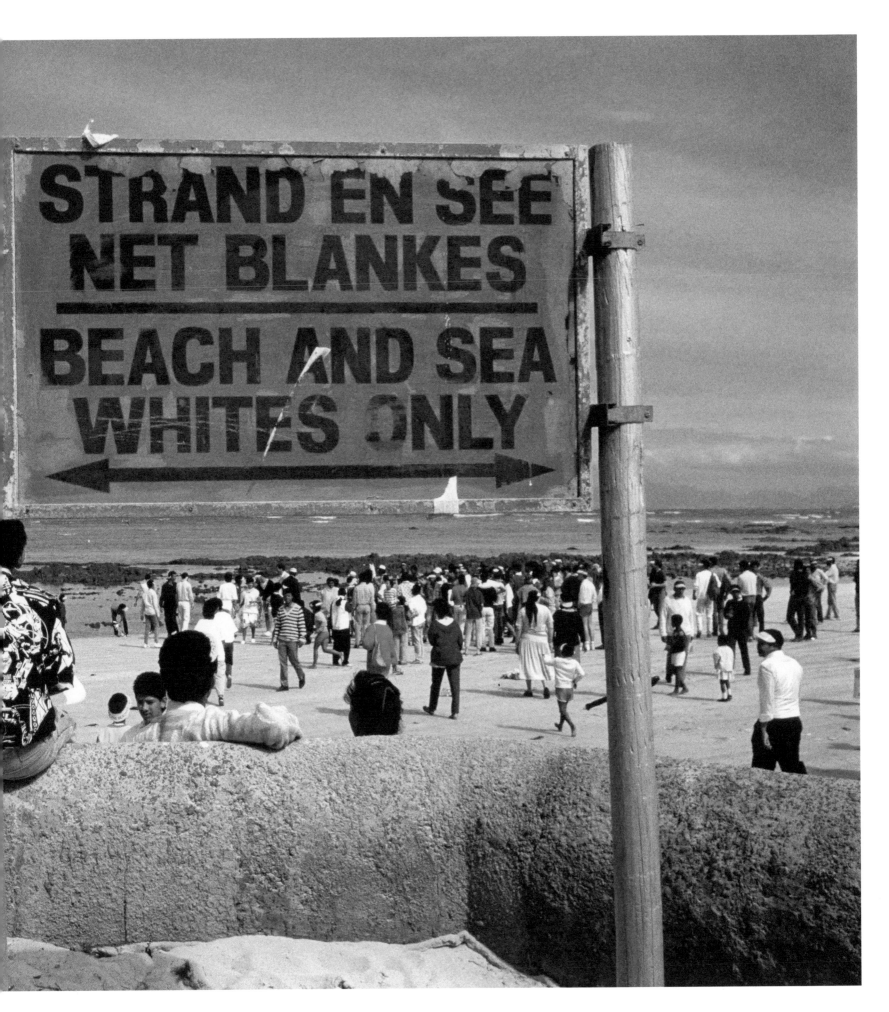

457

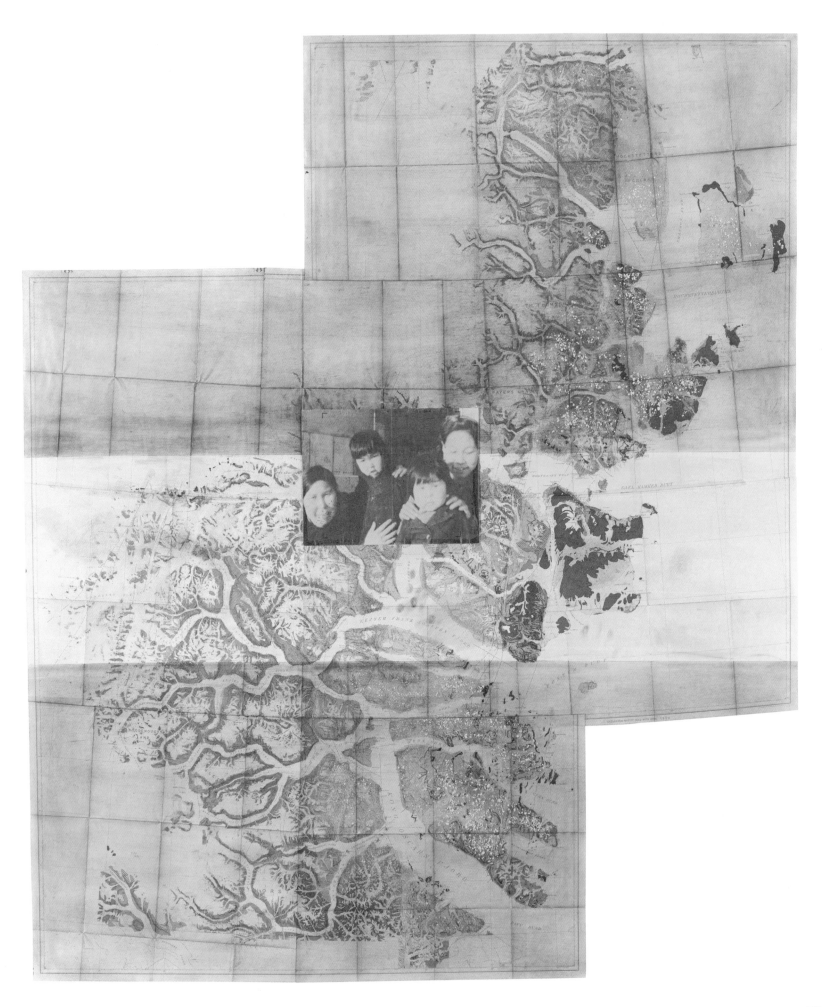

458

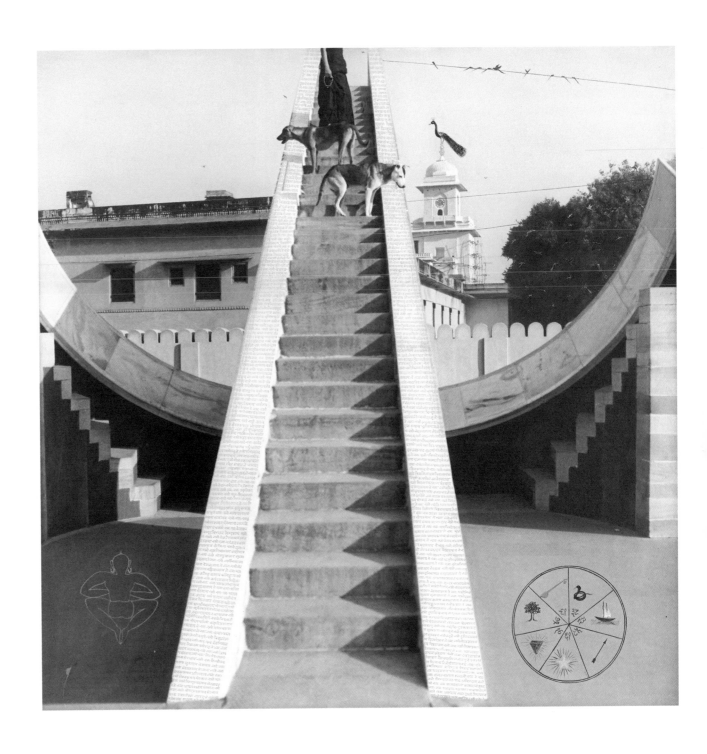

Pia Arke, *Legend I–V*, 1999

Pamela Singh,
Tantric Self-Portrait
in Jaipur #18, *c*.2000–1

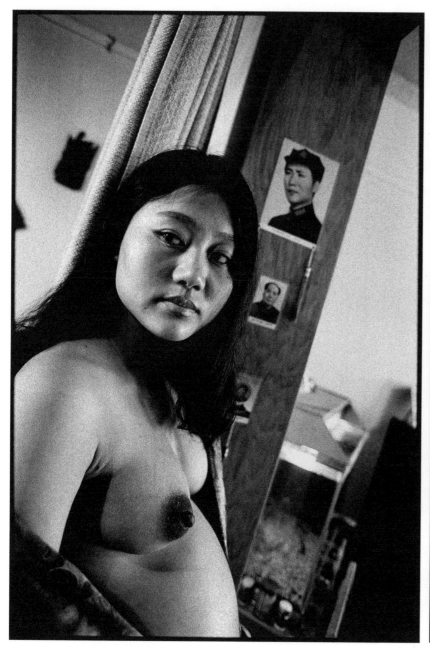

Xing Danwen,
Born with the Cultural Revolution,
1995

461

Dayanita Singh,
House of Love, 2010

Tracey Moffatt, *Doll Birth*,
from the series 'Scarred for Life', 1994

Tracey Moffatt

Doll Birth, 1972 His mother caught him giving birth to a doll.
He was banned from playing with the boy
next door again.

Nan Goldin, *Cookie and
me after I was punched,
Baltimore, Maryland*, 1986

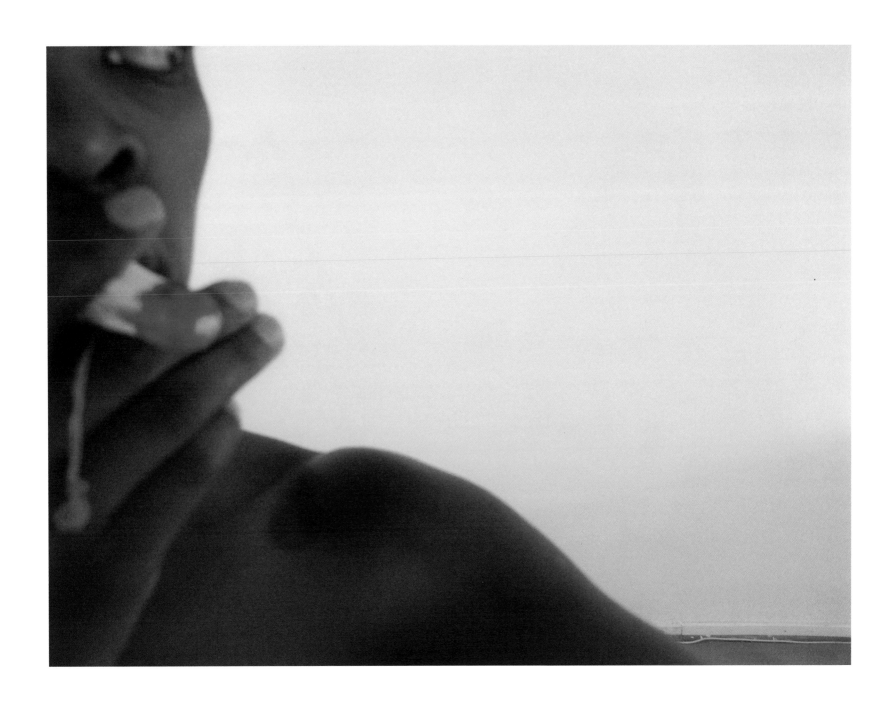

Rineke Dijkstra, *Odessa, Ukraine*,
from the series 'Beach Portraits',
4 August 1993

Zanele Muholi, *Untitled*,
from the series 'Only Half the Picture', 2006

467

Shadi Ghadirian, *Untitled*,
from the series 'Like Every Day',
*c.*2000–1

Shelley Niro, *T-shirt #3*, 2003

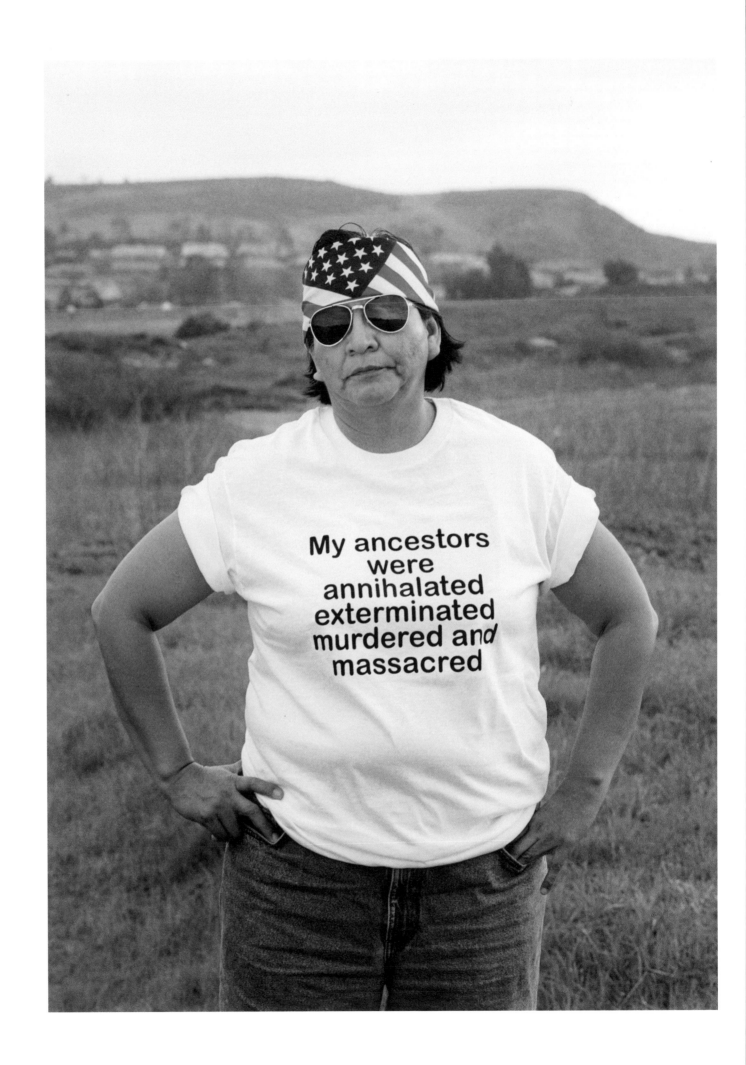

469

Newsha Tavakolian,
Portrait of Negin in Tehran, 2010

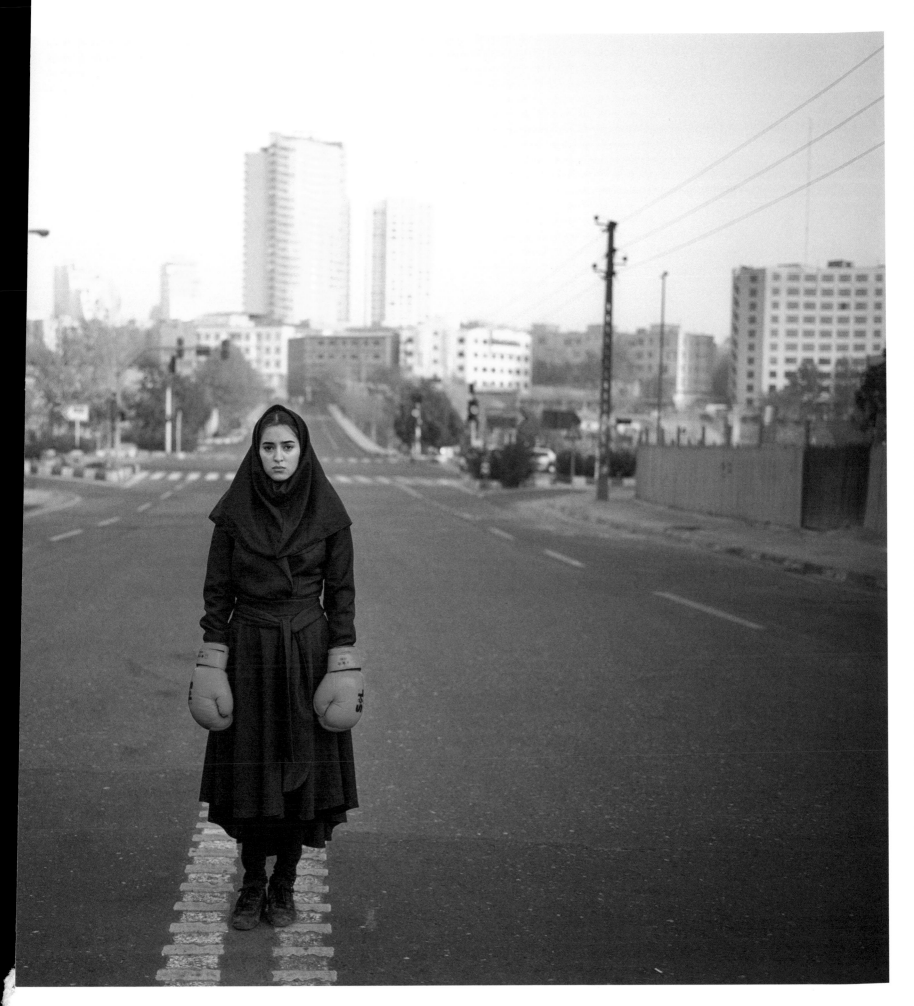

Select bibliography

Books and exhibition catalogues

Alfano Miglietti, Francesca, *Through Women's Eyes: From Diane Arbus to Letizia Battaglia – Passion and Courage*, exh. cat., Venice: Marsilio, 2015

All Americans: Images by Professional Women Photographers – A Photographic Exhibition, exh. cat., Garden City, NY: Nassau Community College, 1997

Armstrong, Carol, *Scenes in a Library: Reading the Photograph in the Book, 1843–1875*, Cambridge, MA and London: MIT Press, 1998

Armstrong, Carol, and Catherine de Zegher, (eds), *Ocean Flowers: Impressions from Nature*, New York and Princeton, NJ: Drawing Center and Princeton University Press, 2004

Barrayn, Laylah Amatullah and Adama Delphine Fawundu, *MFON: Women Photographers of the African Diaspora*, New York: Eye & I Incorporated, 2017

Beckers, Marion, and Elisabeth Moortgat (eds), *Kriegsfotografinnen*, 'Fotogeschichte' series, Marburg: Jonas, 2014

Beckmann, Anne-Marie, and Felicity Korn (eds), *Women War Photographers: From Lee Miller to Anja Niedringhaus*, Munich: Prestel, 2019

Bethune, Beverly Moore, and Mimi Fuller Foster (eds), *Women in Photojournalism*, Durham, NC: National Press Photographers Association, 1986

Bianco, Silvia and Walter Liva, *Donne e fotografia*, Udine: Lithostampa, 2017

Blessing, Jennifer (ed.), *Rrose is a Rrose is a Rrose: Gender Performance in Photography*, exh. cat., New York: Guggenheim Museum, 1997

Boffin, Tessa, and Jean Fraser (eds), *Stolen Glances: Lesbians Take Photographs*, London: Pandora Press, 1991

Boice, Judith (ed.), *Mother Earth Through the Eyes of Women Photographers and Writers*, San Francisco: Sierra Club Books, 1992

Bouqueret, Christian, *Les Femmes photographes: De la nouvelle vision en France, 1920–1940*, Paris: Marval, 1998

Bouveresse, Clara, *Femmes à l'oeuvre, femmes à l'épreuve : Eve Arnold, Abigail Heymann, Susan Meiselas*, Arles: Actes Sud, 2019

Bouveresse, Clara, and Sarah Moon (eds), *Women Photographers*, 'Photofile' series, London and New York: Thames & Hudson, 2020, 3 vols

Brettle, Jane and Sally Rice (eds), *Public Bodies / Private States: New Views on Photography, Representation and Gender*, Manchester and New York: Manchester University Press, 1994

Breuer, Gerda, and Elina Knorpp (eds), *Gespiegeltes Ich: Fotografische Selbstbildnisse von Künstlerinnen und Fotografinnen in den 1920er Jahren*, Berlin: Nicolai, 2013

Bright, Susan, *Home Truths: Photography and Motherhood*, London: Art / Books, 2013

Bright, Susie, and Jill Posener (eds), *Nothing But the Girl: The Blatant Lesbian Image*, New York and London: Freedom Editions, 1996

Bronfen, Élisabeth, *Photos de femmes*, Paris: Plume, 2001

Bush, Kate, and Mark Sladen (eds), *In the Face of History: European Photographers in the 20th Century*, London: Black Dog Publishing, 2006

Butler, Cornelia, and Lisa Gabrielle Mark (eds), *Wack! Art and the Feminist Revolution*, Los Angeles: MOCA and MIT Press, 2007

Butler, Cornelia, and Alexandra Schwartz (eds), *Modern Women: Women Artists at the Museum of Modern Art*, exh. cat., New York: Museum of Modern Art, 2010

Butler, Susan, *Shifting Focus: An International Exhibition of Contemporary Women's Photography*, exh. cat., Bristol and London: Arnolfini Gallery and Serpentine Gallery, 1989

Calado, Jorge, *Au féminin: Women Photographing Women, 1849–2009*, exh. cat., Paris: Centre Culturel Calouste Gulbenkian, 2009

Chadwick, Whitney, *Mirror Images: Women, Surrealism, and Self-Representation*, Cambridge, MA: MIT Press, 1998

Conger, Amy, and Elena Poniatowska, *Compañeras de Mexico: Women Photograph Women*, Riverside, CA: University Art Gallery and University of California, 1990

Costa, Guido, Elisabeth Sussman, Joanne Lukitsh and Mark Durden, *5 Great Women Photographers: Mary Ellen Mark, Julia Margaret Cameron, Dorothea Lange, Lisette Model, Graciela Iturbide*, London: Phaidon, 2005.

Costa, Heloise, and Zerwes, Erika, *Mulheres Fotógrafas / Mulheres Fotografadas: Fotografia e Gênero na América Latina*, São Paulo: Intermeios, 2020

Csilla, Csorba, *Magyar fotográfusnők,1900–1945*, Budapest: Enciklopédia Kiado, 2001

Davidov, Judith Fryer, *Women's Camera Work: Self / Body / Other in American Visual Culture*, Durham, NC: Duke University Press, 1998

Delaney, Max et al, *Unfinished Business: Perspectives on Art and Feminism*, Southbank, Victoria: Australian Centre for Contemporary Art, 2017

Di Bello, Patrizia, *Women's Albums and Photography in Victorian England: Ladies, Mothers and Flirts*, Aldershot and Burlington, VT: Ashgate, 2007

Dimond, Frances, and Roger Taylor, *Crown and Camera: The Royal Family and Photography 1842–1910*, Harmondsworth: Penguin, 1987

Eskildsen, Ute (ed.), *Fotografieren hieß teilnehmen: Fotografinnen der Weimarer Republik*, exh. cat., Essen: Museum Folkwang, 1994

Eyene, Christine, *Where We're at! Other Voices on Gender*, Milan and Brussels: Silvana Editoriale and Bozar Books, 2014

Fabry, Alexis, and Maria Wills, *Sol Negro / Black Sun: Mujeres en la fotografía / Women in Photography*, Mexico and Paris: RM Editorial and Toluca Éditions, 2019

Fawundu, Adama Delphine, and Laylah Amatullah Barrayn, *MFON: Women Photographers of the African Diaspora*, Brooklyn, NY: Eye & I Inc., 2017

Fisher, Andrea, *Let Us Now Praise Famous Women: Women Photographers for the U.S. Government 1935 to 1944*, London and New York: Pandora Press, 1987

Fraser, Hilary, *Women Writing Art History in the Nineteenth Century: Looking Like a Woman*, Cambridge: Cambridge University Press, 2014

Friedewald, Boris, *Women Photographers: From Julia Margaret Cameron to Cindy Sherman*, Munich, London and New York: Prestel, 2014

Fuku, Noriko, *An Incomplete History: Women Photographers from Japan, 1864–1997*, Rochester, NY: Traveling Exhibition Service and Visual Studies Workshop, 1997

Galifot, Thomas, Ulrich Pohlmann, and Marie Robert (eds), *Qui a peur des femmes photographes? 1839-1945*, exh. cat., Paris: Musée d'Orsay, Musée de l'Orangerie and Hazan, 2015

Gili, Marta, and Lourdes Peracaula, *Les Dones fotògrafes a la República de Weimar, 1919–1933*, Barcelona: Fundació La Caixa, 1995

Gonnard, Catherine, and Élisabeth Lebovici, *Femmes artistes, artistes femmes: Paris, de 1880 à nos jours*, Paris: Hazan, 2007

Gover, C. Jane, *The Positive Image: Women Photographers in Turn of the Century America*, New York: State University of New York Press, 1988

Graeve Ingelmann, Inka (ed.), *Female Trouble: Die Kamera als Spiegel und Bühne weiblicher Inszenierungen*, exh. cat., Munich: Pinakothek der Moderne, 2008

Gresh, Kristen (ed.), *She Who Tells a Story: Women Photographers from Iran and the Arab World*, Boston: Museum of Fine Arts, 2013

Griffith, Bronwyn A. E. (ed.), *Les Ambassadrices du progrès: Photographes américaines à Paris, 1900–1901*, exh. cat., Giverny: Musée d'Art Américain, 2001

Hall, Barbara, and Jenni Mather, *Australian Women Photographers, 1840–1960*, Richmond, Victoria: Greenhouse Publications, 1986

Hallet, George, Neo Ntsoma and Robin Comley (eds), *Women by Women: 50 Years of Women's Photography in South Africa*, Johannesburg: Wits University Press, 2006

Hayes, Patricia (ed.), *Visual Genders, Visual Histories*, Oxford: Blackwell, 2006

Heron, Liz, and Val Williams (eds), *Illuminations: Women Writing on Photography from the 1850s to the Present*, London and New York: I. B. Tauris, 1996

Herz, Rudolf, and Brigitte Bruns, *Hofatelier Elvira 1887–1928: Ästheten, Emanzen, Aristokraten*, exh. cat., Munich: Fotomuseum im Münchner Stadtmuseum, 1985

Hopkinson, Amanda (ed.), *Desires and Disguises: Five Latin American Photographers*, London: Serpent's Tail, 1992

Horwitz, Margot F., *A Female Focus: Great Women Photographers (Women Then, Women Now)*, New York: Franklin Watts and Grolier, 1996

Hudgins, Nicole, *The Gender of Photography: How Masculine and Feminine Values Shaped the History of Nineteenth-Century Photography*, Abingdon-on-Thames: Taylor & Francis Ltd, 2020

Iakovlenko, Kateryna (ed.), *Why There Are Great Women Artists in Ukrainian Art*, Kiev: Pinchuk Art Centre, 2019

Inselmann, Andrea (ed.), *A Second Look: Women Photographer of the Gernsheim Collection*, exh. cat., Austin, TX: Harry Ransom Humanities Research Center, 1993

Jansen, Charlotte, *Girl on Girl: Art and Photography in the Age of the Female Gaze*, London: Laurence King Publishing, 2017

Jobling, Paul, *Bodies of Experience: Gender and Identity in Women's Photography Since 1970*, London: Scarlet Press, 1997

Johannesson, Lena, and Gunilla Knape (eds), *Women Photographers: European Experience*, Gothenburg: Acta Universitatis Gothoburgensis, 2004

Jones, Amelia (ed.), *The Feminism and Visual Culture Reader*, London: Routledge, 2003

Jones, Laura, *Rediscovery: Canadian Women Photographers 1841–1941*, exh. cat., London, Ontario: London Regional Art Gallery, 1983

Kalmus, Yvonne et al., *Women See Men*, New York: McGraw-Hill, 1977

Karlekar, Malavika, *Visualizing Indian Women, 1875–1947*, Oxford: Oxford University Press, 2006

Keller, Judith, and Katherine Ware, *Women on the Edge: Twenty Photographers in Europe, 1919–1939*, exh. cat., Santa Monica, CA: J. Paul Getty Museum, 1993

Kreisel, Martha, *American Women Photographers: A Selected and Annotated Bibliography*, Westport, CT and London: Greenwood Press, 1999

Lahs-Gonzales, Olivia, and Lucy Lippard, *Defining Eye: Women Photographers of the 20th Century*, exh. cat., Saint Louis, MO: Saint Louis Art Museum, 1997

Latimer, Tirza, and Harriet Riches, *Women and Photography*, Oxford: Oxford University Press, 2006

Lederman, Russet, Olga Yastskevich and Michael Lang (eds), *How We See: Photobooks by Women*, New York: 10 × 10 Photobooks, 2018

Lewis, Emma, *Photography: A Feminist History – How Women Shaped the Art*, London: Ilex Press, 2021

Mann, Margery, and Anne Noggle (eds), *Women of Photography: An Historical Survey*, exh. cat., San Francisco: San Francisco Museum of Modern Art, 1975

Manthorne, Katherine, *Women in the Dark: Female Photographers in the US, 1850–1900*, Atglen, PA: Schiffer Publishing Ltd, 2020

Mavor, Carol, *Pleasures Taken: Performances of Sexuality and Loss in Victorian Photographs*, Durham, NC: Duke University Press, 1995

Maxwell, Anne, *Women Photographers of the Pacific World, 1857–1930*, London: Routledge, 2021

McCusker, Carol, *First Photographs: William Henry Fox Talbot and the Birth of Photography*, New York: PowerHouse Books, 2002

McCusker, Carol (ed.), *Breaking the Frame: Pioneering Women in Photojournalism*, exh. cat., San Diego: Museum of Photographic Arts, 2006

McEuen, Melissa A., *Seeing America: Women Photographers between the Wars – Doris Ulmann, Dorothea Lange, Marion Post Wolcott, Margaret Bourke-White, Berenice Abbott*, Lexington, KY: University Press of Kentucky, 2000

Metz, Annie, and Florence Rochefort (eds), *Photo Femmes Féminisme: Collection de la bibliothèque Marguerite Durand, 1860–2010*, Paris: Paris Bibliothèques, 2010

Miljakovich, Helen, and Reiko Ikeda, *Women Photographers: New York / Tokyo – Our Illusions and Reality*, New York: The Sister City Program of the City of New York in collaboration with Professional Women Photographers Inc., 1990

Mitchell, Margaretta, *Recollections: Ten Women of Photography*, New York: Viking Press, 1979

Moeller, Madelyn, *Nineteenth-Century Women Photographers: A New Dimension in Leisure*, exh. cat., Norwalk, CT: Lockwood-Mathews Mansion Museum, 1987

Monk, Lorraine, *The Female Eye*, Toronto and Vancouver: National Film Board of Canada and Clarke, Irwin and Company, 1975

Moore, Catriona, *Indecent Exposures: Twenty Years of Australian Feminist Photography*, St Leonards, NSW: Allen & Unwin, in association with the Power Institute of Fine Arts, 1994

Morineau, Camille (ed.), *elles@ centrepompidou: Artistes femmes dans les collections du Musée national d'art moderne*, exh. cat., Paris: Centre Pompidou, 2010

Morris, Richard, *Penllergare: A Victorian Paradise – A Short History of the Penllergare Estate and its Creator, John Dillwyn Llewelyn (1810–82)*, Llandeilo: The Friends of Penllergare, 1999

Moutoussamy-Ashe, Jeanne, *Viewfinders: Black Women Photographers*, New York and London: Writers & Readers Publishing, Inc., 1993

Müller, Ulrike, *Bauhaus Women: Art, Handicraft, Design*, Paris: Flammarion, 2009

Muschter, Gabriele (ed.), *DDR Frauen fotografieren: Lexikon und Anthologie*, Berlin: Ex Pose Verlag, 1989

Muzzarelli, Federica, *Femmes photographes: Émancipation et performance (1850–1940)*, Paris: Hazan, 2009

Naggar, Carole, Michiko Kasahara and Paula V. Kupfer, *What They Saw: Historical Photobooks by Women, 1843–1999*, New York: 10 × 10 Photobooks, 2021

Nelson, Andrea (ed.), *The New Woman Behind the Camera*, exh. cat., Washington, DC: National Gallery of Art, 2020

Neumaier, Diane (ed.), *Reframings: New American Feminist Photographies*, Philadelphia: Temple University Press, 1995

New Focus (various contributors), *No Man's Land: Young People Uncover Women's Viewpoints on the First World War*, Bradford: New Focus and Impressions Gallery, 2017

Newbury, Darren, Lorena Rizzo and Kylie Thomas (eds), *Women and Photography in Africa: Creative Practices and Feminist Challenges*, London: Routledge, 2020

Newman, Cathy, *Women Photographers at National Geographic*, Washington, DC: National Geographic Society, 2000

Newton, Kate, and Christine Rolph, *Masquerade: Women's Contemporary Portrait Photography*, exh. cat., Cardiff: Ffotogallery, 2002

Niccolini, Dianora, *Women of Vision: Photographic Statements by Twenty Women Photographers*, Verona, NJ: Unicorn Publishing House, 1982

Niedermaier, Alejander, *La Mujer y la Fotografía: Una imagen espejada de autoconstrucción y construcción de la historia*, Buenos Aires: Leviatán, 2008

Olivares, Rosa, and Sougez, Marie-Loup, *Mujeres: 10 Fotografas / 50 Retratos*, Madrid: Telefonica and Fundacion Arte y Technologia, 1994

Otto, Elizabeth, and Rocco, Vanessa, *The New Woman International: Representations in Photography and Film from the 1870s through the 1960s*, Ann Arbor, MI: University of Michigan Press, 2011

Palmquist, Peter E., *Camera Fiends and Kodak Girls: 50 Selections by and about Women in Photography, 1840–1930*, New York: Midmarch Arts Press, 1989

Palmquist, Peter E., *Shadowcatchers I: A Directory of Women in California Photography Before 1901*, Arcata, CA: self-published, 1990

Palmquist, Peter E., *Shadowcatchers II: A Directory of Women in California Photography 1900–1920*, Arcata, CA: self-published, 1991

Palmquist, Peter E., *Catherine Weed Barnes Ward: Pioneer Advocate for Women in Photography*, Arcata, CA: self-published, 1992

Palmquist, Peter E., *A Bibliography of Writings by and about Women in Photography 1850–1990*, 2nd revised and expanded edition, Arcata, CA: self-published, 1994

Palmquist, Peter E., *Camera Fiends and Kodak Girls: 60 Selections by and about Women in Photography, 1855–1965*, New York: Midmarch Arts Press, 1995

Palmquist, Peter E., and Gia Musso, *Women Photographers. A Selection of Images from the Women in Photography International Archive 1852–1997*, Kneeland, CA: Iaqua Press, 1997

Parreño, José María (ed.), *Miradas de mujer: 20 fotógrafas españolas*, Segovia: Museo de Arte Contemporáneo Esteban Vicente, 2005

Pepper, Terence, *Edwardian Women Photographers: Eveleen Myers, Alice Hughes, Christina Broom and Olive Edis*, exh. cat. London, National Portrait Gallery, 1994

Pogačar, Tadej, *Code: Red*, Ljubljana: P.A.R.A.S.I.T.E. Institute, 2011

Raymond, Claire, *Women Photographers and Feminist Aesthetics*, London: Routledge, 2017

Rice, Shelley (ed.), *Inverted Odysseys: Claude Cahun, Maya Deren, Cindy Sherman*, New York: Grey Art Gallery, New York University, Museum of Contemporary Art, North Miami and MIT Press, 1999

Rogers, Fiona, and Max Houghton, *Firecrackers: Female Photographers Now*, London: Thames & Hudson, 2018

Rogers, Molly, *Delia's Tears: Race, Science, and Photography in the Nineteenth Century*, London: Yale University Press, 2010

Rosenblum, Naomi, *A History of Women Photographers*, New York: Abbeville Press, 1994

Rosgen, Petra, *Frauenobjektiv: Fotografinnen 1940–1950*, exh. cat., Cologne: Wienand Verlag, 2001

Rosler, Martha, *Decoys and Disruptions: Selected Writings, 1975–2001*, Cambridge, MA: MIT Press, 2004

Rossellini, Isabella, and Sara Stevenson, *Magna Brava: Magnum's Women Photographers*, Munich: Prestel, 1999

Samoilova, Gulnara, *Women Street Photographers*, London and New York: Prestel, 2021

Sandler, Martin W., *Against the Odds: Women Pioneers in the First Hundred Years of Photography*, New York: Rizzoli, 2002

Sawelson-Gorse, Naomi, *Women in Data*, Cambridge, MA: MIT Press, 1998

Schirmer, Lothar (ed.), *Frauen sehen Frauen: Eine Bildgeschichte der Frauen-Photographie von Julia Margaret Cameron bis Inez van Lamsweerde*, Munich: Schirmer/Mosel, 2001, 2nd edition 2020

Schirmer, Lothar (ed.), and Naomi Rosenblum (introduction), *Women Seeing Women: A Pictorial History of Women's Photography from Julia Margaret Cameron to Annie Leibovitz*, New York: Norton, 2003

Schor, Gabriele (ed.), *Woman: The Feminist Avant-Garde of the 1970s – Works from the Sammlung Collection, Vienna*, Vienna, Bozar Books and Sammlung Verbund, 2014

Seiberling, Grace, *Amateurs, Photography and the Mid-Victorian Imagination*, Chicago: University of Chicago Press, 1986

Shaw, Stephanie J., *What A Woman Ought to Be and to Do: Black Professional Women Workers during the Jim Crow Era*, Chicago and London: University of Chicago Press, 1996

Siegel, Elizabeth, Marta Weiss and Patrizia Di Bello, *Playing with Pictures: The Art of Victorian Photocollage*, exh. cat., Chicago: Art Institute of Chicago, 2009

Smith, Lindsay, *The Politics of Focus. Women, Children and Nineteenth Century Photography*, Manchester: Manchester University Press, 1998

Smith, Marthe, *In Praise of Women Photographers (And Photographers Who Just Happen to Be Women)*, New York: Time Inc., 1993

Solomon-Godeau, Abigail, *Photography at the Dock*, Minneapolis and Oxford: University of Minnesota and Oxford University Press, 1995

Solomon-Godeau, Abigail, *Chair à canons: Photographies, discours, féminisme*, 'L'Écriture photographique' series, Paris: Textuel, 2016

Solomon-Godeau, Abigail, and Constance Lewallen, *Mistaken Identities*, Santa Barbara, CA: University of California, 1993

Sontag, Susan, *On Photography*, New York: Farrar, Straus and Giroux, 1977

Steinert, Otto (ed.), *Fotografinnen: Beispiele aus der Arbeit von Fotografinnenin Deutschland seit 1925*, exh. cat., Essen: Museum Folkwang, 1970

Sullivan, Constance (ed.), *Women Photographers*, New York: Abrams, 1990

Sykora, Katharina, Annette Dorgerloh, Doris Noell-Rumpeltes and Ada Raev (eds), *Die neue Frau: Herausforderung für die Bildmediender Zwanziger Jahre*, Marburg: Jonas, 1993

Tenneson, Joyce, *In/Sights: Self-Portraits by Women*, Boston: Godine, 1978

Thompson, Barbara, *Black Womanhood: Images, Icons, and Ideologies of the African Body*, Seattle: University of Washington Press, 2008

Till, Jennifer E., *Seven Female Photographers of the Oklahoma and Indian Territories,1839–1907*, College Park, MD: University of Maryland, 1997

Tucker, Anne (ed.), *The Woman's Eye*, New York: Alfred A. Knopf, 1973

Tucker, Marcia, *Bad Girls*, exh. cat., New York and Cambridge, MA: New Museum of Contemporary Art and MIT Press, 1994

Vogt, Christian, *In Camera: Eighty-Two Images by Fifty-Two Women*, Geneva: Roto Vision, 1982

West, Nancy Martha, *Kodak and the Lens of Nostalgia*, Charlottesville and London: University Press of Virginia, 2000

Wiesenfeld, Cheryl, Yvonne Kalmus, Sonia Katchian and Rikki Ripp (eds), *Women See Woman*, New York: Thomas Y. Crowell, 1976

Williams, Val, *Women Photographers: The Other Observers 1900 to the Present*, London: Virago Press, 1986

Williams, Val, *Warworks: Women, Photography and the Iconography of War*, London: Virago Press, 1994

Willis, Deborah, *An Illustrated Bio-Bibliography of Black Photographers, 1940–1988*, New York and London: Garland, 1989

Select bibliography

Willis, Deborah, *Reflections in Black: A History of Black Photographers, 1840 to the Present*, New York and London: Norton & Company, 2000

Willis, Debora, and Carla Williams, *The Black Female Body: A Photographic History*, Philadelphia: Temple University Press, 2002

Winkelbauer, Andrea, and Iris Meder (eds), *Vienna's Shooting Girls: Jüdische Fotografinnen aus Wien*, exh. cat., Vienna: Jüdisches Museum and Metro, 2012

Women Come to the Front: Journalists, Photographers, and Broadcasters During World War II, exh. cat., Washington, DC: Library of Congress, 1995

Women Photographers of the Farm Security Administration, exh. cat., Bradford: National Museum of Photography, Film and Television, 1983

Zaidman, Sylvie, Felicity Korn and Anne-Marie Beckmann (eds), *Les femmes photographes de guerre*, exh. cat., Paris: Paris Musées, 2022

Ziębińska-Lewandowska, Karolina, and Julie Jones, *Elles sont modernes, elles sont photographes*, exh. cat., Paris, Centre Pompidou, 2015

Ziębińska-Lewandowska, Karolina, Lech Majewski and Marcin Wawrzynczak (eds), *She-Documentalists: Polish Women Photographers of the 20th Century*, exh. cat., Warsaw: Zachęta National Gallery of Art and Bosz, 2008

Articles and grey literature

Anonymous, 'Employment of Women in Photography', *Photographic News*, 25 January 1867, pp. 37–8

Anonymous, 'Die Frauenarbeit in den Wiener Ateliers', *Photographische Correspondenz*, no. 104, 1873, p. 33ff

Anonymous, 'Women Photographers of British Columbia', *West Coast Review*, vol. 20, no. 1, June 1985

Anonymous, 'Women in Photography', *American Photo*, special number, March–April 1998

Anthony, Arthé A., 'Florestine Perrault Collins and the Gendered Politics of Black Portraiture in 1920s New Orleans', *Louisiana History: The Journal of the Louisiana Historical Association 43*, no. 2, Spring 2002, pp. 167–88

Armstrong, Carol, 'From Clementina to Käsebier: The Photographic Attainment of the "Lady Amateur"', *October*, vol. 91, 2000, pp. 101–39

Baker, Tracey, 'Nineteenth-Century Minnesota Women Photographers', *Journal of the West*, 28 January 1989

Bartra, Eli, 'Women and Portraiture in Mexico', *History of Photography*, Autumn 1996

Bowen, Claire, 'Recording Women's Work in Factories during the Great War: The Women's Work Sub-Committee's "Substitution" Photographic Project', *Revue LISA/LISA e-journal*, vol. 6, no. 4, 2008, <http://lisa.revues.org/957>

Brady, Emily, '"Boss Lady": The Diagonal Networks of African American Women Photographers from Reconstruction to the Harlem Renaissance', thesis, supervised by Zoe Trodd and Robin Vandome, University of Nottingham, September 2017

Condé, Françoise, *Les Femmes photographes en France, 1839–1914*, thesis, supervised by Michelle Perrot, Université Jussieu Paris 7, June 1992

Denny, Margaret, 'Royals, Royalties and Renumeration: American and British Women Photographers in the Victorian Era', *Women's History Review*, vol. 18, no. 5, 2009, pp. 801–18

Eastlake, Lady Elizabeth, 'Photography', *Quarterly Review*, vol. 101, 1857, pp. 442–68, reprinted in Newhall, Beaumont (ed.), *Photography: Essays and Images*, New York: Museum of Modern Art, 1980

Eskildsen, Ute, 'A Chance to Participate: A Transitional Time for Women Photographers', in Marsha Meskinnon and Shearer West (eds), *Women and the Visual Arts in Weimar Germany*, Aldershot: Ashgate, 1995

Galifot, Thomas, 'La parentèle au risque de la photographie? Amateures et professionnelles au XIXe siècle et au début du XXe siècle (France, Grande-Bretagne, États-Unis)', in Claire Barbillon, Pascal Faracci, Camille Morineau, Raphaële Martin-Pigalle and Hanna Alkema (eds), *Parent-elles: Compagne de, fille de, sœur de … Les femmes artistes au risque de la parentèle*, acts of the colloquium organized by the Musée Sainte-Croix à Poitiers, 23 and 24 September 2016, Poitiers and Paris: Université de Poitiers (CRIHAM) and Archives of Women Artists, Research and Exhibitions (AWARE), 2017

Galifot, Thomas, 'Autour de Frances Benjamin Johnston, Gertrude Käsebier et Catharine Weed Barnes Ward: Stratégies séparatistes dans l'exposition des femmes photographes américaines au tournant des XIXe et XXe siècles', *Artl@s Bulletin*, vol. 8, no. 1, 2019

Hayes, Patricia, 'The Form of the Norm: Shades of Gender in South African Photography of the 1980s', *Social Dynamics*, vol. 37, no. 2, June 2011, pp. 263–77

Heathcote, Bernard, and Pauline F. Heathcote, 'The Feminine Influence: Aspects of the Role of Women in the Evolution of Photography in the British Isles', *History of Photography*, vol. 12, no. 3, July–September 1988, pp. 259–73

Hughes, Jabez, 'Photography as an Industrial Occupation for Women', *Photographic News*, 9 May 1873, pp. 217–18

Lessmann, Sabina, 'Weiblichkeit ist Maskerade: Verkleidungen und Inszenierungen von Frauen in Fotografien Mme D'Ora, Marta Astfalck-Vietz und Olga/Ajoran Wlassics', in Katharina Sykora, Annette Dorgerloh, Doris Noell-Rumpeltes and Ada Raev, *Die Neue Frau: Herausforderung für die Bildmedien der Zwanziger Jahre*, Marburg: Jonas, 1993, pp. 149–50

Lowe, Sarah M. (ed.), 'Women in Photography', *History of Photography*, Autumn 1994

Mann, Margery, 'Women of Photography: An Historical Survey', *Camera 35*, vol. 19, no. 6, August–September 1975, pp. 36–43

Matzer, Ulrike, 'Unsichtbare Frauen: Fotografie / Geschlecht / Geschichte', in Holzer, Anton (ed.), *Fotogeschichte*, 32nd year, no. 124, 2012, pp. 29–35

McCaroll, Stacey, 'Feminist Photography', in Lynn Warren (ed.), *Encyclopedia of Twentieth-Century Photography*, vol. 1, New York and London: Routledge, 2006, pp. 507–9

Moeller, Madelyn, 'Ladies of Leisure. Domestic Photography in the Nineteenth Century', in Kathryn Grover (ed.), *Hard at Play. Leisure in America, 1840–1940*, Rochester, NY: University of Massachusetts Press, 1992, pp. 139–60

Molderings, Herbert, and Barbara Mülhens-Molderings, 'Mirrors, Masks and Spaces: Self-portraits by Women Photographers in the Twenties and Thirties', *Jeu de Paume, le magazine*, 2011, <http://lemagazine.jeudepaume.org/2011/06/molderings>

Nimis, Érika, 'La féminisation des métiers de l'image au Nigeria', in Jean-François Werner (ed.), *Médias visuels et femmes en Afrique de l'Ouest*, Paris: L'Harmattan, 2006

Noble, Mary, 'Iowa's Women Professional Photographers', *Books at Iowa*, no. 65, November 1996, pp. 2–16

Nochlin, Linda, 'Why Have There Been No Great Women Artists?', *Artnews*, New York, 1971, reprinted in *Why Have There Been No Great Women Artists?*, 50th anniversary edition, London: Thames & Hudson, 2021

Palmquist, Peter E., 'Pioneer Women Photographers in Nineteenth-Century California', *California History*, Spring 1992, pp. 111–27

Robert, Marie, 'Femmes et photographie: un genre mineur dans un art mineur?', in Marie-Jo Bonnet (ed.), *Créatrices: L'émancipation par l'art*, exh. cat., Rennes: Musée des Beaux-Arts and Ouest-France, 2019, pp. 82–3

Robert, Marie, '"A Photographer who happens to be a Woman": Quand les femmes photographes écrivent sur la photographie', in Galifot, Thomas, Ulrich Pohlmann, and Marie Robert (eds), *Qui a peur des femmes photographes? 1839-1945*, exh. cat., Paris: Musée d'Orsay, Musée de l'Orangerie and Hazan, 2015, pp. 156–71

Roberts, Hilary, 'British Women Photographers of the First World War', Imperial War Museum, <http://www.iwm.org.uk/history/british-women-photographers-of-the-first-world-war>

Rosenbloom, Jean, 'Nineteenth Century Lady Photographers', *The Photographist*, no. 39, Winter 1978, pp. 12–15

Rosenblum, Naomi, 'Introduction', in *Women Photographers at National Geographic*, Washington, DC: National Geographic Society, 2000

Sheehi, Stephan, and Verde, Tom, 'Women Behind the Lens: The Middle East's First Female Photographers', *AramcoWorld*, March–April 2019, pp. 28–30

Solomon-Godeau, Abigail, 'Nouvelles femmes et photographie de la Nouvelle Vision dans le creuset de la modernité', *Jeu de Paume, le magazine*, 2015, <http://lemagazine.jeudepaume.org/2015>

Starl, Timm, 'Frauen und Fotografie: Eine Bibliographie aus internationalen Zeitschriften 1857–1991', *Frauen Kunst Wissenschaft*, vol. 14, October 1992

Starl, Timm, 'Frauenberuf und Liebhaberei. Fotografinnen in Österreich bis zum Ersten Weltkrieg', 2014, <http://www.fotokritik.at/Text 93>

Tellgren, Anna, 'Les Femmes photographes: Aspects of French Photo History From the Perspective of Women Photographers', in Lena Johannesson and Gunilla Knape (eds), *Women Photographers: European Experience*, Gothenburg: Acta Universitatis Gothoburgensis, 2004

Various contributors, *L'Insensé photo: Femmes and photographie*, no. 1, Paris, 1999

Various contributors, *Women Only*, *British Journal of Photography*, April 2014

Various contributors, *On Women*, *Photoworks*, vol. 22, 2015

Various contributors, *Objective: Into the Light*, no. 12, 2015

Various contributors, *On Feminism*, *Aperture*, vol. 225, Winter 2016.

AA[1] Alix Agret
AA[2] Andrea Aguad
AA[3] Alina Akoeff
BA Bérénice Angremy
DA Damarice Amao
GA Georgia Atienza
IA Irini Apostolou
LA Line Ajan
MA Marie Auger

CB[1] Clara Bolin
CB[2] Clara Bouveresse
DB[1] Daria Bona
DB[2] Dominique Brebion
HB Hélène Bocard
JB Joëlle Bonardi
LB-R Laurence Butet-Roch
MB[1] Marion Beckers
MB[2] Mattie Boom
NB Nocebo Bucibo
REB River Encalada Bullock
SB[1] Sophie Bertrand
SB[2] Susanna Brown
SBG Sarah Bay Gachot

EC Éléonore Challine
HC Héloïse Conésa
JC Julie Crooks
MC Molly Caenwyn
MC-B Marine Cabos-Brullé
VC Virginie Chardin
YC Yudit Caplan

AD Aldeide Delgado
DD[1] Delphine Desveaux
DD[2] Deepali Dewan
FD Françoise Denoyelle
LD Lourdes Delgado
MD Marta Dahó

EE Esa Epstein
HE[1] Helen Ennis
HE[2] Heloisa Espada

AF Anaïs Feyeux
ADF Adama Delphine Fawundu
CF Clare Freestone
EF Eva Fisli
KF Kateryna Filyuk
LF Lena Fritsch
MF Monika Faber
OF Orla Fitzpatrick

AGE Anahita Ghabaian Etehadieh
BG Bettina Gockel
HG Hélène Giannecchini
KG[1] Katarzyna Gębarowska
KG[2] Kristen Gresh
LG Laetitia Guillemin
LG-F Laura González-Flores
MG[1] Marta Gili
MG[2] Maria Gourieva
NGB Natalya Guzenko Boudier
PGR Pamela Glasson Roberts
RG Rebekka Grossmann
SGC Susana Gállego Cuesta

AH Awel Haouati
CH Charlene Heath
EH Elina Heikka
LH Lisa Hostetler
MH Melissa Harris
NH Nathalie Herschdorfer
SH[1] Sophie Hackett
SH[2] Sabine Hartmann
YH Yining He

CJ Candice Jansen
JJ Julie Jones
SJ-G Sabina Jaskot-Gill
VJ Victoria Jonathan

CK Corey Keller
MEK Monica E. Kupfer
MK[1] Maria Kapajeva
MK[2] Malavika Karlekar
MK[3] Magda Keaney
PK Paula Kupfer
RK Rym Khene
SK Sara Knelman

AL[1] Anne Lacoste
AL[2] Annabelle Lacour
AL[3] Anne Lyden
CL Cat Lachowskyj
JL Joanne Lukitsh
LL Luce Lebart
ML Martha Langford
SL[1] Sylvie Lécallier
SL[2] Sigrid Lien

AM Anne Maxwell
CM Christelle Michel
EM Elisabeth Moortgat
FM[1] Fulufhelo Mobadi
FM[2] Federica Muzzarelli
GM[1] George Mind
GM[2] Gaëlle Morel
IM-S Ieva Meilutė-Svinkūnienė
JM[1] Jasmin Meinold
JM[2] Jeanne Mercier
LMD Lola Mac Dougall
MM Margarida Medeiros
SM[1] Sandra Maunac
SM[2] Shoair Mavlian
TM Tanvi Mishra
VM Victoria Munro

CN Constantia Nicolaides
EN Érika Nimis
NN Nestan Nijaradze
SN Suryanandini Narain
YNT Yasmine Nachabe Taan

AO'H Anne O'Hehir
OCO Oluremi C. Onabanjo
PO Pippa Oldfield

CP Claudia Polledri
CPdL Carolina Ponce de Léon
DP[1] Daria Panaiotti
DP[2] Deniz Pehlivaner
KP-R Karolina Puchała-Rojek
NP Nikoo Paydar
PP Penelope Petsini

HR[1] Helihanta Rajaonarison
HR[2] Hilary Roberts
JR Julie Robinson
KR Kateryna Radchenko
MR[1] Martine Ravache
MR[2] Marie Robert
NFR Núria F. Rius
RR Raisa Rexer
SR Scarlett Reliquet
ZR Zsófia Rátkai

AS[1] Agnès Sire
AS[2] Anna Sparham
AS-G Abigail Solomon-Godeau
ÆS Æsa Sigurjónsdóttir
DCS Diana C. Stoll
FS Franziska Schmidt
GS Gabriele Schor
KS[1] Karen Smith
KS[2] Katharina Sykora
LS[1] Letta Shtohryn
LS[2] Lyudmila Starilova
MS Mette Sandbye
NS Nani Simonis

AT[1] Anna Tellgren
AT[2] Aliki Tsirgialou
BT Baiba Tetere
FT Flora Triebel
RT Rose Teanby
VT Valentina Tong
ZT Zoë Tousignant

AVB Arola Valls Bofill
DV Dominique Versavel
HV Hripsimé Visser
PV Pauline Vermare
SV[1] Silvia Valisa
SV[2] Sonia Voss

FW Francesca Wilmott

CY Cynthia Young
DYD Demet Yıldız Dinçer

EZ Erika Zerwes
KZ-L Karolina Ziębińska-Lewandowska
MZ Maria Zagala
OZ Oksana Zabuzhko

General editors

Luce Lebart
Luce Lebart is a photography historian, exhibition curator and researcher at the Archive of Modern Conflict. Her work focuses on overlooked photographs and photographers. She has curated more than twenty exhibitions on the history and heritage of photography in France and around the world. Her books include *Mold is Beautiful* (Poursuite, 2015), *Lady Liberty* (Seuil, 2016), *Les Silences d'Atget* (Textuel, 2016), *Les Grands photographes du XXe siècle* (Larousse, 2017), *Gold and Silver* (Rvb-Books, 2018), *Inventions* (2019), and *Le Musée Albert Kahn* (Gallimard, 2022).

Marie Robert
Head curator for photography and cinema at the Musée d'Orsay, Marie Robert has curated more than fifteen exhibitions from a sociohistorical perspective, including *Misia, Reine de Paris* (2012), *Splendeurs et misères: Images de la prostitution* (2015), *Qui a peur des femmes photographes?* (2015), *Jazz Power!* (2021) and *Enfin le cinéma!* (2022). Her research focuses on the role of women in the history of photography, as well as the relationship between photography and other mediums (literature, music, painting, cinema). She aims to underline the political dimension of images.

Contributors

Alix Agret
Art historian Alix Agret has a PhD from the Royal College of Art in London, with her thesis focusing on French erotic magazines from the 1930s. She regularly contributes to art magazines and exhibition catalogues.

Andrea Aguad
After gaining her degree in the theory and history of art from the University of Chile, Andrea Aguad went on to become deputy director of the National Centre for Photographic Heritage at Diego Portales University (CENFOTO UDP) in Santiago, where she has developed research projects focusing on photography archives, curation and publishing.

Line Ajan
Line Ajan is a curator and art historian based in Chicago and Paris. She has a masters in art history from Paris 1 Panthéon-Sorbonne University and is currently a Barjeel Global Fellow at the Museum of Contemporary Art, Chicago.

Alina Akoeff
Alina Akoeff is a freelance researcher and a journalist for the Russian daily newspaper *Severnaya Ossetia*. She lives and works in Vladikavkaz in southern Russia, where she has organized many exhibitions for the Vladikavkaz Museum of Photography and Film. Her research focuses on photography in the late nineteenth and early twentieth centuries.

Damarice Amao
A historian of photography with a PhD in art history, Damarice Amao was co-curator of the exhibitions *Eli Lotar* (Jeu de Paume, 2017), *Photographie, arme de classe* (Pompidou Centre, 2018) and *Dora Maar* (Pompidou Centre, 2019). She is currently a curator in the photography department at the Pompidou Centre.

Bérénice Angremy
Bérénice Angremy is the co-founder, with Victoria Jonathan, of the French–Chinese artist agency Doors. Together they ran the Jimei × Arles festival (2017–19), created by the Rencontres d'Arles photography festival in China, and have curated many exhibitions on Chinese photography and art.

Irini Apostolou
Having gained her PhD at the Sorbonne, Irini Apostolou is now associate professor of French cultural history in the department of French language and literature at the National and Kapodistrian University of Athens. Her research interests include the iconography and literature of journeys, as well as Eastern photography.

Georgia Atienza
Georgia Atienza studied art history at the Autonomous University of Barcelona and paper conservation at Camberwell College of Arts in London. She has been an assistant curator of photography at the National Portrait Gallery in London since 2004.

Marie Auger
Marie Auger has a PhD from Paris 1 Panthéon-Sorbonne University and was a Fulbright scholar. Her research focuses on photographic experiments in three-dimensionality and spatiality between 1960 and 2020. She is editor of *Photographica*.

Sarah Bay Gachot
A freelance curator, author of art books including *Robert Cumming: The Difficulties of Nonsense* (Aperture, 2016), and creator of cultural works, Sarah Bay Gachot works in Los Angeles.

Marion Beckers
An expert in cultural studies, since 1990 Marion Beckers has been director and chief curator of the Hidden Museum (Das Verborgene Museum – Documenting Women's Art), an association in Berlin dedicated to showcasing the work of forgotten female artists. She writes about the history of photography.

Sophie Bertrand
Freelance photographer and critic Sophie Bertrand has contributed articles to multiple magazines, including *Ciel variable* (Quebec) and *L'Oeil de la photographie* (France). She is currently finishing her masters in museum studies at the University of Quebec in Montreal.

Hélène Bocard
Head curator for cultural heritage at the Palais de la Porte Dorée exhibition hall, Hélène Bocard's research interests include early photography exhibitions, amateur photographers (Olympe Aguado, the Marquis de Bérenger, Jean-Marie Taupenot) and the relationship between photography and architecture, as well as photography and urban environments.

Clara Bolin
A PhD candidate and research assistant in the Department of Art History at Cologne University, Clara Bolin specializes in photography exhibitions from the 1950s.

Daria Bona

Daria Bona studied romance languages, art management and art history in Cologne, and is currently the recipient of a Museum Curators for Photography programme scholarship from the Alfried Krupp von Bohlen und Halbach Foundation.

Joëlle Bonardi

Art historian Joëlle Bonardi specializes in cultural and communication studies. While studying for her masters at the University of Lausanne, she focused on the work of female artists in Switzerland. She has worked at the Musée de l'Élysée in Lausanne, where she was responsible for managing the Suzi Pilet collection. In 2019, she co-founded the Swiss Women Artists Project (SWAP), which aims to promote research about female artists in Switzerland.

Mattie Boom

Mattie Boom is a photography curator at the Rijksmuseum in Amsterdam and co-editor of the book series 'Rijksmuseum Studies in Photography'. She has curated many exhibitions, including *Modern Times: Photography in the 20th Century* (2014) and *New Realities: Photography in the 19th Century* (2017). In 2019, she published *Everyone a Photographer: The Rise of Amateur Photography in the Netherlands, 1880–1910*.

Clara Bouveresse

Photography historian Clara Bouveresse is the author of *Histoire de l'agence Magnum* (Flammarion, 2017) and *Femmes à l'oeuvre, femmes à l'épreuve: Eve Arnold, Abigail Heyman, Susan Meiselas* (Actes Sud), the catalogue for an exhibition at the Rencontres d'Arles photography festival in 2019. With Sarah Moon, she has co-edited three volumes of *Femmes Photographes* in the 'Photo Poche' series (Actes Sud, 2020).

Dominique Brebion

Dominique Brebion is a curator and art critic based in Martinique, and president of the AICA (International Art Critics Association) Southern Caribbean. From 1987 to 2016, she was an advisor on art and museums to the Regional Office of Cultural Affairs of Martinique.

Susanna Brown

Susanna Brown is currently a photography curator at the Victoria and Albert Museum in London and has previously worked at the National Portrait Gallery. She has overseen many major exhibitions, as well as contemporary and historical books on photography and portraiture.

Nocebo Bucibo

Photographer Nocebo Bucibo has a bachelor's degree in town planning and a masters in fine art from the University of Johannesburg. Now studying for her PhD at Wits City Institute, she also has a national diploma in photography from Vaal University of Technology.

River Encalada Bullock

Curator of the Beaumont and Nancy Newhall Collection in the photography department at the Museum of Modern Art, New York, River Encalada Bullock worked on the exhibition *Dorothea Lange: Words & Pictures* (2020). She has a PhD in art history from the University of Wisconsin-Madison.

Laurence Butet-Roch

Canadian photographer and author Laurence Butet-Roch investigates trends in forms of visual representation, especially in the media, in order to better understand the discourse perpetuated by photography, particularly surrounding Indigenous people and environmental issues.

Marine Cabos-Brullé

Marine Cabos-Brullé has a PhD in art history, specializing in the history of photography in China. She runs the website photographyofchina.com and teaches in London and Paris.

Molly Caenwyn

Molly Caenwyn is a photographer and photography historian who divides her time between Cardiff and Stockholm. She has a bachelor's degree in photography from Arts University Bournemouth and a master's degree in the history of photography from De Montfort University. In 2019, she received the Avril Rolf Bursary from the Women's Archive Wales for her work on Mary Dillwyn.

Yudit Caplan

Yudit Caplan is a photography curator at the Israel Museum in Jerusalem and manages the photography archive collections. She has a master's degree in art history from the Hebrew University of Jerusalem. Over the years, she has curated many exhibitions and contributed to the accompanying catalogues, including Roee Rosen's *Live and Die as Eva Braun* and *Woman with a Camera*, which brought the work of German photographer Liselotte Grschebina to a wider audience. For some years, she has managed the photography archives of Tim N. Gidal, Shmuel Joseph Schweig and Yaakov Ben Dov.

Éléonore Challine

Éléonore Challine is a photography historian, a lecturer at Paris 1 Panthéon-Sorbonne University and the author of *Une histoire contrariée: Le musée de photographie en France* (Macula, 2017). She is editor-in-chief of the journal *Photographica*.

Virginie Chardin

Virginie Chardin has written books and curated exhibitions on Antonin Personnaz, the Séeberger brothers, Willy Ronis, Ernst Haas, Pierre de Fenoÿl, Sabine Weiss and Denis Darzacq. Her research centres on the relationship between painting and photography and the history of photography in Paris.

Héloïse Conésa

Héloïse Conésa has a PhD in art history and is curator for cultural heritage in charge of photography in the department of prints and photography at the Bibliothèque Nationale de France. She has curated numerous exhibitions, including *Denis Brihat, photographies: De la nature des choses* (Bibliothèque Nationale de France, 2019) and *Josef Koudelka: Ruines* (Bibliothèque Nationale de France, 2020).

Julie Crooks

Julie Crooks is a photography curator at the Art Gallery of Ontario (AGO) in Toronto, where she has put on the exhibitions *Free Black North* (2017), *Mickalene Thomas: Femmes noires* (2018) and *Photography, 1920s–1940s: Women in Focus*, which has been ongoing since 2017. Before joining AGO in 2017, she curated exhibitions for

many institutions, including Black Artists' Networks in Dialogue (BAND) and the 'Of Africa' project at the Royal Ontario Museum. She holds a PhD from the department of history of art and archaeology at the School of Oriental and African Studies (SOAS), University of London. She specializes in the art of Africa and the diaspora.

Marta Dahó
Marta Dahó has a PhD in art history and her research interests centre on practices in photography. She curated the group exhibition *Fotografías como espacio público* (Barcelona, Arts Santa Monica, 2018), as well as retrospectives of the work of Graciela Iturbide (Madrid, MAPFRE Foundation, 2009) and Stephen Shore (MAPFRE Foundation, 2014).

Aldeide Delgado
Founder and director of the Women Photographers International Archive, Aldeide Delgado's research focuses on the relationship between feminism, racial identity and photography. She is the author of the *Catalogue of Cuban Women Photographers*, both in print and online.

Lourdes Delgado
Lourdes Delgado has a PhD in human sciences from the Pompeu Fabra University in Barcelona and was co-curator of the exhibition *Una cámara propia: Mujeres y prácticas fotográficas*, which brought together photographs taken between 1900 and 1980 and was shown at the Casa Elizalde cultural centre in Barcelona in 2019.

Françoise Denoyelle
Historian Françoise Denoyelle is the author of around thirty books, including *François Kollar: Le choix de l'esthétique* (Éditions de la Manufacture, 1995), *La Lumière de Paris, 1919–1939* (L'Harmattan, 1997), *La Photographie d'actualité et de propagande sous le régime de Vichy* (CNRS Éditions, 2003), *Le Siècle de Willy Ronis* (Terre bleue, 2012) and *Arles: Les Rencontres de la photographie* (Éditions de La Martinière, 2019).

Delphine Desveaux
Delphine Desveaux has a PhD in art history and is director of the Roger-Viollet collection and a curator at the Historical Library of the City of Paris, where she has managed the collections since 1997 and curated numerous exhibitions, some thematic and others focusing on the work of individual artists. She writes about the history of photography in particular, but also about the history of art and its relationship with literature at the turn of the twentieth century.

Deepali Dewan
Deepali Dewan is the Dan Mishra Curator of South Asian Art & Culture at the Royal Ontario Museum and a lecturer at the University of Toronto.

Helen Ennis
Professor emeritus in the school of art and design at the National Australian University in Canberra, Helen Ennis was formerly a photography curator at the National Gallery of Australia and director of the Centre for Art History and Art Theory at the Australian National University. She has curated numerous exhibitions for national cultural institutions and published many books on photography in Australia. In 2019, she published *Olive Cotton: A Life on Photography* (HarperCollins).

Esa Epstein
An author, archivist, curator and director of the sepiaEYE Gallery in New York (dedicated to promoting photography and film work originating from Asia), Esa Epstein has published many books on modern and contemporary photography. She has contributed to the Alkazi Collection, which brings together an impressive body of work by Indian photographers of the nineteenth century.

Heloisa Espada
Heloisa Espada has a PhD from the University of São Paulo and has been curator of visual arts at the Moreira Salles Institute since 2018. She is the author of numerous works, including *Geraldo de Barros e a Fotografia* (IMS, 2014) and *Monumentalidade e sombra: O centro cívico de Brasília por Marcel Gautherot* (Annablume, 2016).

Monika Faber
After working as a curator at the Museum of Modern Art Ludwig Foundation in Vienna since 1979, Monika Faber joined the Albertina Museum in 1999 as head curator of the photography collection. Since 2011, she has managed the Photoinstitut Bonartes in Vienna and overseen research projects on central European photography from the 1840s and the work of VALIE EXPORT.

Adama Delphine Fawundu
Born in Brooklyn, New York, to parents from Sierra Leone and Equatorial Guinea, Adama Delphine Fawundu is an artist, author and educator. She has a master's degree from Columbia University and is co-author of the book *Mfon: Women Photographers of the African Diaspora*. She uses photography, film, sculpture and prints to explore new transhistorical identities and Afrofuturist ideas. She has received numerous awards and her works have been published and exhibited internationally.

Anaïs Feyeux
Anaïs Feyeux has worked in France and the United States and is currently a lecturer at Paris 1 Panthéon-Sorbonne University. She is an art historian and has curated many exhibitions, including *Une image morcelée: Photographies et films féministes en France dans les années 1970* (2019). She specializes in the German photography scene.

Kateryna Filyuk
Curator and art critic Kateryna Filyuk works on international exhibitions and contributes to many magazines and websites, both in Ukraine and abroad. She is head curator at the Izolyatsia Foundation in Donetsk, Ukraine.

Eva Fisli
Historian, exhibition curator, author and editor Eva Fisli has a PhD from Sciences Po University in Paris and ELTE University in Budapest. She manages the international collection of the historical photography department at the Hungarian National Museum. From 2012 to 2018, she was secretary of the Hungarian Society for the History of Photography, editing the society's website and organizing its lecture series 'Women Photographers'.

Orla Fitzpatrick

Orla Fitzpatrick is a faculty member of the library at the National Museum of Ireland in Dublin and a lecturer at the National College of Art and Design. Her research interests centre on amateur photography, and her PhD focused on Irish photography books.

Clare Freestone

Clare Freestone studied fine art, and in 2000 joined the National Portrait Gallery in London, where she is a photography curator. She curated the 2011 exhibition *Ida Kar: Bohemian Photographer*.

Lena Fritsch

Lena Fritsch is a curator of modern and contemporary art at the Ashmolean Museum, University of Oxford. She is the author of *The Body as a Screen: Japanese Art Photography of the 1990s* (Olms, 2011) – based on her doctoral thesis – and *Ravens and Red Lipstick: Japanese Photography since 1945* (Thames & Hudson, 2018).

Susana Gállego Cuesta

Susana Gállego Cuesta is head curator of cultural heritage and director of the Museum of Fine Arts of Nancy. Born in Spain, she studied at the École Normale Supérieure in Paris and the École du Louvre and has a PhD in comparative literature. For ten years, she managed the photography collection at the Petit Palais in Paris.

Katarzyna Gębarowska

Photography historian, exhibition curator, editor and photographer Katarzyna Gębarowska has a PhD from the Academy of Fine Arts in Warsaw. She has a passion for historical photography, and since 2015 she has run the Vintage Photo Festival – International Analog Photography Lovers Festival in Bydgoszcz.

Anahita Ghabaian Etehadieh

Anahita Ghabaian Etehadieh is an expert on Iranian photography. She is the founding director of the Silk Road Gallery, the first gallery in Tehran to specialize in photography. She has a PhD in history and a master's degree in information technology from Paris Diderot University, and has curated many exhibitions, including *Iran: Year 38* at the Rencontres d'Arles festival in 2017.

Hélène Giannecchini

Writer and art theorist Hélène Giannecchini has a PhD in literature, and her research focuses on the relationship between text and images. She manages the Alix Cléo Roubaud collection and curated the retrospective of the photographer's work at the Bibliothèque Nationale de France in 2014. She is the author of *Une image peut-être vraie: Alix Cléo Roubaud* (2014) and *Voir de ses propres yeux* (2020), published by Éditions du Seuil as part of the collection 'La Librairie du XXIe siècle'. From 2019 to 2020, she was a fellow at the Villa Medici: The French Academy in Rome.

Marta Gili

Marta Gili has curated numerous exhibitions, both thematic and focused on the work of single artists, and has edited more than three hundred publications on photography, film and contemporary art. Since 2013, she has been on the advisory board of the Museo Nacional Centro de Arte Reina Sofía in Madrid. She was director of the Jeu de Paume in Paris from 2006 to 2018, and since September 2019 she has been director of the National School of Photography in Arles.

Pamela Glasson Roberts

Freelance researcher, curator and author Pamela Glasson Roberts was an exhibition curator for the collection of the Royal Photographic Society in Bristol for nineteen years. Her publications include, among others, works on Alvin Langdon Coburn, Fred Holland Day, Madame Yevonde, Helen Messinger Murdoch, *Camera Work* and the history of colour photography.

Bettina Gockel

Bettina Gockel teaches history of art at the University of Zurich, where she is chair of History of the Fine Arts and director of the Centre for Studies in the Theory and History of Photography. Previously, she was a member of the School of Historical Studies at the Institute for Advanced Study, Princeton, and a research fellow at the Max Planck Institute for the History of Science in Berlin. She is editor of the 'Theory and History of Photography' series (De Gruyter, Berlin).

Laura González-Flores

Laura González-Flores is a full-time researcher at the Instituto de Investigaciones Estéticas at the National Autonomous University of Mexico and a member of Conacyt, the National Council on Science and Technology, in Mexico. She is the author of *La Fotografía ha muerto, viva la fotografía* (Herder, 2019) and curator of the exhibitions *Manuel Alvarez Bravo* (Paris, Jeu de Paume, 2012), *Edward Weston/Harry Callahan* (Madrid, Círculo de Bellas Artes, 2013) and *Rodrigo Moya Moya México* (Puebla, Museo Amparo, 2019).

Maria Gourieva

Maria Gourieva is an associate professor at the European University at St Petersburg, Russia, and co-organizer of the 'After Post-Photography' conference (www.after-post.photography). Her interests centre on photography in the private sphere and the social history of photography.

Kristen Gresh

Kristen Gresh is Senior Curator of Photography at the Museum of Fine Arts (MFA) in Boston. A curator, researcher and lecturer specializing in photography and digital media, she is the author of the award-winning books *She Who Tells a Story: Women Photographers from Iran and the Arab World* and *Graciela Iturbide's Mexico*. Before working at the MFA, she was a curator of twentieth-century photography in Paris and Cairo, where she also taught the history of photography.

Rebekka Grossmann

Rebekka Grossmann is a researcher at the Pacific Regional Office of the German Historical Institute of the University of Berkeley, California, whose work examines the links between Jewish political history and the global history of visual culture. Her first book project focuses on photography as a space for formulating ideas of national belonging in the Jewish diaspora. Her work has been published in the journals *Jewish Social Studies* and *Leo Baeck Institute Yearbook*.

Laetitia Guillemin
Iconographer Laetitia Guillemin has taught the aesthetics of photography at Paris 1 Panthéon-Sorbonne University and now teaches courses on the narrative and analysis of images at Gobelins, l'École de l'Image. She is co-president of the National Association of Iconographers and co-founder of the Circulation(s) festival.

Natalya Guzenko Boudier
Natalya Guzenko Boudier is a journalist, former editor-in-chief of *Harper's Bazaar Ukraine*, and founder of the art blog Amuse A Muse. She works on French–Ukrainian cultural projects, with a particular focus on female French artists of Ukrainian origin.

Sophie Hackett
Sophie Hackett is a photography curator at the Art Gallery of Ontario (AGO) in Toronto, where she curated the exhibition *Diane Arbus: Photographs, 1956–1971* (2020). She is an adjunct professor teaching on the master's programme in film and photography preservation and collections management at Ryerson University.

Awel Haouati
Awel Haouati is a photographer and PhD student at the School for Advanced Studies in the Social Sciences (EHESS) in Paris. Her research centres on the practice and political uses of photography in the context of the Algerian Civil War of the 1990s.

Melissa Harris
Former editor-in-chief of *Aperture* magazine, Melissa Harris has edited, among others, Donna Ferrato, *Living with the Enemy* (1991), Sally Mann, *Immediate Family* (1992), Graciela Iturbide, *Images of the Spirit* (1996), Letizia Battaglia, *Passion, Justice, Freedom: Photographs of Sicily* (1999) and Mary Ellen Mark, *Tiny: Streetwise Revisited* (2015). Her biography of Josef Koudelka is forthcoming, published by Aperture.

Sabine Hartmann
After studying cultural studies and history of art, Sabine Hartmann left East Germany and moved to West Berlin. From 1983 to 2019, she was the archivist in charge of the photography collection at the Bauhaus-Archiv. She has worked on exhibitions and catalogues about the photography of the Bauhaus and was curator of the exhibition *Lucia Moholy, Bauhaus photographer* in 1995.

Yining He
Yining He studied at the London College of Communication at the University of the Arts London and works as an exhibition curator and author, specializing in photography and visual arts. Her exhibition projects have been staged at museums, art galleries and other institutions in China and Europe. She is the author of *Photography in the British Classroom* (2016), *The Port and the Image* (2017) and *Abode of Anamnesis* (2019).

Charlene Heath
Charlene Heath works at the Peter Higdon Research Centre, at the Ryerson Image Centre in Toronto. Her forthcoming dissertation focuses on the lasting impact of political photography in Britain in the 1970s and 1980s.

Elina Heikka
Elina Heikka has been director of the Finnish Museum of Photography in Helsinki since 2007. She has a master's degree in art history, and from 1994 to 1998 she was an editor and then editor-in-chief at the photography magazine *Valokuva*. From 2001 to 2007, she was a researcher at the Finnish Museum of Photography and the Finnish National Gallery – Central Art Archives. She has written widely about contemporary photography and the history of the medium in Finland.

Nathalie Herschdorfer
An art historian specializing in the history of photography, Nathalie Herschdorfer is director of the Museum of Fine Arts in Le Locle, Switzerland, and teaches contemporary photography at Lausanne University of Art and Design (ECAL). She is active in the contemporary photography scene, closely following its latest developments, and has organized many international exhibitions. She is the author of many works, including *Coming into Fashion: A Century of Photography at Condé Nast* (Thames & Hudson, 2012), *The Thames & Hudson Dictionary of Photography* (Thames & Hudson, 2018) and *Body: The Photography Book* (Thames & Hudson, 2019).

Lisa Hostetler
Lisa Hostetler specializes in photography of the twentieth and twenty-first centuries and is head curator of the photography department at the George Eastman Museum in Rochester. She previously worked at the Smithsonian American Art Museum in Washington, DC, the Milwaukee Art Museum and the Metropolitan Museum of Art in New York, where she organized many exhibitions.

Candice Jansen
Candice Jansen is a photography writer. She is a research fellow working on visual identity in art and design at the University of Johannesburg and is responsible for archives, research and exhibition programming at the Market Photo Workshop in Johannesburg.

Sabina Jaskot-Gill
Sabina Jaskot-Gill is a photography curator at the National Portrait Gallery in London. She has taught the history and theory of photography at Sotheby's Institute of Art and worked at Autograph ABP and the University for the Creative Arts in the UK.

Victoria Jonathan
Victoria Jonathan is the co-founder, with Bérénice Angremy, of the French–Chinese artist agency Doors. Together they ran the Jimei × Arles festival (2017–19), created by the Rencontres d'Arles photography festival in China, and have curated many exhibitions on Chinese photography and art.

Julie Jones
Julie Jones is a photography historian with a PhD in art history. She is an assistant curator at the Pompidou Centre and teaches at the École Nationale Supérieure des Arts Décoratifs (ENSAD) in Paris. She has curated numerous exhibitions, including a 2019 retrospective of the duo Shunk-Kender.

Maria Kapajeva
Maria Kapajeva is an Estonian artist living in London. Her work has been exhibited at the Berlin Feminist Film Week (Germany, 2016), NexT Film Festival (Romania, 2017), FOKUS Video Art Festival (Denmark, 2018), where she won the Runner-Up Award, and Luminocity Festival (Canada, 2018). Her first book was shortlisted for the Aperture Book Award in 2018.

Malavika Karlekar

Malavika Karlekar is the editor of the *Indian Journal of Gender Studies* published by the Centre for Women's Development Studies in New Delhi. For twenty years, she has worked on the Centre's archives of work by women photographers, organizing and programming its exhibitions. She has been a university professor for almost ten years and is also an author, artist and gardener.

Magda Keaney

Magda Keaney is head curator of photography at the National Portrait Gallery in London. Over the past twenty years, her writings on photography – published in books, museum catalogues and magazines – have sought to open up a debate about the relationship between fashion and culture, representational politics and gender in photography. She has overseen many exhibitions in collaboration with contemporary artists, both in a freelance capacity and an institutional context.

Corey Keller

Corey Keller has been a photography curator at the San Francisco Museum of Modern Art since 2003. She has curated numerous exhibitions on a variety of subjects, ranging from scientific photography of the nineteenth century to a major retrospective of the contemporary photographer Dawoud Bey.

Rym Khene

Rym Khene is a researcher and photographer. Her work – both writings and photographs – has been published in various journals and essay collections, including *Transition Magazine* (Harvard University), *Marcher! Nous autres: Éléments pour un manifeste de l'Algérie heureuse* (Chihab) and *Apulée* (Zulma).

Sara Knelman

An educator, art curator and writer from Toronto, Sara Knelman's research centres on the history of photography exhibitions, feminism and photography in global contemporary art.

Monica E. Kupfer

Monica E. Kupfer has a PhD in art history and works as a historian, critic and curator specializing in modern and contemporary Latin American art, with a particular focus on Central America. She is founding director of the Panama Art Biennial (1992–2008) and author of many publications, including the book *Sandra Eleta: The Invisible World* (2019).

Paula Kupfer

Paula Kupfer is a Panamanian–German art historian, author and editor specializing in modern art and Latin American photography. She is studying for a PhD in art history at the University of Pittsburgh.

Cat Lachowskyj

Canadian author, editor and researcher Cat Lachowskyj works in Europe. Her writing has been published in many magazines, including *Unseen Magazine*, *Foam Magazine* and *Rum Magazine*, and she has written conceptual essays on archive photography and the materiality of photographs for books and museums.

Anne Lacoste

Anne Lacoste has a PhD in art history and has worked as a curator at the J. Paul Getty Museum in Los Angeles and the Musée de l'Élysée in Lausanne. She is now director of the Lille Photography Institute. Her publications on the history of photography include monographs of Felice Beato, Philippe Halsman and Irving Penn, as well as works on the history of slideshows and photography archives and collections.

Annabelle Lacour

Annabelle Lacour has managed the photography collections of the Musée du Quai Branly-Jacques Chirac since 2018. Her research focuses on early photography in the Middle East and Central Asia, as well as Indonesian photography from the 1920s to the 1940s.

Martha Langford

Martha Langford is a member of the Royal Society of Canada, director of the Gail and Stephen A. Jarislowsky Institute for Studies in Canadian Art, and Distinguished University Research Professor in art history at Concordia University in Montreal. She has written numerous books and articles on the history and theory of photography, focusing especially on experimentation in photography.

Sylvie Lécallier

Sylvie Lécallier manages the photography collection at the Palais Galliera, City of Paris Fashion Museum. She is an expert on fashion photography, an exhibition curator, an author and editor of the 'Fashion Eye' series published by Louis Vuitton.

Sigrid Lien

Sigrid Lien is a professor of art history and photography studies at the University of Bergen, Norway. Her work on twentieth-century, modern and contemporary photography has been widely published.

Joanne Lukitsh

A professor of art history at the Massachusetts College of Art and Design in Boston, Joanne Lukitsh has published numerous works on Julia Margaret Cameron. With Juliet Hacking, she co-edited *Photography and the Arts: Essays on 19th-Century Practices and Debates* (Bloomsbury Visual Arts, 2020).

Anne Lyden

Anne Lyden is head curator of photography at the Scottish National Portrait Gallery in Edinburgh. Her latest book is *A Perfect Chemistry: Photographs by Hill and Adamson*.

Lola Mac Dougall

Lola Mac Dougall has a PhD from the Pompeu Fabra University in Barcelona, where her thesis focused on Indian women photographers. She is founding director of GoaPhoto, an international photography festival that stages exhibitions in private homes. Before that, she was artistic director of the open-air JaipurPhoto festival. Her articles have been published in *Indian Quarterly*, *Der Greif*, *The Hindu* and *American Suburb X*.

Sandra Maunac

Sandra Maunac is a freelance curator who specializes in post-colonialism and cultural studies, working on projects that question the status of the image. Since 2017, she has been director of Trobades i Premis Mediterranis Albert Camus in Menorca, Spain.

Shoair Mavlian

Shoair Mavlian is director of Photoworks. From 2011 to 2018, she was assistant curator of international art and photography at Tate Modern, London, where she worked on major exhibitions including *Conflict, Time, Photography* (2014), *The Radical Eye: Modernist Photography from the Sir Elton John Collection* (2016) and *Shape of Light: 100 Years of Photography and Abstract Art* (2018).

Anne Maxwell

An associate professor at the University of Melbourne, Anne Maxwell has published numerous articles and essays on colonial literature and photography, as well as the role of women in photography. Her books include *Colonial Photography & Exhibitions* (Leicester University Press, 2000), *Picture Imperfect: Photography and Eugenics, 1870–1940* (Sussex Academic Press, 2008), *Shifting Focus: Colonial Australian Photography, 1850–1920* (Australian Scholarly Publishing, 2015) and *Women Photographers of the Pacific World, 1857–1930* (Routledge, 2020).

Margarida Medeiros

Margarida Medeiros has a PhD in communication studies and is a professor at NOVA University Lisbon, where she teaches courses on photography, visual culture and film. She has published many books on photography, as well as articles in academic journals.

Ieva Meilutė-Svinkūnienė

Ieva Meilutė-Svinkūnienė has a degree in art history and criticism from Vilnius Academy of Arts. From 2008, she was a curator and project coordinator for the Lithuanian Photographers Association at the Kaunas Photography Gallery in Vilnius, and in 2015 she was named director of the new Vitas Luckus Centre at the Photography Museum. She is currently a freelance curator of art photography.

Jasmin Meinold

Historian and curator Jasmin Meinold has worked for the Heidelberger Kunstverein, the Museum for Photography Brunswick and as a cultural mediator for the German pavilion at the Venice Biennale.

Jeanne Mercier

Since 2005, Jeanne Mercier has worked as a curator and critic in Europe and Africa. She is co-founder and editor-in-chief of *Afrique in visu*, a platform for African photographers. She is particularly interested in new practices in photography and questions around new imaginaries. She is currently working on numerous exhibition projects in Europe and Africa, and contributes to various photography publications such as *British Photography Journal*, *Photomonitor*, *Fisheye Magazine*, *Diptyk* and *Yet Magazine*.

Christelle Michel

An art historian specializing in photography, Christelle Michel has worked in the collections department at the Musée de l'Élysée in Lausanne since 2014 and regularly contributes to photography publications.

George Mind

An art historian specializing in nineteenth- and twentieth-century photography, George Mind divides her time between the National Portrait Gallery in London and the University of Westminster, where she is a collaborative doctoral student whose research focuses on women and portraiture in the period 1888–1914. Before starting her PhD, she worked for the art festival HOUSE, Photoworks and the Brighton Photo Biennial. With Terence Pepper, she runs the Instagram account Sisters of the Lens, which showcases the work of little-known female amateur photographers and female professional photographers from the period 1840–1940.

Tanvi Mishra

Based in New Delhi, Tanvi Mishra is an exhibition curator and the editor of numerous books on photography. She is especially interested in the politics of representation in the medium of photography and their impact on South Asian narratives, as well as the concept of fiction in photography, particularly in the current political context. She is artistic director of the political and cultural journal *The Caravan* and part of the editorial team for the South Asian magazine *PIX*. She has sat on numerous juries, including that of the World Press Photo Awards.

Fulufhelo Mobadi

South African photographer and exhibition curator Fulufhelo Mobadi studied photojournalism and documentary photography at the Market Photo Workshop in Johannesburg. Her photography and curation work centres on everyday problems faced by women in contemporary South African society and the African continent in general. She is a course coordinator at the Market Photo Workshop, and in 2020 she received a curatorial research grant from the Rencontres d'Arles photography festival – Africa Project.

Elisabeth Moortgat

Cultural scientist Elisabeth Moortgat has published various monographs and essays on the history of photography in the twentieth century. She sits on the board of the Hidden Museum (Das Verborgene Museum – Documenting Women's Art) in Berlin.

Gaëlle Morel

Gaëlle Morel has a PhD in art history and is a curator at the Ryerson Image Centre in Toronto. Her research interests focus on photojournalism, artistic and cultural recognition of photography and modernism in photography.

Victoria Munro

Artist and curator Victoria Munro teaches art and art history. She is executive director of the Alice Austen House, dedicated to the history of the LGBTQI rights movement, the only museum in the United States to exhibit works by the American photographer Alice Austen.

Federica Muzzarelli

Federica Muzzarelli teaches photography and visual arts at the University of Bologna in Italy. She is editor-in-chief of the 'Cultures, Fashion and Society' series (Pearson) and coordinator of the Culture Fashion Communication – International Research Centre in Bologna.

Yasmine Nachabe Taan
Professor of art and design at the Lebanese American University in Beirut, Yasmine Nachabe Taan's work focuses on representations of gender in Middle Eastern and North African photography. She has overseen many exhibitions and published books on Arab typography and design.

Suryanandini Narain
Suryanandini Narain is a lecturer in photography, visual culture, aesthetics and critical writing at the school of arts and aesthetics at Jawaharlal Nehru University. Her articles have been published in many journals and books.

Constantia Nicolaides
Constantia Nicolaides studied art history at the Chelsea College of Art and Design and the University of Sussex. Since 2003, she has worked as an assistant curator of photography at the National Portrait Gallery in London.

Nestan Nijaradze
Nestan Nijaradze co-founded the first institution in Georgia dedicated to contemporary images in their different forms – photography, film and new media. She is also artistic director of the Tbilisi Photo Festival, the first international photography festival in Georgia and the southern Caucasus, which she founded in 2010 in partnership with the Rencontres d'Arles photography festival. She has curated numerous exhibitions promoting Georgian visual culture in Georgia and throughout the world.

Érika Nimis
A photographer, historian specializing in Africa and associate professor of art history at the University of Quebec in Montreal (UQÀM), Érika Nimis is known for her work on the history of West African photography.

Anne O'Hehir
A photography curator at the National Gallery of Australia, Anne O'Hehir has overseen numerous exhibitions, including *Carol Jerrems: Photographic Artist* (2012), *Light Moves: Contemporary Australian Video Art* (2015), *Diane Arbus: American Portraits* (2016) and *California Cool: Art in Los Angeles 1960s–70s* (2018–19). She regularly publishes work and gives lectures on different aspects of contemporary and historical photography, with a special interest in women and modernism.

Pippa Oldfield
Pippa Oldfield is head of programmes at Impressions Gallery in Bradford, United Kingdom, and a visiting research fellow at Leeds Art University. She has overseen many exhibitions, including *No Man's Land: Women's Photography and the First World War* (2017). She is the author of *Photography and War* (Reaktion, 2019).

Oluremi C. Onabanjo
Formerly exhibition director at the Walther Collection in Neu-Ulm, Germany, Oluremi C. Onabanjo is a curator and expert on African art and photography with a PhD in art history from Columbia University.

Daria Panaiotti
An expert on the history of photography, Daria Panaiotti is a curator of contemporary art at the Hermitage Museum in St Petersburg. She is also a member of the College Art Association and sits on the committee for the international conference 'After Post-Photography'.

Nikoo Paydar
An assistant curator at Fisk University Galleries in Nashville, Tennessee, Nikoo Paydar's research focuses on American art and orientalism in the twentieth century. She has a PhD from the Courtauld Institute of Art in London.

Deniz Pehlivaner
Deniz Pehlivaner has a degree in English literature from Istanbul University (2005) and a master's degree from Yeditepe University. She has worked at the Istanbul Museum of Modern Art since 2009.

Penelope Petsini
Penelope Petsini has a master's degree in image and communication from Goldsmiths College, University of London, and a PhD from the University of Derby. She is principal researcher in the post-doctoral programme Censorship in Visual Arts and Film (CIVIL) in the department of political science and history at Panteion University in Athens, where she teaches the course 'Censorship: Interdisciplinary Approaches'.

Claudia Polledri
Claudia Polledri is a postdoctoral researcher in the department of art history and film studies at the University of Montreal. She obtained her PhD in comparative literature, specializing in photographic representations of Beirut in the period 1982–2011, from the same university. Her research focuses on contemporary Middle Eastern photography and she curated the exhibition *Iran: Poésies visuelles* in Quebec in 2019.

Carolina Ponce de Léon
Carolina Ponce de Léon is a freelance curator, researcher and art critic based in Bogotá, Colombia. With Sam Stourdzé, she co-curated the exhibition *La Vuelta: 28 photographes et artistes colombiens* for the Rencontres d'Arles photography festival in 2017. She is the author of many books, including *Jesús Abad Colorado: Mirar de la Vida Profunda* (Planeta, 2015).

Karolina Puchała-Rojek
Art and photography historian Karolina Puchała-Rojek is co-founder and president of the Archaeology of Photography Foundation, one of the first institutions in Poland dedicated to exploring the archives of major Polish photographers. She coordinates international projects on the curation of archives, and is an author, editor and photography exhibition curator. She currently works at the National Museum of Poland in Warsaw.

Kateryna Radchenko
Since 2015, Ukrainian curator, artist and researcher Kateryna Radchenko has been director of the international festival Odesa Photo Days, which she founded. She has curated many exhibitions in Ukraine, South Korea, Sweden and Latvia and has published articles in international magazines including *Fotograp*, *Magenta*, *EIKON* and *FOAM*.

Helihanta Rajaonarison
Helihanta Rajaonarison teaches and researches at the University of Antananarivo. Her thesis was on the social uses of

photography in Antananarivo from the mid-nineteenth to the mid-twentieth century. She is co-founder and president of the Madagascar Museum of Photography.

Zsófia Rátkai
A master's student in art history, Zsófia Rátkai lives in Budapest. She specializes in Hungarian contemporary photography and works as a gallery assistant.

Martine Ravache
Photography critic Martine Ravache studied at the École du Louvre. She has curated exhibitions including *Lartigue: La vie en couleurs* (Paris, Maison Européenne de la Photographie, 2015), and is the author of seven books, including *Regards paranoïaques: La photographie fait des histoires* (Éditions du Canoë, 2019).

Scarlett Reliquet
Scarlett Reliquet is an art historian specializing in the history of transatlantic artistic exchanges from the early twentieth century. She has published a biography of the collector and writer Henri-Pierre Roché and, with Philippe Reliquet, she edited the correspondence between Marcel Duchamp and Roché for publication. She regularly contributes essays on female artists for exhibition catalogues and dictionaries.

Raisa Rexer
Raisa Rexer is a lecturer in French at Vanderbilt University in Nashville, Tennessee, and the author of *The Fallen Veil: A Literary and Cultural History of the Photographic Nude in Nineteenth-Century France* (University of Pennsylvania Press, 2021).

Núria F. Rius
Núria F. Rius has a PhD in art history from the University of Barcelona. Her research interests centre on amateur photography in Spain from the early twentieth century to the 1960s.

Hilary Roberts
Hilary Roberts is a photography curator at the Imperial War Museum, London. She specializes in the history and practice of photography during wartime and has contributed to many publications and exhibitions, including *Don McCullin: Shaped by War* (2010–12), *Cecil Beaton: Theater of War* (2012) and *Lee Miller: A Woman's War* (2015–16). In 2017, she won the Award for Curatorship from the Royal Photographic Society in Bristol.

Julie Robinson
Since 1998, Julie Robinson has been an exhibition curator at the Art Gallery of South Australia in Adelaide, where she is curator of printed documents, drawings and photographs. She has worked on numerous exhibitions and written about various aspects of Australian and European art, specializing in historical and contemporary photography. She organized the 2004 edition of the Adelaide Biennial of Contemporary Art – Contemporary Photomedia and the 2007 exhibition *A Century in Focus: South Australian Photography, 1840s–1940s*, the first exhibition tracing the history of photography in South Australia, which was accompanied by an extensive catalogue.

Mette Sandbye
Mette Sandbye is professor of photography in the Department of Arts and Cultural Studies at the University of Copenhagen. She is the editor of the first history of Danish photography (*Dansk Fotografihistorie*, 2004), and has written many books and articles on photography.

Franziska Schmidt
Art and photography historian Franziska Schmidt has worked across Germany, in Halle-sur-Saale, Dresden, Munich and Essen. She was director of the Galerie Berinson in Berlin, the Museum for Photography Brunswick, and the photography department at the Grisebach in Berlin. In 2020, she was named director of the Galerie Parterre in Berlin.

Gabriele Schor
Creator of the Verbund Collection in Vienna, Gabriele Schor coined the term 'avant-garde feminist' to highlight the pivotal role of female artists in the 1970s. She has edited many publications on Birgit Jürgenssen, Cindy Sherman, Francesca Woodman, Renate Bertlmann and Louise Lawler.

Letta Shtohryn
New-media artist and researcher Letta Shtohryn studied photography, philosophy, gender studies and digital art. Her research-based practice combines the historical and the contemporary, exploring the relationship between modern technology and early industrial practices.

Æsa Sigurjónsdóttir
Æsa Sigurjónsdóttir is an associate professor at the University of Iceland in Reykjavik. She writes about contemporary art, photography and visual culture in general. As a freelance curator, she has worked on a number of exhibitions at museums and galleries across Iceland and Europe.

Nani Simonis
German painter and sculptor Nani Simonis has lived and worked in New York, Paris and Munich. She is the daughter of Elisabeth Hase and has collected an archive of her mother's works.

Agnès Sire
After working for Magnum Photos for twenty years, Agnès Sire became general director of the Henri Cartier-Bresson Foundation, curating most of its exhibitions until 2018. She has published around fifty books on photography and curated approximately fifty exhibitions.

Karen Smith
British exhibition curator and art historian Karen Smith specializes in contemporary Chinese photography. She has been based in China since 1992 and currently lives in Shanghai. She is founding director of OCAT Xi'an, a contemporary art museum that belongs to the OCAT Museum Group. In recent years, she has also been in charge of exhibition programming at the Shanghai Centre of Photography, founded in 2015.

Abigail Solomon-Godeau
Professor emeritus in the art history department at the University of California, Santa Barbara, Abigail Solomon-Godeau is the author of *Photography at the Dock: Essays on Photographic History, Institutions and Practices* (University of Minnesota Press, 1992), *Male Trouble: A Crisis in Representation* (Thames & Hudson, 1997),

Chair à canons: Photographie, discours, féminisme (Textuel, 2016) and *Photography After Photography: Gender, Genre, History* (Duke University Press, 2017), as well as monographs on the artists Rosemary Laing (2011) and Birgit Jürgenssen (with Gabriele Schor, 2013). Her essays on eighteenth- and nineteenth-century art and photography, feminism and contemporary art have been widely published and translated into multiple languages. She lives and works in Paris.

Anna Sparham
Anna Sparham has worked in the cultural sector since 2001 and was a photography curator at the Museum of London for thirteen years. She is now a freelance exhibition curator, author and researcher.

Lyudmila Starilova
Author and researcher Lyudmila Starilova works at Rosphoto, a photography institution in St Petersburg, where she manages the early twentieth-century photography collection.

Diana C. Stoll
Freelance art critic and editor Diana C. Stoll has published critical essays on photography in *Burnawat*, *Hyperallergic* and *Aperture*, where she was an editor from 2000 to 2013. She was one of the main contributors to *A World History of Photography*, edited by Naomi Rosenblum and published by Abbeville in 2019.

Katharina Sykora
German art historian Katharina Sykora specializes in the social construction of gender and authorship, visual culture and the interrelation between photography, painting and film. From 1994 to 2018, she was a professor at the Ruhr-University Bochum and Brunswick Arts University in Germany.

Rose Teanby
Rose Teanby is a PhD student at the Photographic History Research Centre at De Montfort University in the United Kingdom, working on early female photographers from the period 1839–60. She is also an associate member of the Royal Photographic Society in Bristol.

Anna Tellgren
Anna Tellgren is a photography curator and research director at Moderna Museet in Stockholm. She has curated many exhibitions, including *Arbus, Model, Strömholm* (2005), *Lars Tunbjörk: Winter / Home* (2007) and *Francesca Woodman: On Being an Angel* (2015).

Baiba Tetere
Teacher and researcher Baiba Tetere's interdisciplinary research brings together visual culture, history of science and studies in material culture, focusing especially on photography studies. Since 2000, she has regularly organized artistic education projects related to photography.

Valentina Tong
Valentina Tong is a Brazilian architect and curator. She was assistant curator of the exhibitions *Claudia Andujar: In the Place of the Other* (2015) and *Claudia Andujar: The Yanomami Struggle* (2018) at the Moreira Salles Institute in Brazil.

Zoë Tousignant
An art historian specializing in Canadian photography, Zoë Tousignant is an assistant photography curator at the McCord Museum in Montreal.

Flora Triebel
Curator Flora Triebel manages the nineteenth-century photography collection in the department of prints and photography at the Bibliothèque Nationale de France.

Aliki Tsirgialou
A photography historian and head curator of the photography archives at the Benaki Museum in Athens, Aliki Tsirgialou has written articles on Greek photography, organized many exhibitions and contributed to the accompanying catalogues.

Silvia Valisa
An associate professor in Italian studies at the University of Florida, Silvia Valisa's research focuses on the concept of gender in Italian culture and modern technology – prints and photography in particular. She leads two digital humanities projects about the history of Italian publishing, and

has written on themes such as gender in the Italian novel, the relationship between literature and photography, and the Italian photographer Wanda Wulz, among others.

Arola Valls Bofill
A researcher, professor at the University of Barcelona and curator specializing in the relationship between contemporary art and education, Arola Valls Bofill has created mediation projects for contemporary art exhibitions at CaixaForum.

Pauline Vermare
A photography historian based in New York, Pauline Vermare is cultural director of Magnum Photos and sits on the board of the Saul Leiter Foundation. She has worked as an exhibition curator at the International Center of Photography and the Museum of Modern Art. From 2002 to 2009, she worked at the Henri Cartier-Bresson Foundation in Paris.

Dominique Versavel
Paleographer and archivist Dominique Versavel has been, since 2002, head curator of modern photography and, since 2014, head of the photography team in the department of prints and photography at the Bibliothèque Nationale de France. She has taken part in many conferences and contributed to numerous exhibitions and the accompanying catalogues, including *Icônes de Mai 68: Les images ont une histoire* (Bibliothèque Nationale de France, 2018). She was also co-curator of the exhibition *Noir & blanc, une esthétique de la photographie: Collection de la Bibliothèque Nationale de France* (RMN-Grand-Palais, 2020).

Hripsimé Visser
Hripsimé Visser studied art history at Leiden University, specializing in the history of photography. Since the 1990s, she has worked as a photography curator at the Stedelijk Museum in Amsterdam, where she has curated a number of exhibitions and contributed to publications on twentieth-century photography.

Sonia Voss

Curator and author Sonia Voss oversaw the exhibitions *Sophie Calle et son invitée Serena Carone* at the Museum of Hunting and Nature in Paris in 2017–18 and *Corps impatients: Photographie est-allemande 1980–1989* at the Rencontres d'Arles photography festival in 2019.

Francesca Wilmott

A freelance curator and PhD student at the Courtauld Institute of Art in London, Francesca Wilmott has worked as an exhibition curator at the Museum of Modern Art in New York and the Jan Shrem and Maria Manetti Shrem Museum of Art at the University of California, Davis.

Demet Yıldız Dinçer

Demet Yıldız Dinçer is based in Istanbul, Turkey, and is the Photography Department Manager at the Istanbul Museum of Modern Art. She has taught several courses on art at the Sabancı University and continued her career in contemporary art at the Istanbul Biennial, before taking up her current position at Istanbul Modern in 2015. In addition to curating photography exhibitions, Yıldız Dinçer contributes to various publications and holds jury membership and nominator positions at various international photography festivals and events.

Cynthia Young

Cynthia Young has been curator of the Robert Capa Archives at the International Center of Photography (ICP), New York since 2010 and has overseen many exhibitions there, including *The Mexican Suitcase: The Rediscovered Negatives of Capa, Chim and Taro* (2010), *We Went Back: Photographs from Europe 1933–1956 by Chim* (2013) and *Capa in Color* (2014). She has also published books related to these exhibitions, including *Ralph Eugene Meatyard* (ICP, 2004) and *Unknown Weegee* (Steidl, 2006).

Oksana Zabuzhko

Ukrainian author, essayist and intellectual Oksana Zabuzhko's books have been translated into sixteen languages and won many prizes (Ukraine's Shevchenko National Prize, the Angelus Central European Literary Prize and a MacArthur Grant). She wrote the preface for the first book on photographer Sophie Jablonska-Oudin (Rodovid, 2018).

Maria Zagala

An associate curator of prints, drawings and photography at the Art Gallery of South Australia in Melbourne, Maria Zagala has curated many photography exhibitions, including *Tracey Moffatt: Narratives* (with Stephen Zagala, 2011) and *Trent Park: The Black Rose* (with Julie Robinson, 2015), and is the author of *Ian North: Art, Work, Words* (2019). From 2006 to 2019, she was also an associate professor in art history, history and politics at the University of Adelaide.

Erika Zerwes

Erika Zerwes gained her PhD in history from Unicamp in São Paulo and spent time studying at the School for Advanced Studies in the Social Sciences (EHESS) in Paris. She was also a postdoctoral researcher at the Museum of Contemporary Art in São Paulo. She has published widely on art history, the history of photography and contemporary history.

Karolina Ziębińska-Lewandowska

Karolina Ziębińska-Lewandowska has a PhD in art history and is a photography curator at the Pompidou Centre. She was a curator at the Zachęta National Gallery of Art in Warsaw from 1999 to 2010, co-founded the Archaeology of Photography Foundation and was its president until 2014. She has worked on around forty exhibitions and their accompanying catalogues, including *Documentalistes: Femmes photographes polonaises du 20e siècle* (2008), *The Chronicles: Zofia Chometowska, Maria Chrzaszczowa* (2012), *Wojciech Zamecznik: Photo-Graphics* (2016), *Brassaï: Graffiti, Le langage du mur* (Xavier Barral, 2016), *David Goldblatt: Structures de domination et de démocratie* (Steidl, 2018) and *Dora Maar* (Pompidou Centre, 2019).

Acknowledgments

General editors' acknowledgments

This book would not have been possible without the vital collaboration of the 162 contributors who helped us to find and select women photographers for inclusion, discovered hundreds of new image sources, and made many suggestions for picture material. We are particularly grateful to them for helping us to understand the role of women in the field of photography and of art in general within their country or culture.

This book has benefited from the expertise of many specialists who have provided wise advice and valuable contacts. Our gratitude is owed to them and to anyone whose name may have been omitted. Our deepest thanks go to the following experts in their subject or geographical area: Érika Nimis (Africa), Florian Ebner, Ute Eskildsen and Ulrich Pohlman (Germany), Sara Knelman (North America and Western Europe in the twentieth century), Marta Daho, Laura González-Flores, Elena Navarro and El Centro de la Imagen (Latin America, Mexico and Spain), Soledad Abarca (South America and Chile), Helen Ennis, Shaun Lakin and Julie Robinson (Australia), Gabriele Schor (Austria and feminist photographers), Thyago Nogueira (Brazil), Laurence Butet-Roch and Marta Langford (Canada), Bérénice Angremy and Victoria Jonathan (China), Joana Toro (Colombia), Aldeide Delgado (Cuba), Mette Sandbye (Denmark), Lourdes Delgado and Marta Ponsa (Spain), Lesley Martin, Nikoo Paydar, Raisa Rexer and Francesca Wilmott (USA), Elina Heikka (Finland), Nestan Nijaradze (Georgia), Clare Freestone and Sabina Jaskot-Gill (Britain), Anne-Claire Jonnard, Penelope Petsini and Aliki Tsirgialou (Greece), Deepali Dewan (India), Æsa Sigurjónsdóttir (Iceland), Yudit Caplan (Israel), Federica Muzzarelli (Italy), Jean Kenta Gauthier (Japan), Maria Kapajeva (Latvia, Lithuania, Estonia, Russia and countries of the former Soviet Union), Elisabeth Grech (Malta), Anne Maxwell (New Zealand and Australia in the nineteenth century), Sigrid Lien (Norway), Mattie Boom (Netherlands), Annabelle Lacour (non-European photography in the nineteenth century), Julien Faure Conorton (Pictorialist photography), Teresa Castro and Raquel Guerra (Portugal), Anna Tellgren (Sweden and the Nordic countries), Marc Donnadieu, Tatyana Frank and Carole Sandrin (Switzerland), Isabel Swchebor Pellegrino (Uruguay), Natalya Guzenko Boudier (Ukraine).

For their useful critiques, their moral and logistical support and their kindness throughout this project, we would also like to thank: Raven Amiro, Lisa Gwen Andrews, Naazish Ataullah, Sylvie Aubenas, Simon Baker, Stéphanie Barbier, Julie Barrau, Christine Barthes, Clara Bastid, Patrizia Di Bello, Carolle Benitah, Claire Bernardi, Isabelle Bideau, Lillian Birnbaum, Jennifer Blessing, Sylvie Blocher, Denis-Michel Boëll, Paul-Emile Boëll, Marie-Jo Bonnet, Sonia Bost, Caroline Brun, Elvire Caupos, Sabine Cazenave, Normand Charbonneaux, Fabienne Chevallier, Sheba Chhachhi, Hector Inclan Cienfuegos, Guy Cogeval, Linda Conze, Luis Aysleth Corona, Agnès Defaux, Magali Delporte, Laurence des Cars, Marie Docher, Fabienne Dumont, Cyrielle Durox, Susan Ehrens, Fannie Escoulen, Ekow Eshun, Christophe Fouin, Geneviève François, David Franklin, Michel Frizot, Julien Frydman, Emmanuelle Fructus, Julie Fuster, Sabeena Gadihoke, Thomas Galifot, Jean-Baptiste Garnero, Nathaniel Gaskell, Laurence Geai, Oriane Girard, Nathalie Giraudeau, Catherine Gonnard, Lina Gouger, Érika Goyarrola, Inka Graeve Ingelmann, Vincent Guyot, Juliet Hacking, Emilie Hallard, Morgane Hamon, Etienne Hatt, Katharina Hausel, Karen Hellman, Lauriane Hervieux, Marion Hislen, Mariana Huerta Lledias, Marion Jacquier, Philippe Jacquier, Louise Janet, Marguerite Janet, Leila Jarbouai, Jade Jollivet, Dorothée Joly, Peter Junk, Marine Kisiel, Jérôme Kohler, Christina Kott, Mikhail Krasnov, Nicolas Krief, Anaïs Lancien, Andrée Lancien, Martin Lanthier, Ludovic Lebart, Claire Lebouc, Manon Lecaplain, Jérôme Legrand, Sophie Leromain, Pauline Martin, Jean Matheson, Florence Mauro, Sarah Meister, Mouna Mekouar, Isabelle Morin Loutrel, Camille Morineau, Renée Musai, Mathieu Nicol, Marian Nur Goni, Dominique Païni, Abigail Pasillas, Sylvie Patry, Carine Peltier-Caroff, Paul Perrin, Altinai Petrovitch Njegosh, Michel Poivert, Timothy Prus, Ram Rahman, Sandra Reinflet, Françoise Reynaud, Evelyne Robert, Vincent Robert, Holly Roussel, Esther Ruelfs, Stéphanie Salmon, Cécile Schall, Anja Scherz, Kathrin Schönegg, Pierre Sciot, Vanessa Schwartz, Mark Sealy, Victor Secretan, Lisa Silverman, Gayatri Sinha, Sam Stourdzé, Thomas Szlukovenyi, Frances Tanzer, Katerina Thomadaki, Alice Thomine Berrada, David Thomson, Usha Titikshu, Chantal Tremblay, Lisa Tremblay Goodyear, Béatrice Tupin, Gabriel Wegrowe, Marta Weiss.

Our sincere thanks to our publishers Marianne Théry and Manon Lenoir, whose commitment to the cause of women is exemplary, and their formidable team of staff: our thanks to Giorgia Passaro, Cécile Barthes-Krompaszky, Julie Malinvaud, Violaine Aurias, Raphaëlle Picquet, Agnès Dahan and Sylvie Bellu.

Publisher's acknowledgments

Les Éditions Textuel would like to thank Sam Stourdzé and Kering whose early involvement was crucial to the launch of this ambitious project, as well as Marion Hislen (Delegate for Photography to the French Ministry of Culture), whose help and encouragement have been invaluable throughout.

Our thanks to Agnès Saal (Senior Officer for Equality, Diversity and Prevention of Discrimination, under the Secretary General of the Ministry of Culture) for her support, as well as Hélène Furnon-Petrescu and Carole Modigliani-Chouraqui (Department of Women's Rights and Gender Equality, under the Minister Delegate for Equality, Diversity and Equal Opportunities). We would also like to thank Xavier Person, Alice Meiringer and Laurence Vintéjoux from the Île-de-France Region (Board of Culture – Books and Reading Department).

Finally, we would like to thank Frédérique Destribats for all her help, along with the assistance of Floriane de Saint-Pierre.

Many people shared information, contacts and advice with us during the making of this book. Our thanks to: Carlos Aguirre, Damarice Amao, Raven Amiro, Bérénice Angremy, Sylvain Besson, Gülderen Bölük, Victoria Bonet, Deborah Cherry, Juliette Collomb, Pierre-Edouard Couton, Lea Czermak, Fernando and Carolina Eseverri, Joan Fontcuberta, Isabelle Georjon, Anahita Ghabaian, Joséphine Givodan, Bérangère Gouttefarde, Laetitia Guillemin, Yining He, Luis H. Inclán Cienfuegos, Lanese Jaftha, Naïma Kaddour, Maria Kapajeva, Cat Lachowskyj, Tracy Mallon-Jensen, Lesley Martin, Sandra Maunac, Françoise Morin, Patricia Morvan, Érika Nimis, Deniz Pehlivaner, Ramón Reverté, Bertrand Richard, Isabelle Sadys, Maarten Schilt, Diran Sirinian, Karen Smith, Olivia Snaije, Lisa Tremblay-Goodyer, Ivan Vartanian, Caroline Wall.

Massachusetts © President and Fellows of Harvard College; **p. 219** Digital image Musées de la ville de Marseille, Dist. RMN-Grand Palais. © All rights reserved; **p. 220** © Anna Riwkin/Moderna Museet, Stockholm; **p. 221** Swiss Literary Archives (SLA), Bern. Estate of Annemarie Schwarzenbach, Call No. SLA-AS-5-11/239; **p. 222** National Galleries of Scotland, Edinburgh. Presented by Wolfgang Suschitzky 2004. Digital image National Galleries of Scotland, Edinburgh. Edith Tudor-Hart © Copyright held jointly by Peter Suschitzky, Julia Donat & Misha Donat, The Estate of W. Suschitzky; **p. 223** Digital image Magyar Fotográfiai Múzeum, Kecskemét. Kata Kálmán © DACS 2022; **p. 224** Digital image Museum of Photography, Kraków. © All rights reserved; **p. 225** © Eva Besnyö/Maria Austria Instituut, Amsterdam; **p. 226** Courtesy the George Eastman Museum, Rochester; **p. 227** Gerda Taro/International Center of Photography, New York/Magnum Photos; **p. 228** Digital image National Gallery of Australia, Canberra. © Courtesy the Cotton family and Josef Lebovic Gallery, Sydney; **p. 229** © The Zofia Rydet Foundation, Kraków; **p. 230** © Courtesy Tayfun Serttaş; **p. 231** © Rheinisches Bildarchiv Cologne, rba_d031510; **p. 232** Museu Nacional d'Art de Catalunya, Barcelona. Long-term loan from the Agrupació Fotogràfica de Catalunya, 2003. Digital image Museu Nacional d'Art de Catalunya, Barcelona 2022. © The artist or the heirs; **p. 233** © Eve Arnold/Magnum Photos; **p. 234** Courtesy Özgün Akbayır; **p. 235** © 2005 Ana María Norah Horna y Fernández (all rights reserved); **p. 236** Magyar Fotográfiai Múzeum, Kecskemét; **p. 237** © Ata Kandó/Nederlands Fotomuseum, Rotterdam; **p. 238** Homai Vyarawalla Archive, The Alkazi Collection of Photography, The Alkazi Foundation for the Arts, New Delhi; **p. 239** The Museum of Modern Art, New York. Acquired through the generosity of Harriette and Noel Levine, Object No. 42.1992. Digital image 2022, The Museum of Modern Art, New York/Scala, Florence. Helen Levitt © Film Documents LLC. Courtesy Galerie Thomas Zander, Cologne; **p. 240** Digital image Special Collections, Leiden University Libraries. © Leiden University (Joost Elffers), all rights reserved; **p. 241** Digital image Danish Arctic Institute, Copenhagen. Jette Bang © DACS 2022; **p. 242** © Tsuneko Sasamoto/Japan Professional Photographers Society, Tokyo; **p. 243** National Gallery of Art, Washington, DC Corcoran Collection (Museum Purchase), Accession No. 2016.117.15. Digital image National Gallery of Art, Washington, DC © All rights reserved; **p. 244** © Fonds Suzi Pilet, ADSP/Photo Elysée, Lausanne; **p. 245** © Estate of Iryna Pap; **p. 246** Digital image Wisconsin Historical Society, Madison, Image ID WHS-12156 © Dickey Chapelle. Courtesy the Meyer family; **p. 247** Frances McLaughlin-Gill/Condé Nast/Shutterstock; **p. 248** © Edwige Razafy; **p. 249** Alice Brill/Instituto Moreira Salles Collection; **p. 250** Janine Niépce/Roger-Viollet; **p. 251** © Harry Ransom Center, The University of Texas at Austin; **p. 252** Art Gallery of Ontario, Toronto. Purchase with funds donated by David G. Broadhurst, 2012, 2012/23. Digital image Bruce Silverstein Gallery, New York. © Estate of Marie Cosindas; **p. 253** © The Estate of Diane Arbus; **p. 254** Private collection, Paris. Digital image Nicolas Brasseur. © All rights reserved; **p. 255** © Inge Morath/Magnum Photos; **p. 256** © Alice Springs/Maconochie Photography, London; **p. 257** Bettmann/Getty Images; **p. 258** © Sabine Weiss; **p. 259** © Lisetta Carmi/Martini & Ronchetti, Genoa; **p. 260** Digital image Musée Nicéphore Niépce, Ville de Chalon-sur-Saône. © Fonds Dominique Darbois/Françoise Denoyelle; **p. 261** © Archivo Fotográfico Mariana Yampolsky, Biblioteca Francisco Xavier Clavigero, Universidad Iberoamericana, Mexico City; **p. 262** © Estate of Vivian Maier. Courtesy Maloof Collection and Howard Greenberg Gallery, New York; **p. 263** Paraska Plytka-Horytsvit © The community of the village of Kryvorivnya; **pp. 264–5** Digital image IMEC, Fonds MCC, Saint-Germain-la-Blanche-Herbe, Dist. RMN-Grand Palais/Gisèle Freund. © RMN gestion droit d'auteur/Fonds MCC/IMEC; **p. 266** Gerda Taro/International Center of Photography, New York/Magnum Photos; **p. 267** © Lee Miller Archives, England 2021. All rights reserved. www.leemiller.co.uk; **p. 268** National Gallery of Art, Washington, DC Corcoran Collection (Gift of the Artist, Constance Stuart Larrabee WWII Collection), Accession No. 2016.117.299. Digital image National Gallery of Art, Washington, DC © All rights reserved; **p. 269** © Fonds Suzi Pilet, ADSP/Photo Elysée, Lausanne; **p. 270** Digital image Special Collections, Leiden University Libraries. © Leiden University (Joost Elffers), all rights reserved; **p. 271** Courtesy Özgün Akbayır; **pp. 272–3** © Sabine Weiss; **p. 274** © Center for Creative Photography, The University of Arizona Foundation/DACS 2022; **p. 275** © Tsuneko Sasamoto/Japan Professional Photographers Society, Tokyo; **p. 276** © Rheinisches Bildarchiv Cologne, rba_d031517; **p. 277** Wisconsin Historical Society, Madison, Image ID WHS-115283; **p. 278** © Lisetta Carmi/Martini & Ronchetti, Genoa; **p. 279** Digital image Throckmorton Fine Art Gallery, New York. © Mariana Yampolsky. Exhibition Fund, Centro de la Imagen, Mexico City. Mariana Yampolsky's work is part of UNESCO's Memory of the World Programme, Mexico (2021); **pp. 280–1** © Courtesy Tayfun Serttaş; **p. 282** © Eve Arnold/Magnum Photos; **p. 283** © Estate of Iryna Pap; **p. 284** © Harry Ransom Center, The University of Texas at Austin; **p. 285** © Inge Morath/Magnum Photos; **pp. 286–7** Janine Niépce/Roger-Viollet; **p. 288** © Estate of Vivian Maier. Courtesy Maloof Collection and Howard Greenberg Gallery, New York; **p. 289** Digital image International Center of Photography, New York. Helen Levitt © Film Documents LLC. Courtesy Galerie Thomas Zander, Cologne; **p. 290** Private collection, Paris. Digital image Nicolas Brasseur. © All rights reserved; **p. 291** Digital image Musée du quai Branly – Jacques Chirac, Paris, Dist. RMN-Grand Palais. © Thea Segall; **p. 292** © Marilyn Silverstone/Magnum Photos; **p. 293** Digital image Jeff McLane. © Courtesy Bunny Yeager Archive and GAVLAK, Los Angeles/Palm Beach; **p. 294** © Rosalind Fox Solomon, www.rosalindfoxsolomon.com; **p. 295** Digital image Galerie Vrais Rêves, Lyon. Irina Ionesco © ADAGP, Paris and DACS, London 2022; **p. 296** Collectivité territoriale de Martinique – Musée d'archéologie, Inv. No. 2012.0.1.12/15; **p. 297** © Evelyn Richter Archiv der Ostdeutschen Sparkassenstiftung im Museum der bildenden Künste Leipzig; **p. 298** Digital image Tokyo Metropolitan Foundation for History and Culture Image Archives. Toyoko Tokiwa © Courtesy Ayuko Kuribayashi; **p. 299** © Claudia Andujar. Courtesy Galeria Vermelho, São Paulo; **p. 300** Maureen Bisilliat/Instituto Moreira Salles Collection; **p. 301** Digital image Museo Nacional de Bellas Artes, Buenos Aires. © María Cristina Orive; **p. 302** Museo Nacional Centro de Arte Reina Sofía, Madrid. Long-term loan of Fundación Museo Reina Sofía, 2016. Donation of Silvia Gold and Hugo Sigman. Photographic Archives, Register No. AD03277. Digital image Museo Nacional Centro de Arte Reina Sofía, Madrid. © Sara Facio; **p. 303** Digital image courtesy Istanbul Museum of Modern Art. © Courtesy Yıldız Moran Archive; **p. 304** © Xiao Zhuang; **p. 305** Private collection, Paris. Digital image Nicolas Brasseur. © Helena Almeida; **p. 306** Collection CAPC Musée d'art contemporain de Bordeaux. Digital image Photo ISO © Estate Bernd and Hilla Becher, represented by Max Becher. Courtesy Die Photographische Sammlung/SK Stiftung Kultur – Bernd and Hilla Becher Archive, Cologne; **p. 307** © Jo Spence Memorial Archive, Ryerson Image Centre, Toronto; **p. 308** Museu Nacional d'Art de Catalunya, Barcelona. Long-term loan from the Generalitat de Catalunya. National Photography Collection, 2017. Digital image Museu Nacional d'Art de Catalunya, Barcelona 2022. © Arxiu Joana Biarnés, Barcelona; **p. 309** Digital image International Center of Photography, New York. © Letizia Battaglia; **p. 310** © Felicia Abban. Courtesy Exit Frame Collective; **p. 311** The Museum of Modern Art, New York. Gift of the Contemporary Arts Council, Object Nos. 156.1989.a, 156.1989.b, 156.1989.d. Digital image 2022, The Museum of Modern Art, New York/Scala, Florence. Anna and Bernhard Blume © DACS 2022; **p. 312** Courtesy ZW Foundation/Natalia LL Archive, Toruń; **p. 313** © Joan Lyons, collection of The Museum of Modern Art, New York; **p. 314** © Marianne Wex. Courtesy Tanya Leighton, Berlin; **p. 315** © Martine Franck/Magnum Photos; **p. 316** Private collection, Paris. Digital image Nicolas Brasseur. © Courtesy the estate of Ferenc

Index

Numerals in *italics* indicate illustrations

Index

502